PERU
KINGDOMS OF THE SUN AND THE MOON

PERU KINGDOMS OF THE SUN AND THE MOON

Edited by Victor Pimentel

With the cooperation of
Walter Alva
Ulla Holmquist
Natalia Majluf
Luis Eduardo Wuffarden

THE MONTREAL MUSEUM OF FINE ARTS

President
Brian M. Levitt

Director and Chief Curator
Nathalie Bondil

Director of Administration
Paul Lavallée

*Director of Communications
and Director of the Montreal Museum
of Fine Arts Foundation*
Danielle Champagne

The Montreal Museum of Fine Arts would like
to thank Scotiabank for agreeing to sponsor
the Montreal presentation of the exhibition.

The exhibition benefits from the invaluable support
of the Volunteer Association of the Montreal Museum
of Fine Arts, whose fundraising activities enable
the Museum, among other things, to publish art books
related to many of its exhibitions.

The international exhibition program of the Montreal
Museum of Fine Arts receives financial support from
the Paul G. Desmarais Fund and the Exhibition Fund
of the Montreal Museum of Fine Arts Foundation.

The Museum wishes to thank the Volunteer Guides
of the Montreal Museum of Fine Arts for their
unflagging support. The Museum is also grateful
to its members and the many corporations,
foundations, and individuals for their contributions,
and, in particular, the Arte Musica Foundation,
headed by Pierre Bourgie, and the Fondation
de la Chenelière, headed by Michel de la Chenelière.

The Museum would also like to acknowledge
the essential assistance of Quebec's Ministère
de la Culture et des Communications, as well as
express its gratitude to the Conseil des arts
de Montréal for its ongoing support. Finally,
the Museum thanks Astral Media, *La Presse*
and *The Gazette*, its media partners, and Air Canada,
its official transportation partner.

CATALOGUE

THE MONTREAL MUSEUM OF FINE ARTS

Edited by
Victor Pimentel
Archaeologist and Curator of Pre-Columbian Art

Publisher
Francine Lavoie
Head, Publishing Department

Production Assistant
Sébastien Hart
Publishing Assistant, Publishing Department

Editorial Coordination
Erell Hubert
Ph.D. candidate in Archaeology, Cambridge University

Revision and Translation
Donald Pistolesi
Kathleen Putnam

Technical Support
Magdalena Berthet

5 CONTINENTS EDITIONS

Editorial Coordination
Laura Maggioni
assisted by
Daniele Mignanego

Translation
Imogen Foster
Isabel Ollivier

Editing
Charles Gute

Art Direction
Annarita De Sanctis

Maps and Layout
Giorgia Bianchi

Production Manager
Enzo Porcino

Colour Separation
Pixel Studio, Milan

The exhibition *Peru: Kingdoms of the Sun and the Moon* is conceived, organized, and toured by The Montreal Museum of Fine Arts.

EXHIBITION VENUES
Canada
The Montreal Museum of Fine Arts
Jean-Noël Desmarais Pavilion
February 2 to June 16, 2013

Summer Educational Program
June 17 to September 15, 2013

United States
Seattle Art Museum
October 17, 2013 to January 5, 2014

The Montreal Museum of Fine Arts would like to offer its thanks to the government of the Republic of Peru and, in particular, to the Ministry of Culture for their assistance and support in organizing this exhibition.

CURATORIAL AND SCIENTIFIC COMMITTEE

Under the Directorship of
Nathalie Bondil
Director and Chief Curator
The Montreal Museum of Fine Arts

Curator
Victor Pimentel
Archaeologist and Curator of Pre-Columbian Art
The Montreal Museum of Fine Arts

Assistant Curator
Erell Hubert
Ph.D. candidate in Archaeology
Cambridge University

Scientific Committee
Walter Alva
Archaeologist
Director
Museo Tumbas Reales de Sipán, Lambayeque
Director of the excavations of the royal tombs
of Sipán following their discovery in 1987

Ulla Holmquist
Archaeologist
Curator of Collections
Museo Larco, Lima

Natalia Majluf
Director and Chief Curator
Museo de Arte de Lima
Specialist in 18th- and 19th-century Peruvian art

Luis Eduardo Wuffarden
Independent researcher and curator
Specialist in colonial and post-colonial Peruvian art
Member of the Instituto Riva-Agüero
and of the Cultural Committee of the Museo
de Arte de Lima

PRODUCTION OF THE EXHIBITION

General Coordination
Pascal Normandin
Head, Exhibitions Management
The Montreal Museum of Fine Arts

Architecture and Museography
Sandra Gagné
Head, Exhibitions Production
The Montreal Museum of Fine Arts

Exhibition Layout and Setting
Projectiles, Paris

▪ Acknowledgements

We are deeply grateful to all individuals
and institutions who contributed to the exhibition
and this catalogue, especially:

Ministerio de Cultura, Lima
Luis Peirano Falconí, Minister
Rafael Varón Gabai, Deputy Minister of Cultural
 Heritage and Cultural Industries
Ana María Hoyle Montalva, Director General
 of Cultural Heritage
Luisa María Vetter Parodi, Director of Museums
 and Moveable Heritage

And, in particular, our partners at the Seattle Art
Museum, for their professionalism, their implication
and their enthousiasm.

Seattle Art Museum
Charles Wright, Board Chair
Winifred Stratton, Board President
Kimerly Rorschach, Director
Chiyo Ishikawa, Deputy Director of Art
Lowell Bassett
Barbara Brotherton
Zora Hutlova Foy
Sandra Jackson-Dumont
Lauren Mellon
and their teams

LENDERS
We sincerely thank the administration and staff
of the museums, public and private, as well
as the private collectors who generously agreed
to loan works in their collections to this exhibition:

CANADA
**Bibliothèque et Archives nationales du Québec,
Montreal**
Lisa Miniaci
Isabelle Robitaille

**Centre Canadien d'Architecture /
Canadian Centre for Architecture, Montréal**
Mirko Zardini, Director and Chief Curator
Iglika Avramova
Julia Dawson

Private Collection, Québec

Royal Ontario Museum, Toronto
Janet Carding, Director and CEO
Arlene Gehmacher
Barb Rice
Nicola Woods

FRANCE
Musée du quai Branly, Paris
Stéphane Martin, President
Karim Mouttalib, Deputy Director General
Constance Dereux
Almudena Hitier
Paz Núñez-Regueiro

GERMANY
Museum für Völkerkunde, Hamburg
Wulf Köpke, Executive Director
Bernd Schmelz, Director, Scientific Department
Anja Battefeld
Christine Chávez

PERU
Archivo Fotográfico Martín Chambi, Cuzco
Teo Allain Chambi, Director

Barbosa-Stern Collection, Lima
Aldo Barbosa Stern
Silvia Stern de Barbosa

José Carlos Delgado Collection, Lima

Vivian and Jaime Liébana Collection, Lima

Pastor de la Torre Collection, Lima
Celso Pastor Belaúnde
María Isabel Pastor Besoain

Private Collection, Lima

**Susana and Álvaro Roca-Rey Miro
Quesada Collection, Lima**

Mónica Taurel de Menacho Collection, Lima

**Escuela Nacional Superior Autónoma
de Bellas Artes del Perú, Lima**
Luis Guillermo Cortés Carcelén, Director
Luz Fabiola Figueroa Cárdenas

**Fundación Miguel Mujica Gallo, Museos
"Oro del Perú" – "Armas del Mundo," Lima**
Milagros Mujica Diez Canseco, Director
Pedro Mujica Diez Canseco, Director
Victoria Mujica Diez Canseco, Director
Patricia Arana Bullón

Monasterio Nuestra Señora del Prado, Lima
Reverend Mother E. Córdova Huertas,
 Superior General
Reverend Mother Yenny Bulnes, Vicar General

**Municipalidad Metropolitana de Lima
Pinacoteca Municipal "Ignacio Merino"**
Susana Villarán de La Puente, Mayor
Pedro Pablo Alayza Tijero
Susana Córdova Ávila
Mary Takahashi Huamancaja

Museo Arqueológico Nacional Brüning
de Lambayeque
Carlos Wester La Torre, Director

Museo Banco Central de Reserva del Perú, Lima
Museo Numismático del Perú, Lima
Cecilia Bákula Budge, Director
Jacqueline Daza Pinillos
Rina Manche Espinoza

Museo de Arqueología, Antropología e Historia,
Universidad Nacional de Trujillo
Ricardo Morales Gamarra, Director
Enrique Vergara Montero, Administrative Director
María Isabel Paredes Abad

Museo de Arte de Lima
Natalia Majluf, Director and Chief Curator
Cecilia Pardo Grau
Claudia Pereyra Iturry
Pilar M. Ríos Ramírez
Maria Inés Velarde

Museo de Arte del Sur Andino, Urubamba
José Ignacio Lámbarri Orihuela, Director
Juan Carlos Lámbarri Orihuela

Museo de Artes y Tradiciones Populares, Instituto
Riva-Agüero, Lima
Luis Repetto Málaga, Director
Claudio Mendoza Castro

Museo de la Nación, Lima
Luisa María Vetter Parodi, Director
Margarita Ginocchio Lainez-Lozada, Director
 until 2011

Museo de Sitio Chotuna, Lambayeque
Marco Antonio Fernández Manayalle, Director

Museo de Sitio de Huaca Rajada, Sipán
Luis Chero Zurita, Director
Ceyra Pasapera Rojas
Carmen Isabel Urteaga López

Museo de Sitio Túcume
Bernarda Delgado Elías, Director
Alfredo Narváez Vargas

Museo Larco, Lima
Andrés Álvarez Calderón Larco, Director
Rocío Aguilar Otsu
Isabel Collazos Ticona
Ulla Holmquist Pachas

Museo Nacional de Arqueología, Antropología e
Historia del Perú, Lima
Carmen Teresa Carrasco Cavero, Director
Merli Costa Castro
Luis López Flores
Jaime Mariazza Foy
Miguel Ángel Vidal Trujillo

Museo Nacional de la Cultura Peruana, Lima
Soledad Mujica Bayly, Director
Fedora Martínez Grimaldo
Luis Ramírez León

Museo Nacional Sicán, Ferreñafe
Carlos G. Elera Arévalo, Director
Víctor Curay Rufasto

Museo Pedro de Osma, Lima
Patricia Pinilla Cisneros, Director
Andrea García Ayulo

Museo Tumbas Reales de Sipán, Lambayeque
Walter Alva Alva, Director
Edgar Bracamonte Lévano
Lourdes León Ángeles

Pontificia Universidad Católica del Perú, Lima
Programa Arqueológico San Losé de Moro, Lima
Marcial Antonio Rubio Correa, Rector
Luis Jaime Castillo Butters
Enrique Gonzáles Carré
Peter Kaulicke
Luis Armando Muro Ynoñán
René Ortiz Caballero

Mario Testino

Universidad Nacional de Ingeniería, Lima
Aurelio Padilla Ríos, Rector
Fernando Caller Salas, Director of the Central Office
 of Culture
Eilen Alva M.
Álvaro Montaño Freire

Universidad Nacional de Trujillo
Proyecto Arqueológico Huacas del Sol y de la Luna,
Trujillo
Santiago Uceda Castillo, Director
Nadia Gamarra Carranza
Ana Sofía Linares Alvarado
Moisés Tufinio Culquichicón

UNITED STATES
American Museum of Natural History, New York
Ellen V. Futter, President
Laurel Kendall, Chair, Division of Anthropology
Samantha Alderson
Sumru Aricanli
Barry Landua
Kristen Mable
Mary Lou Murillo
Charles Spencer

Hispanic Society of America, New York
Mitchell A. Codding, Director
Marcus Burke
Margaret E. Connors McQuade
Patrick Lenaghan
Daniel A. Silva

The Metropolitan Museum of Art, New York
Thomas P. Campbell, Director
Caitlin Carrigan
Julie Jones

The Museum of Modern Art, New York
Glenn D. Lowry, Director
Cornelia H. Butler
Lily Goldberg
Eva Respini
Cora Rosevear
Jennifer Schauer

New Orleans Museum of Art
Susan Taylor, Director
Jennifer Ickes
Marie-Page Phelps
Lisa Rotondo-McCord
Paul Traver

Pace/MacGill Gallery, New York
Kimberly Jones, Director

The Irving Penn Foundation, New York
Tom Penn, Executive Director
Dee Vitale-Henle, Associate Director
Matthew Krejcarek

Seattle Art Musuem
Kimerly Rorschach, Director

Yale Peabody Museum of Natural History,
New Haven
Derek E.G. Briggs, Director
Richard L. Burger
Roger Colten
Jason Nesbitt
Lucy C. Salazar

CONTRIBUTORS
We are also deeply indebted to the people and
institutions of Peru and elsewhere who gave us
their support throughout the various stages of the
exhibition and catalogue's development, or who
contributed in various ways:

Peruvian and Canadian diplomatic representatives:

Embassy of Canada in Peru and Bolivia, Lima
Patricia Fortier, Ambassador
Andrea Voto-Bernales

Embassy of Peru in Canada, Ottawa
Harold Forsyth Mejía, Ambassador

Consulate General of Peru in Montreal
Doris Sotomayor-Yalán, Consul General
Lucía Trinda de Buitrón, Consul General until 2012

For the restoration of Pre-Columbian textiles
from the collection of the Montreal Museum
of Fine Arts in the exhibition:

Centre de Conservation du Québec
René Bouchard, Director
Daniel Bastille, Director until 2012
Louise Lalonger, Textile Studio Representative
Jacques Beardsell
Nicole Charley
Rachel Dessaints
France-Éliane Dumais

Art Resource, New York
Jennifer Belt, Associate Permissions Director

Biblioteca Nacional del Perú, Lima
Ramón Elías Mujica Pinilla, Director
Natalia T. Deza de la Vega
Manolo Ramos Zegarra

Bibliothèque Nationale de France, Paris
Virginie Raimbault

Dumbarton Oaks Research Library and Collection,
Washington, D.C.
Jan M. Ziolkowski, Director
Francisco López
Colin McEwan
Juan Antonio Murro
Joanne Pillsbury

Fowler Museum at University of California Los Angeles
Christopher B. Donnan
Don McClelland

Ibero-Amerikanisches Institut, Berlin
Gudrun Schumacher
Gregor Wolff

Museo de América, Madrid
Nuria Moreu Toloba

Museo de Arqueología y Antropología, Universidad Nacional Mayor de San Marcos, Lima
Pieter Van Dalen Luna, Director
Fernando Federico Fujita Alarcón, Director until 2012

Museo de Arte Religioso, Arzobispado del Cusco
Mgr. Juan Antonio Ugarte Pérez, Archbishop of Cuzco
Juan Girón Gutiérrez

Museo de la Casa Nacional de Moneda, Fundación Cultural BCB, Potosí
Rubén Julio Ruiz Ortiz, Director
María Luisa Soux de Wayar

Museo Machu Picchu, Universidad Nacional San Antonio Abad del Cusco
Jean-Jacques Decoster, Director
Cayo García Miranda
Oscar Paredes Pando

Musées royaux d'Art et d'Histoire, Brussels
Greet Van Deuren

National Geographic Stock
Susan G. Henry

Orden de San Agustín / Convento de San Agustín, Lima
Reverend Father Alexander Lam Alania, O.S.A., Prior Provincial
Reverend Father Edilberto Flores Hurtado, O.S.A., Superior

Phoebe A. Hearst Museum of Anthropology, University of California at Berkeley
Alicja Egbert

Proyecto Especial Arqueológico Caral-Supe, Lima
Ruth Shady Solís, Director
Marco A. Chacón Navarro
Edna Quispe Loayza

Real Biblioteca de Madrid
Silvia Rueda

And:
Jacqueline Aranibar Ávila
Geoffrey Baker
Adelma Benavente
Christine and Jacques Blazy
Luis Martín Bogdanovich Mendoza
Roxana Chirinos Lazo
César Coloma Porcari
Thomas B. F. Cummins
Marina J. Crovari
Sebastián Ferrero
Carole Fraresso
Ana María Gálvez Barrera
Jorge Gamboa Velásquez
José García Bryce
Daniel Giannoni Succar
José Miguel Goytisolo Vega
Rossana Kuon Arce
Isabel Larco de Álvarez Calderón
Yvonne and Javier Luna Elías
Gerardo Moreno Arias
Vilma Real Macedo
Krzysztof Makowski
Luis Millones Santagadea
Sébastien Petrie
Luisa Spissu de Pimentel
Ignacio Prado Pastor
Joaquín Rubio Roach
Isabel Sabogal Dunin Borkowski
Flor de María Salas Salas
Mónica Taurel de Menacho
Sandra Téllez Cabrejos
Susyet Ivo Ucovich Dorsner
Fernando Villegas Torres
Luis Eduardo Wuffarden
Rosario Yori de Vivanco

Coordination in Lima for the Montreal Museum of Fine Arts
Patricia Amalia Arana Bullón

We are especially thankful to the Peruvian artists and intellectuals who gave their time to discuss various issues of the exhibition:

José Matos Mar
Víctor Pimentel Gurmendi
Ruth Shady Solís
Fernando de Szyszlo
and
Mario Vargas Llosa

SUMMER EDUCATIONAL PROGRAM
The summer educational program for this exhibition (June 17 to September 15, 2013) benefits from the generous support of Montreal institutions, for which we are most grateful:

Concordia University
Alan Shepard, President and Vice-Chancellor
Lisa Ostiguy, Interim Vice-Provost – Teaching and Learning
Joée Côté, Department Administrator, Classics, Modern Languages and Linguistics

McGill University
Heather Munroe-Blum, Principal and Vice-Chancellor
James Archibald, Director, Department of Translation Studies
Leah Moss, Director, Faculty Partnerships and Summer Studies
Jorge Bravo
Rosa Neyra Burga
Bryan Jim
Daniel Zamorano

Université de Montréal
Guy Breton, Rector
Hélène David, Vice-Rector, International Relations, Francophonie and Institutional Partnerships
Georges L. Bastin, Director, Department of Modern Languages and Literatures
Sylvie Dubuc, Director, Language Centre
Danielle Vaillancourt, head of Spanish language courses

Université de Québec à Montréal
Claude Corbo, Rector
Robert Proulx, Vice-Rector
Mónica Soto, Director, Spanish programs, Language School

YMCA International Language School, Montreal
Emmanuèl Pradel, Director
Elsa Fuentes, Pedagogical Advisor – Spanish

SYMPOSIUM
The symposium *Empire et nations du Pérou : continuités et ruptures* (April 23 to 27, 2013) stems from a collaboration between Université de Montréal and the Montreal Museum of Fine Arts. Our warmest thanks to the organizers:

Juan Carlos Godenzzi, Associate Professor, Department of Literature and Modern Languages
Catherine Poupeney Hart, Associate Professor, Department of Literature and Modern Languages
Sebastián Ferrero, Department of Art History and Film Studies

And finally, the Montreal Museum of Fine Arts especially thanks its various teams that have worked towards bringing this complicated and ambitious project to completion. We would like to mention the contributions made by interns Leslie Barry, Camille Benecchi, Pierrette Besse, Candide Harvey, Raphaëlle Occhieti, Anne Pascal and Léa Richer.

Lenders

CANADA
Bibliothèque et Archives nationales du Québec, Montreal
Centre Canadien d'Architecture / Canadian Centre for Architecture, Montréal
The Montreal Museum of Fine Arts
Private collection, Québec
Royal Ontario Museum, Toronto

FRANCE
Musée du quai Branly, Paris

GERMANY
Museum für Völkerkunde, Hamburg

PERU
Archivo Fotográfico Martín Chambi, Cuzco
Barbosa-Stern Collection, Lima
José Carlos Delgado Collection, Lima
Vivian and Jaime Liébana Collection, Lima
Private Collection, Lima
Pastor de la Torre Collection
Álvaro and Susana Roca-Rey Collection, Lima
Mónica Taurel de Menacho Collection, Lima

Escuela Nacional Superior Autónoma de Bellas Artes del Perú, Lima
Fundación Miguel Mujica Gallo, Museos "Oro del Perú" – "Armas del Mundo," Lima
Monasterio Nuestra Señora del Prado, Lima
Municipalidad Metropolitana de Lima Pinacoteca Municipal "Ignacio Merino"
Museo Arqueológico Nacional Brüning de Lambayeque
Museo Banco Central de Reserva del Perú, Lima
Museo de Arqueología, Antropología e Historia, Universidad Nacional de Trujillo
Museo de Arte de Lima
Museo de Arte del Sur Andino, Urubamba, Cuzco
Museo de Artes y Tradiciones Populares, Instituto Riva-Agüero, Lima
Museo de la Nación, Lima
Museo de Sitio Chotuna, Lambayeque
Museo de Sitio de Huaca Rajada, Sipán
Museo de Sitio Túcume
Museo Larco, Lima
Museo Nacional de Arqueología, Antropología e Historia del Perú, Lima

Museo Nacional de la Cultura Peruana, Lima
Museo Nacional Sicán, Ferreñafe
Museo Numismático del Perú, Lima
Museo Pedro de Osma, Lima
Museo Tumbas Reales de Sipán, Lambayeque
Pontificia Universidad Católica del Perú, Programa Arqueológico San José de Moro, Lima
Universidad Nacional de Ingeniería, Lima
Universidad Nacional de Trujillo Proyecto Arqueológico Huacas del Sol y de la Luna

UNITED STATES
American Museum of Natural History, New York
Hispanic Society of America, New York
The Metropolitan Museum of Art, New York
Museum of Modern Art, New York
New Orleans Museum of Art
Pace/MacGill Gallery, New York
The Irving Penn Foundation, New York
Seattle Art Museum
Yale Peabody Museum of Natural History, New Haven

Bringing together works from close to fifty public and private collections, the exhibition *Peru: Kingdoms of the Sun and the Moon* presents an extensive selection of pre-Columbian treasures and masterpieces from the colonial era to Indigenism, including over one hundred pieces that have never before been seen outside of Peru. The Volunteer Association of the Montreal Museum of Fine Arts is therefore very proud to be associated with this lavishly illustrated volume, which will contribute to enriching our knowledge and appreciation of all the splendours of Peruvian art.

Since 1948, the Museum's Volunteer Association, made up of many passionate and dedicated individuals, has been committed to stimulating community interest in the Museum while raising funds to support its growth and development. Each year, the Association donates over a million dollars to the Museum, funds raised through events like the annual Museum Ball, benefit soirées, cultural trips and tours, and lunchtime talks.

We hope that readers of this book will enjoy discovering more about Peru's rich artistic heritage.

Linda Greenberg
Alexandra MacDougall
Co-Presidents
Volunteer Association of the Montreal Museum of Fine Arts
2012–2013

■ Table of Contents

Authors

Walter Alva
Director, Museo Tumbas Reales de Sipán,
Lambayeque

Geoffrey Baker
Reader in Musicology
and Ethnomusicology, Department
of Music, Royal Holloway,
University of London

Nathalie Bondil
Director and Chief Curator, The Montreal
Museum of Fine Arts

Richard L. Burger
Charles J. MacCurdy Professor
of Anthropology, Yale University,
New Haven

Luis Jaime Castillo Butters
Professor of Archaeology, Departamento
de Humanidades, Pontificia Universidad
Católica del Perú, Lima

Director, Programa Arqueológico San José
de Moro

Roxana Chirinos
Museologist, Dirección de Museos y
Bienes Muebles, Ministerio de Cultura,
Lima

Thomas B. F. Cummins
Dumbarton Oaks Professor of the History
of Pre-Columbian and Colonial Art,
Harvard University, Cambridge

France-Éliane Dumais
Textile Conservator, Centre
de conservation du Québec

Carlos G. Elera
Director, Museo Nacional Sicán, Ferreñafe

Sebastián Ferrero
Lecturer and Ph.D. candidate in Art
History, Département d'histoire de l'art
et d'études cinématographiques,
Université de Montréal

Carole Fraresso
Research Associate, Museo Larco, Lima,
and Institut Français d'Études Andines,
Lima

José García Bryce
Architect, Professor in History
of Architecture, Universidad Nacional
de Ingeniería, Lima

Ulla Holmquist
Curator of Collections, Museo Larco, Lima

Erell Hubert
Lecturer and Ph.D. candidate
in Archaeology, Cambridge University

Natalia Majluf
Director and Chief Curator, Museo de Arte
de Lima

Krzysztof Makowski
Professor in Archaeology, Departamento
de Humanidades, Pontificia Universidad
Católica del Perú, Lima

Fedora Martínez
Ethnologist, Ministerio de Cultura, Lima

Luis Millones
Emeritus professor in Social Sciences, Universidad Nacional Mayor de San Marcos, Lima

Director, Fondo Editorial, Asamblea Nacional de Rectores del Perú

Soledad Mujica
Director, Museo Nacional de la Cultura Peruana

Alfredo Narváez Vargas
Archaeologist, Museo de Sitio Túcume

Cecilia Pardo Grau
Curator of Collections and Curator of Pre-Columbian Art, Museo de Arte de Lima

Sébastien Petrie
Independant researcher, Montreal

Victor Pimentel
Archaeologist and Curator of Pre-Columbian Art, The Montreal Museum of Fine Arts

Lucy C. Salazar
Research associate, Yale University, New Haven

Bernd Schmelz
Director, Scientific Department, Museum für Völkerkunde, Hamburg

France Trinque
Art Historian, The Montreal Museum of Fine Arts

Santiago Uceda Castillo
Professor of Archaeology, Departamento de Arqueología y Antropología, Universidad Nacional de Trujillo

Director, Proyecto Arqueológico Huacas del Sol y de la Luna

Fernando Villegas
Ph.D. candidate in Art History, Universidad Complutense de Madrid

Carlos Wester La Torre
Director, Museo Arqueológico Nacional Brüning de Lambayeque

Director, Proyecto Chotuna-Chornancap

Luis Eduardo Wuffarden
Independant curator and researcher, Lima

Rosario Yori
Editor in Chief, PuntoEdu, Pontificia Universidad Católica del Perú, Lima

Master's student in Journalism, Arthur L. Carter Journalism Institute, New York University

The Twenty-first Century Opposes the "Poaching of Memory"[1] From Artwork to Cultural Property: A History of Peruvian Identity

Nathalie Bondil
Director and Chief Curator
The Montreal Museum of Fine Arts

Peru, with its millennia-old culture, is now considered one of the six cradles of civilization, along with Mesopotamia, Egypt, India, China, and Mexico. This recently earned recognition is fundamental to constructing and recovering the identity of a long-colonized country. Unlike the rest of these cultures (except Mexico, where the thread of centuries of history has come down to us through writings and accounts dating back to ancient times), Peru's status was not established until the late twentieth century. Archaeologists played a critical role in this recognition—so vital to a young nation—by interpreting both material and non-material heritage. The archives of pre-Hispanic history have long been a closed book and, in the absence of a written tradition, are likely to remain so indefinitely. The colonial period's thirst for gold led to the melting down of objects, and their memory disappeared along with them. The slaughter of the indigenous peoples and the destruction of their cultures during the Viceroyal period meant that only glimmers of the syncretism that makes up the nation today have filtered through.

Another kind of destruction, paradoxical in that it was the basis for a re-evaluation of history, began with the archaeological adventure, which must not be judged according to anachronistic scientific or ethical standards. The "rediscovery" of Machu Picchu in 1911 by the American Hiram Bingham took hold as the symbolic cornerstone of the building of a collective patriotic memory in the twenty-first century. Impressive ceremonies in conjunction with the inauguration of the first indigenous president of the Republic of Peru, Alejandro Toledo—in Inca costume—took place on the site of the sanctuary itself in 2001. Ten years later, for the centennial of "One Hundred Years of Machu Picchu in the World," an exhibition at the Palacio de Gobierno in Lima, under the auspices of Peru's Instituto Nacional de Cultura, marked the return of some 360 objects and 1,000 fragments from a total of 46,000 artifacts that had been carried off to Yale University in the United States between 1912 and 1916 subsequent to Bingham's sensational expedition; they were not gifts but on loan for eighteen months. The entire "Yale collection" is to be repatriated by the end of 2012, which will make possible the establishment of a museum and study center in Cuzco. This highly acclaimed outcome brought years of demands to a felicitous conclusion, with an agreement between the two parties that preserves their exchange of academic research.[2] In rural areas, local residents are also increasingly aware of the need for heritage protection and recovery because of the potential impact on their economy and tourism, and no longer only for nationalistic reasons.

Although Peruvian legislation has prohibited illegal excavations since 1893, it has nevertheless proved to be ineffectual in curbing the collection of protected objects, since those in possession of them need only declare them in order to legitimize their right of ownership: "It's as if growing coca leaves was illegal but using cocaine was not."[3] This is why Peru, which has inestimable riches in keeping with the stature of the extraordinary Andean civilization, is notorious as a country whose archaeological sites suffer large-scale pillaging. This massive drain, which reached its peak in the late 1980s, fuels a lucrative black market that extends its network around the world; the path from pillager to collector is complex and difficult to trace. However, international conventions protecting archaeological heritage—the UNESCO agreement of 1970 and the more stringent UNIDROIT (International Institute for the Unification of Private Law) agreement of 1995[4]—have made possible sensational seizures in foreign countries. The effects of looting have brought the cultural disaster inherent in the loss of historical memory to the attention of international public opinion: long legitimized by art lovers and collectors for their aesthetic and intrinsic value, artworks—partial in both senses of the word—assume a role as witness to non-material culture

once they are considered in their whole context. Therefore, public and private collections have become the focus of increasingly insistent demands on the part of governments.

In 2008, Peru's Instituto Nacional de Cultura exhibited 45 of the 207 archaeological pieces recovered from the charismatic Costa Rican collector Leonardo A. Patterson. Seized in Munich after being stored in Galicia for more than ten years (in this case, Spain could defend its ownership under its laws), this restitution marked the beginning of cooperation between the two countries, Peru asserting its rights for the first time in the face of Spain. Presented with great pomp in November 1996 in Santiago de Compostela, in an exhibition entitled *O espírito da América Prehispánica, 3.000 años de cultura* (the catalogue of the collection was published in English in the United States in 1997),[5] this outstanding group had been offered for purchase to the government of Galicia. Research quickly confirmed that the majority of the pieces had been looted, as some well-known experts had already pointed out: of the 1,500 objects catalogued, 1,100 were from illegal digs. From the same collection, a spectacular Mochica gold forehead ornament from the fourth or fifth century (cat. 140) representing a terrifying sea god surrounded by eight tentacles was intercepted in a London gallery by Scotland Yard, pursuing a lead in 2004 from a private informer, Michel van Rijn. Instantly dubbed the "Peruvian Mona Lisa," the famous Mochica octopus recovered in 2006 by the Peruvian authorities was displayed at the Museo de la Nación in Lima. According to archaeologist Walter Alva, it came from the illegal excavation of a tomb at La Mina in the Jequetepeque Valley, which had been extensively pillaged in 1988. The present Canadian exhibition of this symbol of the war on art trafficking is its first showing outside Peru since its edifying and incredible story. Although Peru can derive satisfaction from the international cooperation among governments and Interpol in what has become an effective campaign, the defendants in such disputes always oppose their good faith (on the grounds of ignorance and acquisition date—prior to 1970, naturally) to investigators' concern to trace the provenance of the pieces. To be continued . . .

According to the Peruvian section of Interpol, in 2011 Peru was the Latin American country most affected by antiquities trafficking, followed by Bolivia and Mexico. However, the success of an active policy of combating this trafficking is undeniable. With 2,700 objects recovered in the past five years, Peru, as described by Ministerio de Cultura spokesperson Blanca Alva at a workshop held in conjunction with UNESCO in Lima in October 2012, is "the world's leader in repatriation, recuperation and in resolving cases . . . In the past few years, we have resolved almost 50 cases in 14 countries." On the same occasion, ICOM (the International Council of Museums) added, "nevertheless, the number of clandestine excavations at archaeological sites has increased, as have thefts from churches and museums" in Peru because "the wide variety of artifacts and historical periods make it particularly difficult to provide adequate protection." ICOM concluded that "illicit trade in Peruvian cultural property causes irreparable damage to the country's heritage and identity, and constitutes a serious loss for the memory of mankind."[6]

In fact, this policy results from the quest to reclaim an identity that is at the core of our undertaking. *Peru: Kingdoms of the Sun and the Moon* explores for the first time the founding images of modern Peru through the representation and reinterpretation of myths, rituals, and other primordial identity symbols, which have survived through the centuries in contrasting artistic traditions. This book follows three stages in the development of a living cultural identity. First, it explores the myths and rituals of ancient Peruvian cultures, their role in forming Andean cosmology, and the symbols later periods continued to draw upon. Next, it shows how they were perpetuated, concealed, and hybridized under the Spanish Viceroyalty. And finally, it considers their resurgence, affirmation, and transformation in the modern era, especially through the *indigenista* movement, whose superb but little-known art proclaims the pride of an independent nation.

In continuity with *Cuba: Art and History, from 1868 to Today*, we wished to offer another exploration of the American continent beyond aesthetics and history. We thank all those who contributed to this original endeavor, in particular our many contributors and individual and institutional partners in Peru, especially the Ministerio de Cultura, in the United States, among them the Seattle Art Museum, and elsewhere. We are also deeply grateful to our devoted and enthusiastic staff, who have worked in the spirit of a Montreal Museum of Fine Arts . . . and of civilizations.

1. This expression is from Laurent Flutsch and Didier Fontannaz, *Le pillage du patrimoine archéologique* (Lausanne: Éditions Favre SA, 2010).

2. "Yale to Return All Machu Picchu Artifacts by December 2012," *Andean Air Mail & Peruvian Times* [Lima], March 31, 2011.

3. See Mariana Mould de Pease, "Los mochicas, sus herederos y el rescate de un tocado prehispánico," *Uku Pacha*, 5/10 (December 2006): 112. This historian also exposed the criminal origins of the Patterson collection at 69th Annual Meeting of the Society for American Archaeology in Montreal (March 31–April 4, 2004).

4. In June 2012, 122 countries ratified the first, and only 32 the second.

5. Mariano Cuesta Domingo, ed., *Prehispanic America: Time and Culture (2000 B.C.–1550 A.D.)* (New York: Epsy Art, 1997).

6. "Peru Recovers 2,700 Pieces of Cultural Property over Past Five Years," *Andean Air Mail & Peruvian Times* [Lima], October 25, 2012.

A Word from the Peruvian Minister of Culture

Luis Alberto Peirano Falconí
Peruvian Minister of Culture

Peru: The Kingdoms of the Sun and the Moon provides the perfect opportunity to showcase the fertile culture of the country. The history and identity of the nation's societies, past and present, lives in each of the works in the exhibition. These pieces reflect the Peru of yesteryear and today, and constitute a heritage that must be preserved, for they represent who we are and where we are going. The care we take of these objects—and of our heritage overall—will prevent these symbols belonging to our collective memory from disappearing over time and will foster deep-rooted social unity.

Each work in the exhibition stands out for its artistic merit and ingenuity, while also bearing witness to a society that came before. The examples of pre-Inca and Inca pottery and metalwork, colonial paintings, and contemporary folk art all testify to historical developments and sustain every Peruvian's sense of identity. The country's culture inhabits all of these items, which tell the story of the permanency and adaptability of the symbols, imagery, myths, and legends transmitted to us through the ages, whether applied to new mediums, merged, syncretised, or even reinvented. They also exhibit the exquisite artistry and technical prowess of the societies that made them. The underlying symbolic content of these objects provides the basis of this exhibition, which examines Peru as an imagined community whose identity is constantly redefined.

This rich cultural heritage requires preservation and protection, not only in terms of care and conservation or restoration work, but also in terms of policies to curb illegal trafficking. Notably, along these lines, nearly 2,700 Peruvian cultural artifacts have been recovered in the last five years, making Peru a world leader in the recovery and repatriation of cultural property. Nevertheless, our greatest efforts are being directed toward a reappraisal of heritage as a preventive measure against having cultural property taken from the country illegally.

This exhibition includes a symbol of Peru's fight against the illegal trafficking of its cultural property: the Mochica gold forehead ornament with anthropomorphic face and eight tentacles, stolen away from the country in 1988 and fortunately recovered in London by Scotland Yard and repatriated to Peru in 2006. This ornament, away from its place of permanent display in Lima only to grace this exhibition, stands for many things, including a new appreciation of the country's past, the fight against the illegal trafficking of cultural property, and what is behind Peruvian cultural identity.

We hope that this exhibition and the invaluable information provided in this catalogue on the works and the contexts in which they were made will contribute to a greater knowledge of Peru and to an appreciation of the country's cultural heritage, the nation's pride. This exhibition and the accompanying catalogue, prepared and produced by the Montreal Museum of Fine Arts, are without a doubt an important means to understanding Peru.

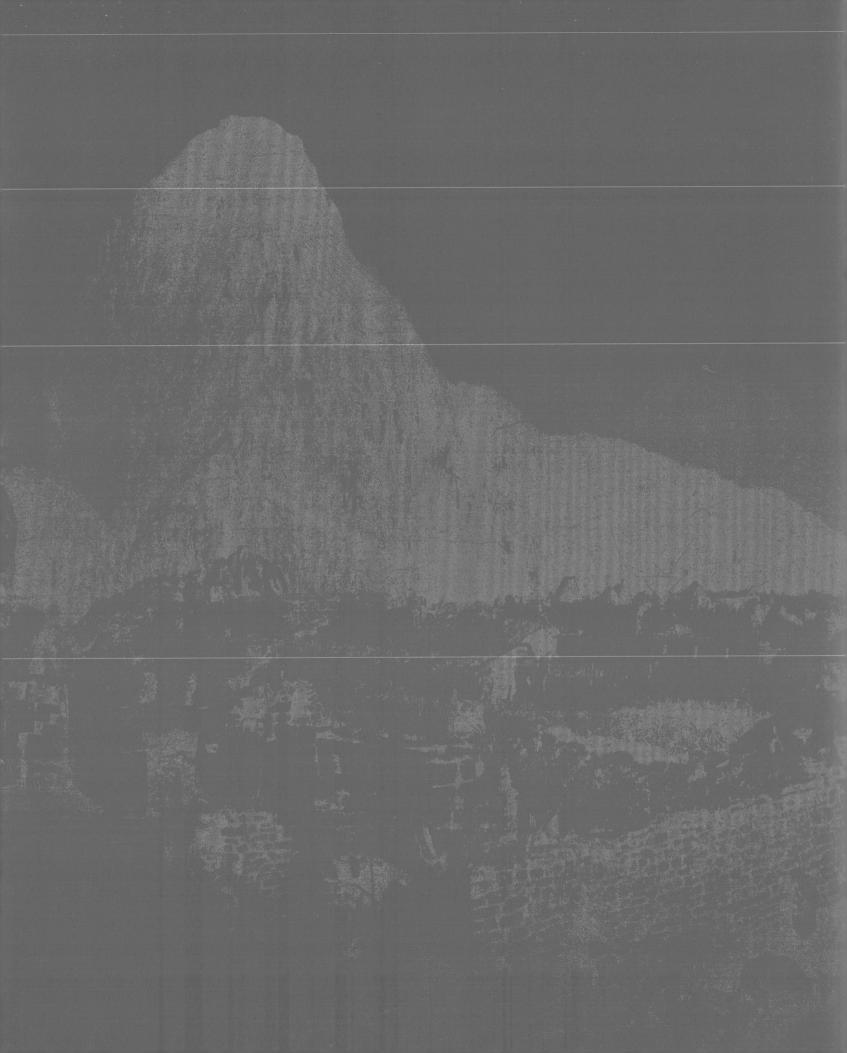

Peru: Kingdoms of the Sun and the Moon

Victor Pimentel – Erell Hubert

With the official proclamation of 2011 as a celebration of "One Hundred Years of Machu Picchu in the World," the government of Peru underscored the scientific discovery of this major historical Inca sanctuary—one of the seven wonders of the modern world and a UNESCO World Heritage site since 1983. Machu Picchu is an icon of Peruvians' common identity, and its discovery is surely one of the most important milestones in the reappropriation of ancient Peru.

This centennial celebration culminated in the initiation of the return of all the artifacts found by the Yale University expeditions to Machu Picchu, a measure that was the result of protracted and complex negotiations. It is estimated that by 2013, all this material—a total of 46,311 objects and fragments that have been in the United States for nearly a century—will have been returned to Peru.

These events, which captured the attention of the Peruvian and international press, not only revealed the importance of cultural heritage in the collective Peruvian imagination but also awakened a profound satisfaction and engendered national pride. In an interview with the local press, Peruvian archaeologist Luis Jaime Castillo referring to the return of the objects taken from Machu Picchu summed up these sentiments: "Now that they are on our native soil, we can indeed feel satisfied. We will surely go to see them at the Palacio de Gobierno or, better yet, at the Casa Concha in Cuzco, to immerse ourselves in 'Peruvianness' in the Andean atmosphere" (Castillo 2011).

"Peruvianness," a nationalistic feeling rooted in the very beginnings of the republic, does not take the form of a specific image but is expressed through symbols and various cultural phenomena. A feeling that bonds the peoples and inhabitants of Peru of predominantly native and Creole ancestry (Vega 1997), Peruvianness represents what Benedict Anderson (1993) has called the "imagined community," a socially constructed nation whose collective identity, based on the colonial heritage and the indigenous presence, is essential to national unity.

In constructing this national Peruvian identity, special importance was given to the constant commemoration of a past rediscovered and reinvented through a series of founding symbols and myths. It is precisely in this context that the evocative power of images plays a leading role in the history of ancient, colonial, and modern Peru.

From this perspective, by seeking a deeper understanding of the symbolic content of artworks and their role during different periods, it is possible to base a consideration of the ongoing construction of Peru's rich identity on a dialogue between the varied pre-Hispanic handcraft production, the enormous artistic creation during the Viceroyalty, and the robust indigenist output from the first half of the twentieth century.

Through the representation and reinterpretation of the myths and rituals of the ancient Andean civilizations, their perpetuation, concealment, or hybridization under the Viceroyalty, and their rediscovery and reappraisal in the twentieth century, it seems possible to reconstruct the founding images of modern Peru.

Discovering the Past

Given the absence of writing in the pre-Hispanic Andes, archaeology is our main source of knowledge of the past. In the late nineteenth century and early twentieth century, scholars finally recognized the uniqueness and intrinsic value of the Native American cultures (Tello 1942). The great archaeological advances of the twentieth century—

outstanding among which are the exploration of Machu Picchu in the 1910s (Bingham 1930, 1948), the discoveries made by Rafael Larco Hoyle (1938–39, 1948) on the coast of Peru, and the discovery of the Chavín and Paracas cultures by Julio C. Tello (1943, 1960), who is considered Peru's first native archaeologist—played a decisive role in the rise and development of a national conscience characterized by the quest for a truly indigenous Peruvian identity (Castillo 2001; Burger 2009).

Sovereigns of the Sun and Moon

The central Andean region, which generally corresponds to the territory of Peru, was a cradle of civilization where rich and complex societies that produced exceptional works of art developed independently. The Caral site, on Peru's central coast, is considered the oldest city in the Americas and the emblem of the development of a decidedly unique Andean civilization originating in the third millennium B.C.

Ancient Peruvian societies played a key role in developing Andean cosmology and creating symbols that subsequent periods referred to almost constantly. The Cupisnique and Chavín cultures were vital to the crystallization of the Andean visual vocabulary around the second millennium B.C, incorporating symbolic elements from the coast, mountains, and tropical lowlands. Andean cosmology shows a central preoccupation with the organization of the world in regenerative cycles (see Holmquist in the present catalogue).

One of the main structural principles in the Andes was the concept of duality, seen in the paired arrangement of motifs and objects and the combination of materials, particularly gold and silver. Nevertheless, the interrelationship between different worlds based on geographic divisions (sea, mountains, jungle) as well as on ontological divisions (deities, death, life) was also essential in pre-Columbian Andean societies.

Deities, ancestors, and the living participated in rituals intended to guarantee the perpetuation and reproduction of society. Images of female divinities associated with the moon and male divinities associated with the sun, supernatural anthropomorphic beings that take various more-or-less naturalistic shapes, ancestors who interact with the living, and sexual relations connected with the notion of social and biological reproduction all illustrate the importance of spiritual life to pre-Columbian peoples (see Makowski in the present catalogue).

The sacrifice of human beings and animals, a favored means of establishing contact with the supernatural realm in many of the world's societies, was practiced in almost all pre-Columbian societies. The Andean cultures are distinct for their emphasis on sacrifice by throat slitting and decapitation (Benson 1999). The preference for representing animals that decapitate their prey and for offerings of skulls and trophy heads shows the importance attributed to the separation of the head from the body in rites of sacrifice, which were perceived as a vehicle of regeneration in the Andes.

The sacrificial ceremony was perhaps the most important event in the ritual calendar of the Mochicas, whose society developed on the north coast of Peru between 200 and 800 A.D. This ceremony contributed to the perpetuation of the supernatural and social orders (see Castillo in the present catalogue). The grave goods buried with the Mochica lords of Sipán can be associated with the main participants in the sacrificial ceremony (see Alva in the present catalogue).

Another essential component of Andean spirituality is the relationship with death, in particular the constant dialogue between the world of the living and the world of the dead. The ancestors continued to be actively involved in the lives of the living and even took part in political decisions. This participation was not only perceived as influences from the realm of the dead but also promoted by the prolongation of the relationship with the deceased's body. The fundamental manifestation of this corporeality in relation to death is the practice of mummification. Mummies were visited regularly by the living and were included in processions at specific celebrations (see Uceda in the present catalogue).

The ancestor cult was especially important in the Lambayeque and Chimú cultures of the north coast of Peru between the eleventh and fifteenth centuries A.D. The rich ornamentation of a corpse with jewels, masks, and weavings indicates an uninterrupted veneration of the departed and a belief in the afterlife. The continued relationship with the ancestors is also illustrated in representations of the mythical ancestor Naymlap (see Elera and Wester in the present catalogue).

In the mid-fifteenth century, the Incas established a huge empire, which they called Tahuantisuyu. This empire provides the founding myth of the Peruvian nation (Burga 2005). The pre-Hispanic Inca past was idealized and elevated to the rank of a social and political utopia. Owing to this privileged status in the Peruvian imagination and the proximity of the Incas in time, Inca beliefs and visual vocabulary became the main pre-Columbian reference in later periods (Majluf and Wuffarden 1999).

Inca art emphatically reveals the need to unify and organize a far-reaching empire, which led to the development of an imperial style—a coherent, evocative visual system employing standardized forms and geometric motifs. This effort at stylistic integration coincided with the development of a system of socio-political integration carefully organized around a complex ceremonial calendar (Zuidema 2010; see Narváez in the present catalogue).

Ancient Gods, New Gods: Conquest and Hybridization in the Andes

Spain's conquest of Peru in the sixteenth century unquestionably brought about the most drastic change the region ever experienced. The overthrow of the socio-political hierarchies, economic structure, and religious beliefs caused the destructuring and rapid fall of the Inca Empire. Colonization is an encounter, albeit intrinsically asymmetrical, between two worlds—in this case Europe and Native America.

Closely linked to the Conquest and colonization, the spread and teaching of Catholic doctrine led to important changes in the artistic production of the Andean world. Local artistic traditions were brusquely curtailed, to be replaced by European visual culture (Wuffarden 2004). European-produced images representing the new religion—prints, panel paintings, and canvases—began circulating in the Andean territory early on. Years later, during the rule of the Viceroys, mass use of these representations would become the tool of choice for transmitting knowledge and Christianizing the aboriginal peoples.

Despite the tremendous effort expended on evangelizing the conquered peoples, Catholicism could not completely efface the religious traditions of the millennial Andean world. The convergence of the two belief systems gave rise to Catholic devotions and cults that recalled or sought points in common with pre-colonial cults (see Martínez and Mujica and also Petrie in the present catalogue).

European domination of art was especially prevalent in the sixteenth and early seventeenth centuries. Artistic production for the most part imitated European models. The paintings often imitated European prints, some of which were produced in large quantities to be sent to America. The persistent work of European masters and the organization of workshops in which Creoles, mestizos, and natives were trained in the various artistic occupations favored the rise of the historical schools of painting in Peru from the last third of the seventeenth century. Local techniques and stylistic choices based on the colonial socio-cultural context were thus introduced in architecture, painting, and sculpture.

Beginning in the late seventeenth century, most of the artists working in Peru were native. It is estimated that approximately three-quarters of the Cuzco School artists were native. Highly prolific and perhaps the most important in Spanish America, the Cuzco School is remarkable for its originality and high artistic level. In it, Western artistic tradition and pre-Hispanic tradition converge. In this regard, far from being a peripheral derivative of European art (Kubler 1968), the art of the Viceroyal period in Peru is in fact the result of the hybridization of European models and native sensibilities, basically conveyed through the reinterpretation of European art, especially religious art (see Wuffarden in the present catalogue). The impact of the art produced in Cuzco was reinforced by the serial production of paintings that were distributed throughout the Viceroyalty of Peru.

The appearance of Inca symbols and figures in the art of this period tellingly illustrates both the encounter between peoples and a complex situation that intermingled the subjugation of the Incas with the recognition of some noble Inca families. The Spanish elite, in particular the Jesuits, made political alliances with noble Inca families to legitimize their own social position. The use of Inca insignias of nobility to connote the divinity of some Christian figures signals an awareness of the importance of taking into account the predominantly native population of Viceregal Peru and the use of a specific visual vocabulary.

One of the most obvious features of local artistic production is the use of local materials like agave (maguey) and cedar. Although Peruvian artists of the colonial period respected the European iconographic canons their patrons expected, their works included elements proper to the region, such as South American flora and fauna. Peruvian artists, particularly the Cuzco School painters, also showed a stylistic preference for floral ornamentation and gilding.

The painting of the late seventeenth century and the eighteenth century is characterized by a tendency towards pictorial archaism that is expressed both stylistically, for example through an apparent lack of interest in perspective, and iconographically, through the choice of medieval versions of Christian subjects. These archaic forms are not due to any lack of skill on the artists' part but rather to a confluence of factors such as local stylistic preferences, the use of prints as models, and the need for a clear visual language for spreading the Gospel to the native population.

Evangelization was a fundamental goal of Spanish colonization. From the founding of the colony, the Franciscans and Jesuits were aware of the power of images and encouraged artistic production in their efforts at

conversion. Promoted by the Counter-Reformation in Europe, the representation of the triumph of Christianity was an even more important feature of Catholic propaganda in Peru. Emphasis was placed on didactic illustrations of figures who defended Catholicism against pagans and other religions. These figures were reinterpreted in the colonial context. For example, in depictions of Santiago Matamoros (Saint James the Moor Slayer), a central figure in Spanish art, the aborigines (that is the Incas) take the place of the Moors.

The concern to evangelize the local people is also seen in the choice of alternative versions of important Christian themes and in a preference for figures that were less frequently illustrated in Europe, especially archangels. In the art of the Viceroyalty, archangels—including the apocryphal ones—frequently symbolize the Church Triumphant. By combining Christian and military prints, artists even developed a uniquely Peruvian type: the *arcángel arcabucero* (arquebusier archangel).

Local participation in the Catholic cult was further reinforced by references to local saints and divine interventions. Many paintings depict statues (frequently of the Virgin) that refer to local apparitions or to which miracles were attributed. These miraculous images coincided perfectly with indigenous beliefs in the power of idols.

A particularly popular image in art during the Viceroyalty is that of the Virgin wearing a large triangular cloak, carrying the Infant Jesus in her arms. The shape of her clothing has been related to the shape of the mountains, and she herself has been associated with the cult of Mother Earth (Pachamama). The miracles of the Virgin and the building of altars dedicated to her, at which pre-Hispanic forms of worship were conducted, suggest a Christian appropriation of sacred places and a transference of the veneration of pre-Hispanic idols to the Virgin, without there necessarily being a total rupture with the religious practices of the indigenous population.

The sculptures so frequently represented in painting were regularly carried in processions during various religious celebrations. Considering that processions were a feature of European religious practice, this tradition, in keeping with native rituals, was readily adopted by the Andean peoples. These celebrations represented Catholic propaganda in the public space but at the same time involved all segments of society. Processions thus served an important function in forging a collective Peruvian identity.

Corpus Christi was one of the first Christian feasts celebrated in the colony, and the practice has persisted to this day. It provided an opportunity for the various segments of Viceregal society to see themselves represented in public with lavish costumes, music, and dance (see Cummins and Baker in the present catalogue). Besides their religious content, these festivals provided a theatrical representation of the socio-political status of the participants and their local histories. In this sense, processions were not only collective expressions of the Christian faith but also an important site for the negotiation of identity (see Millones in the present catalogue).

The Representation of Peru

"In the future, the aborigines shall not be called Indians and natives. They are children and citizens of Peru and they shall be known as Peruvians." This decree, signed on August 28, 1821, by the Argentinean general José de San Martín, a central figure in South American independence, set the tone for a key aspect of the emerging nation of Peru: its indigenous population.

Peru had declared its independence the previous month. In order to build a nation, Peruvians had to construct a collective memory that would enable them to unify a heterogeneous population characterized by a combined pre-Columbian and colonial past. Nevertheless, the indigenous reality of nineteenth-century Peru is difficult to establish. The intelligentsia of the day tried to distinguish themselves from Spain but disparaged the natives, considering their traditions primitive and incompatible with a modern nation.

The idealization of the pre-Hispanic past, in particular the Inca Empire, and the reappropriation of this past by the people of Peru provided the groundwork essential to building the nation. This idealization of the past is frequently expressed through romantic representations of the Incas. Increased interest in local themes at this time is reflected particularly in the work of Francisco Laso. Nonetheless, Europe continued to be the main stylistic reference, and the aborigines were still represented as the Other, as was the case with *costumbrismo*, a literary and pictorial genre emphasizing and interpreting local ways.

Peruvian Indigenism

In the early twentieth century, the indigenist movement that arose throughout the Americas transformed Peru's artistic and intellectual milieus through a reappraisal and reaffirmation of the Peruvian native heritage. The native Peruvian then passed from the status of Other to symbol of the nation. The symbol of a glorious past and a socio-

political utopia, this native was also a fictional type with whom not only the local peoples identified but also the mestizos and the Creoles, that is, Peruvian-born descendants of Europeans (see Majluf in the present catalogue).

The creation of the emblematic native marks a distinct change in attitude towards the native population. In fact, an indigenist political movement led by José Carlos Mariátegui set out to expose the political and economic exploitation of native people and defend them against specific problems. The contribution of various artists to publications at the time, especially the magazine *Amauta*, directed by Mariátegui, shows that pictorial and literary expressions of indigenism were inseparable from a broader intellectual context.

The exhibition "Impresiones del Ccoscco," which José Sabogal presented in Lima in 1919, is considered the starting point for indigenism in Peruvian painting. This movement, which reached its peak in the 1920s, was headed by Sabogal and shaped by other renowned artists like Camilo Blas, Enrique Camino Brent, and Julia Codesido. Their work is characterized by bold colors and gestural brush strokes that bespeak a great originality. Indeed, indigenism was a modern art movement that broke decisively with the artistic traditions of the colonial period and the nineteenth century.

Far from limiting themselves to a particular aesthetic, indigenist artists were aware of international art trends and developed their pictorial language within the broader transformation art was undergoing in the twentieth century. These artists were generally from the mestizo or Creole elite, and they almost all traveled to Europe. Among the main artists of this movement, the only one of native origin is the photographer Martín Chambi, known for the great documentary and artistic value of his works (see Majluf in the present catalogue).

The indigenist artists' predilection for the native population took form in various mediums, like painting, photography, and printmaking. Portraits of natives are one of the movement's most characteristic aspects. Depicted as dignified persons deserving of respect, figures of aboriginal origin become references to their own political organization. These depictions are inseparable from the perception of the indigene as the symbol of a glorious past mentioned above. To Sabogal's way of thinking, moreover, the strength of character that emerges in these portraits is more important than the intention to represent actual appearances. Still, the portraits—particularly prints—endow the sitters with great individuality rather than subsuming them into an "exotic" type, as had occurred in the nineteenth century.

The depiction of native people in their natural and cultural settings also contrasts significantly with nineteenth-century depictions of indigenes and *costumbrismo*. This indicates not only a preoccupation with the way particular surroundings shaped the Peruvian people but probably also a concern for the political concept of "the land," along with an interest in indigenous traditions as a whole. Christian, native, and hybrid ceremonies and feasts, then, are essential to indigenist art. A re-evaluation of the cultural traditions of the Andean peoples of Peru was part of the indigenist agenda of revitalizing the native setting.

The indigenists lay claim to the pre-Columbian heritage, establishing a direct link between contemporary and pre-Hispanic inhabitants. In art, this claim is manifest in the interest in pre-Columbian Inca and colonial motifs. Theoretical studies of pre-Columbian artifacts and works of pre-Columbian inspiration are quite common. *Keros* decorated with figurative scenes, mainly of the Conquest and Inca authority, which the indigenists often took as a model, are in fact colonial creations whose discourse coincides with that promoted by the indigenists.

Popular Faith and Traditional Celebrations in Peru Today

The reappraisal of native traditions is consistent with the recognition of folk art. This recognition is part of the quest for "authenticity." The indigenist artists studied and represented folk art and traditional costumes in addition to encouraging the native peoples to renew their artistic and religious traditions (see Villegas in the present catalogue).

Colorful altarpieces, ceramic sculpture, and carved *mate* gourds provide magnificent examples of a richly varied art displaying stylistic combinations and unique reinterpretations that resulted from the hybridization of the pre-Columbian, colonial, and modern contributions. Folk art is furthermore an expression of living traditions, and celebrations that are still held today attest to the place of popular faith in the collective identity of contemporary Peru.

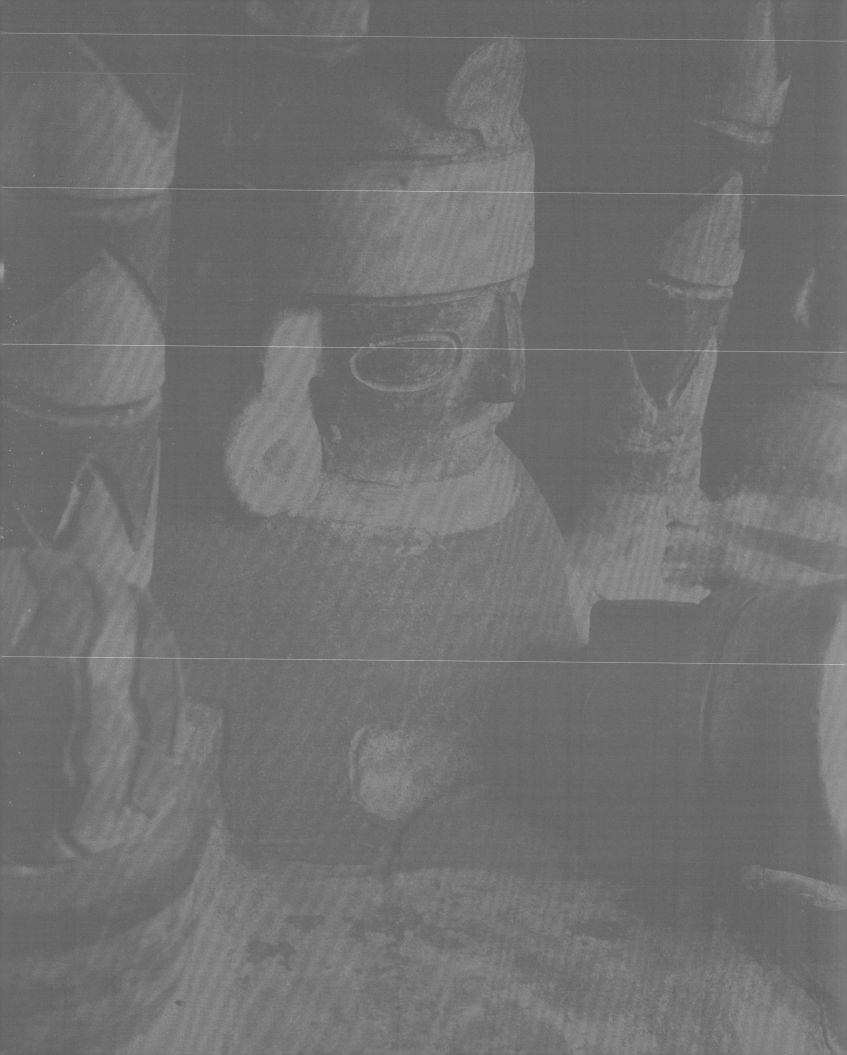

ARCHAEOLOGY
WRITING HISTORY

Hiram Bingham III and Machu Picchu: Contextualizing the "Scientific Discovery" and its Protagonist

Richard L. Burger – Lucy C. Salazar

For almost a century, the main source of information on Machu Picchu's discovery was the writings of Hiram Bingham III (1913a, 1913b, 1922, 1930, 1948). In these and other publications, Bingham presented himself as a bold explorer and fearless adventurer embodying the qualities valued in the expansive United States of the early twentieth century. The romantic image of Bingham, the explorer, reinforced by his own black-and-white photographs, has been an enduring source of inspiration for generations of potential archaeologists throughout the world, as well as for Steven Spielberg's Indiana Jones (cat. 5). His role as a serious scholar and a pioneer of Inca archaeology has received much less attention.

In fact, over the last decade, another picture of Bingham has been advanced, one that is much less sympathetic to him. In these accounts, Bingham is presented as exaggerating his role in Machu Picchu's discovery and taking credit for a find made by others. Even worse, some have claimed that Bingham plundered Machu Picchu and smuggled precious metal treasures from the site out of Peru. As if these criticisms were not enough, some revisionists have leveled the greatest slander of all by calling Bingham the first *tourist* to visit Machu Picchu.

In this essay we will explore the chasm between Bingham's traditional image and recent revisionist claims by examining the history of the three Yale Peruvian Scientific Expeditions directed by Hiram Bingham III and contextualizing the activities of Bingham within early twentieth-century Peru. We conclude that while Bingham's original image may have been a carefully crafted and self-serving portrayal, the revisionist commentaries are likewise deeply flawed. In most cases this is because these criticisms are based on late twentieth-century and twenty-first-century assumptions and attitudes, and do not attempt to understand Bingham within the historical context in which he operated.

Questioning Bingham's Role in the Scientific Discovery of Machu Picchu

On the morning of July 24, 1911, Bingham followed Melchor Arteaga, a local farmer, and Sergeant Carrasco, a military escort assigned to Bingham by the government of Peru's President Leguía, across the torrential Vilcanota River on a precarious bridge made up of logs lashed together with vines. The other members of Bingham's expedition team, naturalist Harry Foote and medical doctor William Erving, had chosen to remain in camp rather than face the flimsy bridge and the heavily wooded slopes leading up to the ruins. A fall into the Vilcanota could have been fatal, and rumors of the ruins in the forested lands above had been vague. While in Cuzco, Bingham had heard from a miner of the existence of a group of ancient buildings called "Huayno Picchu" that were finer than Choqeqquirau. Bingham connected this story to rumors of ruins called "Huaina Picchu" or "Matcho-Picchu" told decades before to the Austrian-

French explorer Charles Wiener while he was in Ollantaytambo. Wiener never reached Machu Picchu, although he did put it on his map, and the anonymous miner's account that reached Bingham had only limited credibility. Thus, Bingham did not know what to expect as he crossed the river and ascended the slopes. On the way up, Arteaga met some farmers and, since he had already visited the ruins, decided to remain behind with his friends. As a result, Bingham and Carrasco ended up being led up to Machu Picchu by a "young boy" who remained unnamed in Bingham's publications. In his early accounts, Bingham noted that several families were farming around the Inca ruins and that they had cleared some of the thick vegetation around the temple to plant "a vegetable garden."

Once at the ruins, Bingham spent several hours documenting Machu Picchu photographically and drew a sketch map of the main temple area. He was impressed by the quality of the stonework and the size of the stones, but he was not sufficiently intrigued to warrant returning to the site the next day with his colleagues; instead, when morning came, he continued down the Vilcanota Valley with Foote and Erving, still searching for "the lost city of the inca."

Bingham's description of the discovery was not published until two years after the discovery; it was repeated with minor variations in popular articles that appeared in *Harper's Monthly* (1913a) and *National Geographic* (1913b), and then elaborated upon in *Inca Land: Explorations in the*

Fig. 1. Inca, *paccha* (libation vessel) in the shape of a hand holding a *Kero* (ceremonial cup), 1450–1532 A.D., Universidad Nacional de San Antonio Abad del Cusco

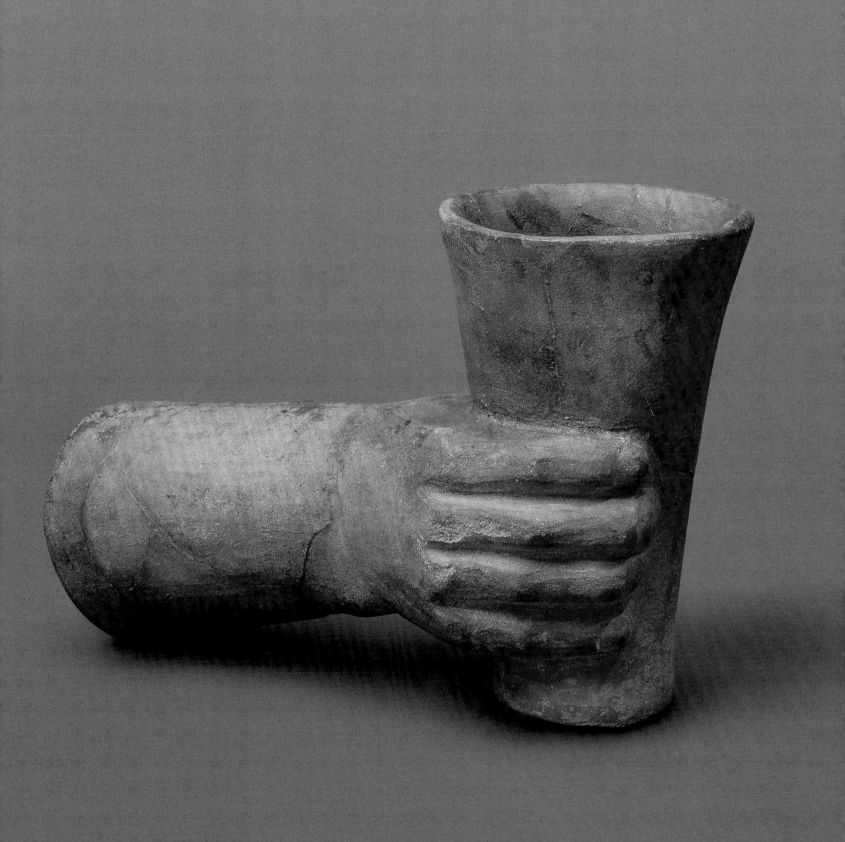

Highlands of Peru (1922) and yet again in *The Lost City of the Inca* (1948).

Since then, one batch of evidence that has been interpreted by some as undermining Bingham's claim of discovery is a series of nineteenth-century maps, some dating as far back as 1867, in the collection of Peru's Biblioteca Nacional showing the location of Machu Picchu or Huayna Picchu (Greer 2009; Mould de Pease 2008). Yet, after reviewing the maps and their purpose, it cannot be concluded that they constitute evidence for the "scientific discovery" of Machu Picchu prior to 1911 or that they influenced Bingham in any way. On the contrary, they seem to have been produced as part of a highly speculative investment scheme designed to convince investors living in Lima and abroad that there were either gold deposits or Inca gold objects waiting to be exploited in the Mandor Pampa area and that, with sufficient capital, these could be turned into gold ingots at a scale that would richly repay investors. As in the case of Wiener, there is no evidence that the makers of the maps or the organizers of these schemes ever visited Machu Picchu or appreciated the singular importance of the ancient site. The fact that the locations of Machu Picchu and Huayna Picchu are inverted on some of these early maps further suggests that the cartographers responsible never actually reached the Inca ruins.

A second criticism of Bingham's claims for discovery accuses him of inadequate recognition of Augustín Lizárraga, a local farmer who scrawled his name on the temple wall of Machu Picchu seven years prior to Bingham's arrival. Some even implied that Bingham tried to cover up this earlier discovery in order to take the credit. Yet, contrary to such claims, Bingham's original account of his July 24th visit to Machu Picchu repeatedly refers to Lizárraga's earlier visit to the site (Bingham 1922, 219, 221, 226). For example, Bingham writes: "Their neighbor, Lizárraga [...], had reported the presence of the ruins which he first visited in 1904" (Bingham 1922, 221). Lizárraga made no attempt to inform the wider world of the ruins at Machu Picchu either because he failed to appreciate their importance or because he planned to loot the site and wanted to keep its location secret. While

Bingham did erase Lizárraga's graffiti, it was not to deprive Lizárraga of any credit that he was due, but because he believed that the modern writing defaced the walls of the Inca temple.

A third criticism leveled by Mould de Pease and others suggests that Bingham underplayed the presence of resident farmers in order to make his "discovery" seem more heroic. This argument seems especially forced since Bingham always mentioned the local farmers in his accounts, even specifying the last names of two of the three families: Richarte and Álvarez. Moreover, Bingham repeatedly photographed these farmers in conjunction with the Inca buildings (cat. 4). Finally, by stating that he was led to the Machu Picchu by a young boy, Bingham undermined whatever appearance of daring that might have been accrued to him from his descriptions of the difficult river crossing and initial ascent.

The Black Legend of Machu Picchu's Golden Treasures

While Bingham was still working at Machu Picchu, the tabloids in Cuzco began reporting rumors that his claim of finding only shattered ceramics, bone, and stone artifacts was false and that he was, in fact, smuggling precious metal objects out of Peru by mule trains via Bolivia. This accusation may have seemed plausible at the time, given the historic Spanish accounts of abundant gold and silver objects utilized on a daily basis by the Inca royalty as well as the modern discovery of precious metal artifacts at Inca sites in Cuzco. How was it possible that a site with magnificent architecture and masonry such as Machu Picchu could fail to yield similar valuable objects? A governmental commission was then established, led by journalist and historian Luis Valcárcel, one of Bingham's most severe critics. Eventually, Valcárcel's committee exonerated Bingham and declared that the rumors were entirely without basis (Bingham 1989, 305–309). Despite this, baseless accusations persisted and they continue to this day.

Fortunately, we finally understand why Bingham failed to find the precious metal objects. As a country palace probably used

only during the winter months (June–August), Machu Picchu was never a permanent settlement of the Inca elite, nor were the elite buried in its cemeteries (Salazar 2004, 2007, Salazar and Burger 2004). Located only three to four days north of Cuzco, the elite would have been returned to the Inca capital for burial if they died while at Machu Picchu; when Atahualpa's execution in Cajamarca led to the collapse of the Inca royalty, those elite temporarily residing at the country palace would have returned to Cuzco with their valuables. In this light, it is not surprising that the numerous excavations at Machu Picchu over the last four decades have likewise failed to encounter precious metal objects. The single exception to this generalization was the gold bracelet recovered on the bedrock surface beneath three meters of intentional stone fill; this was the first and only time that an excavation of such depth was attempted (Burger 2004, 102).

Hiram Bingham: Pioneering Archaeologist or First Tourist?

Bingham, specialist of the economic and political history of South America, was the first faculty member with a Latin American focus to be appointed to Yale University. At the time, archaeology was still in its infancy in the United States (Patterson 1995; Willey and Sabloff 1974), and at Yale, as at most centers of higher education, the prehistory of Peru was ignored. With the exception of German Scholar Max Uhle (Rowe 1954), non-specialists, particularly historians, engineers, and other intellectuals were responsible for most archaeology carried out in Peru prior to 1919. Bingham's lack of specialized archaeological training was typical of his time.

It is to Bingham's credit that he attempted to integrate early archaeological procedures into his Peruvian expeditions. For example, although he spent only a few hours at Machu Picchu during his first visit there, he took the time to sketch the layout of the ceremonial center of the site (fig. 2, p. 33) and to take numerous photographs of the visible architecture for which he kept meticulous records (cats. 3, 4). This photographic record continues to provide the best data on the

condition of Machu Picchu when it was first scientifically documented. Even though Bingham did not return to Machu Picchu that year, he did send two members of his expedition team, Herman Tucker and Paul Baxter Lanius, back to Machu Picchu in September to clear a portion of the site and to produce a more detailed map of the site using the a plane table and alidade (Bingham 1989).

In preparation for the 1912 excavations at Machu Picchu, Bingham composed an Official Circular (No. 13) that described procedures related to the collection (including the documenting of archaeological contexts and the stratigraphic position of artifacts), the numbering, and the packing of all cultural materials encountered. It is noteworthy that the 1912 Yale Peruvian Scientific Expedition collected animal bones, stone flakes, undecorated pottery fragments, and many other items with no aesthetic or market value. The justification for this policy, one that was not shared by many coeval field projects, was that the scientific analysis of these materials would yield a better understanding of the archaeological site. Bingham excavated burials but also followed a forward-looking strategy of sampling the sub-surface remains from architectural features in different portions of Machu Picchu, inferring the activities carried out at the site from an analysis of the materials recovered in each sector (Bingham 1930) (cat. 2).

Moreover, a close reading of Bingham's publications reveals that the excavation of objects was not his priority at Machu Picchu. Bingham's primary commitment was to create an accurate map of this unusually well-preserved site, and far more time and effort was devoted to the clearing of the site than to the search for and excavation of burials. It is justifiable to say that Bingham was successful in this endeavor since the map produced by the Yale Peruvian Scientific Expedition in 1912 has remained the most reliable documentation of Inca architecture at the site for nearly a century. This detailed map of the site was complemented by hundreds of photographs of the architecture, all carefully labeled and described (cat. 1).

Bingham's second priority was situating Machu Picchu in relation to other Inca sites and road systems. Even while his team was investigating Machu Picchu, Bingham continued to explore the surrounding area in search of other Inca settlements. Bingham's emphasis on settlement patterns and their geographic and agricultural context was the forerunner of archaeological approaches that became popular during the second half of the twentieth century.

Another aspect of Bingham's research that has been insufficiently appreciated was his advocacy of a multi-disciplinary approach to archaeology (Burger 2004). Bingham recognized that specialists from many fields were necessary to fully understand the Inca past, and toward that end he recruited a host of remarkable individuals to assist him in this task. Among these were topographers Kai Hendriksen and Albert Bumstead, osteologist George Eaton, geologist Herbert Gregory, geographer Isaiah Bowman, and C.H. Mathewson, an authority on ancient metals. During the three expeditions, Bingham and his team collected remains of plants and animals that could be analyzed by botanists and zoologists at museums throughout the world, and these provided the basis for a detailed understanding of the environment of Machu Picchu and the larger Cuzco region. A partial list of the publications resulting from the three Yale Peruvian Scientific Expeditions includes over fifty items (Bingham 1989, 362–367) (cat. 16, p. 39).

In summary, Hiram Bingham III may have been trained as a historian, but his research at Machu Picchu and the surrounding region was based on solid scientific foundations. His investigations produced new knowledge not only about the architecture and artifacts of Machu Picchu, but also about the lives of the people who worked there and the natural environment that supported their efforts. It also provided a broad vision of the regional settlement and road system in which Machu Picchu existed. Given these scholarly achievements, it is not surprising that Luis Valcárcel, Julio C. Tello, and other contemporary archaeologists praised Bingham in their writings and letters as a pioneer of Inca archaeology. In 1948, only eight years before his death, the Peruvian government honored Bingham at a ceremony inaugurating the newly constructed road up to Machu Picchu, christening it as the Carretera Hiram Bingham.

While the romantic photographic images of Bingham and the evocative swash-buckling prose that accompanied his popular writings may suggest to the modern reader more of a dashing adventurer and explorer than a dedicated scholar, a careful consideration of Hiram Bingham's work within its historical context confirms the fundamental seriousness of his scientific research and his pioneering contributions to the archaeology of Peru.

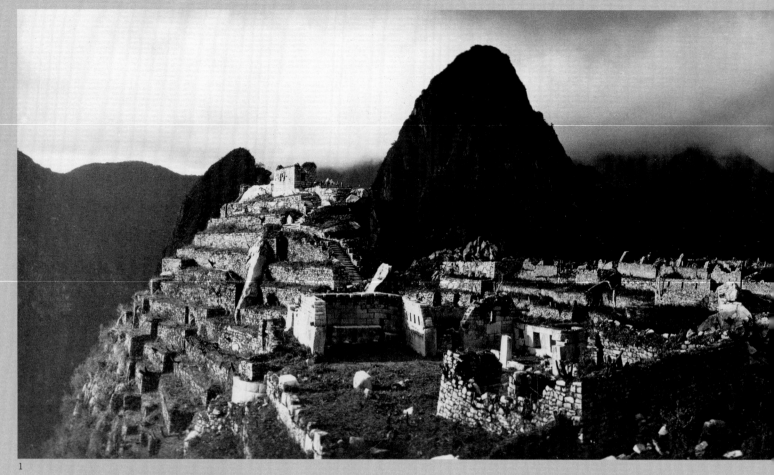

1

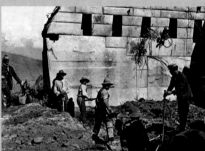

2

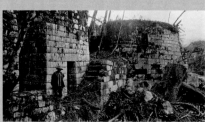

3

4

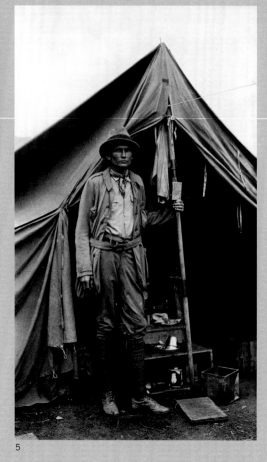

5

1.
Hiram Bingham
*Panorama of Machu
Picchu*
About 1911–1913

2.
Hiram Bingham
*Excavations
at the Main Temple*
1912

3.
Hiram Bingham
*Three-sided building
later called the Principal
or Main Temple*
About 1911–1912

4.
Hiram Bingham
*View of the Side of
the Torreón after Bingham
Cleared It of Vegetation*
About 1911–1912

5.
Ellwood C. Erdis
*Hiram Bingham
at the Main Camp*
1912

6.
Martin Chambi
*Aerial View of Machu
Picchu with Mountains
in the Background, Peru*
1927

7.
Martin Chambi
*View of the Upper
Portion of the Staircase
of the Fountains with
Unidentified Buildings
on the Left, Machu
Picchu, Peru*
1927

8.
Martin Chambi
*Partial View of the
King's Group Showing
the Courtyard and
Unidentified Buildings,
Machu Picchu, Peru*
1927

9.
Martin Chambi
*Interior View of the Royal
Mausoleum Showing
the Entrance Stonework
Below the Torreón,
Machu Picchu, Peru*
1927

Fig. 2
Hiram Bingham
Map of the ceremonial
centre of Machu Picchu
July 24, 1911
Manuscripts and
Archives, Yale University,
New Haven

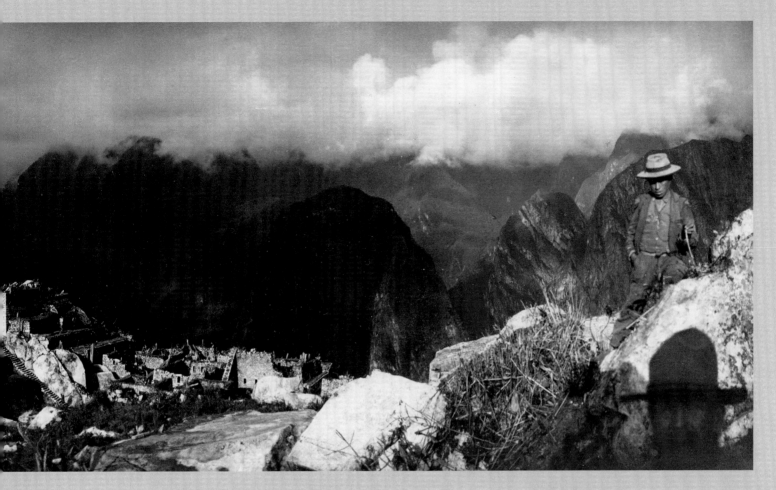

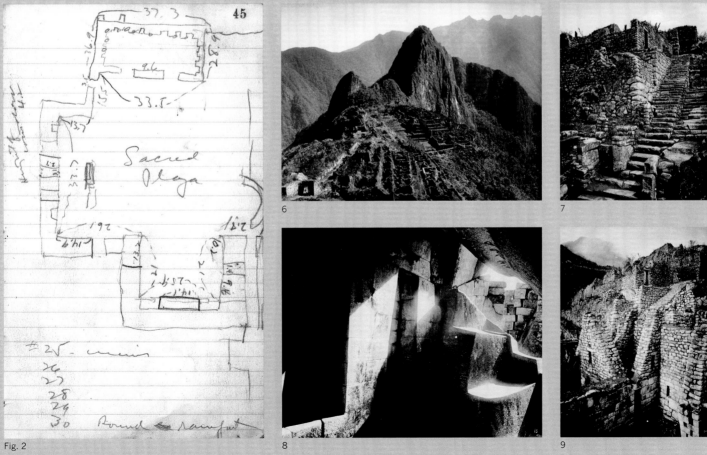

Fig. 2

6

7

8

9

The Material Construction of the Past: A Brief Account of the Creation of Archaeological Collections in Peru

Cecilia Pardo Grau

The first government order for the protection of Peru's historic and archaeological monuments, passed in 1822, required "that objects found in *huacas* and burial sites be deposited in a national museum" (Tello and Mejía Xesspe 1967, IV). Only a year after independence, the nascent Peruvian state was already showing its interest in building and protecting collections and housing them in a place of collective memory where the nation's heritage could be preserved (ibid.). Three centuries and more of plunder, and the removal from Peru of much of its portable heritage during the colonial period, had left a country that was ravaged and in a pitiful state that had to be confronted and remedied. But it would take time before these good intentions could be put into effect, because it was not possible to immediately establish on a sound, long-term basis an institution that would meet those objectives. The country had to wait for over a century before the project could be realized.

The formation of pre-Hispanic collections in Peru is part of a broader picture in which a series of events and key figures played a crucial role. Determining factors included the undeveloped state of archaeology and its evolution into a scientific discipline, the cohort of European travelers intent on documenting what they saw in Peru, the contribution of individual local initiatives in building collections, and the lack of a firm governmental framework within which appropriate institutions could be created without undue delay.

The Beginnings of the Museo Nacional and its Collections

The Museo Nacional (1822–1881), the first institution devoted to preserving Peru's national heritage, established at the personal initiative of Mariano Eduardo de Rivero y Ustáriz (Arequipa, 1798–Paris, 1857), was for decades a weak, impecunious body, known under various names, housed in a number of premises and "founded" more than six times. One of its early responsibilities, which it could not, unfortunately, perform effectively, was to prevent the export of archaeological objects. As a scientist and naturalist, Rivero helped create Peru's first archaeological and natural science collection, housed in the recently established museum. On his return from Peru after a period spent in Chile, he embarked on a series of journeys to different parts of the country, documenting archaeological sites and collecting objects that would be of value to the museum. After retiring as director in 1829, Rivero continued to acquire collections for the state (fig. 5, p. 39).

But the Museo Nacional was unable to place on an official footing the tasks it had set itself in its early days. The weakness of state institutions in the early years of the republic, combined with the growing number of narratives and reminiscences published by North American and European travelers and scholars, resulted in an upsurge of interest among foreign collectors in Peru's past and the objects that represented it. Thus began the process of "marketizing" archaeological objects, which meant that many highly significant collections left Peru (Riviale 1996). Humboldt, Markham, Squier, Bandelier, Wiener, and Raimondi were among the foreign travelers who wrote extensively on Peru's natural and cultural riches, thereby creating new interest in all things local. The archaeological and natural history collections built up in the course of their scientific expeditions included the one made by the Italian researcher and naturalist Antonio Raimondi (Milan, 1824–San Pedro de Lloc, 1890), which was dispersed many years later, eventually forming part of the collections of the Universidad Nacional Mayor de San Marcos.

The War of the Pacific (1879–1883), a tragic episode that saw the ransacking of the collections of the Museo Nacional, its temporary closure, and a halt to the development of its collections, left a void that appeared impossible to fill. In the years that followed the war, there was an upsurge in local interest in collecting, which developed alongside the first systematic archaeological excavations. There was a new interest in owning national treasures, expressed as antiquarianism, and private collections were established, many of which, to our great loss, found a permanent home abroad. Among the great collections that left the country during those years were Macedo's collection, sold to Berlin's Museum für Völkerkunde in 1886; the Garcés collection, purchased in 1889 by Adolfo Bandelier for New York's Museum of Natural History; the Uhle collection, which moved to Berlin in 1895; and the two collections of Gaffron, sold to New

10. Recuay, *paccha* (libation vessel) depicting a scene of ritual intercourse, 200–600 A.D.

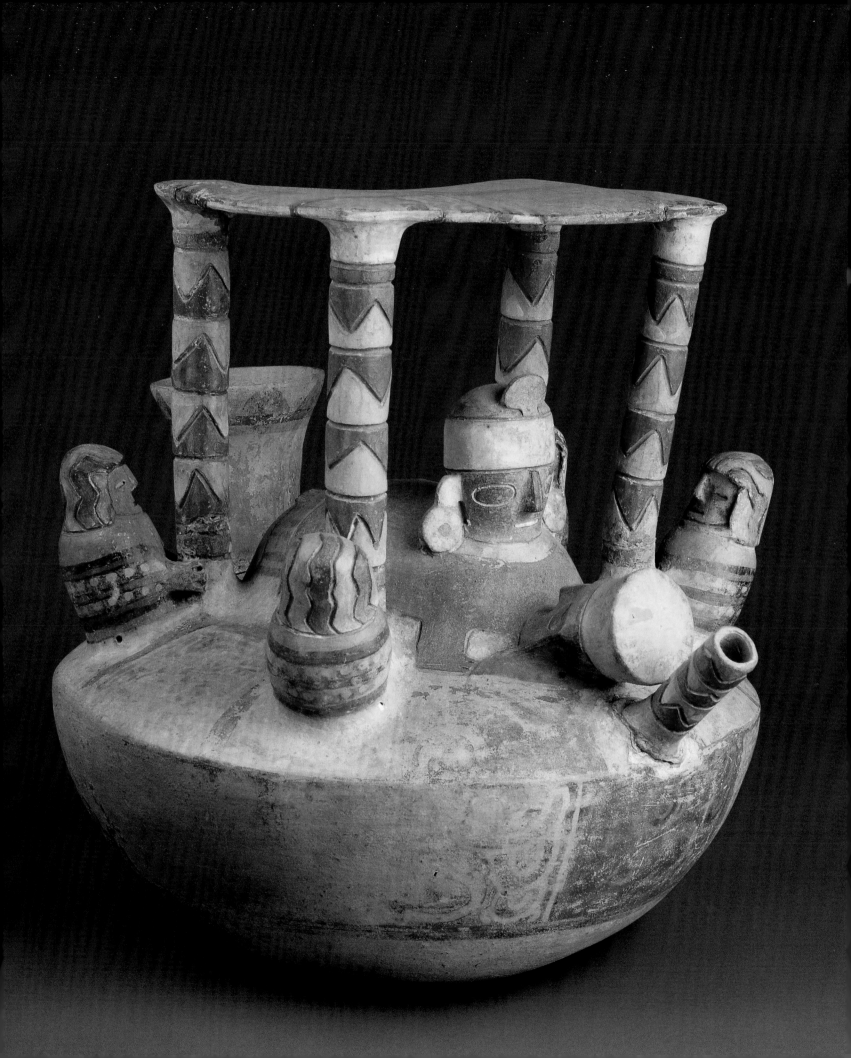

Fig. 1

Fig. 2

Fig. 3

Fig. 4

11

Fig. 1
Portrait of Max Uhle
Ibero-Amerikanisches
Institut, Berlin

Fig. 2
Portrait of Julio C. Tello
Archivo Tello, Museo de
Arqueología y Antropología
Universidad Nacional Mayor
de San Marcos, Lima

Fig. 3
Portrait of Hans H. Brüning
1882
Museum für Völkerkunde,
Hamburg

Fig. 4
José Alcántara La Torre
*Portrait of Javier Prado
Ugarteche*
About 1920
Museo de Arte de Lima

11.
Anonymous
*Rafael Larco Hoyle with
a vessel from his collection*
n.d.

York and Munich in 1902 and 1907 respectively. Those collections that remained in Peru would therefore form the basis of its future museums (Tello and Mejía Xesspe 1967).

The opening in 1905 of the Museo de Historia Nacional by President José Pardo, housed on the upper floors of the former Palacio de la Exposición, marked the beginning of a new phase in archaeological collecting in Peru. Max Uhle (Dresden, 1856–Loben, 1944) (fig. 1), a German citizen who had first arrived in Peru in 1896 for the purpose of collecting items for the Berlin Ethnographic Museum (Rowe 1998), was appointed director of the new museum's archaeology department. Uhle's task was to build up its archaeological collections by organizing expeditions and excavations, as well as incorporating acquisitions through purchase and donation (Tello and Mejía Xesspe 1967, 71). When he left, the Museo de Historia Nacional owned 8,675 archaeological objects, over sixty percent of which came from systematic excavations, the rest being bought or donated (Hampe 1998). Uhle was succeeded by Julio C. Tello (Huarochirí, 1880–Lima, 1947) (fig. 2). On his return to Peru in 1913, after studying in the United States and Europe, he had been appointed head of the museum's department of anthropology. Even at that early stage, Tello demonstrated his concern regarding "the vandalism that is increasing by the day, stealing and destroying forever the most precious evidence of our nation's history" and his wish to organize, classify, and preserve scientifically the archaeological objects held by the museum (Tello and Mejía Xesspe 1967, 82). The first decades of the twentieth century were a difficult time for Tello and the Museo Nacional, due to a series of political events that made it impossible to find a secure, permanent home for the nation's archaeological collections. The situation did not improve until the early 1920s, when Julio C. Tello became the chief curator of those collections (cats. 22-24).

From Private to Public

While the sale of pre-Columbian antiquities developed, and the Museo Nacional was trying to become at last an institution with a sound footing, a series of private individuals with altruistic motives were beginning to create their own collections. One of them was a landowner from Trujillo, Víctor Larco Herrera (Trujillo, 1870–Santiago de Chile, 1939), whose collection formed the core of those now held by the Museo Nacional de Arqueología, Antropología e Historia del Perú. As a young man, Larco involved himself in the agricultural activities of his father, who grew sugar and cotton in the Virú valley, and he supported a variety of philanthropic, cultural, and social activities (Valdizán 1934, 21). While traveling in Europe he was able to visit a wide range of museums. He realized that archaeological collections, in addition to offering individual collectors opportunities for self-indulgence, or presenting what were merely decorative objects, could also serve important educational purposes. He was strongly influenced by that idea in forming his own collection, which grew considerably when in 1919 he acquired a number of other private archaeological collections (Tello and Mejía Xesspe 1967, 119). Later in that year he invited Julio C. Tello to advise him on setting up a museum of archaeology for Peru, based on his own collection (Daggett 1991, 38). In the course of the following year, on Tello's advice, other collections originating from Lima, Cuzco, Ica, Nazca, and Pisco were acquired, with a view to creating one that would be more wide-ranging and would give greater prominence to Peru's pre-Columbian cultures (ibid.). Hermilio Valdizán has made the point that the museum that Larco Herrera eventually created was an achievement based on massive activity on the part of private collectors, considerable expenditure, and very effective research into all those other small collections which, since they belonged to many private individuals, were likely to find their way into the "shameful" export market (Valdizán 1934, 177). It was clear that the exportation to which Valdizán was referring could only be counteracted by the existence of the private collections that were being amassed in different parts of the country, independently owned resources that would eventually be acquired by the national museums as a way of enriching their collections.

In that process, the major acquisition in the history of the Museo Nacional was unquestionably that of Víctor Larco Herrera's Museo Arqueológico, which was taken over by the state in 1924. Its enormous holdings of over 20,000 items totally transformed the main national collection, which until then had consisted of the archaeological collection of the former Museo de Historia Nacional and a mass of material resulting from the excavations carried out in Cuzco by Yale University (Tello and Mejía Xesspe 1967, 137). When he organized the first inventory of the collections of the new Museo de Arqueología Peruana, of which he was director, Tello warned that while the country's archaeological heritage had great intrinsic value from an artistic point of view, its potential interest was undermined by lack of information about its provenance, the circumstances in which it was acquired or found, and the connections and relationships between different objects (ibid., 139). Another collection bought by the state at around that time was the one belonging to the German Hans Hinrich Brüning (1848–1928) (fig. 3). He had arrived in Peru in 1875 and built up an outstanding collection and an important photographic record of the north coast. These collections in fact reflected the emergence of scientific archaeology in Peru (cats. 12-15). But it was only thanks to the contributions of researchers such as Uhle, Tello, and their colleagues that the discipline became firmly established, creating an awareness of the importance of its archaeological contexts for an understanding of pre-Columbian history.

In parallel with the development of the Museo de Arqueología Peruana, a businessman from northern Peru, Rafael Larco Hoyle, found himself in a position to form what is today the most important collection of pre-Hispanic material devoted to the north coast. Growing up on his family's estate in Chiclín, in the Chicama Valley, Larco inherited the interests of his father, who in the early twentieth century had begun putting together a collection of the pre-Colombian objects found in the area. Starting in 1924, Larco Hoyle set about avidly buying up private collections, and at the same time he organized systematic excavations and explorations (cats. 19, 21), resulting in substantial

additions to his collection. This material remained in his museum in Chiclín (cat. 20) until 1949, when the collection was moved to Lima. It was installed in a mansion in the district of Pueblo Libre, where it is still open to the public (Evans 2011). Rafael Larco Hoyle is considered one of the country's pioneers in the development of systematic archaeology, and his legacy and contribution are still of importance today, ranging from the identification of new cultures to the reconstruction of the pre-Hispanic chronology of the north coast (Castillo 2001a).

Another important private initiative dating from that period is the collection created by the politician and intellectual Javier Prado Ugarteche (Lima, 1871–1921) (fig. 4) in the early years of the twentieth century. Javier Prado set up his own museum, which was a product of his intellectual calling and of his interest in the past, which also extended

to the Peru of his day (Portocarrero 2007, 103). After studying law at the Universidad de San Marcos, Prado embarked on a series of intense political and intellectual activities that made him one of the country's most influential public figures. His brilliant career contributed to the history of one of the most powerful families in twentieth-century Peru (ibid., 92). In 1935, more than ten years after his death, the Prado collection was transferred to the mansion of the Peña Prado family, in Chorrillos, which had a suitable space in which it could be housed. The Museo Prado was formally opened there, in memory of its founder. Prado's collection remained there until 1961, when his brother, then-president Manuel Prado Ugarteche, announced that the collection was to be donated to the Patronato de las Artes and the recently opened Museo de Arte de Lima.

The collections formed in the early twentieth century represent a crucial stage in a long process that began in the years following the War of the Pacific; they were a resource that made it possible to shape and preserve the memory of the past. Scientific archaeology and collection building sprang mainly from individual initiatives, undertaken for the most part without the involvement of the state. Each of these examples shows how the majority of Peruvian museums came into existence in similar ways; starting as private collections consisting of isolated objects, they mutated into public collections. Personal efforts—later evolving into museum projects—made it possible to build collections that today offer the public genuine access to their country's past. And it is precisely thanks to these initiatives that it is gradually becoming possible to shape a collective view of the art and history of Peru.

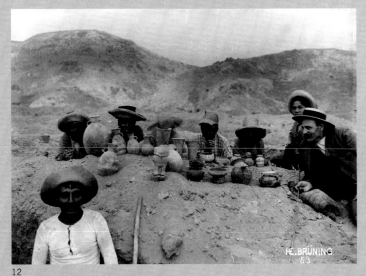

12

13

14

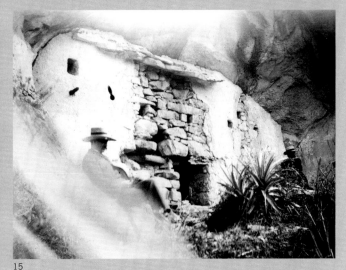

15

Fig. 5

16

17

18

12.
Hans H. Brüning
Excavation, Hacienda Huando, Chancay Valley
1899

13.
Hans H. Brüning
Pre-Hispanic Wall Near Galindo
1894

14.
Hans H. Brüning
Two Columns and Ruins in Huaca de Sacachique
1895

15.
Hans H. Brüning
Ancient Tomb, Palo near Chancay
1888

Fig. 5
Mariano Eduardo de Rivero and Juan Diego de Tschudi
Antigüedades Peruanas
[Peruvian Antiquities]
1851
Biblioteca Manuel Solari Swayne, Museo de Arte de Lima

16.
Cover of *National Geographic*, vol. 24, no. 4
April 1913

17.
Cover of *Estudios monográficos del departamento de Lambayeque*, fascicle II, "Olmos"
Ed. Dionisio Mendoza, Chiclayo, 1922

18.
Cover of *Estudios monográficos del departamento de Lambayeque*, fascicle III, "Jayanca"
Ed. Dionisio Mendoza, Chiclayo, 1922

19

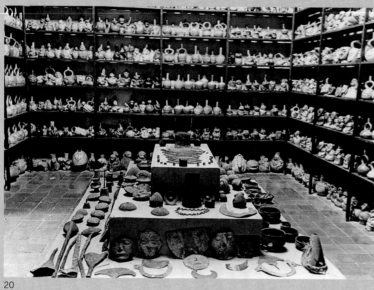

20

21

19.
Anonymous
Rafael Larco Hoyle
in the Field
n.d.

20.
Anonymous
Chiclin Museum
n.d.

21.
Anonymous
Young Rafael Larco Hoyle
in the Field
n.d.

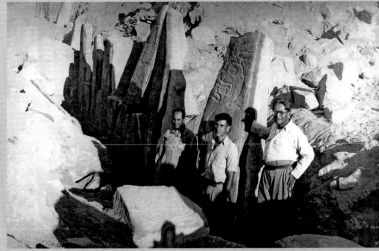

22

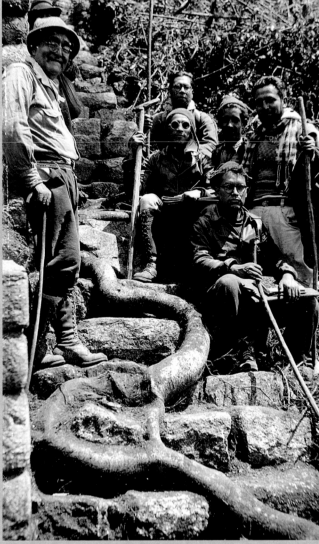

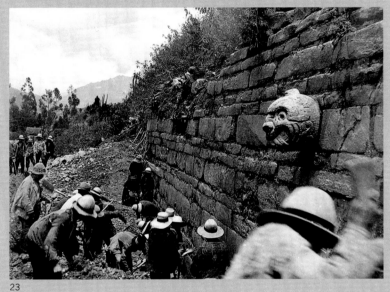

23

24

22.
Anonymous
Julio C. Tello during the
Unearthing of the Stone
Sculptures at Cerro
Sechín
1937

23.
Anonymous
West Side of the Main
Temple at Chavín
de Huántar
1940

24.
Anonymous
Julio C. Tello with Genaro
Farfán, Julio Espejo,
Manuel Chávez Ballón,
Luis Ccosi Salas and
Pedro Rojas Ponce in
Wiñay Wayna (Cuzco)
1942

KINGDOMS OF THE SUN
AND THE MOON

An Overview of the Art and Archaeology of the Pre-Columbian Civilizations of Peru

Erell Hubert

At the time of the Spanish Conquest, the Inca ruled most of the Andes. Yet this domination was a recent development compared to the impressive diversity and long history of Peru's pre-Columbian cultures. Indeed, like Egypt, Mesopotamia, India, China, and Mesoamerica, the Andes are one of the first regions in the world where civilization developed. Because pre-Hispanic Andean cultures did not develop writing systems, our knowledge of them depends on archaeological sources. The outstanding artworks produced by these peoples reveal a complex, fascinating worldview that seems to have taken shape in the third millennium B.C..

Monumental architecture emerged in the Late Pre-ceramic Period (3500–1800 B.C.), particularly along the coast. This monumental architecture implied mobilizing the population for a long-term common project and therefore required a more complex social organization. Exchange relationships seem to have developed between some inland sites, engaged in agricultural activities, and coastal sites, where the people harvested the riches of the Pacific Ocean, for example between Caral and Aspero.

Caral (3000–2000 B.C.), in the Supe Valley, is undeniably the major site of this period with its pyramidal platforms, large circular or semi-circular plazas, and a spatial organization which shows that duality was already a fundamental structural principle in the Andes (Shady Solís 2006). The site has yielded numerous body ornaments made from various materials, musical instruments such as flutes with engraved patterns, and hundreds of unfired anthropomorphic figurines (fig. 1)—to date the earliest use of clay and the earliest form of figuration in Andean art (Burger 2009).

These early figurative pieces paved the way for a flowering of art in subsequent periods. On the north coast of Peru, the Cupisnique culture (1200–200 B.C.) contributed to the creation of an iconographic language that was perpetuated for centuries. Thus, fangs came to symbolize a figure's divine nature. Stirrup-handled vases, a typical north coast form, appeared in this period, too (cat. 25). Felines, spiders, and other figures with prominent fangs were incised on pottery and engraved in stone in a very sinuous style. The same motifs are found carved in the dry mud of the walls on some sites such as Huaca de los Reyes (Pozorski and Pozorski 2008). Long believed to be a coastal version of the Chavín civilization, the Cupisnique civilization is now considered to be one of its main forerunners (Elera 1993; Burger 2008; Pozorski and Pozorski 2008).

The Chavín civilization (900–200 B.C.) developed around Chavín de Huántar, a highly prestigious religious center in the northern highlands. From the first investigations by Julio C. Tello, who went to Chavín for the first time in 1919, this site was regarded as the source of the widespread "Andean civilization" (Tello 1960). Although this position has now been largely revised, the Chavín de Huántar site remains one of the most important symbols of Peruvian national identity. Chavín art is characterized by very rich imagery, often carved in stone, in which animals such as the jaguar, anaconda, eagle, and caiman are blended to make supernatural hybrid monsters. A fanged anthropomorphic god is also a central figure in religious imagery (fig. 2, p. 48). Chavín culture seems to have deliberately combined various religious traditions (Burger 2008) in a synthesis of the main geographical regions of the Andes: the coast, the mountains, and the Amazonian jungle.

On the southern coast of Peru, the Paracas culture (700–1 B.C.) flourished around the Ica region. Two styles can be distinguished: Paracas Cavernas and the more recent Paracas Necropolis, which gave rise to the Nazca style. One of the characteristics of the Paracas Cavernas style is incised polychrome pottery, painted with resin after firing to obtain the colors (fig. 3, p. 48). The double-spout bottle, which became the typical Nazca form, was already present. Polychrome decoration of ceramics is a significant feature in the history of southern Peru. The Paracas Necropolis style is particularly distinguished by the quality of its cloth, unmatched for its vivid colors, fine weave, and complex embroidered motifs (Proulx 2008). The most impressive textiles are huge funeral mantles used to wrap up the mummies (cat. 29). The patterns often include trophy heads. Here, as in the north, the iconographic language worked out during this period flowered during the artistic apogee of the first millennium.

Fig. 1. **Caral, Male and female figurines,** 3000–2000 B.C., Proyecto Especial Arqueológico Caral-Supe, Lima

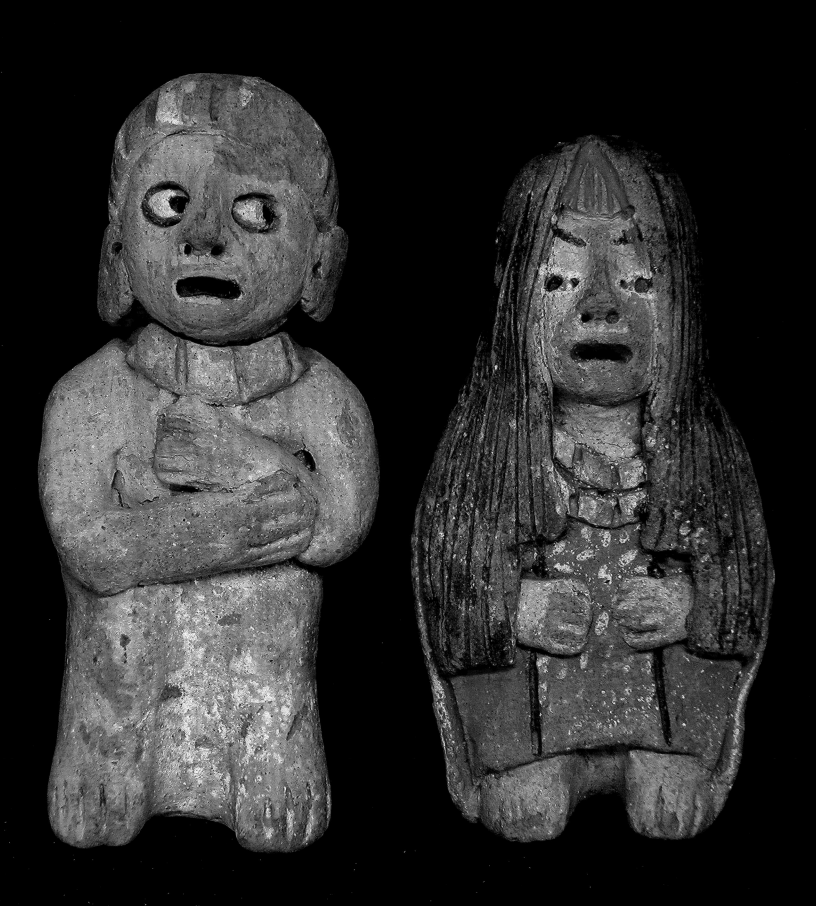

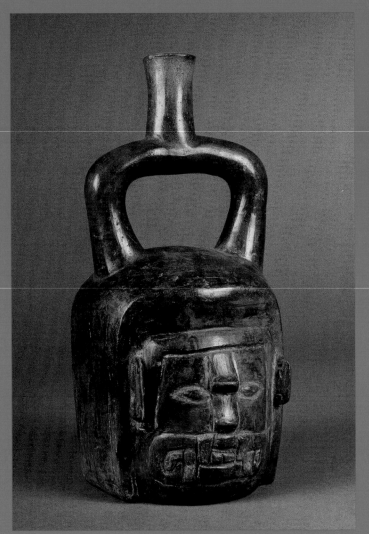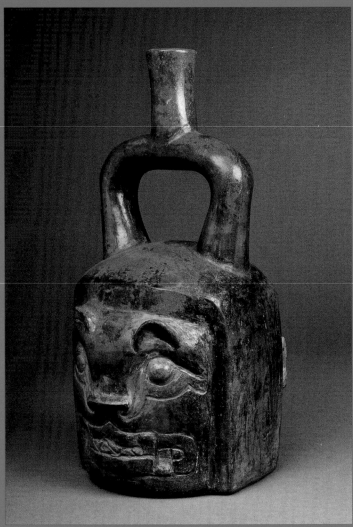

25

25.
CUPISNIQUE
STIRRUP-SPOUT BOTTLE DEPICTING A HUMAN HEAD AND A FELINE HEAD
1200–200 B.C.

This bottle, with its shiny, gray-black surface, realistic modeling, incisions highlighted with red pigment applied after firing, and its slightly trapezoidal stirrup handle, is typical of the Cupisnique culture. As for its iconography, on one side of the bottle the and position of the ears, the incisions forming a motif around the eyes like a design drawn on the animal's pelt, the shape of the muzzle and the fangs make it possible to identify the face represented on the bottle as that of a feline. On the other side, the face is more human, especially with its long ears, set on either side of the face. This human person nevertheless has

a number of feline aspects, such as fangs, which in the art of the north coast were to become the symbol of the supernatural nature of the creatures represented.

The feline, both a dangerous predator and a powerful, solitary hunter who provides a model to follow, occupies a primal place in the symbolic world of the Cupisnique and is frequently represented on their household furniture and buildings. It is also often the alter ego of their shamans. Cupisnique culture seems to have been based on powerful shamanic beliefs, and it is perhaps that aspect to which the bottle illustrated here refers.

Shamans were thought to be able to transform themselves, often using psychotropic drugs such as the San Pedro cactus, in order to communicate between natural and supernatural, human and animal worlds. The division of this bottle into two distinct surfaces, and the presence of feline features on the human face suggest that it represents the process of transformation of a human shaman into his feline alter ego, a juxtaposition of opposites that recurs in Cupisnique art.

E.H.

Two cultures marked the first millennium with the excellence of their art: the Mochica (100–800 A.D.) on the north coast and the Nazca (1–700 A.D.) on the south coast. In Mochica society, the power of the ruling class was largely based on religious ideology and on control of the material symbols associated with it (Castillo and Uceda 2008). Two-tone ceramic recipients sculpted and/or finely painted with complex scenes were the preferred vectors for this ideology, which, by the fifth century A.D., had spread nearly 700 kilometers, from the Piura Valley in the north to the Huarmey Valley in the south. The Mochica symbolic language probably crystallized in the Chicama and Moche Valleys, around the most impressive site, Huacas de Moche. Mochica art is particularly realistic and favors themes associated with certain myths and rituals (cat. 28). The discovery of rich tombs in which the deceased were buried with ornaments made of precious metals and gemstones identical to those shown in the iconography indicates that the ruling class took part in the rituals depicted (Alva 2004; Alva and Donnan 1993). The Mochica were also in contact with the Recuay (200–600 A.D.) from the highlands, who are known for their anthropomorphic monoliths and painted pottery made from kaolin (cat. 10).

The Nazca lived in the valleys on the south coast of Peru. The Nazca style seems to derive from the Paracas style, but with ceramics as its principal means of expression. The Nazca favored polychromy, using up to twelve different colors painted on unfired clay and fixed by firing (Proulx 2006) (cat. 27, p. 48). Some iconographic motifs are recurrent, becoming more stylized as the Nazca style evolved, especially fantastic beings such as the mythical anthropomorphic being. The presence of trophy heads, whether real or represented in their art, suggests a society in which warfare played a major role (fig. 5, p. 199). The geometrical and biomorphic geoglyphs inscribed in the desert soil of the Nazca valley are certainly one of this culture's best-known art forms. They are now generally interpreted as having a ritual purpose, perhaps in relation to water, which was vital for the irrigation of the arable land in the Peruvian coastal desert (Silverman and Proulx 2002).

The transition from the first to the second millennium is marked by the emergence of innovative cultural centers in the central and southern highlands. Two contemporary cultures (700–1200 A.D.) existed side by side: the Huari, whose influence radiated over a huge part of Peru from the site of the same name in the Ayacucho region, and the tiahuanaco, whose sphere of influence stretched southwards from the site of the same name on the banks of Lake Titicaca, in present-day Bolivia. Both cultures shared an artistic language that displays similarities in typology (four-cornered hats) (cats. 30, 31, 33, 34) and iconography (gods with staffs, radiant faces) (fig. 6, p. 59). There seems to have been some interaction between the two groups, but differences in their weaving techniques, architecture, and socio-political organization show that they were separate entities. With the exception of Omo in the Moquegua valley, the absence of sites reproducing the monumental architecture of the Tiahuanaco site outside the basin of Lake Titicaca supports the theory that the Tiahuanaco established relationships with other groups that were not under direct control from the capital (Goldstein 2005; Isbell 2008). The Huari adopted more imperialist expansion strategies, setting up administrative centers such as Pikillacta with buildings divided into orthogonal cells (McEwan 2005). Certain forms—such as the *kero*, a cup with slightly tapering sides—and some gods seem to have been copied by the Inca (Isbell 2008).

Yet the dynamism of the highlands does not imply cultural stagnation on the coast. The Lambayeque culture (750–1375 A.D.) developed in Peru's northern valleys with Batán Grande then Túcume as political and religious centers that flourished until the Chimú conquest. Lambayeque art is characterized by the recurring image of an anthropomorphic figure with elongated wing-shaped eyes (cats. 41, 91), who has been identified from stories collected in the sixteenth century as their mythical ancestor, Naymlap (Cabello Valboa 1951 [1586]). The Lambayeque also excelled in metallurgy, a skill exploited by the Chimú and then the Inca.

The Chimú (900–1476 A.D.) exercised their hegemony on the north coast of Peru until the Inca Conquest, developing a worldview in which ancestor worship and the moon were primordial. The capital of the Chimor Empire was Chan Chan in the Moche Valley, where the various types of architectural complexes reveal great social inequality, in particular a strong separation between royalty and the commoners. The *ciudadelas* are large complexes reserved for royalty, playing the dual role of palace and funeral monument. Indeed, it appears that each new Chimú king had to build his own palace because the old palace was dedicated to the worship of the dead king (Conrad 1982). The iconography includes representations of anthropomorphic deities, which have lost most of the feline features typical of previous periods: a male god with staffs and a goddess with symbols linked to the sea and the moon (Moore and Mackey 2008). These deities are usually represented in relief on ceramics in a grayish color obtained by firing in a reducing atmosphere (fig. 4, p. 58).

On the central coast, the Chancay (1100–1450) wove magnificent funeral cloth and made cream pottery decorated with black patterns. The anthropomorphic statuettes known as *cuchimilcos* (fig. 5, p. 58) are one of the most typical forms (Stone-Miller 2002).

The Inca Empire (1450–1532 A.D.) was therefore built on thousands of years of history, but adapted its strategies to a larger and more diversified territory than all the lands controlled or influenced by its predecessors. The Inca culture developed first in the Cuzco region before launching into a policy of expansion that gave rise to the *Tahuantinsuyu*, an immense empire that unified under its control the greater part of the Andes from Colombia to Chile and developed a highly centralized administrative system. A complex road network, administrative centers, the displacement of population groups, the development of a notation system (*quipu*) (cat. 120), the imposition of a common language (Quechua), and a ritual calendar helped unify this empire. Unlike most of the preceding Andean cultures, Inca art favored geometrical motifs, perhaps in response to the need to federate very diverse groups. The *aryballo*, a large jar with a conical base and long, tapering

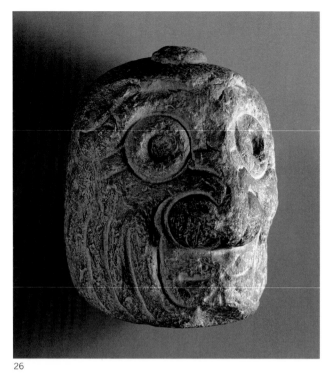

26

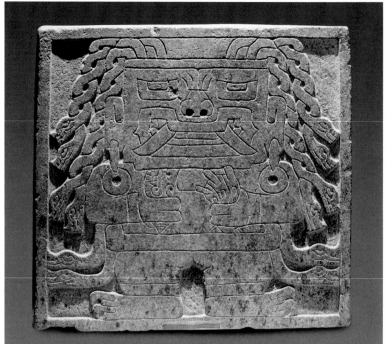

Fig. 2

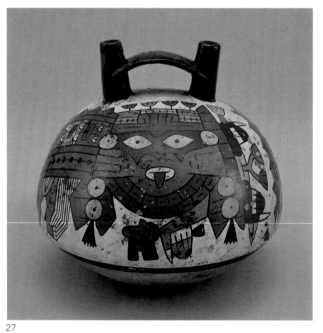

27

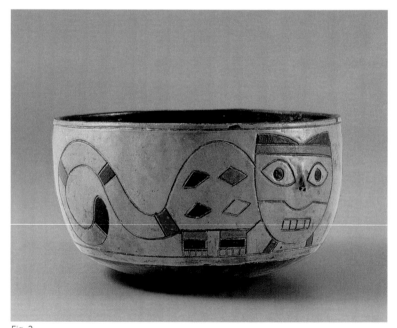

Fig. 3

neck (cats. 115, 116), is the most characteristic form of Inca imperial art (Bray 2003, 13). These pots were distributed throughout the empire from Cuzco, or imitated by local elites as a way of asserting their status by association with the empire (Covey 2008). The highly emblematic polished stone architecture was used exclusively for imperial buildings. The Spanish invasion and, with it, the introduction of European diseases, in the midst of a crisis for the succession to the Inca throne, sounded the knell of the last indigenous state in the Andes.

26.
Chavín
Tenon head
900–200 B.C.

Fig. 2.
Chavín
Fanged anthropomorphic
deity holding shells
(*Strombus* and *Spondylus*)
in each hand
900–200 B.C.
Museo Nacional Chavín,
Ancash

27.
Nazca
Double-spout vessel
depicting the mythical
anthropomorphic
being
1–700 A.D.

Fig. 3.
Paracas
Bowl depicting felines
700–1 B.C.
The Montreal Museum
of Fine Arts

28.
Mochica
Stirrup-spout bottle
depicting a human figure
taking coca
100–800 A.D.

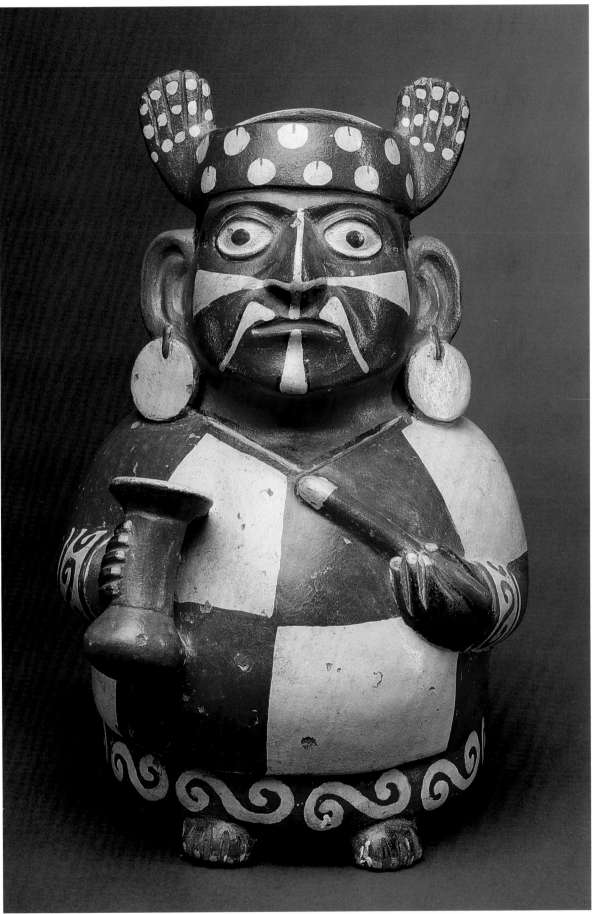

28

29.
PARACAS
MANTLE WITH ANTHROPOMORPHIC FIGURES
700–1 A.D.

This large piece of cloth, colored and decorated with supernatural creatures, is typical of the Paracas culture, which developed on the southern coast of Peru. Cloths of this type, called *mantas*, were used to cover *fardos*, or funerary bundles. The Paracas people would place the body of the deceased in a basket, in the fetal position, accompanied by offerings. The basket was then covered in several layers of *mantas*, giving the funerary bundle a conical appearance. Some *fardos* were up to a meter and a half tall.

This funerary *manta* in camelid wool is woven using a simple warp and weft. It is decorated with embroidery representing an anthropomorphic creature that has the face of a spider, four lateral pieces suggesting spider's legs, and human legs. In one hand it brandishes a knife, a trophy head in the other. Thread of different colors has been used to create this embroidery.

The embroidered motif is repeated on a dark blue background, on both the face and the back of the cloth. The creature also appears on the lower border, which is red. The eighty-five embroidered figures of the supernatural creature are evidence of the amount of work needed to make this *manta* and of the high status of the deceased who was wrapped in it.

F.E.D.

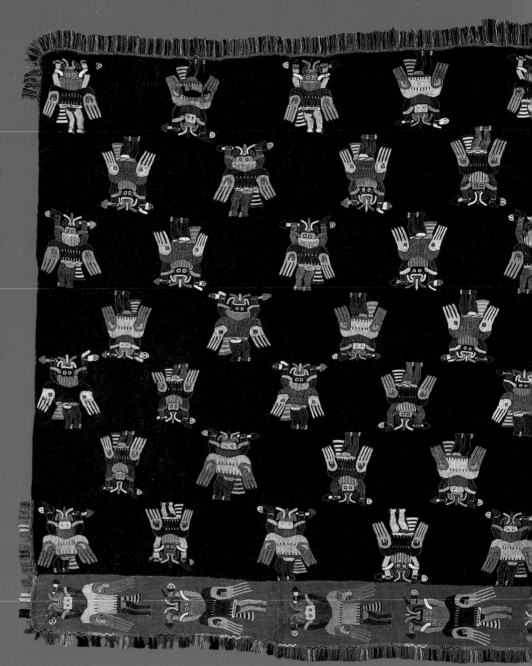

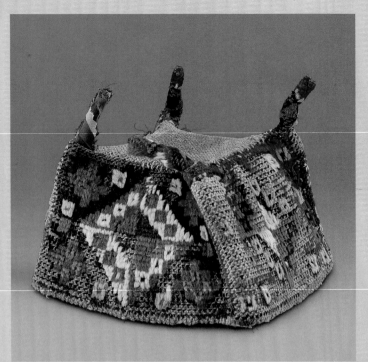

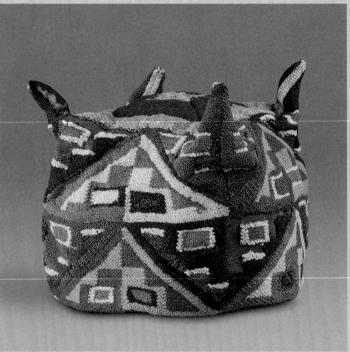

30

31

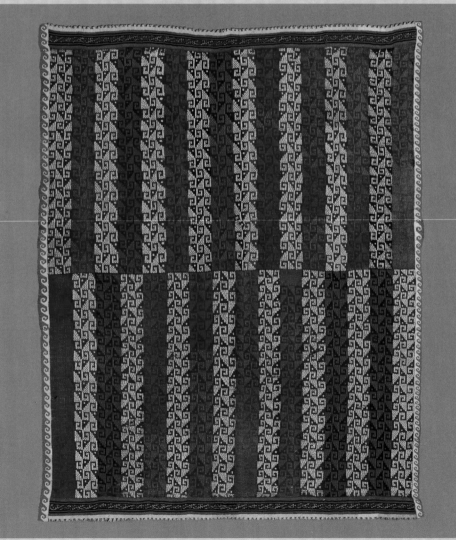

32

30.
Huari
Four-cornered hat
with geometric motifs
700–1200 A.D.

31.
Tiahuanaco
Four-cornered hat
with geometric motifs
700–1200 A.D.

32.
Chancay
Mantle with geometric
motifs
1100–1450 A.D.

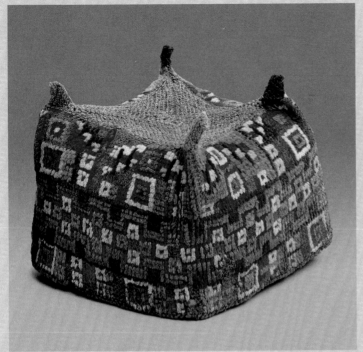

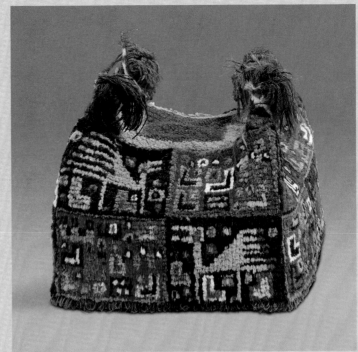

33

34

33.
Huari
Four-cornered hat
with geometric motifs
700–1200 A.D.

34.
Huari
Four-cornered hat
with geometric motifs
700–1200 A.D.

35.
Huari
Face-neck jar depicting
a figure wearing a striped
poncho
700–1200 A.D.

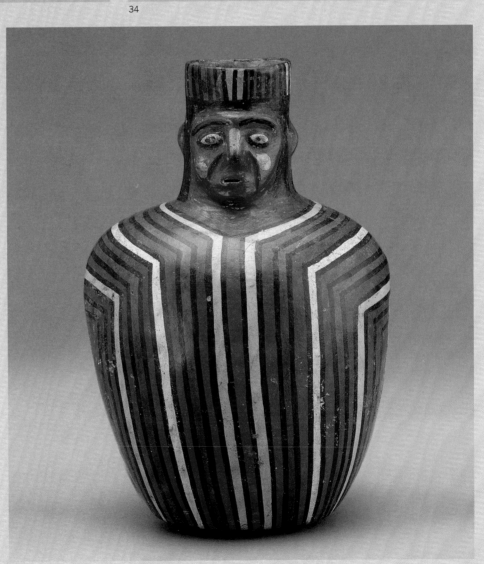

35

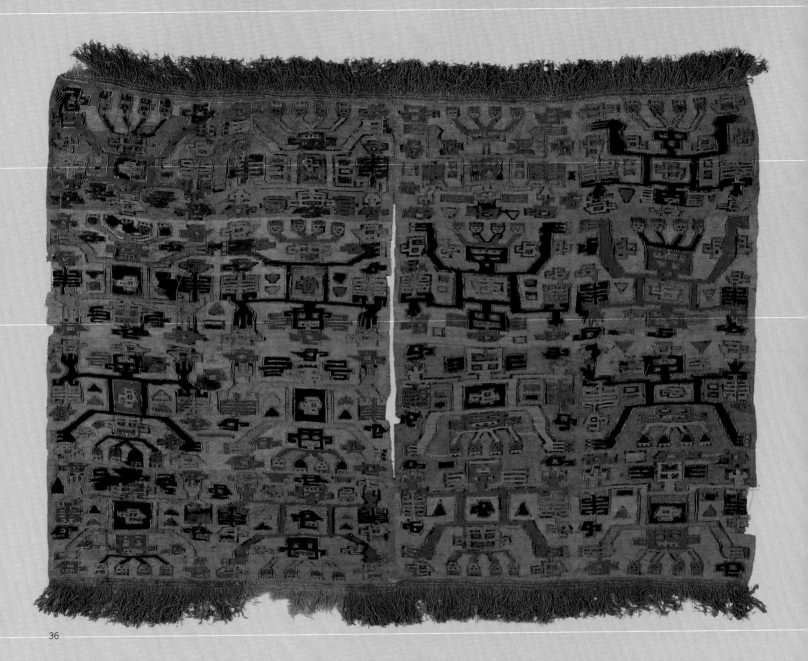

36

36.
Poncho with stylized
anthropomorphic designs
Nazca
1–700 A.D.

37.
Mantle fragment with
anthropomorphic figures
Lambayeque
750–1375 A.D.

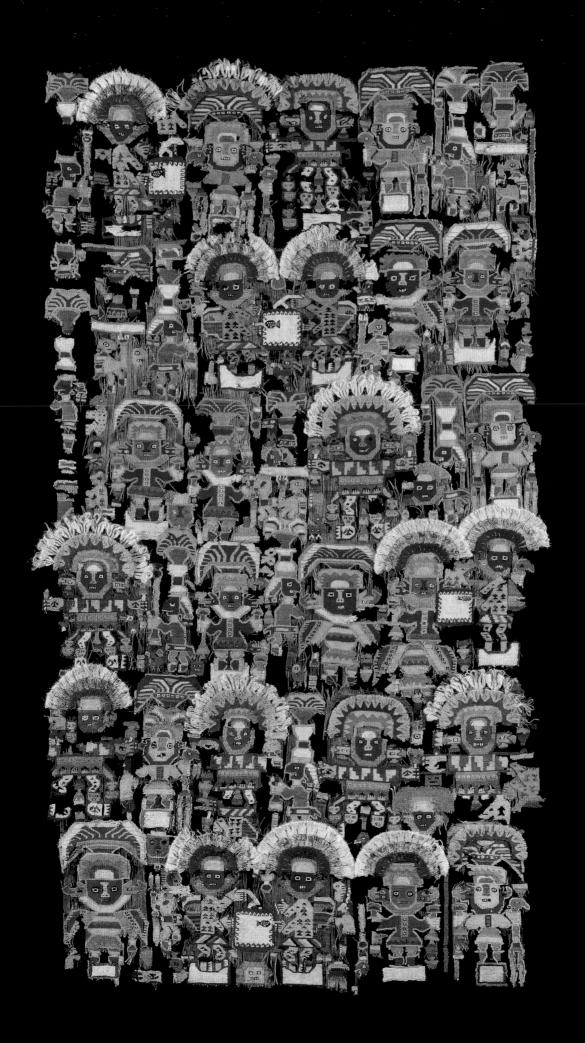

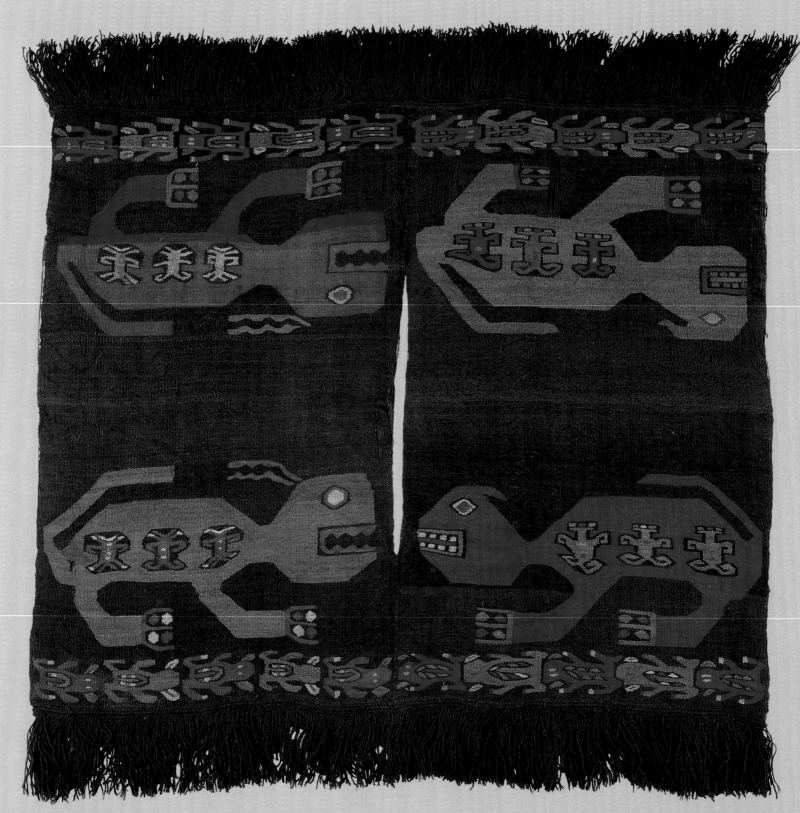

38

39

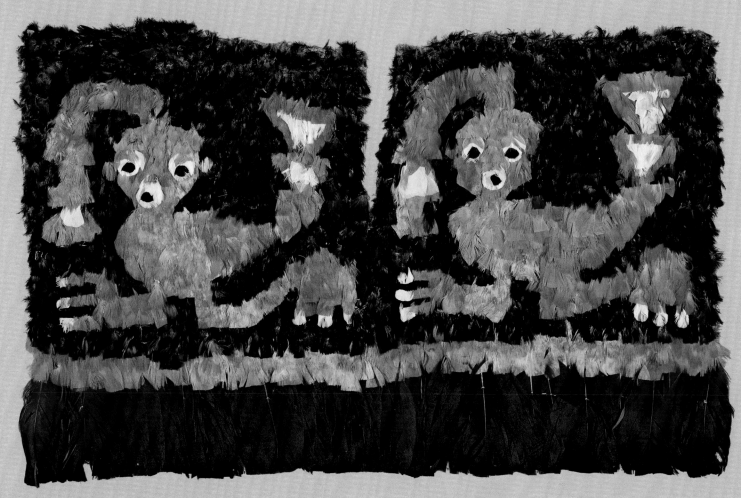

40

38.
Nazca-Huari
Poncho with felines
500–900 A.D.

39.
Huari
Feathered hanging
700–1200 A.D.

40.
Chimú
Poncho with stylized felines
900–1476 A.D.

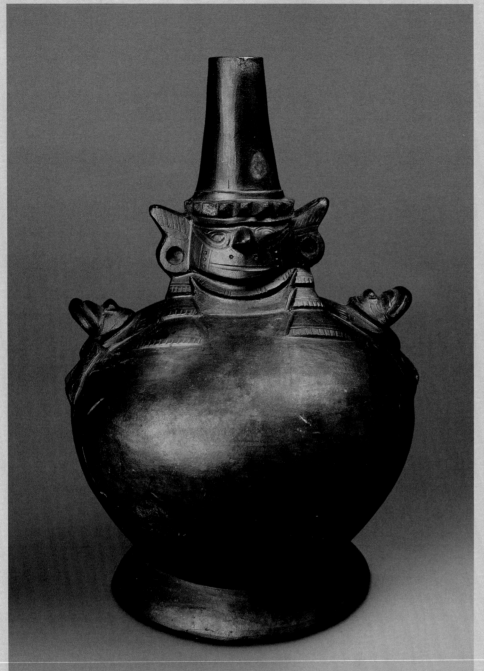

41

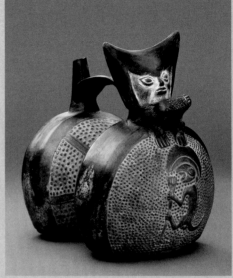

Fig. 4

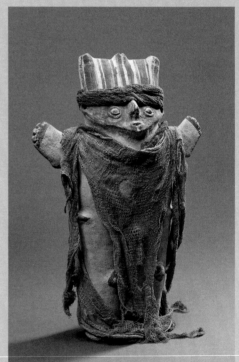

Fig. 5

41.
Lambayeque
"Huaco Rey" bottle
(with Naymlap's
[winged figure] face
depicted on the spout)
750–1375 A.D.

Fig. 4
Chimú
Double-chambered
bottle depicting the deity
of the Moon and the Sea
and zoomorphic beings
900–1476 A.D.
The Montreal Museum
of Fine Arts

Fig. 5
Chancay
Male Statuette
(*Cuchimilco*)
1100–1450 A.D.
Musées royaux d'Art
et d'Histoire, Brussels

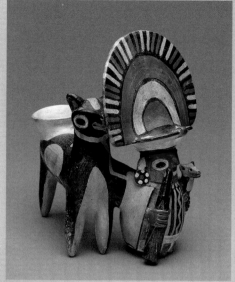

42

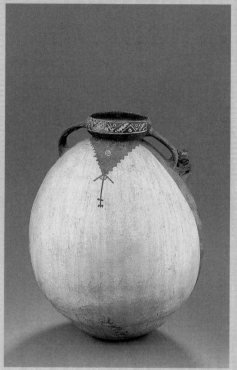

43

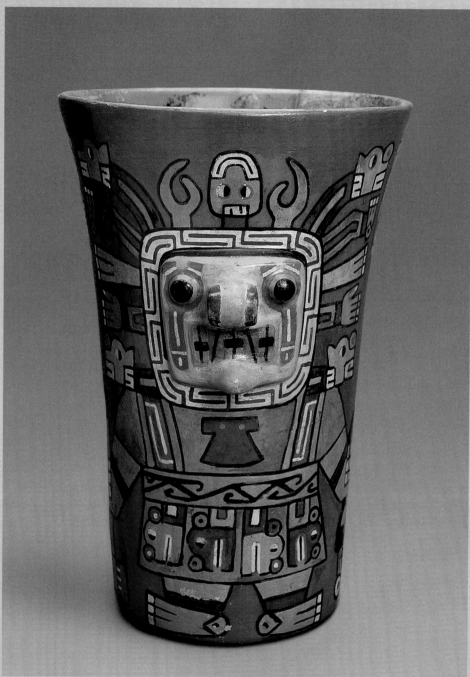

Fig. 6

42.
Recuay
Bottle in the shape
of a man with a llama
200–600 A.D.

43.
Chancay
Ovoid vessel with handles
1100–1450 A.D.

Fig. 6
Huari
Kero (ceremonial cup)
depicting a figure with
rays coming out of its
head holding a knife
and a severed head
700–1200 A.D.
Programa Arqueológico
San José de Moro, Lima

Rulers, Gods, and Myths in Ancient Peru

Krzysztof Makowski

The images that have come down to us from the highly developed coastal cultures of pre-Hispanic Peru are not sources that are easy to interpret, either by scholars or by those with a more general interest. In contrast to ancient Mexico, Peru's indigenous people did not leave written or illustrated manuscripts that would give us access to a world of concepts and customs that are very distant from those of twenty-first-century urban societies. In most cases, the images we do have represent strange-looking figures, their appearance either that of a human being or a fantastical, hybridized combination of the physical elements of more than one species. It is only their attributes that suggest their nature or sphere of activity. Despite these difficulties, iconography is in fact the only source of first-hand information with which we can counteract the biases of colonial documents, a result of their links with evangelization and with lawsuits. Because of these distortions, controversies surrounding the nature of indigenous religions and political systems still permeate the literature on the subject.

The imagery of the Moche of the north coast (100–800 A.D.) has some exceptional characteristics in comparison with other visual expressions of pre-Hispanic Peru, because it frequently contains scenes of unusual figurative complexity. Its apparent similarity to Greco-Roman iconography has led many researchers (e.g. Donnan 1975) to believe that its images represented predetermined subjects. One need only assemble a corpus of the most complex scenes, and then the rest of the images could be assigned to a particular subject, one that appeared to relate to a specific episode in a ceremony. However, it has subsequently been shown that Moche visual codes and rules of composition are different from those governing the thematic structure of Western art; they are more like the conventions of a cartoon strip, in which the continuous narration obviously dispenses with writing, and is nourished by oral tradition, as well as by the shared experiences of the maker and the user of the work (Makowski 1996).

These narrative characteristics become evident when one compares the polychrome reliefs recently discovered in the Moche temples to the fine line decoration painted on ceramics. It is clear that the artisans of the north coast represented sequences of two, three, or more episodes from a myth or a ritual activity. In the case of ritual scenes, living men and women are shown interacting without wearing disguises: fighting, hunting, playing games with dice and seeds, running races, and participating in dances, banquets, and orgiastic rites. Those taking part and officiating in these rites would gather on the islands, on the seaboard, in the desert, in ceremonial centers of the plains and foothills, or cross the coastal strip towards the sea or the sierra. A central purpose of these ceremonies was to train young warriors through participation in races and battles. At the same time, there is a wish to buy the favors of the gods of the sky, earth, ocean, and underworld with the blood of human and animal sacrifice. It was also believed that games could reveal the wishes of the ancestors.

Representations of myths can easily be distinguished by the supernatural characteristics with which the protagonists are endowed: radiant halos and elements based on plants and animals, prominent fangs in the mouth in particular (Giersz et al. 2005). The dead deserve special mention; they appear on the surface of the earth, naked or clothed, or as skeletons, and are also seen dancing in the darkness of the world below. Supernatural beings carry out almost all the actions performed by humans. This demonstrates the implicit desire to legitimate every human action, including rituals and celebrations, by reference to the principles of the natural and social order established by the gods and the ancestors in the remote mythical past.

In order to reconstruct narrative sequences (Makowski 1996, 2001) we have to start from the most complex images in which various protagonists are shown taking part. For example, when comparing two figures facing one another, we can be certain that figure A represents a different being from figure B. Using this simple comparative method, various scholars have independently obtained results that coincide to a large extent as far as the composition of the Moche pantheon is concerned (Lieske 2001, Giersz et al. 2005). Once we have established the preliminary cast of characters, we have to compare it with a

44. Mochica, bottle depicting the deity called "Wrinkle Face," 100–800 A.D.

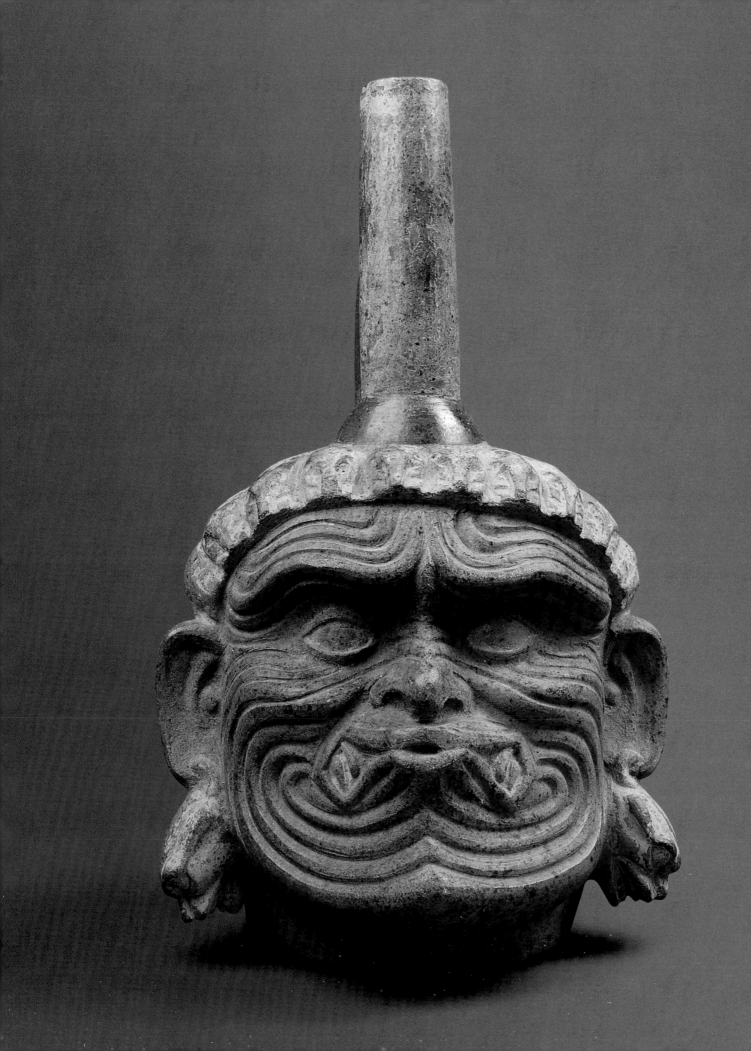

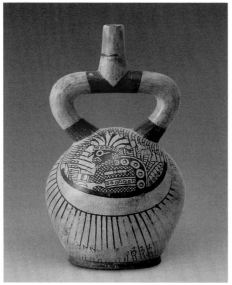

Fig. 1

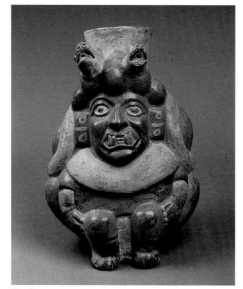

Fig. 2

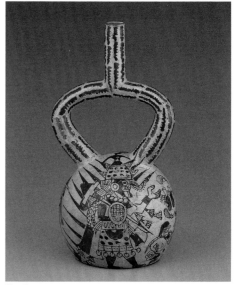

Fig. 3

larger body of pictorial and sculptural representations. In that way we can define the range of actions a given figure is performing, and also the list of attributes (Giersz et al. 2005, Woloszyn 2008) that distinguish him or her from other figures, permanently or in a given context. In order to offer a serious, convincing descriptive interpretation of narrative sequences, it is vital that the individual protagonists and the conventions used to represent settings and actions are identified correctly.

Thanks to the process we have described, it is possible to define the ceremonial roles of warriors, priests, and priestesses, to reconstruct the large number of deities venerated in Moche temples from about 500 to 800 A.D., and to suggest a hypothetical narrative structure for some myths. The pantheon is presided over by a deity who is sometimes androgynous, with an old man's face, a bald head, and monstrous snakes climbing up his back (fig. 2). The mouth with fangs is a deliberate allusion to the Cupisnique culture (1200–200 B.C.), as if to assert that this is an ancestral god, venerated by peoples now extinct. The ancient god of the earth is accompanied by the great ancestor-goddess of all women, who travels across the sea and the sky, riding on the moon, which takes the form of a *caballito de totora*, or "little reed horse," the typical fishing boat of northern Peru (Castillo and Holmquist 2000) (fig. 1). She is differentiated from other supernatural beings by her long braids—which have

become monstrous snakes—and her tunic belted at the waist, as well as by the scavenging birds that accompany her. In this primordial couple, the woman rules over the distant ocean and the night sky, the old man over the underworld.

The land of the living appears to have been ruled by four male deities. Two of them hold the high rank of warrior-chiefs, judging from the finery they wear. One of them is crossing the daytime sky in a litter. His figure is usually surrounded by a radiant halo, a feature that suggests his association with the sun (fig. 3). The style of his garments and headdresses identifies this deity with the warrior elites of the coast. The second member of the hierarchy has opposite characteristics from those of the first: he is usually depicted in the dress of a warrior from the sierra, a tunic covered in metal plates, and a headdress with two plumes. He often has the physical features of a owl, and like the owl, he lives in caves and holes in the mountains (fig. 5).

The other two gods are of lower rank and appear to watch directly over the destinies of mortals. One of them is often dressed like the warriors from the coastal valleys. This figure, with his characteristic belt of monstrous snakes, acts as both the civilizing hero and the tutelary ancestor, since he is represented sharing with human beings all their most important social activities: he has sexual relations with mortal women, tortures and buries a goddess, and plays games with dice or seeds with his

subordinates; he also fights with his coequal (who is dressed as a fisherman), dies in the fight or is thrown off a cliff, crosses the sea and travels through the bowels of the earth, dances with the dead, and emerges victorious from the underworld after defeating many dragons (Castillo 1989) (fig. 4). The last god is dressed and behaves like an inhabitant of the coast, a fisherman and seal hunter (fig. 6). He accompanies the goddess of the Sea and Moon on her travels and confronts his coequal in a fight to the death, in which he is the victor.

Each of the six gods described above is occasionally represented holding a cup in which to receive sacrificial blood, and with a radiant halo of snakes, rays, or clubs. Prisoners defeated in ceremonial battles are sacrificed in honor of each of them, but in different places. The blood intended to please the gods of the sea is shed on the islands, while the gods of the underworld receive the blood of those thrown over cliffs and dismembered, which is shed in the foothills of the mountains. The libation to the god of the skies is offered on the ceremonial sites adjacent to the cultivated valley. It must be emphasized that these conclusions do not spring from fully developed theories, but simply from a descriptive, comparative study of the images.

There is substantial evidence of a direct link between the cosmological concepts inferred from a study of the religious iconography of the coastal region, on the one hand, and the key political ideas that

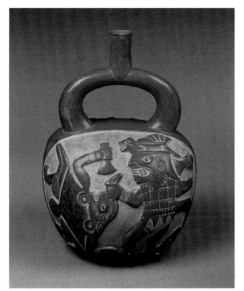

Fig. 4

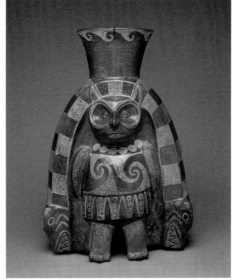

Fig. 5

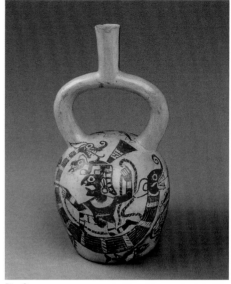

Fig. 6

prevailed there, on the other. In the first place, human beings wear the same outfits and headdresses as supernatural beings. Those who wielded power, the Moche chiefs and kings, are dressed like the four male warrior deities, while the priests and priestesses are dressed like the god of the Bowels of the Earth and the goddess of the Sea and the Moon respectively. Recent excavations have made it increasingly clear that those responsible for performing funeral rites and producing offerings deliberately emphasized the kinship of the rulers and the principal deities through the way clothing, ornaments (Sipán and Loma Negra: Makowski 1994, 2003, 2008; Cao: Franco 2008), and coffins (San José de Moro: Castillo 2001b) were decorated, as well as through the design of staves of office and decorated ceramics (Virú: Mogrovejo 2008). The evidence adduced suggests that the power system to which the images allude shows some of the characteristics of a diarchy, or dual political system.

That system was described by historians in sixteenth-century documents that made reference to the entire coast of Peru (Rostworowski 1983; Netherly 1990; Ramírez 1981, 1996). Although the government was in the hands of a single person, he had to share power with another *curaca*, or cacique, whose authority extended over half of the territory. The upstream and downstream halves had their own overlords and were also subdivided into two halves and four further subdivisions under lower-

ranking chiefs, creating a pyramid of power. That type of organization meets the administrative needs of territories that use irrigation, in the context of a political system that does not include the concept of individual ownership of arable land or flocks of animals. Each *curaca* controlled the labor of a specific group of farmers who settled along a canal or a smaller irrigation channel. His authority, according to Ramírez (1996), depended on the ability to negotiate. The political equilibrium could easily be broken if an ambitious subordinate chief attempted to rebel.

The Moche world began to collapse in the eighth century A.D., and in the course of the ninth century an iconography of power that was radically different in form and content replaced the old one almost completely. The new rulers gave up the wearing of headdresses and the use of the ceremonial *tumi* knife and Moche drinking cups, replacing them with foreign symbols: the four-cornered Wari hat and the *kero*, a particular type of drinking vessel originally from the distant basin of Lake Titicaca. The astonishing diversity of Moche mythological beings was replaced by a single figure, surrounded by a smaller number of acolytes. Scholars agree that he probably represents the founder of the dynasty of Lambayeque rulers, Naymlap, with the mask of his protector god, Yampallec.

A comparison of Moche architecture and iconography with those of Lambayeque demonstrates the substantial change in

power strategies. To judge from the results of excavations at Huaca de la Luna, the capitals of the Moche kingdom were in the nature of ceremonial centers, without palatial buildings that might overshadow the grandeur of the temple (Uceda 2008). In terms of iconography, the emphasis was on rituals involving a number of communities, enabling various groups and political confederations to coexist peacefully, and on the myths promoting interdependence among the overlords of moieties and their subdivisions. In contrast, the Lambayeque capital at Poma (Batán Grande-Sicán: Shimada 1995) consisted of palace-temples for the funerary veneration of rulers (Makowski 2006). The images of the founder of the dynasty and his palace, disseminated in thousands of reproductions, refer beyond a doubt to the dynastic myth as the principal means of legitimating the new political order.

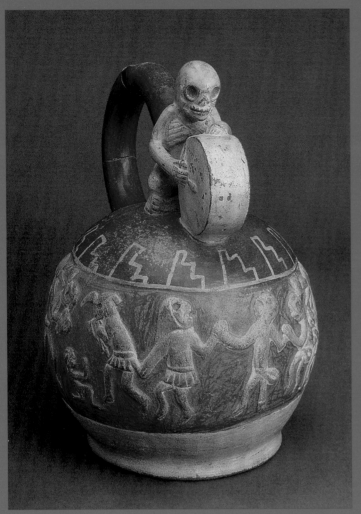

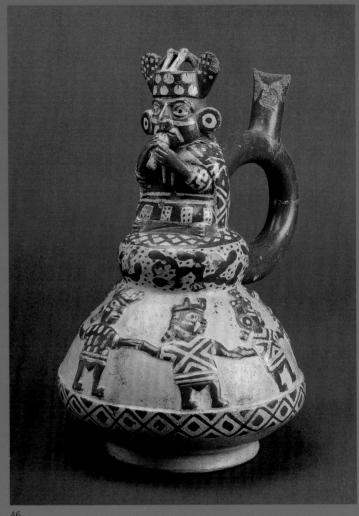

45

46

45.
MOCHICA
STIRRUP-SPOUT BOTTLE DEPICTING A DANCE OF THE DEAD
100–800 A.D.

The dance of the dead decorating this bottle is a recurrent theme in Mochica iconography. A skeletal figure at the top of the bottle, molded in three dimensions, seems to be beating time on a drum. Other skeletal figures on the belly of the bottle, this time in low relief, are holding hands, a gesture that symbolizes dance in Mochica art. The inclination of the head and upper body of some dancers strengthens the impression of movement. Musicians are present, too, some playing panpipes. Incidentally, panpipes are more often seen in scenes where the dancers are dead than in scenes where the dancers are alive. The presence of women and children is another feature of the dance of the dead.

Interpretation of this type of scene is still largely speculative, but we can reliably say that the dances were usually part of a broader ritual context. The skeletal appearance of the figures emphasizes the continuity of the rituals into the world of the dead and the importance of the ancestors in the perpetuation of the world of the living. A stick with some sort of foliage at the top can be seen on the back of the belly of this bottle. Christopher Donnan (1982) has suggested that this scene may be related to the *ayrihua* dance described by the Jesuit missionary Pablo José Arriaga, during which ears of corn were tied to willow branches to secure a plentiful harvest. Anne-Marie Hocquenghem (1987) thinks that scenes of the dead dancing to the sound of flutes and drums may be related to ceremonies marking the end of the wet season, because the dead are associated with the dank underworld.

E.H.

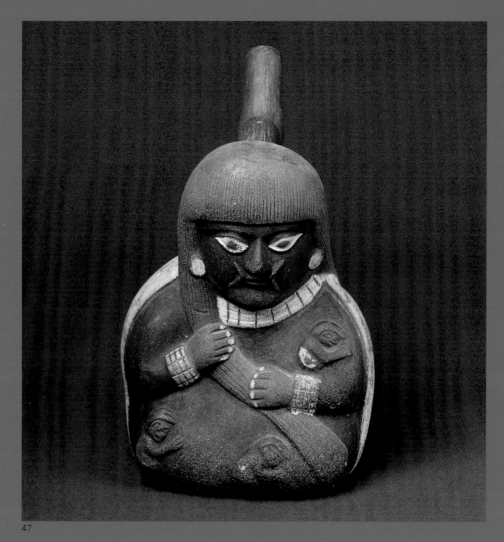

47

47.
MOCHICA
STIRRUP-SPOUT BOTTLE DEPICTING A DEITY
WITH MINIATURE HUMAN FIGURES STUCK TO ITS BODY
100–800 A.D.

This stirrup-handled bottle represents a seated anthropomorphic figure holding in its hands a strand of its long hair, and with three miniature human forms affixed to its body. The prominent fangs protruding from the mouth indicate its supernatural status. The cape and the type of necklace, a wide band made up of rectangular shapes, are more frequently associated with female figures in Mochica iconography. It is therefore possible to imagine that this is the representation of a female deity. Other bottles depicting the same figure, recognizable from its face and physical posture, have lice, rather than human figures, on the body. These similarities have led some

scholars, such as Christopher Donnan (1978), to connect this representation with a text recorded in the early seventeenth century in the Jequetepeque Valley by the Augustinian friar Antonio de la Calancha.

In his *Crónica moralizada del orden de San Agustín en el Perú* (1638), Calancha recounts how a magician named Mollep ("louse-ridden" in the Mochica language) announced to the population that human beings were going to multiply like the lice on his body. This association between the proliferation of lice and that of human beings may explain the two types of representations present in Mochica art. Although it is

not possible to make a direct connection between that text, written in the colonial period, and the beliefs that were current in the age of the Mochica, the existence in the region's oral tradition of a myth that coincides so closely with an iconographical motif supports the thesis that there may have been a degree of cultural continuity. Taking the text as a point of reference, the presence of miniature human figures on the body of the female deity could suggest abundance and fertility, both among the population, but perhaps also in relation to harvests.

E.H.

The Symbolic Language of Ancient Peruvian Art

Ulla Holmquist

"... the symbol itself may be considered as a language which, although conceptual, is nevertheless capable of expressing a coherent thought on existence and on the world. The symbol reveals a pre-systematic ontology to us, which is to say an expression of thought from a period when conceptual vocabularies had not yet been constituted" (Mircea Eliade, *Symbolism, the Sacred and the Arts*)

Pre-Columbian art objects demonstrate the quality and technical mastery achieved by artists in the various societies that came into existence in ancient Peru. But above all, they show us how these societies understood and shaped their understanding of the world, and how the beings who inhabited those societies interacted. Ceramic sculptures and vessels, woven blankets and pieces of clothing, metal ornaments and vessels, and items carved in wood, shell, or stone, are all artifacts by means of which their makers created meaning within the cultural system to which they belonged (Golte 2009, 18).

In the Andes, traditional forms of expression emphasized the visual and physical qualities of objects (Cummins 1998, 95). In that respect, art objects constituted highly symbolic systems of visual communication. Nevertheless, the ethnic and linguistic diversity of the Andean region (Makowski 2000, XXII) suggests that there was probably no single visual language, but several. These had their own structures and rules of composition, and they consisted of signs and messages whose meaning depended on the context in which they were made and used.

We should not forget that in fact there was great cultural diversity in the Andes, the result of adaptation to a great variety of natural environments as well as the political and religious integration of different populations (Makowski 2000, XXI). In those cases, certain symbols and the compositional rules of the visual language appear to have created a kind of *lingua franca* with which it was possible for meaning to be transmitted and shared by people who probably belonged to different ethnic groups and spoke different languages (Golte 2009, 417). These peoples lived side by side and interacted in the region for thousands of years, developing complementary strategies by which to adapt to a complex, diverse geography. That interaction, and the constant interchange of goods and information, seems to have resulted in the development of at least some shared concepts and categories for organizing time and space, and for shared conventions of visual communication.

Funerary Objects

The pre-Columbian objects now held in museums and other collections come mainly from the burial sites of the rulers, priests, and priestesses of ancient Peru. Most of these objects were designed to serve specific purposes in the rituals commemorating the dead. Other objects buried in tombs had previously been used in various ceremonies, or had been worn by political or religious leaders during their lives and were subsequently buried with them. We are thus confronted by objects that communicate religious and cosmological messages in predominantly ceremonial contexts, and which also act as indices or markers of identities, positions, and hierarchies (Makowski 2008, 6). The messages embodied in these objects had meaning in the specific context in which they were used and according to the actors through whom the objects became part of the process in question.

Worldview and Symbols

Archaeological, anthropological, ethnographic, and ethno-historical research has made it possible to point to the existence of certain shared categories. In the Andes, it seems usual to have categorized space, time, and social relations in pairs of complementary opposites, or *yanantin*, which come together at some moment of spatial and temporal contact; it is this meeting, or *tinkuy* in Quechua, that produces life and ensures continuity. The binary categories used to subdivide time and space are based on the reproductive model of the human couple (cat. 48). Thinking in terms of "mirror images," some homologous categories can be identified: day, the external world (thought of as "above"), the dry season, and the sun all appear to be male (cat. 50); while night, the internal world (thought of as "below"), the wet season, and the moon are

48. Salinar, stirrup-spout bottle depicting a woman masturbating a man, 200 B.C.–100 A.D.

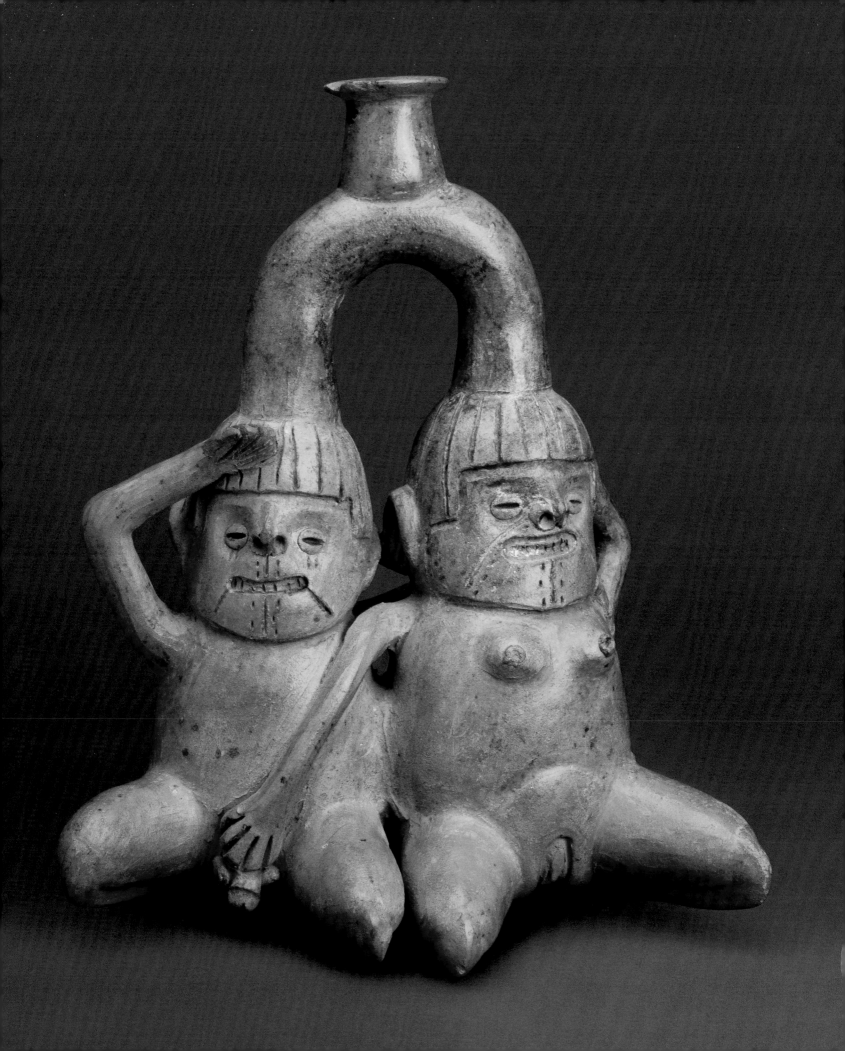

female (cat. 51). Nature is also understood in those terms: hills and mountains are male, while valleys and the interior of the earth are female.

This way of categorizing time, space, and social relations was expressed in art objects that, taken together, constitute a visual language that involves not only the designs, motifs, and scenes depicted, but also the material qualities of the objects themselves. Equally as important as the figures were the raw materials selected, the techniques used, and the colors and positions of designs and motifs in the spaces created by an object's shape. In order to explain these concepts more fully, we will focus on the art of the Mochica.

Ceramics: Transmitters of Messages

In the Andean region, ceramics became, at a very early date, a privileged medium for expressing ideas about the world in a creative way and for communicating them in the contexts in which the ceramics were used. Potters worked with earth, water, fire, and air, and they transformed shapeless, malleable material into objects that could serve various purposes and could represent the most diverse things and living creatures. For more than 3,500 years, they gave form to a variety of objects, among which we recognize types of vessels: bottles (cat. 44), jugs (cat. 52), bowls (cat. 56), etc., objects producing sound or music (cat. 102), and some that are both vessels and sound-producing objects such as "whistling bottles" (cat. 87). Some objects, called *pacchas*, were used not as receptacles but more as circuits through which liquids would pass (cats. 10, 105, 117).

Two forms occur most frequently among pre-Columbian funerary ceramics: the bottle "with a spout or handle in the shape of a stirrup," characteristic of the northern tradition (cat. 55); and the "bottle with two necks joined by a bridge handle" found in the south (cat. 27). In Mochica ceramics, the forms found most often are stirrup-spout bottles, bottles with a wide mouth (cat. 83), bottles with a single spout, *cancheros*, drinking cups, and flaring bowls. The form and composition of the images found on these ceramics express concepts from the Mochica world order (Golte 2011, 1).

In the case of stirrup-spout bottles, the arched handle with a central spout was attached to objects used as containers. The body of these bottles was molded and modeled in such a way that the empty space was "contained" in different forms representing mountains and temples (cat. 62), human or mythological figures (cats. 47, 67), animals (cat. 57), fruits or tubers (cat. 54), or combinations of these (cat. 53), all sculpted with great skill. In other cases, the space was "contained" in parallelepipeds or spheres that were combined with figurative sculptural compositions (cat. 61). The spherical forms (cat. 60) allowed more detailed cosmological narratives to be worked out.

These bottles are hollow sculptures whose interior is connected with the exterior by the formal device of the handle. If liquid is poured down the spout it will run through both channels, reinforcing the symbolic idea of connection. However, in order to pour the liquid out of the bottle, fluids have to flow in a different way: air passes into one channel, and the liquid runs out of the other. Given that this type of container is associated with funerary rituals, stirrup-spout bottles present themselves as objects with a powerful symbolic charge referring to the link between the exterior and the interior world, which occurs at the precise moment of death (Li Ning 2000, 69–72).

The *canchero* is a shallow dish with a fairly small opening in the top and a long handle, associated with offerings to the world "below," conceived of as a female world whose fertility has to be propitiated with male offerings such as semen, real or symbolic. These *cancheros* are even represented in scenes of masturbation, in which beings from both worlds take part (cat. 49). The message of some *cancheros* is quite explicit, with the orifice of the vessel shown as a vulva or a woman's face, in the same attitude as that shown in representations of women performing acts of fellation (figs. 1, 2).

The drinking cup is a type of vessel found in the context of Mochica funeral rites for persons of the highest rank (cat. 64). They are used in rituals connected with the meeting between the wet nocturnal world and the dry diurnal world, which are usually preceded by ritual battles and sacrifices. The sense of connection, or *tinkuy*,

between the two worlds is reinforced by the type of symbols found round the vessel, in some cases consisting of symbols in the shape of stairs, or triangles of contrasting colors, inverted so that they meet at the corners (Golte 2011, 6).

Among ceramic vessels we also find some with composite forms (Golte 2011). These examples show how Mochica vessels may be thought of as signs in a visual language in which it is even possible to construct complex signs by "agglutination," thus creating composite forms that would allow new meanings to be communicated. They show that the actual shapes of ceramic vessels may be understood as semantic units in this communication system, which can be reconfigured to create new signs, thus transmitting new meanings and creating new forms of discourse (Jackson 2008, 155).

A Communication System with a Configurational and Spatial Syntax

The highly developed symbolism of Mochica ceramics makes it possible to describe its elements, taken as a whole, as a semasiographic communication system in which the images are inseparable from their physical existence as objects. Unlike a writing system, configurations of symbols and signs have no sequential or linear syntax, but a presentational one (Jackson 2008, 154).

Studies of Mochica ceramics that interpret them in semiological terms make essential the taking into account of the placement of the motifs, figures, actions, and configurations depicted, whether sculpted or in relief, in their specific positions in the three-dimensional space of the objects and in relation to possible horizontal and vertical axes. They also show that certain formal elements that are also highly symbolic, such as the arched handle, serve as devices for visual organization. The handle creates a form of spatial order, formalized in the body of the bottle, in which the specific configurations formed by figures and actions are arranged. The spatial convention that is formalized in the case of Mochica stirrup-spout bottles with a spherical body appears to have made the distinction between an upper and a lower hemisphere, assuming a horizontal axis formed by the "equator" of

49.
Mochica
Stirrup-spout bottle
depicting a woman
masturbating a skeletal
male figure
100–800 A.D.

50.
Mochica
Bottle in the shape
of male genitalia
100–800 A.D.

Fig. 1
Mochica
Portrait vessel depicting
a woman with her mouth
open to perform fellatio
100–800 A.D.
Museo Larco, Lima

Fig. 2
Mochica
Canchero depicting
a woman with
disproportionate genitals
100–800 A.D.
Museo Larco, Lima

51.
Mochica
Stirrup-spout bottle in the
shape of female genitalia
100–800 A.D.

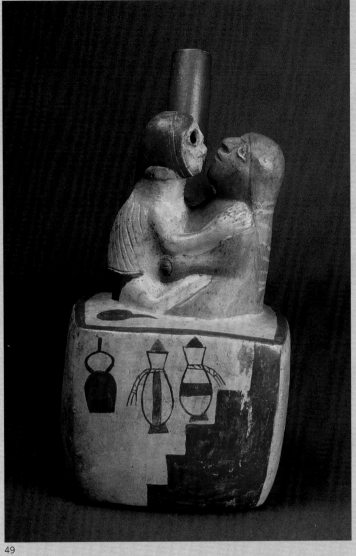
49

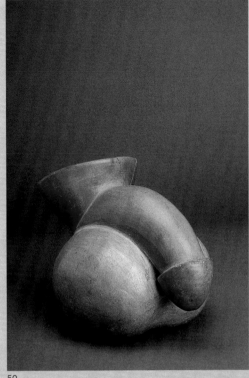
50

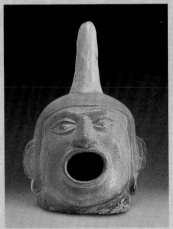
Fig. 1

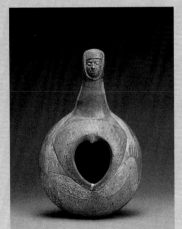
Fig. 2

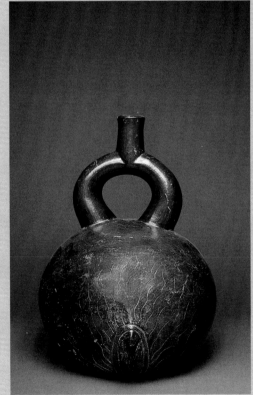
51

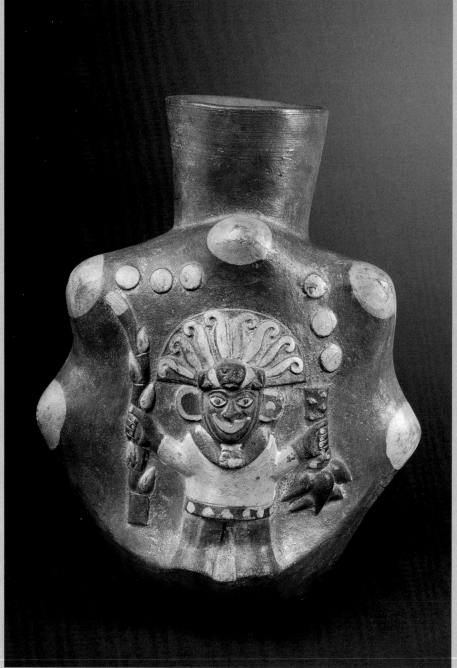

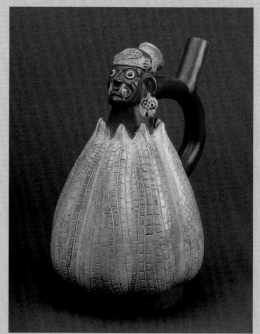

53

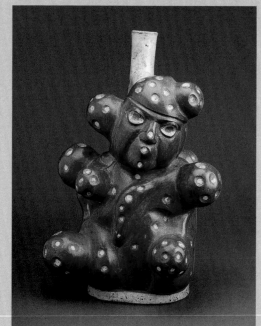

52

54

52.
Mochica
Bottle depicting
a mountain deity holding
maize and yucca
100–800 A.D.

53.
Mochica
Stirrup-spout bottle
in the shape of a deified
maize cob
100–800 A.D.

54.
Mochica
Stirrup-spout bottle
in the shape of an
anthropomorphized potato
100–800 A.D.

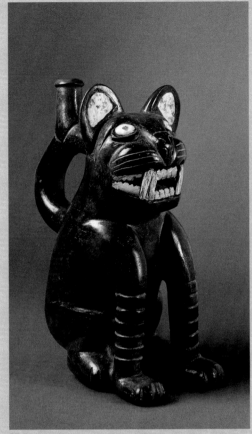

55

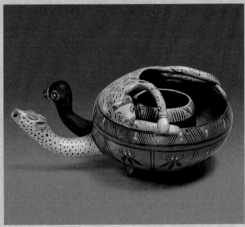

56

57

55.
Mochica
Stirrup-spout bottle
in the shape of a seated
feline
100–800 A.D.

56.
Inca
Double bowl depicting
a bird, a camelid and
a feline
1450–1532 A.D.

57.
Mochica
Stirrup-spout bottle
depicting a sea eagle
catching a fish
100–800 A.D.

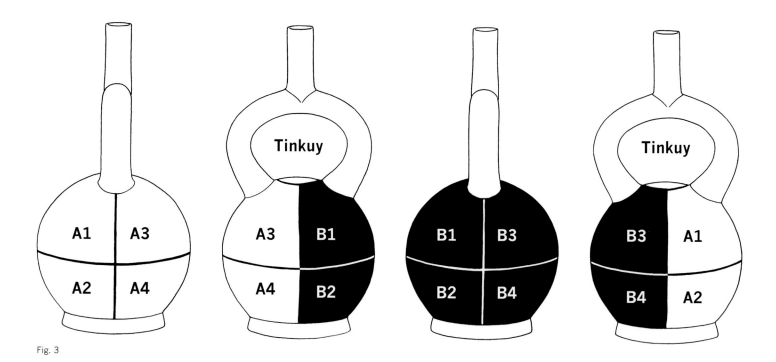

Fig. 3

Another "Reading" of a Familiar Image

The most complex configurations of images in Mochica art, such as those called "Sacrifice Ceremony and Presentation Theme" (cat. 58), are found on bodies of spherical stirrup-spout bottles. These and other complex scenes, when we "read" them in the light of the recent studies of Mochica art referred to above, reveal greater complexity than would emerge from a reading of the image alone, in isolation from the bottle.

the spherical piece, or hemispheres parallel with the stirrup spout, or connected by it. This system of representation would seem to have permitted communication between the opposing and complementary categories of space and time central to the Mochica worldview, using this particular formalized spatial arrangement (fig. 3).

By studying a bottle upon which the Sacrifice Ceremony is represented, we see that the two largest figures in the scene, wearing symbolic elements that put them in different time frames (fig. 4A: a radiant diurnal deity who rules in the dry season, and fig. 4C: a nocturnal deity who rules in the wet season) are placed in opposite hemispheres of the bottle, assuming a vertical subdivision along a line marked by the stirrup spout. If we look at the horizontal axis defined by the longer diameter of the spherical vessel (marked visually by the two-headed serpent encircling the piece), we see that they are placed in the upper hemisphere, reinforcing the reference to creatures of the world "above." Intermediate creatures are clearly placed in positions of transit, close to the vertical axis: an osprey and the Moon Goddess bind together the dark/nocturnal/wet world and the bright/diurnal/dry world (fig. 4B). If we look more closely at the vertical axis, we can see that the configurations of

figures and actions located at the point of contact between the two hemispheres are like "visual sentences" that refer us to the moments of contact between both "time frames" (the equinoxes): in one case, we see the confronted heads of the two-headed snake, and above them, the image of clubs and shield, indicating warfare (fig. 4D), while on the opposite side, we see the Moon Goddess moving peacefully between one time frame and the other, carrying the sacrificial offering (Golte 2009, 77–79).

This reading, which suggests an interpretation of the scene in terms of a broadly expressed reference to the calendar, is only possible if we believe we are looking at objects that form part of a "mixed" system of communication that combines characteristics of pictorial and notational languages in which symbols and signs are combined to create syntactic, configurational, and spatial structures (Jackson 2008, 91).

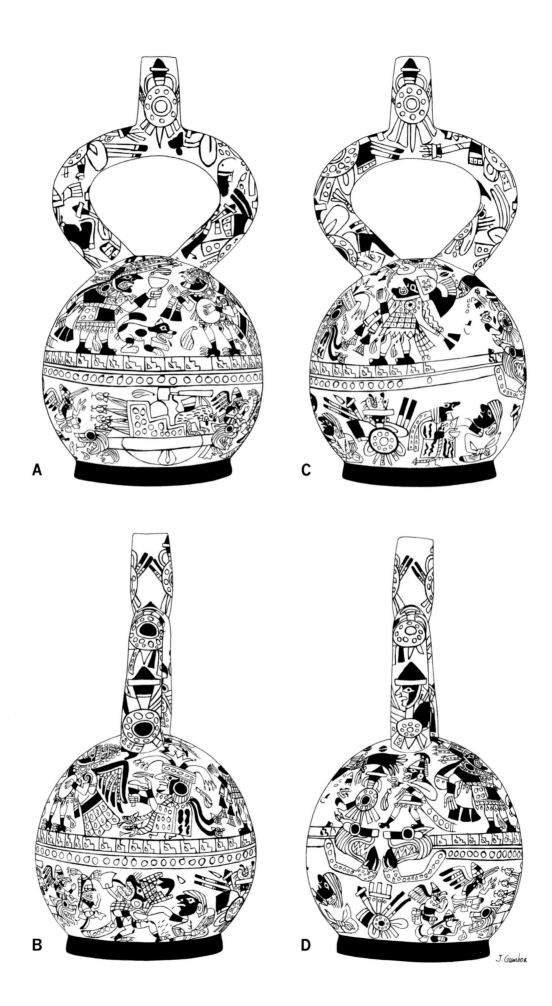

Fig. 3
Jorge Gamboa
(after Jürgen Golte)
Diagram of use of spaces
on the surface of
a stirrup-spout bottle

Fig. 4
Jorge Gamboa
(after Jürgen Golte)
Spatial organization
of the representation
of the sacrifice ceremony

A

C

B

D

J. Gamboa

Mochica Rituals of Battle and Human Sacrifice

Luis Jaime Castillo Butters

Representations of battle and human sacrifice produced by Mochica artisans, either painted, carved, or modeled in the form of murals, ceramics, and wooden or metal objects, are among the most emblematic elements in the iconography of ancient Andean societies. These images portray in vivid detail a series of ritual activities that included combat and the capture of prisoners, as well as elements associated with this subject matter, such as weapons used in battle and the blood of prisoners. It has taken a long time to read and interpret these images, as archaeological research has thrown light on different aspects of that society in succession. For example, for many years it was thought that these images of battle depicted the wars of expansion waged by the Mochica, but now, as we shall see, they are believed to illustrate a complex ritual that began with battles between different Mochica communities. These conflicts led to the capture of prisoners, who were later sacrificed and whose blood was offered to the major deities, who themselves represented members of the ruling class of these societies.

Mochica societies developed in the fertile valleys of the north coast of Peru between 100 and 800 A.D., in other words, in the period between the development of the formative societies and the rise of the Huari Empire. The north coast of Peru, in contrast with almost all the rest of the country, is a flat, arid region—an alluvial plateau located between the Pacific Ocean and the Andes, where rain is very infrequent and falls only when there is an occurrence of the El Niño phenomenon. From a very early date ancient societies in this region developed survival strategies that took different forms from those seen in Middle Eastern, Asian, and European societies. For example, these early societies based their development, and fed their populations, on resources obtained from the sea, fish and shellfish being exceptionally abundant in the waters off the coast of Peru. This strategy, which we have called the "Maritime Foundations of Andean Civilization," enabled societies to develop very early on at sites such as Caral, Sechín, and Huaca Prieta (Moseley 2001). But the major change occurred with the introduction of water engineering technology, which made it possible to irrigate the coastal deserts and to create an agricultural economy that produced large surpluses. The wealth produced by an agricultural system based on intensive irrigation enabled Mochica societies to develop at various places along the north coast (Quilter and Castillo 2010).

Recent archaeological research has shown that many Mochica states coexisted on the north coast, taking very different forms, some of them small local chiefdoms, others powerful regional states, one of which, based at Huacas del Sol y de la Luna, was an expansionist state that conquered a large area of the north coast (Castillo and Uceda 2008). While these states were politically independent, they developed in common a number of ceremonial activities that ensured the Mochica elites, the royal houses, remained connected with one another over long periods of time. Relations between the elites, especially royal marriages, meant that the different Mochica societies shared a series of religious rituals and cultural phenomena, giving them a high degree of homogeneity for 700 years. The central focus of this common religious liturgy that linked together the Mochica from different places were the Rituals of Battle and Sacrifice, whose material remains, in the form of monuments and artifacts (with slight regional differences), have been documented in every part of the north coast, covering the entire history of Mochica societies (Donnan 2010).

The narrative structure of the Ceremony of Battle and Sacrifice can be reconstructed step by step from the representations left to us by the Mochica from different times and places. The first part of the ceremony, the Ritual Battle, began with the preparation for battle of the warriors, who wore their most magnificent clothes and ornaments, consisting of gilded copper decorations and brilliant, multicolored feathers, metal crowns, nose ornaments, rattles, and bells. If we consider the dress, headgear, and ornaments they wore, it is obvious that the warriors were not attempting to keep a low profile or to go unnoticed onto the battlefield. Rather, they seemed to be doing their best to display their identity and status. The headdress they wear is extremely large and flamboyant, surely because it is the insignia of the warrior and his clan or social group (cats. 59, 63). We can see the warriors marching in single file to the field of battle, most of them wearing the same type of headdress and carrying a very small

58. Mochica, stirrup-spout bottle depicting the "sacrifice ceremony," 100–800 A.D.

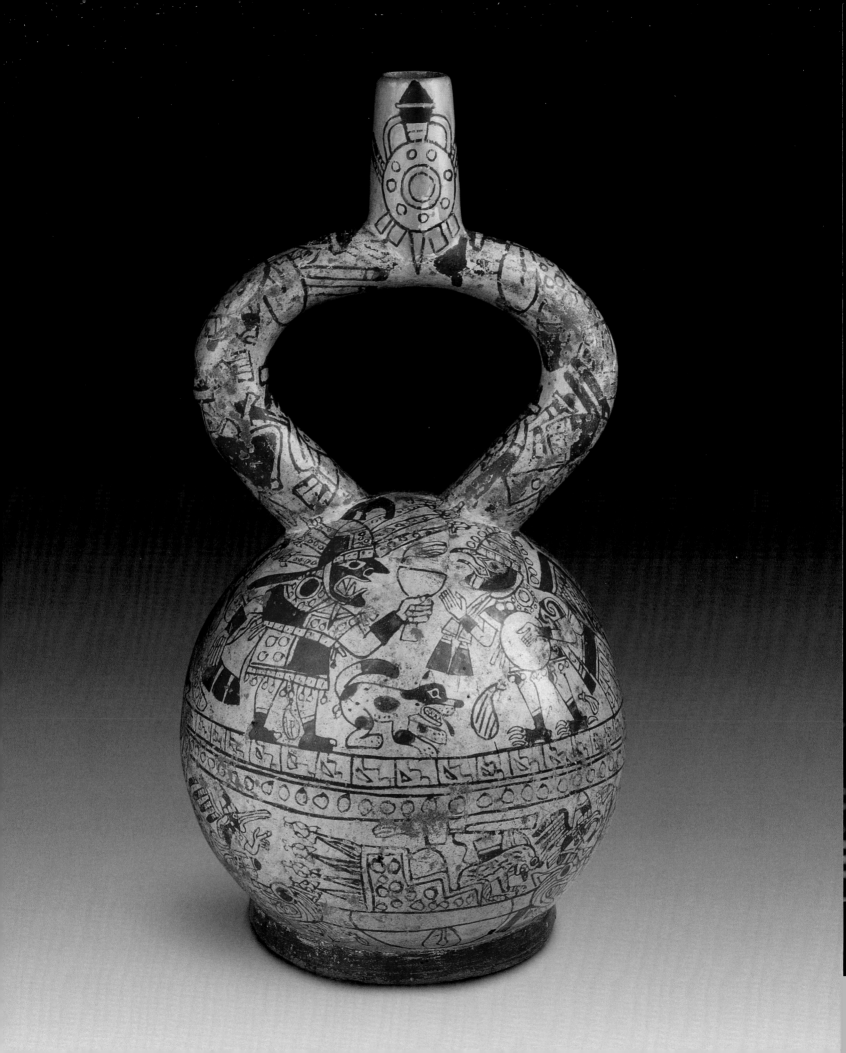

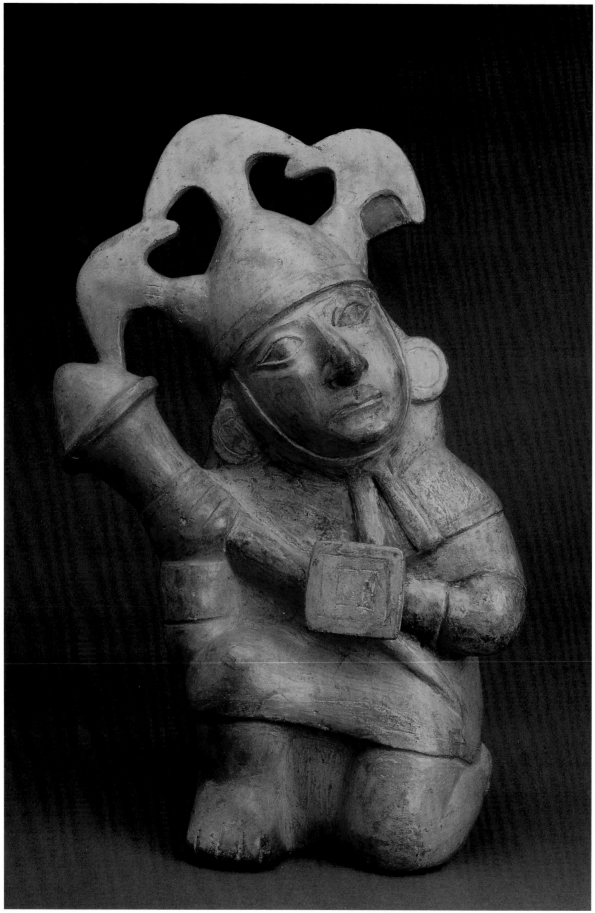

59

59.
Mochica
Stirrup-spout bottle
in the shape of a kneeling
warrior
100–800 A.D.

Fig. 1
Donna McClelland
*Mochica Warriors Walking
Towards the Battlefield*

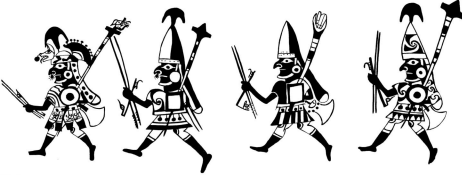

Fig. 1

shield and a club carved from a single piece of carob wood (fig. 1).

The different groups of warriors would gather in an open space on the outskirts of the urban centers, in mountainous areas that supported cactuses and other succulents but where there were very few trees to be seen. The confrontation would begin when the warriors on each side divided into small groups and fought in single combat. The representations suggest no kind of military strategy, nor is there any sign that one group might try to surround another, or that they used weapons with a longer reach, such as spears hurled with the use of spear-throwers or projectiles launched from war slings, all of which might be expected in a real battle. The images all indicate that the real aim of the battle was to pull off an opponent's headdress, and that to do this the warriors punched and shoved each other, struck blows with their clubs and shields, and jumped and chased one another. That goal meant that the encounter had more in common with a game than with war, and the Ritual Battle was clearly distinguished from any actual battle, since in no case was there any attempt to kill or seriously wound an opponent. Just as a boxing match, with its rules and fixed duration, is distinguished from a brawl in the street, Mochica opponents confronted one another in accordance with an agreed-upon plan and abided by a series of rules governing their behavior. At the end of the battle one of the warriors would succeed in pulling off the other's headdress, and thus he would cease to resist. Without his headdress, the warrior's hair was visible, which seems to have been a sign that he was defeated and humiliated. In some scenes we see the way the victorious warrior grips the vanquished one by the hair, and how the latter shows submission to his opponent (cat. 60). The defeated warrior knows what his fate will be, and—in the representations at least—accepts with a good grace what will happen. On the battlefield itself the defeated warriors are stripped naked; their clothes and weapons are tied to their clubs, their hands are tied behind their back, and a rope is tied round their neck. The clubs of the vanquished, with all their weapons, insignia, and clothing, appear to be taken as booty by the victor. Some warriors thus become prisoners and the second part of the ritual begins (cat. 61).

The activities that lead to the Ceremony of Sacrifice begin with the Presentation of the Prisoners. The prisoners, naked and bound with ropes, are led through the city by the victorious warriors, possibly to courtyards near the temples or to small structures built especially for the ceremony. In these places the warriors would meet a number of very richly attired figures, to whom they would present their prisoners (cat. 61), and this would mark the start of what would appear to be a transaction in which the fate of the defeated warriors would be decided (fig. 2). At this point the narration diverges, as it would seem that the fate of some prisoners was to be sacrificed on the Guano Islands, while others were kept for the Ceremony of Sacrifice. The passage from the Ritual Battle and the Presentation of the Prisoners to the Ceremony of Sacrifice seems also to have represented a breach in the barrier between the human world and the supernatural, and from then on the participants would all be gods or demigods who appear in anthropomorphic form.

The Ceremony of Sacrifice was carried out in places that appear to have been enclosed and reserved for the exclusive use of the high priests of the Mochica (cats. 58, 62; fig. 7, p. 80). There the prisoners were brought bound hand and foot, and a minor deity—a bat, a great cat, or even an anthropomorphized object—would slit their throats and collect the blood in a vessel. It is quite possible that the Mochica priests were dressed as these divinities or even as the major gods, in ritual re-enactments of the myths that explained the origins and rationale of these ceremonies. The final part of the ritual consisted of the presentation of the prisoners' blood to the major gods in the Mochica pantheon. This presentation was made using goblets designed for this purpose (cat. 64; fig. 7B, p. 80). In the surviving versions of this part of the ritual we see a male warrior god, with the fangs of a great cat, receiving the cup containing the blood of the vanquished and drinking from it (figs. 3, 7A, p. 80). The cup is presented by a god who is half man and half eagle (figs. 4, 7C, p. 80); behind him stands the priestess, a goddess represented with braided hair and wearing a long garment and a curious headdress with two big "plumes" with serrated edges (figs. 5, 7D, p. 81). Behind them appears a god from whose body emanates beams or war clubs. This god carries weapons and wears a headdress with a semicircular ornament at the front (figs. 6, 7F, p. 81).

Over the past twenty years, research at Mochica sites has confirmed that mythical narratives and rites such as the Battle and the Sacrifice did in fact take place and that the Mochica re-enacted the rituals at regular intervals in their major temples or at *huacas*, or funeral mounds. Bodies of prisoners have been found in the Huaca de la Luna. Apparently bound and sacrificed in the back of the temple, these individuals died from massive head trauma, but they may well have first been partially bled in the Ceremony of Sacrifice, the blood likely having been drunk by the high priests (Uceda and Morales 2010). The tombs of Mochica kings and queens show they were buried with the clothing, ornaments, and artifacts used in re-enacting the myths. For example, the Lord of Sipán, whose burial was excavated by Walter Alva and his team in the Lambayeque Valley, was dressed as the person who received the goblet containing the blood (Alva 2004), while in San José de Moro, seven tombs have been found that

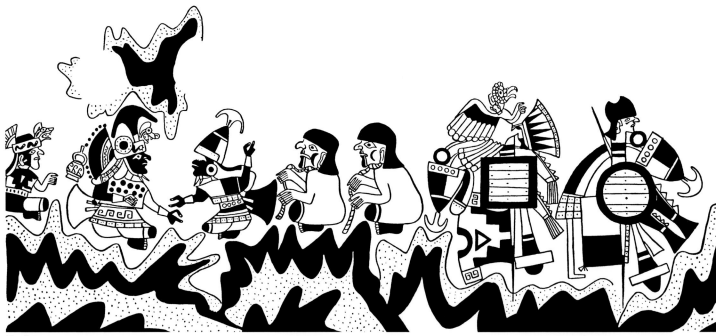

Fig. 2

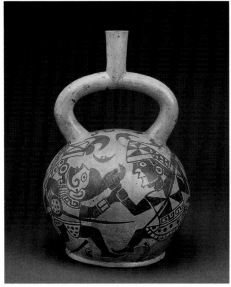

60

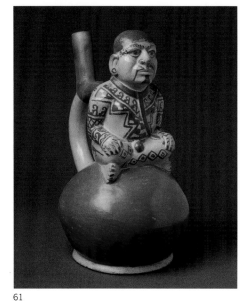

61

62

belonged to women buried with the dress and ornaments of the priestesses involved in the rituals of sacrifice, including the goblets used to present the warriors' blood (Castillo 2005, Donnan and Castillo 1992). This means that the correspondence between Mochica myths and the rituals represented at the major burial sites is confirmed by the existence of archaeological evidence, including not only representations of battle and human sacrifice, but also the remains of the participants and the utensils and ritual paraphernalia they used in these cosmological dramas.

It is a little more difficult to explain the role these rituals may have played in Mochica societies than it is to reconstruct them. It is clear that the rituals recreate and illustrate a particular social order, that they reproduce a hierarchy that claims legitimacy through its roots in the mythic age of the creator gods. The ritual battles also provided a cultural setting for ancestral practices that threatened the well-being of the community while simultaneously making a clear statement of what the governing elites were capable of doing— the fury and violence they were capable of unleashing against themselves or anyone else. Of course, images in which robust young men meekly accept being sacrificed certainly do not reflect what actually happened. And the battles, depicted in the images as mere games, were in fact battles to the death, since a slow, painful death befell those who were defeated. The end of the Mochican era, around 800 A.D., marked the end of large-scale human sacrifice in Andean societies, but it also, perhaps fortuitously, marked the decline of theocratic societies in which the elites held both political and military power, embodied, however, in very eloquent ritual performances. The end of the Mochica marked the passage to more secular societies in which the gods and their priests were separated from the rulers and warriors, perhaps thereby also keeping their destinies separate.

Fig. 2
Donna McClelland
Presentation of Prisoners

60.
Mochica
Stirrup-spout bottle
depicting a combat
and prisoner-taking scene
100–800 A.D.

61.
Mochica
Stirrup-spout bottle
depicting a seated
prisoner
100–800 A.D.

62.
Mochica
Bottle in the shape
of a pyramidal
architectural structure
100–800 A.D.

63.
Mochica
Warrior statuette
100–800 A.D.

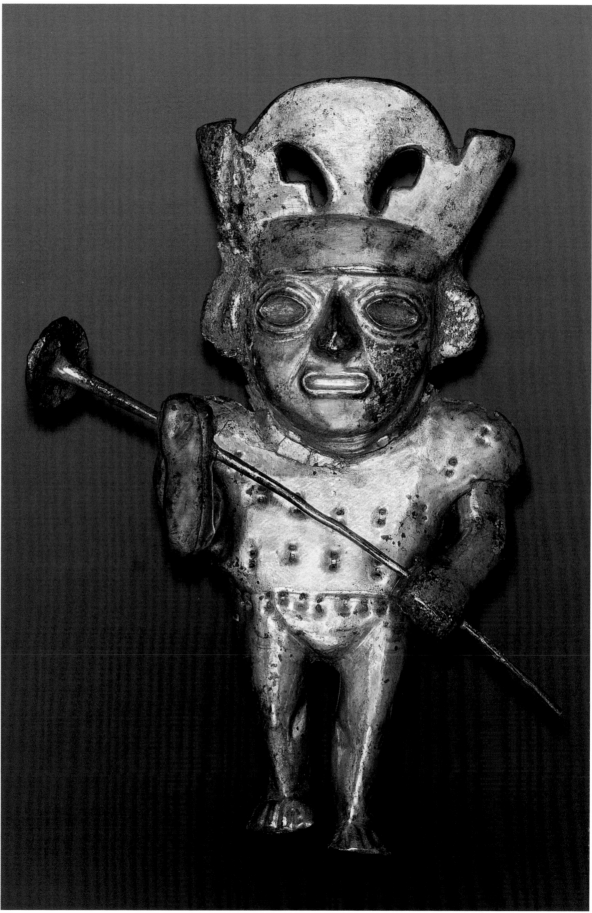

63

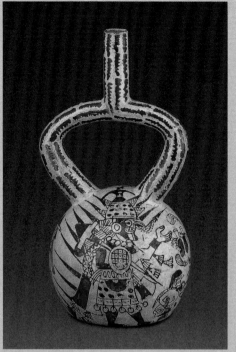

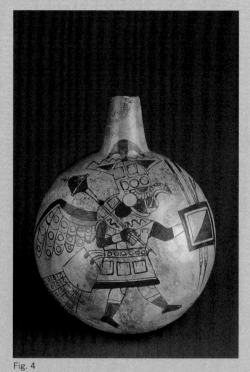

Fig. 3

64

Fig. 4

Fig. 3
Mochica
Stirrup-spout bottle
depicting a figure
surrounded by a radiant
halo
100–800 A.D.
Museo Larco, Lima

64.
Mochica
Cup with rattle base
decorated with geometric
motifs
100–800 A.D.

Fig. 4
Mochica
Canchero depicting
the Bird Warrior-Priest
100–800 A.D.
Museo Larco, Lima

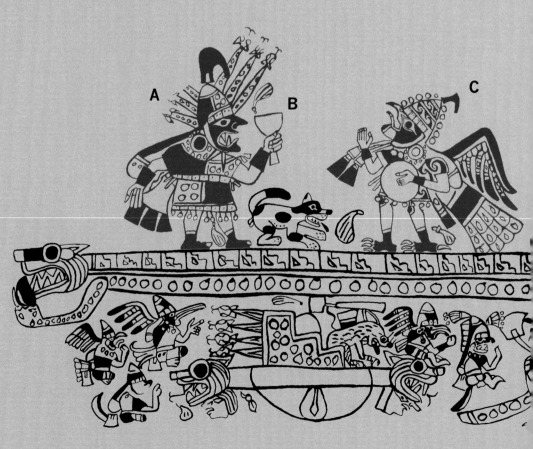

A B C

Fig. 7

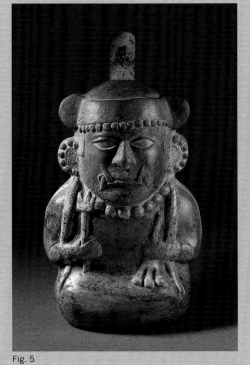

Fig. 5

65

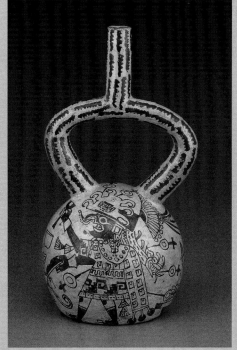

Fig. 6

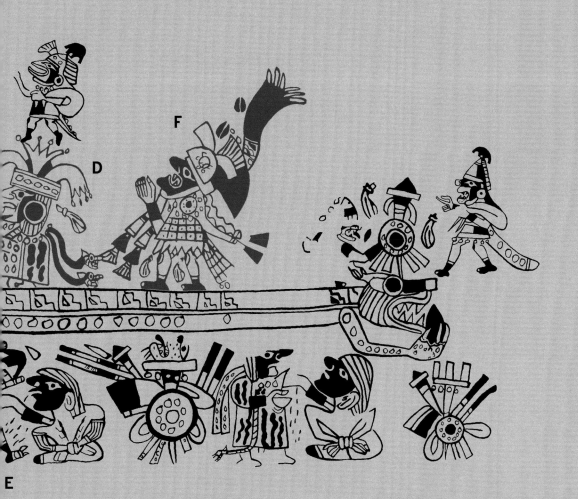

D

F

E

Fig. 5
Mochica
Stirrup-spout bottle
depicting a female
anthropomorphic figure
(priestess or Moon
Goddess)
100-800 A.D.
Museo Larco, Lima

65.
Mochica
Tumi (ceremonial knife)
100–800 A.D.

Fig. 6
Mochica
Stirrup-spout bottle
depicting a supernatural
anthropomorphic figure
(*Aia Paec*)
100–800 A.D.
Museo Larco, Lima

Fig. 7
Donna McClelland
*Scene of Prisoner
Sacrifice and Presentation
of the Blood*

66.
MOCHICA
FIGURINE DEPICTING THE GODDESS
OF THE SACRIFICE CEREMONY
100–800 A.D.

This figurine represents the goddess offici-
ating at the Sacrifice Ceremony. Her fangs
indicate her divinity while her plaits and
long tunic are symbols of her femininity.
This supernatural woman can be associ-
ated with the Sacrifice Ceremony because
of her characteristic plumed headdress and
the cup and disk she is holding in her
hands. The cup is the one used by the god-
dess to catch the blood of the sacrificial
victims, and the disk, often held by super-
natural figures in Mochica iconography,
has sometimes been interpreted as a cala-
bash used to cover the cup. All these ele-
ments are not only to be seen in painted
representations of the Sacrifice Ceremony,
but have also been found in the tombs of
women from the elite at San José de Moro.

In Mochica art, it is very unusual to be
able to identify exactly the person repre-
sented by a figurine. Indeed, these figu-
rines, often found in a domestic context,
usually show naked or partly undressed
women wearing few ornaments, in strong
contrast with the dominant visual language
that favors images of the male members of
the elite. It is therefore interesting to note
that, of the four main figures in the Sacrifice
Ceremony, it is the goddess, a female figure,
who has been represented here. Whereas
the three other figures are sometimes
shown on whistles or sculptural vessels,
the goddess of the sacrifice is almost never
represented on a three-dimensional sup-
port. The Mochica seem therefore to have
represented male and female figures on dif-
ferent supports, suggesting a pronounced
gender division in their society.

E. H.

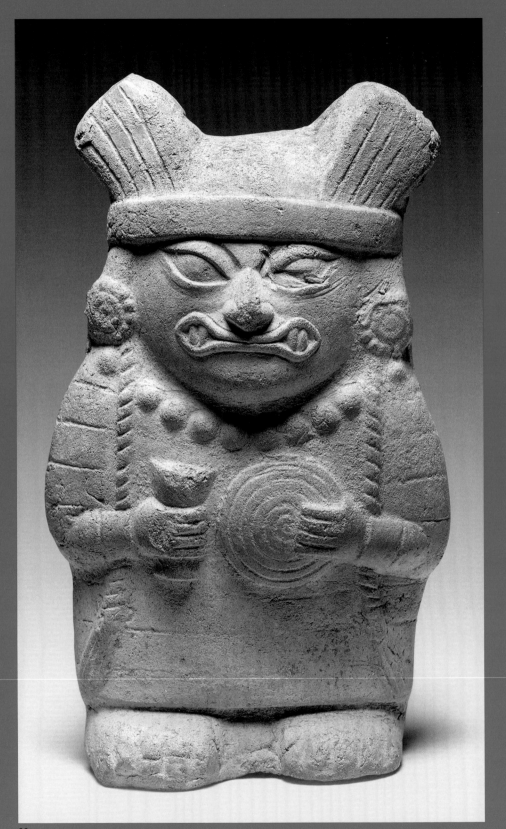

66

67.
Mochica
Stirrup-spout bottle
depicting a seated deity
with its hands joined
100–800 A.D.

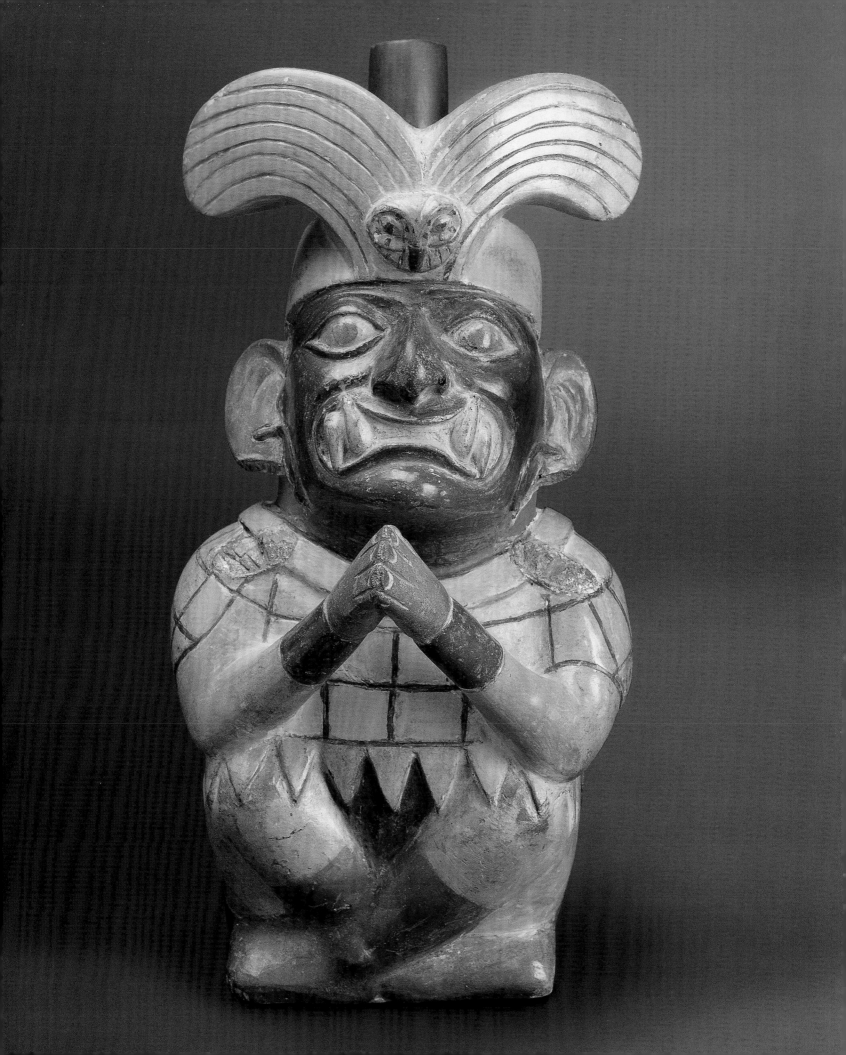

The Royal Tombs of Sipán

Walter Alva

For the Mochica, death was not the end. Human beings continued to live on another earthly plane with the same duties or privileges. That was why they were buried with goods and provisions, but it was also the cause of ruthless grave robbing, from the time of the Spanish Conquest and especially during the past fifty years. Despite that destruction, archaeologists have identified a variety of burials. The most basic are those of poor peasants, wrapped in nothing but a blanket and buried in a simple pit. Others contained some offerings; the body was wrapped in a protective "bundle" and placed in a rectangular adobe or stone tomb. Lastly, for those of high rank, there were elaborate cane coffins and chambers with niches for many offerings. Every burial thus reflected a person's role and social status.

In 1987, a small team of Peruvian archaeologists, of whom I was one, rescued from destruction the first intact tomb of a ruler of ancient Peru. The discovery of the so-called "Tomb of the Lord of Sipán" immediately attracted the interest of the world's media, who followed the excavations closely, considering it one of the great discoveries of the twentieth century and comparing it with the tombs of Tutankha-mun and the Maya King Pacal, and the discovery of Machu Picchu. *National Geographic* published details of the find, calling it the richest tomb in the New World (Alva 1998). These comparisons aside, Peruvian archaeology made great strides, throwing new light on the social, political, techno-logical, artistic, and religious dimensions of Mochica life, immediately creating an extraordinary level of interest in the study of that culture. Sipán brought the world's attention to the mystery and splendor of Peru's ancient cultures, and provided us with invaluable historical information.

Excavating the Royal Tombs of Sipán

From the discovery of the first tomb, our fieldwork revealed a total of fifteen tombs belonging to various periods and to persons of different social ranks, as the locations and contents showed. Indeed, the burial platform revealed not only the splendid burial place of a ruler, but also those of various members of the elite of their day, some of which are still waiting to be uncovered and have yet to reveal their complex history. Each tomb contains the body and all the accoutrements, ornaments, and goods used by the deceased. This enables us to understand the complex social and political structure of Mochica society, at whose apex was the lord, followed by the priest, then, on a third level, by the military leaders, and after them, by the warriors and religious auxiliaries. So far, we have recorded three tombs of lords, one of a priest, three of military leaders, one of a warrior, two of dignitaries, four of royalty, and one of a warrior priest.

The human remains of the "Lord of Sipán" were found in a wooden coffin along with an impressive set of ornaments and emblems in gold, silver, gilded copper, and other materials used in making his ritual attributes and symbols of rank and power. Surrounding the burial chamber, and inside it, we also found the burials of eight companions—three young women, a military leader, a standard bearer, a child, a lookout, and a soldier guarding the tomb—and three animals: two llamas and a dog. In five niches or compartments we found over two hundred vessels portraying prisoners, warriors, and figures in reverential postures, all carefully arranged to form a kind of funeral scene. Similarly, the remains and ornaments were deliberately positioned with symbolic reference to the concepts of dualism and complementarity, gold ornaments being placed on the right and silver on the left, a reference to east and west, sun and moon, male and female—in other words, to everything that was opposite but complementary, preserving the balance of the universe according to Mochica religious beliefs.

Excavation of this splendid tomb took over a year, during which we cleaned, recorded, and preserved for posterity human remains, ornaments, wonderful jewelry, and even minute traces of material that had disintegrated. As a result, we were able to recover around six hundred items used by this dignitary during his lifetime, enabling us to identify him as a ruler who wielded military, religious, and civil power.

The royal jewelry that we recovered included three exquisite pairs of gold and turquoise earspools representing a sacred bird associated with fertility rituals, a type

68. Mochica, earspool depicting a warrior, 100–800 A.D.

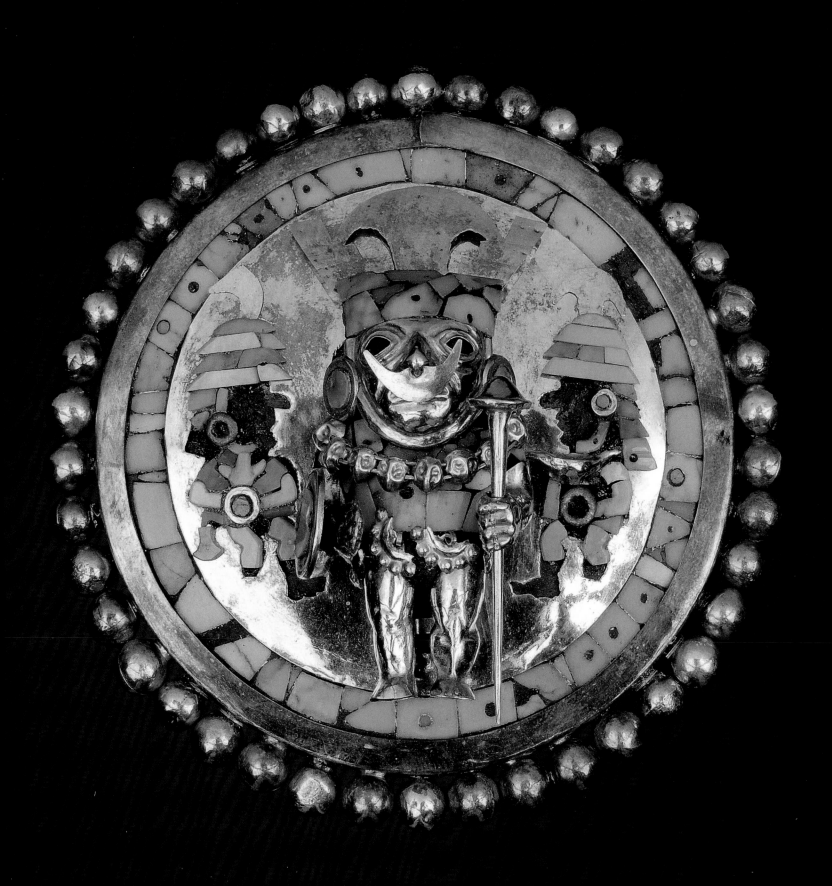

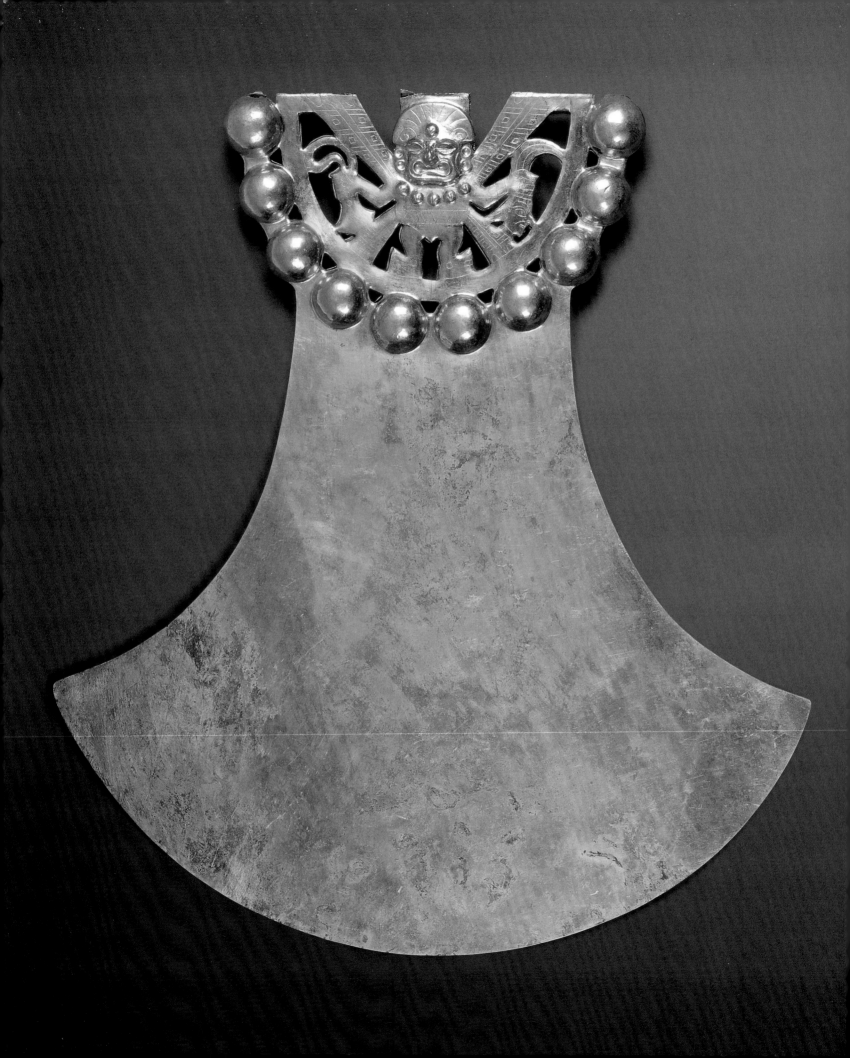

of deer connected with ancestor worship, and—the most extraordinary of all these ornaments—a miniature gold image of the lord himself, flanked by two warriors (cat. 68). On his right hand rested a metal scepter, topped by an inverted gold pyramid, with reliefs depicting the military victory of a warrior over subdued prisoners, the primary symbol of power and authority. We also recovered emblems or standards of gilded copper, which may represent religious images or the heraldic symbols of this royal dynasty; they carry the figure of a deity with arms open and extended. A necklace representing twenty peanuts, half of them made of gold and half of silver, also expresses the dualistic nature of Mochica religion. We also found pectorals consisting of small beads carved from tropical shells such as the *Spondylus* (cat. 70). Underneath the human remains we found the royal crown, shaped like a large gold half-moon, which confirmed the authority the deceased person had exercised in life (cat. 71). Another remarkable ornament was a gold coxal protector weighing about a kilo, which he must have worn around his waist when he presided over ceremonies on the top of the pyramids (cat. 69).

In a second tomb located on the same platform we found the remains of a figure belonging to the second rank in the social hierarchy. He was a priest, and judging from his accoutrements he performed only religious functions, also being represented in the most important rituals of Mochica society as half bird, half man (cat. 72).

Some time later, our archaeological investigations revealed a third tomb located in the oldest structure making up the burial platform. Despite its initially modest appearance, it proved to belong to another lord, evidently a predecessor of the dynastic line of the first one we had discovered. In fact, the quantity and quality of some of his ornaments, emblems, and accoutrements were very similar to those of the "Lord of Sipán." To our surprise, we found on the surface of the funerary bundle a set of ten exquisite representations of gold spiders forming a necklace, each with the face of a dignitary on its body (cats. 73, 74). The most extraordinary of the offerings included religious images in gilded copper

representing a feline deity crowned with two-headed serpents, the crab deity, a pectoral in the form of an octopus, which this lord must have worn for some special religious ceremony, and an exquisite gold and silver nosepiece with a miniature portrait, probably of the lord himself. Among his ornaments were three gold and three silver necklaces with the heads of old men, the faces of a feline (cats. 75, 76), and the faces of young men and mythological creatures, a combination of man and feline. The grave also included ten gold rattles (cat. 77), one gold coxal protector, and others of silver (cat. 78). This figure, whom we call the "Old Lord of Sipán," was buried only with one young woman and a llama. In his day, he must have filled both a political and a religious role, functions that later became separated.

Our excavations at this extraordinary archaeological site were obviously not limited to locating and recording tombs, and a great part of our time was devoted to a careful study of its architectural setting. Dozens of drawings, plans, and cross sections show every aspect of the structure and indicate the places where it had been altered. Using all the available data, Susana Meneses and Luis Chero, members of our team, were able to identify in the burial platform ten phases of increasingly extensive construction (Alva 2004, 201-209). The Mochica gradually enlarged its volumes horizontally and raised the levels of the sanctuary in order to meet the needs of ritual and funerary practice. The tomb of the "Old Lord of Sipán" is clearly associated with the first levels, and the tombs of the priest and the first lord discovered are part of a final construction phase.

Contributions to Understanding Mochica Culture

In the tombs of Sipán we discovered for the first time a surprising correlation between iconographic conventions and the goods used to demonstrate status and leadership during the lifetime of the deceased. In fact, this discovery made it clear that many of the subjects represented in Mochica art, including figures receiving honors and

offerings, were not purely mythological. The attributes of the principal figure who appears in many such scenes would seem to suggest that he is the "Lord of Sipán," who presided over the most important religious and political events of his day and was buried about 1,500 years ago. The images represented on these ornaments and accoutrements belong to a system of symbols that refer to the rituals, mythology, and complex religion of the Mochica, based on notions of dualism and complementarity, or unity in opposites. In a society based primarily on agriculture, these gods, demigods, and mythical beings are constantly preoccupied with fertility and life.

The contents of the tomb of the so-called "Lord of Sipán" also reveal his absolute authority. His ornaments, emblems, and manner of dress made it possible to demonstrate conclusively the historical existence of the figures that ruled the society of his day. It was organized on the basis of lordly "domains," which were like independent states in each of the valleys that shared the customs, practices, technology, religion, and art common throughout Mochica culture. Research carried out in the past two decades makes it possible to say that Mochica culture was based on a set of small local kingdoms, or domains, governed by a caste of autocratic rulers who inherited semi-divine dynastic power. Following the discovery of the "Lord of Sipán," we found the tombs of a priestess in the southern valley of Jequetepeque, and after that, the so-called "Lady of Cao" in the valley of Chicama, providing evidence of a diversified social and political structure in which women played a prominent part.

The materials we found in the tombs reflect a wide network of exchange relationships in exotic products that could have come from what are now the more isolated areas of the Peruvian Andes and the Amazon River Basin, or from Ecuador, Bolivia, and Chile in the case of gold, *Spondylus* shells, and semiprecious stones. At the same time, metalworking techniques, such as gilding copper, indicate a sophisticated level of development. These are textbook examples of gold- and silver-smithing, both artistically and technically.

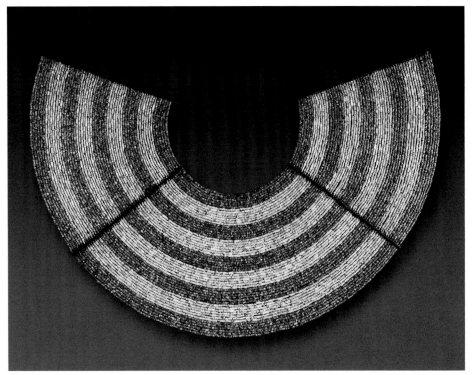

70

71

Protection and Promotion
of the Cultural Heritage

In parallel with our fieldwork, the project took responsibility for conserving and restoring the ornaments of copper, gilded copper, and silver that needed immediate treatment to prevent their irremediable damage. The materials from the tomb of the "Lord of Sipán" were restored at the Römisch-Germanisches Zentralmuseum, Mainz. A little later, a laboratory was set up in the Lambayeque region, where the contents of the tomb of the "Old Lord of Sipán" and other burials are being conserved.

The significance of this find and the international interest it aroused meant that a museum had to be designed in which these cultural treasures could be preserved and fittingly exhibited to the world. The long, complex process finally culminated in the opening in late 2002 of the Museo Tumbas Reales de Sipán, a repository for Peruvian identity, a cultural and research center, and a promoter of regional development. While we have welcomed thousands of visitors, we are still waiting to continue the archaeological work that will lead to new discoveries and make new contributions to the history of American cultures.

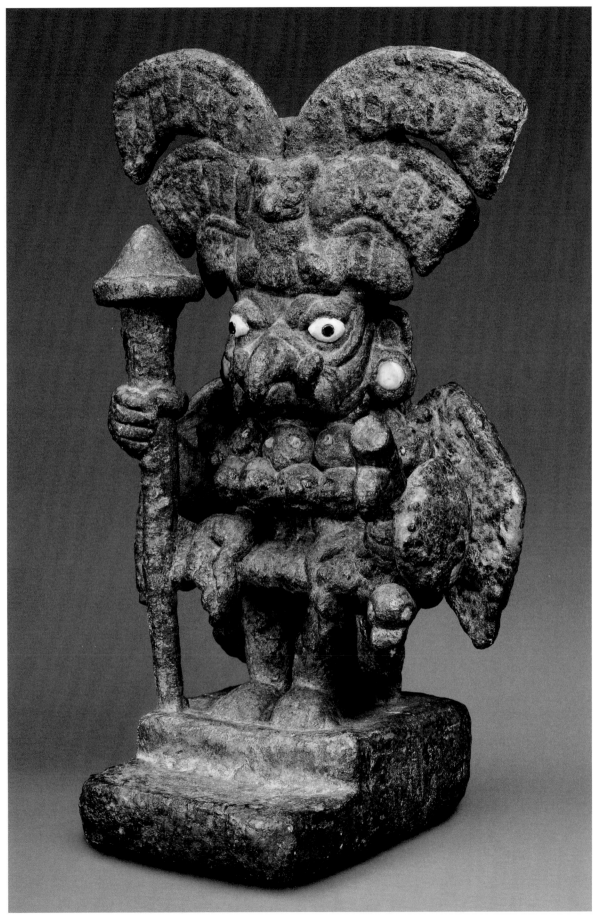

72

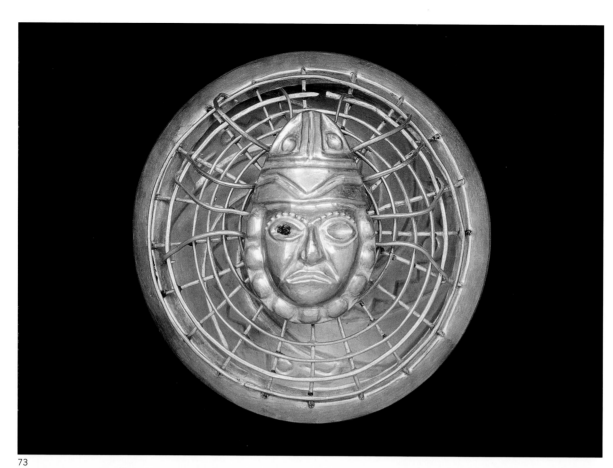

73

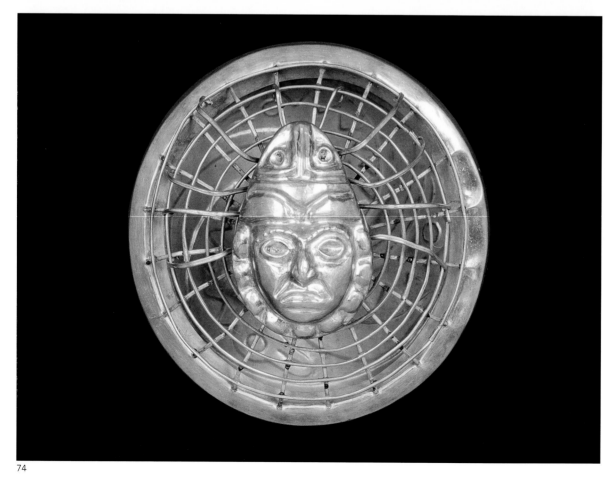

74

73.
Mochica
Bead from a necklace
depicting a spider
on its web and whose
body is a human face
100–800 A.D.

74.
Mochica
Bead from a necklace
depicting a spider
on its web and whose
body is a human face
100–800 A.D.

75.
Mochica
Necklace component
in the shape
of a feline head
100–800 A.D.

76.
Mochica
Necklace element
in the shape
of a feline head
100–800 A.D.

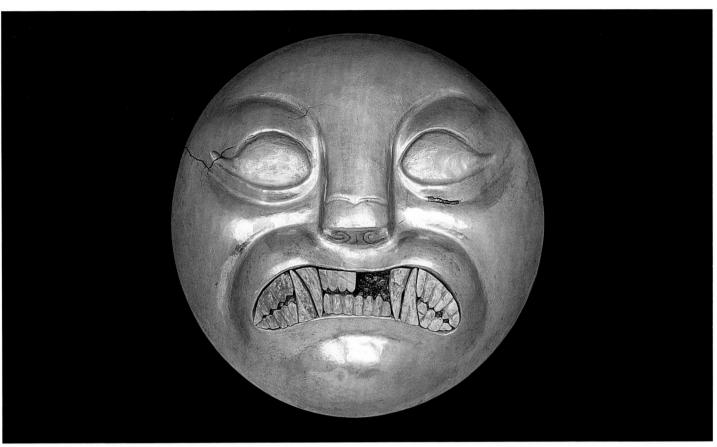

75

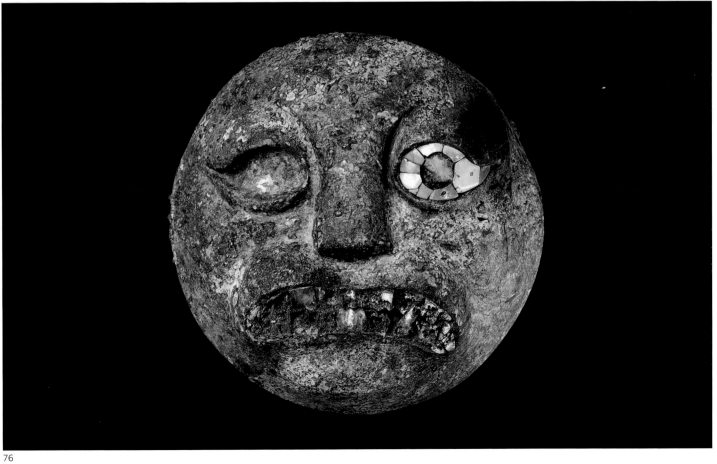

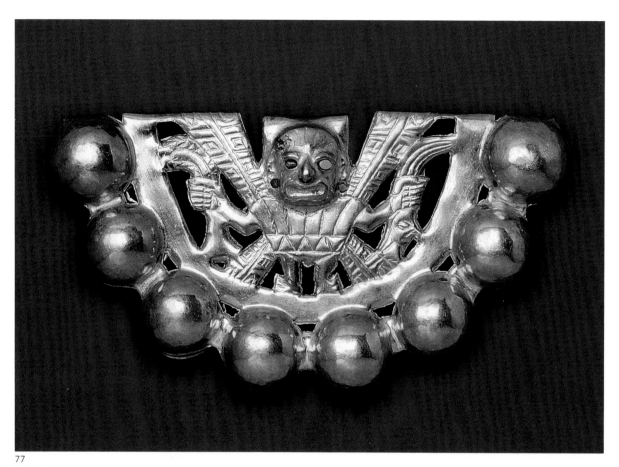

77

77.
Mochica
Rattle depicting a figure
holding a knife
and a severed head
100–800 A.D.

78.
Mochica
Rattle depicting a figure
holding a knife
and a severed head
100–800 A.D.

79.
Mochica
Ornament in the shape
of a human head
100–800 A.D.

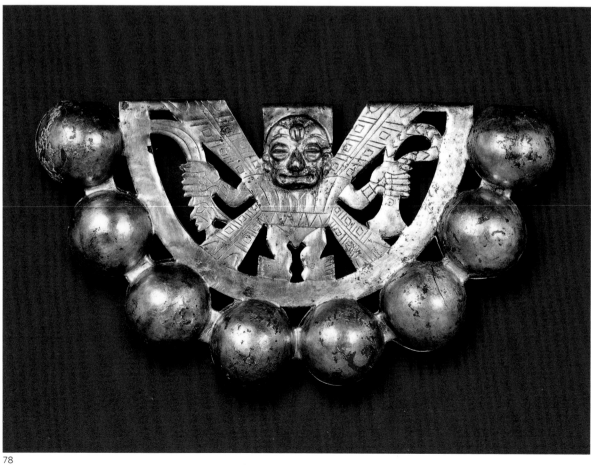

78

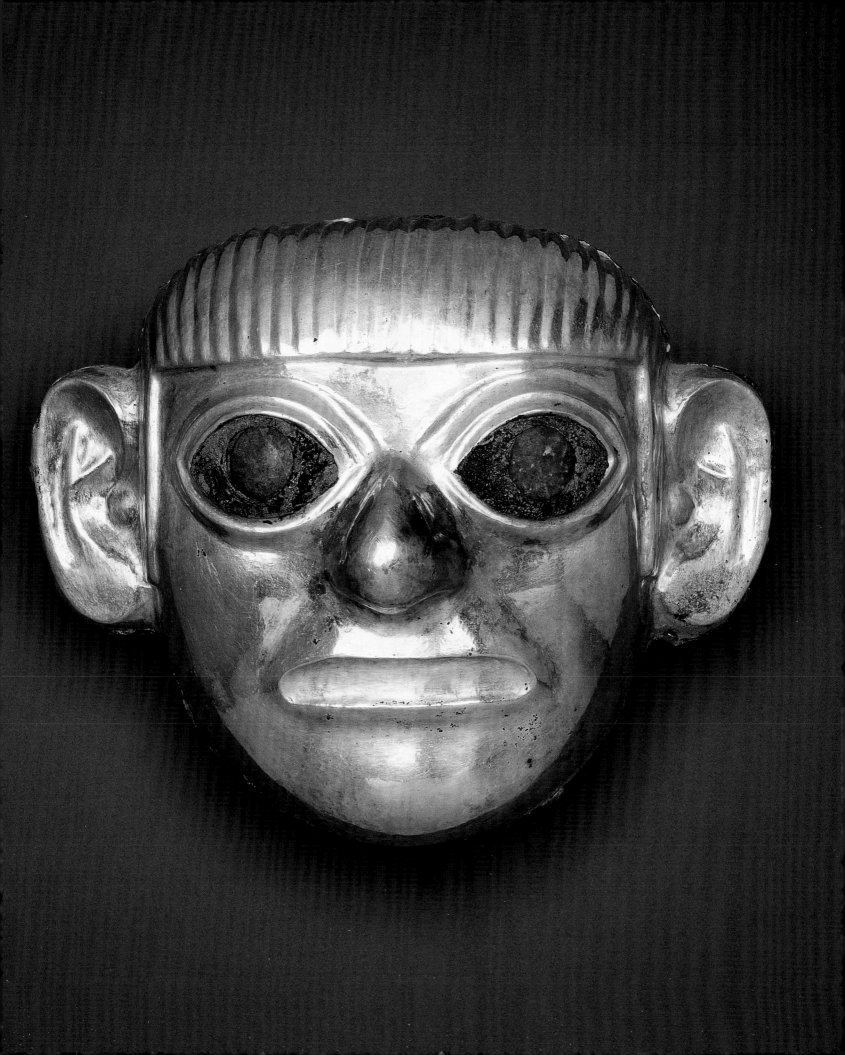

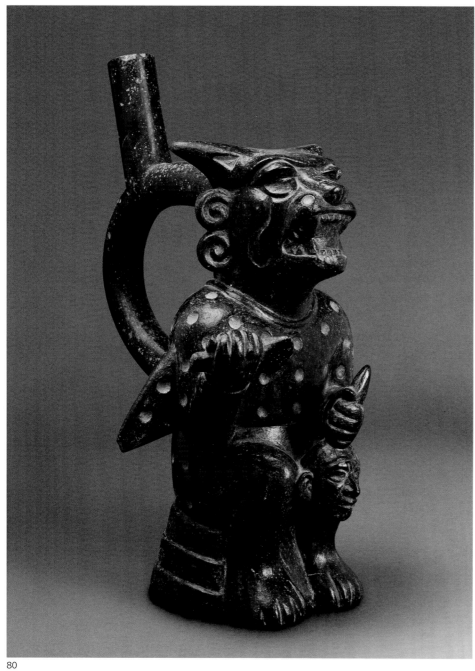

81

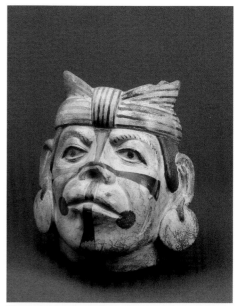

82

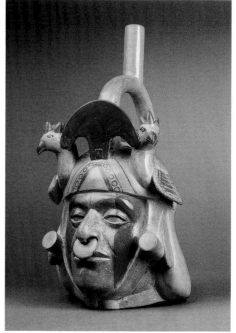

80

80.
Mochica
Stirrup-spout bottle
in the shape of a feline
holding a knife and
a severed head
100–800 A.D.

81.
Mochica
Portrait vessel depicting
a Recuay man
100–800 A.D.

82.
Mochica
Portrait vessel depicting
a Mochica lord
100–800 A.D.

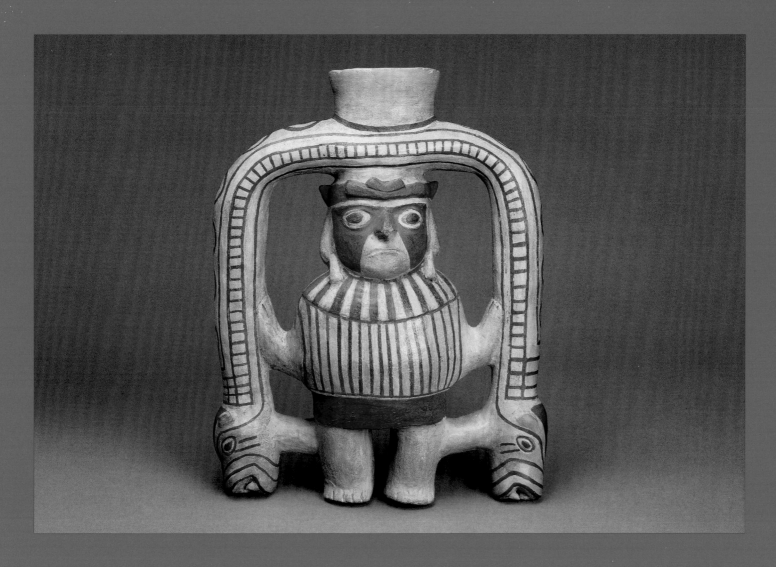

83.
MOCHICA
BOTTLE DEPICTING A HUMAN FIGURE BELOW A BICEPHALOUS SNAKE
100–800 A.D.

This large bottle, decorated with the red and cream slip characteristic of the Mochica style, represents an anthropomorphic figure standing under an arch formed by a two-headed serpent. The figure is wearing a small headdress, earrings, and a striped tunic with a large collar or pectoral, and there are painted decorations on his face. His appearance suggests that the figure is a human being who belongs to the world of the living rather than that of the dead or the supernatural world, but it is not possible to identify his status or his precise role in Mochica society. The serpent's body is decorated with circles and a hatched band evoking the patterns on a snake's skin. The

supernatural aspect of the serpent is nevertheless emphasized, by its two heads, of course, but also by the feline appearance of those heads with their little ears.

The two-headed serpent is a recurrent motif in Mochica art. When it forms an arch above a human or supernatural figure, as here, or above narrative scenes, especially those depicting rituals involving the consumption of coca, it is interpreted as symbolizing the heavenly world and the world of night. In some scenes, it is also accompanied by heavenly bodies, probably stars. The two-headed serpent was sometimes also linked with the rainbow. The creature, which is supernatural in itself, is also

frequently associated with deities and rituals. It is found, for example, forming a frame round the Mountain God, or the Owl-Warrior God, or separating the earthly and supernatural worlds in the Ceremony of Sacrifice (see Castillo, this volume). This aspect of the boundary between the worlds is relevant to the interpretation of the bottle seen here. It could also be seen as representing a human being occupying the earthly space of the living, separated from the celestial world of the deities by the two-headed serpent.

E.H.

The Face Behind the Mask

Carlos G. Elera

A mask is a temporary or permanent covering for the face. A person wearing a mask communicates an identity other than their own. In the Andean world, especially in the Central Andes, the wearing of masks is a very long-standing tradition. This article focuses on the wearers of funerary masks in the Middle Horizon, specifically during the development of the Sicán or Lambayeque culture, between 750 and 1375 A.D. Similar representations, on other media, will be used for purposes of comparison in the discussion that follows. In the context of Sicán society, certain individuals acted as intermediaries in a shared religious worldview that legitimated the sociopolitical power of the elite, which was itself sustained ideologically by a creation myth based on the immediately surrounding environment. Our focus will be on the deity who is thought to have been represented by the funerary mask, and on the sector within the highly stratified Sicán society that, exclusively, used masks to cover their face after death, symbolically immortalizing themselves and ensuring that they were venerated as ancestors. These rituals had a specific place in the annual cycle of the seasons and the renewal of nature in the geographical area in which the ancestral Sicán leaders emerged, lived, and died.

Sicán Masks and Mythical Ancestors

Funerary masks have been made in a variety of designs. In the case of Sicán masks, the predominant medium was metal: silver, gold, and copper, including alloys of the last two, known as *tumbaga*. Every mask, from the simplest to the most complicated with moving parts, starts as a sheet of metal that is hammered and in places embossed. The most brilliant, resplendent gold is always found in specific areas of metal masks. They vary in the size and quality of the metal used, the way in which they are painted, the addition of feathers, the presence or absence of pendants of emeralds or resins that resemble (and sometimes are) amber, as well as the use of cords and cloth of native cotton fibers that tie the masks onto the "face" of the funerary "bundle" (cats. 85, 89).

The masks represent in hieratic style a deity with human and bird-like attributes. The eyes are in the shape of the wings of a plummeting bird, a nose ornament with pendants drapes from the nose, and a circular earspool is represented at the bottom of each ear, which is also in the shape of a plummeting bird's wings. Morphologically, the mask is a magnificent abstract piece that clearly represents a supernatural being with ancestral significance, associated with the creation myth of the ancient Lambayeque people. These masks, with human and bird characteristics, seem to have been "inhabited" by the numen of a figure who was consecrated in his lifetime and who continued to be venerated by his descendants after death. The living or dead figure who wore the mask would also enter into direct association with the human-bird deity it represents, and would thus be influenced by its vital and symbolic powers. When wearing a mask, a person experiences the loss of his previous personality and acquires a new one. That powerful symbiotic relationship between the wearer and the human-bird mask continues even after their temporary union has ended.

The representation of a high-ranking member of the Sicán elite, masked, suggests that prominent members of that elite used masks to assert their sacred kinship with the original ancestor (cat. 84). The same type of mask was used in the funerary bundles of members of the high Sicán elite. The basic role of the human-bird funerary mask was to create a sense of continuity and close union between the present moment and primordial times, which were associated with the first appearance of the deity. When a member of the Sicán elite died, the face of his funerary bundle was covered by a mask and he entered into communication with the other world. In this way he was deified and venerated in perpetuity.

The Proyecto Arqueológico Sicán (Sicán Archaeological Project), directed by Izumi Shimada and the Museo Nacional Sicán, established that the use and accumulation of objects made of precious metals were a prerogative of the Sicán elite. These metals were used in the expression of every aspect of Sicán culture, both material and intangible, and served as markers of social status. Access to different metals was clearly demarcated: those not part of the elite could use arsenical copper, the lower elite

84. Lambayeque, bottle depicting a masked figure carried on a litter, 750–1375 A.D.

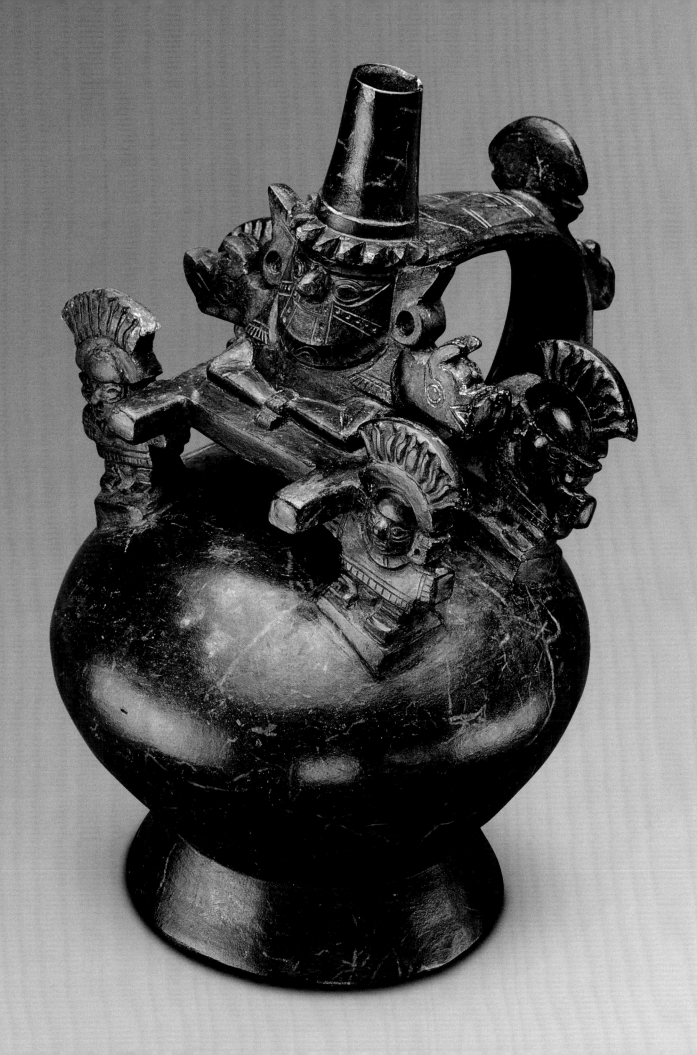

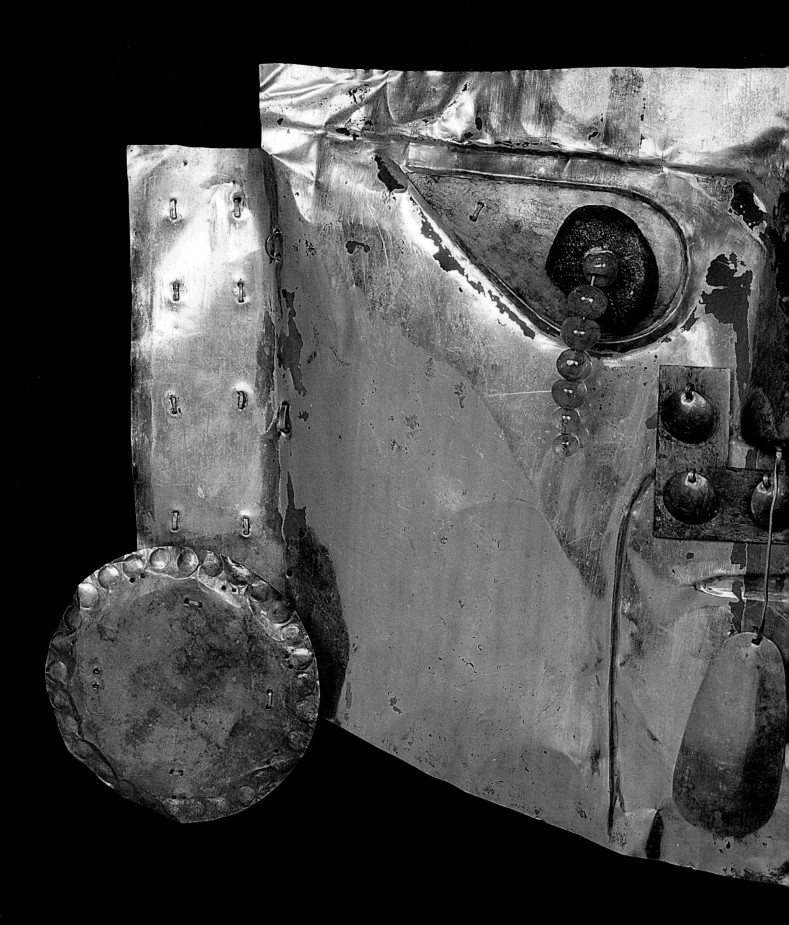

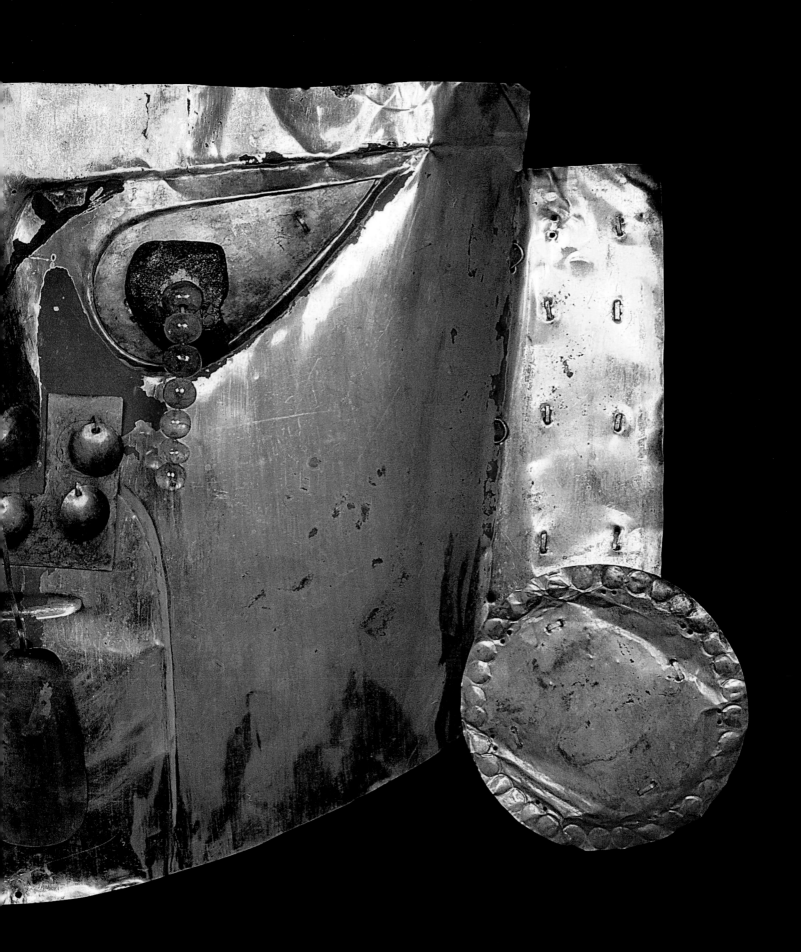

Fig. 1

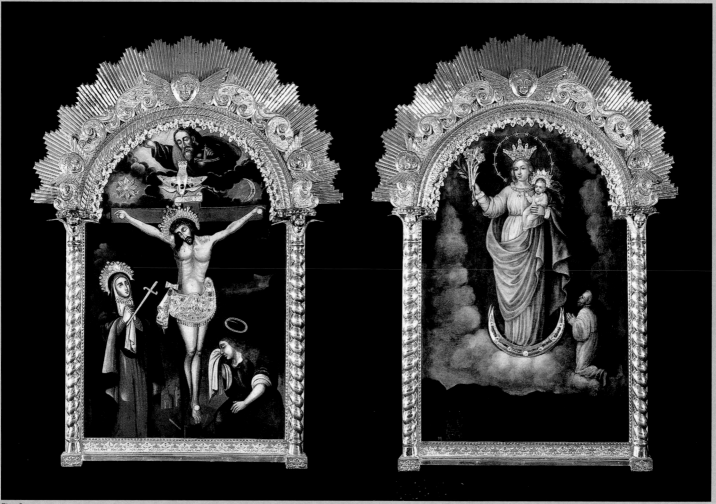

Fig. 2

Fig. 1
C. Samillián
(based on the original
by Izumi Shimada)
Reconstruction
of the representation
of the "Sicán
Cosmovision" found
in Huaca Las Ventanas
Proyecto Huaca Las
Ventanas, Lambayeque

Fig. 2
Anonymous
Painting from
the Santuario de
Las Nazarenas in Lima
—Lord of the Miracles
(obverse) *and Virgin*
Mary (reverse)
Late 17th century
Santuario de Las
Nazarenas, Lima

arsenical copper and *tumbaga*, and the upper elite any metal, including alloys of high-carat gold. They also had access to precious stones such as emeralds from the Northern Andes. This is consistent with a passage in the myth of Pachacamac that was current on the coast between Piura and Arica (Tello 1923), according to which the Sun gave his son Vichama three eggs: one of gold, another of silver, and the third of copper. From the golden egg sprang the *caciques*, or chiefs; from the silver one, the wives of the nobles; and from the copper one the plebeians and their wives.

The Mythical Masked Figure in the Sicán Worldview

The burial sites of Huaca las Ventanas and Huaca del Oro are representative examples of the cultural context of the royal ancestors of Sicán, not only thanks to some recent discoveries but also because of their orientation and their position midway between the Sicán ceremonial sites at Pomac. Situated in the Batán Grande Archaeological and Ecological Park, Huaca las Ventanas and Huaca del Oro were on the crucial axis that formed a symbolic line linking the temples (following the movement of the sun and moon) with particular hills, forests, islands, and the ocean. Surface water from the La Leche River, flowing from the east, and groundwater, whose level started to rise at the summer solstice, may intentionally and symbolically have been allowed to cover the burial chambers in the tombs of the elite, thus uniting them during nature's annual renewal. We believe that water and other environmental phenomena were connected with ancestor worship; in other words, that every Sicán temple-mausoleum at Pomac, with its symbolic link with water and the landscape, was part of a program of purely funerary construction, legitimating the power of the descendants of those ancestors, who "personified" the forces of nature and were descended from a common ancestor.

We are looking at true royal temple-mausoleums (Elera 2008) in which heads of lineages were buried. Their descendants were later buried in the area around the principal tombs; their tombs in turn were sealed up following a concentric plan as the pyramidal temple grew larger (Shimada and Elera 2007).

In ethno-historical terms, the Sicán or Lambayeque culture has been reconstructed on the basis of the presumed historical veracity of the legend or myth of Naymlap and his dynasty, from which the kings of Lambayeque were descended. The legend was recorded in early colonial times, in the locality of Túcume (Cabello Balboa 1951 [1586]) and two hundred years later at Mórrope (Rubiños y Andrade 1936 [1782]), places to the west of the La Leche Valley. Naymlap means "bird of the water" in the extinct Muchik language and in the second (Mórrope) version of the myth. This figure, who came from across the sea with his followers, was a wise, charismatic man, and when he died he made his people believe that he had grown wings and flown up into the firmament (cat. 87). The arrival of Naymlap by sea, and the bird's characteristics he acquired when he left this world, were decisive in his being worshipped as the original ancestral deity.

Llapchillulli, an official and a maker of feather garments, accompanied Naymlap when he arrived at Lambayeque by sea. In return for his loyalty and respectfulness he was made ruler of the La Leche Valley, which is the origin of the prestigious Kingdom of Jayanca. Until the eighteenth century, the ruler of that geo-political area retained the memory of his first ancestor: Llapchillulli. As Zevallos (1989a) has noted, this is the only instance on Peru's north coast and sierra of a ruler remembering his original ancestor, who was already a mythical figure in pre-Hispanic times. It was the descendants of Llapchillulli who were the absolute rulers of Pomac, according to the will published by Zevallos, and the story of Naymlap thus bears a close relationship with the origins of the sacred elite who ruled the valleys of Lambayeque and La Leche.

An elite tomb was discovered by Izumi Shimada and Carlos Elera in 1991, in the temple-mausoleum of Huaca Las Ventanas. It had been partially ransacked but some of the contents were recovered. They included a fragment of cotton cloth attached to a thin sheet of copper, on whose white background was painted an extraordinary representation of the "Sicán cosmovision" (fig. 1). This piece of funerary cloth was placed in the tomb in an east-west orientation, like that of the tomb itself. In the east we see the sun, with the typical human-bird funerary mask, while in the west is painted a waxing crescent moon. Between the moon and the sun there are waves, with fish and *Spondylus* shells, which are associated with fertility cults. In the center is a representation of the principal deity, with a human-bird mask and open mouth, showing the fangs of a feline. In his right hand he holds a decapitated head, painted white like the moon and yellow like the sun, and with winged eyes, like the principal divinity. In his left hand is a knife with a half-moon blade, very similar to the crescent moon painted on the far western end of the cloth. This is the earliest known occurrence in pre-Hispanic Peruvian religious imagery of an iconographic scheme in which the sun (male) is placed on the right of the central figure and the moon (female) on the left, this imagery being incorporated by a process of syncretism into the Christian religion brought to Peru by the Spaniards in the sixteenth century. The Lord of Pachacamilla, or Lord of the Miracles (fig. 2), who is also associated with Pachacamac (Rostworowski 1992), displays the same ancient Andean sun-moon opposition and complementarity identified in the "Sicán worldview" of Pomac and later inherited by the Chimú and the Inca.

The painted cloth is thought to represent the ancestral divinity at a specific point in space and time: at the celestial zenith, over the sea, and at the time of year when food, on the land and in the sea, is abundant. The presence of the ceremonial *tumi* knife and the decapitated head is not accidental, and probably refers to the practice of human sacrifice performed by the divinity in earliest times. Human sacrifice was thought to create a balance between the complementary opposites—between the rising sun in the east and the waxing moon in the west—and to control high tides. The decapitated head held by Naymlap has features that identify it with the Sun and the Moon, but as a unity; in other words, it could represent the symbolic sacrifice of a son of the Sun and Moon, designed to ensure abundant supplies of food.

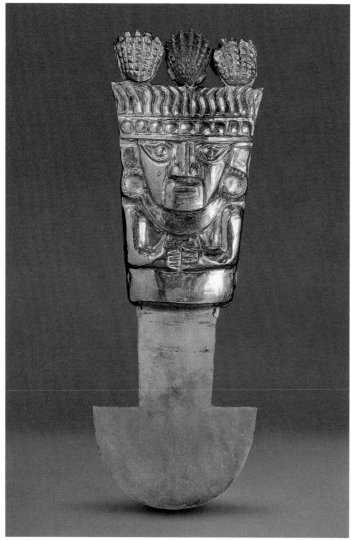

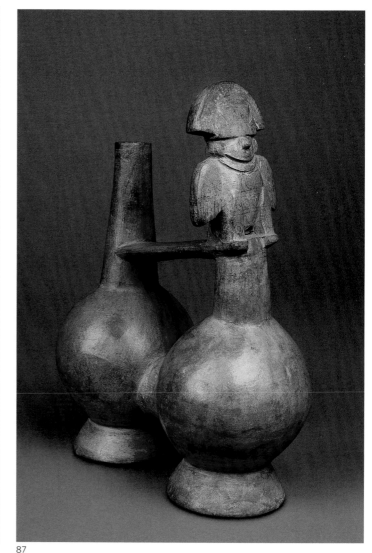

86

87

Sicán funerary masks evoke the historic founder of the Lambayeque elite, a figure already deified in life and after death turned into the "Primordial Ancestor" of the Lambayecan lines of descent. The message they express is the renewal of nature at a time when water, and therefore abundance on land and in the sea, reaches its highest point. It is then that the ancestor who is the "soul" of all life attains his greatest power. The masked dead are gathered like an army in their human-bird funerary bundles, arranged in the same east-west orientation as their temple-mausoleums: from the sources of fresh water in the mountains in the east to the sea in the west. These bundles were always shown as offering a toast, holding a drinking cup in their modeled right hand and their left arm raised to the same level as the right. The act of making this toast is the supreme expression of hospitality, "offered in a timeless way towards the setting sun." The eschatological complex of ideas around the setting sun is fundamental, above all in relation to the annual renewal of nature. The summer solstice, when the sun's rays are at their most intense, coincides with the arrival of the waters and the abundant harvests from land and sea that are the symbolic essence of the worship of the masked and sacred ancestors, seen as evoking the founding ancestor: Naymlap, the "Bird of the Water."

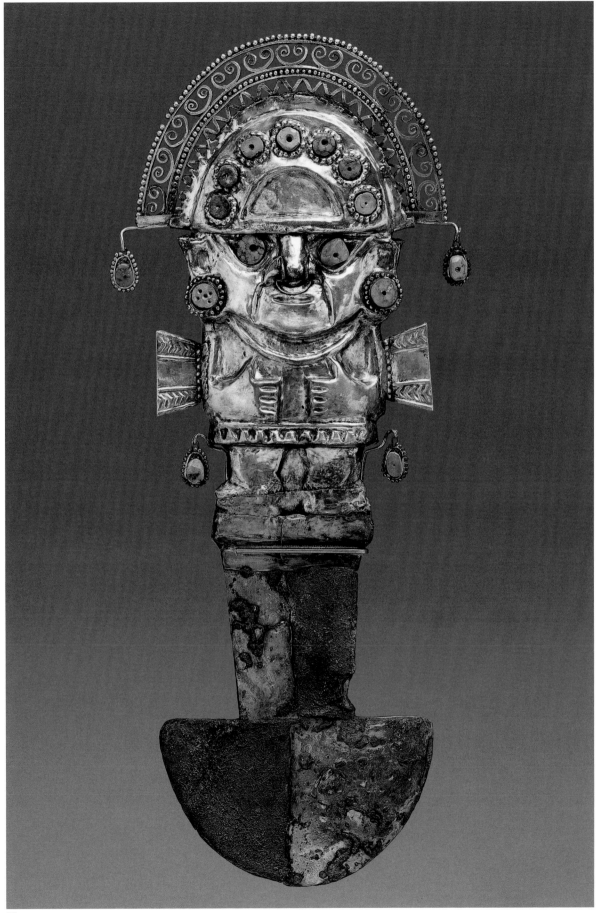

88

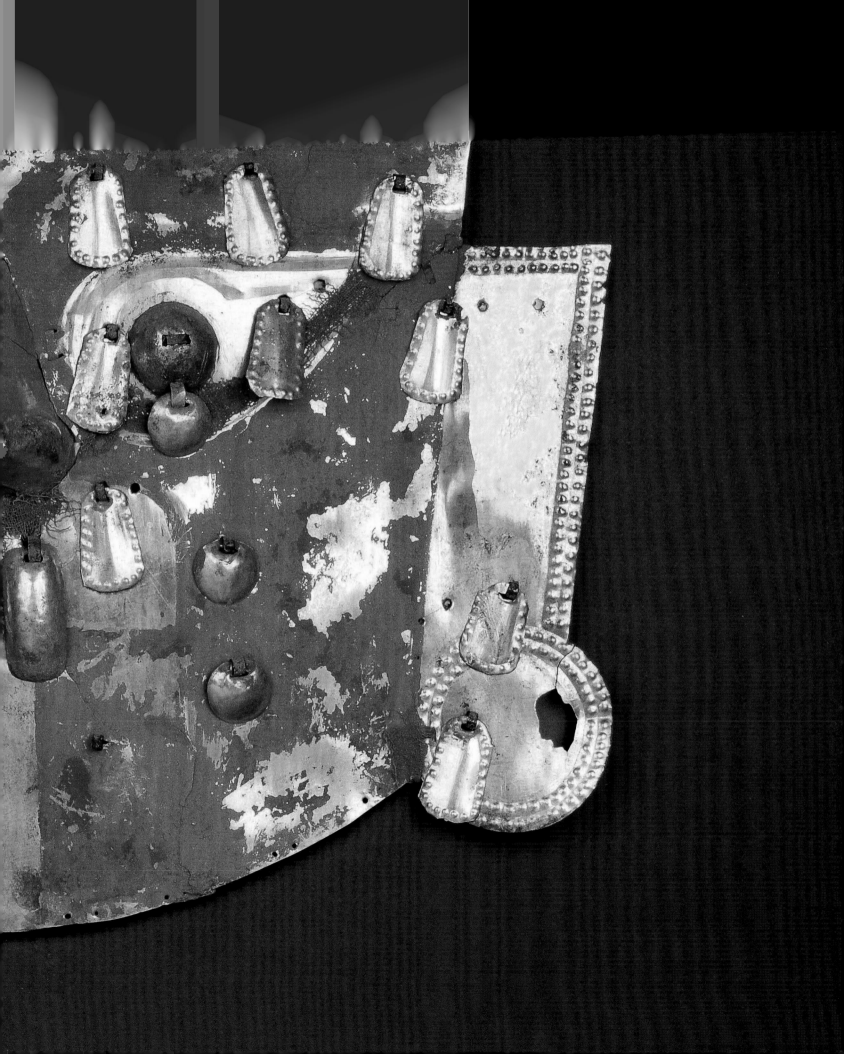

Fig 3

90.
MOCHICA
STIRRUP-SPOUT BOTTLE DEPICTING
THE "BURIAL SCENE"
100–800 A.D.

The finely drawn decoration of this stirrup-spout bottle is typical of the final phase of Mochica culture (fig. 3). The finesse of the decor—red lines laid on a cream background before firing—permits the representation of complex scenes, here the so-called Burial Theme. Christopher Donnan and Donna McClelland (1979) believe it is a combination of four separate events. The burial of a high-ranking figure (hence the name) is presided over by two supernatural figures, supervising the lowering of the body into a horizontal funeral chamber. On each side of the tomb is a gathering of people, animals, and supernatural beings. On the other side of the bottle, a kneeling figure under an architectural structure is receiving or giving shells. The scene above it represents a sacrifice.

The repetition of the figures—the anthropomorphic lizard appears in the burial scene, the assembly scene, and the sacrifice scene—suggests a narrative sequence, although the chronological order is not clear. These events may even be connected with other narrative scenes in Mochica art, such as the rebellion of the artifacts and the Ceremony of Sacrifice. The almost identical repetition of the same sequence of scenes on several bottles suggests a reference to a myth and/or rituals and ceremonies that held an important place in Mochica social and religious organization. The interweaving of the scenes reveals a way of imagining the story that is different from the linear narrative model we are accustomed to. This bottle was found in a tomb on the San José de Moro site, and it is one of the rare pieces with a known context.

E.H.

Fig. 3
Donna McClelland
Representation of the
So-Called Burial Theme

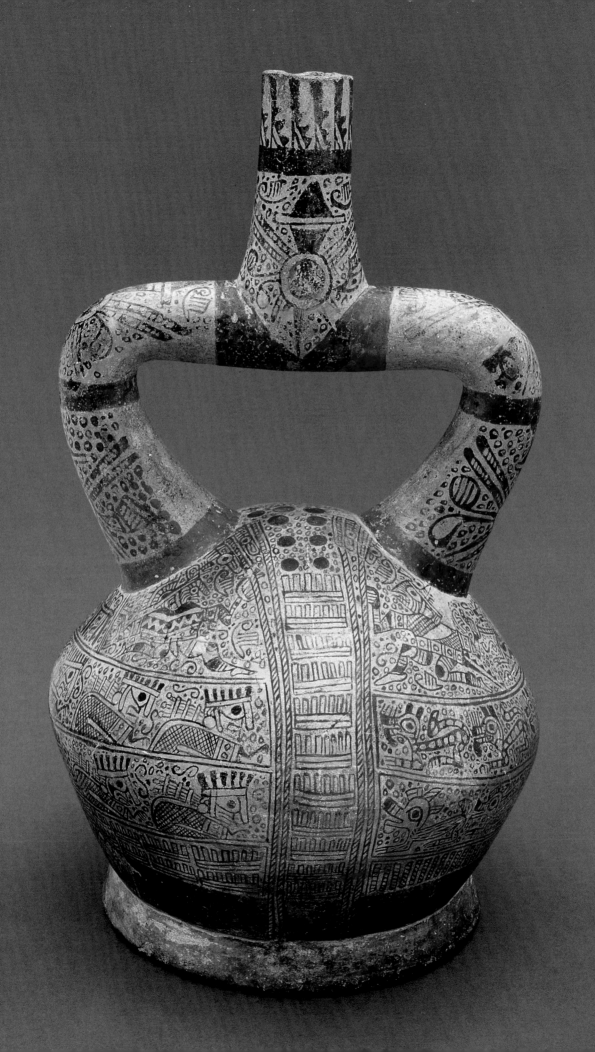

The Naymlap Legend: Between Mystery and Fact

Carlos Wester La Torre

The Naymlap Legend

First recorded in the sixteenth century by Miguel Cabello Valboa (1951 [1586]), who had heard it from Martín Farrochumbi, the *curaca*, or chieftain, of Túcume, the Naymlap legend recounts episodes from the origin and foundation of the Lambayeque culture, which flourished from 750 to 1375 A.D. It was associated with the arrival on the coasts of Lambayeque of a legendary figure accompanied by his principal wife, his concubines, and a small army of officials and servants. This account contains a description of the route they took, from their sea journey to their disembarkation, their settlement and integration into an area that contained a great variety of scenery, settings, places, and characters, and finally the dynastic succession of the ruler. The version of the Naymlap legend recorded by Justo Modesto Rubiños y Andrade, a priest in Pacora and Mórrope, in the eighteenth century (1936 [1782]), is not a completely different account; on the contrary, the overlap of many features are of particular historical value in reconstructing the past of the Lambayeque region. It gives us insight into the process of formalization and definition of a cultural style, which beyond question established itself on the north coast of Peru, the location of the so-called "collapse" of Mochica society.

Many scholars have helped to further our understanding of the meaning and importance of the Naymlap legend. They include Brüning (1989 [1922]), Larco (1948), Kosok (1965), Schaedel (1966, 1985), Kauffmann Doig (1992), Zevallos (1971, 1989b), Trimborn (1979), Donnan (1989, 1990), Shimada (1985, 1986, 1990, and 1995), Alva and Meneses (1983), Narváez (1995, 1996), Fernández (1992, 1994, 2004), Paredes (1987), and Rucabado (2008), all of whom try to either confirm or reject the historical validity of this transcendental story. For some, the oral tradition represents an account of imaginary events designed as a tool for exercising political and ideological control (Rucabado 2008). At the same time, the story has also presented an enormous challenge to a large group of scholars: that of understanding the narrative's content, its meaning, its implications, and its congruity with the environmental and cultural context to which it belongs.

Among the various episodes of the legend, of special interest is the polemic attitude of Fempellec, or Tempellec, the last member of Naymlap's dynasty. Because he wished to transfer to another location the idol erected at Chot, and to have sexual relations with the demon disguised as a woman, Fempellec was punished. His sacrilege had a profound effect on the kingdom, causing thirty days of rain and a year of drought, and bringing with it hunger, destitution, and death. That tragedy, which forms the epilogue of the fantastic narrative, makes us consider the possibility that the removal of the idol may have coincided with the construction of one of the temples in the Chotuna Complex, and that this coincided with an occurrence of the El Niño phenomenon, which causes havoc due to the heavy rainfall associated with it. Brüning (1989 [1922]) maintains that Chornancap may have been the original Chot, and we believe that the present Huaca Chotuna may be the place to which the mythical ancestor was transferred.

Archaeological Discoveries

Over the past twenty-five years the north coast of Peru has been of special interest to researchers, who have documented important burial sites containing extraordinary material, revealing unsuspected aspects of the power, religious practices, and achievements of the region's pre-Hispanic societies. Some important Lambayeque burial sites were excavated in the 1990s (Shimada 1995). The contents of these graves reflect the power and wealth of an elite represented by figures who enjoyed a supreme authority that was not only divine but fundamentally political (see Elera in this volume).

Archaeologists have attempted to corroborate the story of Naymlap, and their arguments are increasingly convincing, both in terms of place-names and the relationship between the visual elements represented on various objects and the story itself. Our excavations at the Chotuna-Chornancap site, thought to be the place where Naymlap arrived, reveal features that correspond with episodes described in the legend.

The throne of Chornancap, excavated in 2009, is a structure closely connected with the way Huaca Chornancap functioned.

91. Lambayeque, double-spout vessel decorated with human figures and snake heads, 750–1375 A.D.

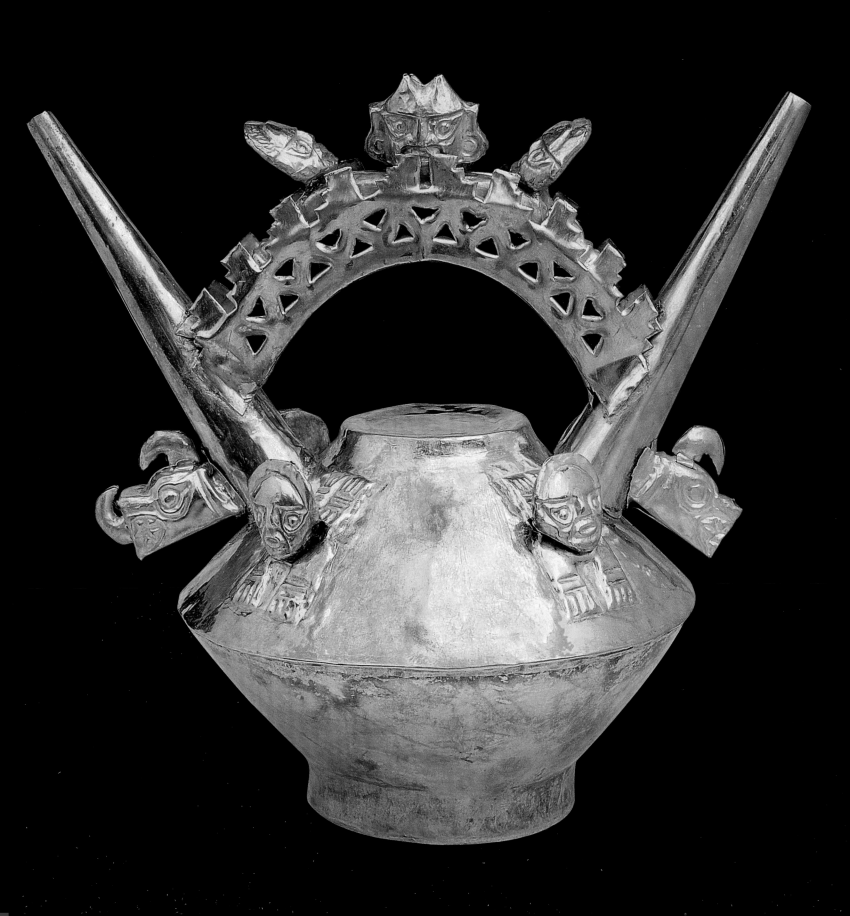

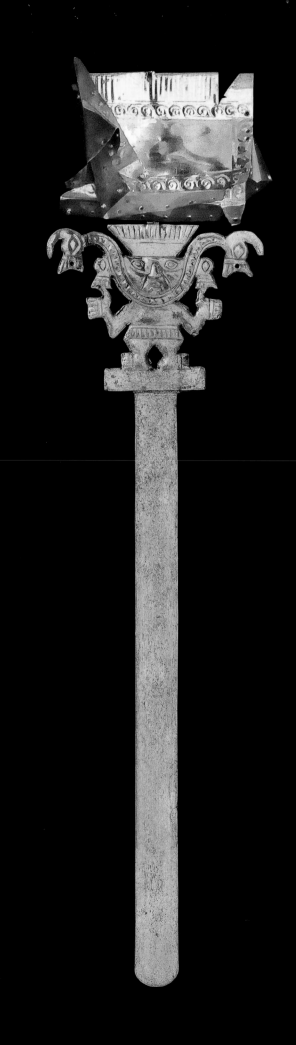

Fig. 1
Lambayeque
Sceptre of the Priestess
of Chornancap depicting
a deity
750–1375 A.D.
Proyecto Chotuna-
Chornancap

Fig. 2
Lambayeque
Earspool of the Priestess
of Chornancap depicting
the "Anthropomorphic
Wave"
750–1375 A.D.
Proyecto Chotuna-
Chornancap

Fig. 3
Lambayeque
Earspool of the Priestess
of Chornancap depicting
a figure wearing
a semi-lunar headdress
750–1375 A.D.
Proyecto Chotuna-
Chornancap

PAGES 112-113:
92.
Lambayeque
Back of litter
750–1375 A.D.

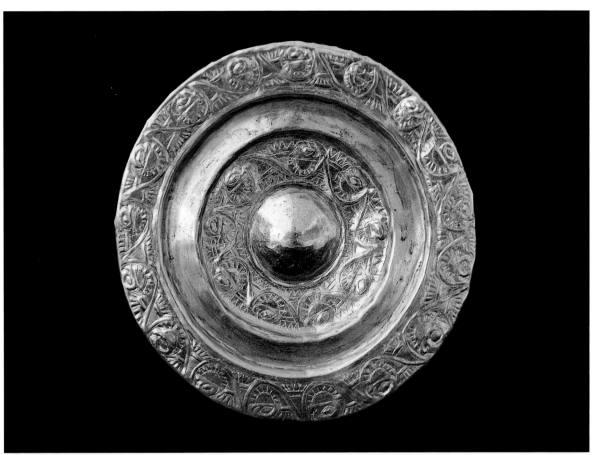

Fig. 2

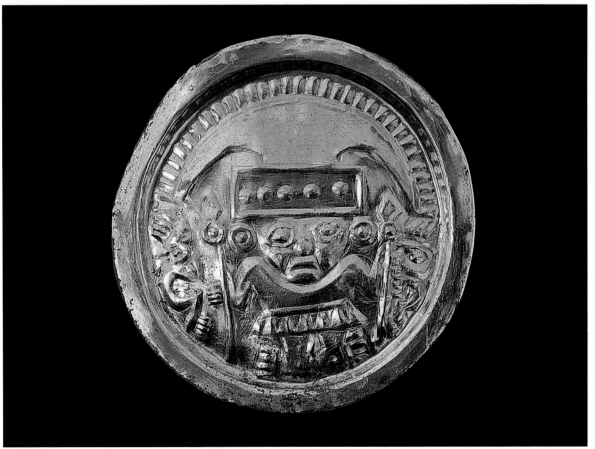

Fig. 3

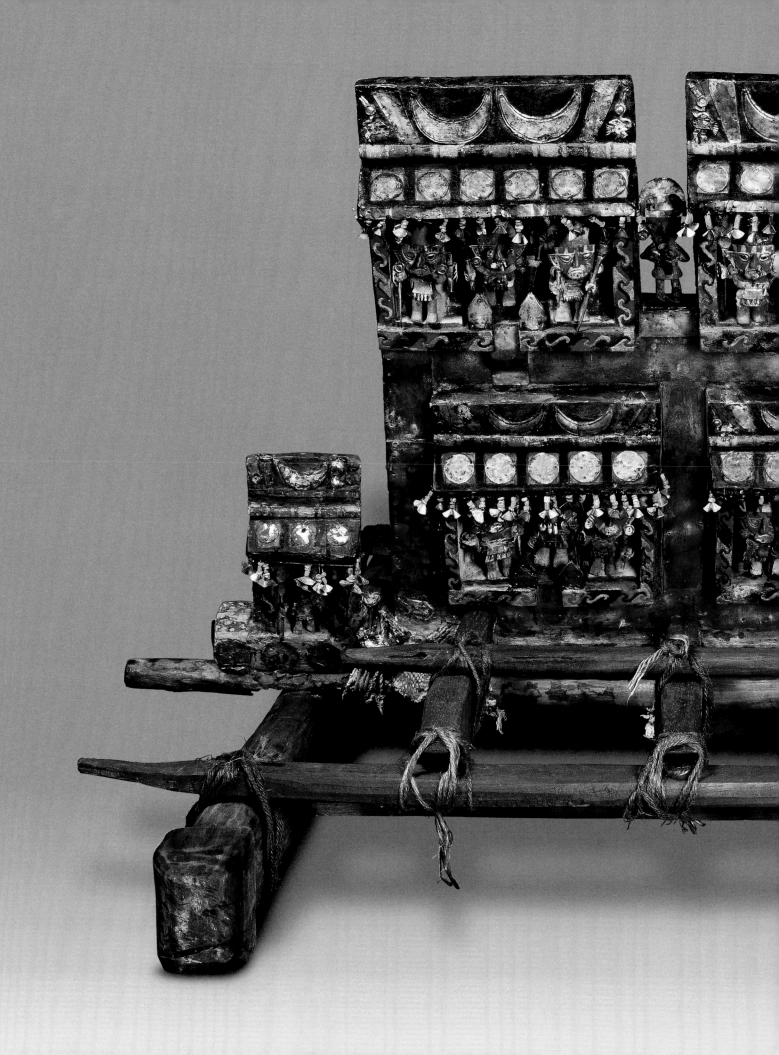

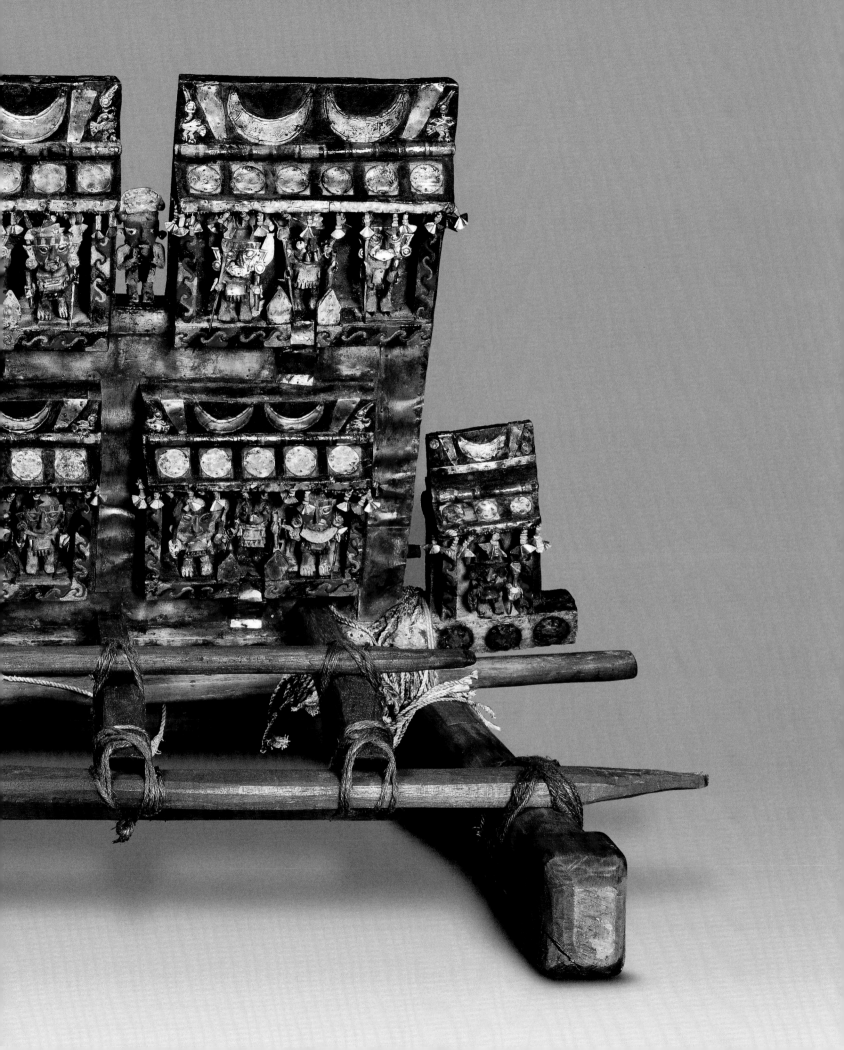

The platform on which the throne stood, the altar, the sacristy, and the decorative items are not only physically adjacent, but form part of a religious complex that the Huaca designated as both the area devoted to the ancestor and as the place where the ruler exercised and demonstrated his power. Small enclosures or cubicles arranged symmetrically in front of the throne (which may indicate days and/or weeks of solar rituals conducted in the east and lunar ones in the west) suggest that the religious authorities maintained control over a ceremonial calendar that we have called "time." In the lower section, where there are altars and pedestals in the form of half a *chacana*, or "Andean cross," with a circle in the center, power is asserted over earth and sea, day and night, sun and moon, and male and female, representing a concept of dualism and complementarity that we have called "space." It is possible that in this sacred space the ruler of Lambayeque, seated on the throne, presided over the rituals of ancestor worship according to a ceremonial calendar.

Starting in February 2011, we excavated a mound situated to the south of Huaca Chornancap. The site, which contains evidence of rooms—areas for rituals, feasts, and storage—may have been that of the ruler's palace, and the ruler may well have occupied the throne described above. Our excavations there also revealed evidence of a very significant tomb. On the eastern side we found a number of ceramic offerings, including classic double-body bottles in the form of shells (*Spondylus* sp.) and sculptural vessels from the Late Lambayeque period (1100–1350 A.D.).

Towards the western part of the tomb, on the same level as the Lambayeque ceramics, we found over forty ceramic vessels of high artistic and technical quality, belonging to Phase IV of the Cajamarca culture. The presence of Cajamarca ceramics may be interpreted as a statement of the bonds and connections between the principal person buried in the tomb and the high Andean region. Those connections may have been family ones (through marriage) or territorial relationships, or more probably those arising from the commercial exchange of goods and resources, but they

confirm a close relationship between the two cultures. It is also possible that the presence of this collection of "foreign" ceramics is explained by a more fundamental connection related to water. The water that irrigates the valleys of the Lambayeque region comes from the Andean slopes of Cajamarca. Water resources were of vital historical importance, and even today they represent a major contribution by the Cajamarca region to the successful irrigation of farmland in the coastal valleys of Lambayeque. This presupposes a relationship that expresses itself in political, religious, and economic terms, but which has its origin in a force of nature.

When the ceramic offerings were removed, we found a painted cotton mantle whose edges were decorated with figures in the form of the "anthropomorphic wave," with ninety copper discs in the center. A similar mantle, folded in three, was found in the extreme west of the tomb. The "anthropomorphic wave" and the circles, recurrent motifs in Lambayeque iconography, refer to the traditional motifs of moon and sea, two overarching themes in the life of Lambayeque society, to which the dead person may have had access in her role as a priestess and a member of a divine hierarchy.

Under the mantle, we found the imperturbable features characteristic of the classic Lambayeque face mask, with winged eyes and representations of tears, which can be seen as expressing the weeping of a divinity. The presence of such a mask in the burial delivers a revelatory and metaphorical message about the afterlife (see Elera in this volume). A silver-plated copper crown and a necklace consisting of twenty-one copper discs were lying on the funerary bundle. Among the offerings was a small gold-plated copper scepter, on the end of which was an image of Naymlap, a pectoral made of white shell (*Conus* sp.), three pairs of dazzling gold earrings (figs. 2, 3, p. 111), five pairs of silver earrings, and a gold crown with a complex scene in which a woman holding a loom rests on the crescent moon, an image that seems to refer to the deity of the Moon, who was present in Andean culture from very early times. An elongated, silver-plated copper drinking vessel, placed on the dead person's right,

means that a link can be made with other visual representations, such as the one in which Naymlap is shown with such a vessel on his right-hand side. At least eight other figures, seated and with limbs flexed, as well as two camelids, accompanied the principal figure, whose bundle (which is still being excavated as I write these lines) was placed on the western side of the tomb. The principal figure is also seated. The location of the bundle is deliberate, in that to the west lies the sea, over which her ancestors arrived. This person, too, may be symbolically connected with the motif of the "anthropomorphic wave," and may represent the head of the wave, which frequently appears in Lambayeque art. But this dead person is facing east, the direction of the kingdom of the Moon. Both features clearly demonstrate the metaphorical ability of this figure, probably a Lambayeque priestess, to penetrate the depths of the sea and to rise into the air, thus resembling the moon.

A gold object of outstanding artistic quality confirms this person's status. It is a ceremonial scepter or staff of office, with one end elongated and laminated and the other end with the representation of a traditional Lambayeque figure. The figure is standing on a podium with arms raised in the act of *mochar*, a ritual gesture described in colonial documents, which consisted of throwing kisses into the air while making a noise with pursed lips (fig. 1, p. 110). A small crown in the form of the body of a diving bird, and a diadem with the classic representation of the body of the mythical bird (Zevallos Quiñones 1971), decorate the head of the figure represented on the scepter. Sewn-on strips of silver-plated copper must have represented the buried person's clothing, like the oval pieces that create the idea of feathers, in a clear reference to the person's symbolic identity as a bird.

This important tomb in the palace of Chornancap belonged to a figure of high rank, a political and religious leader whose influence extended not only to the immediate locality but also to the surrounding region.

Was this figure a member of Naymlap's dynasty? Was she a member of the lineage of bird-men/women? Are her companions members of the royal family? Were some of her companions connected with the

Cajamarca area? When the excavation of this tomb is complete and further research has been carried out, we will know more about the dignitaries of the ancient Lambayeque culture.

Conclusions

The legendary account of the arrival of Naymlap and his court in Lambayeque forms part of an oral tradition that was current in the sixteenth century and later in the eighteenth. Features of the story as it was told in the area where the events took place are supported by archaeological, ethno-historical, linguistic, historical, iconographic, and bio-anthropological evidence. Antecedents of that oral tradition may be found in the ancestral Mochica world, for example in the figure known as the "Bird Priest," who may be considered Naymlap's earliest predecessor.

Most of the names and titles used in the story are connected with actual occurrences; a succession of events is recorded in a particular style, preceded visually by the traditional, emblematic image of a person or deity who is present in all the forms of material production found in Lambayeque culture.

The archaeological discoveries at Chornancap, including the throne and the palace, demonstrate the existence of an elite we now recognize in the Naymlap story. The items recorded in the tomb of the Chornancap priestess all combine to tell a story in which, like the myth, the sea and birds are principal features. In our view, the discovery of the priestess' tomb marks the beginning of the process by which the legend will be transformed from mystery into fact.

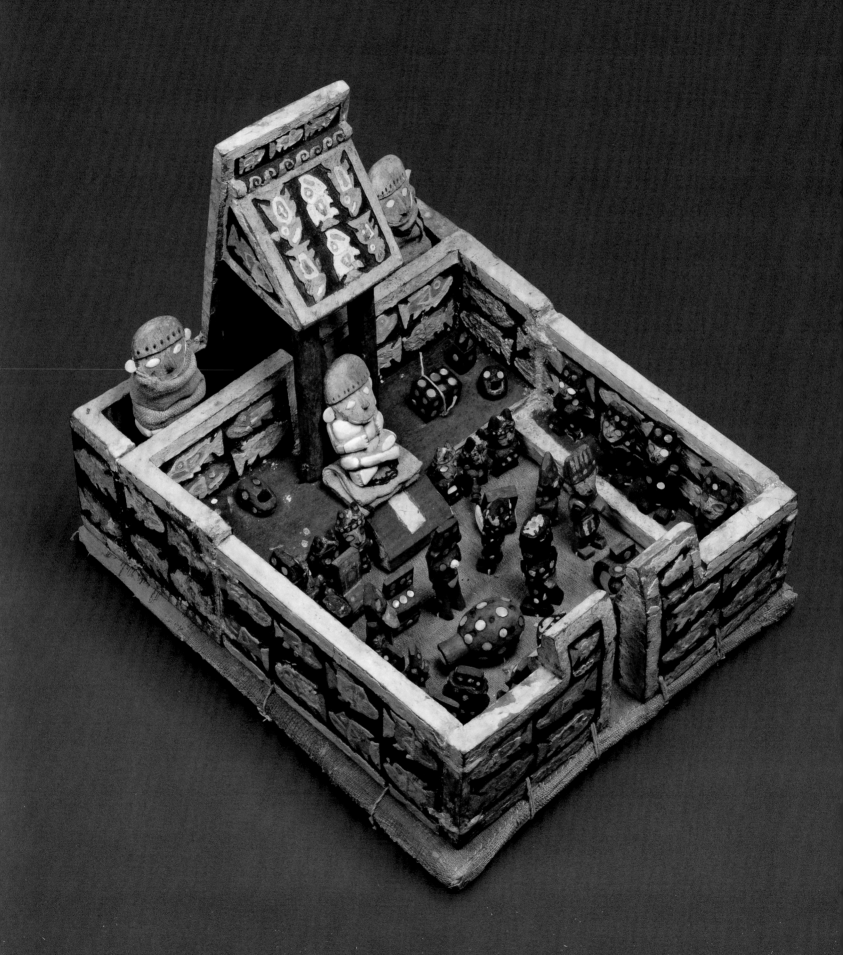

Ancestor Worship in Ancient Peru

Santiago Uceda Castillo

Ancestor worship is an act of devotion characteristic of various world religions, in societies with differing levels of social and economic development. Its purpose is to remember the dead, thus strengthening group cohesion, but also to encourage the ancestors to take care of the living. It is clear that the practice is a sequel to the death of a loved one, and the family carries out the ceremony society has established to guarantee the dead a safe passage to the afterlife.

Not all the dead, however, become ancestors. Depending on the type of society involved, it requires special rituals or simply that the person who has died should fulfill certain conditions. A distinction has also to be made between personal and collective ancestors (Le Guen 2008, 84). Of the latter, depending on the degree of complexity of the society, some become ancestors—or divinities.

Ancestors have been defined in different ways. Olivier Le Guen (ibid.) considers that the criteria are the burial place, the location of the ritual, and the type of ritual behavior involved. Peter Kaulicke (2001, 291), on the other hand, suggests that the study of ancestors in pre-Inca societies has three aspects: a) the transformation of the ancestor, that is, the transformation of his body to emphasize his new role; b) the ancestor and his surroundings, in other words, the presence of specific funerary structures; and c) the ancestor and his world, that is to say, evidence of the ancestral outside of social contexts, or the world of the ances-

tors outside of the natural world. The first two aspects can be successfully approached via archaeology; other sources have to be used in the case of the third.

For as long as the subject has been studied, use has been made of the chronicles and decrees on the eradication of idolatry that record the manners and customs of pre-Hispanic societies from the moment of first contact with the Spanish conquistadors in the sixteenth century. In this essay we will investigate this practice on the basis not only of written information, but also of archaeological data gathered in recent years on the north coast of Peru. In that way we hope to enlarge our existing picture of the practice, which has traditionally been focused on Cuzco and the southern part of the Central Andes.

Death in the Andean World

Faced with death, societies have constructed various ideological and religious systems by which to explain it. Death was one of the major preoccupations in the Andean world. There grew around it a complex system of myths and rituals that might explain it and, more importantly, use it—consciously or not—as a mechanism of power and control (Uceda 1996).

The lack of a scientific or naturalistic explanation of death was the foundation on which to build a complex ideological system in which life and death formed a basic unit. It was death, however, that gave rise to the most important rituals and ceremonies

in pre-Hispanic times: burials, forms of sacrifice, the building of temples, and so on. The ancient Peruvians made death a substantial part of their existence and constantly tried to understand it, but that did not prevent their making use of it. Thus, death and the dead have their own life: they dance, celebrate, and "reproduce" in the same way as those in the world of the living, and they have therefore to be offered the best of everything; they have to be respected and remembered. For that reason, the religious calendars of the different ancient peoples of Peru contained a number of firmly established ceremonies (Oliva 1895 [1598]).

Ancestor Worship: Ceremonies and Rituals in Ancient Peru

The social structure of the pre-Hispanic societies of southern Peru was based on the *ayllu*, the traditional form of community in the Andean world based on the extended family. Under this conception of kinship, the members of *parcialidad* or moiety were the descendants of a common ancestor, real or mythical, who awarded them the privilege of using communal land and the possibility of holding some post or office. The memory of their dead forebears thus provided ideological support for the identity, autonomy, and relative degree of self-government of each *ayllu* or each *parcialidad* within a larger political structure.

These rights, exercised by each lineage group, provided leadership and enabled the

Fig. 1. Chimú, Model depicting ancestor worship in the ceremonial enclosure of a palace of Chan Chan, 900–1476 A.D., Proyecto Arqueológico Huacas del Sol y de la Luna, Trujillo

117

acquisition of a workforce. This was also connected with the position that the founding ancestor of a group occupied in the hierarchy of ancestors or divinities of larger social units, such as chieftaincies or states. This complicated kinship system meant that those in authority had constantly to consolidate their power, both within each extended family group and with the leaders of other lineages, of lower or higher rank. The leaders therefore organized a system of lavish entertainments, held in their homes, as well as a series of public rituals and ceremonies, carried out at locations built for that purpose. The first category of event was part of a reciprocal system through which the leaders obtained their subjects' loyalty, but which also enabled them to redistribute part of the tribute they received, so as to maintain due reciprocity. The second category formed part of the ideological system that underpinned the political power of the elites; these ceremonies and rituals served to legitimate the roles and functions of the elites, using the hierarchies of their mummified ancestors within the kinship system that they had succeeded in establishing over time.

Sources of Information

Whenever we have tried to reconstruct the ceremonies of ancient Peru (for which we have no written records) we have done so on the basis of information compiled by the Spaniards, or using Andean iconography. Most of the information gathered by the Spaniards—apart from the risk of their failure to understand Andean phenomena, or to interpret them within a Judeo-Christian framework—referred to ceremonies connected with Quechua culture. For the north coast, however, we have only a few chronicles, such as those of the Anonymous Jesuit (1968 [c. 1590]), Pedro Sarmiento de Gamboa (1943 [1572]), and Juan de Betanzos (1968 [c. 1551]).

Iconography has been one of the resources most widely used in interpreting ancient societies. On the north coast, the most complex iconographic images belong to Mochica society. Their interpretation has gone from a naturalistic understanding

(Larco 1939) to the thematic interpretation of the depicted scenes (Kutscher 1983; Donnan 1978) and the iconological interpretation of rites and ceremonies (Hocquenghem 1987). These studies accepted a series of assumptions that had never previously been confirmed. On the one hand, the rites and ceremonies were believed to be pan-Andean, with roots in the remote past. That implies that they had not changed substantially, either over time or from one place to another. One the other hand, they tried to study ceremonies and rituals from two points of view, implying that they developed at a specific place and time.

The discovery of an architectural model representing the plaza of a Chimú (fig. 1) palace and of funerary platforms with figures forming scenes, found in a disturbed tomb in Huaca de la Luna (cat. 93; figs. 2, 3, 4), enabled us to describe the rituals connected with the burial of a high dignitary and with the ancestor worship practiced in the Chimú period (Uceda 1999).

The Monumental Architecture of Chan Chan and its Ceremonial Use

In his study of the funerary platforms of the palaces of Chan Chan, Geoffrey Conrad (1980) suggested they were built over a period of time, since when a Chimú king died his palace was turned into a kind of tomb-palace, under the principle of "dual inheritance." The new king had to build a palace of his own and acquire wealth and power by means of new taxation or territorial expansion. The anonymous chronicle mentions a type of temple that contained tombs, which, in the case of a king "...was like a house, with its hall, living room, and bedroom, with all the other places needed for a larder, a kitchen, courtyards, corridors, entrances, etc." (Anonymous Jesuit 1968 [c. 1590], 158). While that description is generic, it closely matches a palace at Chan Chan, although it does not indicate that its function as a tomb followed its use as the king's residence during his lifetime. This account of its use in his two lives gives the king a divine character, which was the basis of the ideological structure of power in Andean societies (Bawden 1994; Uceda 1996).

This duality is an important aspect of Andean social organization for understanding the concept of dual inheritance. That concept has been documented not only for ethno-historical data in the case of the Inca, but it had been noted in the archaeological record by Conrad (1980), who suggested a sequence of construction of the palaces based on the funerary platforms: the oldest palaces would contain more ancillary tombs as the result of there having been many more generations of descendants responsible for venerating the mummy of the dead king.

If we compare the descriptions in the documents of the early chroniclers with the scenes recorded in the tomb of the Huaca de la Luna mentioned above, we find they coincide to a great extent:

Burial Rituals

The bodies of the dead were embalmed and wrapped in order to preserve them, and offerings were made, including the lives of human beings. This practice is well illustrated in the scenes represented on the platforms. We can see the offerings, which include artifacts, llamas, and people stripped naked to be sacrificed (figs. 2, 3, 4), as well as processions in which the body is carried in a coffin, accompanied by relatives of the deceased and individuals bearing the offerings (cat. 93). These offerings were central to the ritual that guaranteed the passage of the deceased from the world of the living to that of the ancestors, but, depending on the type of ritual and offerings, it also created favorable conditions for his becoming an ancestor. That in turn guaranteed that his lineage group would enjoy social prestige, access to power, and the use of the labor of members of the community.

Ancestor Worship

The scene in the interior of the architectural model that represents a plaza shows ancestor worship itself. The mummies, wrapped in their funerary garb, were placed in an open tomb to which there was permanent access from the plaza. That made it possible to remove the mummies and to celebrate the rituals that were an essential

93.
Chimú
Model depicting
a funerary procession
900–1476 A.D.

Fig. 2
Chimú
Flautist leading camelidae,
possibly carrying
offerings for the funeral
of a Chimú king
900–1476 A.D.
Proyecto Arqueológico
Huacas del Sol
y de la Luna, Trujillo

Fig. 3
Chimú
Figures bringing offerings,
possibly powdered
spondylus, **to make**
sacred the space where
the Chimú king will pass
900–1476 A.D.
Proyecto Arqueológico
Huacas del Sol
y de la Luna, Trujillo

Fig. 4
Chimú
Warriors Taking a Naked
Prisoner to His Sacrifice
900–1476 A.D.
Proyecto Arqueológico
Huacas del Sol
y de la Luna, Trujillo

PAGE 120:
94.
Chimú
Model depicting ancestor
worship in a ceremonial
enclosure
900–1476 A.D.

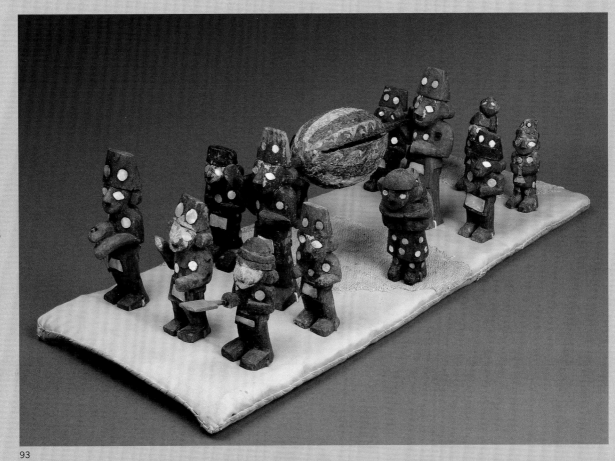

93

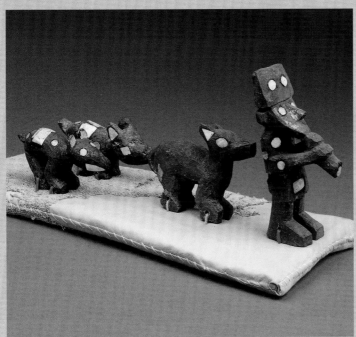

Fig. 2

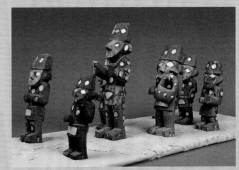

Fig. 3

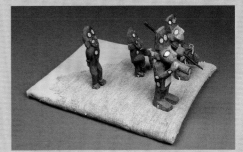

Fig. 4

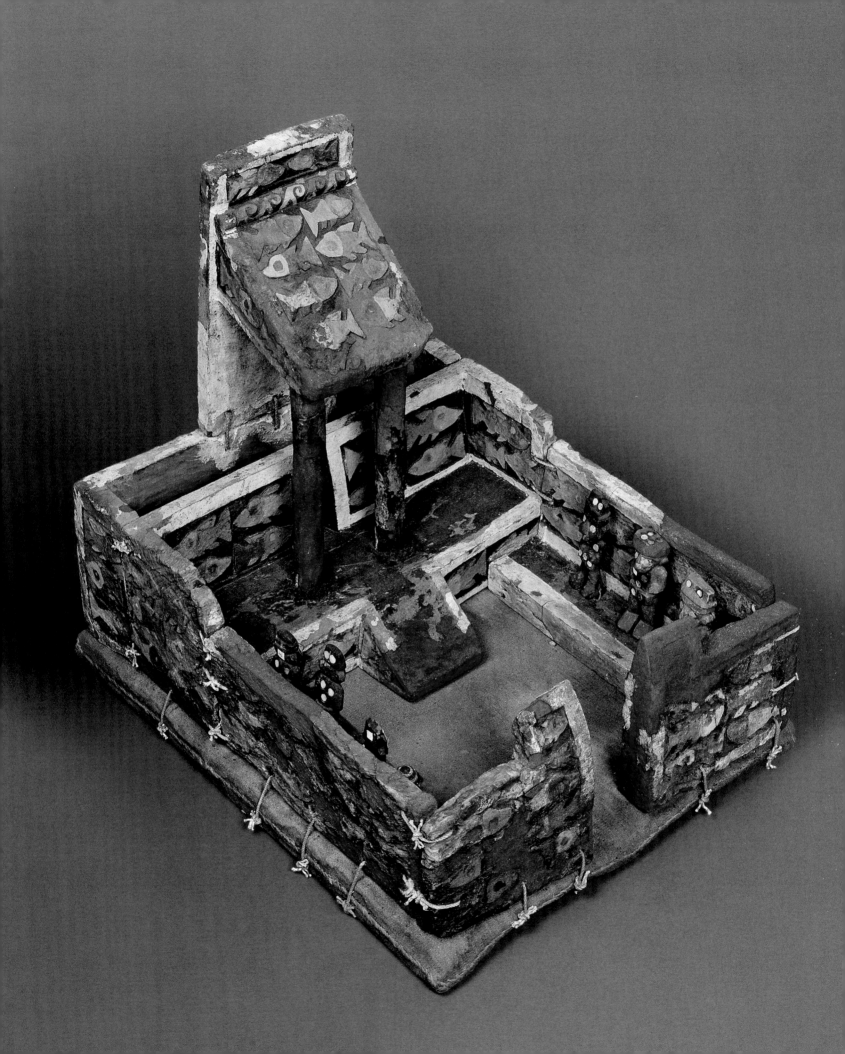

part of ancestor worship, required in order to guarantee the legitimacy of one's lineage and to maintain one's social role. The most important figures in this scene are the three mummies for whom the ritual in the plaza is being performed (fig. 1). The fact that there are two women and one man is doubly interesting. They could be a king and his two wives, a "first" wife and a "secondary" wife, an explanation that might be based on the different way the ears of the two women are represented. The presence of offerings in the corridor may be connected with the ancestral role of high-ranking women: to be the mothers of weavers.

On the floor of the plaza itself, two figures—as we see it—hold the highest rank: the cup bearer, and the one carrying the ladle, both of whom are hunchbacks. This characteristic is very important, since a number of chroniclers have underlined the fact that hunchbacks were selected from among the priesthood to perform the worship of the dead (Valcárcel 1964). The role of the first one was probably to carry the blood of the sacrificial victims, and the role of the second was to serve *chicha*, a fermented maize beer, and sprinkle it on the ground.

Other individuals, painted in black, may represent relatives of the dead, dressed in black. One of them is carrying a fish, which may be connected with offerings of food for the deceased. The musicians carry the two instruments mentioned by the chroniclers in connection with ceremonies of this kind: the drum and the panpipe or flute (Valcárcel 1964).

This wooden architectural model and the platforms on which a series of scenes are depicted, in which the figures described above take part and the objects mentioned appear, agree with many of the chroniclers' accounts and with colonial documents.

It should not be assumed that these architectural models, and similar ones found in the course of archaeological research, served as actual maquettes. On the contrary, they should be seen as symbolic representations.

In short, the scenes represented on the platforms probably show how funeral processions were organized, depicting the roles and status of those who took part, and the basic ensemble of offerings required for this ceremony. The scene of the architectural model shows the moment at which the dead king, following his burial, passed to the world of the *munaos*, the ancestors. He is venerated as an ancestor and his palace becomes a temple. These scenes illustrate clearly the three features that, according to Le Guen (2008), define an ancestor: the rituals that turn a deceased person into an ancestor, the location of the ritual, and the ceremony and offerings involved.

95.
CHIMÚ
FEMALE STATUETTE
900–1476 A.D.

This wooden statuette represents a standing female figure holding a goblet in her hands. Several Chimú statuettes of this type exist, but this one is outstanding for the quality of its craftsmanship, seen in the decorative details on the circular sculpted ear decorations and in the quite realistic treatment of the hands and feet. At the same time, it also has the stiff posture and flat, stylized face, almost like a mask, that is typical of statuettes of this type. Remains of red pigment can also be seen on the face. According to Margaret Jackson (2004), that might suggest an association with funerary rites, in view of the long tradition in the Andes of covering the masks of the mummified dead with red cinnabar.

Although the precise context in which this statuette was found is unknown, very similar examples have been found in niches beside the entrance to the palaces at Chan Chan, the capital of the Chimor Empire, and in the niches surrounding the funerary platforms situated inside the palaces themselves. The association of this statuette with Chimú funerary rites was reinforced by the discovery of models showing scenes consisting of miniature figurines (see Uceda in this volume). Several officiants represented in these models wear trapezoidal headdresses similar to the one worn by the statuette illustrated here. Furthermore, the type of goblet held by the figure seems to have been used in rituals, especially those commemorating ancestors. It is therefore very likely that this female statuette was placed in a niche created in the walls of one of the palaces at Chan Chan, where it could perform the symbolic act of commemoration or even the magical performance of rituals of protection and veneration of the ancestors needed to safeguard the health of the royal Chimú line.

E.H.

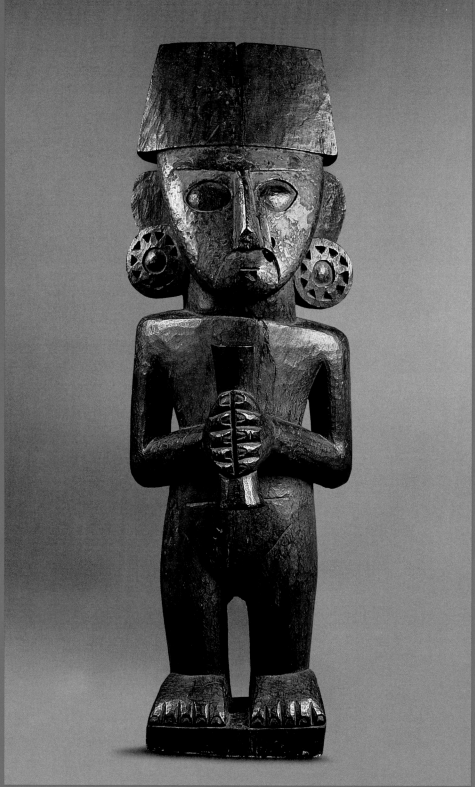

95

96.
Lambayeque
Double-body bottle
depicting a figure carried
on a litter
750–1375 A.D.

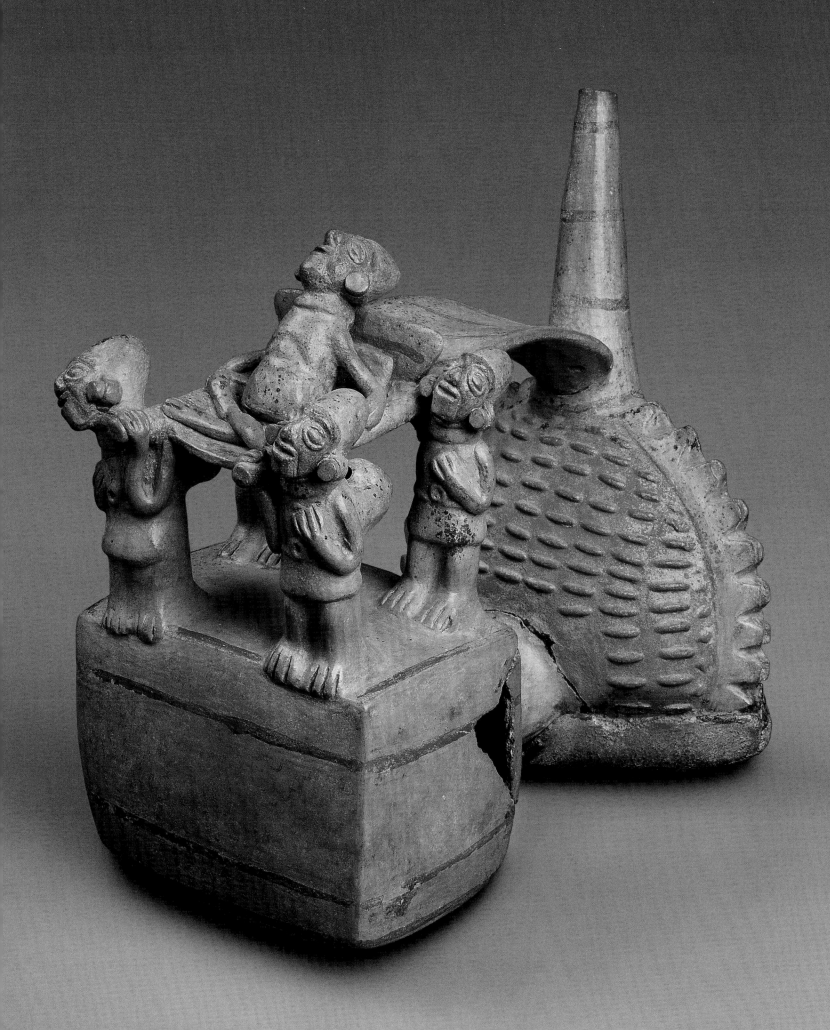

98

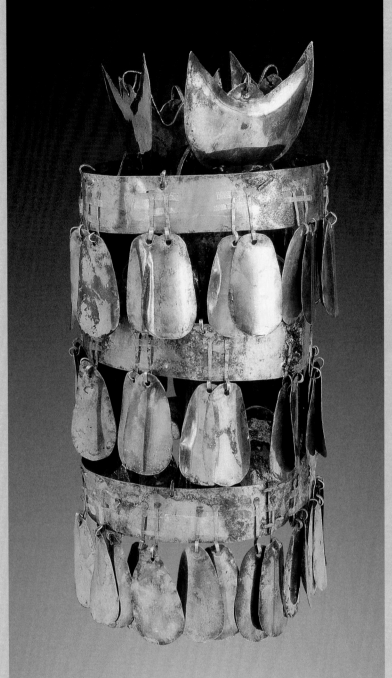

97

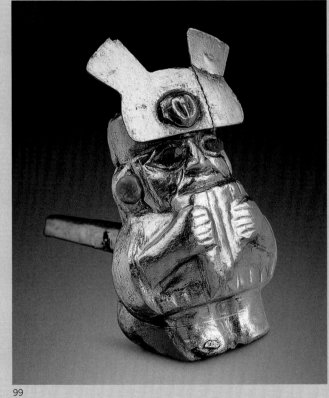

99

97.
Lambayeque
Rattle
750–1375 A.D.

98.
Mochica
Pututo (conch)
100–800 A.D.

99.
Mochica
Whistle depicting a figure
playing the pan pipe
100–800 A.D.

100.
Lambayeque
Miniature ornament
depicting a musician
with a drum and a whistle
750–1375 A.D.

101.
Lambayeque
Miniature ornament
depicting a musician
with a rattle
and a trumpet
750–1375 A.D.

102.
Mochica
Trumpet with warrior-
shaped appliqué
100–800 A.D.

PAGE 126:
103.
Lambayeque
Ornamental plaque
depicting divers collecting
Spondylus shells
750–1375 A.D.

104.
Chimú
Stirrup-spout bottle
depicting a figure holding
a *Spondylus*
900–1476 A.D.

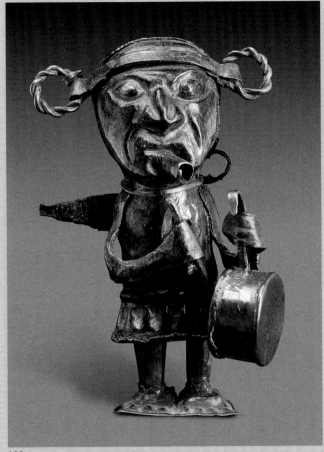

100

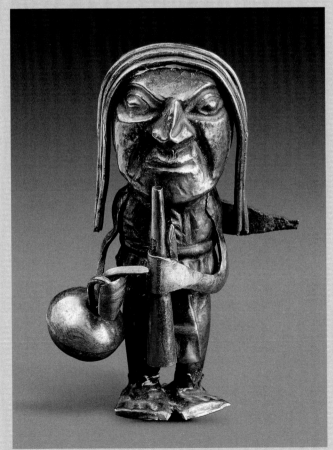

101

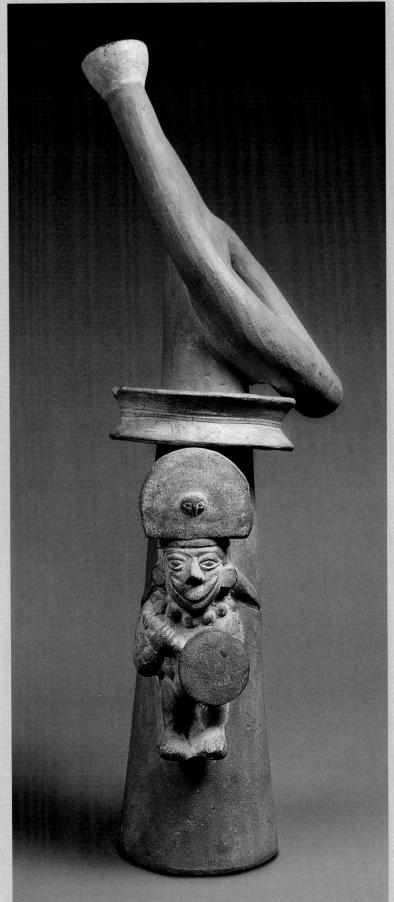

102

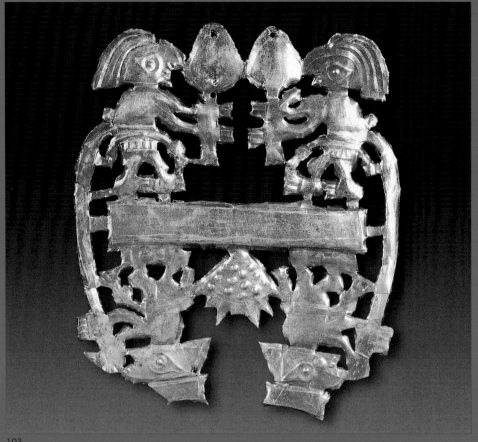

103

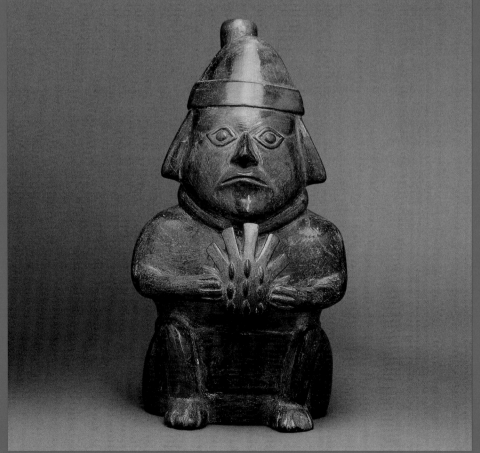

104

105.
INCA
PACCHA (LIBATION VESSEL)
WITH FIVE REPRESENTATIONS
OF *SPONDYLUS*
1450–1532 A.D.

This vase, which is of exceptional quality, is unusual for its beige color and for the highly realistic, three-dimensional representation of five shellfish. These bivalves, with their characteristic spines, are known as *Spondylus*, or as *Mullu* in Quechua. Shells in their natural state and sculpted *Spondylus* shells have been used by pre-Columbian cultures in Peru since the Pre-ceramic Period, and are still used by shamans today. As the *Spondylus* lives in warm water, however, it is not found along the coast of Peru, due to the effect of the cold Humboldt current. It is found only farther north, from the Gulf of Guayaquil in Ecuador, implying that there have been contacts and exchanges between the societies of the central Andes and those of the northern Andes since time immemorial. The exotic nature of the *Spondylus*, and hence the difficulty of obtaining it, must surely have contributed to the value placed upon it by pre-Columbian cultures.

The *Spondylus* is considered in the Andes as one of the most precious offerings. Its importance is demonstrated by its being found in significant locations, such as the royal tombs at Sipán, by its use in the making of objects of great ritual value, such as the Inca figurines (see Narváez in this volume) and by the frequency with which it is depicted. The *Spondylus* was closely connected with the ancestors, and was thought to be their food of choice. It was therefore indispensable in ancestor worship, which ensured the perpetuation of the world. The shape of the vase illustrated here supports the suggestion that it had ritual uses, based on the iconographical motif that was chosen. It is, in fact, a libation vase, or *paccha*. A liquid was poured into the widened vertical neck of the vase, flowing round the inside and out through the side opening before being drunk or poured on the ground as an offering.

E.H.

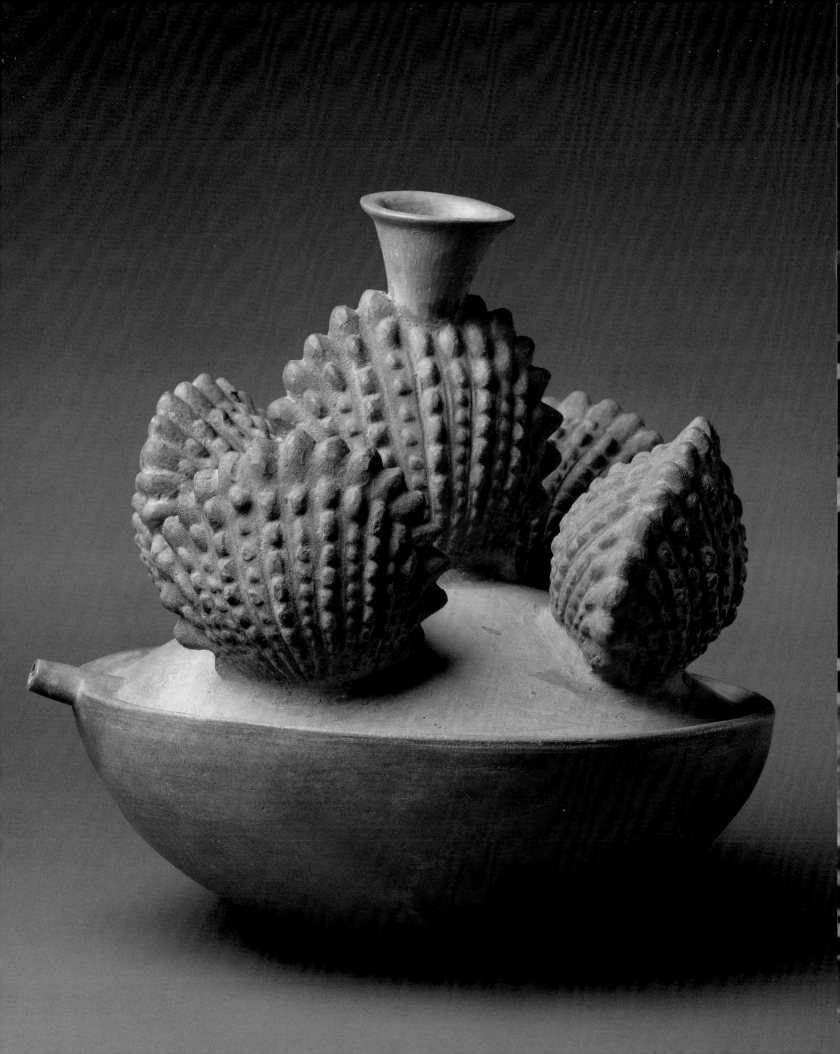

Capacocha: Pilgrimages and Ritual Processions in the Andes

Alfredo Narváez Vargas

The Inca state was one of the largest in the ancient world, including present-day Ecuador, Peru, and Bolivia. It extended as far as southern Colombia, northeastern Argentina and northern Chile. As such, it lasted a little over one hundred years, from the fifteenth until the early sixteenth century, a period during which it was ruled by the successors of Pachacuteq (or Pachacuti Inca Yupanqui), under whose rule began the process of expansion to the four points of the compass, starting from the sacred city of Cuzco.

One of the most intensively studied questions involves the strategies adopted by the state to consolidate its power over places that were so remote from the political center. It is beyond question that the vast road system and the building of administrative centers in strategic locations were successful achievements. At the same time, ideological factors played an extremely useful role in this process, including the establishment of Quechua as the official language, as well as a set of official cults that had the same objective. Within that system, the principal *huacas* (sacred objects) of the conquered provinces were moved and assembled in the Coricancha temple, the focus of the imperial state's religious power in Cuzco. In that way, the government in Cuzco appropriated the most sacred possessions of the peoples it conquered, generating a process of subtle coercion, in order to maintain order and dependency. They were thus ideologically subjugated to the political center, which at the same time became the residence of the most select members of the provincial elites. In fact, palaces were built in Cuzco to house the *curacas*, or chiefs, who were removed from their places of origin and ended their days in the imperial city. The rigid religious and military organization of the state made all this possible, as it implemented an economic policy based on exchange, reciprocity, and the redistribution of wealth.

Although the Inca religious system's structure and the complexity of its pantheon of deities are still a matter of debate, archaeological research has provided evidence for a type of worship of the mountains, accompanied by complex rituals designed to strengthen the relationship between the political center and the conquered territories. This cult involved long pilgrimages, human sacrifices, and offerings of various kinds, which the Inca called *Qhapaq Qocha,* or *Qapaq Ucha,* which can be translated as the "most precious offering." This was a pre-Inca tradition whose aims were to seek the favor of the gods, to ward off imminent danger or crisis, or to reassert power, but it was also a way of complying with the will of the gods. Mountains were centers of special veneration, not only in the sierra or the Amazon basin, but also for coastal societies. Sacred hills had the name *Apu,* which can be translated as "chief overlord," a term applied to deities: *Apu Illapa* was the god of lightning, *Apu Inti* the god of the sun. In that framework, every sacred mountain was a separate divinity, with its own personality and history.

Since the distant past, human sacrifice has been one of the most important means of communicating with the gods. While there was a wide variety of animal sacrifices and offerings, including coca leaves, animal fat, maize flour, the blood of camelids, maize beer, seashells, camelids, and guinea pigs, the most precious offerings were always human sacrifices. The individuals offered up to the mountains might be those defeated in ritual battles, following which their lives were taken in many different ways, or they might be people specially selected, children in particular. The most important high-altitude shrines were tutelary mountains held in great respect and believed to be the birthplaces of peoples or lineages, which received human sacrifices as core features of the rituals. Discussing the child sacrifices offered to the Cerro de Huanacauri, the *pacarina* or birthplace of the Inca dynasty, Molina (1989 [1574–1575]) believed that *Qhapaq Qocha* was an explicit reference to the concept of a "glorious lake" (*Qhapaq* can be understood as meaning illustrious, powerful, majestic, prosperous, etc., and *Qocha* as lake). The mountains are indeed the recipients of rainfall from the heavens, which ends up in lakes, springs, and the sea, the *mamacocha* or mother of the waters, all of which are sacred places. The presence among the offerings of tropical seashells lends further support to that idea. Even today, the peasants of the northern sierra use seawater to "bless" their springs and lakes, praying that they never dry up.

Fig. 1. Inca, silver figurine wearing colourful clothing and feather headdress, found at the Templo de la Piedra Sagrada in Túcume, 1450–1532 A.D., Museo de Sitio Túcume, Lambayeque

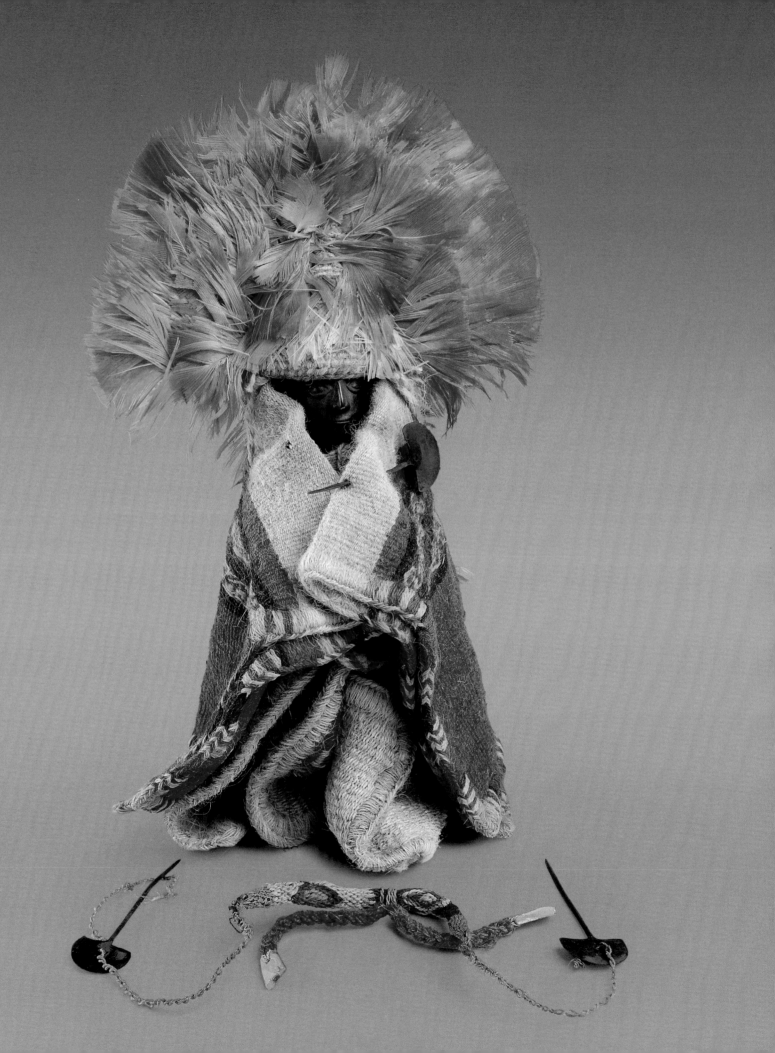

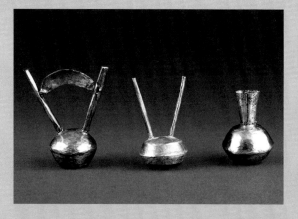

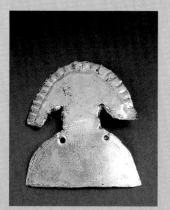

PAGE 132:

106.
Lambayeque
Miniature offerings
750–1375 A.D.

107.
Inca
Tumi (ceremonial knife)
decorated with a camelid
head
1450–1532 A.D.

108.
Inca
Tumi (ceremonial knife)
decorated with a figure
sacrificing a camelid
1450–1532 A.D.

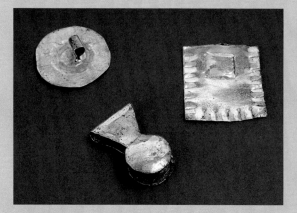
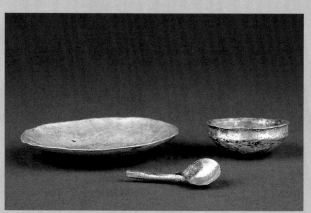
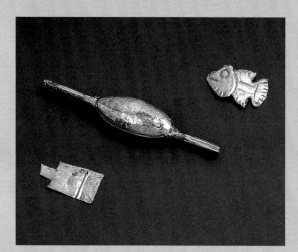
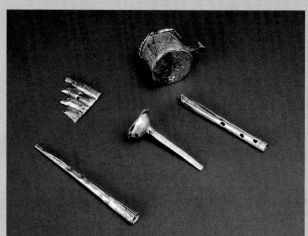
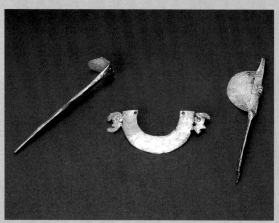
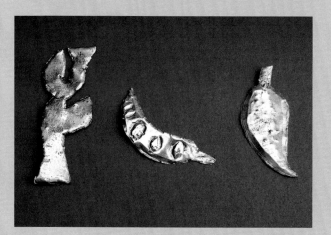

In that area, agriculture depends on rainwater, and periods of drought are the thing most feared.

In the pre-Hispanic past, sacrifices to the mountain gods involved arduous pilgrimages, sometimes to an elevation of around six thousand meters. The human sacrificial victims discovered by archaeologists were richly clothed, and were accompanied by miniature human figurines in gold or silver, or carved in *Spondylus* shell. These figurines were dressed in beautiful garments of fine wool, fixed with metal pins, and also decorated with headdresses made of feathers of Amazonian birds (fig. 1). A *corpus* of offerings from excavated sites also includes fine pottery, figures of animals carved from shell, wooden discs, stone axes, seashells, puma hides, boulders, mortars, pestles, corn cobs, balls of chewed coca leaves, wooden spoons, ceramic vessels, cactus spines, shawl pins (*tupos*), and the familiar silver, gold, or shell figurines. The method by which the sacrifice was performed varied, from poisoning or intoxication to beating or asphyxiation (Scanu 1986–87).

These high-altitude shrines are to be found at various sites in southern Peru, northeastern Argentina and northern Chile, and also in Bolivia and Ecuador. Over a hundred of them may have been recorded up to now. The most important include Cerro Plomo and Cerro Esmeralda in Chile; Aconcagua, Quehuar, and Aconquija in Argentina; Salcantay in Cuzco; Chachani, Pichu Pichu, Cerro Ambato, Mismi, Coropuna, and Misti in Arequipa; and Sara Sara in Ayacucho. They share a number of common features, including a network of access roads, and buildings to meet the needs of rituals and pilgrimages, including rest houses. In many cases, the summits were reserved for special figures such as the *Ukuku* (bear-men). The festival of *Q'olloriti*, the largest and best-known pilgrimage performed today in honor of a mountain deity in the Peruvian Andes, is a good ethnographic illustration of the sacredness of mountain peaks (cat. 241).

Little research has been carried out in northern Peru, and few sites containing the miniature Inca statuettes associated with Capacocha rituals have been recorded. In Cajamarca, there are references to the discovery of one of these silver figurines in the excavations carried out by Reichlen (1949), and Cerro Huaylillas, in Huamachuco, is included among the high-altitude shrines. Offerings of the same type were recently found at Cuélap, an extraordinary stone monument belonging to the Chachapoyas culture in the northeastern Peruvian Andes. They included a *Spondylus* shell figurine of Inca manufacture, very similar to those found in the high-altitude shrines. A llama (*Lama glama*) was found buried with it, in front of the great temple, one of the most important buildings on the site (Narváez 2006). We believe that the monument is the result of corporate work by the Chachapoyas communities, based on religious motives. The mountain on which the monument stands was part of a sanctified area within which there are other sacred mountains, and in addition to them, Lake Cuychaculla, the main *huaca* of the Chachapoyas, is thought of as a *pacarina* from which they originated. The site was the scene of pilgrimages by communities who went there not only to provide their labor, but also to offer up their dead, not just to the mountain but to the site itself, placing them in improvised niches excavated inside its massive walls. It thus became an immense mausoleum, and the remains buried in it sanctified the place. The Inca treated the site with respect; they not only left offerings of the same kind in front of the great temple (which contained an ossuary in the shape of a large bottle), but also built a *callanca*, or great hall, which occupied the upper part of the Old Town. Evidence found there indicates close links with distant regions, such as the sierra of Cajamarca or the site of Huari, in Ayacucho, and the north coast.

Another northern setting associated with *Spondylus* shell and silver figurines, richly dressed and with plumed headdresses, was the Templo de la Piedra Sagrada, at Túcume. It is an enormous site, with twenty-six large pyramidal adobe buildings, a creation of the Lambayeque culture (750-1375 A.D.), which was later conquered by the Chimú and the Inca, before the Spanish Conquest (Heyerdahl, Sandweiss, and Narváez 1995). Inside the small temple, a large, flat, slanting stone was worshipped. This stone came from the Cerro La Raya, in the center of the settlement. This hill was considered a "cosmic axis," and today is a source of power in the eyes of shamanic healers. The bodies of 190 sacrificial victims have been found in the temple, and over a thousand miniature silver offerings, either three-dimensional or cut out of flat metal and embossed. These offerings are extremely varied and cover every kind of human activity: musical instruments, domestic and ritual crockery, shoes, tables, processional litters, hammocks, weapons, looms, personal ornaments and representations of animals, plants, trees, and fruit (cat. 106). Masks representing felines and models of temples have also been found. Many of these objects were found in association with miniature woven garments, and also with *Spondylus* shells. The ceremonial complex, situated beside the road leading to the site, also contained the remains of buried camelids, fragments of pottery, and *Nectandra sp*. At the time of the Inca occupation, veneration of the mountain and the temple dedicated to it involved human sacrifice by decapitation, victims being accompanied by the traditional figurines made of silver or *Spondylus* shell, identical to those found in the high-altitude Inca shrines. That indicates the existence of a state religious practice and its expression in a standardized ritual within the empire, while certain provincial customs were maintained.

Under the Inca empire, not only were there long pilgrimages in the high mountains of the sierra, but coastal societies also adopted this ancient form of worship. This ancestral cult, and the pilgrimages associated with it, has survived, and the mountain gods retain their importance today. They are still seen as protectors, homage is paid to them, and they are given a variety of offerings. The most striking representations of mountain deities are found in Mochica ceramics, in the form of figures with long fangs and ferocious features, associated with human sacrificial victims and surrounded by mountain peaks (Donnan 1978, Figs. 225, 267; Hocquenghem 1987, Figs. 185, 186).

Even today, caves, lakes, crags, high peaks, and inaccessible places are thought of as inhabited by ancestral spirits, and people visit them for different reasons: for

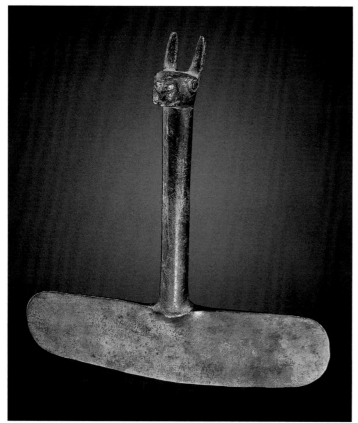

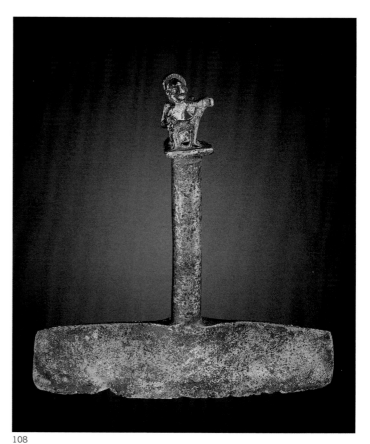

107

108

the sake of their own health and that of the community, for water, good harvests, success in business or marriage, for a safe voyage, or access to natural resources (animal, vegetal, or mineral). Human beings motivated by jealousy, or the desire for revenge for some offence, may also be symbolically "handed over" to the mountain, using prayers, offerings, and clothes belonging to the victim. Bad times are explained by debts owed to the mountain, which must be cleared to avert disasters and other harm. Today these beliefs and practices also involve saints, crucifixes, and figures of Christ and the Virgin; they also take on these duties, of which Peruvian oral tradition contains a rich store of examples.

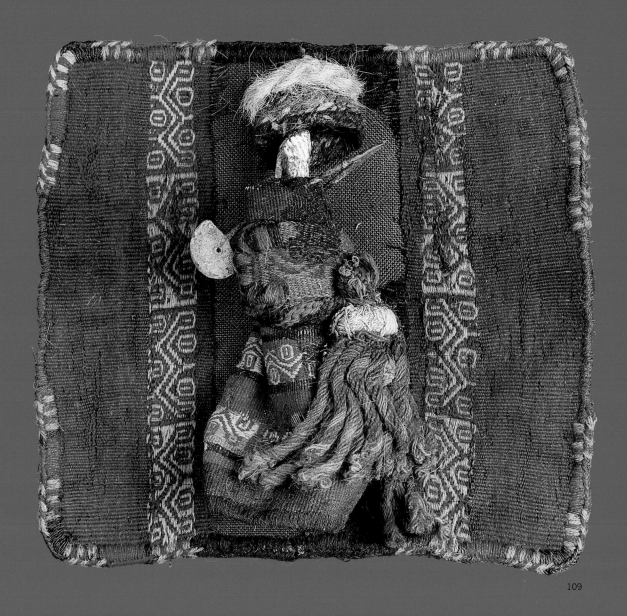

109.
INCA
CLOTHED FEMALE FIGURINE
1450–1532 A.D.

This figurine was carved from *Spondylus* shell and wrapped in several layers of camelid wool cloth decorated with geometrical patterns and secured by copper pins (*tupu*). It is a female figure, recognizable by the grooves representing her long hair, and by her genitals, here hidden under the cloth. The combination of *Spondylus*, a shellfish from the warm waters along the coast of Ecuador, and camelid wool from the highlands, symbolizes the unity of the empire. Figurines like this were probably sent out from the Inca capital, Cuzco, as part of a strategy of imperial unification.

This piece was found in a deposit at the entrance to the temple of Piedra Sagrada in Túcume, along with other male and female figurines made of silver and *Spondylus*. However, most of the time, these figurines seem to have been laid as offerings accompanying sacrifices, especially in the highlands. Such offerings often combined gold, silver, and shell figurines, perhaps in reference to the sun, the moon, and the sea. As stated above, female figurines can be recognized by their long hair, while male figurines usually have a headdress and elongated earlobes, for wearing the heavy earrings

reserved for the elite. In northwest Argentina, Constanza Ceruti (2010) has pointed out a connection between the sex of young sacrificial victims and that of the figurines buried with them, as well as an association between male figurines and llama figures. It may well be that the differences in the context in which the figures were deposited in Túcume and in the southern highlands were partly due to the inclusion of this Inca ritual in regional traditions.

E.H.

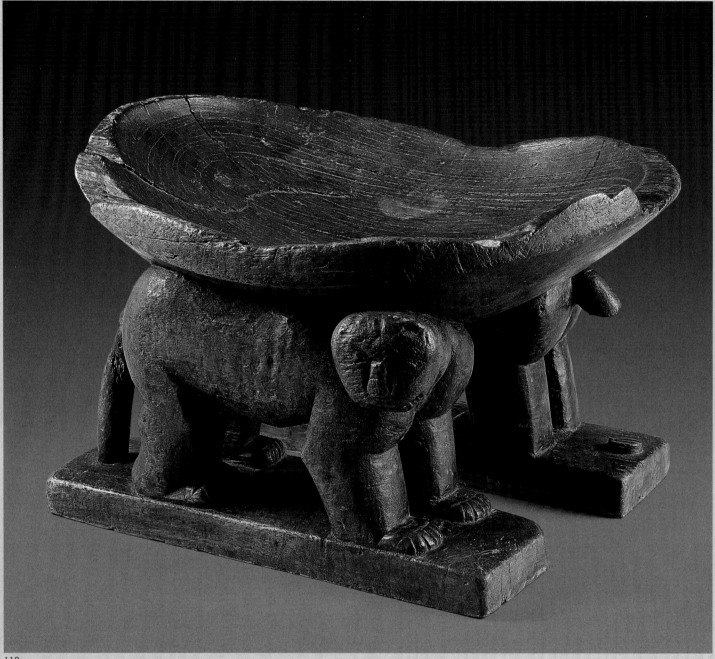

110

110.
Inca
Tiana (seat)
1450–1532 A.D.

111.
Inca
Kero (ceremonial cup)
decorated with geometric
motifs
1450–1532 A.D.

112.
Inca
Pair of *keros*
(ceremonial cups)
decorated with geometric
motifs and camelids
1450–1532 A.D.

113.
Colonial Inca
Kero (ceremonial cup)
depicting the victory
of the Inca over the
Chanca
18th century

114.
Colonial Inca
Kero (ceremonial cup) in
the shape of a feline head
18th century

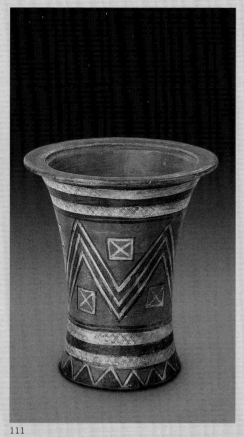

111

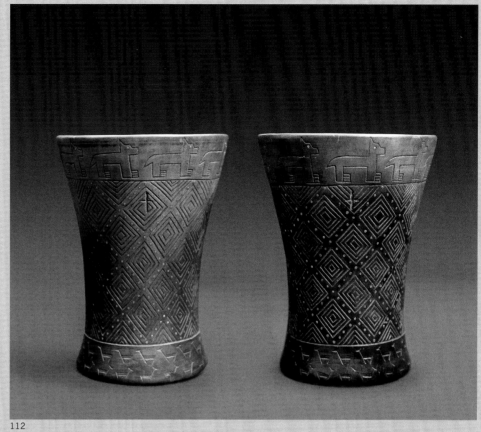

112

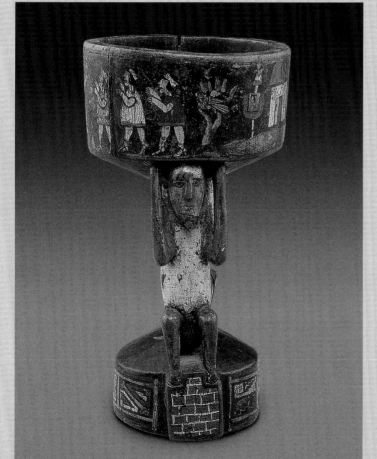

113

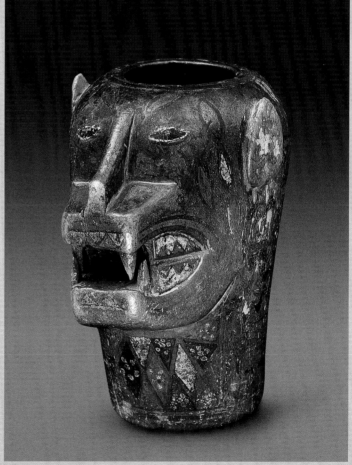

114

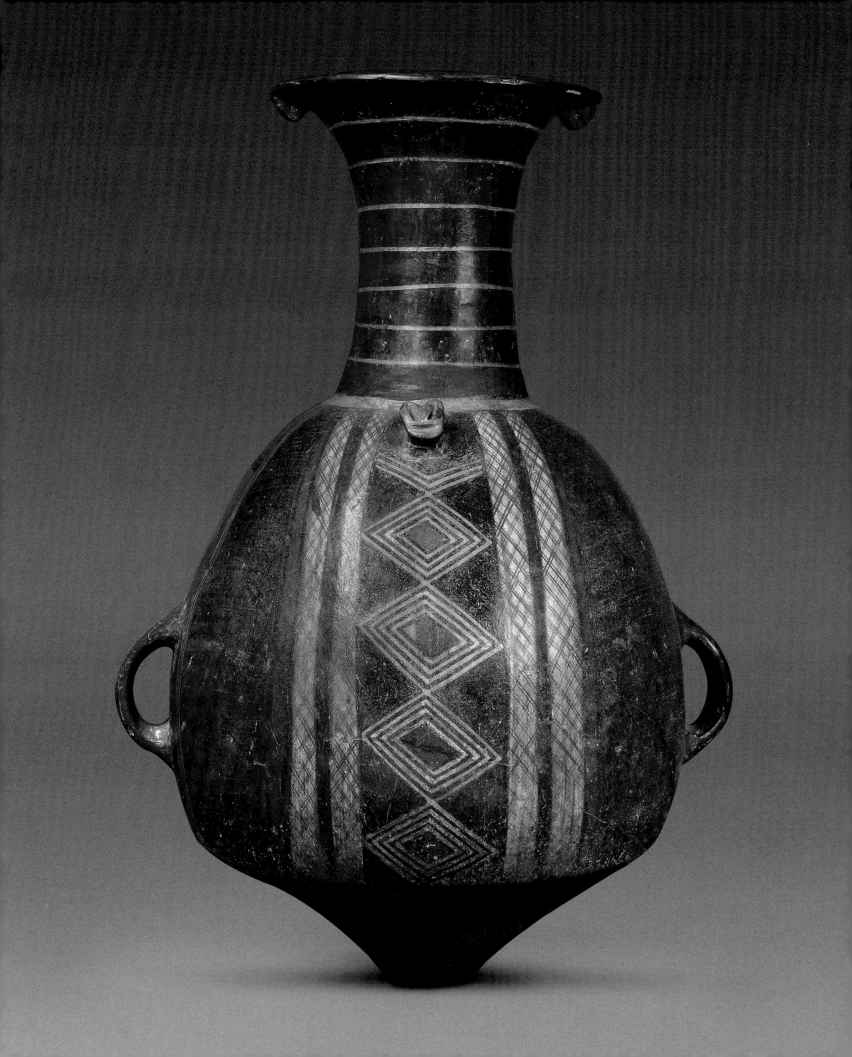

116.
INCA
URPU (ARYBALO) WITH GEOMETRIC MOTIFS
1450–1532 A.D.

The "aryballos" or urpu is the most characteristic and commonest form of Inca pottery. It is found in various sizes but always has a long tapering neck, a broad belly, and a conical base. Handles on the sides and a protuberance at the base of the neck, here in the form of the head of an animal, are also typical and made the aryballos easier to carry. The shape of the aryballoi suggests that they were used to store liquids. Considering the large size of the aryballo presented here, it probably contained the maize beer, or *chicha*, served during major public ceremonies.

Public ceremonies played a significant role in bringing the various regions of the empire under Inca authority. The aryballoi are found in all territories conquered by the Inca, frequently alongside the local style. Often made in the Cuzco region and then dispatched to the four corners of the Empire, the aryballoi symbolized the state's generosity. In particular, the local elites used them to consolidate their status by demonstrating their link with the central power. The insistent repetition of the same form was also part of the Inca strategy of reducing ideology to its basic principles, in order to blend different cultural groups into a single ensemble. This tendency towards simplification is also expressed in a preference for geometrical motifs, such as the lozenges shown here. These lozenges have been interpreted as a symbol of the Empire itself with its four corners and its center in Cuzco.

E.H.

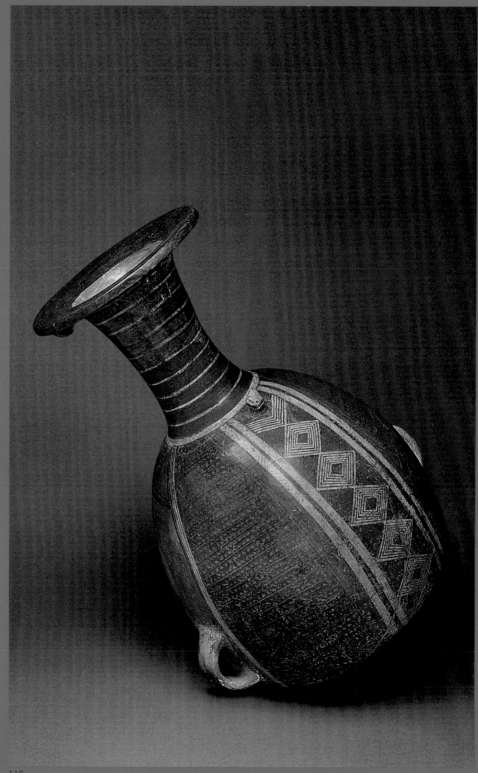

115.
Inca
Urpu (arybalo)
with geometric motifs
1450–1532 A.D.

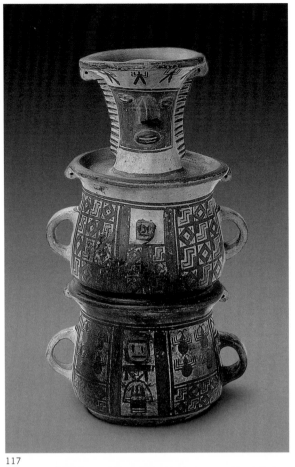

117

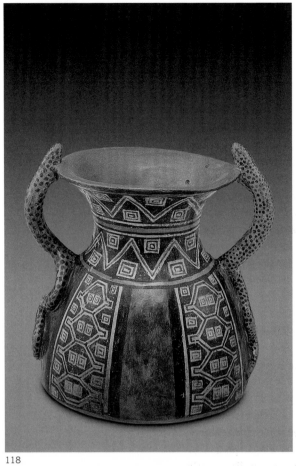

118

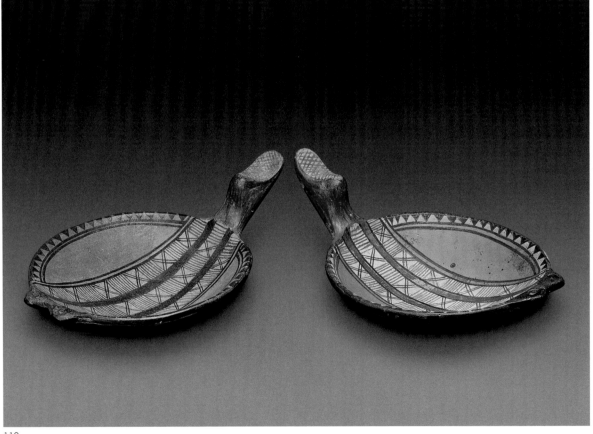

119

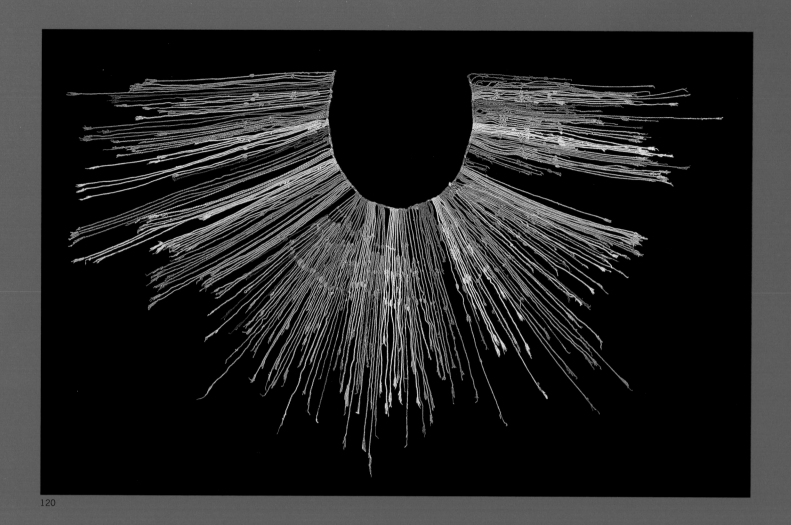

120

120.
INCA
QUIPU (KNOTTED-CORD RECORDS)
1450–1532 A.D.

Khipus (or *quipus*) are sets of knotted dyed cord, made of cotton, as here, or camelid wool. This *khipu* is composed of a primary cord with 226 pendant strings hanging from it; subsidiary strings are attached to some of the pendant strings. The cords are green, brown, cream, or white. The knots are of three kinds: simple, figure eight, and long. The number, position, structure, and color of the threads and knots are a way of coding statistical and narrative information. *Khipus* can therefore contain information on population censuses, tributes sent by conquered people, rituals, genealogy, etc. When they store quantitative information, the grouping of the knots on the Inca *khipus* indicates the use of a decimal system. Although *khipu* already existed under the Huari and the Tiahuanaco, the Inca perfected the system and used it more extensively. The eminently portable *khipus* were precious tools for administering the vast Inca Empire and could be read by specialists called *khipukamayuq*.

The way the information was coded on the *khipus* is still debatable: opinions are divided between a mnemonic system, in which the various patterns of cords and knots enabled specialists to remember specific facts, and a writing system, in which conventionally coded information units can be read. Gary Urton (2003) thinks that *khipus* were probably a combination of both systems. About six hundred *khipus*, varying widely both in complexity and state of preservation, are now kept in public and private collections across the world. The study of these *khipus* continually extends our understanding of this complex information system.

E.H.

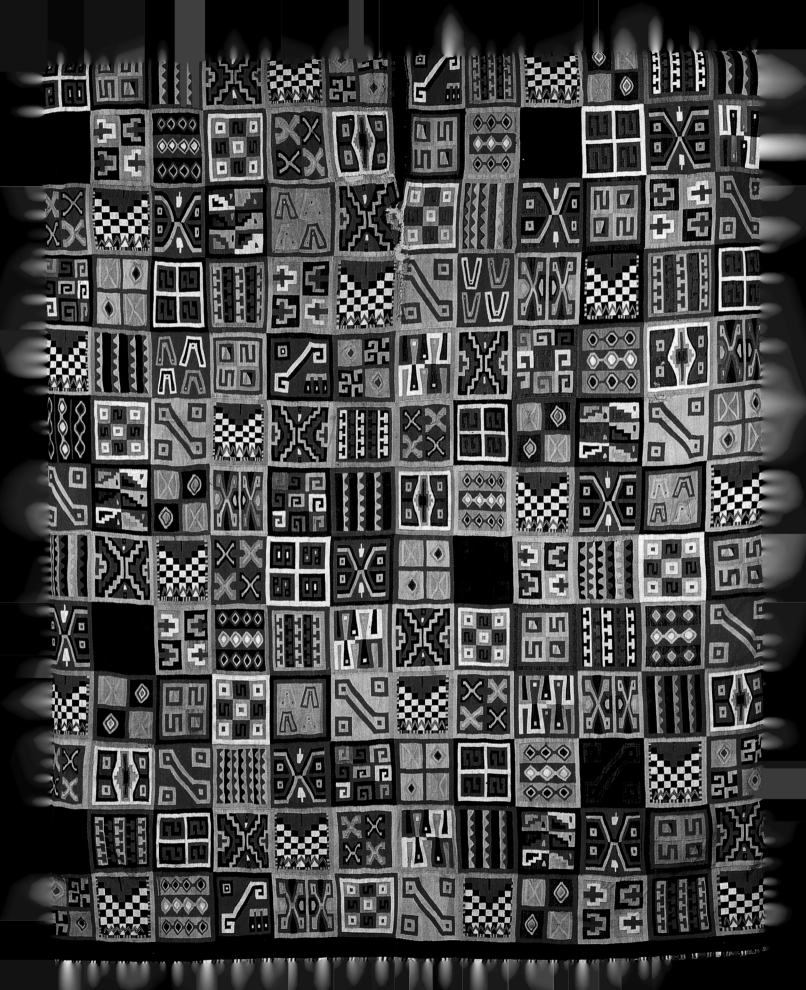

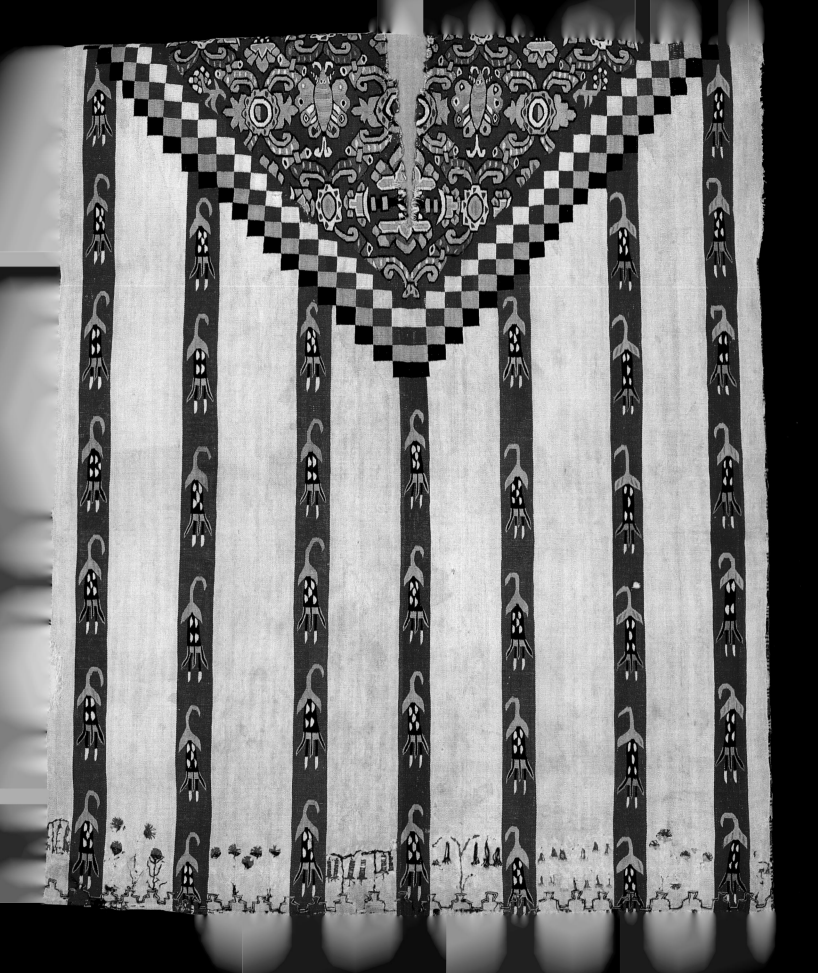

The Sweat of the Sun and the Tears of the Moon: Gold and Silver in Ancient Peru

Introduction

In ancient Peru, gold, silver, and copper were the favored materials for depicting figments of the imagination and materializing social codes and beliefs through body ornaments. Ancient Peruvian civilizations left us, in the intimacy of their tombs, veritable treasures: status symbols, tokens of belonging, special trade items, magical media for communicating with the gods, and unalienable possessions. The way they used gold and silver provides unique information about these vanished civilizations, because these valuable metals, brilliant and eternal, had an influence on the course of their history and the relationships between men and the gods.

Gold and Silver in the Andean Cosmology

Changeless and immortal, shiny and sonorous, malleable or resistant, but also rare and costly, gold and silver were the noble metals *par excellence* in the Andes. Their value was not strictly economic but derived much more from their function as symbols of a worldview and as ostentatious displays of power by gods and rulers, who both played a crucial role in keeping social order.

The colors of gold (yellow) and silver (white) parallel the colors of the sun and the moon. Those heavenly bodies dominated the sky by day and night, respectively. They were therefore considered to be the main gods. The sacred brilliance and apparent eternity of gold and silver, due to their intrinsic physical and chemical properties, made these precious metals the material expression of divine powers (Lechtman 1991; Fraresso 2011). Gold symbolized the diurnal sun god, who gave life and made plants grow. It evoked the "sweat of the sun" and the male gods who lived in the upper world (*Hanan Pacha*), as well as the power of the rulers, who were their legitimate representatives on earth (*Kay Pacha*). Its eternal brilliance proved also the immortality of the ancestors. Silver symbolized the moon, a nocturnal heavenly body, seen as a wife or sister to the sun, and evoked the "tears of the moon." The moon symbolized the female goddesses associated with the fertility of Mother Earth, *Pachamama*, and a dark, damp underground world (*Uku Pacha*), where plants and sacred "stones" (minerals) were born. Copper, an oxidizable metal, was similar to mortals. It evoked transformation, such as a solar body turning into a lunar body, and its red color symbolized the blood of sacrificial victims that was periodically offered to the gods (Holmquist 2010; Fraresso 2011) (cat. 65).

The parallel symbolism—sun/moon, male/female, day/night, upper/lower, dry/humid—translates the reciprocal relationship between men and the gods and consequently the balance between the different worlds. Gold and silver materialize the concept of duality, which is basic in the Andean view of the cosmos. In the Mochica coastal culture (100–800 A.D.), this duality is materialized by the careful arrangement of funerary goods, gold on the right of the deceased and silver on the left. Gold and silver were also sometimes combined in the same object (Alva and Donnan 1993). This symbolic practice—which in technical terms requires a knowledge of alloys and the melting temperatures needed to make strong, invisible welds—is also found among the Chimú, for example, on the sumptuous gold and silver ceremonial bowl, which has a finely chased mythical figure in the center, sprouting extra zoomorphic heads (cat. 122). The Inca also illustrated this duality through statuettes of humans and llamas, which were used in the Inca ritual sacrifice *Qhapaq Qocha* (Itier 2008) (cats. 124-129).

The pre-Columbian universe is divided into three levels or worlds that must be connected to maintain the harmony of society and ensure reproduction: the upper world (the gods) symbolized by birds; the earthly world (men) inhabited by felines; and the underworld (the dead and the ancestors) represented by snakes. These three realms are in constant interaction. But this harmony was not automatic; it was achieved by the acts of giving and receiving (Mauss 1923-1924). That is why men organized rituals in exchange for favors from the gods (Holmquist 2010). The shaman, whose task was to preserve universal harmony, had the power to metamorphose into a divine animal (cat. 25), whose qualities he borrowed to travel from one world to another. He could communicate with all beings and visit the dead in the house of the ancestors. Some figures, worked in gold, such as the "spider-man" on the beads of the Old Lord of Sipán's necklace, probably represent spiritual entities glimpsed during shamanic rites involving hallucinogenic experiences, which played a crucial

122. Chimú, ceremonial bowl with anthropomorphic figures, 900–1476 A.D.

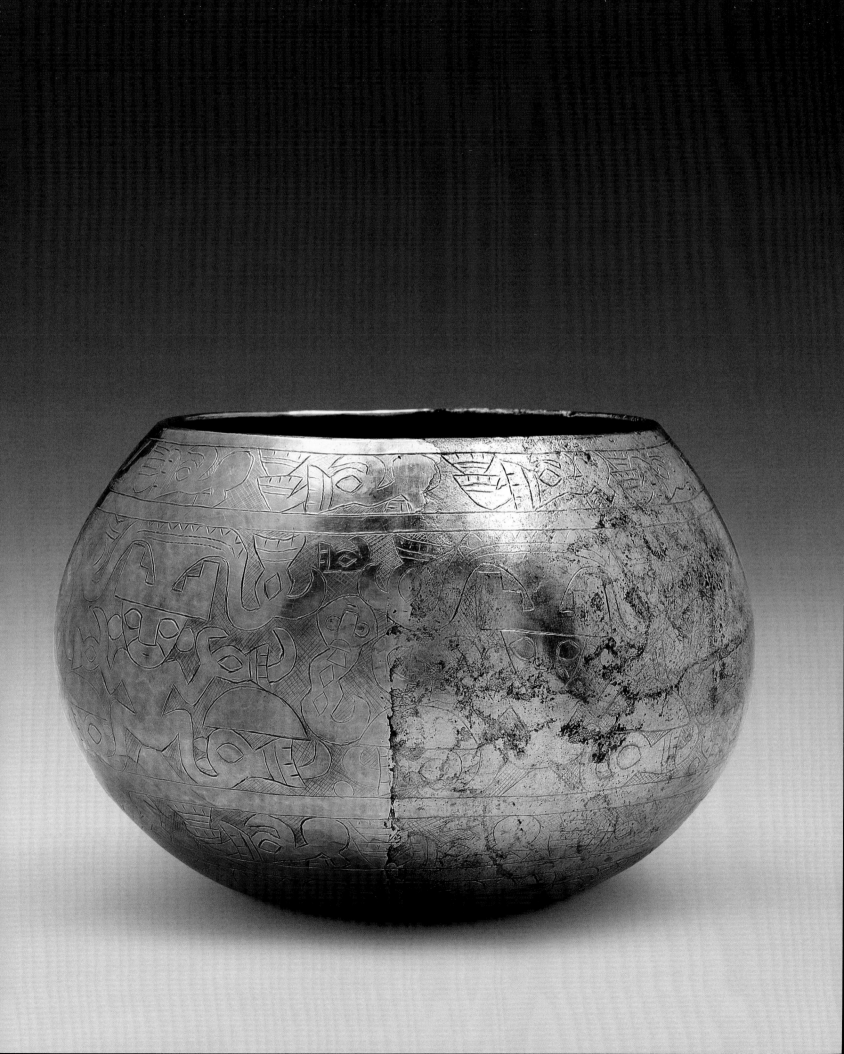

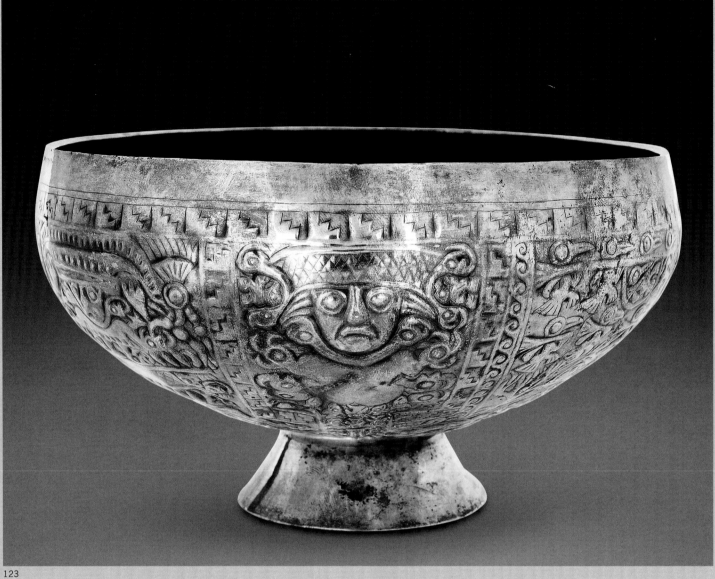

123

123.
Chimú
**Cup depicting a scene
of shell (*Spondylus*)
collection**
900–1476 A.D.

124.
Inca
Male figurine
1450–1532 A.D.

125.
Inca
Female figurine
1450–1532 A.D.

126.
Inca
Male figurine
1450–1532 A.D.

127.
Inca
Female figurine
1450–1532 A.D.

128.
Inca
Llama figurine
1450–1532 A.D.

129.
Inca
Llama figurine
1450–1532 A.D.

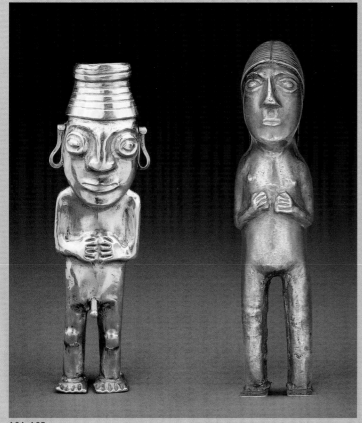

124, 125

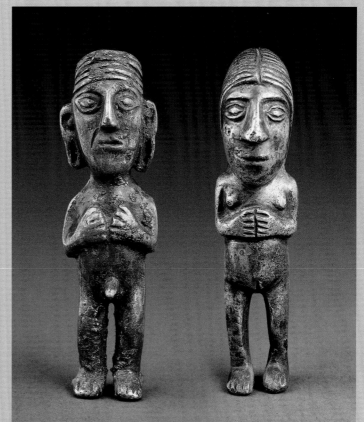

126, 127

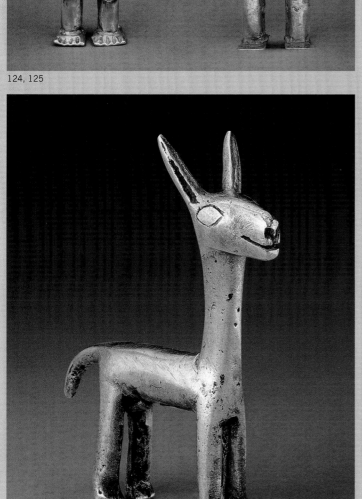

128

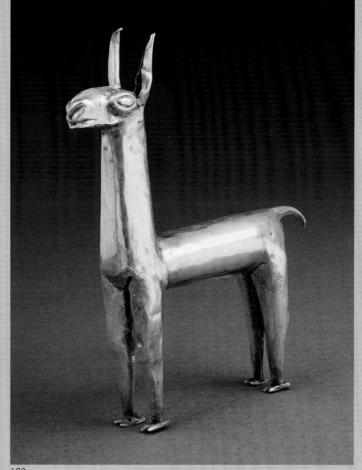

129

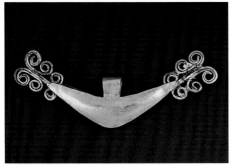

130

131

132

role in pre-Columbian religions (Reichel-Dolmatoff 1988) (cats. 73, 74).

Popular Beliefs and Andean Goldsmiths

Because ancient Peruvian societies were animist, gold and metals were considered to be "living beings," endowed with a soul or a mystic spirit and subject to the same life cycle as men, animals, and plants. Like living species, metals were born, grew, and died; and they were regenerated in the earth, where they took on sacred value (Salazar 1993; Carcedo and Vetter Parodi 1999).

Only the goldsmith (*amauta*) knew the secrets of transforming metal, which are also the symbolic processes of fertilization (Falchetti 2003). He mastered the technical skills handed down by the ancestors and had the gift of transmitting *camac*, the vital breath that brought cult objects or identity markers to life (Taylor 1980, Fraresso 2007). So body ornaments became outward signs of the sensory powers of the ruling classes. Earspools, the ultimate symbols of ruling status, attracted attention to the rulers' wisdom and incomparable listening skills (cat. 134); nose ornaments accentuated the nobles' superior breathing qualities and by extension the superiority of their souls (cats. 130-132, 135). Often isolated from the rest of the community, metal workers were perceived as intermediaries between the gods and men—magicians able to transform natural elements into brilliant, sonorous, eternal objects in the likeness of the gods (Fraresso 2011). As they were believed to have divine powers, the *amautas* enjoyed a privileged social position, closely linked to the rulers, and some of them were buried in privileged places along with their sacred tools and highly symbolic headdresses (Fraresso 2007; Castillo *et al.* 2009).

Metalworking also required, beyond a sound religious training, learning the various metal-processing techniques (Uceda and Rengifo 2006; Fraresso 2010). This specialized training was long and costly for the elites, the main "consumers" of gold and silver; they invested in the development of metalworking arts, which were needed to materialize ideologies and group identity. This investment can be gauged by the vestiges that make up the greater part of Peru's archaeological and museum collections. It can also be judged by the ingenuity and technical skill of their craftsmen in the three major steps in metalworking: foundry techniques (cats. 107, 108), plastic deformation (cat. 140), and decoration and finishing techniques (Fraresso 2007, 2008a).

Divine Finery: Social Language and Identity Codes

In pre-Columbian societies, community leaders distinguished themselves by decorating their bodies with insignia that were instantly recognizable because they were inherent to the exercise of their authority, both in the world of the living and in the world of the dead. The taste for jewelry developed as the social hierarchy took shape, and the need for outward signs of status, age, function, or identity became more pressing. Identity was never fixed; it developed by stages related to age or various events in life, and the transformation continued even after death (Fraresso 2011).

The treasures of the Mochica, Lambayeque, Chimú, and Inca cultures provide evidence of the astonishing know-how of the goldsmiths on the north coast of Peru. These singular objects emphasize the devotion of generations of artisans, who, for three thousand years, used inimitable metalworking techniques to shape the ideological discourse of a

succession of rulers. The objects, usually finely hammered leaves (less than one millimeter thick), decorated with *repoussé* and chased patterns, were produced according to age-old traditions. However, they have stylistic or even technical characteristics that differ from one society to another. The luxurious goldware of the Lambayeque kingdom, decorated with a *repoussé* figure of the founding deity Naylamp, and the silverware of their Chimú neighbors, which pays homage to the moon god Shi and the sea god Ni, were vessels for sacred fluids handled only by the nobles during libations connected with fertility rituals (cats. 123, 141-144, 146). They were used during the regional festivals that structured the agrarian calendar and during the celebrations of local ancestors. By their use of metals with distinct symbolic systems, these pieces of jewelry and cult objects clearly show that the two coastal societies, although contemporary, belonged to different religious and cultural groups. Formal and iconographic differences can also be seen within the same ethnic group because each object is personalized and unique, in other words, an identity marker.

Apart from their symbolic and ritual aspects, crowns, nose ornaments, pectorals, earrings, and necklaces are pieces of jewelry whose ornamental function brings us close to the secular political power (cats. 133, 135-138). This prestigious finery was made to impress, to command respect, and to glorify the wearer, as is shown by the important gold funeral trousseau in the collection of the Larco Museum in Lima (cat. 139). This treasure—unique in the world and thought to have belonged to one of the ten rulers (Holmquist 2010) of the Chimú dynasty—is a reminder of the prestige and power of some rulers. Their magnificence was displayed during public or more intimate ceremonies, during official meetings with real or

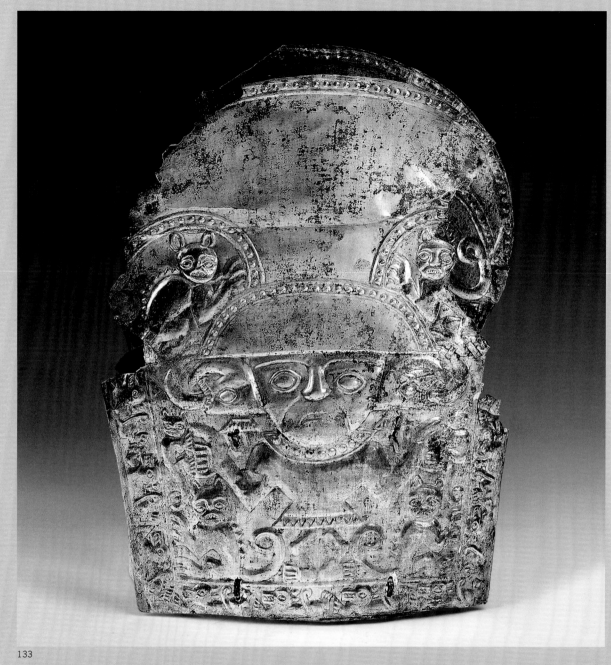

133

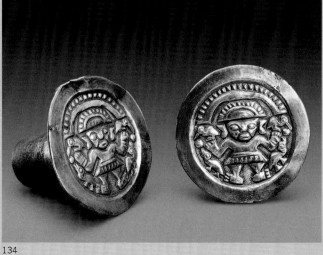

134

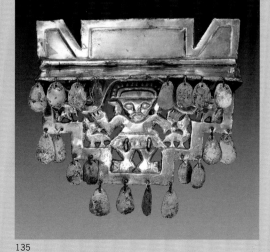

135

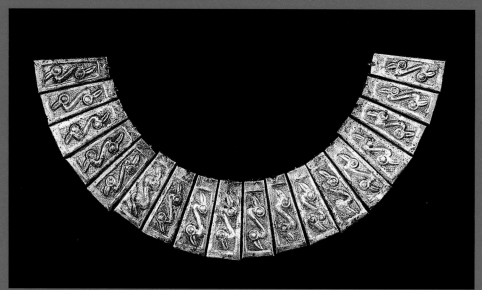

136

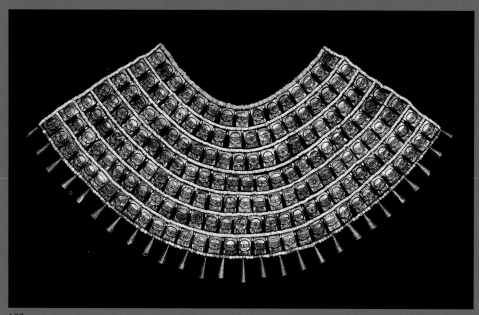

137

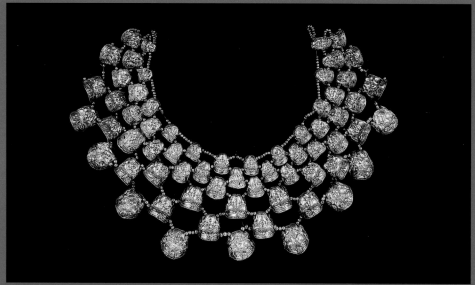

138

139.
CHIMÚ
SET OF HEAD AND BODY
ORNAMENTS
900–1476 A.D.

This seven-piece (probably funerary) set of finery is made of an alloy of gold, silver, and copper; it includes a crown, two earspools, a necklace, a pectoral, and two epaulettes. All the pieces are decorated with hammered figurative motifs, demonstrating the great skill of the Chimú goldsmiths. Small figures wearing a half-moon headdress and earspools, symbols of high social status, adorn the various pieces. Some (on the earspools and epaulettes) are more clearly anthropomorphic while others (on the crown and pectoral) have hybrid, and particularly feline, features. On the epaulettes, the figures are holding severed heads, indicating that they took part in ritual sacrifices. A symbolic relationship to the sun has also been suggested on account of the golden color of the material and the plumes attached to the crown and the pectoral, as birds are the only creatures able to approach the sun.

This is one of the most complete sets of adornments known today. It gives an idea of the rich body ornamentation of the Chimú elite. Even if its exact provenance is unknown, the themes of the decoration, the rich materials, and the fine craftsmanship suggest that this finery probably came from the tomb of a great lord buried in Chan Chan itself, the Chimú capital. It is therefore the materialization of the dead man's splendor and power.

E.H.

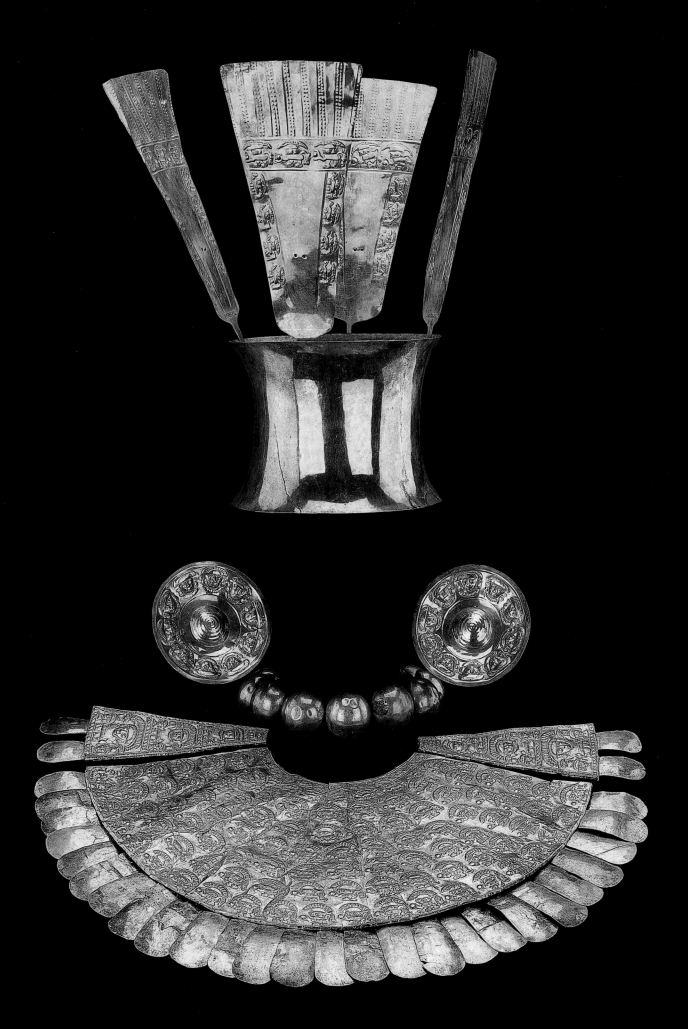

supernatural powers: in other words, with the political authorities or the gods. Some of these meetings took place, for example, during the presentation of the cup containing the blood of warriors sacrificed to the principal Mochica god. The real function of the mythical officiants represented in Mochica iconography can be seen in the tombs (Uceda 2004a, 2004b) (fig. 1) on pieces of finery such as this majestic octopus-shaped frontal ornament (cat. 140). This unique piece from the looted La Mina site, made of *tumbaga* (an alloy of gold, copper, and silver), speaks of men who filled very precise functions in the rituals.

Warriors' helmets, metal feathers, backflaps, and clubs also give us information about warfare, in which there is only a fine line between ritual, mythical, and real combat (cats. 63, 68, 71). Dressed in their shiny, ringing, and clanging accoutrements, the warrior chiefs fought like the gods in their mythology. Bells, rattles, trumpets, and whistles sounded during the official ceremonies (cats. 77, 78, 97-101). They produced deep or high-pitched, festive or solemn sounds, depending on the thermomechanical treatment given to the metal (Hosler 1994; Fraresso 2008b). Gold whistles show religious officiants holding panpipes, emphasizing the close link between music and battle (cat. 99). Music and dancing are mainly seen in the battles that preceded the sacrifice of the defeated, or in celebration of the dead who were to continue their journey into the world of the ancestors (Hocquenghem 1996).

Lastly, some pieces of finery show what Annette Weiner (1992) understands as the unalienable role imputed to the identity of an individual (and, by extension, the group) in life or at the moment of death. Some objects had to be preciously guarded and protected as *unalienable possessions,* because they formed the link with the ancestors needed to preserve the proper balance (Ramírez 2002). For example, funeral masks were identity symbols that were particularly important for communities who buried their rulers, because they identified the ancestor. Made from large sheets of metal—gold, silver, copper-gilt or copper—they represent a human face, occasionally divinized (cat. 89). They are sometimes "made up" with pigments, bright red cinnabar or green malachite, but they always wear the circular earrings that are the insignia of government (Carcedo and Shimada 1985; Carcedo and Vetter Parodi 1999) (cat. 85). This symbolic finery was intended to help the body travel to the world of the dead, where it would be transformed into an ancestor. Once the natural balance was re-established, the communities were free from all disruptive influence ... until the next death.

Conclusion

Jewelry and ceremonial objects that still bear witness to the vitality of Peruvian artistic communities reflect only a part of the fundamental importance of these ideological systems. For pre-Columbian peoples, the disappearance of these treasures due to looting and the destruction and melting down of the symbols of divinity and government meant that their links with their ancestors were broken. The loss of identity symbols, related to the arrival of the Spanish and the establishment of the Catholic religion, led to the collapse of political and religious power centers, carrying with them the beliefs, expertise, and secrets of the prestigious pre-Columbian *amautas.*

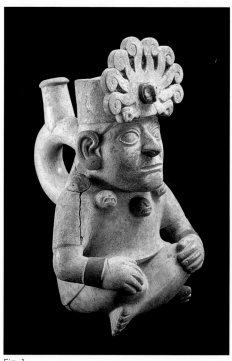

Fig. 1

Fig. 1
Mochica
Stirrup-spout bottle
in the shape of figure
wearing a headdress
depicting an owl head
surrounded by octopus
arms, found in tomb
two of Dos Cabezas
100–800 A.D.
Dos Cabezas
Archaeological Project

140.
Mochica
Forehead ornament
with feline head
and octopus tentacles
ending in catfish heads
100–800 A.D.

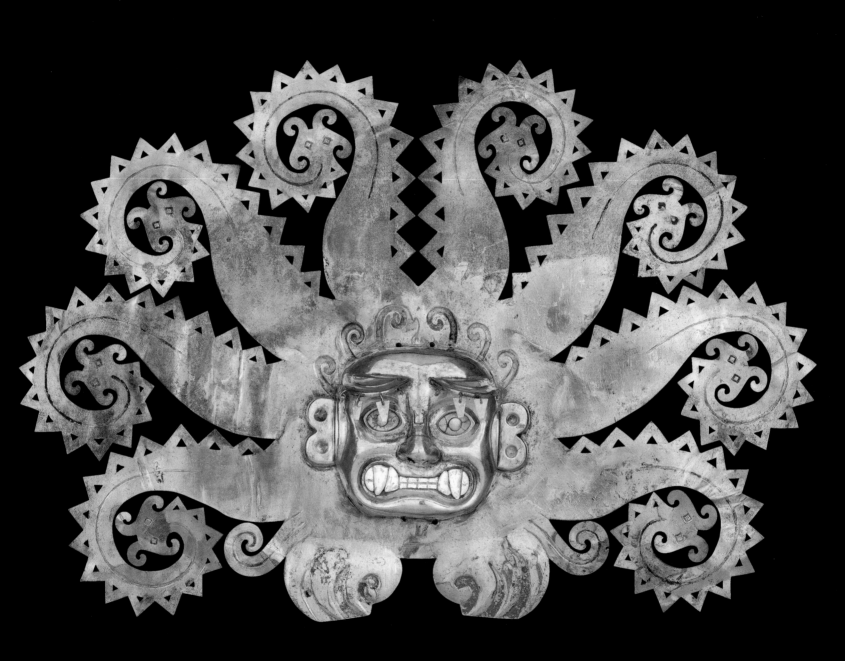

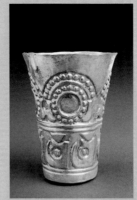
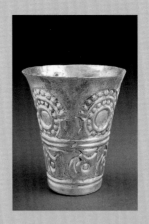
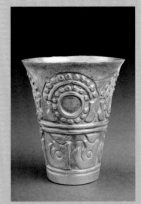

141

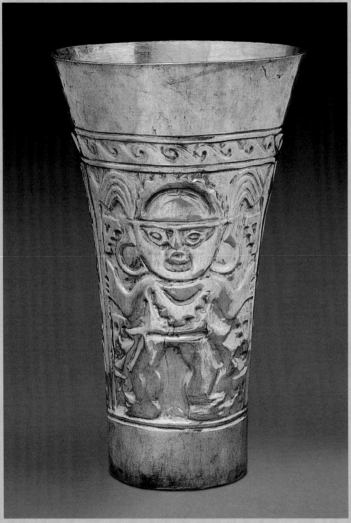

142

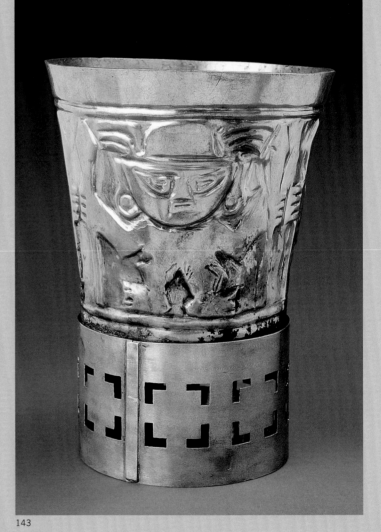

143

141.
Lambayeque
Set of ornaments in the
shape of miniature cups
750–1375 A.D.

142.
Lambayeque
Drinking cup depicting
standing figures
750–1375 A.D.

143.
Lambayeque
Drinking cup with rattle
base decorated
with standing figures
750–1375 A.D.

144.
Lambayeque
Drinking cup with rattle
base and circular
incrustations
750–1375 A.D.

PAGES 154-155:
145.
Lambayeque
Gloves decorated
with standing figures
and geometric motifs
750–1375 A.D.

146.
Lambayeque
Drinking cup decorated
with standing figures
750–1375 A.D.

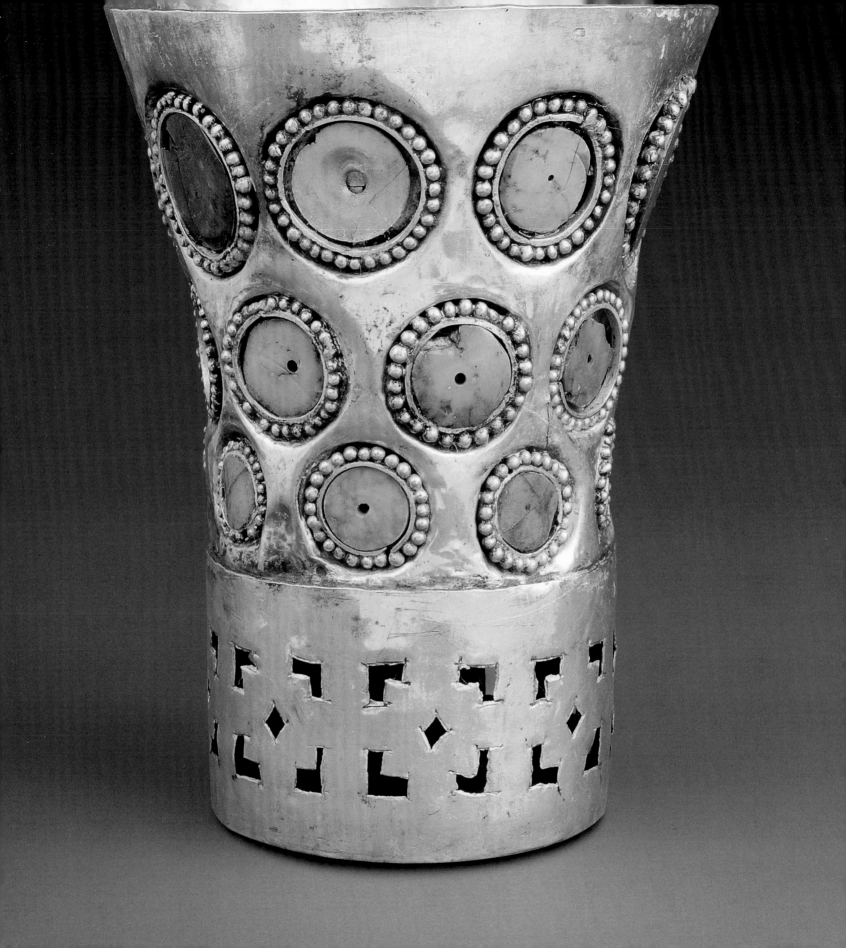

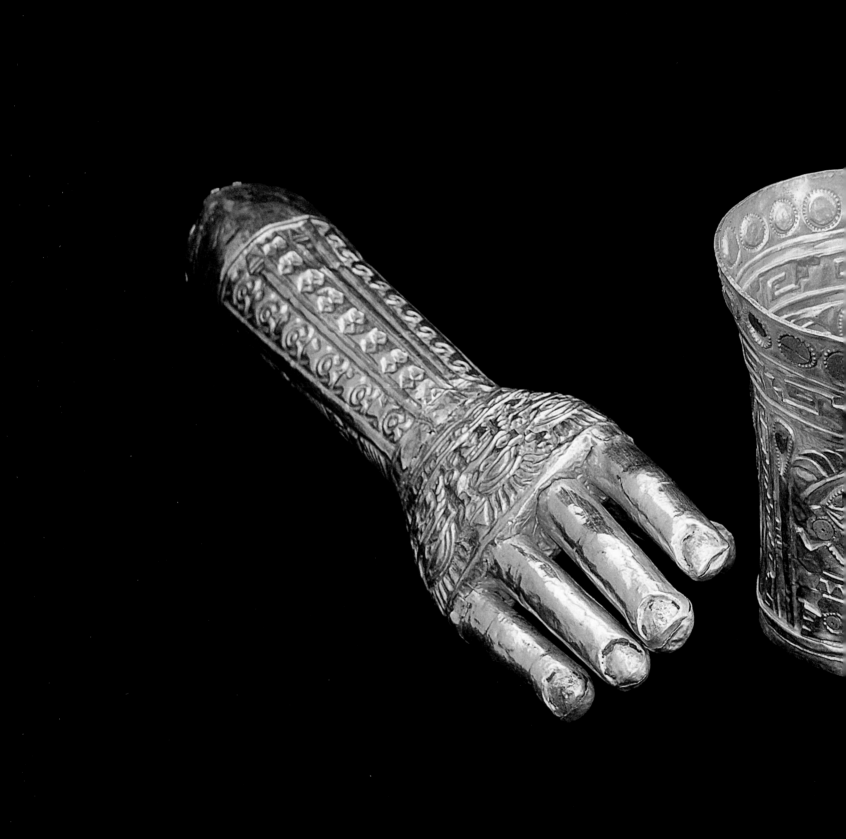

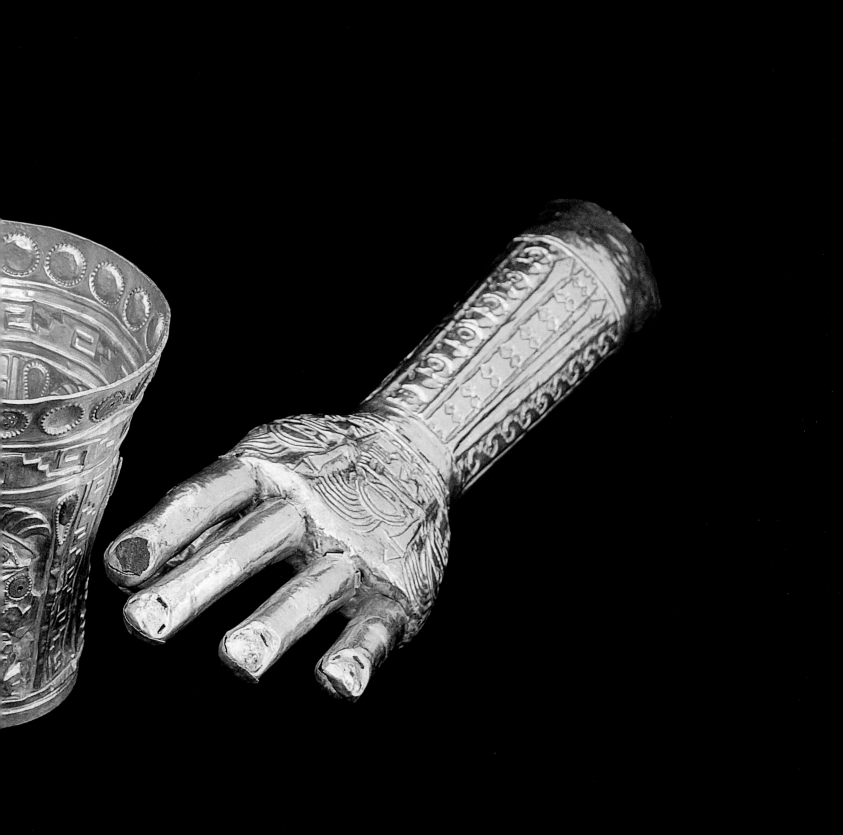

BETWEEN COLONIAL ART
AND VICEREGAL ART

Ethnicity, Religiosity, and Iconographic Innovation in Painting under the Viceroyalty

Luis Eduardo Wuffarden

Schools of painting became firmly established in Peru during the last third of the seventeenth century. Many mestizo, indigenous, and Creole artists were trained entirely in Peru. It was not by chance that these native painters, and their guilds and workshops, achieved fame and recognition at a time of consolidation of the viceregal society and its various ethnic groups.[1] Hence the close relationship that developed between painting and burgeoning Creole patriotism that resulted in the "Inca renaissance," a cultural movement actively promoted by the indigenous elites of the Southern Andes (Rowe 1951; Gisbert 1980; Majluf 2005). From then on, pride in one's locality would be expressed in painting in the form of religious subjects that reflected the firm implantation of Catholicism on American soil and the growing prestige of the first saintly figures born in the New World.

At the same time, the splendor of the great colonial cities fired the Creole imagination, and they became a prominent subject in art (Kagan 1998; Wuffarden 1999a). From about 1630, conventual writers had begun to produce works celebrating city life, but the subsequent proliferation of paintings and engravings depicting both realistic and allegorical urban scenes, and the portrayal of American saints and local acts of devotion, was good evidence of the adoption and dissemination of those ideas. In a process that was both subtle and effective, the visual arts gave a wider public access to expressions of "Creolist" arguments that

highlighted local achievements and claimed privileged positions within colonial society.

As might be foreseen, depictions of the local environment began to be produced in Lima at the same time that a more naturalistic art arrived in Peru from Andalusia. Artists in Cuzco quickly and creatively adopted that style, painting scenes of processions and public ceremonies. A typical example is the Corpus Christi series that an anonymous, probably indigenous group of painters painted for the parish of Santa Ana, under the patronage of the celebrated Bishop Mollinedo, from about 1673 to 1675. Its subtle, complex iconographic program successfully combined panoramic urban views with individual and group portraits, religious allegory, and political themes. The influence of this crucial cycle is clearly visible in its eighteenth-century successors, such as the one held by the Museo Pedro de Osma, in which any sense of individual identity is lost in a swarming multitude of nameless figures (cat. 148). Most of them are works of a markedly *costumbrista* character, smaller in size and covered in the rich *brocateado*, or gilding, favored in the region.

Favorite Genres

Among the religious genres in greatest demand were "images of piety," whose precious, affected style marks them out in the context of Andean painting. They usually show Christ, the Virgin, Saint Joseph, and other central figures of the Gospel story in the foreground, without a narrative

context, reflecting the gaze back towards the viewer in order to encourage private contemplation. The figures are placed against dark or neutral backgrounds, surrounded by delicate borders of flowers, derived from Flemish baroque. In addition to a usually refined, highly detailed facture, local artists emphasized the striking iconic effect of these works by the use of gold leaf, especially on the clothing.

Within that style we often find subjects connected with the childhood of Jesus or the Virgin Mary. For example, *Young Virgin Spinning* (cat. 149) and *Child of the Thorn* (cat. 150) are both apparently based on passages from the Apocrypha. The two subjects were almost always painted as a pair and were often hung in the communal areas of convents of nuns. The little Virgin spinning sometimes wears a wedding ring on her left hand, which may be a reference to the shared ideals of industriousness and commitment to spiritual marriage with Christ that governed the life of those communities.[2]

Another important category was that of "painted sculptures," which were an effective means of disseminating more widely the most venerated Marian images. They are "veristic" representations of venerated statues and therefore usually appear housed in altarpieces or side chapels, framed in heavy curtains, as the effigy would appear to devotees and pilgrims on high days and holidays. They are covered by rich mantles in conical shape, and glitter with the heavy jewels placed on them as offerings by parishioners, since these were statues "for

147. Anonymous, *The Child Jesus Wearing the Imperial Inca Crown and the Robes of a Catholic Priest*, first half of the 18th century

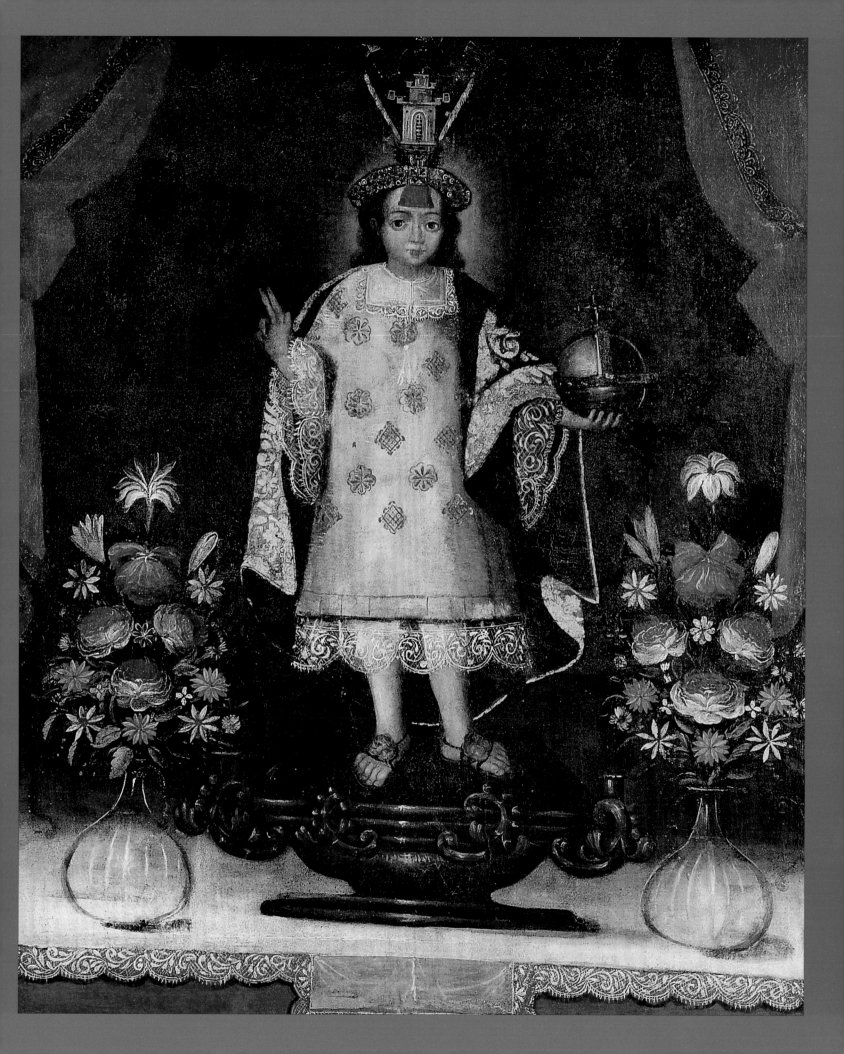

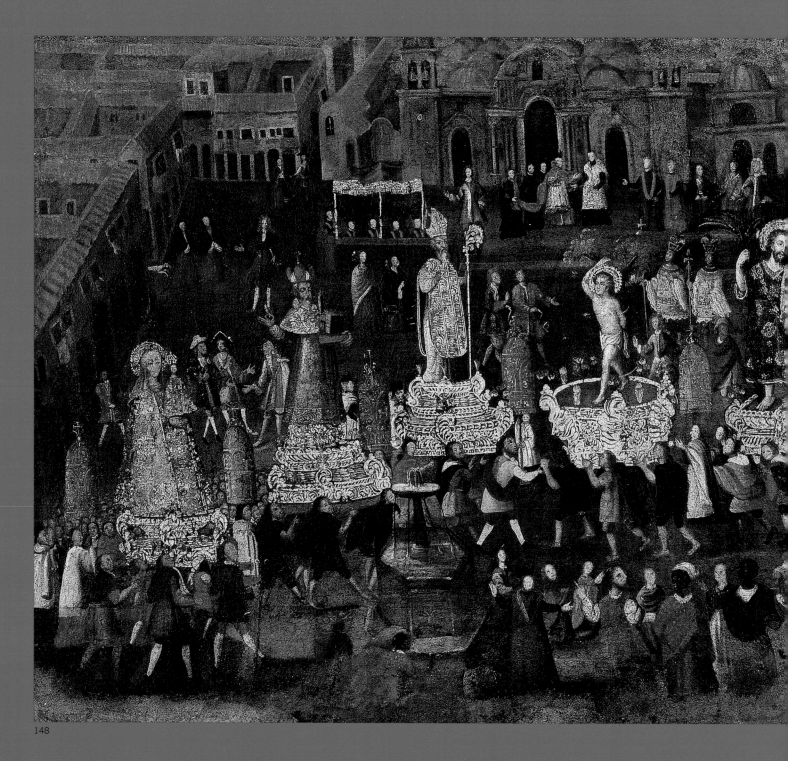

148

148.
148.
ANONYMOUS
CORPUS CHRISTI PROCESSION
About 1740

The feast of Corpus Christi, which celebrates the triumph of the Eucharist over heresy, was the most important in the colonial liturgical calendar. In the Andes it happened to coincide with the celebration of the *Inti Raymi,* an Inca festival celebrated at the summer solstice, dedicated to the Sun god. Many features of pre-Hispanic festivals, such as dancing, costumes, and music, also formed part of this Catholic ritual, which gave rise to a set of disparate emotional responses and cultural tensions around issues of appropriation and domination.

This canvas, probably executed in the early decades of the eighteenth century, does not have the idealistic quality of the famous series of paintings on the theme of Corpus Christi painted for the parish of Santa Ana. On the contrary, it presents itself as a much more realistic image. The painter has chosen to give us a snapshot of the preparations for the *fiesta,* with the

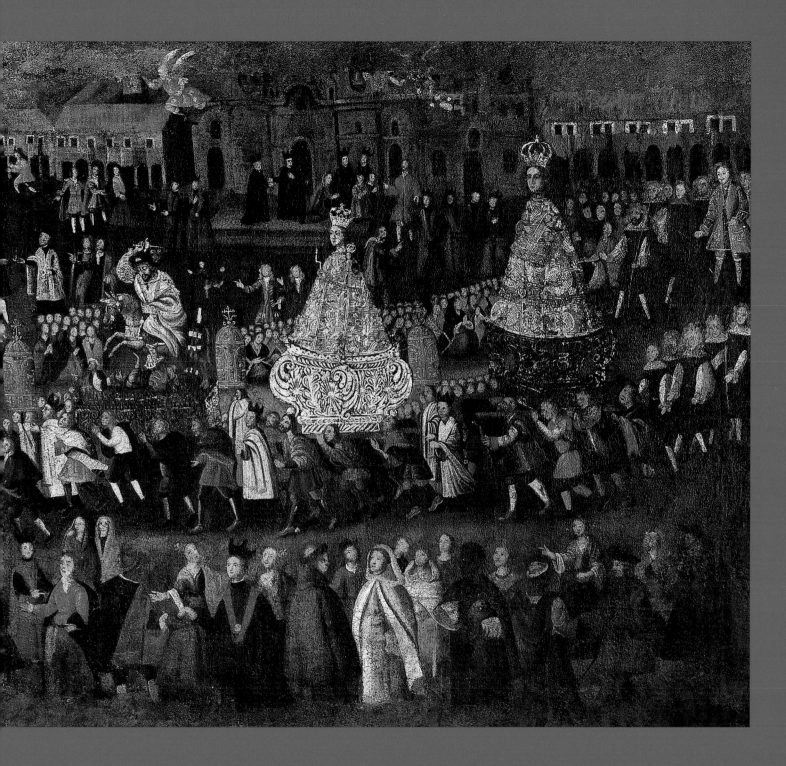

arrival, carried shoulder-high, of the effigies of the patron saints of Cuzco's parishes, as well as the excited crowds flocking to the *plaza mayor*.

The artist was concerned to show Cuzco's multiethnic character, offering us an image of a heterogeneous society consisting of whites, mestizos, blacks and Indians. In the central area of the painting we also see two *caciques*, wearing the royal vestments of the Inca: the *uncu* (tunic) with the *tocapu* and a solar disc on the breast, and the *mascaipacha* (the imperial headdress). The wearing of royal vestments by local elites was a way of keeping alive the memory of the Inca Empire during the colonial period.

Lastly, it is important to note the distorted view of the *plaza mayor* presented by the artist. By reducing one of the sides of the square, the painter has been able to place in the background, in equal size, the Cathedral of Cuzco (on the left) and the Jesuit Church (on the right). Aside from the possible appreciation of the painter for the Jesuits, this image of the city, which forced the apparition within the scene of the Jesuit church, may suggest the tensions that existed between the secular clergy and the Society of Jesus.

S.F.

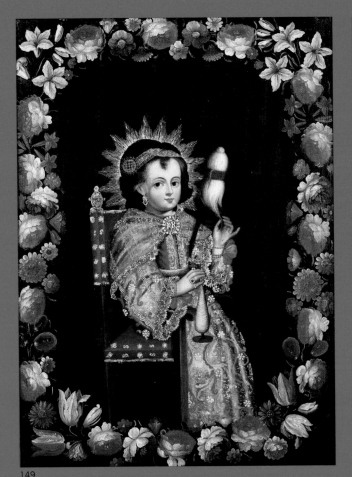

149

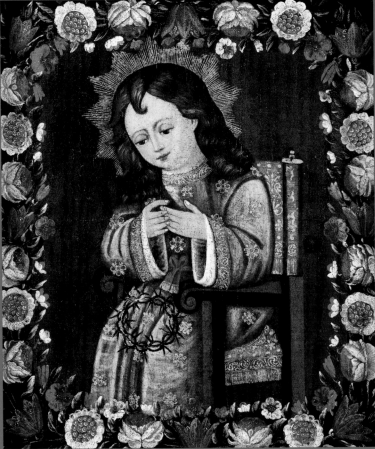

150

149.
ANONYMOUS
YOUNG VIRGIN SPINNING
Second third of the 18th century

The iconography of the *Young Virgin Spinning* is based on a number of passages in the apocryphal gospel of Pseudo-Matthew, in particular on those that describe Mary's everyday activities in the temple, where she devoted a third of her day to spinning and weaving. That subject, a symbolic representation of the Virgin's virtuous way of life, was very popular in enclosed convents, where the nuns also devoted themselves to weaving, among other activities.

The subject of the *Young Virgin Spinning* occurs frequently in European iconography from the Middle Ages to the present day. In the early seventeenth century, the Spanish painters Juan de Roelas (1560–1625) and

Pedro Núñez Villavicencio (1640–1695) established new conventions that provided the basis for images produced later in Peru. Furthermore, historical sources have paid special attention to the symbolic importance that this subject acquires in an Andean cultural context. It is reasonable to assume that from the reception of the works a connection can be made between these images and the tradition surrounding the figure of the *aclla* ("chosen virgins" or "virgins of the Sun"). Under the Inca Empire the *acllas* were confined to the temple (*aclla huasi*), spending most of their time weaving fine garments for use by the Inca and in religious ceremonies.

The painting is enhanced by rich *brocateado* (gold-leaf overlay), covering her robe with floral motifs and highlighting her jewels, her halo, and her brooch with an anagram of the name María. A floral border, executed with great care and naturalism, is reminiscent of the work of Flemish painters, for example Jan Brueghel ("Velvet Brueghel," 1568–1625), or Daniel Seghers (1590–1661). That way of decorating iconic images with beautiful garlands of flowers was characteristic of Andean colonial art.

S.F.

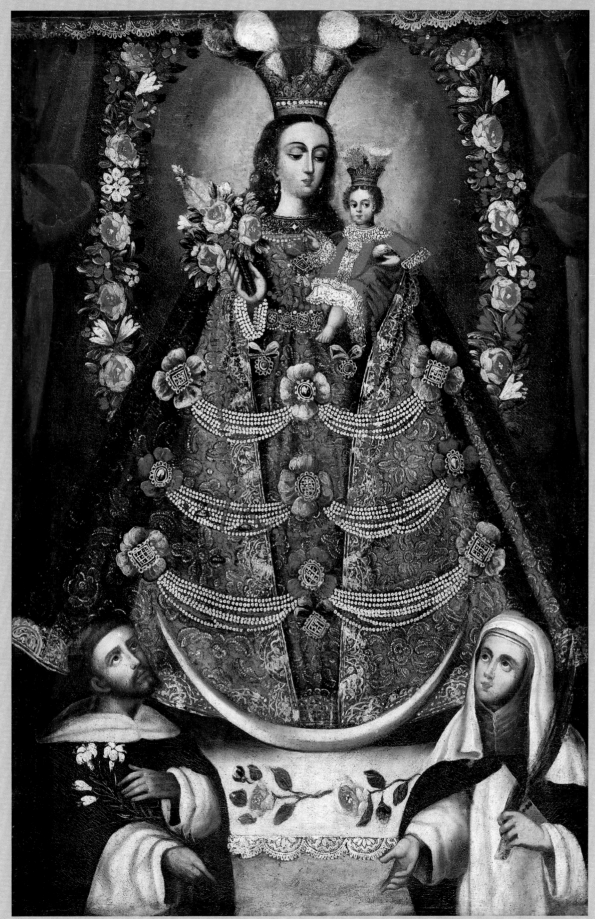

151

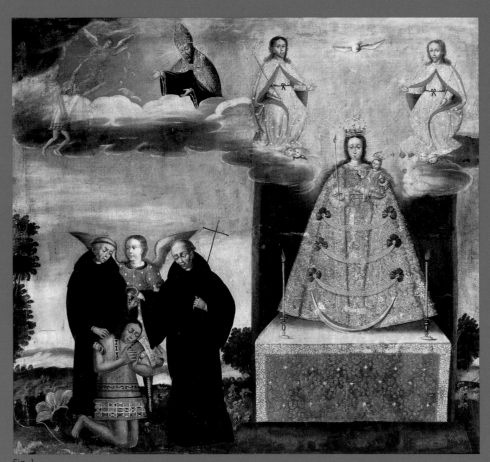

Fig. 1
Anonymous
*Two Augustinian Friars
Baptizing an Inca Noble*
Late 17th century
Ignacio Prado Pastor,
Lima

Fig. 1

152.
ANONYMOUS
VIRGIN OF COCHARCAS
18th century

In the Americas, the different names of the Virgin Mary that had originated in Spain acquired new identities that met the particular devotional needs and circumstances of each region. For example, the Virgin of Cocharcas was based on the famous Virgin of Copacabana (Bolivia), which in turn was a regional transformation of the Virgin of the Candelaria.

The legend recounts that because of the miraculous favors he had received from the Virgin of Copacabana, an Indian from Cocharcas, Sebastián Quimichi, had a copy made of that image, so that he could take it back to his birthplace. Once it arrived at Cocharcas, the image of the Virgin began to work countless miracles for those who venerated it. These miraculous interventions

by the Virgin of Cocharcas won her great popularity and veneration throughout the Viceroyalty, and the image and its sanctuary became one of the most important places of pilgrimage in the Andes.

The various paintings depicting the Virgin of Cocharcas are only one indication of her undisputed fame and devotional importance. Almost all of them, like the canvas shown here, have in their center a colossal representation of the Virgin and Child, wearing a triangular mantle with floral motifs, standing on a pedestal under a canopy decorated with silver bells. In other words, it is a representation of an effigy of the Virgin, of the material object through which the divine is channeled.

Without a doubt, the most interesting feature of these paintings is the topographi-

cal representation of the *pueblo* of Cocharcas, its church (where the image was kept), and the mountainous countryside of the region, with the road from Ayacucho and the Rio Pampas that runs through the valley. This area was traveled and settled by the many pilgrims who used to come from every direction to venerate the miraculous image of the Virgin. The topographical representation of the landscape in relation to the divine is evidence of the Christianization of Andean sacred space, formerly made up of *huacas* (natural features with religious significance or the locus of a divinity) and pre-Hispanic places of worship.

S.F.

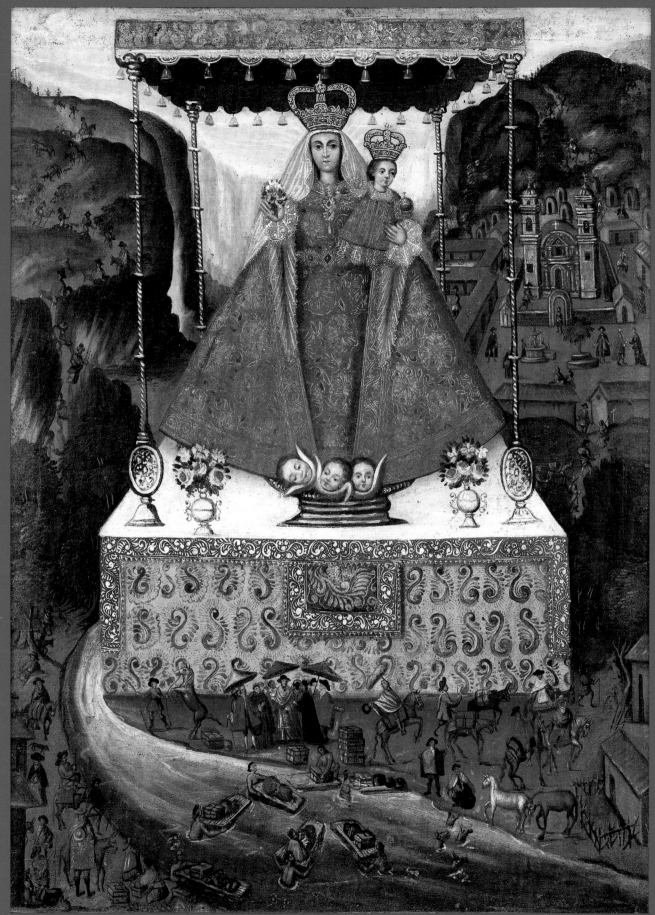

153.
ATTRIBUTED TO BERNARDO LEGARDA
VIRGIN OF THE FIFTH SEAL
About 1740

This image of the Blessed Virgin Mary is in the tradition in which she is identified with the Woman of the Apocalypse, who had the attributes described in the account of Saint John's vision on the island of Patmos: a crown of twelve stars, a half-moon, and the Serpent of the Apocalypse beneath her feet, all symbols of the triumph of the Church and its doctrine. She is sometimes represented wearing the eagles' wings with which the Woman of the Apocalypse was endowed in order to flee from the beast with seven heads. The image of the winged Woman of the Apocalypse was disseminated in the Americas via European engravings such as those by Juan de Jáuregui, published in 1614. While images of winged Virgins gained popularity in the New World, its use significantly decreased in Europe.

Bernardo de Legarda was chiefly responsible for bringing that tradition into the realm of sculpture and certainly for popularizing it in artistic circles in Quito. The Virgin made by Legarda in 1734 for the convent of San Francisco (the only work he signed with his name) soon became the model for innumerable versions of the subject. The localist character and regional success of these works meant that they are known under the name *Virgin of Quito*. The sculpture illustrated here retains much of the elegance of Legarda's works, including the graceful posture of the body and the hands, which has led critics to see these Virgins as true dancers. The same should be said of the sweetness of the Virgin's face and its porcelain-like quality. At the same time, this work should only be attributed to Legarda's workshop with a degree of caution. A characteristic feature of these Virgins is the use of pieces of silver on their wings, crowns, and halos.

We should also mention the theory put forward by Constanza Di Capua (2002), who suggests a possible use of these images by the Franciscan order as a tool in the struggle against idolatry. Making an allusion to the myth of Atahualpa's return to Quito in the form of an *amaru* (serpent), the Virgin of the Apocalypse is presented here as an image that expresses triumph over pre-Hispanic forms of worship that were always liable to return.

S.F.

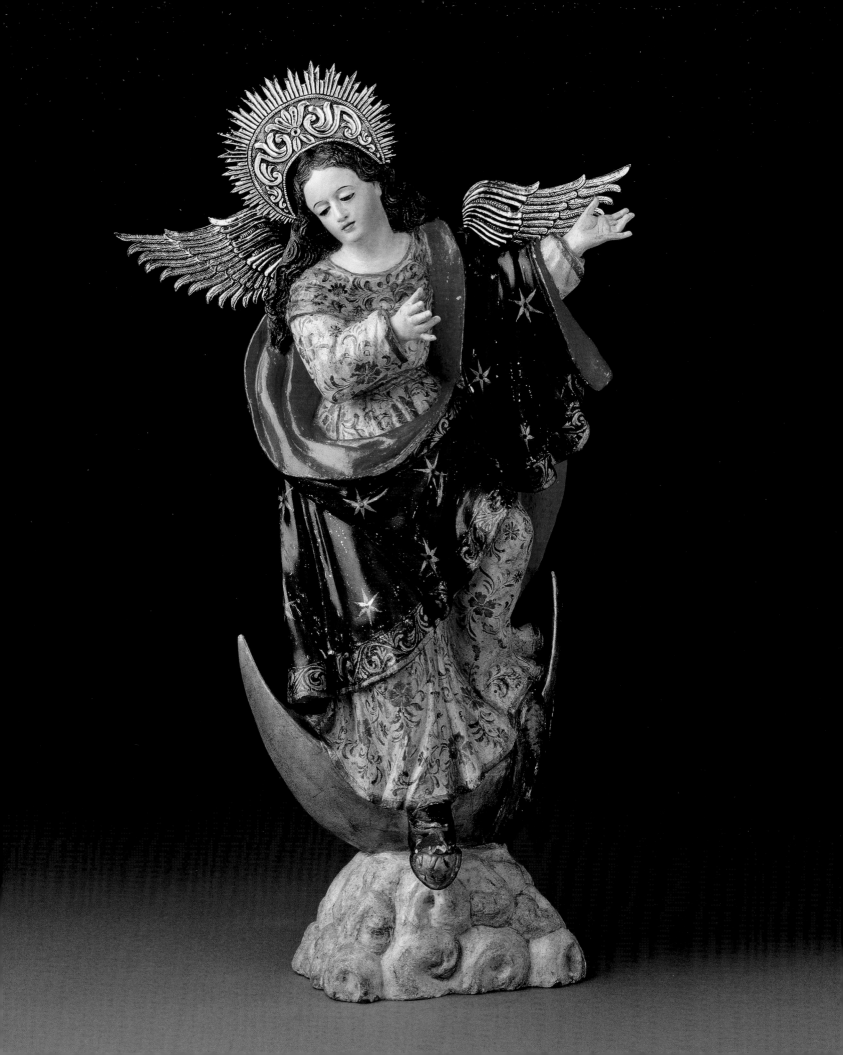

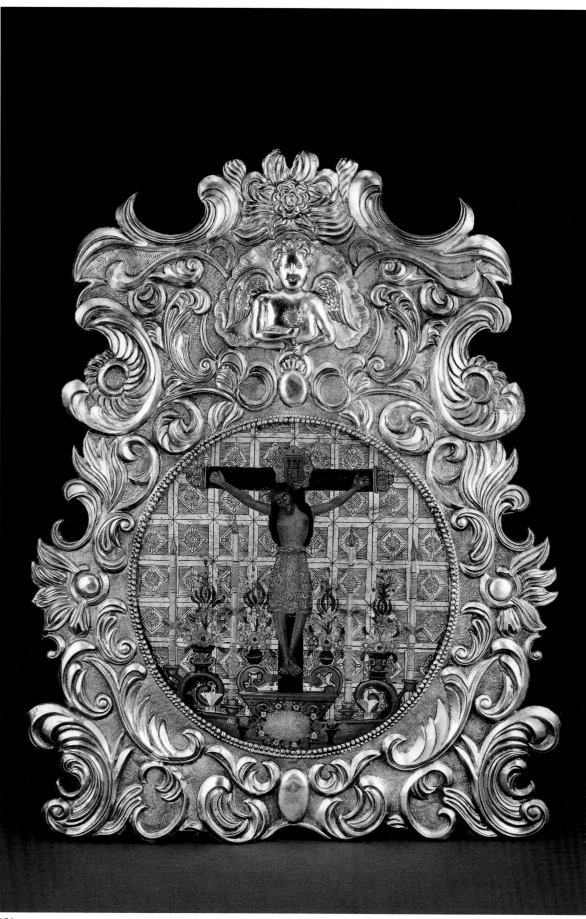

154.
Anonymous
Lord of the Earthquakes
18th century

155.
Anonymous
Lord of the Earthquakes
18th century

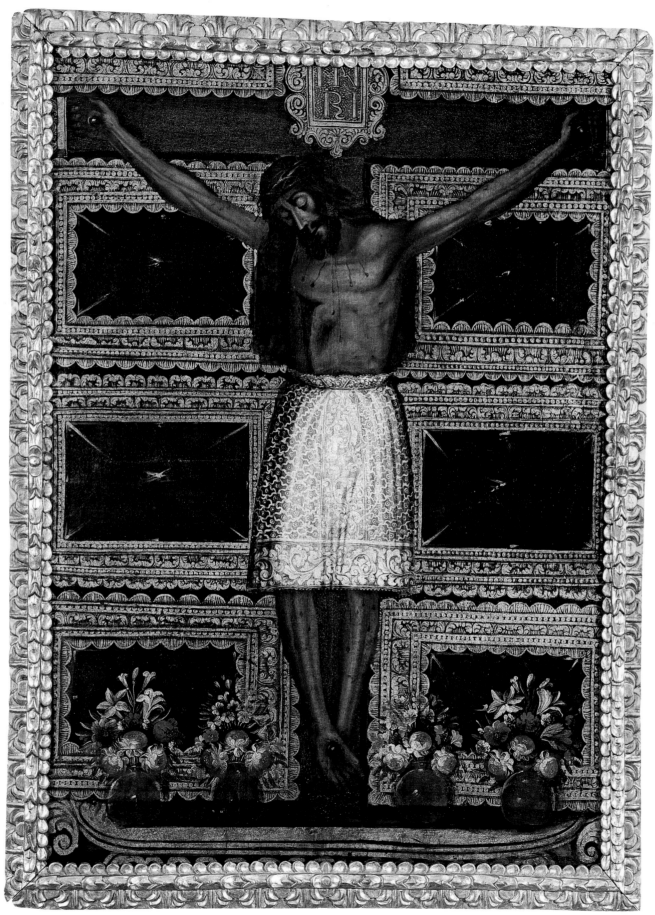

dressing." The painted versions did not omit details such as pedestals, lighted candles, and vases of flowers. At the same time, the pictorial treatment and the gilding flatten their spatial quality and give the statue a majestic frontality.

In that way, spectators in those days could become familiar with the devotional cults of more distant places, the attributes of each dedication making them easily distinguishable. For example, the *Virgin of the Rosary of Pomata* (cat. 151) wore a royal crown or papal miter, decorated with colored feathers that evoke ancient local traditions. *Virgin of Cocharcas* (cat. 152), a copy of the *Virgin of Copacabana*, and her rival, was shown under a canopy, surrounded by tiny scenes depicting miracles and pilgrimages. A narrative composition unusually emphasizes the relationship of the *Virgin of Copacabana* with the process of evangelization on the Altiplano. In front of her altar we see a pair of the Augustinian friars responsible for her cult baptizing an indigenous *curaca*, marking his conversion to the Catholic faith (fig. 1). The new religious fervor was thus attributed to the miraculous sculpture, the work of a native sculptor, replacing an ancient pre-Hispanic cult.

Of all the sculptural images of Christ transferred to canvas, the most popular was the *Lord of the Earthquakes*, patron saint of Cuzco (cats. 154, 155). Veneration of this ancient figure of Christ Crucified (made by an anonymous indigenous craftsman in imitation of the *Christ of Burgos*) gained force as a result of the great earthquake of 1650 and again following the terrible plague of 1719. Innumerable painted versions recreate the archaized figure of Christ, above his altar or on his processional litter, with the flowers and candles with which he is always accompanied. In the eighteenth century, images of the "Taitacha de los Temblores"[3] acquired their local associations at precisely the time when strong regional identities were beginning to emerge.

Iconographic Innovations

When evangelization and the administrative system of the Viceroyalty had become settled realities, the colonial Church authorities began to show even greater openness to local expectations. They tried in that way to attract the indigenous population through persuasion, leaving behind the repressive phase of "extirpation of idolatries." That policy would result in a series of motifs borrowed from medieval art, recreations of European baroque iconography or genuine local innovations that reflected the diverse expressions of religious devotion characteristic of the colonial world. This explains the proliferation of sacred representations that appear to be heterodox, such as the Trinity embodied in three equal persons or a "three-faced" version of it (cat. 156). They enabled people to approach the complexity of this mystery of Christian theology through images that had formerly been proscribed by the European Church (Gisbert 1980, 88–90; Koninklijk Museum voor Schone Kunsten 1992, no. 240; Stastny 1993, 16–18; Gutiérrez de Ceballos 1999; Mujica Pinilla 2002).

The *Defense of the Eucharist* is both a religious and political allegory, created in Cuzco under the influence of Bishop Manuel de Mollinedo (1673–1699), that strongly persisted until the early nineteenth century. It depicts the king of Spain, sword in hand, preventing the monstrance, standing on a column, from being pulled down by a group of Saracens. The Andean ecclesiastical authorities were thus sending a subtle but effective warning to those who might not accept the truths of the faith, and were at the same time demanding loyalty to the Spanish crown, the armed branch of Catholicism. To make it more effective, the *Defense of the Eucharist* was sometimes "Peruvianized" by adding Santa Rosa de Lima—the first saint born in the Americas—as support of the monstrance, thus symbolizing the emergent role of Creole society within the Spanish empire and the universal Christianity (cat. 158).

The hosts of angels and archangels armed with arquebuses were also a clearly local contribution to religious iconography. In contrast with their European counterparts, who appear armed like ancient Romans, these winged Andean figures carry firearms and are dressed like the royal guards of the day (cat. 159). It is said that artists in Cuzco may have turned to Flemish prints illustrating treatises on the use of the arquebus in order to learn how the weapon was held and carried (Gheyn 1607). Wearing big plumed hats and the splendid military attire then in fashion, the Cuzco archangels strike the poses in which to handle their weapon as if they were performing an elaborate ritual. In addition to this, these depictions frequently included apocryphal names, based on medieval traditions concerning angels.

According to some writers, this innovative motif owed its success largely to the impact since the Conquest of firearms, which indigenous peoples identified with *Illapa* or the thunder god (Mujica Pinilla 1992, 168–171; Statsny 1976). The Jesuit José de Arriaga suggested this in 1621, when he remarked that the Indians called "arquebuses [...] *Illapa* or lightning" (Arriaga 1999 [1621], 27). In this respect it is interesting to note that *Illapa* is also symbolically identified with Saint James the Apostle, who was said to appear, miraculously, in the company of the Virgin Mary (fig. 2, p. 177), in a number of decisive battles, helping the Spaniards overcome resistance by the indigenous population (Alcalá 1999). That explains the popularity in the Andes of the traditional subject of Saint James "Matamoros," or "Moorslayer" (cat. 161), and why it is occasionally changed to "Mataindios," or "Indian slayer" (fig. 3, p. 177), referring to the legendary miraculous assistance the Conquistadors received from the Apostle in defeating the rebel Inca troops of Manco II, who were crushed or routed.

The "Inca Renaissance"

In a social environment in which artistic images were unusually important, the "Inca renaissance," led by the Inca nobility and some of the religious orders, was one of the fundamental elements of urban culture in the Andes. From the last third of the seventeenth century until the rebellion of the *curaca* Túpac Amaru II[4] and his catastrophic defeat in 1781, the aspirations of a powerful indigenous aristocracy eager to enlarge its privileged space within colonial society were expressed in a multitude of decorative, dramatic, and pictorial works. Influenced by the idealized vision of the *Tahuantinsuyu*, or Inca Empire, found in the *Comentarios Reales*

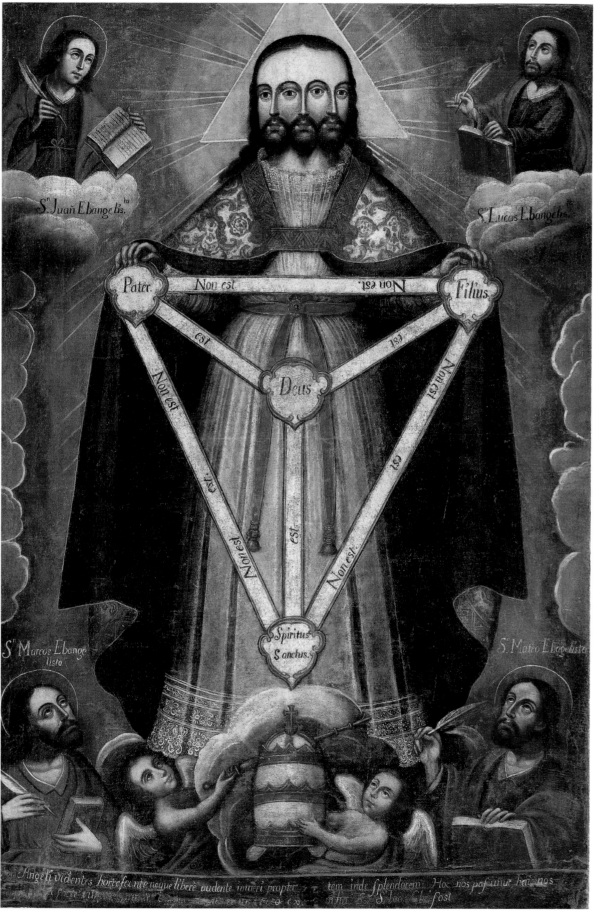

156

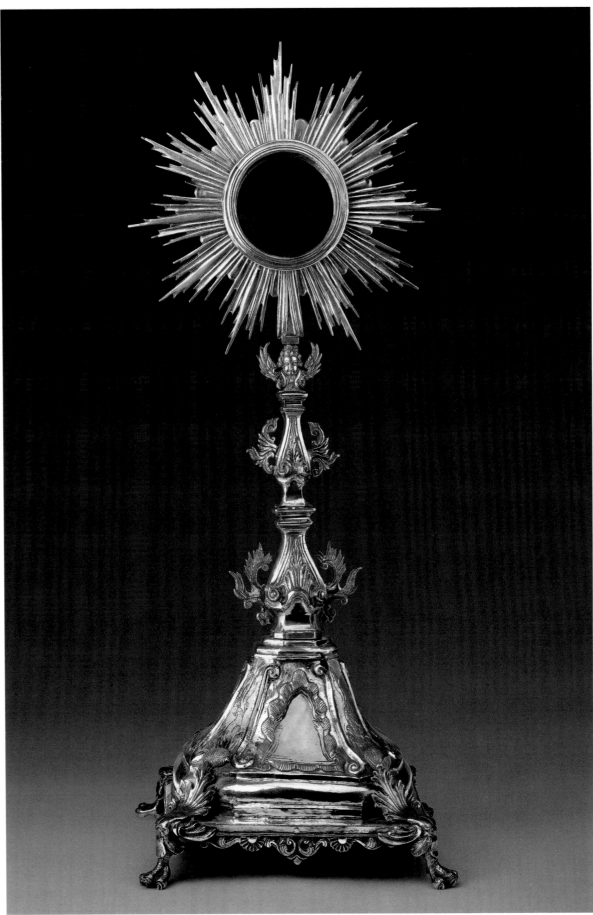

157.
Anonymous
Monstrance
1770–1780

158.
Anonymous
*Defense of the Eucharist
with Saint Rose of Lima*
About 1675–1685

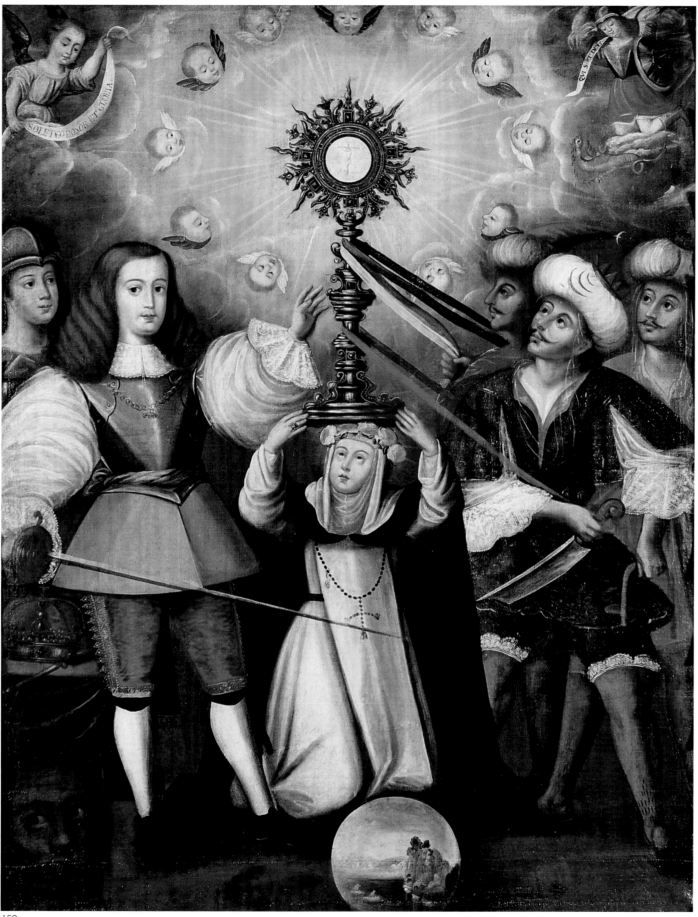

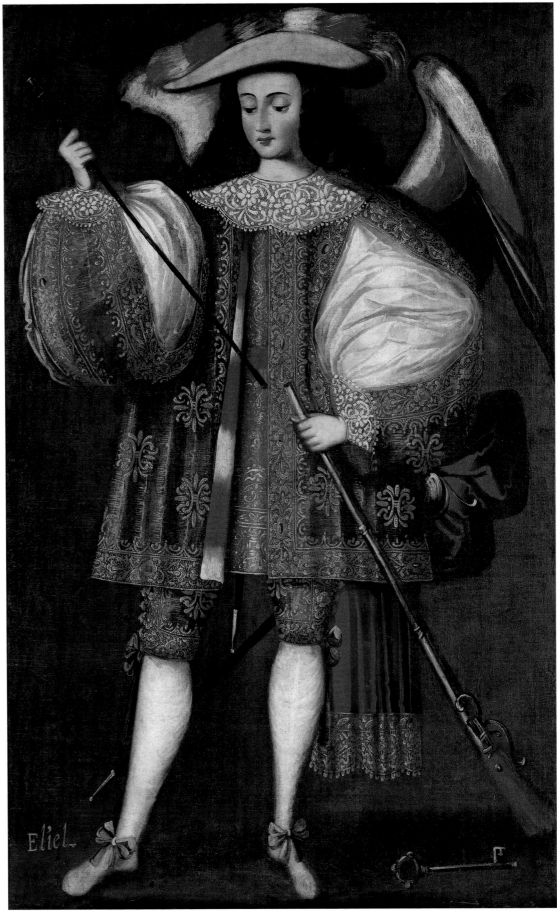

159

159.
Anonymous
Archangel Eliel
with Harquebus
About 1690–1720

160.
Anonymous
Archangel Michael
Triumphant
17th century

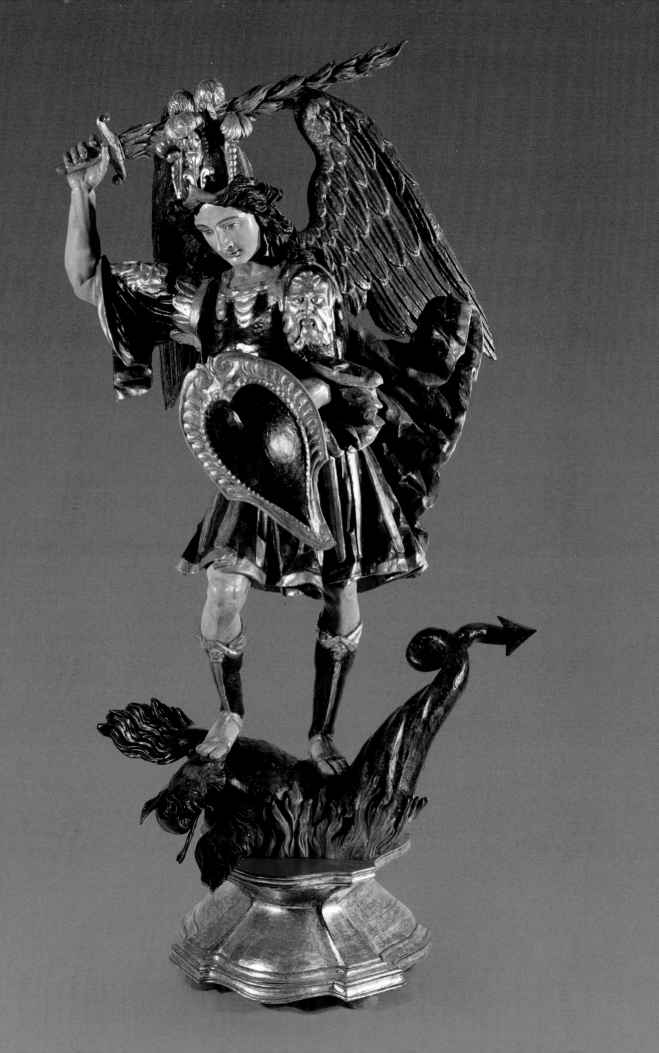

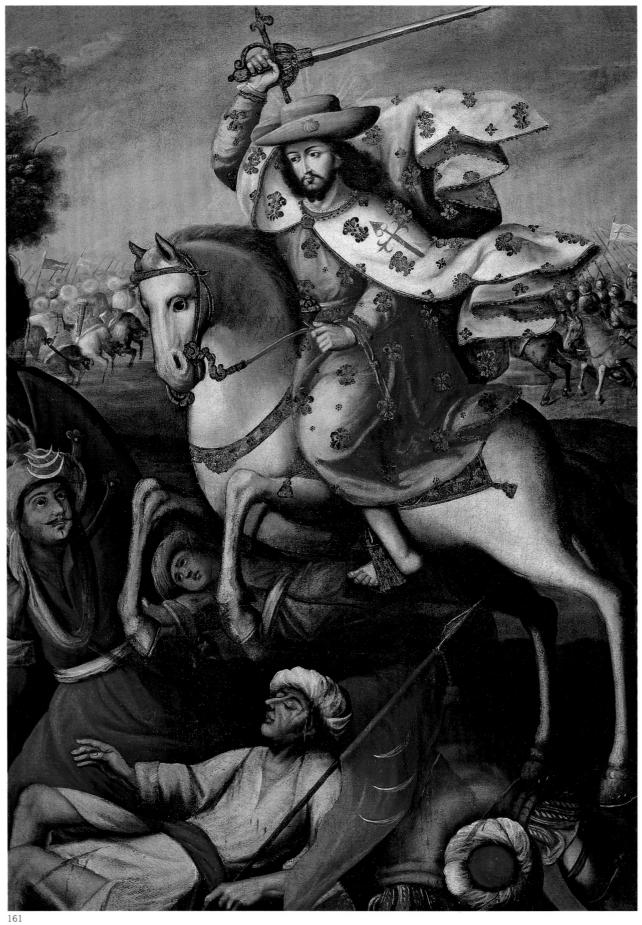

161

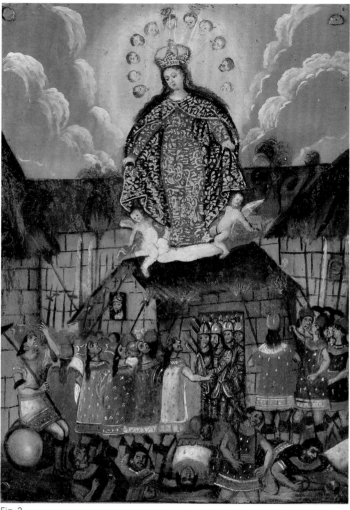

Fig. 2

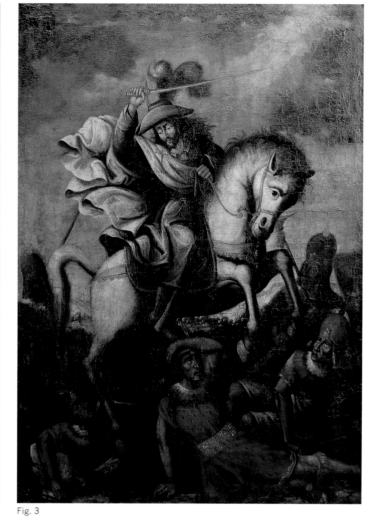

Fig. 3

161.
Anonymous
*Saint James
the Moorslayer*
18th century

Fig. 2
Anonymous
The Virgin of Sunturhuasi
18th century
Colección Barbosa-Stern,
Lima

Fig. 3
Anonymous
*Saint James the Indian
Slayer*
18th century (partially
repainted 19th century)
Museo de Arte del Sur
Andino, Urubamba,
Cusco

162.
Anonymous
*The Rest on the Flight
into Egypt*
About 1750

163.
Anonymous
The Adoration of the Magi
18th century (?)

164.
Anonymous
Saint Agnes
1650–1720

165.
Anonymous
The Last Supper
n.d.

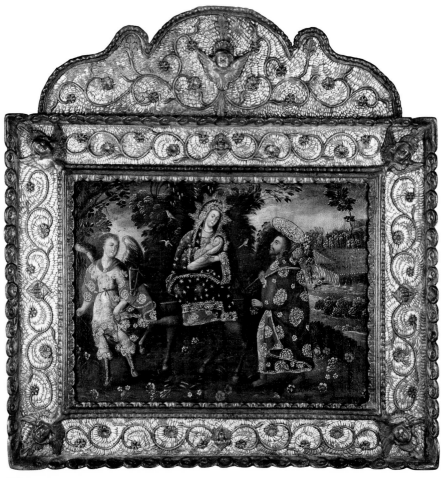

162

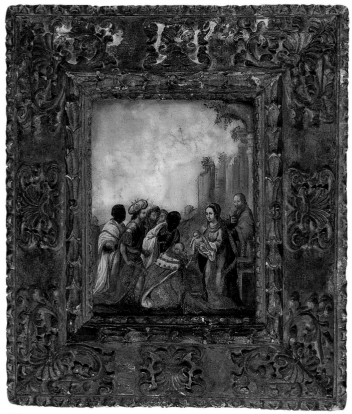

163

164

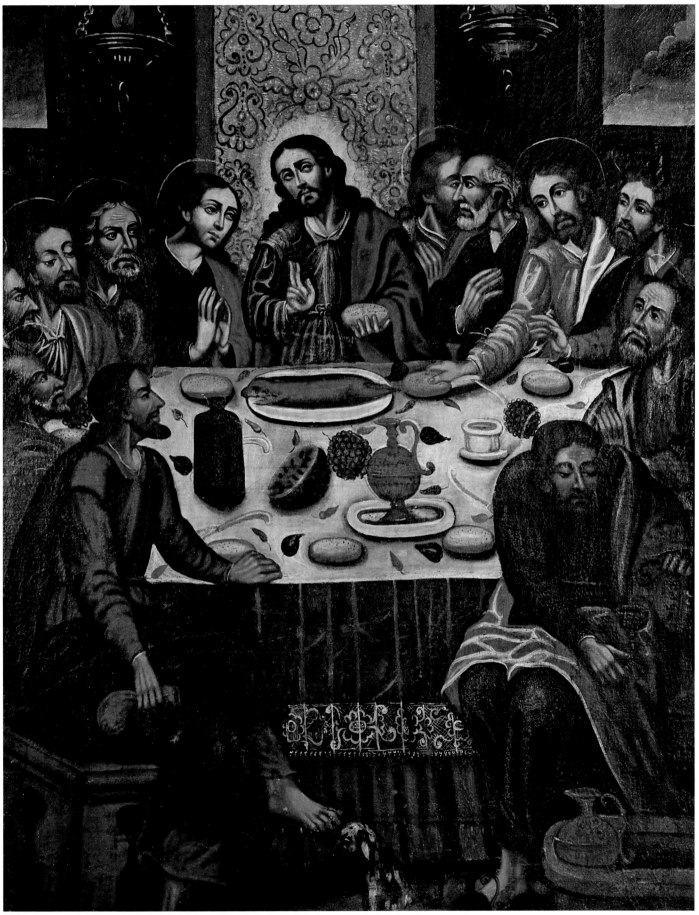

165

166.
ANONYMOUS
NATIVITY CHEST
18th century

This chest depicts a large number of scenes connected with the Nativity. Those most easily identified include an Annunciation scene, one showing Paradise, with Adam and Eve in the foreground, the Nativity in the middle at the back, and the visit of the Three Kings and the circumcision of Jesus in the upper corners. Other subjects include Joseph's Dream, the Presentation in the Temple, the Flight into Egypt, the Massacre of the Innocents, Christ among the Doctors, and the Baptism of Christ. All these scenes from the gospels are shown in a familiar setting, a town with its plaza and fountain, balconies and porticoes, and even its green hills in the background. The figures are also dressed in the styles of eighteenth-century colonial Peru. It is interesting to note that the figures and the decor are partly modeled in pieces of maguey (*agave americana*); the artist or artists who made this piece have thus used a local material to depict the Catholic subjects brought by the Spanish Conquistadors.

The virtuosity required to make this chest expresses itself in, for example, the way in which its three-dimensional parts fit together perfectly when it is closed. The ability to close the chest has the effect of associating it with the tradition of portable altaras that the Catholic missionaries took with them to Amerindian villages as teaching aids in religious instruction. However, the size of the chest shown here, which is over one meter wide, probably means that it was not often transported. But it seems clear that it was used to support Catholic teaching. It is, in fact, a kind of illustrated catechism, reflecting the power of the image in Andean faith, as well as the fact that many people were unable to read or even to understand Latin or Spanish.

E.H.

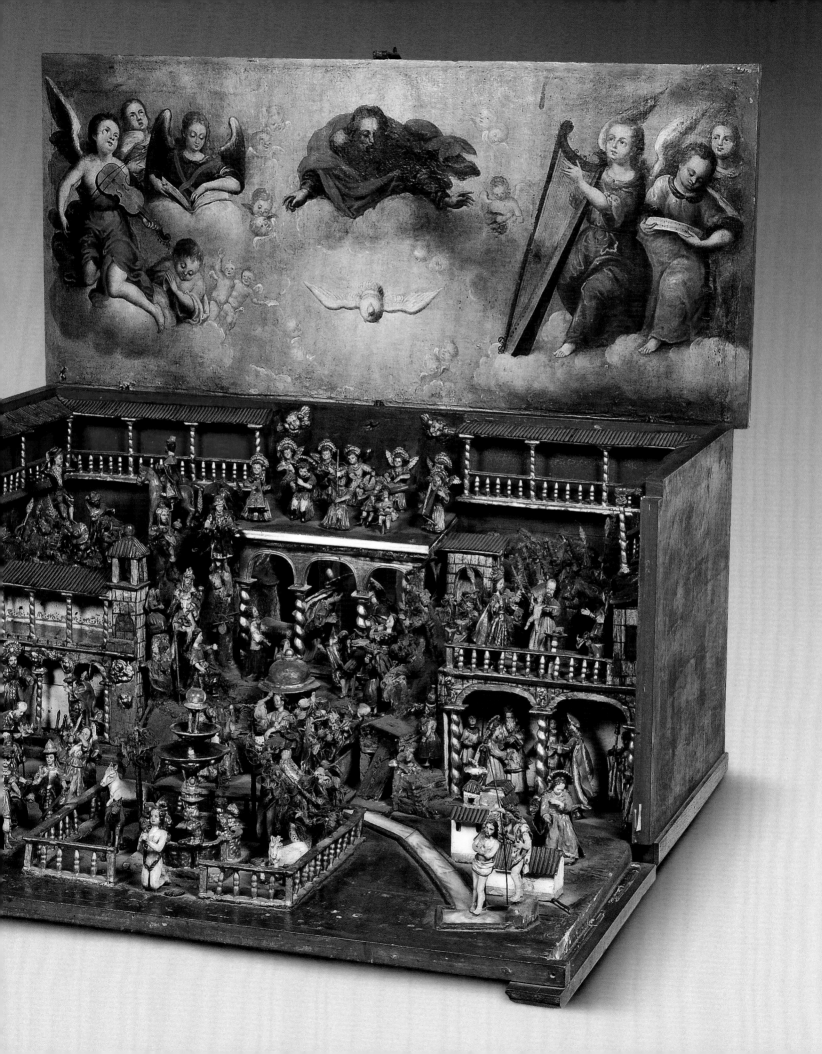

167

168

169

170

167.
Garcilaso de la Vega
*Primera parte de los
commentarios reales
[First Part of the Royal
Commentaries]*
Pedro Crasbeeck, Lisboa,
1609

168.
Garcilaso de la Vega
*Histoire des Yncas,
rois du Pérou
[History of the Inca,
Kings of Peru]*
Jean Frederic Bernard,
Amsterdam, 1737

169.
Theodore de Bry
and Girolamo Benzoni
*Americae pars sexta
[America Part Six]*
Theodor de Bry,
Frankfurt, 1596

170.
George Juan
and Antoine de Ulloa
*Voyage historique de
l'Amérique méridionale fait
par ordre du roi d'Espagne
[Historic Trips to South
America Done by Order
of the King of Spain]*
Arkstee & Merkus,
Amsterdam-Leipzig, 1752
1752

171.
ANONYMOUS
***UNION OF THE IMPERIAL INCA
DESCENDANTS WITH THE HOUSES
OF LOYOLA AND BORGIA***
1718

Two marriages are commemorated in this painting. The first is that of Captain Martín García de Loyola, prominent in overcoming in 1572 the Inca rebellion and resistance at Vilcabamba and grand nephew of Saint Ignatius Loyola (founder of the Jesuit Order), and the *ñusta* Beatriz Clara Coya, daughter of the last *Sapa Inca* recognized by the colonial administration, Sayri Tupac, in other words, the only direct descendant of the Inca dynasty. Setting aside any doubts that might be raised by the genealogical information provided in the cartouche of this canvas, the second marriage ceremony represented here is accepted as being that between the daughter of Martín and Beatriz, Ana María Lorenza de Loyola and Juan Henríquez de Borja, great-grandson of another Jesuit saint, Saint Francis Borgia.

Many copies of this subject were made and distributed to various parts of the Viceroyalty. Through these paintings the Jesuits of Peru were representing themselves as the inheritors and custodians of Inca dynastic tradition. A political alliance was thus created between the Society of Jesus and the Inca nobility, an alliance with a theocratic flavor, based on consanguineous marriages between the most distinguished members of the order and the Inca dynasty.

The *ñusta* Beatriz wears Inca-style clothing appropriate for a woman of her rank. Both her *lliclla* (a mantle worn over the shoulders) and her *acsu* (robe) are decorated with *tocapu* (geometrical motifs that may have served as mnemonic devices). Her half-open *acsu* reveals the Spanish fashions Beatriz is wearing under her Inca garments, reaffirming her dual ethnicity.

Reference has been made to the wealth of decoration in the marriage painting exhibited here. It can be seen in the use of *brocateado* (gold-leaf overlay) on the figures' clothing, and on the royal Inca insignia and weapons of the group made up of Beatriz's family members: her parents, Sayri Túpac and Cusi Huarcay, and her uncle, Túpac Amaru.

S.F.

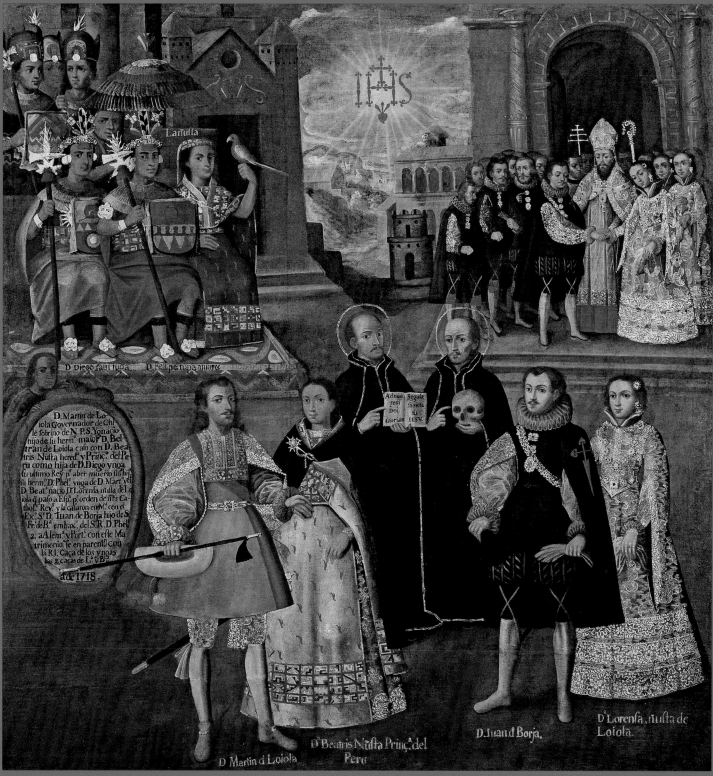

171

of the Inca Garcilaso de la Vega (cat. 167), of which a second edition was published in 1723, the successors of the Inca constantly sponsored fantasizing recreations of the imperial past, following baroque rhetoric.

As educators of the indigenous elite, the Jesuits played an unusually active part in that process. In the late seventeenth century they designed for their church in Cuzco an iconographic program that emphasized the links between the Society of Jesus and the imperial Inca lineage. The painting depicts the marriage of Martín García de Loyola, nephew of Saint Ignatius, to the *ñusta* Beatriz, a princess of the Inca royal blood, and that of their daughter to a descendant of Saint Francis Borgia. In the paternal presence of the great Jesuit saints, the two couples celebrate their union in an idyllic setting (cat. 171). The violent history of the Conquest is thus transformed into a peaceful wedding ceremony between the victors and the vanquished, who have been incorporated into the theocratic utopia of the Jesuits. Some members of the native nobility, who had traditional links with the order, commissioned copies of this scene to hang in their homes, and even took it as a model for their portraits in the "Inca style" (Gisbert 2004, 153–157; Stastny 2001; García Sáiz 2002; Wuffarden 2005).

Starting with the public celebration of the beatification of Ignatius Loyola in 1610, the Society of Jesus promoted the cult of the Infant Jesus "de Huanca," who was dressed as an Inca. This sculptural image, the "patron" of an indigenous fraternity, wore the *mascapaycha*, or red woolen fringe, tied round its head, instead of the traditional European royal crown, as well as the *llauto*, a kind of headband, and the *uncu*, a tunic, all symbols of imperial Inca power. Veneration of the image spread far and wide when it was transferred to canvas in the form of "painted

sculptures," of which only two have survived (cat. 147). The cult was banned, first by the ecclesiastical authorities and later under the repression that followed the rebellion of Túpac Amaru II. The majestic figure of this Infant Jesus was an attempt to identify indigenous society with a divine authority that pre-dated the Conquest, embodying political legitimacy in the Andes and at the same time tying it to the founder of the Jesuit order (Estenssoro 2005). It has also been suggested that the image may have served the rebel *curaca* as a means of promoting the idea of a Catholic Inca, legitimating him as a revolutionary leader trying to establish a utopian Andean monarchy, independent of Spain (Mujica Pinilla 2004).

When it arrived in Lima, the center of political power, the renaissance expressed the aspirations of the indigenous elite living in the capital. Its most important visual manifestation was a genealogical painting showing the succession of the Inca, seamlessly continued by the kings of Spain. The Spanish monarchs thus assumed the legitimate role of "Incas," and as such were invoked as protectors of the native population against local rulers. Crowning the composition, the figure of Christ as "King of Kings" carries an olive branch and a sword (fig. 4, p. 186-187) to suggest the rewards earned by those who deferred to his authority and the punishment that awaited the disobedient (Buntinx and Wuffarden 1991). Shortly after independence, painters in Cuzco radically reworked this iconographic program, eliminating the Spanish monarchs, the figure of Christ, and the religious symbols, and thus proclaiming the imagined restoration of the empire of the Inca, following the final overthrow of the colonial regime (cat. 172).

This process of exchange, assimilation, and reaction formed part of the intense struggle for symbolic power that accompa-

nied the military campaigns for independence, and their contribution was decisive for the success of Peru's national cause. Paradoxically, the process did not at the time involve a break with previous artistic conventions, but only some subtle—though crucial—modulations, designed to reflect the political ideals of the revolution and its emancipatory effect, and to create new emblems for the independent nation, demonstrating the rich vitality of the artistic traditions of the Viceroyalty. During the course of the nineteenth century, while European-style academicism was adopted in Lima by liberal Creole society, those traditions found refuge in the Andes, gradually evolving into the so-called popular provincial arts of the Republic of Peru.

1. The legendary fame of certain artists under the Viceroyalty, especially indigenous artists, can be glimpsed in some topographical texts, such as the chronicle of Bartolomé Arzáns de Orsúa y Vela (1965). In the case of Cuzco painters like Diego Quispe Tito or Basilio Santa Cruz, their current prestige is connected with the *indigenista* movement.
2. Although the iconography of the *Child Virgin Spinning* is derived from the Seville school of painting, she has been seen as an Inca *ñusta*, or princess, because of her luxurious attire, which suggests a *lliclla* or mantle, and because she is spinning a skein of wool. But all these elements are present in earlier Spanish versions of the subject, suggesting that a more cautious reading is needed (Mesa and Gisbert 1982, 305; Gradowska et al. 1992, 35–38 and 124–125; Wuffarden 1999b).
3. *Taitacha* is the diminutive of *taita*, the Quechua word for "father." The indigenous population still uses the term in colloquial speech to refer to Christ.
4. This *curaca*'s real name was José Gabriel Condorcanqui (1738–1781). He was descended from a daughter of Túpac Amaru, the last rebel Inca of Vilcabamba, in whose memory he adopted the name. Following his defeat and execution, expressions of the "Inca renaissance" in art were strictly prohibited.

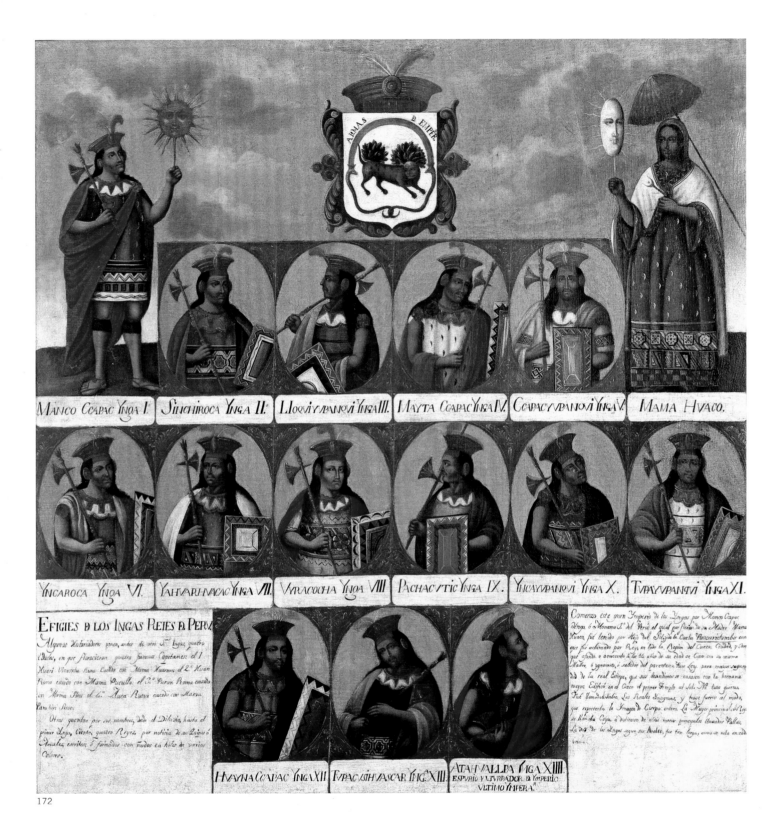

172.
Anonymous
Genealogy of the Inca
About 1835–1845

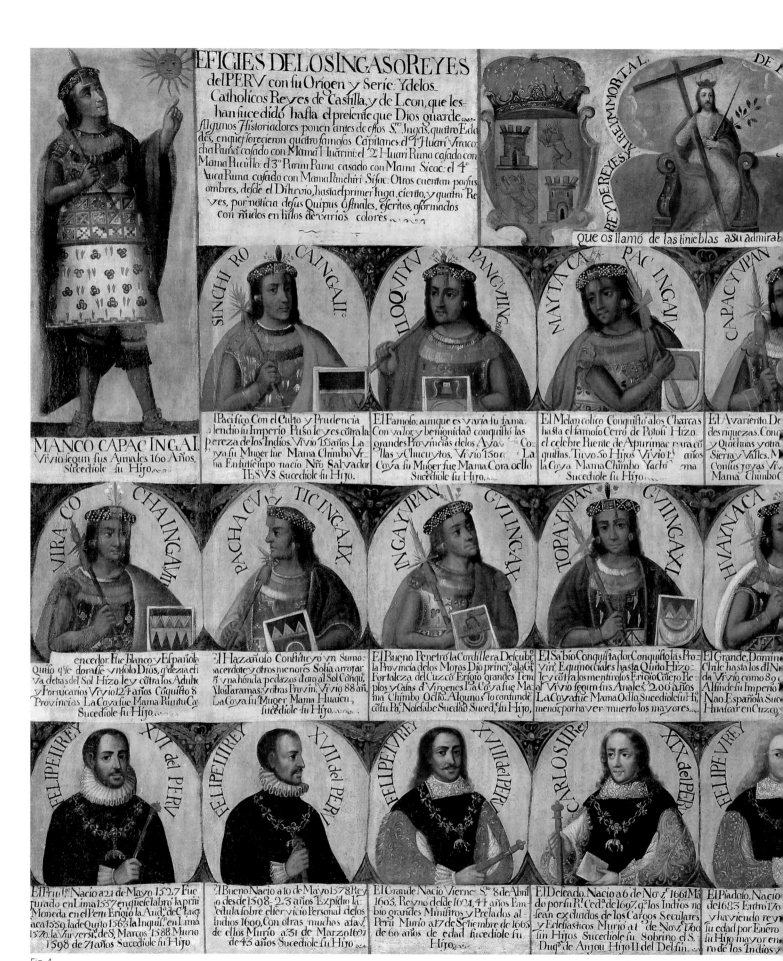

Fig. 4

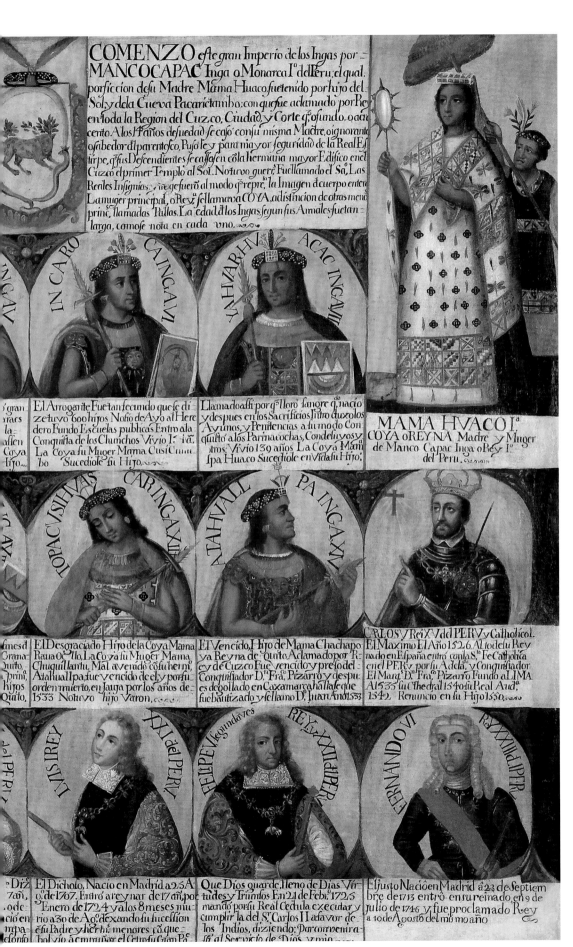

Fig. 4
Anonymous
*Effigies of the Inca
and of the Kings of Spain*
About 1725
Beaterio del Convento
Nuestra Señora
de Copacabana, Lima

Inca Heritage in Peruvian Colonial Art

Thomas B. F. Cummins

"Notwithstanding the Wars and Destruction of the Indians, there is still a Family of the Race of the Inca living at Lima, whose chief, call'd Ampuero,[1] is acknowledg'd by the King of Spain as a Descendent of the Emperors of Peru: As such, his Catholick Majesty gives him the Title of Cousin, and orders the Viceroy, at his entering into Lima, to pay him a Sort of publick Homage. Ampuero sits in a Balcony, under a Canopy, with his wife; and the Viceroy, mounted on a Horse managed for that Ceremony, causes him to bow his Knees three times, as paying him Obeysance so often. Thus, at every Change of a Viceroy, they still, in Show, honour the Memory of the Sovereignty of that Emperor, whom they have unjustly deprived of his Dominions; and that of the Memory of the Death of Atahualpa, whom Francis Pizarro caused to be cruelly murder'd, as is well known. The Indians have not forgot him: The Love they bore their native Kings makes them still sigh for those Times, of which they know nothing but what they have been told by their Ancestors. In most of the great Towns up the Country, they revive the Memory of that Death by a Sort of Tragedy they act in the Streets on the day of the Nativity of the Virgin. They cloathe themselves after the ancient Manner, and still carry the Images of the Sun their deity, of the Moon, and of the other Symbols of their Idolatry; as for instance, Caps in the Shape of the Heads of Eagles, or the Birds they call Condors, or Garments of Feathers with Wings, so well fitted, that at a Distance they look like Birds. On those Days they drink much, and in a manner all Sorts of Liberty. Being very dextrous at throwing Stones, either with their Hands, or Slings, Wo be to them that light of their Strokes on those Festivals, and during their Drunkenness; the Spaniards, so much dreaded among them, are not then safe: The Discreetest [wisest] of them shut themselves up in their Houses, because the Conclusion of those Festivals is always fatal to some of them. Endeavours are constantly used to suppress those Festivals; and they [the Spaniards] have of late Years debarr'd them the Use of the stage, on which they represented the Death of the Inca" (Amédée-François Frézier, *A Voyage To the South Sea, and Along the Coasts of Chili and Peru in the Years 1712, 1713 and 1714*)

Bedecked with images of the sun and moon, the idols of their past; fabulously dressed as birds and dancing in the streets; drinking raucously in forlorn remembrance of their ancient kings while stoning, even killing, Spaniards with slings; performing theatrical re-enactments of the death of Atahualpa, the heritage of the Inca was alive and well for the Indians of Peru and their art when Amédée-François Frézier recorded the details of his visit to Peru in 1713. Despite Spanish attempts to suppress the festivities that Frézier witnessed, they continued to be celebrated throughout the eighteenth century as is evidenced by the watercolor illustrations commissioned by Baltasar Jaime Martínez Compañón y Bujanda, bishop of Trujillo, between 1782 and 1785. Among the several thousands of images that depict the people and customs of the north coast of Peru, at least five illustrations depict dances with men dressed as different birds (fig. 2, p. 191). In another illustration, we see two dancers, one of whom wears the symbol of the sun as his headdress while the other wears the moon (fig. 3, p. 191). We also see in one illustration a man dressed as an Inca seated on a golden throne (fig. 2, p. 196). In the following watercolor, the Inca king has been pulled from his throne and has been decapitated by the Spaniards (fig. 3, p. 196). These two images represent the re-enactment of the death of Atahualpa that Frézier describes, and they harken to an earlier pen and ink drawing in which the historical death of Atahualpa is depicted also by his decapitation (fig. 4, p. 196). Created in 1615 by the native artist Guamán Poma de Ayala, this drawing is part of a now-famous thousand-page illustrated manuscript, one of only three produced in the colonial period, which narrated the Inca and colonial history of Peru. All three manuscripts were intended for the king of Spain so that Guamán Poma's composition did not remain in Peru as a source for these later images described by Frézier and depicted by Martínez Compañón. What is therefore important is that both Guamán Poma's historical image and the eighteenth-century reenactments are imaginative alterations of the nature of Atahualpa's execution. From all eyewitness accounts, Atahualpa was garroted, not decapitated. But

Fig. 1. Anonymous, *The Carriage of Saint Christopher,* Corpus Christi series from the Church of Santa Ana in Cuzco, About 1675–1680, Museo de Arte Religioso, Arzobispado del Cusco

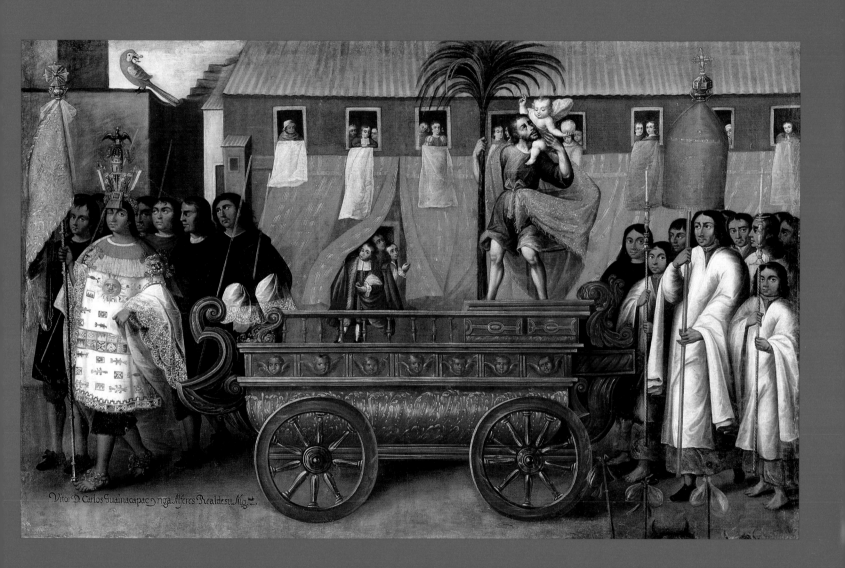

Vitoi D Carlos Suainacapac ynga Alferes Realdesu M...

within the Andean imagination, decapitation was not just an act of execution; the severed head, in general, suggested the possibility of regeneration. The colonial image of and belief in the decapitation of Atahualpa is tied to that tradition, and it came to imply the return of the Inca, a messianic idea that was recounted in oral myth, depicted in paintings, and inspired several revolts during the colonial period.[2] This belief is what stood behind the Spanish worries about and desires to suppress these plays and any images of them. Their prohibition was finally and decidedly enforced when all Inca representations were strictly forbidden. Those that existed were ordered to be destroyed after the great revolt of Túpac Amaru in 1780, a revolt that nearly drove the Spaniards from the Southern Andes.

Nonetheless, these vivid eighteenth-century descriptions and images by Frézier and Martínez Compañón of the Inca and their descendants in Lima and Trujillo are only a small part of the Inca heritage in colonial art. Many of the images and rituals were newly invented so as to accommodate the Inca past with the colonial present for different audiences. For example, the homage paid by the new Viceroy who bowed his horse three times before the costumed descendants of the Inca as they entered into Lima, the capital of Peru, was pure political theater that really had nothing to do with the majority of Andeans. However, other inventions were a melding of Inca traditions and newly imported European forms that were meant for and created by the Andeans themselves. In Cuzco, for example, a series of paintings, most likely painted by native artists, depict the leaders of the Indian neighborhoods dressed as Inca, wearing the royal crown (*mascapaicha*), a red wool fringe over the forehead, and a tunic (*uncu*) decorated with abstract geometric designs (*tocapu*), as they lead the religious floats that carried the sculpture of their patron saint during Corpus Christi (fig. 1, p. 189). These images asserted the sincere Catholic devotion of the Inca descendants in Cuzco while reasserting their descent from the royal Inca dynastic kings and the social prestige and political authority that they were accorded by the Spanish crown.

The careful depiction in the Corpus Christi paintings of the details of their beautiful regalia exhibits not only the skill of the native artists in Cuzco, many of whom signed their names with the title Inca, but the paintings demonstrate that the great textile tradition of the Inca and their predecessors continued well into the colonial era. Colonial Andean weavers were asked to create new beautiful tapestries to hang in Spanish houses, convents, and churches, some with familial coats-of-arms (cat. 173) and others with religious subjects. They also continued to weave fine Inca-style tunics as well as women's *mantas* (shawls) and *acusas* (dresses) that were worn by colonial Inca nobility. Colonial Inca weavers also turned their prodigious talents to the sacred, just as they had done before the arrival of the Spanish (fig. 2, p. 140). They wove new, smaller tunics that were used to dress the Catholic statues of the Christ Child, many of which were carved by native artists. These new tunics (*uncus*) combined Christian religious symbols such as the initials of Christ and Mary with *tocapu*, the abstract geometric designs of the Inca that had been divinely inspired (cat. 121). These precious tunics were placed on the sculptures along with the Inca crown (the *mascapaicha*), and the dressed images became the devotional focus for native confraternities in Jesuit churches throughout Peru. The first eyewitness description of this image comes from 1610, when the Jesuit founder Ignacio de Loyola was beatified. The Jesuits in Cuzco duly organized a grand celebration in which all of the Indian parishes of the city participated, just as they did in the Corpus Christi celebrations. Many of the elite descendants of the Inca kings dressed in the clothing of their ancestors, including the *mascapaicha*, and paraded into the plaza, where they paid homage to the Jesuits and to their newly beatified founder by singing ancient songs of Inca triumphs, but now dedicated to Loyola. Similar processions took place throughout Peru, in towns such as Potosí, Cajamarca, and Lima. In Cuzco, members of the parish of Hospital de los Naturales entered the plaza singing a song from the time of the Inca King Huayna Cápac. They were greeted by the Confraternity of Jesus, a lay group attached to the Jesuit Church, who brought out the statue of the Infant Jesus (Niño Jesús) dressed in Inca imperial clothes, meaning that he wore an *uncu* (tunic), a *mascapaicha*,

and perhaps a cloak around his shoulders, as well as sandals with the heads of pumas or lions as depicted in later paintings (cat. 147).

The tunics and other regalia described in 1610 for the Christ Child statues were similar in style to the tunics worn by Inca descendants in festivals and in their own portraits. They also appear as the royal dress of the ancient Inca kings, which were painted as a series of portraits during the entire colonial period. The first set of oil-on-canvas Inca portraits was commissioned by the Viceroy Toledo in 1570, and they were painted by native artists. The portraits were sent to Philip II in Madrid where they were hung in the royal palace in the same room with Titian's equestrian portrait of Charles V as well as his portrait of Philip II and the victory at Lepanto. These first Inca portraits have been lost, but they established a tradition that continued throughout the colonial period (cat. 172). Inca descendants owned and displayed them in their homes in Cuzco, and they were hung in the Jesuit schools for the sons of Inca nobility. Many of the series of portraits of the Inca kings and their queens, painted in Cuzco, were also sold in Lima, and it is there that Amédée-François Frézier saw them and copied them. His watercolor sketch of portraits of the first Inca king, Manco Cápac, and his queen, Mama Ocllo, served for an engraving that precedes Frézier's description of colonial customs cited at the beginning of this essay (fig. 4, p. 191). The French engraver misunderstood many of the costume elements as copied by Frézier, but one can nonetheless see how the iconography of the colonial Inca created in Cuzco was spread throughout the Viceroyalty of Peru.

In addition, the European introduced oil painting techniques in which Andeans became very adroit. Native artists adapted venerable objects to carry new images that were used in rituals to remember and celebrate their Inca past. The most important of these objects was the *kero*, a wooden drinking vessel. These cups were used by the Inca as gifts and then as ritual objects to celebrate feasts in the great plaza spaces built throughout *Tahuantinsuyu*, the Inca Empire. *Keros* were always made in pairs because, within Andean etiquette, one never drank alone, but with a partner so as to

Fig. 2

Fig. 3

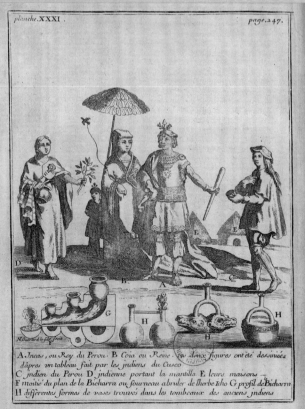

Fig. 4

Fig. 2
Baltasar Jaime Martínez
Compañon
Dance of Huacamaios
1782–1785
Real Biblioteca de Madrid

Fig. 3
Baltasar Jaime Martínez
Compañon
Dance of Huacos
1782–1785
Real Biblioteca de Madrid

Fig. 4
François-Amédée Frézier
Print Depicting in its
Centre the King and
Queen of the Inca
1716
Bibliothèque Nationale
de France

PAGE 192:
173.
Anonymous
Tapestry panel depicting
coats of arms
17th century

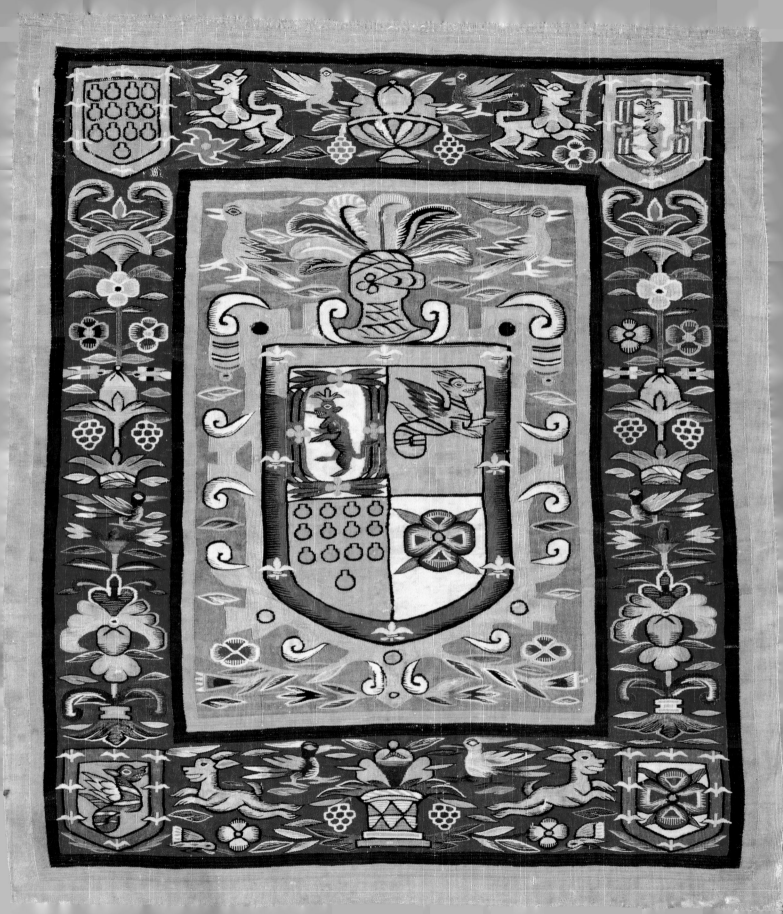

symbolically express the social reciprocity that was the backbone of Andean society (cat. 112). Therefore, it is not so surprising these vessels continued to be made and used in Andean villages throughout the Viceroyalty. Inca *keros* were always incised with geometric abstract designs, similar to *tocapu*. Colonial *keros* began to be decorated with figural designs that most often depicted the Inca and his queen in various narrative compositions (cats. 113, 114). The forms of the figures were carved into the wooden surface and a resin that was mixed with different colors was used to fill in the figural forms and to add details (cat. 275). These now very colorful vessels were used in community rituals to remember the Inca and their past power while the participants celebrated spring planting, fall harvest, and other agricultural and pastoral feasts. Again, as with portraits of Inca kings, the re-enactments of the death of Atahualpa, and the weaving of tunics to dress the Christ Child as an Inca, it was native artists who carved and painted these wooden cups.

What Amédée-François Frézier saw and described at the beginning of the eighteenth century was only a small part of the Inca heritage in colonial art. Silversmiths, painters, sculptors, actors, and musicians all carried on traditions that they had inherited from the Inca. But they all creatively adapted them to a different reality. Nonetheless, they kept the memory of the Inca very much alive throughout the Andes until today, and this is their legacy.

1. The Ampueros were one of the founding families of Lima, and among those who greeted the first Viceroy to the city (Cobo 1956 [1639], 325–327). Francisco de Ampuero married doña Inés Quispicizae, granddaughter of Huayna Cápac (Murúa 1616, Folio 141 v). It is probable therefore the Ampuero referred to by Amédée were the descendants of this conquistador and Inca princess.
2. For more information on these re-enactments see Millones (this volume) and Wachtel (1971).

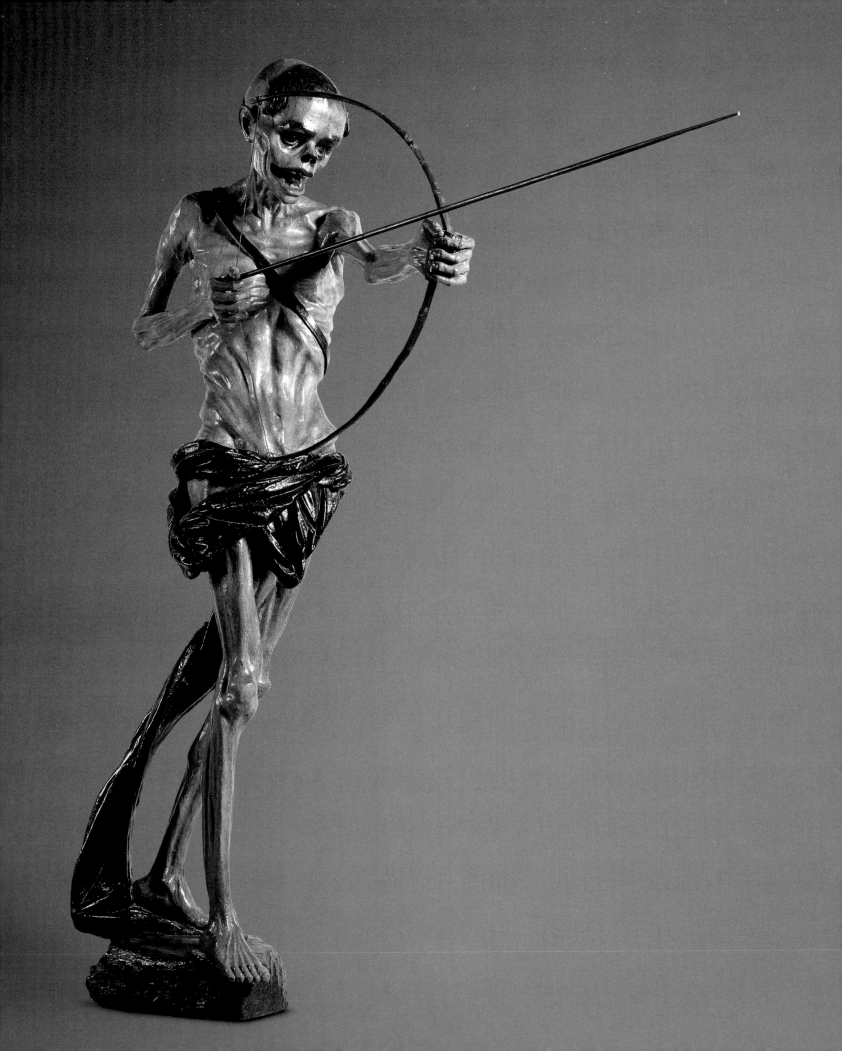

Colonial Theater in the Andes

Luis Millones

Pre-Columbian Festivals in the Andes

Nothing reveals more clearly the perplexity experienced by the conquistadors as their use of analogies in trying to understand the things they were discovering. This can be seen in Bernal Díaz del Castillo's account of the march of the European army to Tenochtitlán:

"...we saw such great numbers of cities and populous towns in the water, and other large settlements on dry land, and that road, so straight and level, that led to Mexico, [that] we were amazed, and said it resembled the wonders that are told of in the book by Amadís [de Gaula], with its great towers and *cúes* [i.e. temples] and buildings that stood in the water, and all built of stone and rubble. Some of our soldiers wondered if what they were seeing were some kind of dream..." (Díaz del Castillo 1991 [1632], 238).

That transition from the visual to the conceptual on the part of the sixteenth-century Spaniards was also seen in the Andes.

The same could be said of the impression created by Andean festivals. Five hundred years later, the spectacle still astonishes those who witness it: the explosion of colors, the music, the dancing, and the participants' total surrender to the ecstasy of the *fiesta*. At the same time, the sixteenth-century European observer could find no better way of recounting what he saw than to analyze his experi-ence in terms of the literary and dramatic genres with which he was familiar, hence the idea that there existed a pre-Colum-bian theater in the Andes.

It we refer to the chronicle of Santa Cruz Pachacuti (Millones 1979, 123–161) we will find up to three places where there are descriptions of spectacles defined as theater by the criteria of the day. In the first case, as an old man, the Inca Pachacuti organized a ceremonial battle in which his son Túpac Yupanqui and his grandson Huayna Cápac played the part of victors. The event involved the deployment of vast numbers of actors, who went through all of Cuzco, their performance followed by an excited crowd. In the final pages of the chronicle there is a description of a great parade, in which Pizarro, Valverde, and Manco Inca took part. The magnificence of the event, celebrated just when the *Tahuantinsuyu*, the Inca empire, was in steep decline, led the chronicler to compare the participants with the king of Spain and the pope, who were in some way or other represented by the figures mentioned above.

There are undeniable similarities between the events described in the chron-icle of Santa Cruz Pachacuti and those mentioned in ethnographic reports of con-temporary Andean festivals. It is not diffi-cult to see historical continuity between these spectacles, with all the reservations one may have in view of their chronologi-cal separation. Historians, philologists, and literary scholars who have studied indigenous theater up to the mid-twentieth century have seen in these colonial Quechua plays (such as *Ollantay*) the expression of an Andean dramatic tradition, which had followed the same paths as those of Europe. That approach, which was very controversial at the time, is explained by the way our intellectuals are educated. The powerful influence of the "indigenist" movement meant that every European cultural phenomenon had to have a national counterpart.

A more appropriate approach would perhaps be to ask a different kind of ques-tion, putting the issue of origins aside for the moment. For example, if we think about the general nature of the *fiesta* and the many functions performed in the course of the festive activities, it is possible to interpret the fragmentary accounts in the chronicles more cautiously.

There is a frequently occurring concept in the Andean chronicles that, because of its comprehensiveness, better describes the ensemble of actions that take place during the *fiesta*. This is the *taki*, defined in vari-ous regularly recurring ways in the diction-aries of the time: "Taquini or taquicuni = to sing without dancing or to dance while singing" (González Holguín 1952, 338). Since in Spanish the words "sing" and "dance" are usually thought of as mutually exclusive, the compiler of the dictionary has difficulty in finding a suitable translation of the verb *takiy*, which in early colonial times applied to an ensemble of festive activities.

The sense of disorder in Andean *fiestas*, communicated by the chroniclers, contrasts

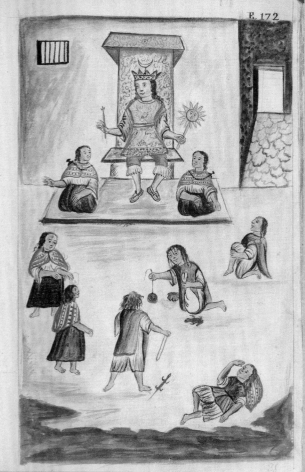

Fig. 2

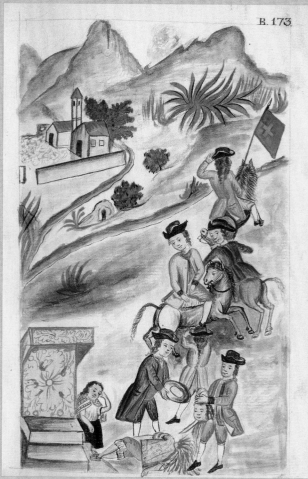

Fig. 3

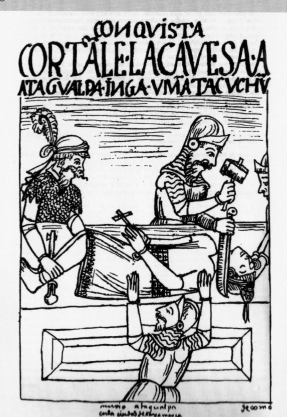

Fig. 4

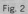

Fig. 2
Baltasar Jaime Martínez
Compañon
Dance of the Decapitation
of the Inca
1782–1785
Real Biblioteca de Madrid

Fig. 3
Baltasar Jaime Martínez
Compañon
Dance of the Decapitation
of the Inca
1782–1785
Real Biblioteca de Madrid

Fig. 4
Guamán Poma de Ayala
Conquest. He Cuts
the Inca Atahualpa's
Head off
1615

PAGE 199:
Fig. 5
Nazca
Trophy head vessel
1–700 A.D.
The Montreal Museum
of Fine Arts

with the careful planning of the ceremonial calendars, under which every gathering created a world of actions that came into being with the festival and ceased to exist when it ended. When the Inca came to power, the same dispersed pattern of land-holding continued; the inhabitants of each region would meet only as provided for in a ceremonial calendar, which in some areas was reinforced by the efforts of Inca offi-cials and by the wealth of their storehouses. Each festive occasion meant the temporary creation of a space occupied by crowds of people; the ceremony conferred on the place new ideological significance, bring-ing together gods, priests, and political leaders who used rituals to reinforce devo-tion to these values. When the gathering was over, the people would disperse, and the ceremonial activity would move to other places. Every *fiesta* included a series of *takis*, involving masked dancers, music, and songs, in which the crowd was encouraged to par-ticipate. And while the occasions might vary—harvesting, sowing, irrigation, an act of penitence, or a war—the participants knew there was an underlying pattern that shaped the spectacle.

If we wish to understand the *taki* as a precursor of Andean theater, we need to begin by acknowledging its specific charac-ter and by considering the possibility that continuities may link them with indige-nous dramas of the colonial period. It has hitherto been much simpler to assume that Andean festivities did not disappear with the Conquest. They dwindled for economic and social reasons, but were re-established by being incorporated into Catholic cere-mony, the Church having decided to assim-ilate them (partially at least) in order to broaden its appeal to new Christians.

European Theater in Latin America: Strategies of Evangelization

It can always be argued that the Andean *takis* were choreographed spectacles and that their present forms are derived from the theater imported from across the Atlantic. Even if we agree about that, since the links between dramatic representations such as the dance of Moors and Christians and the dance of the Conquest of Mexico, or the representation of the death of Atahualpa, are clearly visible, we have to conclude that these are not isolated dramatic cycles. There must have been a whole corpus of *fiestas* that came into contact with the native corpus, which makes it legitimate to think that the origins of the present dance/the-ater phenomenon are to be sought in both traditions (Jáuregui and Bonfiglioli 1996, 12).

In any case, the legal and religious need to evangelize the new subjects made the-ater a vital ally. The potential of the *taki* as a tool for conversion was clear from the first days of contact. It had been observed in Mexico (Ramos 1990, 20, 24), with its indigenous dances and songs, and as with all such phenomena, it was used as a model in the Andes. As Armas Medina (1953, 413–422) has shown, the European clergy were aware that ostentation and display were vital in making an impression on the "uncouth nation"—meaning the Native Americans.

The use of theater and other spectacles had periods of greater and lesser accep-tance by the Church. There were long periods of crisis when these performances were suppressed. There must have been a very difficult moment in the seventeenth century, when the edicts on the "eradica-tion of idolatry" were launched. That was the name given to campaigns against the remnants of pre-Columbian cults and the religious practices that had emerged since the time of Pizarro. The "witch hunts" died out at the end of the seventeenth century, but years later the songs, dances, and dra-mas were again being suppressed, because it was thought the references to the glori-ous past were liable to create unrest among the indigenous population, as appears to have happened with the rebellion of Túpac Amaru II in 1780.

Indigenous Theater in the Colonial Period

Not all authors of plays were religious fig-ures. While the Church did not cease to play an important part in the production of this literary genre, other members of colo-nial society were carving out parallel roles for themselves. In every region, clerks, local officials, teachers, and other laymen were able to turn themselves into "organic intellectuals." But priests or not, it was these local "literati" who collected and preserved the forms of knowledge that were in the air.

Literati of that kind also existed in places of less cultural importance than Cuzco or Lima, and drew on folk knowl-edge to create musical, literary, and dra-matic works, as a means of expressing the feelings of their people. It seems clear that the ultimate goal of these composers and directors was to situate their communities in the country's wider history, and to give their locality a place of its own within the global society to which it belonged.

Alongside this feeling of love for one's own country, which, as we have seen, can also be expressed through theater, we can detect a messianic way of thinking, visible at times in contemporary popular culture, but with considerably older roots. In the Andes, that mind-set is related to ideas concerning the Inca, whose historical meanings have mutated into hopes for change. This is not an explicit attitude that can be defined simply. Its elements make up a set of messianic expectations that have not been resolved, and which manifest themselves in familiar forms of cultural expression: songs, poems, myths, dances, and theater. In drama, where this message is most obvious, one of the most prominent examples is the spectacle known as "The Death of the Inca Atahualpa."

The earliest image of this spectacle was collected in the eighteenth century by Baltasar Jaime Martínez Compañón y Bujanda, appointed Bishop of Trujillo in 1779. His pastoral visitation lasted three years, during which he employed indige-nous artists to draw the characters and customs and the fauna and flora of his jurisdiction, intending to accompany their work with a text he failed to write or which has been lost. These illustrations are like an ethnographic handbook for the modern reader. They include two plates depicting scenes from the drama entitled "The Beheading of the Inca" (Martínez Compañón 1978, E 172 and E 173) (figs. 2, 3, p. 196). Before that, there are isolated references to the play, for example, a performance in Potosí in 1555, but that is the first time it can be partially, but unequivocally, identi-fied and reconstructed.

The historical facts on which the work is based are very familiar. It is a dramatic recreation of the period from the capture of Atahualpa in 1532 to his execution a few months later. Having disembarked at Tumbes, Pizarro and his men learned that Atahualpa was heading for Cuzco to take control of the *Tahuantinsuyu*. The Spaniards ambushed him in Cajamarca, where he was taken prisoner, and after studying the potential of the newly discovered kingdom, they decided to go on to Cuzco. The Inca was condemned to be burned at the stake, but the sentence was commuted to being garroted, after converting to Christianity. Immediately afterwards he was buried in the recently built church of Cajamarca, but his followers stole his body during the night and it disappeared.

The drama, which is still staged in various places in Ecuador, central Peru, the Sierra Norte, and some parts of the coast, has also been recorded in Oruro, Bolivia, northeastern Argentina, and northern Chile. The versions contain significant differences, including the addition of Huáscar and Toledo to the usual list of characters: Atahualpa, Pizarro, Valverde, the translator Felipillo, and various Spanish and indigenous leaders. In the versions that have come down to us, the climax comes with the execution of the Inca, and the ending tends to have the mood of a *fiesta*, in which the audience is eventually involved.

None of the versions can claim to be directly derived from performances in colonial times, although it is most likely the differences were minimal, to judge by Martínez Compañon's plates and by a painting held in the Museum of the University of Cuzco, which must be contemporary with the Bishop of Trujillo's illustrations. It is interesting to note that the depictions mentioned are consistent with Guamán Poma de Ayala's drawings, and that they also change death by strangling or garroting to beheading (fig. 4, p. 196). Judging from pre-Columbian iconography in which the figure of the decapitator is a constantly recurring motif, the theme of a vanquished leader losing his head goes back a long way. In pre-Hispanic iconographic convention (Nazca, for example) (fig. 5, p. 199), the mummified head of an enemy usually turns into or is associated with the seeds of the main cultivated plants. Which brings us to a different type of conceptualization: if the Inca's head was cut off—and that is the version of events accepted in the Andean imagination—it would contain in itself the ability to return and to rise again, like seeds.

It is not surprising, therefore, that in the 1960s, oral versions of the story of Inkarrí or Incarrey began to be discovered. After the Inca was beheaded, a new body was said to have grown from his head, which when it was complete would return and restore social harmony. This popular story, since known as the "Inkarrí myth," reinforces and gives consistency to visual and dramatic expressions of the hopes invested in the Inca. But contemporary drama would seem to need no help in demonstrating its vitality. We happened to meet the leaders of a community near the Cerro de Pasco mines, who were looking for somebody who could direct a stage presentation of the Inca's death. There is no doubt that the drama is still popular. Summoned by the people, the Inca returns to the scene, and his execution, endlessly repeated, means only that he has to die in order to ensure his return.

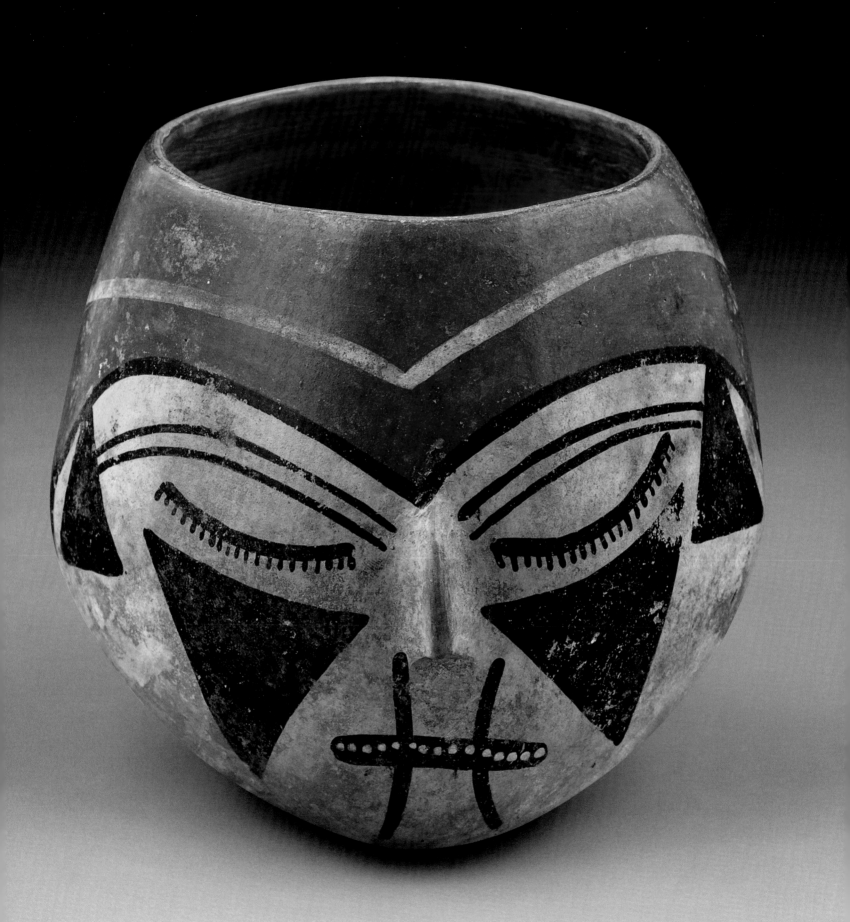

Music at Corpus Christi in Colonial Cuzco

Geoffrey Baker

Corpus Christi was of paramount significance in Cuzco because it not only allowed the city's elites to "perform" their privileged status within this highly stratified society, but also it re-enacted the triumph of Christianity over native "idolatry" in the symbolic heart of Andean civilization (Dean 1999). Eighteenth-century eyewitness descriptions by Cosme Bueno (1951, 95), Don Alonso Carrió de la Vandera (Concolorcorvo 1965, 264–265), and Ignacio de Castro (1978, 57) of the Corpus Christi procession all emphasize the ornate ephemeral architecture, the splendid costumes of the Andean dancers, and the participation of the Indian parishes from the city and provinces with the statues of their patron saints carried on their shoulders (cat. 148). However, only that of Carrió de la Vandera briefly alludes to the aural aspect. Nevertheless, there are a number of other sources that permit a partial reconstruction of the sound world of Corpus Christi in colonial Cuzco.

The earliest account of music at Corpus Christi was written by Garcilaso de la Vega, who stated that, during the 1551 festival, the cathedral chapelmaster Juan de Fuentes had adapted an Inca victory song called a *haylli* for performance by eight mestizo choirboys in native costume (Stevenson 1980, 2). Garcilaso also records the participation of the Andeans: "each province singing in its own particular language [...], to differentiate one ethnic group from another. [...] They carried their drums, flutes, conch shells, and other rustic musical instruments" (Garcilaso de la Vega 1964, 139). During the first century of colonial rule, the Corpus celebrations thus filled the city center with indigenous music, more or less hybridized, accompanying the colorful dances.

Much as these accounts suggest the vitality of Cuzco's Corpus festivities, little information can be gleaned about the participation of the city's church musicians or about the European-derived music that they performed. Furthermore, there are virtually no descriptive accounts from Cuzco's artistic "golden age," which lasted approximately from the mid-seventeenth century until 1720, and reached its apogee during the tenure of Bishop Manuel de Mollinedo y Angulo (1673–99) (Dean 1999, 82). Fortunately, a series of paintings of the Corpus procession probably dating from 1674 to 1680 provides vital clues about the musical aspects of this festival and about the wider musical life of the city at this time of cultural florescence.

Saint Rose and "La Linda": Confraternity Music in Cuzco

One of the most prominent images of musicians appears in the canvas depicting the procession of the confraternities of Saint Rose and "La Linda" (fig. 1). This painting shows up to six Andean musicians playing shawms and a sackbut, accompanying the litter on which the statue of Saint Rose is mounted. The image underlines the contribution to the urban soundscape of confraternities, corporations that have been entirely passed over by musicological studies of the region. My research in Cuzco's archives has shown that confraternities were important promoters of musical activities and employers of musicians, and therefore any consideration of music in colonial Cuzco, or, indeed, in any other Andean city, would be incomplete without a consideration of these corporations.

Music was required on a regular basis by Hispanic confraternities, and these confraternities employed considerable numbers of indigenous musicians at their ceremonies. During the years for which records survive (1644–1673), the Cofradía del Santísimo Sacramento of the cathedral employed a similar ensemble to the one depicted in this painting to provide music at the confraternity's weekly Thursday services, on those occasions when the Holy Sacrament was taken to the sick, and during the octave of Corpus Christi. The indigenous inhabitants of the Andes also took to the confraternity system with enthusiasm, and festivities were repeated within each Indian parish. Music played a central part in the activities of these confraternities, as is evidenced by surviving confraternity account books and contracts between musicians and brotherhoods.

The most prominent confraternities during the Corpus festivities were those of the Holy Sacrament, though their musical activities extended well beyond this feast. The accounts of the Cofradía del Santísimo Sacramento of the parish of

Fig. 1. Anonymous, *Confraternities of Saint Rose and "La Linda"*, Corpus Christi series from the Church of Santa Ana in Cuzco, About 1675–1680, Museo de Arte Religioso, Arzobispado del Cusco

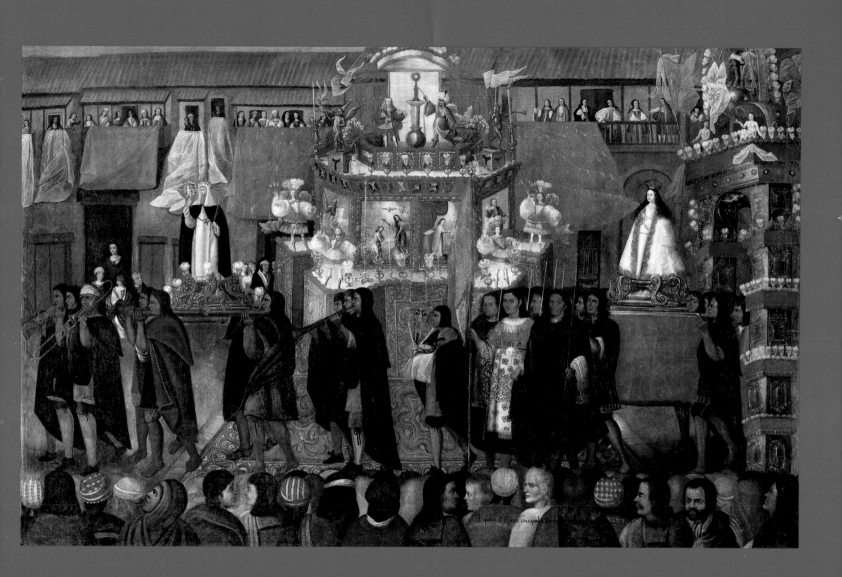

Hospital de los Naturales show that the fiesta of Corpus Christi might involve hiring drummers, trumpeters, singers, a harpist, shawmists, and could also include fireworks (Archivo Arzobispal del Cusco). Thus any account of music during the Corpus festivities in colonial Cuzco must take into consideration the activities of indigenous parish musicians who performed European-derived music, both sacred and secular, as well as a range of institutional patrons and performance contexts, including the cathedral, the central procession, and the churches and plazas of the eight indigenous parishes.

Corregidor Pérez: Hispanic Musicians in the Central Procession

The painting *Corregidor General Alonso Pérez de Guzmán* (fig. 2) depicts a triumphal arch and a temporary altar, to the left of which can be seen a harpist and some figures, both adults and children, whom I would identify as singers. One adult and one boy appear to be holding sheets of music, which might imply the performance of polyphony. All are Hispanic and dressed in ecclesiastical robes. The only male Hispanic polyphonic ensembles in Cuzco during this period were the singers of the cathedral, including the *seises*, or choirboys, and a closely linked group maintained by the Seminary of San Antonio Abad. *Seises* were a permanent feature of the city's musical structure, and their identification here is unproblematic. The identity of the adult singers, however, needs to be considered further.

In the earliest days of the colony, Cuzco Cathedral established a music chapel that quickly grew to play the leading role in the urban soundscape. However, two key events in the early seventeenth century served to alter fundamentally the musical panorama of the city: the foundation of the seminary of San Antonio Abad in 1605, and the division of the diocese of Cuzco into three parts in 1609, leading to a dramatic decline in revenues and consequent reductions in the cathedral musicians' salaries (Stevenson 1980, 12; Esquivel y Navia 1980, 26–27). The seminary's constitution indicates the intention of its founder, Bishop Antonio de

la Raya, that "all will learn to sing." According to Robert Stevenson, Bishop de la Raya was "the first to set aside an endowment in a New World seminary specifically for the teaching of vocal and instrumental music" (1980, 10). From the start, the seminary's musicians participated for free in cathedral functions and took the church's message out to the urban population to the accompaniment of chant and polyphony. This musical link between seminary and cathedral was not without precedent in the New World. However, there are indications that Cuzco was a unique case among Peruvian cities in the high musical profile of its seminary (Unanue 1985, 249).

In 1648, the institution's rector, Don Juan de Cárdenas y Céspedes, wrote that the seminary had its own *capilla de música*, with more than thirty musicians and a *maestro de capilla*, singing at the Thursday Masses of the Holy Sacrament and accompanying the Holy Sacrament on its forays out to the sick (Archivo General de Indias). The seminary then played an increasingly important role in the music performed within the cathedral, while continuing to sing in processions through the city and going forth to represent the cathedral at external functions. By the eighteenth century, seminarians even began to supplant the cathedral singers within the cathedral itself (Esquivel y Navia 1980). By the mid-eighteenth century there is no mention of cathedral musicians other than the seminarians.

As the seminary musicians frequently represented the cathedral outside the institution's walls and were particularly associated with processions of the Holy Sacrament, it is logical to identify the clerical singers in the canvas of Corregidor Pérez as members of the seminary. The evidence from the painting suggesting that the seminarians were performing polyphony is bolstered by the report of the bishop dating from 1625, which specifies that the *colegiales* sang polyphony during their processions to the sick. There are also a number of *villancicos* in the seminary music archive dedicated to Corpus or to the Holy Sacrament, which may have been performed during processions as well as during services in the cathedral (Claro 1969).

Thus sacred polyphony, performed at temporary altars by the seminary singers, should feature in our account of music in the Corpus procession.

Hospital de los Naturales: A Vision of the Future

A painting depicts the procession of the indigenous parish of Hospital de los Naturales, including a carriage in which three musicians are performing (fig. 3). Given that carriages did not appear in processions in Cuzco until 1733, Carolyn Dean argues that it was copied from a seventeenth-century Spanish festivity book by Juan Bautista Valda (Dean 1999, 84–85). The hospital canvas, with its prominently displayed symbol of Hispanic modernity—a Spanish carriage complete with musicians of Hispanic appearance—thus depicts an imagined future scene that should be considered as constructing and projecting a particular self-image and a distinctive vision of colonial culture on the part of the painting's sponsors, presumably members of the indigenous parish of Hospital de los Naturales. Artists in Cuzco, like musicians, generally belonged to the upper echelons of mid-colonial indigenous society, and their sponsors too are likely to have been well-born Andeans. The Corpus series therefore represents, in all probability, a variety of perspectives of the native elites on this central religious festival.

The role assigned to the indigenous population by the Hispanic elite in the Corpus festivities was primarily to "perform" their indigeneity and thereby act out the role of the defeated Other in the triumph of Christianity over native religion. Native display was doubly important to the colonial elite: not only did "traditional" indigenous culture mark out the Other to be vanquished, but also, "Cuzco's colonial leaders had an interest in constructing remembrances of the Incaic past because their prestige within the Viceroyalty hinged on its historic glory," (Dean 1999, 25) hence the efforts of these leaders to promote "folklorized" indigenous participation from the mid-sixteenth century onwards. The performance of native music and dances in Corpus Christi not only evidenced

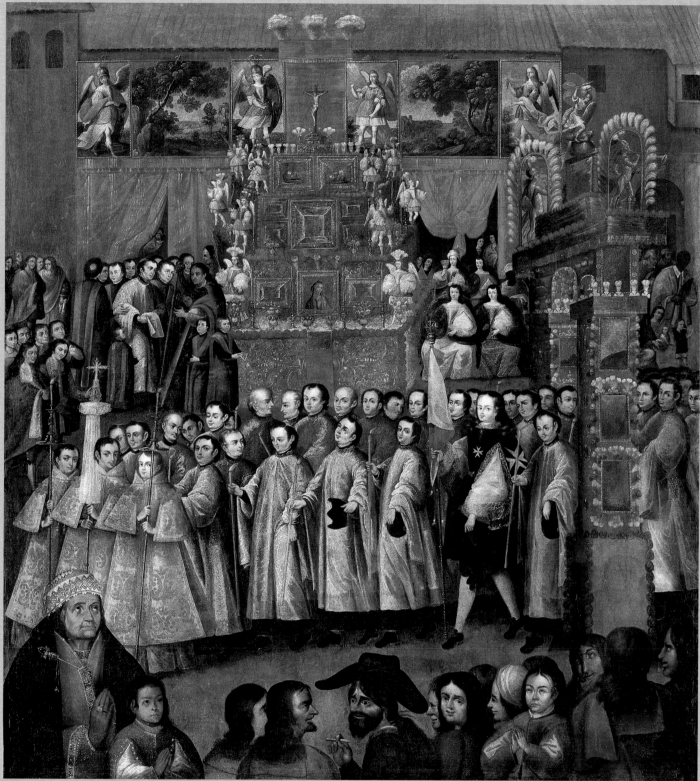

Fig. 2

Fig. 2
Anonymous
Corregidor General
Alonso Pérez de Guzmán
Corpus Christi series
from the Church of Santa
Ana in Cuzco

About 1675–1680
Museo de Arte Relígioso,
Arzobispado del Cusco

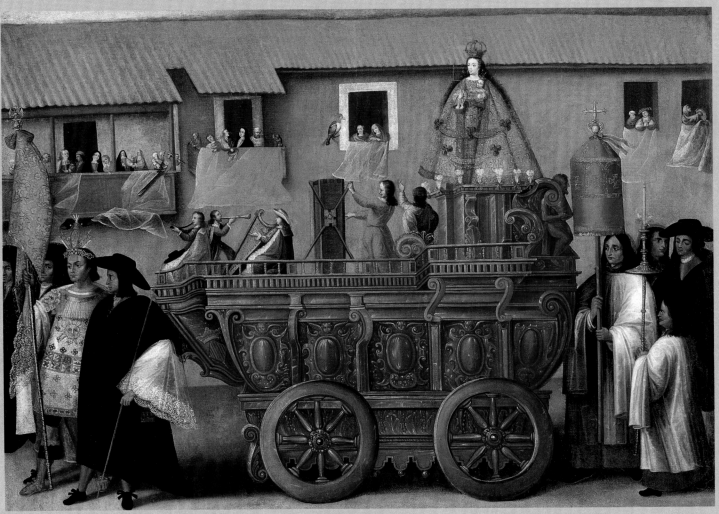

Fig. 3

Fig. 3
Anonymous
Parish of the Hospital
de los Naturales
Corpus Christi series
from the Church of Santa
Ana in Cuzco
About 1675–1680
Museo de Arte Religioso,
Arzobispado del Cusco

successful evangelization, however, but also reproduced and legitimated the unequal power relations of colonial society (Dean 1999, 39) and thus native music was inextricably linked to subordination.

The indigenous artists of this painting preferred to foreground a more "modern," Hispanic vision of colonial Andean culture, identifying the depicted native subjects with European music. The confraternity canvas also highlights the European as well as the Andean aspect of colonial music through the depiction of European instruments and the linking of the Andean musicians to two primary religious and cultural symbols of the Hispanic colonial elite: the images of Saint Rose and "La Linda." These paintings, I would suggest, propose an Andean alternative to the Hispanic vision, in which conversion is not linked with submission: they envisage conformity to expectations of Christian devotion, yet also a refusal to perform difference through a display of "exotic" music. The decision to underline pictorially the Hispanic elements of colonial Andean culture reveals a certain desire for equality through cultural assimilation, and a rejection of the subordinate status associated with cultural difference that lay at the heart of the Spanish colonial vision of Corpus in Cuzco.

The familiarity with European music expressed in these works may also be intended to draw attention to the cultural flexibility, and therefore high social status, of their subjects. The prestige of the indigenous elite rested on its ability to draw upon the symbolic resources of both European and indigenous cultures. While the maintenance of certain traditional trappings of power was important to preserving authority within indigenous society, displaying selected signs of acculturation was equally important to success in the Hispanic world (Dean 1999, 169). Identification with European religious music, either professionally, as a sponsor of musical activities, or even through visual images in paintings such as the Corpus series, may have been a display of "privileged interculturality" on the part of aspirational native elites who sought to leave behind certain elements of their stigmatized Andean past—including, perhaps, native music—and assimilate with the colonial elite. Indeed, the implication of these paintings is that, in the context of Corpus Christi in mid-colonial Cuzco, difference was performed visually, for example through ceremonial dress and headwear, while assimilation was performed musically.

By focusing on the musical iconography of these paintings, then, we may be able to shed light on identity construction by the upper strata of Andean society. The inclusion of musicians in the paintings of the Hospital de los Naturales and Saint Rose and "La Linda" suggests that European music was significant to the self-image of their patrons. European music appears as a symbol of prestige, of religious devotion, of modernity and cultural flexibility, a symbolic element utilized by the native elite in the construction of "a postconquest identity that was other than the homogeneous 'Indian' of European manufacture" (Dean 1990, 356). Whether "traditional" music was seen as backward by some sectors of society is hard to determine, but these images seem to provide evidence that European-derived music was viewed positively by the native elite as an attribute of a forward-looking, culturally mobile identity.

The Silversmith's Art from the Viceroyalty to the Republic

Luis Eduardo Wuffarden

From the perspective of cultural history, the development of Peruvian silversmithing following the Conquest involves a series of changes that are as complex as they are surprising. In contrast to other branches of the arts, such as painting, metalworking had been widely practiced in the region for centuries. In fact, beyond mineral resources, which seemed inexhaustible, the first European colonists were struck by admiration for the technical skill of indigenous gold- and silversmiths, traditional *ayllu* communities and whole towns or villages being devoted to such work. This explains the effort made by the colonial administration to incorporate the native workforce, adapting its sophisticated techniques to the styles imposed by European masters. This process involved a fundamental change for local craftsmen and led to their abandoning their traditional iconographic repertoire that was associated with old religious beliefs. They instead put themselves at the service of Catholicism and the new modes of life in Creole society.

The so-called *lujo indiano*, or "Indian luxury," an image that was associated with the Spaniards of the New World and made Peru universally famous as a place of immense wealth, was based above all on the abundance of silver. Only thirteen years after the Conquest, in 1545, the Spaniards discovered the *Cerro Rico*, the "rich mountain" of Potosí, which not only nourished the legend and caused a sudden inflation in the European economy, but also (paradoxically) provided curious forms of "spiritual" justification for the rule of the Spanish monarchy in the Andes. Indeed, the defenders of the colonial system came to interpret this discovery as a gift of divine providence to those who had succeeded in incorporating the vast *Tahuantinsuyu*, the Inca Empire, into the universal Christian Church. It is therefore not strange that some paintings from upper Peru should represent the *cerro* of Potosí transfigured into the Virgin Mary, whose silver mantle protects the king of Spain and the pope, both of whom are shown praying at her feet (fig. 1).

Ecclesiastical Silverware

In a social context so thoroughly imbued with piety, it was to be expected that items for ecclesiastical use should be by far the most numerous and most precious, prized not only for their intrinsic value but also for their rich ornamentation. This became clear in the period from the second half of the seventeenth century to the end of the eighteenth, which saw the rise to its apogee of "American baroque" church plate and treasures (Esteras Martín 1997; Stastny 1997). Among the most original and impressive Peruvian works were portable monstrances, in which the host was displayed to be venerated by the faithful, either inside the church or in religious processions (cat. 157). They consist of a base or pedestal into which a vertical, highly ornamented element is inserted. This element in turn supports an image of the sun, in the center of which the Sacrament is placed, surrounded by resplendent shafts in the form of the sun's rays. Strong evidence of the importance of these treasures for the Andean imagination is to be found in the many pictorial representations of the adoration of the Eucharist or its allegorical defense against the infidels by the king of Spain (cat. 158).

A similar purpose was served by the large monstrances or reliquaries in the form of a pelican (symbolizing Christ's sacrifice) held in some monasteries in Lima, Cuzco, and Arequipa (cat. 174). Lecterns, sumptuous stands on which to display the Holy Scriptures, were more directly connected with the liturgy of the mass. They consist of thick layers of embossed silver on a wooden frame (cat. 176), covered in relief decoration, with motifs in the "mannerist grotesque" style, combining luxuriant vegetation with imaginary figures and rigorously filling the whole available space. Their technique and ornamental structure mean that lecterns are closely connected with altar frontals and with a type of rectangular salver for use in churches (cat. 177), another item of prime importance among silverware made under the Viceroyalty. Significantly, all these forms seem to echo the decorative vocabulary of Southern Andean architecture of the time, in which the "planiform" or mestizo style is predominant.

In the final years of the Viceroyalty, widespread economic difficulties brought

Fig. 1. Anonymous, *The Virgin Depicted as the "Cerro Rico de Potosí"*, About 1740, Museo de la Casa Nacional de Moneda, Fundación Cultural BCB, Potosí, Bolivia

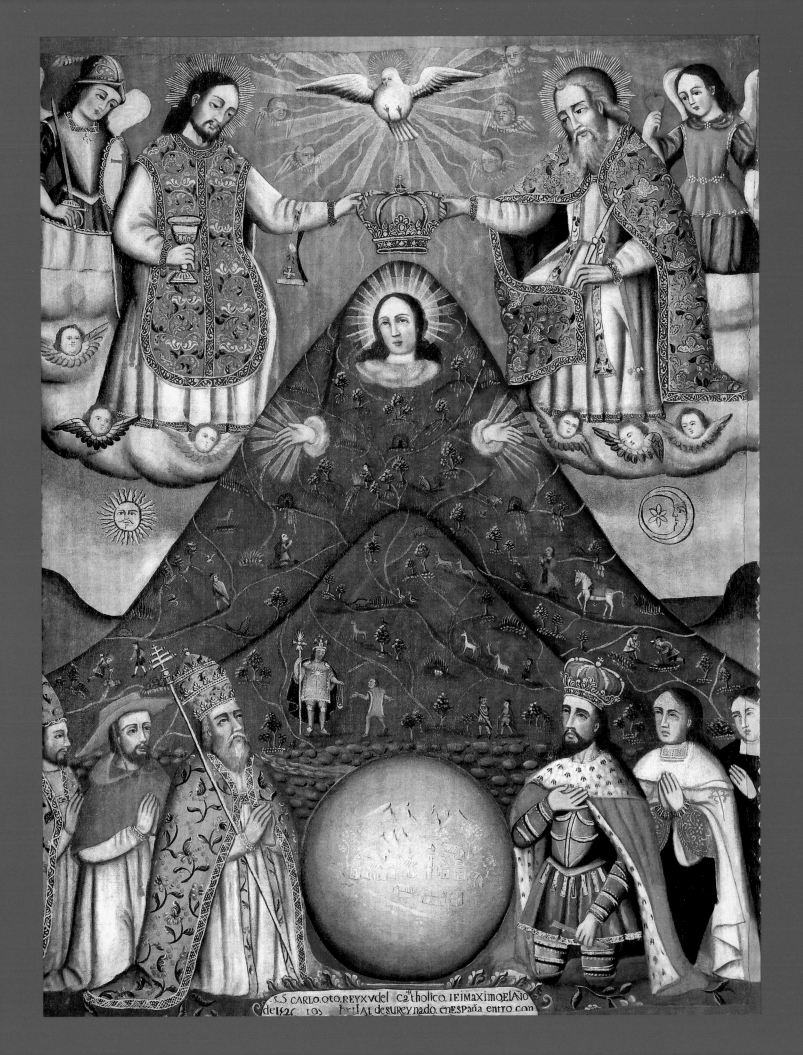

S.S CARLO. Q.TO. REY X.V.DEL C.a.tholico. I.E I MAXIMO ELAÑO
DE1.5.2.... LOSrIAL DESVREYNADO. ENESPAÑA ENTRO CON

174.
ANONYMOUS
EUCHARISTIC URN IN THE SHAPE OF A PELICAN
About 1750–1760

Peruvian gold- and silver-smithing reached high levels of development during the colonial period. Ostentatious pieces of silverware found a place in both secular and religious settings. Especially important in the religious context was the making of altar frontals and other objects for liturgical use, such as monstrances and Eucharistic urns.

The example shown here, probably made in a Lima workshop, is one of the finest and most elaborate of its type that is known. It was made entirely in silver, without the wooden frame often found in similar pieces. Gold decoration has been added to the heart and the crest of the pelican, which is encrusted with precious stones. Its pre-

sumably high cost has led Cristina Esteras (2004) to believe that it may have come into the possession of the convent of Augustinian Recollect nuns in Lima as the result of a private donation. She also suggests that it was made shortly after 1748, that is, at the same time as the Monastery of Nuestra Señora del Prado was being reconstructed following the severe earthquake that struck the capital of the Viceroyalty in 1746.

As was usual for works of this type, this urn was an integral part of the temporary altars made for the celebrations of Holy Thursday. The inclusion of the pelican feeding her young with blood from her own breast comes from the Christological significance that the bird has had since late

antiquity. According to the medieval bestiary known as the *Physiologus* (*Version Y*, ca. IV century A.D.), the pelican killed her chicks, mourned them for three days, then sprinkled them with her blood and thus brought them back to life. A number of medieval writers seized on the observations of the *Physiologus* and made an analogy between the pelican's behavior and Christ's charity in redeeming humanity with his own blood. The Christological symbolism of the pelican was universally accepted, and in the modern era it has continued to appear on monstrances and Eucharistic receptacles.

S.F.

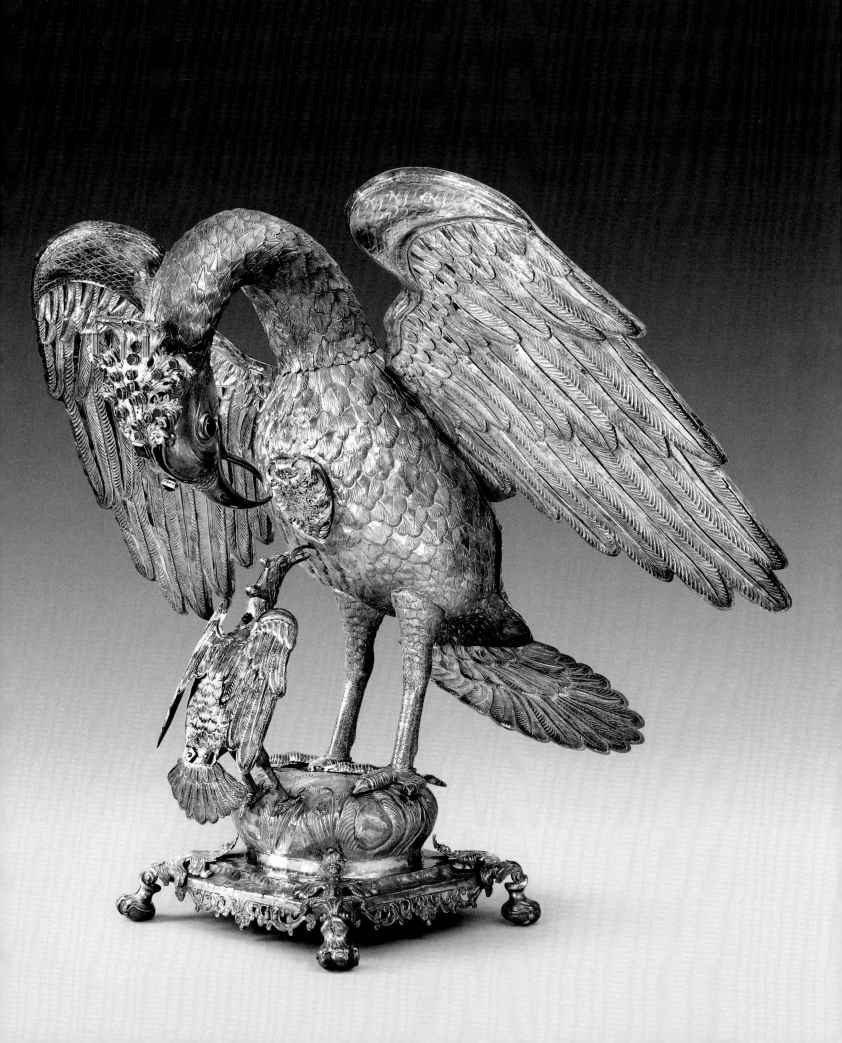

about an understandable decline in ecclesiastical patronage. The secularization of religious practice was accentuated in the early days of the Republic, and hardly any large pieces of church silver were commissioned. On the other hand, the new times provided opportunities for ever greater civil and popular initiatives, expressed in a wide range of religious objects. These included votive offerings, made at the request of fraternities, their patrons, and individual devotees. Gratitude was also expressed by providing the effigy of a saint with an *ajuar* ("dowry" or "trousseau"), adorning it with haloes, crowns, and other attributes, or even dressing it completely in the white metal (cats. 178, 180).

But as one might expect, patriotism was predominantly expressed through secular objects. So, for example, colonial-style incense-burners had interesting, overtly republican counterparts in the Andean interior. They took the form of an armadillo, whose body appears adorned with a neoclassical garland and sometimes displays the Peruvian coat of arms, introduced in 1825 (cat. 175). Curiously, this design reflects an old European allegory of the New World, created in the sixteenth century and revived in keeping with nineteenth-century taste. It was apparently based on a drawing by Martín de Vos, engraved by Adrian Collaert in 1589 for a series depicting the "four parts of the world" (Mujica Pinilla 2009). Thus the idea of an American nation, stimulated by pan-continental liberation movements and the integrationist thinking of the *Libertador* Simón Bolívar, gave rise to this exotic allegorical representation, which is usually crowned by the figure of an indigenous American in the role of the "noble savage."

The Tupu, Ancient Survival

Among items of silverware made for personal use, the *tupu* is an exceptional example of survival through time, given that it has been, without interruptions, a feature of the Andean world from the pre-Inca period until the present day. *Tupu* or *topo* is, in fact, the generic name for various types of metal ornament, like a brooch, worn by indigenous women to fasten their clothes. They consist of a sharp pin, the utilitarian part, and a decorative "head," which may take many forms. From the earliest times they have been made in copper, bronze, and especially silver, probably because of its ancient association with the tears of the moon, or *quilla*, and as such, with the worship of a Moon goddess identified with the female aspects of the cosmos (cat. 187).

It is significant that the word *tupu*, with its variants and derivatives, appears in the first Quechua and Aymara glossaries compiled by remarkable Jesuit lexicographers in the early seventeenth century. First, there was the *tupu* properly speaking, or the *phitu*, consisting of large pieces used in pairs to fasten the *axso* or *saya* at the neck. Worn like that, *tupus* were tied together with woolen cords or thin metal chains, from which their decorative "heads" were suspended (Vetter Parodi and Carcedo de Mufarech 2009). The word *tupu* was also applied to the most common variant, the *ttipqui* or *picchi* (Bertonio 1612). *Ttipquis* are fastened individually and horizontally on the *liclla*, or mantle, and are the best-known form of *tupu*, not only because so many exist, but also for their decoration.

As far as pre-Columbian Peru is concerned, almost all the major Andean cultures used such objects. Following the Conquest, *tupus* appear to have been quickly adapted for use in new circumstances. They continued to identify women of the indigenous aristocracy, which was recognized by the colonial administration, and frequently appear in wills and inventories of the time, as well as in portraits of native donors depicted at the feet of venerated images. It is therefore logical that their use should have reached a peak during the so-called "Inca Renaissance," from approximately 1680 to 1780 (cat. 171).

Among *tupus* from the period of the Republic, the type most frequently found, especially in the Southern Andes, is perhaps the one given the name of "spoon" (cat. 188). While there are precedents for it in the eighteenth century, everything suggests that it was after the great rebellion of Túpac Amaru that this design began to gain ground, perhaps because it looked more "inoffensive," in symbolic terms, than the *tupus* decorated with motifs taken from Inca heraldic iconography (Stastny 1981, 245–247). Spoon *tupus* had most or all of their decoration in their concave area, made with a burin, or engraver's chisel. The decoration is romantic in nature, and includes subjects ranging from birds and plant motifs to mermaids, and even representations of the sun and the moon (cat. 182).

Fiestas and Dances

Through their persuasive ceremonial devices, the major celebrations that were held under the Viceroyalty helped to form collective identities, both around specific religious observances and at other regularly recurring events in the civic calendar. The power of the *fiesta* to mobilize groups of people and to create shared cultural patterns continued to exert a powerful influence over Andean society after the Independence, thanks to the cohesion confraternities, and the prestige of a number of honorary positions. They included the *alferazgos* or *mayordomías*, leadership positions that every year fell upon local notables, who were responsible for meeting the costs incurred in holding a particular festivity. It was a system that created complex relationships of emulation and competition among the various communities and corporations.

In the central sierra, the silver finery identified the Christmas *comparsas*, or troupes of processional dancers, of Huánuco and Huancavelica. Between Christmas and Epiphany, troupes of *negritos* would run through the streets, stopping to pay homage to the Infant Jesus at the Nativity scene installed at each church. For that reason they were led by a "chief," who carried whips, called *chicotillos*, which were used to "control" his subordinates in ritualized fashion (cat. 190). They are beautifully made, in several jointed pieces, with little figures of *chunchos* ("Indians"), *negritos*, and animals on the handle, and bunches of little bells on the end. They were still recorded as in use in 1940 at the *fiesta* of San Miguel in the town of Moya, Huancavelica (Majluf 2004a).

Closely connected with them are the *varas* or dance staffs carried at these events,

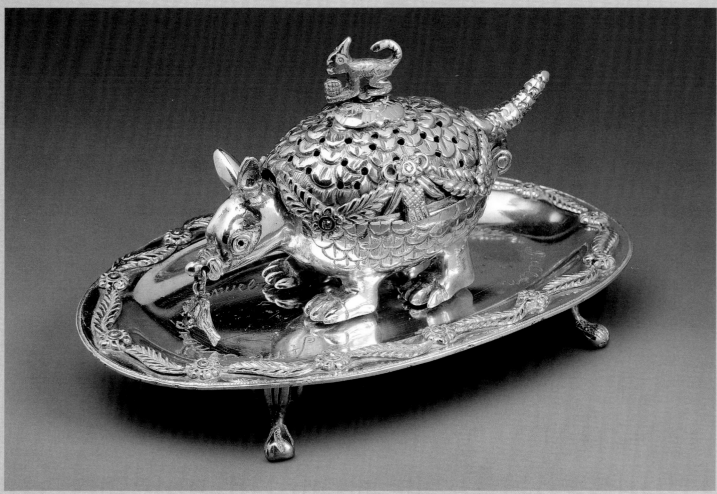

175

176

177

175.
Anonymous
**Incense burner in the
shape of an armadillo**
Second half
of the 18th century

176.
Anonymous
Missal stand
18th century

177.
Anonymous
**Tray with poppies
and chinchillas**
About 1730

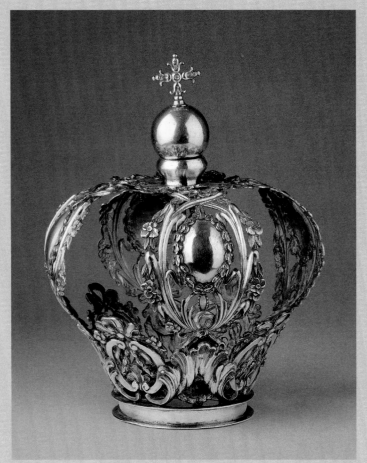

178

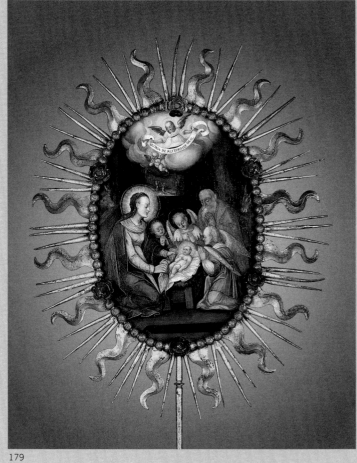

179

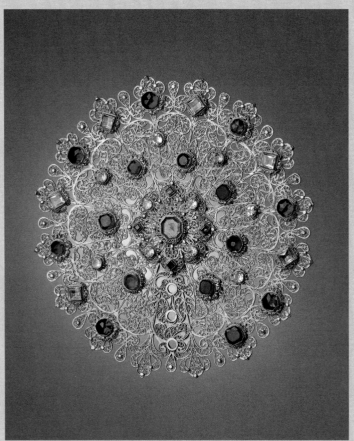

180

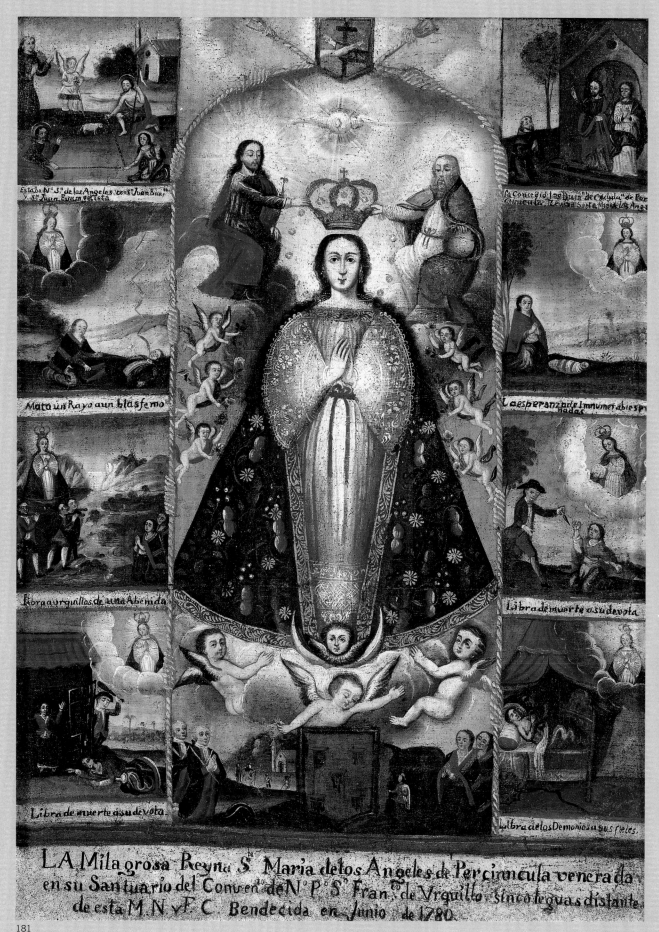

Estaba Na Sa de los Angeles con Sn Juan Bau.
y Sn Juan Evangelista

Mata un Rayo a un blasfemo

Libra a Urquillos de una Abenida

Libra de muerte a su devota

La Concegid las Biuda de Cecilia de Por-
Cinncula, teniad Santa Maria de los Ange

L a esperanza del innumerables pr
nadas

Libra de muerte a su devota

Libra de los Demonios a sus fieles.

LA Milagrosa Reyna Sa Maria de los Angeles de Percinncula venerada
en su Santuario del Conven de N P S Fran de Urquillo sinco leguas distante
de esta M N V F C Bendecida en Junio de 1780

181

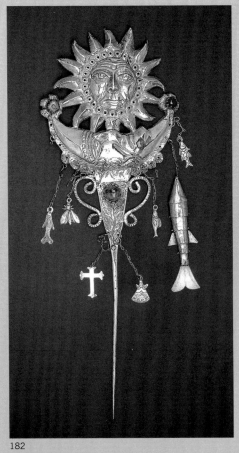

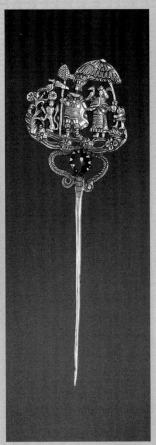

182

183

184

185

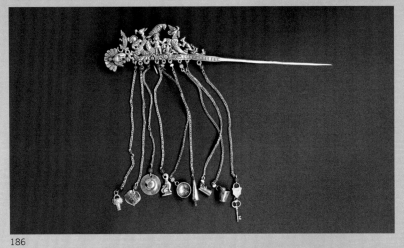

186

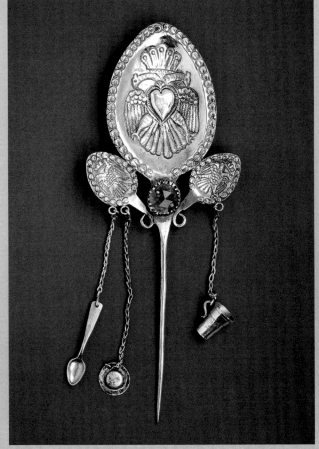

187

188

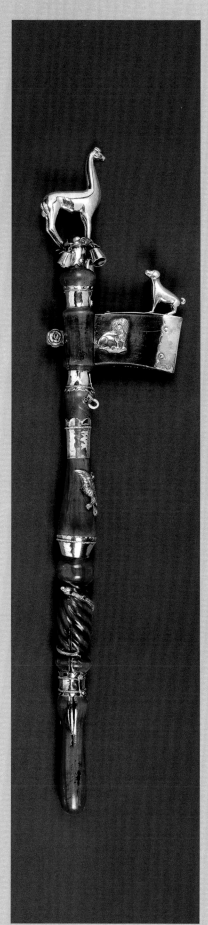

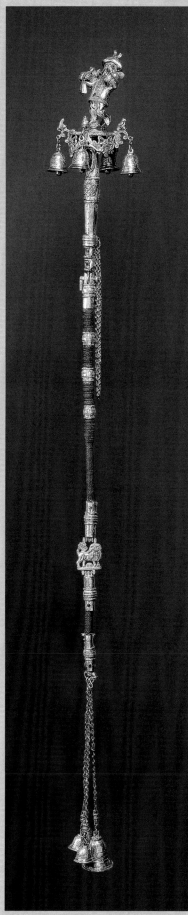

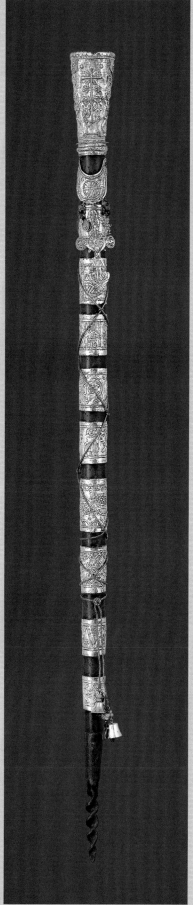

189

190

191

192

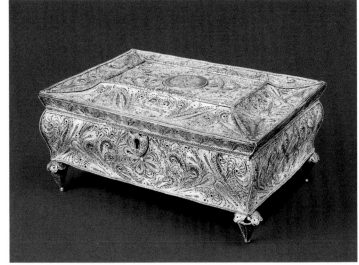

193

made of wood covered in silver and decorated with figures, charms, and precious stones. On the end of the staff, carried by the *mayordomo* or patron of the *comparsa*, there was a sculpted image evoking the *fiesta*. A bunch of small bells suspended from it marked the rhythm of the dance.

The Art of Filigree

Although the art of silver filigree was known to the ancient Peruvians, under the Viceroyalty their knowledge was combined with the new styles that had arrived from Andalusia. Its basic technique consists of twisting and weaving together thin silver wires to create a fine metallic mesh. Items were made in that way under the Viceroyalty in various parts of the country, from as early as the seventeenth century, but it was only with the Republic that the art really reached its height. That late flowering of filigree was primarily an ingenious response by silversmiths to the problems posed by the increasing scarcity and cost of silver.

Evidence suggests that in the modern period this delicate art first reached a peak in the Huamanga area and in the Mantaro Valley. Huamanga appears to have become increasingly famous for its silversmiths in the course of the nineteenth century, when demand in the capital was growing and when the best examples of filigree were produced.

In his wordy account of everyday life in Lima from 1884 to 1887, Pedro Benvenuto emphasizes the presence of these small silver pieces in the capital's homes, especially at Christmas (Benvenuto Murrieta 2003, 301). For many years, shops in Lima sold filigree work from the Ayacucho region. It ranged from objects for personal use—cigarette cases, pillboxes, and card cases—to a variety of miniatures and "playthings," among them complete sets of tiny furniture, designed for doll houses or Christmas cribs (cats. 192, 193). That was the origin of cheap, easily transportable tourist souvenirs. With these lightweight pieces, made in a huge variety of neo-baroque decorative forms, twentieth-century Peruvian silversmiths not only reinvented traditional designs with great virtuosity, but also created new ones, demonstrating their vitality and their vigorous presence in contemporary Andean culture.

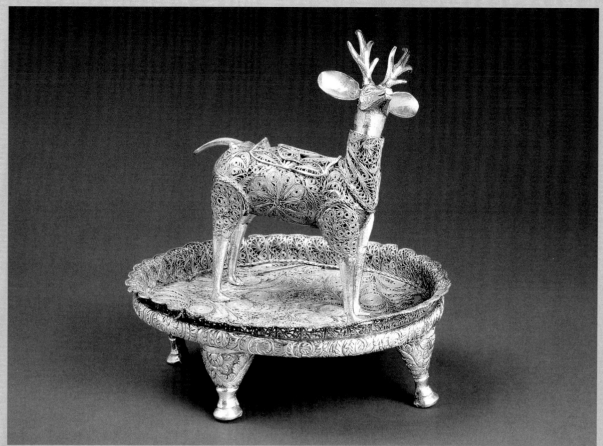

194

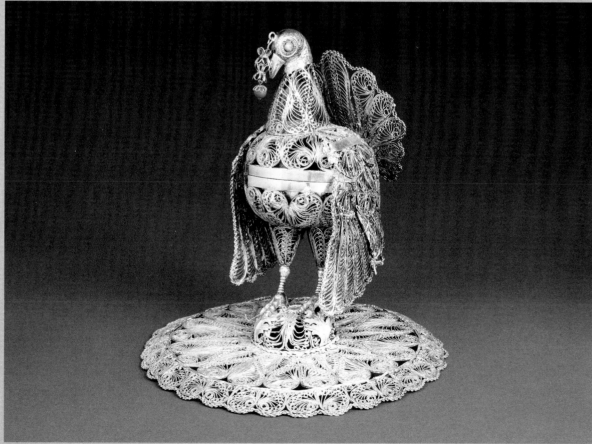

195

Architecture under the Viceroyalty and the Republic

José García Bryce

Architecture and urban development were important tools in establishing Spanish rule in the Andean territories that became present-day Peru. Alongside its geography, they set the framework for the gradual process of Occidentalizing indigenous cultures through settlement, the new legal system that was established, and evangelization.

The foundation of new cities was a central factor in exploiting the territory, running its economy, exercising authority, and implementing the massive program of evangelization of indigenous peoples conducted under the authority of the Crown and the Church. The highly developed physical and administrative infrastructure of ancient Peru was the starting point for the creation by the Spaniards of a network of cities, beginning in the sixteenth century. These new cities were strategically located in terms of agriculture, mining, or transport. Some were built on the site of existing cities, such as Cuzco, the capital of the Inca Empire. The plan of a Hispano-American city was a checkerboard or grid around a central plaza. Located in the plaza were the principal church, the office of the town council, and the houses of leading citizens. The plaza was also the place for business transactions, civic and religious ceremonies, public performances, and executions. This type of town plan was also adopted for the Indian settlements, or "reductions," where sections of the indigenous population were forced to live for the purposes of more effective social

control, the collection of taxes, and religious indoctrination.

Peruvian versions of European architectural types and methods were generated from the beginning. With the Conquistadors came craftsmen, who started to apply the architectural techniques and conventions with which they had been familiar in Spain, using indigenous people as their workforce. In time, those working in the building trades began to form guilds and corporations, whose membership included both Spanish and indigenous master builders and craftsmen, as well as those of African origin. The existence of rich pre-Hispanic traditions of design and construction was an important aspect of the "new" architecture.

Colonial Religious Architecture

Religious architecture was the most prestigious. Convents and monasteries occupied one or more city blocks, and their towers and domes dominated the skyline. The typical convent took the form of cloisters surrounded by all the facilities needed by the religious community: large communal areas, including the refectory and chapter house, groups of cells, a place for the seminarians, the infirmary, kitchens, laundries, housing for servants and other employed people, farmyards, stables, and gardens. The most important areas were situated in the first cloister, which was accessible from the street through the porter's gate and was directly connected with the order's church (fig. 2, p. 220).

Church building types differed according to whether they were urban or rural, whether they belonged to the diocese or to a religious order, and changed as styles of architecture evolved. The oldest type shows the influence of the "Isabelline" architecture of Spain, with a nave and chancel separated by a large triumphal arch and an octagonal apse. Their wooden roofs could be of the collar beam, the *alfarje* (paneled ceiling), or the coffered type, often showing Mudéjar influence. In new churches or those rebuilt in the seventeenth century, this type began to be replaced by one based on the Latin cross, with vaulted roofs and a dome above the crossing (fig. 1, p. 219). This type is associated with the Counter-Reformation, whose doctrines permeated the activities of the Church and strongly influenced the development of religious art in the Baroque period.

A processional plan of three naves, with the canons' choir in the middle of the central nave, was adopted for cathedrals, notably those of Cuzco and Lima (fig. 3, p. 220). The cathedrals, and many conventual churches, had side chapels ranged along their naves. They could be allocated for the use of sororities or fraternities, and dedicated to the church's patron saint or virgin. Some belonged to distinguished families, whose tombs were often located there. The vestibule of a church was also frequently used for burials.

Stone was used for building in the sierra, and brick (as in Spain) on the coast, combined with adobe, wood, and *quincha*,

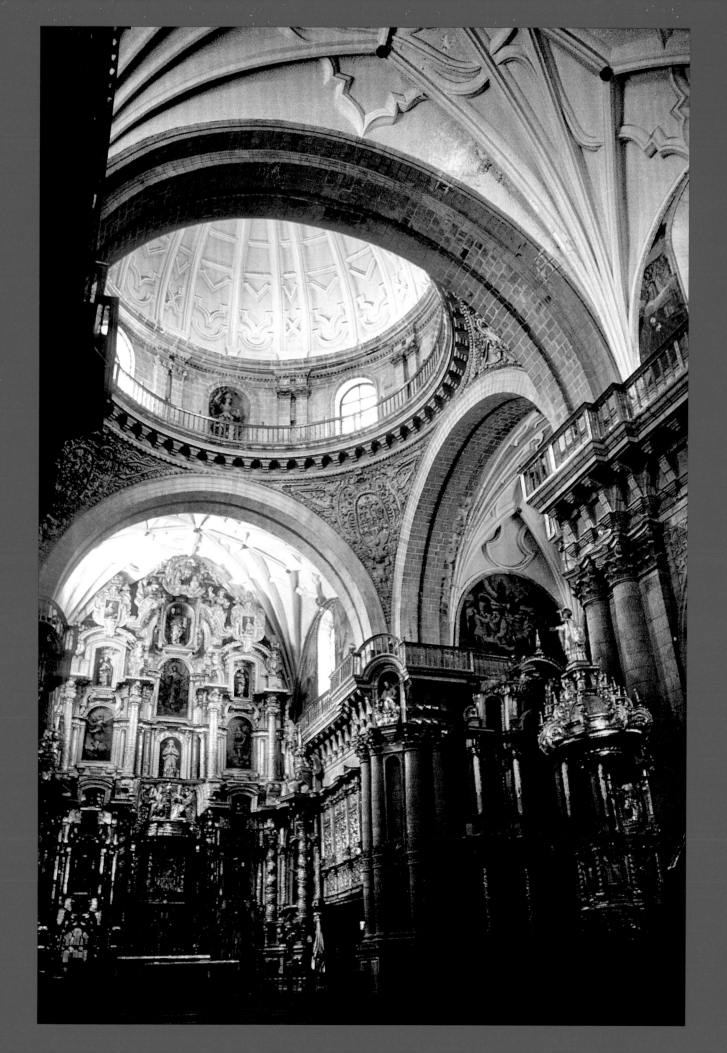

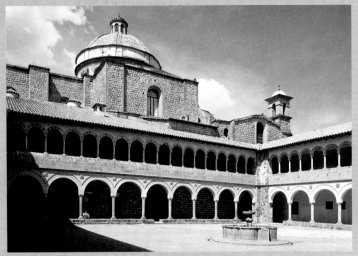

Fig. 2

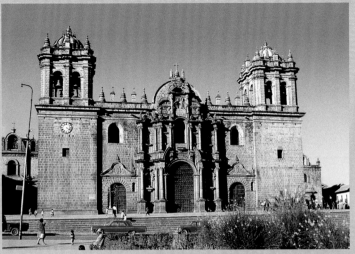

Fig. 3

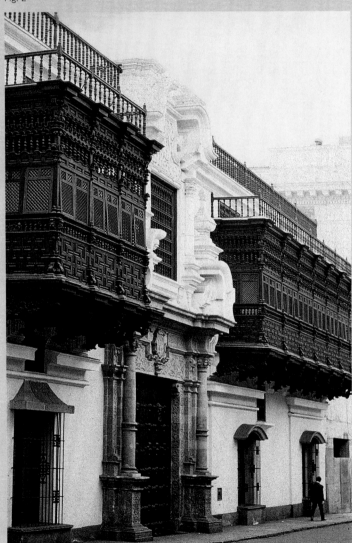

Fig. 4

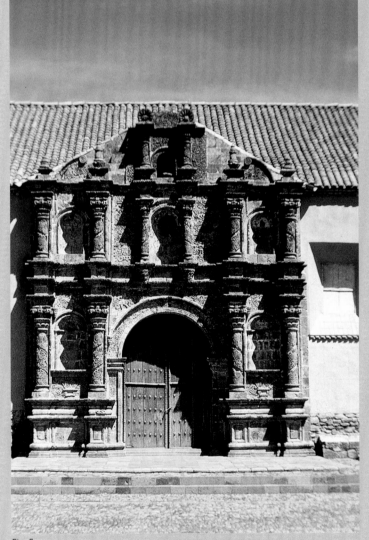

Fig. 5

Fig. 2
Cloister of the old Jesuit
College and Church
of the Society of Jesus,
Cuzco
Mid- to late 17th century

Fig. 3
Cuzco Cathedral
Early to mid-17th century

Fig. 4
Torre Tagle House, Lima
About 1735

Fig. 5
Lateral door
of the Church
of San Juan, Juli
18th century

which consisted of wood, cane, and mud. Brick or stone arches were a novelty in Peru. The main problem that arose when this building system was introduced in the Andes was the risk of earthquakes. In Lima and on much of the coast, brick was gradually replaced by *quincha*, which had been widely used in pre-Hispanic Peru and was better able to withstand quakes.

The principles of decorum required that the entrance to the church be embellished by a porch with columns or pilasters, an entablature, and niches. The porch acted as a large external altarpiece for the ceremonies celebrated outside the church, and as a background for the performance of plays with a religious theme. It was also a place where religious images could be displayed at the service of the emphasis placed by the Catholic Church on devotion to the Virgin and the Saints, in contrast with the restrictive practices of Protestantism. In the interiors of the churches, that was the function of the altarpieces, whose architectural composition is similar to that of the porches. In the interiors, the combination of powerful architecture, altarpieces, polychrome sculpture, wall paintings, and paintings on wood panels or canvas creates a densely rich impression, which must have had a dramatic impact on the faithful, stimulating their devotion and bringing them, when possible, to a state of mystical ecstasy. In the spirit of the Council of Trent, every artistic and architectural resource was drawn upon in the effort to disseminate Catholic belief and dogma most effectively. The fact that this activity was being pursued in a society in the process of evangelization, where efforts were being made to eradicate ancestral indigenous beliefs, was a fundamental factor that accentuated the need to impress, attract, and persuade. The religious message had to be simple and understandable, and it had to be capable of reaching all the members of a very hierarchical society, made up of castes and social groups that differed markedly from one another.

Secular Colonial Architecture

In Peru, colonial Baroque architecture displayed clear regional stylistic tendencies, oscillating between the European and the Andean ends of the spectrum. The former, which was to a certain degree erudite or academic and followed the rules, reflected the pressure towards uniformity imposed by imperial Spain on its overseas possessions. The latter reflected a Hispanized Peru, but one in which there emerged an increased awareness of what was local and non-European. Features of this tendency included cultural hybridization and the underground survival of various manifestations of ancient cultures and beliefs. The late seventeenth- and early eighteenth-century architecture of Puno and Arequipa, dubbed *mestiza* (hybrid), can also be seen in relation to this second tendency (fig. 5, p. 220). The vernacular architecture of small towns, country houses, and rural areas had a similar character.

From the sixteenth century onwards, hospitals were built, either under the jurisdiction of the town council or administered by one of the religious orders. These hospitals would be situated in the outskirts of a town, in places that were airy and had a good supply of water. In Lima the main area for hospitals was near the *huaca* of the Oráculo del Rímac, in the Barrios Altos district. There were three hospitals there, providing for different ethnic groups: San Andrés for Spanish, Santa Ana for Indians, and San Bartolomé for people of African descent. There were also divisions by status or social function—for priests or for sailors, for example. In these hospitals the main area was the infirmary, which often took the form of a Greek cross, with the altar in the crossing. They were modeled on Spanish hospitals of the sixteenth century.

There was a wide range of housing types in colonial Peru. It included the *callejón* or "narrow street," the farmworkers' quarters on the haciendas, the small two- or three-roomed houses of the modest employee or craftsman, the large, luxurious home of the senior official, the prelate, or the wealthy businessman, and a series of intermediate types. The houses of the upper classes showed the influence of Iberian models and were part of the Mediterranean tradition brought to the Americas by Spain. They were enclosed within an outside wall and had one or more courtyards.

The main features of a large or medium-sized Viceregal Peruvian house were the entrance hall, which was accessible from the street via a gate wide enough to admit mules with their loads, riders with their horses, and even carriages; the main courtyard; the living room; the *cuadra* (the family's bedroom); the chapel (or at least a place for a small altar); and an indeterminate number of rooms and anterooms for the use of the owners, their immediate family, and other dependents. In addition to these rooms there would be a kitchen, a place for washing, a stable, bedrooms for employees and servants, and living quarters for house slaves.

The walls of these houses were built mainly of adobe, and their floors and roofs were wood. The adobe could be reinforced with brick, or in the sierra, with stone. With time, and influenced by earthquakes, the use of *quincha* became widespread in Lima and on the coast for building the upper stories. Rainfall in the sierra meant that roofs had to be pitched and covered with thatch or tiles; on the coast they were flat and covered by a thick layer of mud. Houses in Arequipa did not follow the same patterns, but were built of dressed stone with vaulted ceilings of stone or a combination of stone and brick.

The most conspicuous features of the façades were the grand doorways and—especially in Lima—the enclosed balcony, also called "box balconies" (fig. 4, p. 220). These doorways may be seen as an architectural element that demonstrated noble status, and they could also be a place in which to display a family's coats of arms. With its impactful and aristocratic character, the Baroque was a very suitable style for expressing such ideas. The enclosed wooden balcony with its slatted shutters demonstrated, like the Mudéjar paneled ceilings, the survival of Muslim features in Hispanic colonial architecture. Like the types of entrance hall that hid the courtyard from view from the street, the enclosed balcony was a product of the strict separation between private and public, and of the perceived necessity of concealing the woman's domain and the life of the home.

Architecture in the Republic

Two parallel phenomena mark the architecture of nineteenth-century Peru: on one hand, the survival of traditional house types

and the majority of colonial building methods, and on the other hand, the appearance of new architectural models and the introduction of cast iron as a structural material, as well as a certain degree of industrialization of trades such as carpentry and ironsmithing. The more modest houses continued to be built following the traditional types until the twentieth century, and in many places they are so today. The "courtyard house" persisted in Lima until the late nineteenth century and until the 1920s or 1930s in other cities. It was the style that changed: the colonial Baroque associated with Spanish rule gave way to a sober classicism that reflected the republican spirit of independence (fig. 8, p. 223).

The prosperity that came in the middle of the nineteenth century with the exploitation of guano and the growth of maritime trade set the country on a path of modernization that favored Lima and the coast in general. In the fields of architecture and construction, this transformation was connected with the appearance in Peru of professional engineers and a new type of academically trained architects, who gradually replaced, for major building works, the old master craftsmen. Mention should be made of the establishment in 1872 of the Cuerpo de Ingenieros y Arquitectos del Estado (Association of Engineers and Architects of the State), the association of government engineers and architects, and the foundation in 1875 of the Escuela de Ingenieros Civiles y de Minas (School of Civil Engineers and Mines).

Although some major churches were built in the nineteenth century, religious architecture no longer enjoyed the same preeminence as under the Viceroyalty, due to the process of secularization that affected the whole of the Western world from the 1800s. Meanwhile public buildings gained in importance. The influence of the modern architecture of Europe and North America is apparent in Lima's new public buildings, the first such project being the market. The introduction of a new architectural type can be seen even more clearly in the case of the penitentiary (fig. 6, p. 223), which took for its model the new panopticon, a circular prison with cells arranged around a central well, built around that time in a number of North American cities. In the Dos de Mayo Hospital, the colonial model was put aside and replaced by the "pavilion" system, first introduced into European hospital architecture in the 1770s. A new nineteenth-century architectural form, the national pavilion, designed specifically for international exhibitions, was represented in Lima by the Palacio de la Exposición (fig. 9, p. 223), which was the principal building at the Exposición Nacional, a symbol of the period of public investment associated with the government of President José Balta. The Parque de la Exposición, where the event was held, was Lima's first public park. To a greater or lesser degree, these projects embodied the ideas of service to the community and the sense of civic identity and collective well being. In the context of nineteenth-century republican Peru, they were both socially and architecturally innovative. The demolition of Lima's defensive walls made it possible to create the Parque de la Exposición, speeding up the process of change and marking the beginning of the expansion of the city and the creation of new districts.

Peru's provincial cities changed more slowly, but from the 1840s on, new municipal and administrative buildings, customs houses, barracks, and warehouses had started to appear in a number of them. The new cathedral was built in Arequipa (fig. 7, p. 223) and the principal churches of Tacna and Chiclayo a little later. The heterogeneity and eclecticism of the monumental architecture of the Republic are clearly visible in those two churches.

From 1900, the process of modernization and "Europeanization" that had started under President Balta became more marked. The architectural aspirations of the upper class manifested themselves in the houses they built along the new avenues then opening up—the Paseo Colón and La Colmena—while "official taste" expressed itself in public architecture, including the Cripta de los Héroes (commemorating the dead in the War of the Pacific) and the Palacio Legislativo, the parliament building (fig. 10, p. 223). A new generation of architects, both foreign and Peruvian, trained in Europe, helped to spread the principles and the practice of French-style academic architecture—the Beaux-Arts style.

Portland cement, which, with iron and steel, contributed to the emergence of a new type of global architecture, began to be imported around 1900. The first buildings of reinforced concrete soon appeared in Lima, and in the 1930s traditional materials like adobe and *quincha* began to fall out of use.

One of the most interesting phenomena of that period was the development, from about 1910, of the currents that make up what could be called "Peruvianist" architecture: the neocolonial and the *indigenista*, and the combination of both in the *neoperuano*. Together with European or North American eclecticism, architectural *peruanismo* gradually disappeared in the mid-twentieth century when, from around 1945 to 1950, the conventions of international modern architecture began to assert themselves.

Fig. 6

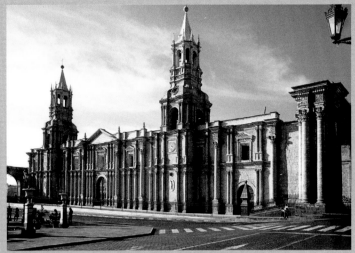

Fig. 7

Fig. 8

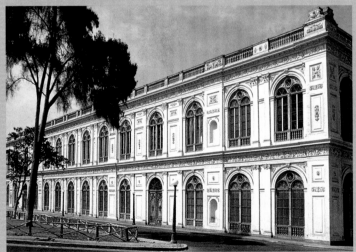

Fig. 9

Fig. 10

Fig. 6
Prison, Lima
1856–1860

Fig. 7
Arequipa Cathedral
Mid- to late 19th century

Fig. 8
Iturregui House, Trujillo
1842

Fig. 9
**Palacio de la Exposición,
Lima**
1870–1872

Fig. 10
**Chamber of Deputies
in the Parliament, Lima**
About 1908

PERU:
CONSTRUCTION
OF A NATION

The Birth and Rise
of Peruvian Indigenismo

The concept of a nation as a community bound together by a common language or culture is a lasting legacy of modernity. It is therefore difficult to imagine that Peru, like all other countries of the Americas, was no more than an administrative unit and a political idea when it won its independence from Spain. The modern sense of the word "nation" gradually established itself over the course of the nineteenth century, and with it came the idea of national art as the aspiration of a common quest and a program of action.

Against that background, Francisco Laso (1823–1869) and Luis Montero (1826–1869), two artists who were born at the time the Republic was founded and were trained in contemporary art schools in Europe, gave in two key works early indications of the divergent routes that Peruvian cultural nationalism would take in the following century. With his huge, ambitious canvas *The Funeral of Atahualpa*, (fig. 3, p. 230–231) painted in Florence in 1867, Montero introduced history painting to South America by attempting to visually reconstruct the pre-Columbian world that was the setting for the birth of the nation at the moment of the Conquest (Majluf 2011). Given its high ambition and the nature of its subject, the painting would come to occupy a crucial position in the country's official visual imagery. Laso's *Inhabitant of the Peruvian Highlands* (1855) (cat. 200), on the other hand, had a less fortunate history. It is a painting which, if it did not receive the same recognition, in time came to rep-

resent Peruvian cultural nationalism in a more permanent way. In it, the figure of an indigenous man of the day presents to the spectator a ceramic vessel representing a Moche prisoner, creating a double allegory of oppression that gives the work a clearly political meaning. And in that way, Laso established the indigenous not only as an enduring cultural resource, but as the very foundation of nationality.

The works of Laso and Montero thus offer two alternatives for a national art, placing in opposition archaeology and history to ethnography, the past to the present, and a presumed objectivity to the adoption of a political position. But despite these differences, both alternatives rest on a dualistic idea of the Peruvian nation, defined by the opposition between what is Hispanic and what is indigenous. It was that second, long-relegated element that would assert itself on the threshold of the twentieth century, when in Peru, as in the rest of the world, a new form of cultural nationalism arose, based on concepts of authenticity and originality, from which "Hispanism" would be largely excluded. The rise of these new ideas coincided with the foundation in 1919 of the Escuela Nacional de Bellas Artes (ENBA), an official body that helped establish the visual arts in the public sphere in Peru. Led by the academic painter Daniel Hernández (1856–1932), two young professors, Manuel Piqueras Cotolí (1885–1937) in sculpture and José Sabogal (1888–1956) in painting, mapped out from the ENBA two distinct routes towards a definition of a national art (fig. 1).

The option chosen by Piqueras in many ways evokes the archaeological and historicist position that Montero established with *The Funeral of Atahualpa*. His "neo-Peruvian" approach was an attempt to reconcile Hispanic and local traditions through a fusion of their most characteristic architectural styles. Following those ideas, the façade that he designed for the National School of Fine Arts was intended to define the institution's nationalist program, under the assumption that styles in art were the complex expression of a culture and a society (fig. 2, p. 229). The decorative motifs of pre-Columbian textiles, wood sculptures, and ceramics would thus join motifs derived from colonial architecture to produce a harmonious synthesis of the two symbolic components of nationality, which until then had been seen as opposite poles in the Peruvian intellectual imagination (Wuffarden 2003).

The idea of the artistic traditions of the past as an expression of a national spirit and a formative element of identities was reinforced in the work of Elena Izcue, an ENBA graduate who was close to Piqueras. From her early days as a schoolteacher in Lima to her later career as a textile designer in Paris, Izcue tried to revive the patterns and motifs of pre-Columbian art for use in modern design. Following many years of systematic study in Peruvian museums, she published *El arte peruano en la escuela* (1925), a publication that, like other similar Latin American works, offered an approach to drawing that would help define national

Fig. 1. José Sabogal, *Chief (Varayoc) of Chinchero*, 1925, Pinacoteca Municipal "Ignacio Merino" de la Municipalidad Metropolitana de Lima

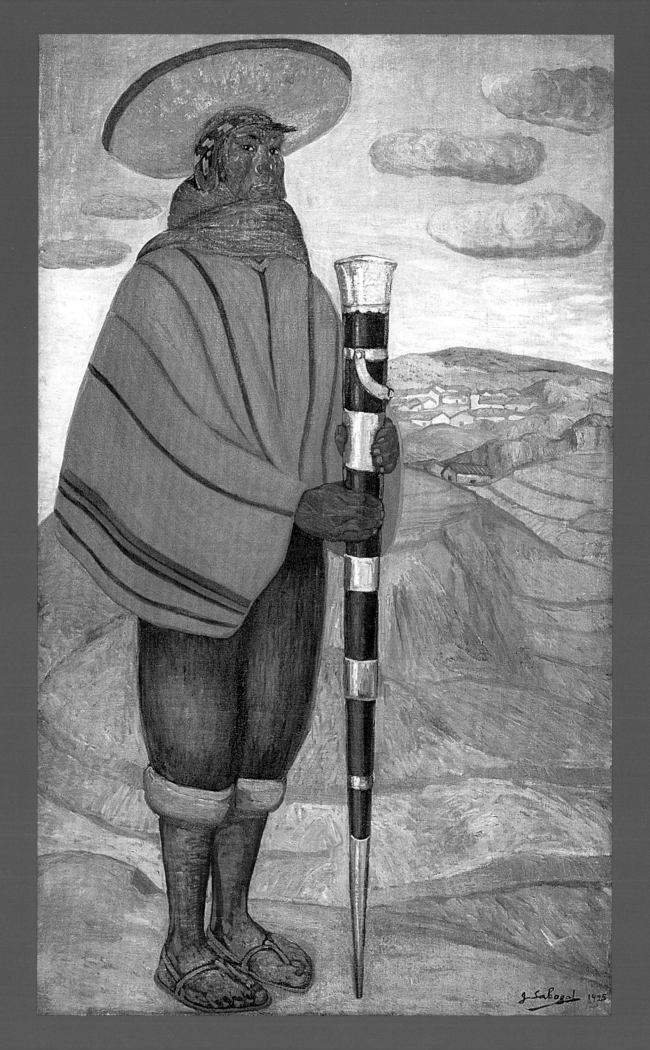

identity on the basis of the pre-Columbian legacy (Majluf and Wuffarden 2008) (cat. 317, p. 358).

In the face of the ignorance that prevailed at the time, figures like Izcue and Piqueras played a fundamental role in the process of validating and disseminating pre-Columbian art as an aesthetic category with its own worth. But with a few exceptions, the archaeological models did not manage to be fully integrated in contemporary creation. On the one hand, it proved difficult to incorporate its motifs into the type of figurative painting that predominated in Peru until the mid-twentieth century. On the other hand, the descriptive nature of painting did not favor historicist representations, but rather tended to focus attention on contemporary subjects.

That idea was the mainstay of the aesthetic program introduced at ENBA by José Sabogal. Following the pattern initiated by Laso, under Sabogal's direction local subjects became the central focus of Peruvian painting. At ENBA he promoted the use of indigenous models in drawing classes (cat. 196); outside the lecture theater, he encouraged his students to take long journeys to various parts of the country, in order to record their landscapes and local ways of life. The works created as a result of these extensive trips transformed the Peruvian visual culture of the 1920s. At exhibitions and annual salons sponsored by ENBA, as well as in the pages of illustrated magazines, paintings depicting scenes of indigenous life began to predominate. The critical and commercial success enjoyed in Lima by paintings of this kind can be seen in the consensus around the idyllic landscapes depicting the Altiplano and the Arequipa countryside painted by Jorge Vinatea Reinoso (1900–1931), without a doubt one of the most outstanding painters of the 1920s.

But it was Sabogal who positioned this artistic production within a new aesthetic discourse. A small group of colleagues and former students established itself around him: Camilo Blas (Alfonso Sánchez Urteaga, 1903–1985), Julia Codesido (1883–1979), Enrique Camino Brent (1909–1960), and Teresa Carvallo (1903–1988) made up the so-called *"grupo indigenista."* The name came from the emphasis they placed on subjects drawn from indigenous life in the Andean south, especially in the Cuzco region and the Altiplano of Puno. In the 1920s, the term was also applied to the various social and political movements that vindicated contemporary Indian culture, ranging from official government projects to the most radical regional proposals (Favre 1996; Degregori 1978). But while *indigenismo* in the visual arts was associated in a general way with those processes, in fact it had other foundations and other motivations, based fundamentally on the idea of authenticity within which cultural nationalism was framed. In that context, rather than referring to a social group and its specific problems, the "indigenous" would be a symbolic category that would define an area of difference, a distant, alien horizon (Majluf 1994; Lauer 1976). The anonymous Indian represented in the visual arts was thus first and foremost a guarantor of the nation's distinctive character.

The search for their own expressive idiom determined in a broader sense the development of the major regional avant-garde movements, and it was one of the central themes in socialist José Carlos Mariátegui's thinking about literature and art in Peru. The links of the indigenist painters with Mariátegui's journal, to which Sabogal himself gave the Quechua name *Amauta* (1926–1930), placed them in the aesthetic and political vanguard in a broader sense (Unruh 1989). And although there is no further evidence of activism among the painters, their sympathies were clearly with progressive, reformist positions.

The most radical manifestations of *indigenismo* in the field of art did not, however, emerge in the capital but in the cities of the Andean south. It was in Puno, under the leadership of brothers Alejandro and Arturo Peralta, that the Grupo Orkopata published *Boletín Titikaka*, a journal that promoted international exchanges with avant-garde groups in Latin America and Europe (Vich 2000). Although its agenda was primarily literary, it also engaged with the visual arts and the development of a clearly primitivist idiom. Probably inspired by Sabogal's early prints, the crude woodcuts associated with the Grupo Orkopata set the pattern of indigenist graphic art in the Andean south, influencing the appearance of magazines and other publications (Majluf and Wuffarden 2010).

Indigenismo also expressed itself in significant ways in other parts of Peru, especially in Cuzco, a city where nationalism was more closely associated with the recovery of the Inca past. From Quechua theater to the photography of Juan Manuel Figueroa Aznar and Martín Chambi, Cuzco's *indigenismo* located the indigenous in a clear relationship with the city's archaeological heritage. In the case of Cuzco, the imperial past and the construction of an identity based on the Inca legacy also formed the basis of regional ambitions, putting new life into the old rivalry between Cuzco and Lima.

While the Cuzco artists and figures such as Piqueras located the models for a national art movement in the pre-Columbian past, Sabogal found them in popular art forms and rural Andean traditions, a choice that reflected his investment in the indigenous culture of his time. He wrote about the *keros* (wooden drinking vessels) (cats. 248, 266), the ceramics of Pucara (cat. 247), the mestizo architecture of the Andean south, and peasant painting, all of them traditions that in one way or another spun a thread of continuity with the present; he recovered Peruvian museum traditions that had been relegated or marginalized, giving them a new centrality in the history of local art. He also supported the work of Alicia and Celia Bustamante, the two most notable proponents of the traditional arts of Peru, and, from the Instituto de Arte Peruano, he initiated with the help of his students an intensive program for the collection, description, and study of rural Peruvian art (Villegas 2006) (cat. 249).

As part of that process, the *indigenistas* promoted and publicized in the artistic circles of Lima a number of provincial artists who represented the best elements of those traditions. One of them was Mariano Inés Flores (c. 1860–1949), an engraver of *mates* (gourds) who supplied the markets of Ayacucho and Huancavelica in the central sierra (Yllia Miranda 2006). He made a *mate* in honor of José Sabogal, decorated

Fig. 2

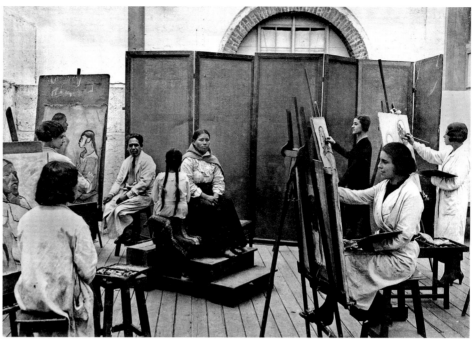

196

with scenes of rural life, and dedicated it to him in 1928 (fig. 5, p. 281). Sabogal himself commemorated Flores in a small woodcut that reflects the simple lines of engraved *mates* (cat. 271). The aesthetic of the *mates* in fact exerted a powerful influence on *indigenista* illustration and engraving; its spirit is expressed in the woodcuts that Sabogal and his group produced from the 1920s onwards, and in the covers and drawings they made for the journal *Amauta* (fig. 7, p. 271).

To the *indigenistas*, art forms such as engraved *mates* were the product of the slow fusion of two cultures; as such they were an expression of the true national culture, which also needed to be forward-looking. What they most valued was its supposed simplicity, which represented its freedom from outside influences and the possibility of a return to a way of life far removed from the excesses of modernity. They found the same things in the gentle, simple scenes of rural life by the self-taught painter Mario Urteaga (1875–1957), whose work came to public notice in Lima in 1934, through an exhibition organized by his nephew, the painter Camilo Blas (Buntinx and Wuffarden 2003). Both his subject matter and his characteristic pictorial style demonstrated his identification with the rural environment of his native Cajamarca, reflecting the basic values of

the traditional world that the *indigenistas* were trying to salvage (cat. 225).

Indigenismo revived artistic traditions that had been marginalized, and in more than one sense, it transformed the dominant perception of the country. But the reformist spirit of the early *indigenismo* of the 1920s was lost as the movement became "official" in the 1930s, when Sabogal was appointed Director of ENBA and his former students found posts as professors and artists in public museums and other state institutions. Coincidently, Piqueras was transferred to the staff of the Escuela de Artes y Oficios. The various approaches to nationalism in the domain of art were thus reduced to the position taken by Sabogal, whose group ended up representing a new orthodoxy. The *indigenistas* then became the target of critics who demanded a renewal of approaches to art and greater diversity in its subject matter. Partly as a response to these demands, or perhaps as a reflection of wider changes in Peruvian culture, from the 1930s onwards, the painters in Sabogal's group expanded their thematic repertory and turned their attention to other parts of the country. Camilo Blas chose to depict the traditions of the coast and Creole life in Lima (fig. 4, p. 251); Codesido—and even Sabogal himself—developed an interest in painting scenes of the Amazon region.

The decline of *indigenismo* as an aesthetic benchmark in Peruvian art in the twentieth century coincided with Sabogal's departure from ENBA in 1943 and the first signs of new modernizing tendencies. Its passing is also connected with the end of the rise of nationalism in general, a global process that also influenced the development of art in other countries of Latin America. Another explanation lay in structural changes that were taking place in Peruvian society, as migration from the countryside to the cities increased, weakening the old dichotomy between indigenous and Hispanic, and dramatically redefining perceptions of the country's underlying problems. Nevertheless, the idea of authenticity and the search for local sources of inspiration for contemporary art would remain central issues in the visual arts, from the "ancestralism" of painters like Fernando de Szyszlo (1925–) to the pre-Columbian references that characterized the work of artists such as Jorge Eduardo Eielson (1924–2006). And outside the field of art, *indigenismo* also helped, in more than one sense, to form an image of Peru that even today holds considerable sway in the nation's collective imagination.

Fig. 3

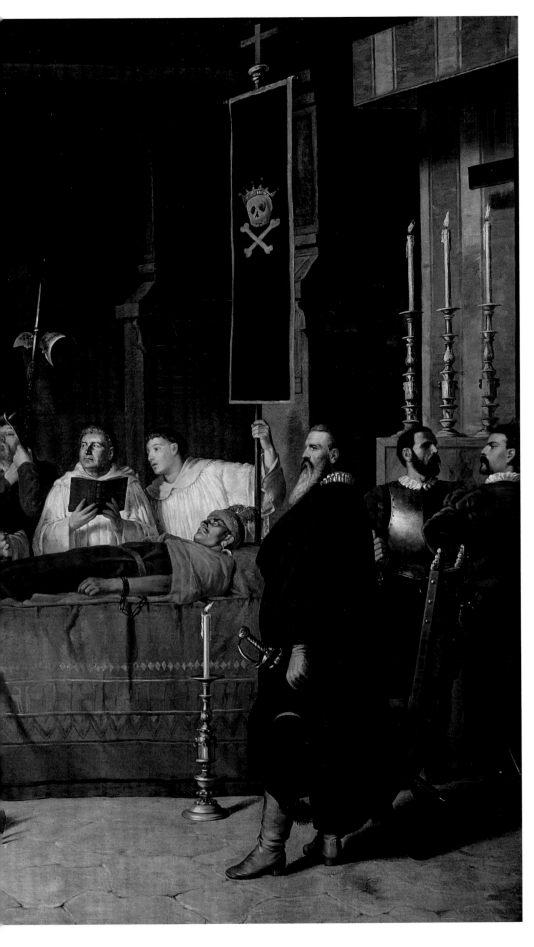

PAGE 229:
Fig. 2
Manuel Piqueras Cotolí
*Façade of the National
School of Fine Arts, Lima*
1924

196.
Anonymous
*Indians Posing in a Studio
of the National Fine Arts
School of Peru*
1934

Fig. 3
Luis Montero
Los funerales de Atahualpa
(The Funerals of Atahualpa]
1867
Pinacoteca Municipal
"Ignacio Merino,"
Municipalidad
Metropolitana de Lima,
in custody of the Museo
de Arte de Lima

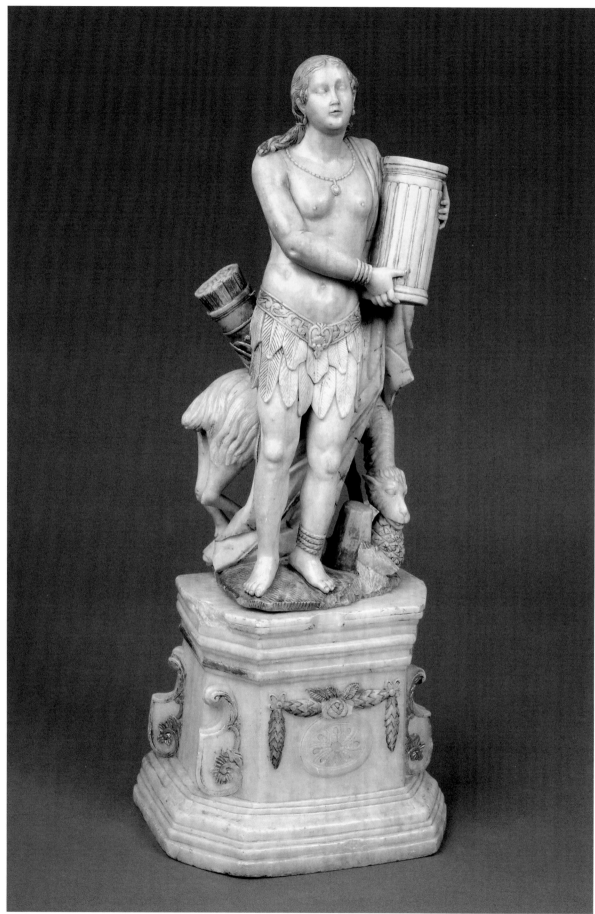

197.
Anonymous
Allegory of America
19th century

198.
Anonymous
*Ecclesiastic Union
of Cuzco and Huamanga*
1825–1835
(retouched in 1943)

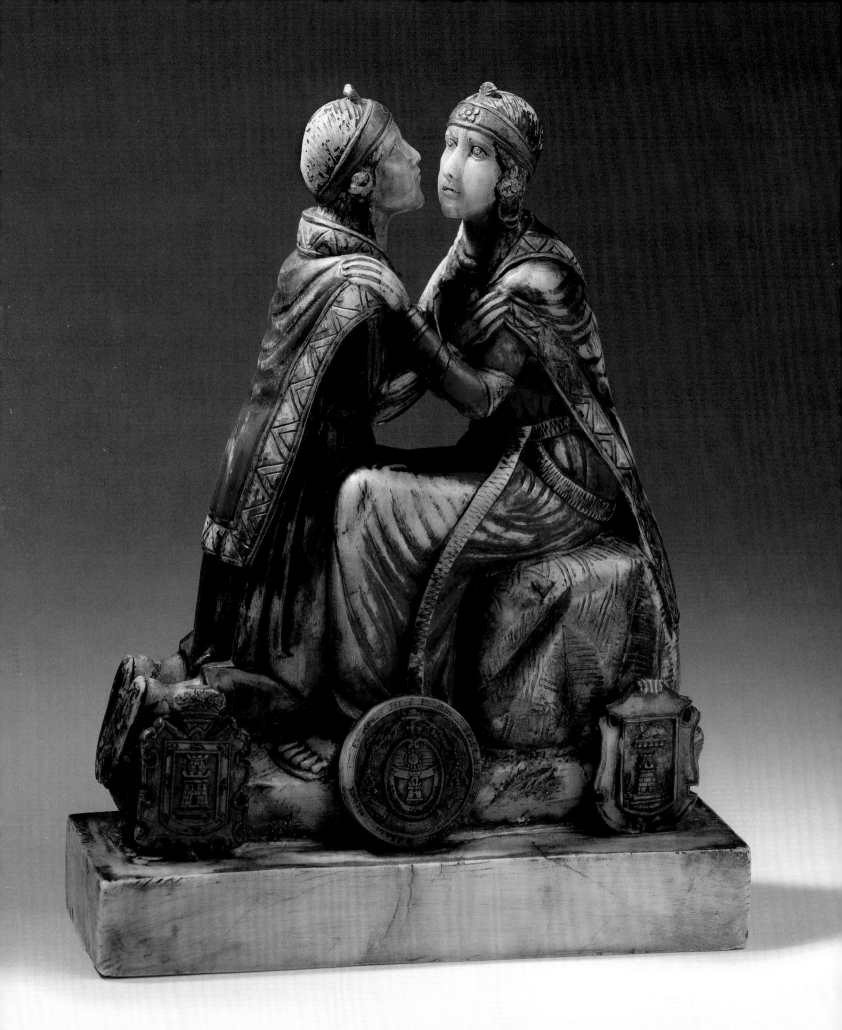

199

199.
Francisco Laso
The Spinner
1849

This is a painting of a man wearing a large black poncho and a broad-brimmed hat with two strips of patterned cloth dangling from it. This contemporary figure, whose clothing identifies him as living in the highlands of Peru, is holding a pre-Columbian Mochica pot representing a prisoner, with his hands tied behind his back and a rope knotted around his neck. The vase is in the center of the composition and probably functions as a symbol of the enslavement of the indigenous people in the nineteenth century. The picture was intended for an international audience, as it was painted in Gleyre's studio, in Paris, for the 1855 World's Fair. Its display alongside a portrait of the conquistador Pizarro, also painted by Laso, gave the work more political impact by identifying the historical origin of the oppression of the Indians.

Majluf (1997) argues that the hieratic, frontal position of the figure, directly challenging the spectator, and the restrained palette of colors, which makes the dark figure stand out against the pale background, turn this painting into an allegorical work, quite unlike the picturesque exotic figures being produced by the *costumbrista* movement at the time. But this allegorical aspect was not understood, or at least not accepted, by contemporary French critics, who sought to interpret it in terms of cultural "authenticity." They saw a representation of Peru in the content, but criticized the use of European pictorial techniques. Laso's painting drew attention to the unenviable situation of the Amerindians and triggered the development of a new image of the country in which modern Peruvians appropriated Peru's pre-Columbian past. Laso's work anticipated, by over half a century, the indigenist movement's attempt to establish an emblematic image of the Amerindian as the basis for a Peruvian identity in the early twentieth century.

E.H.

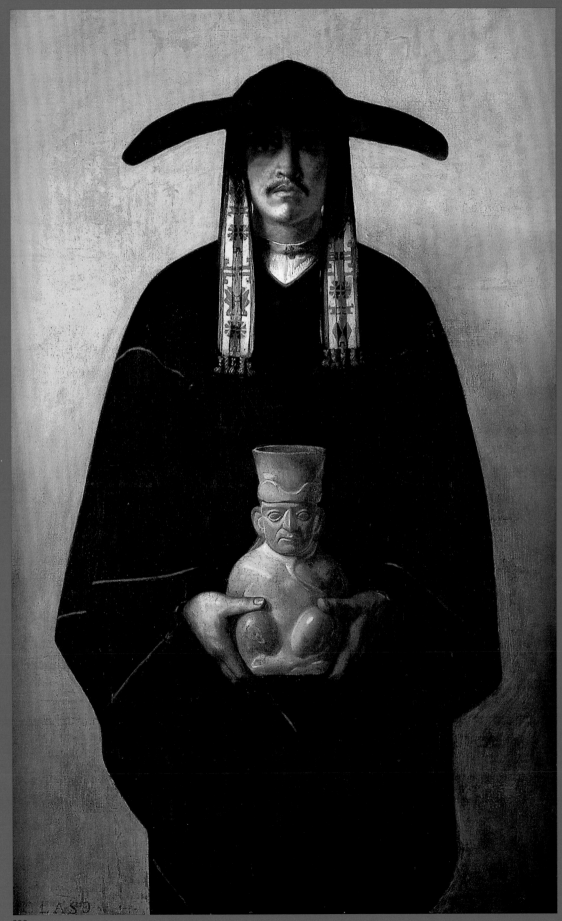

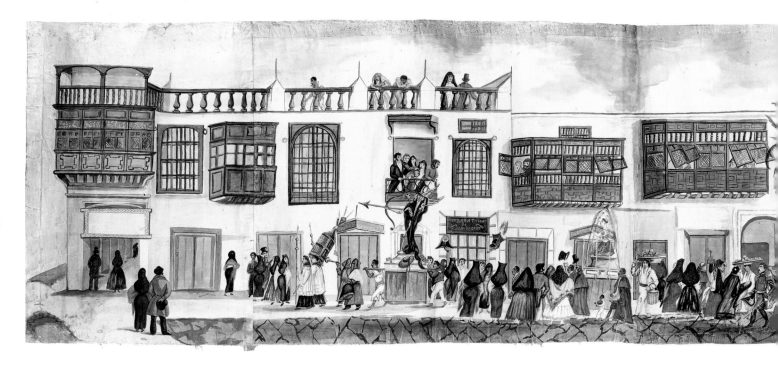

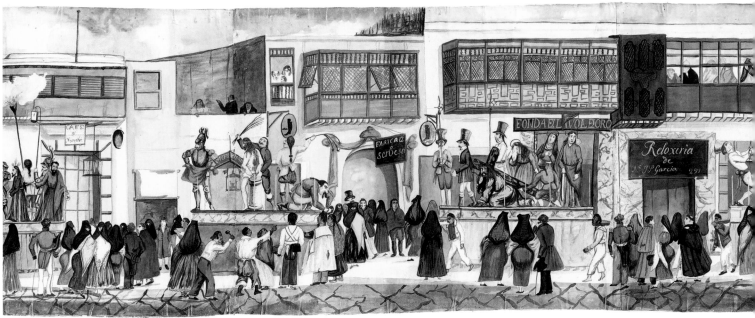

201

201.
Francisco (Pancho) Fierro
Holy Thursday Procession
on San Augustin Street
Mid-19th century

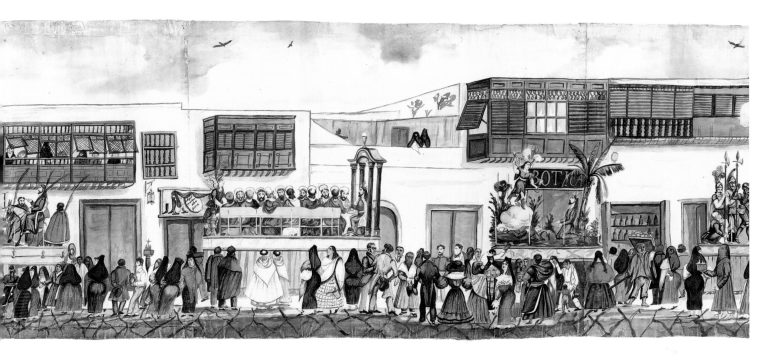

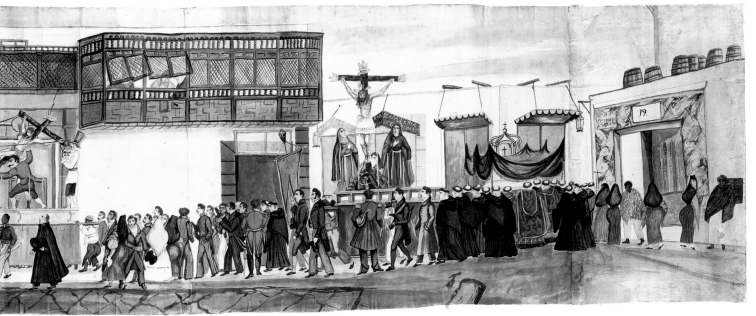

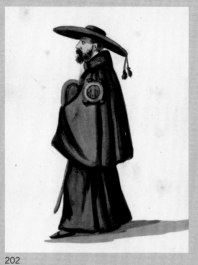

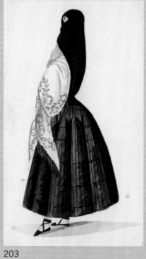

202

203

204

205

206

207

208

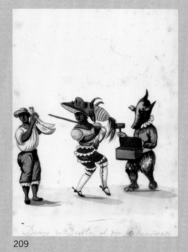

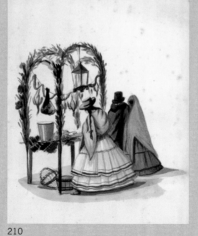

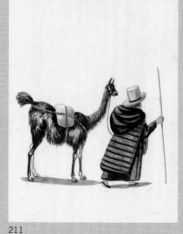

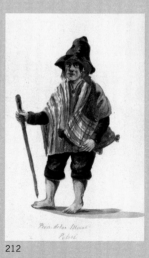

209

210

211

212

202.
Francisco (Pancho) Fierro
Bethlemite Friar
Mid-19th century

203.
Francisco (Pancho) Fierro
*Tapada (Veiled Woman
from Lima)*
Mid-19th century

204.
Francisco (Pancho) Fierro
*Tapada (Veiled Woman
from Lima)*
Mid-19th century

205.
Francisco (Pancho) Fierro
*Father of the Buena
Muerte*
Mid-19th century

206.
Francisco (Pancho) Fierro
*Chicha (Maize Beer)
Seller*
Mid-19th century

207.
Francisco (Pancho) Fierro
*Travelling Soldiers and
Their Camp Followers*
Mid-19th century

208.
Francisco (Pancho) Fierro
*Celebration
at the Cockfight*
Mid-19th century

209.
Francisco (Pancho) Fierro
*Dance of the Devils
on Quasimodo Day*
Mid-19th century

210.
Francisco (Pancho) Fierro
*Christmas Eve
Saleswoman*
Mid-19th century

211.
Francisco (Pancho) Fierro
*The Lama and Chola
of the Sierra*
Mid-19th century

212.
Francisco (Pancho) Fierro
Miner, Potosi (Bolivia)
Mid-19th century

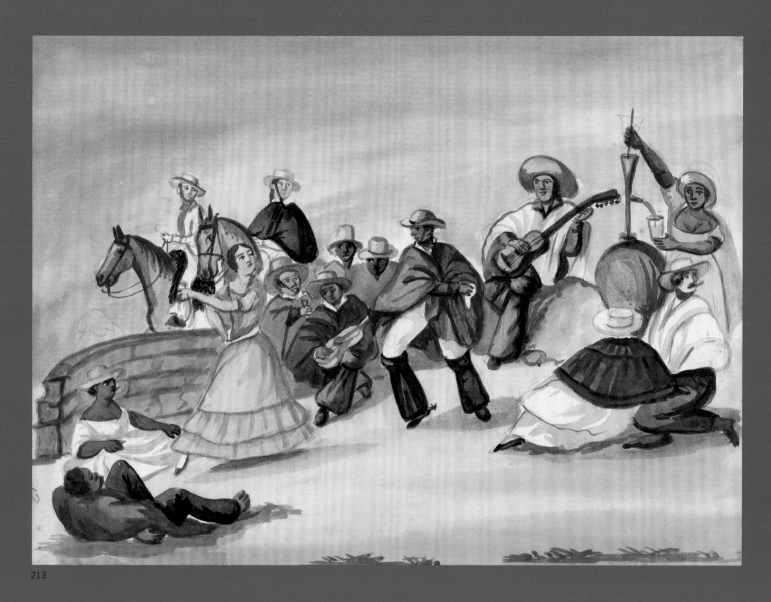

213

213.
FRANCISCO (PANCHO) FIERRO
IN THE HILLS OF AMANCAES
Mid-19th century

This watercolor is one of the few narrative scenes in the art of Pancho Fierro. It depicts a festive occasion on Amancaes Hill, a favorite haunt for the people living in Lima, especially around the festival of St. John the Baptist. The couple in the center is dancing the *zamacueca*, a colonial dance blending African, Andean, and European rhythms. Figures of various ethnic origins are gathered around them, sitting on the ground or on horseback, watching the dancers, strumming a guitar, or serving *chicha* (maize beer). Their clothes, from the Andean poncho to the flounced Spanish dresses, are typical of the period. Indeed, painting cos-tumes is one of Pancho Fierro's specialty. So this watercolor assembles several impor-tant symbols of a Peruvian identity charac-terized by the hybridization of the various cultural groups in Peru: the costumes, the dance, and the *chicha*. It can be seen as a perfect illustration of Peruvian *criollismo*, creating an image of a harmonious, multi-ethnic coastal society that is both nostalgic and imaginary.

This watercolor is part of the Pan-American *costumbrismo* movement, which painted local folk traditions on cheap sup-ports. Natalia Majluf (2008) explains that the representation of types and customs helped build national ideologies and grew out of the interest for classification seen in eighteenth-century scientific works. In Peru, the most significant antecedent is no doubt the collection of watercolors pub-lished by Martínez Compañon. But *costum-brismo* lifted cultural types out of the scientific discourse and sold them as folk art. Majluf argues that Pancho Fierro's works erect invented memory as perceived real-ity: they function simultaneously as sym-bols of Peruvian nationality and illustrations of the past.

E.H.

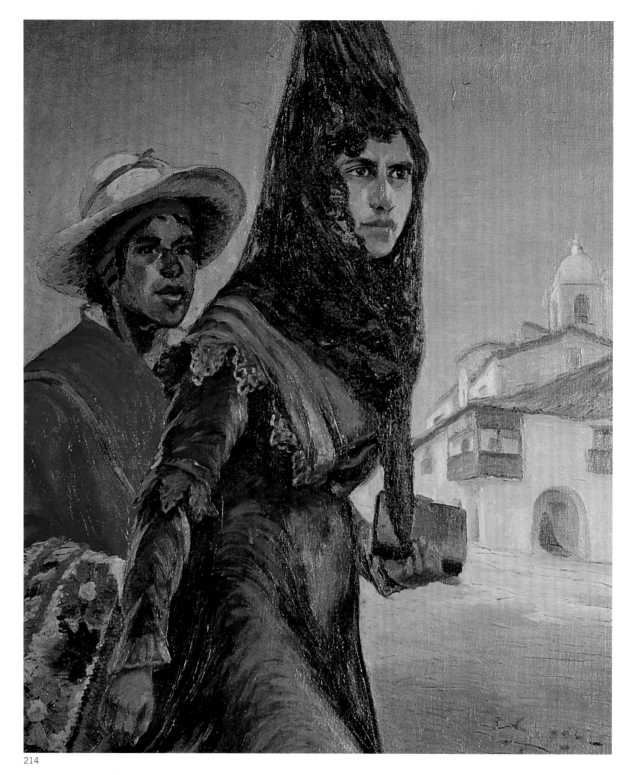

214

214.
José Sabogal
*Woman from Cuzco
Going to Mass*
1919

215.
José Sabogal
Spinner
1923

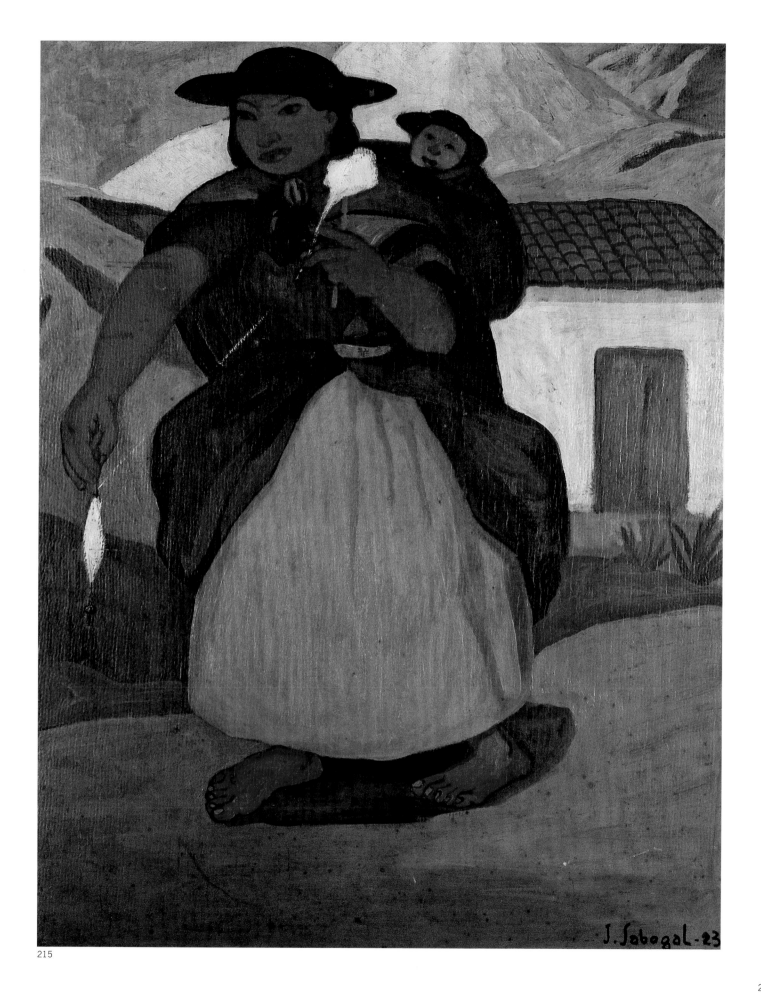

215

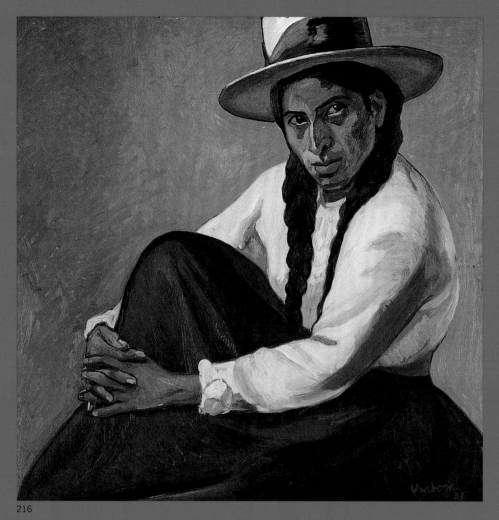

216

216.
José Sabogal
Young Girl from Ayacucho
1937

217.
JOSÉ SABOGAL
THE RECRUIT
1926

This painting illustrates Sabogal's interest in portraits, particularly of Amerindians. The high cheekbones and swarthy skin of the man shown here certainly suggest indigenous origins. He is resting, arms folded, against a plain background, probably a wall, and seems to be lost in thought. Apart from his status as a *recluta* (recruit), there is almost no information about his identity. In his portraits, Sabogal sought to express the emotion and character of the person represented rather than slavishly copy reality. Mariátegui, a socialist philosopher and contemporary of Sabogal, saw that as a sign of Sabogal's emotional affinity with his subjects, which distinguishes his paintings of Indians from the picturesque representations of the previous century.

The preference for feeling over realism is also expressed in Sabogal's resolutely modern style. As can be seen here, Sabogal's painting is characterized by strong, intense colors and sweeping brush strokes, combining influences from the Fauves and the Expressionists. And yet far from reproducing European models, Sabogal tried to develop a truly Peruvian art, particularly by choosing Andean subjects. This approach was in line with indigenist thinking, which sought to give Amerindian heritage its place in Peruvian identity. And yet the indigenists' more political denunciation of the socioeconomic condition of the Amerindians does not appear explicitly in Sabogal's work. Indeed, in the attempt to embody the "values" of the Peruvian people as the indigenist movement understood them, Sabogal's Amerindian figures often project an image of indigenous purity plucked out of the social reality and the modernization processes of the early twentieth century.

E.H.

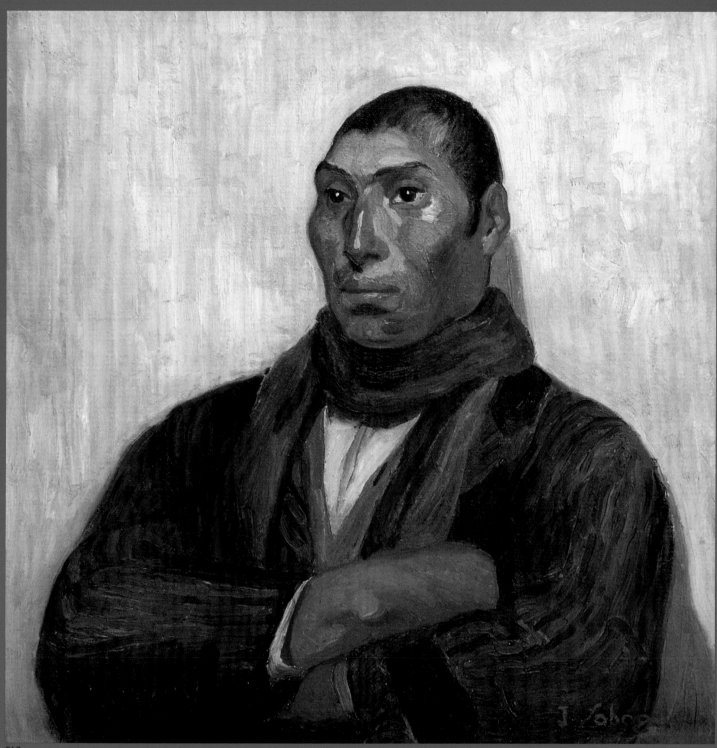

217

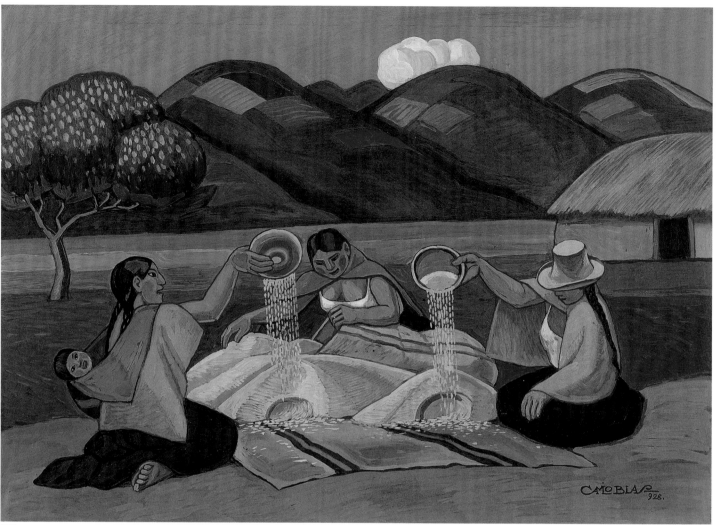

218

218.
Camilo Blas
Indian Women Threshing
1928

219.
Leonor Vinatea Cantuarias
Shepherdesses
1944

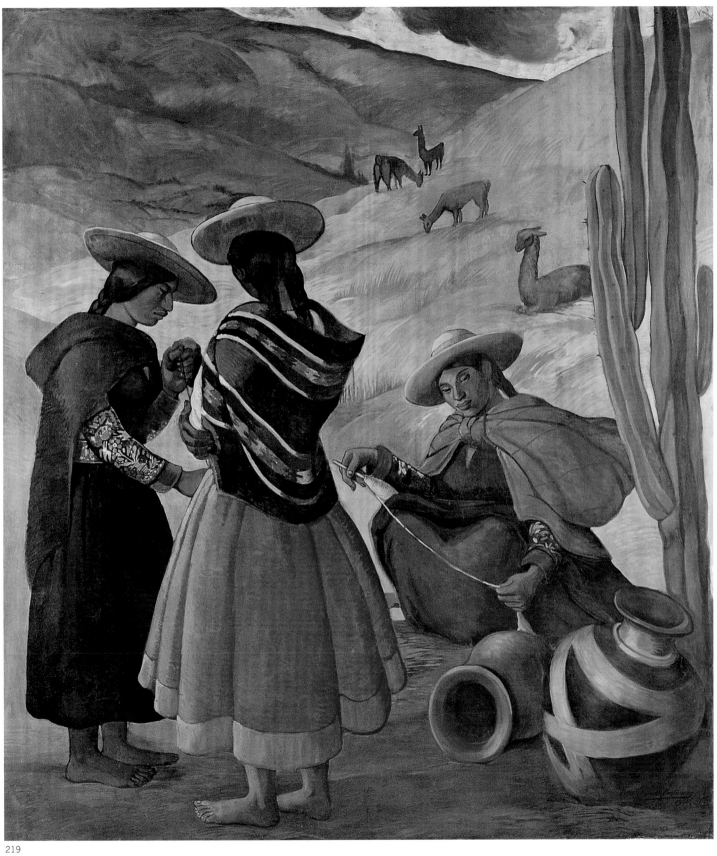

219

220

221

222

223

220.
José Sabogal
Scarlet Tower
1946

221.
Enrique Camino Brent
House
1948

222.
Enrique Camino Brent
Small Highland Village
1946

223.
Enrique Camino Brent
Montesierpe
1946

224.
ENRIQUE CAMINO BRENT
THE RED STAIRWAY, CUZCO
1954

This painting by Enrique Camino Brent depicts the interior of a Cuzco house whose long stair is the central point of the composition. Enrique Camino Brent was one of the major artists associated with the *indigenista* movement. His membership is demonstrated by his preference for "national" subjects such as the landscapes of Peru's upland regions, and for popular art, especially the tradition of the bulls of Pupuja. However, Camino Brent joined the *indigenista* current relatively late, and his art retained a personal style. He is especially noteworthy for the inclusion of architecture in many of his compositions, while many *indigenista* artists preferred to paint figures.

Camino Brent was trained as an architect, and he depicts buildings in a masterly way. He does not try to make a faithful reproduction of reality, but rather to give a strength and an almost phantasmagoric intensity to architectural elements. In *The Red Stairway*, he allows himself to play with lines, angles, and proportions in order to give his painting greater rhythm and fluidity. The arches and zigzag flights of steps give it a great sense of depth, which is typical of his work. This painting is also a striking example of Camino Brent's creative, almost abstract, use of color. The intense orange-red of the upper part of the stair adds to the depth and rhythm of the composition by drawing the eye to the upper part of the painting. Camino Brent also exploits the contrast between the colored areas (the stair, the doors, and the figures dressed in black) and the white of the walls. Enrique Camino Brent is here adapting in a personal way certain modernist elements that were embraced by many Peruvian *indigenista* painters, such as visible brushstrokes and brilliant colors, giving his paintings an intensity all of their own.

E.H.

224

225.
MARIO URTEAGA
BURIAL OF AN ILLUSTRIOUS MAN
1936

According to Urteaga himself, this painting represents the funeral of an Amerindian veteran of the Pacific War, which took place in Cajamarca. It has all the characteristics of the artist's classical period: great care for details (clothing with visible seams, tiles, paving stones), a preference for dark, matte colors, and a combination of several vanishing points within the same painting, so that each element could be shown from the most significant angle. The gutter at the bottom of the picture provides the horizontal base for the composition, while the houses are painted with a vanishing point in the top left corner. These stylistic features recur in painting from northern Peru and are found, in particular, in the work of Arce Naveda in the nineteenth century. The indigenous themes also correspond to a regional preoccupation, well before the indigenist artists of Lima began to show an interest in such themes.

Uniquely in Urteaga's art, this funeral procession includes indigenous and non-indigenous figures. The integration of people of various ethnic origins and the formal balance of the composition project an image of social harmony, an image found throughout Urteaga's work except in a few of his early paintings, which express tensions due to the ethnic mix. Buntinx and Wuffarden (2003) claim that the Peruvian flag and the band, probably hired by the army or the local council, give this painting strong patriotic overtones. They also consider it the most immediately comprehensible of all Urteaga's paintings; this brings it close to the international primitive repertoire and perhaps helps explain its international success, shown by its acquisition by the Museum of Modern Art in New York.

E.H.

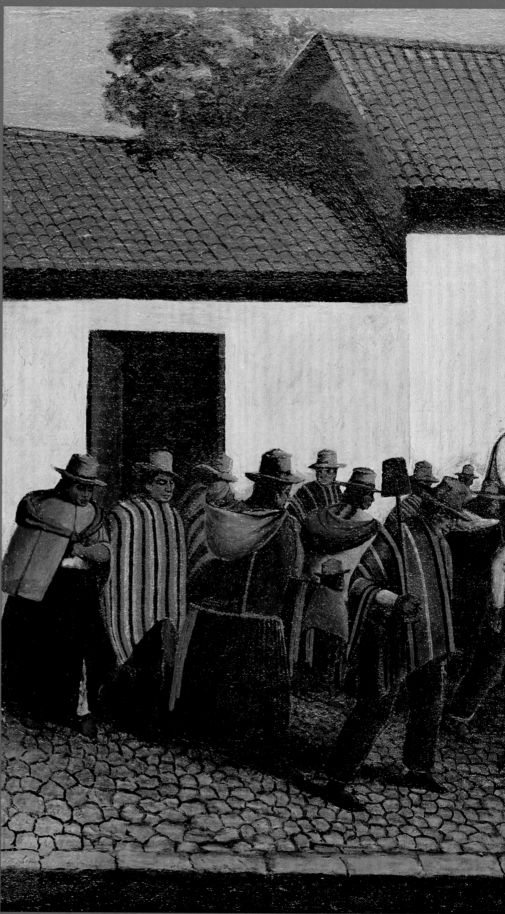

225

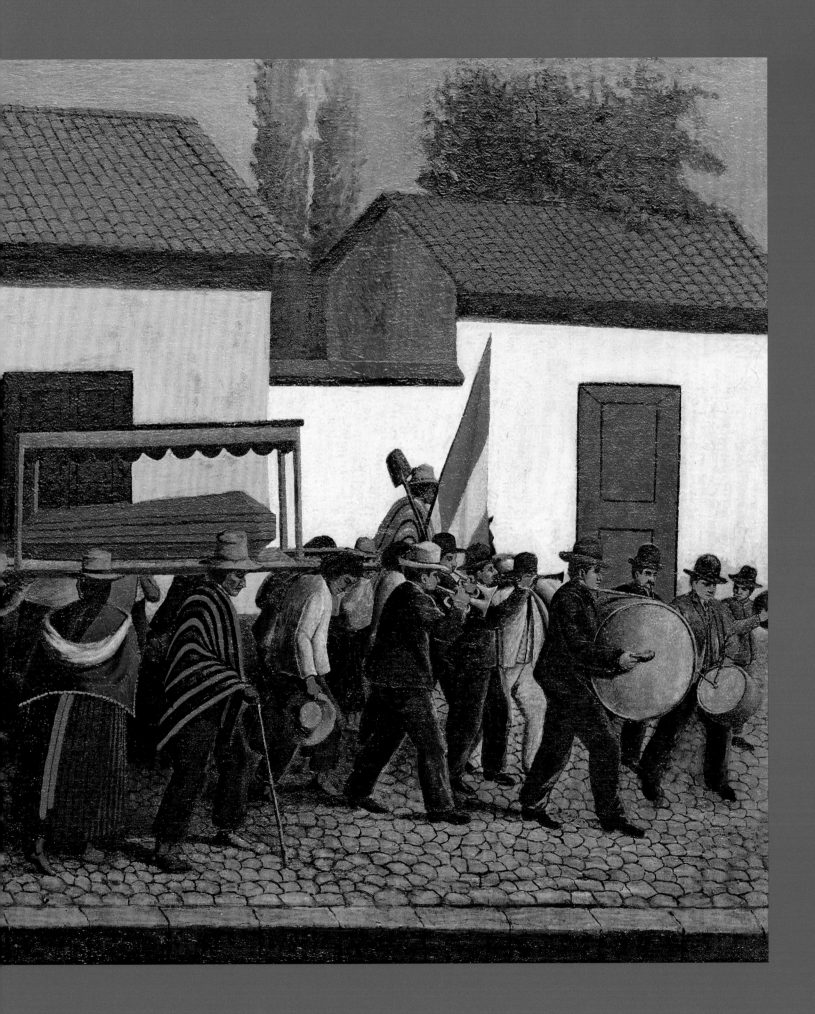

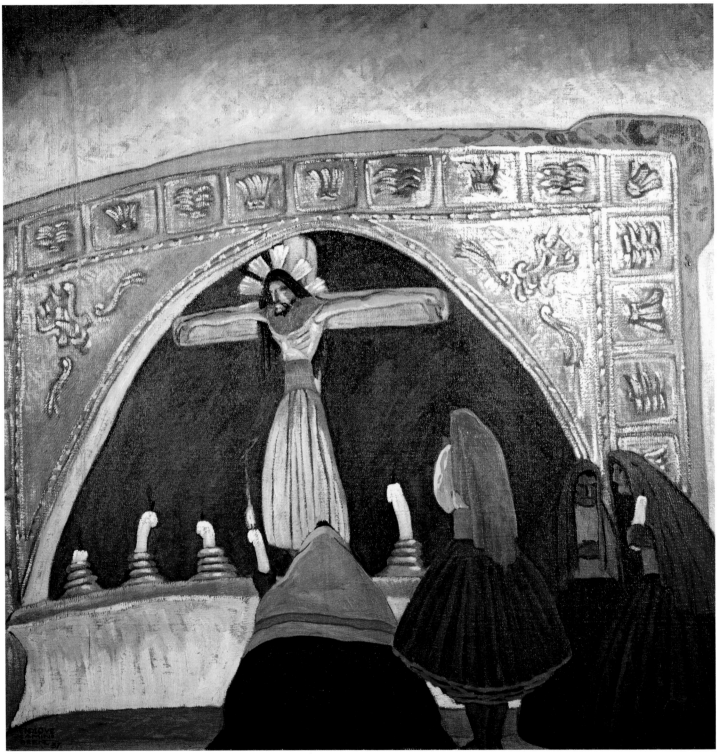

226

226.
Enrique Camino Brent
Christ of Tayankani
1937

Fig. 4
Camilo Blas
Lord of the Miracles
or Procession of the Lord
of the Miracles
1947
Susy and Ivo Ucovich
Dorsner Collection, Lima

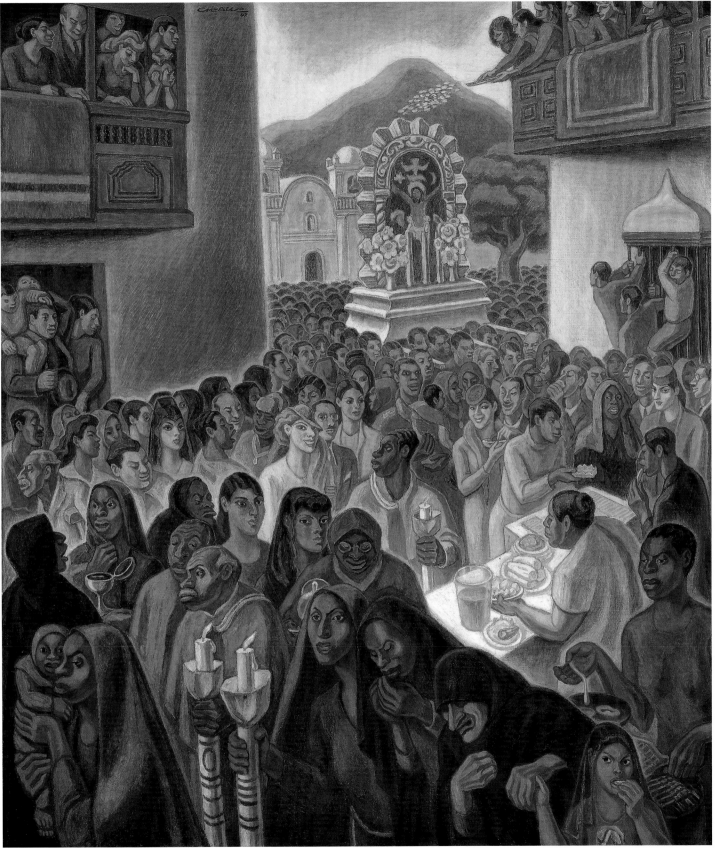

Fig. 4

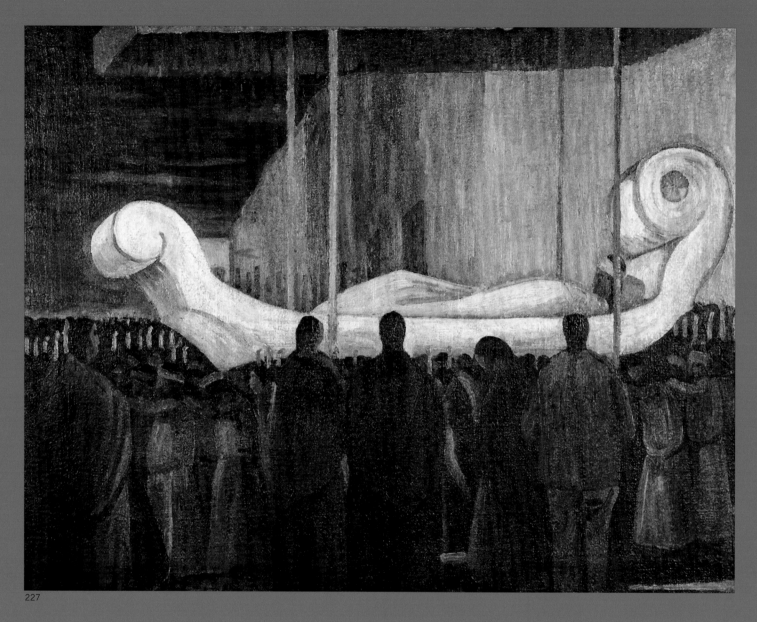

228.
JULIA CODESIDO
THE CANDLES, 1931

This painting by Julia Codesido depicts Amerindian men and women lighting candles. Julia Codesido was a member of the *indigenista* movement and she was beyond a doubt the best-known woman artist in that group, which included Teresa Carvallo, Leonor Vinatea Cantuarias, and Elena Izcue. The work illustrated here is notable for its use of broad brushstrokes and intense colors, and for the way it depicts Amerindians also shows that *The Candles* is a product of the *indigenista* movement. Although it depicts what is probably a Catholic ceremony, Codesido has decided to put the emphasis on the expression of popular devotion rather than the ceremony as

conducted according to ecclesiastical authorities. The Amerindian figures are also recognizable, for example, by the striped ponchos worn by the men, and the colored capes of the women.

The *indigenista* current was a huge intellectual movement, contributing to the construction of a new Peruvian identity in the twentieth century and highlighting the importance of Amerindian culture within it. But in Peruvian painting, *indigenismo* comparatively rarely depicts the problems that the Amerindians of the day were facing. In this painting, Codesido puts more emphasis on the aesthetic aspects of the scene, simplifying the form of her figures in

the modernist style and nearly turning their clothes into colored triangles, while playing on the depth of the composition. The simplification of the faces with their angular features is also very characteristic of the work of Julia Codesido, whom Pauline Antrobus (1997) has described as the most progressive *indigenista* artist. Some of her later paintings are even almost abstract.

E.H.

227.
Pedro Azabache
Holy Sepulchre
Procession
1944

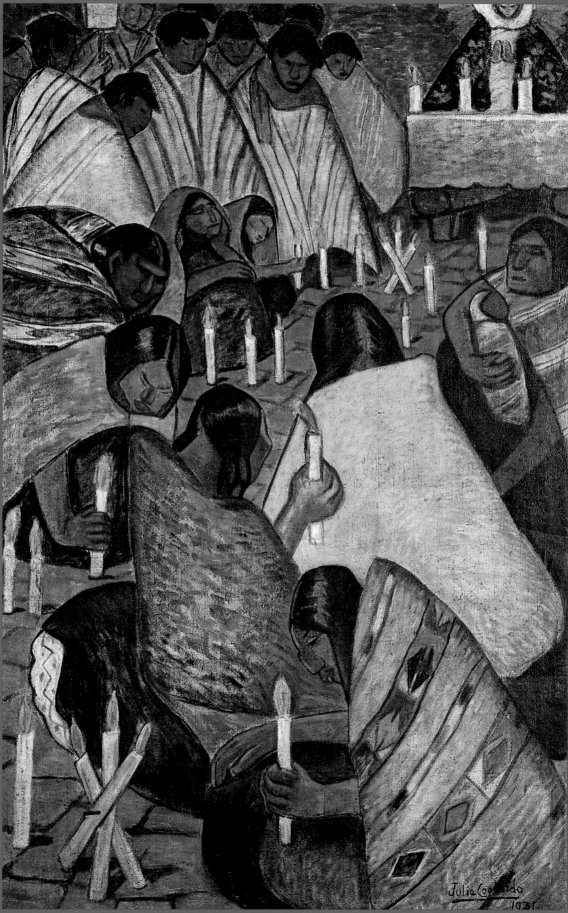

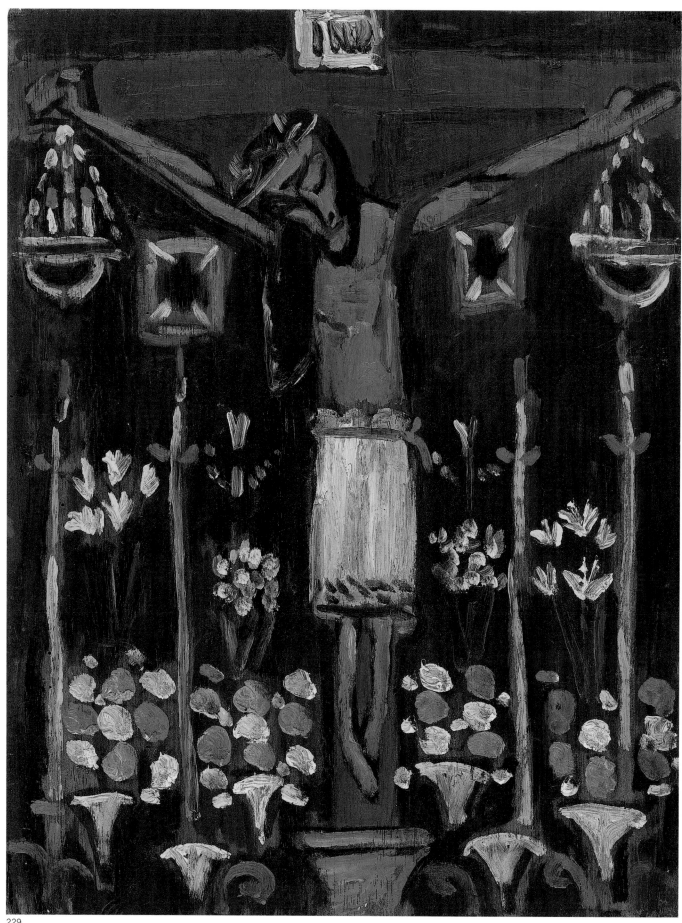

229

230

229.
Julia Codesido
Christ
1907

230.
Julia Codesido
Three Indian Chiefs
About 1950

The Photographic Image of the Indian

Natalia Majluf

It may seem surprising that despite the central place it occupies in Peruvian society and culture, throughout most of the colonial period the complex category of "Indian" should not have been represented visually. It was not until the mid-nineteenth century, with the emergence of the idea of the nation, that visual images of the Indian began to appear as the expression of a new cultural category (Majluf 1995). In painting, artists such as Francisco Laso and Luis Montero helped establish this novel visual motif, but photography was in fact to be the privileged medium in which this image was constructed and disseminated.

Even so, there are no traces of representations of the Indian in the earliest Peruvian daguerreotypes of the 1840s and 1850s, probably because the method was mainly restricted to portraits taken in some big cities, or because its high cost put it beyond the reach of a section of the population that remained marginalized and poor. The first indigenous figures only appeared in photography with the growth of commercial studios in the early 1860s, often in the less costly format of the visiting card (fig. 2, p. 258). But even there they were not featured as portraits but as representatives of anonymous types, as just one subject in a much larger catalogue (cat. 231) that also included photographs of Lima's mestizo and mulatto street vendors, and of aristocratic *tapadas*, ladies dressed in the *saya y manto* that covered their face and body. Like the indigenous subjects who

occasionally appear in watercolors by the Lima painter Pancho Fierro, these images are usually entitled "Indians of the sierra" or "muleteers", or are described in other terms (cats. 211, 212) that emphasize that they are itinerant people, outsiders who are foreign to the ethnic and cultural worlds of Lima (Majluf 1995).

In that way, Peruvian visual culture forged an ethnic and geographical distinction, symbolically dividing the country into an "Indian" sierra and a "Creole" coast (Orlove 1993). This stereotyping division of the national imagination, which was imposed on a reality that was much denser and more complex, was reinforced by the country's unequal development throughout the nineteenth century, which favored the agriculture and commerce of the coastal regions to the detriment of the cities of the interior. That explains why the importation of European goods, and with them, the incorporation of Peru's middle and upper classes into a new international bourgeois culture, took place first in the capital and the coastal cities. As a result, modernization began to be seen as a coastal prerogative, alien to the rest of the country, including the sierra and the Amazon region, which for most of the republic's history would remain the frontier of a distant, unknown world. And that is also why the Indian would be absent from the image of the nation that began to be disseminated from the capital in the mid-nineteenth century, in the form of books, photographs, and postcards. Peru, in fact, projected its

image through the filter of modernization, foregrounding its new public buildings and avenues, its monuments commissioned from architects in Europe, and the railroads that crossed the Andes.

It was only later that the image of the Indian appeared as an emblem of the nation in pictures and books published to satisfy the interest it aroused abroad. A scientific tradition, which emerged with the growth of ethnography and physical anthropology, produced a substantial photographic corpus around the notion of "Indian-ness," created mainly by foreign scholars and explorers working in Peru. Ethnographic and archaeological travelers such as Hans Hinrich Brüning, Julien Guillaume, Ephraim George Squier, and Alphons Stübel, among others, produced visual material of enormous value for the understanding of Andean history and culture (Poole 1997) (cats. 237, 238, 242, 243). But most of these images, published in scholarly journals or collected in archives, were not really influential outside specialized academic circles. On the other hand, commercially produced stereoscopic views and postcards designed to appeal to a wider public had a considerable impact on the incorporation of the Indian population into the country's image.

From the late nineteenth century, indigenous figures appear as an inescapable feature of commercial views of archaeological sites in Peru's Andean south. This motif linked ethnography and archaeology to a discourse that forged a continuity between past and present and fixed the "Indian" as

Fig. 1. **Juan Manuel Figueroa Aznar,** *Luis Ochoa as Ollant,* about 1923, Archivo Figueroa Aznar, Cuzco

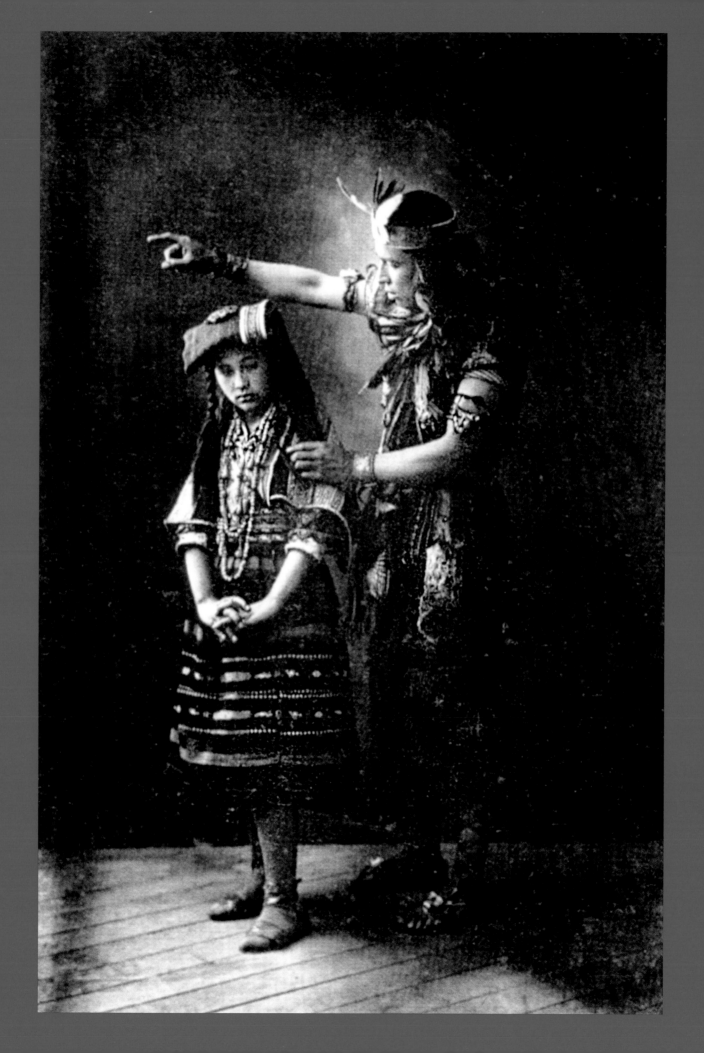

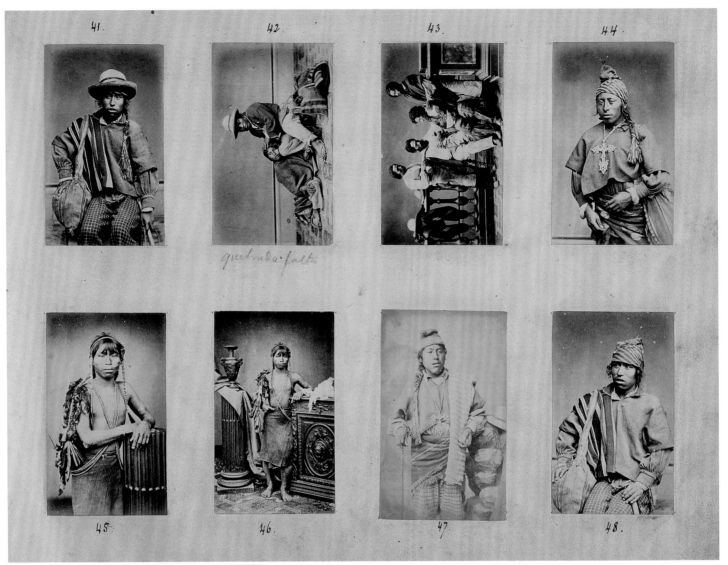

Fig. 2

a timeless, unchanging category. Before long, these views gradually began to replace the images of modern Peru that had predominated on Peruvian postcards. By contrast with studios in Lima, in the Andean south, studios of Luis D. Gismondi, Héctor G. Rozas, and Max T. Vargas (based respectively in Arequipa, Cuzco, and La Paz) were very quick to distribute whole series of such views of pre-Columbian sites (Garay Albújar and Villacorta Chávez 2007) (fig. 3, p. 265).

These postcards are part of a new image of the country, encouraged by the emerging tourist industry and based on the idea of differentiated cultures, untouched by modernity or international bourgeois culture. That view from outside coincided with the development of a new local nationalism, also focused on the search for a

distinctive culture, based on values of authenticity and originality. It was in that context that the "Indian," long relegated to the sidelines, acquired a new centrality. Creoles and mestizos began to see indigenous culture as the basis of national identity and thus, paradoxically, began to identify with a culture they did not consider their own.

In the 1910s and 1920s the new image of the Indian was also being projected in theater, music, literature, and the visual arts. In painting and sculpture, this image was created mainly through institutions located in the capital, the only city in Peru that could boast museums and an art school. Although the majority of *indigenista* painters and sculptors came from the provinces, they practiced their art in the context of trends that predominated in Lima.

Something different happened in the southern Andes, where the fact that culture was not dominated by institutions gave *indigenismo* a different character.

In the main regional centers, photography was, in fact, a more important medium for artistic production than either painting or sculpture. In cities such as Arequipa, Cuzco, Puno, and Trujillo, the photographer's studio was often the center of cultural life, a place where exhibitions were organized and artists and intellectuals could meet. Influenced by the international pictorialist movement in photography, photographers became artists, returning to the central themes of nineteenth-century romanticism (Penhall 2001). Photographers such as Martín Chambi, Juan Manuel Figueroa Aznar, and Max T. Vargas, to name but a few, introduced new

Fig. 2
Estudio Courret Hermanos
Indigenous Types
From the album
Recuerdos del Perú
1863–1873
Luis Eduardo Wuffarden
Collection, Lima

231.
Eugène Courret
Souvenir de Lima,
photographic album
1868–1872

PAGE 260:
232.
Martin Chambi
Woman with Child
About 1926

PAGE 261:
233.
Martin Chambi
Juan de la Cruz Sihuana
1925

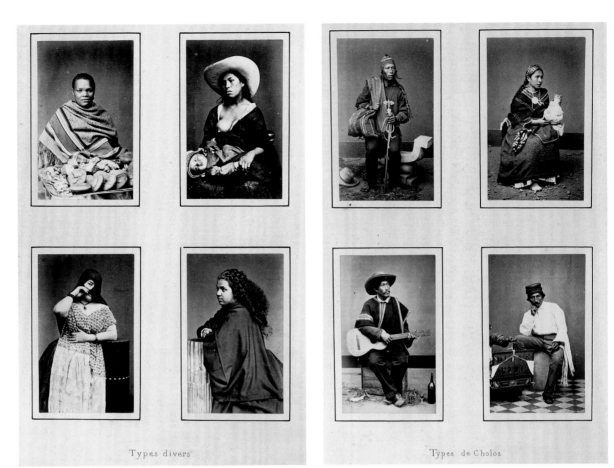

Types divers Types de Cholos

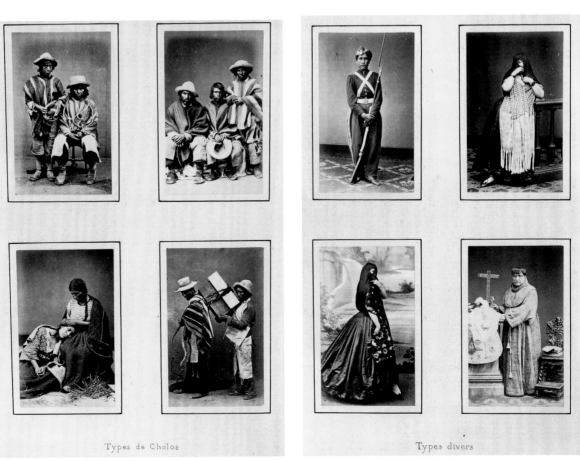

Types de Cholos Types divers

231

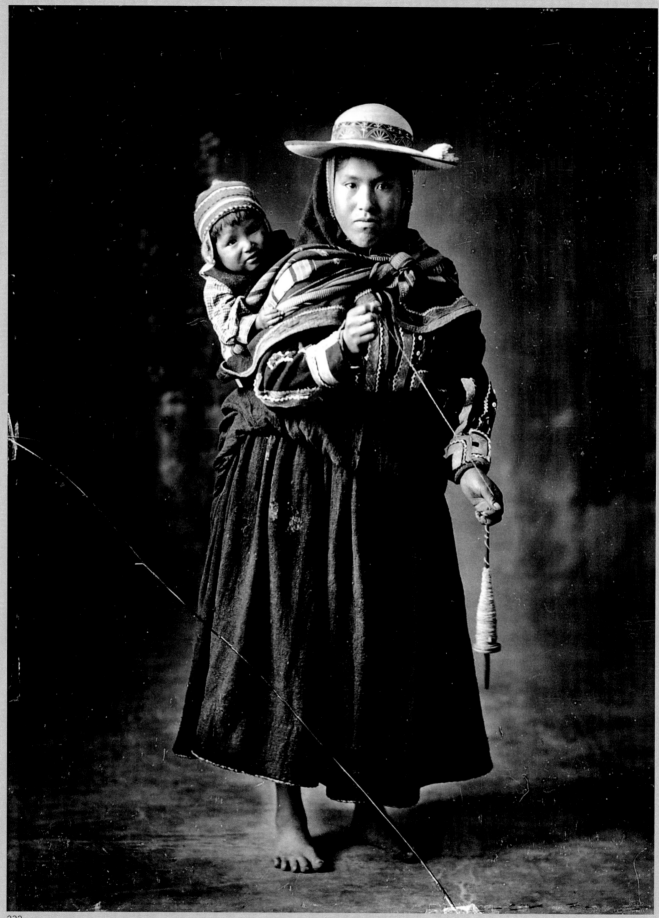

232

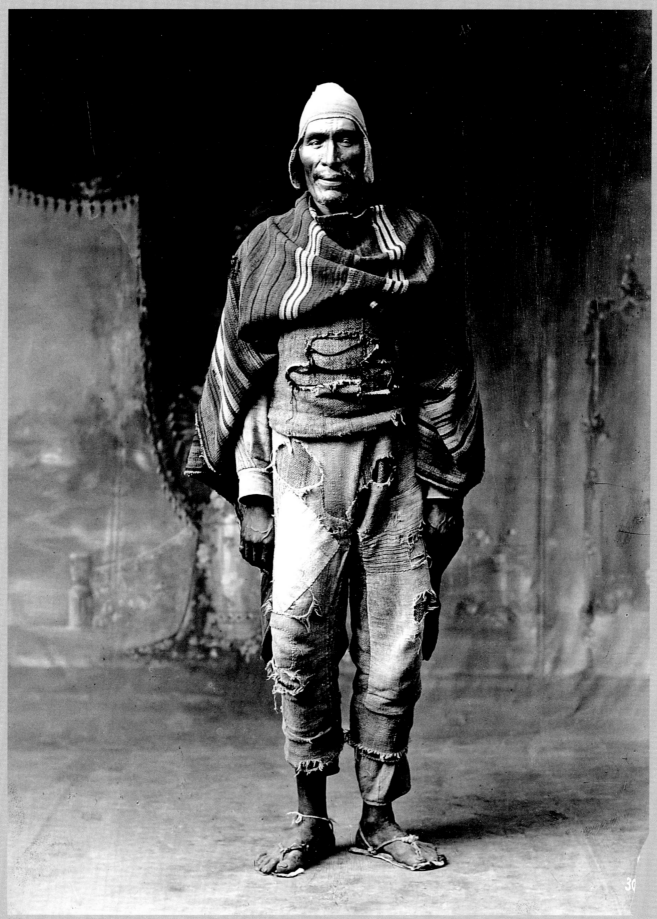

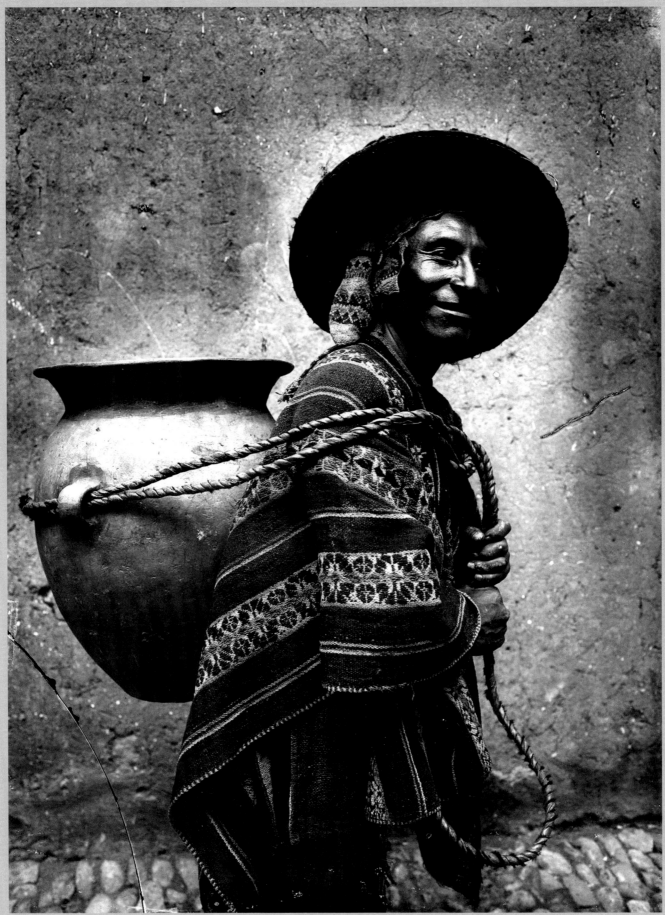

subjects into regional photography, including landscape and portraits of ethnic "types" that were treated in a deliberately rhetorical way, defined by dramatic chiaroscuro and other compositional approaches derived from painting. Photography thus became a kind of substitute for painting and a central vehicle for the expression of southern Andean *indigenismo*.

These photographers could be said to have led double lives, alternating their work as artists of the camera with the standard commercial production of studio portraits. It is important to understand that the studio was more than a physical space for the production of images; it was, in fact, a place that set fashions and visual idioms and explored the diverse possibilities of photography. To pose for the camera, in front of a painted backdrop, forges a very specific consciousness of the studio almost as a theatrical stage. This explains the high degree of awareness on the part of southern Andean photographers of photography as a space for the construction of identities. This is especially clear in the work of Juan Manuel Figueroa Aznar, a painter, photographer, and actor who became a central figure of bohemian life in Cuzco. His skillfully staged images of indigenous figures, or of people dressed as such in the studio, as well as of well-known actors playing the Inca heroes of the Quechua dramas that were then enjoying great success (fig. 1, p. 257), dramatically embody the way photographic representations were constructed (Poole 1997; Barrios and Hare 2010). In a less theatrical way, Martín Chambi also produced images of indigenous people in the studio, both for purposes of ethnographic documentation and for the production of postcards. The *indigenista* repertory of images also included those of intellectuals and members of the middle and upper classes, who participated in the process of staged photography by posing in indigenous costume as if wearing a disguise, a practice that seems to have been common in more than one studio in the southern Andes.

This construction of the meaning of the Indian becomes even clearer in some of Martín Chambi's classic photographs of indigenous subjects. They had a wide circulation in postcard format and were shown at exhibitions and reproduced in art journals. *Indian with a Flute*, for example, is a carefully worked out composition that weaves the indigenous figure into a complex network of relationships with music, the landscape setting, and Andean culture. The photograph was widely known under the title *Andean Sadness, La Raya* (cat. 316, p. 357), expressing a number of ideas, including melancholy, isolation, and timelessness, with which indigenous culture was associated in the Peruvian intellectual imagination.

It is possible to trace parallels between this and other images and the work of *indigenista* painters. But despite the recognition received by figures such as Chambi even during their lifetimes, there does not seem to have been a genuine relationship between the Lima painters and the photographers working in the southern Andes. In the wider context of Peruvian art, photography continued to be seen as a marginal activity. In the provincial cities, however, photographers succeeded in using that marginality to create a distinctive space of their own for artistic production. Working against the grain of the region's social and cultural environment, they were able to produce lasting images of the Indian that helped give the category a firm place in the national imagination.

But while the photographers of the southern Andes constantly portrayed the notion of the "Indian" as an ethnic category and a symbol of the nation, few of them showed real interest in documenting the lives of the inhabitants of the Peruvian sierra. It is surprising, in fact, how few images actually portray the Andean rural environment; with the exception of Chambi, who throughout his life recorded various aspects of people's lives in Cuzco and the surrounding area (cats. 236, 239), no professional photographer of his generation devoted himself to making an ethnographic record of the region, a task that was taken up more seriously in the work of academic anthropologists (Ranney 2001). That in itself helps us understand the real cultural and symbolic meaning of *indigenista* photography, and reveals the wide gulf between the social and political ambitions of the indigenous population and the stereotyped images that *indigenista* discourse proposed as emblems of the nation.

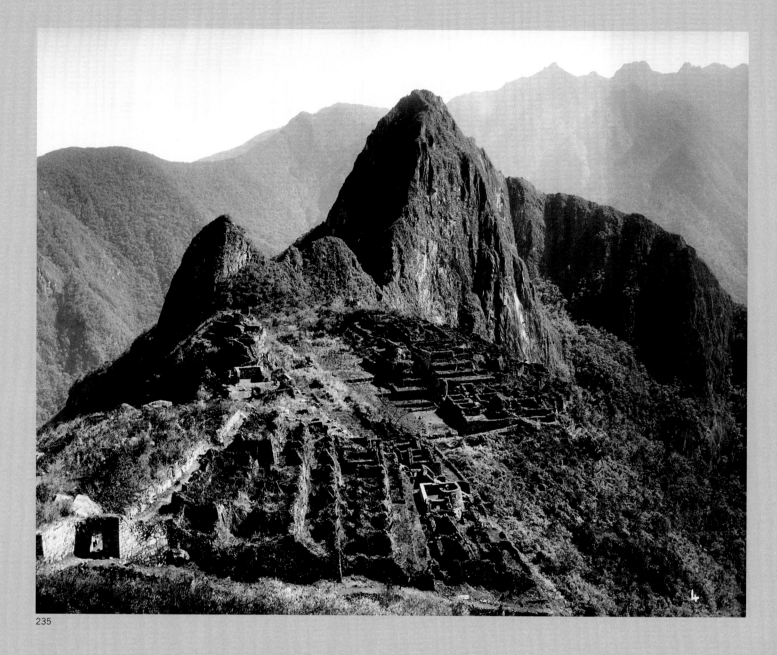

235

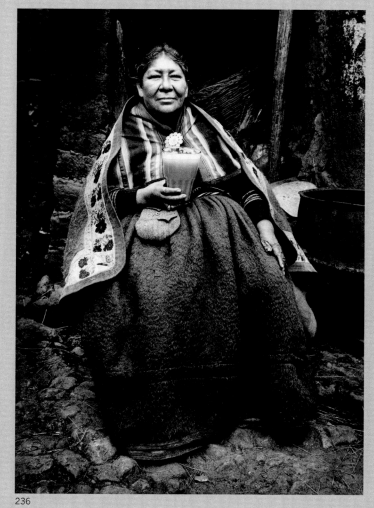

236

237

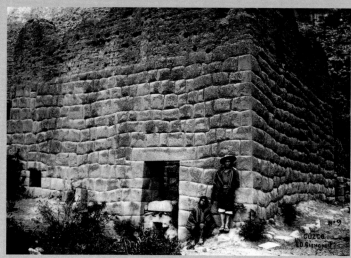

238

Fig. 3

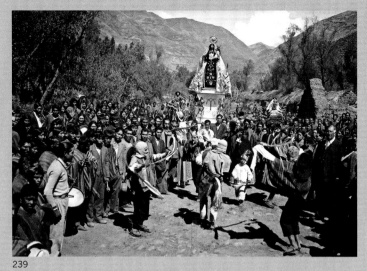

239

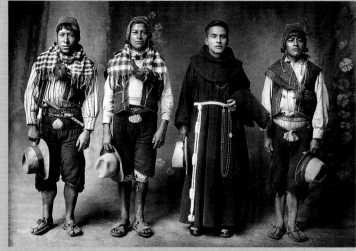

240

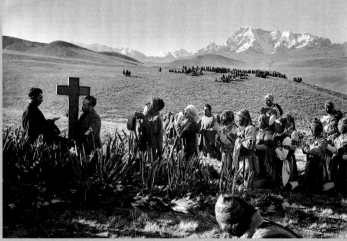

241

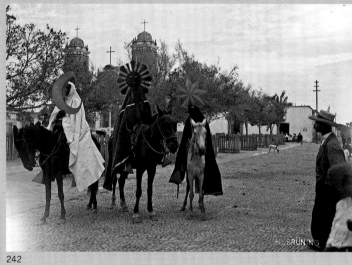

242

239.
Martín Chambi
*Corpus Christi Procession
in the Village
of Andahuaylillas*
1932

240.
Martín Chambi
Brother Priest
1933

241.
Martín Chambi
Q'Olloriti Pilgrims
1931

242.
Hans H. Brüning
*Epiphany in Ferreñafe:
Moon, Sun and Star*
n.d.

243.
Hans H. Brüning
The Deceased Inés Guerra
1890

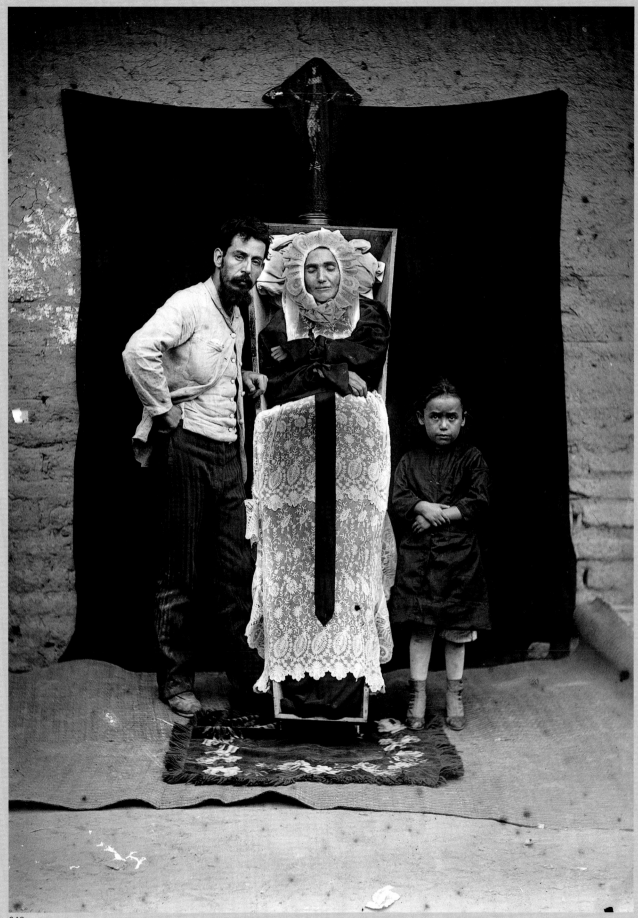

243

The Graphic Arts and Indigenismo

In the 1920s, publishing, in both Lima and the provinces, enjoyed a period of renewal and growth. Intellectuals and artists expressed their modern, avant-garde ideas in books and magazines of innovative design. A number of publications emerged whose agenda was to examine all facets of life in the country's "interior," and thanks largely to them, anthropology, archaeology, art, and folklore gained a voice. In particular, many new periodical publications were launched, which proved to be an effective way of disseminating the concerns of intellectuals committed to social and cultural integration in Peru. The illustrations published in these journals were the visual expression of these ideas, created by a number of artists who used *indigenista* designs and motifs that incorporated elements of pre-Hispanic iconography or Andean subjects.

Within that broad picture, special mention should be made of the magazines *Variedades* (Lima, 1908–1931) and *Mundial* (Lima, 1920–1931). With their wide appeal and commercial success they were landmarks in the development of Peruvian journalism. *Mundial* in particular published some notable reproductions, enabling readers to become familiar with the latest works of prominent Peruvian artists of the day (Wuffarden and Majluf 1997, 27). Its editor-in-chief was Andrés Avelino Aramburú, and it published articles and opinion pieces from distinguished intellectuals, including José Carlos Mariátegui, Luis Alberto Sánchez, and Martín Adán.

Its covers and the articles it published were illustrated by the work of artists such as Jorge Vinatea Reinoso (fig. 2, p. 270), Camilo Blas, Leonor Vinatea Cantuarias, Elena Izcue (fig. 6, p. 271), and José Sabogal (fig. 1, p. 270). In these illustrations, color and national subject matter worked together, forming part of Peruvian identity.

It was *Mundial* that first announced the appearance in bookstores of José Carlos Mariátegui's seminal work, *7 Ensayos de interpretación de la realidad peruana* (1928), of which it published a section. In fact, the modern ideas of the early twentieth century were also expressed with great vigor in the work of novelists, poets, and other intellectuals. Visual artists associated with *indigenismo* collaborated closely with the writers whose work they illustrated. Mariátegui commissioned the design of the cover of his book from Julia Codesido (cat. 246), whose geometric, quasi-cubist art placed her among the avant-garde.

Mariátegui played an important role on Peru's press and publishing scene. In 1925 he founded the *Minerva* publishing house, a venture that supported intellectual endeavor in the shape of its journal, *Amauta* (1926–1930), which carried articles not only on social questions but also on the art and culture of the day. The painter José Sabogal suggested the name *Amauta*, which means "master" in Quechua. Sabogal was also responsible for a number of its covers, with different designs, from those reflecting a pre-Hispanic linear graphic style to the complex art of the carved gourd (fig. 7,

p. 271). In the first issue he published a woodcut entitled *Head of an Indian* (fig. 3, p. 270). The man's serene expression springs from the severe quality of the drawing. Notable in this context is *The Sower* (fig. 4, p. 270), a woodcut of an Indian sowing seeds in the earth. Many years later, Sabogal said: "In one of the first issues I did a drawing for the cover of an indigenous sower, in the ochres and reds that the Indians use. Looking back now, I believe that that ancient Peruvian figure expressed Mariátegui's spirit" (Torres Bohl 1989).

Another periodical to appear on the scene was *La Sierra* (Lima, 1927–1930), published by the Órgano de la Juventud Renovadora Andina and edited by Guillermo Guevara and Amadeo de la Torre, its illustrator. The journal "published the views on national problems of writers and artists from the provinces" (Chang-Rodríguez 2009). Víctor Raúl Haya de la Torre, founder of the Alianza Popular Revolucionaria Americana, was one of its most frequent contributors, alongside politicians such as Luis Alberto Sánchez and Magda Portal (ibid.). Leading figures in the *indigenista* movement, such as Luis E. Valcárcel and José Uriel García also contributed to the magazine. Its covers are notable for their pre-Columbian motifs (fig. 5, p. 270) and their depictions of indigenous people (fig. 8, p. 271). In addition, the views of provincial intellectuals, especially those from the Andean south, were represented in many titles published in Cuzco (for example, *Kosko* and *Kuntur*) and in Puno (*Titikaka*).

244. José Sabogal, *Woman of Collao*, 1925

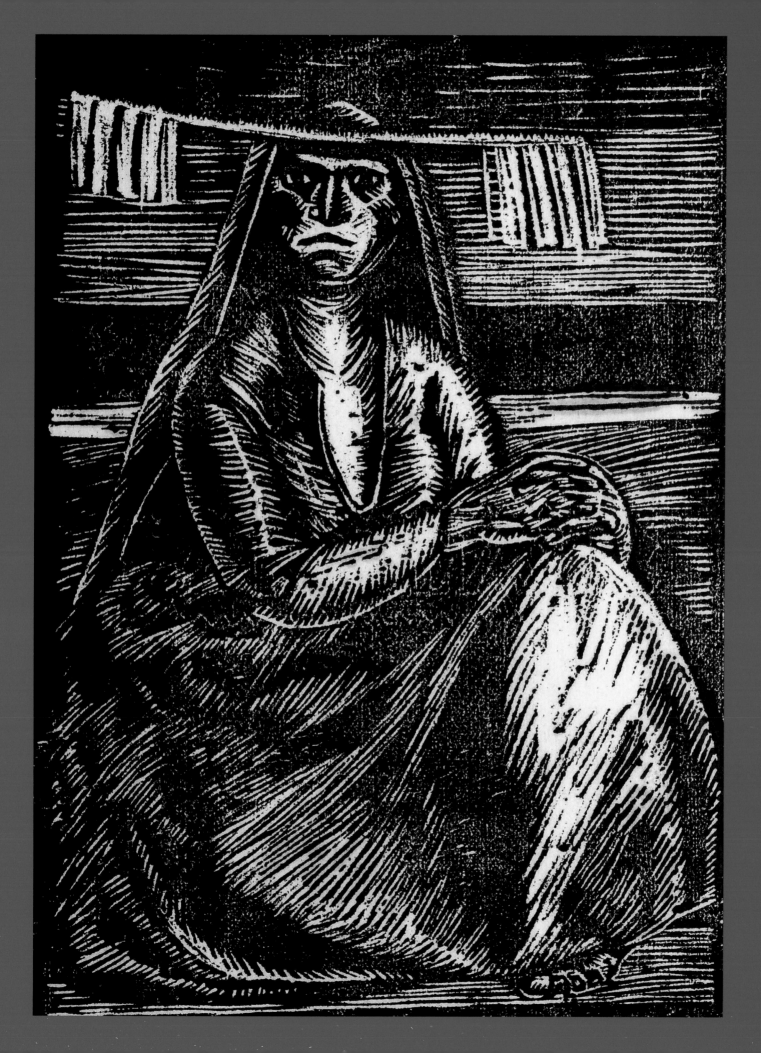

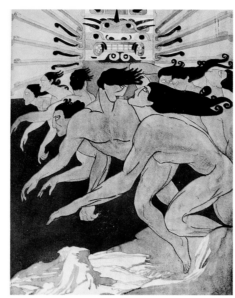

Fig. 1

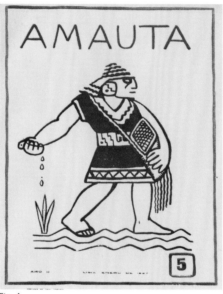

Fig. 2

245

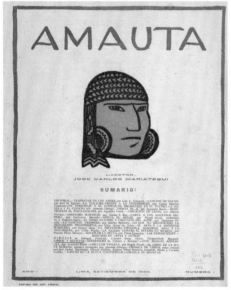

Fig. 3

Fig. 4

Fig. 5

The Instituto de Arte Peruano, founded in 1931 by Luis E. Valcárcel, was headed by the painter José Sabogal, with the artist Camilo Blas leading the "Sección de Investigación Dibujada," its "visual documentation department." Its purpose was to study, promote, and publicize the forms of aesthetic expression and the customs of Peru's diverse cultures, partly through publications such as the *Revista del Museo Nacional* and the *Muestrario del arte* *Peruano precolombino*. José Sabogal also wrote several books, including *El Toro en las artes populares del Perú* (1949) (cat. 247) and *El "Kero", Vaso de libaciones cusqueño* (1952) (cat. 248). *Indigenista* artists such as Julia Codesido, Teresa Carvallo, Alicia Bustamante, Camilo Blas, and Enrique Camino Brent traveled around Peru in order to learn about its ways of life, assisting Sabogal in discovering and preserving the popular art of Peru. *Retablos* from Ayacucho, typical costumes, carved gourds, and processional crosses all featured in these publications. This reflected a new aesthetic sensibility, receptive to the influence of indigenous culture (Kuon Arce *et al.* 2009, 53), clearly visible in the process of affirmation of a Peruvian identity in which indigenous people occupy a central place, one largely disseminated by the magazines and other *indigenista* publications from the 1920s onward.

Fig. 6

246

Fig. 7

247

Fig. 8

248

Fig. 1
José Sabogal
Cover of the journal
Mundial
July 1923
Biblioteca del Ministerio
de Cultura, Lima

Fig. 2
Jorge Vinatea Reinoso
The Origins
Illustration in the journal
Mundial
December 1924
Biblioteca del Ministerio
de la Cultura, Lima

245.
Aristides Vallejo
Cover of the journal
*Peruanidad, Órgano
Antológico del
Pensamiento Nacional*,
Vol. III, no. 14
June-August 1943

Fig. 3
José Sabogal
Cover of the journal
Amauta,
September 1926
Biblioteca del Ministerio
de la Cultura, Lima

Fig. 4
José Sabogal
Cover of the journal
Amauta
January 1927
Biblioteca del Ministerio
de la Cultura, Lima

Fig. 5
Anonymous
Cover of the journal
La Sierra
1929
Biblioteca del Ministerio
de la Cultura, Lima

Fig. 6
Abelardo M. Gamarra
*Manco Cápac, Leyenda
nacional* (illustrations
by Elena Izcue)
(Manco Cápac, National
Legend [illustrations
by Elena Izcue])
1923

246.
José Carlos Mariategui
and Julia Codesido (cover)
*7 Ensayos de
interpretación
de la realidad peruana*
(7 Essays on the
Interpretation of Peruvian
Reality)
Amauta, Lima, 1928

Fig. 7
José Sabogal
*Drawing of a gourd
from Huanta*
Cover of the journal
Amauta
April 1928
Museo de Arte de Lima
Photo Daniel Giannoni

247.
José Sabogal
Cover of the journal
*El Toro en las artes
populares del Perú*
(The Bull in the Popular
Arts of Peru)
Instituto de Arte Peruano,
Lima, 1949

Fig. 8
Leonidas Velazco
Cover of the journal
*La Sierra, Órgano
de la Juventud
Renovadora Andina*,
vol. II, no. 24
December 1928

248.
José Sabogal
Cover of the journal
El "Kero"
Publicaciones
del Instituto de Arte
Peruano 2, Museo de
la Cultura Peruana, Lima,
1952

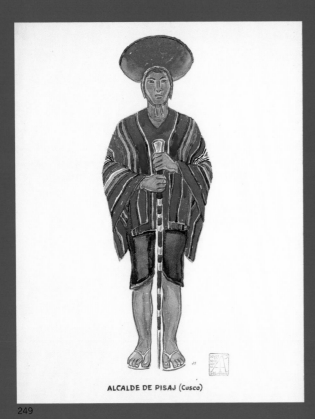

ALCALDE DE PISAJ (Cusco)

249

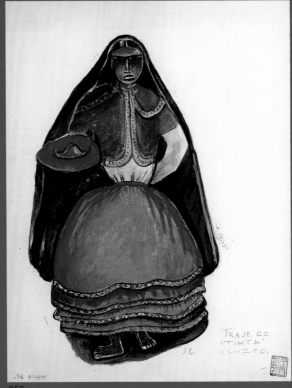

TRAJE DE "TINTA" CUZCO

250

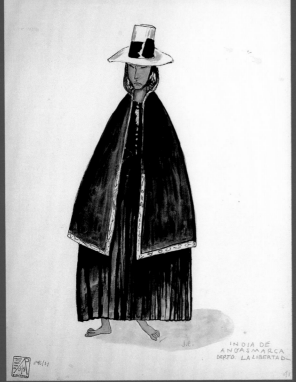

INDIA DE ANGASMARCA DEPTO. LA LIBERTAD

251

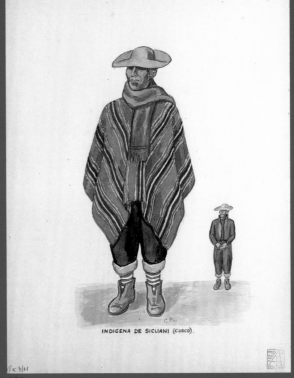

INDIGENA DE SICUANI (CUSCO).

252

249.
José Sabogal
Mayor of Pisaj
About 1950

250.
Julia Codesido
Costume from Tinta
1948

251.
Julia Codesido
Indian of Angasmarca
1951

252.
Camilo Blas
Native of Sicuani
1951

253.
JULIA CODESIDO
INDIAN MUSICIAN FROM PUNO
About 1950

This watercolor depicts a musician playing the flute and wearing a festival costume embroidered with multicolored motifs. His highly decorated costume indicates that he comes from the Puno region. The watercolor is one of a set of over two hundred painted by artists affiliated with the Instituto de Arte Peruano (IAP), headed by José Sabogal, which depict costumes and examples of folk art. The majority of them, like this one, were painted by Julia Codesido. According to Fernando Villegas (2008), it originated in a study program on the characteristics of Peru's typical costumes, launched by the IAP in 1952. These costumes, which were worn by the predominantly Amerindian country people of Peru, are the result of a process of hybridization between Amerindian traditions and European features, and for the artists of IAP they were therefore powerful markers of identity in the Peru of their day.

The watercolor illustrated here is based on a photograph taken by Abraham Guillén, in which we can see two musicians. Julia Codesido decided to paint only one of them. This composition, in which an isolated figure is represented against a neutral background, is derived from the nineteenth-century watercolors of Pancho Fierro, an emblematic figure of Peruvian *costumbrismo* and seen by the *indigenista* artists working under the auspices of the Instituto de Arte Peruano as a model to follow. Codesido has reproduced quite faithfully the musician's posture and the decoration of his costume as they appear in Guillén's photograph, but her personal style still comes through, especially in the simplification of the face. That personal touch makes Codesido's watercolors more than mere documentary records; they are genuine works of art.

E.H.

253

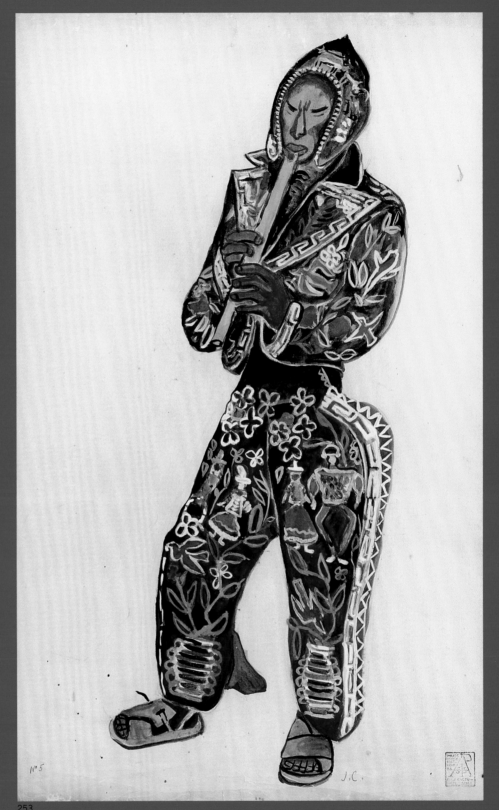

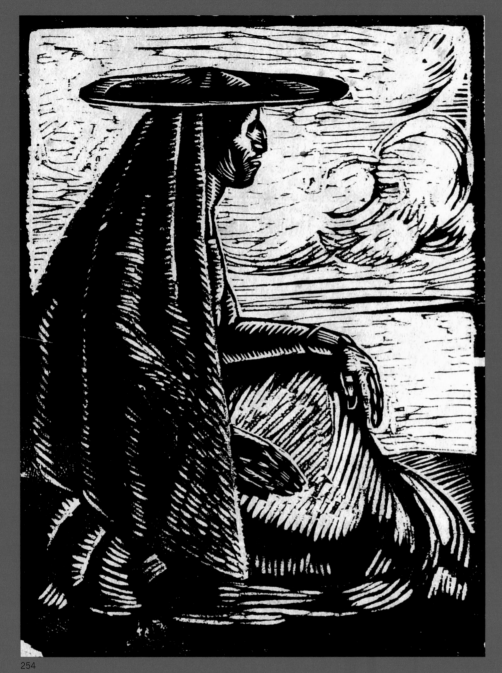

254

254.
JOSÉ SABOGAL
INDIAN OF COLLAO
1928

José Sabogal was first introduced to the art of engraving on a trip to Mexico in 1923 and later trained Camilo Blas and Julia Codesido in printmaking. He saw it as a privileged medium for expressing his view of Peru and his sympathies for the Andean cause. He made numerous prints, particularly on his trips to Cuzco and La Paz in 1925, immortalizing powerful images of the people, architecture, and traditions of the highlands. It was through engraving that Sabogal first expressed his interest in folk art, as can be seen in his portrait of the artist Mariano Flores decorating a gourd (*mate*) (cat. 271).

Although it was not Sabogal's aim, his prints became illustrations par excellence of the indigenist political discourse, particularly through their publication in the avant-garde review *Amauta*. The woodcut *Indian of Collao* (or *India Ccolla*)—a side view of a woman from the Altiplano region, sitting gazing into the distance—is a good example. It illustrated an extract from Valcárcel's *Tempestad en los Andes*, which Mariátegui printed as an introductory text for the first issue of *Amauta* in September 1926. In *Tempestad en los Andes*, Valcárcel promoted the revival of Amerindian culture as a source of a new Andean culture. The power of this print lies, among other things, in the elimination of unnecessary detail and the restricted gradation of colors. The woman, dressed in traditional clothing and conveying an imposing presence against a textured background, presents an image of the Indian woman as a timeless symbol of tradition, an emblem of the stability of imagined cultural authenticity.

E.H.

255.
José Sabogal
Untitled (Portrait of an Indian)
1925

256.
José Sabogal
Portrait of an Indian
n.d.

257.
José Sabogal
The Mayor's Wife
1925

258.
José Sabogal
Old Women from Cuzco
1926

259.
José Sabogal
Cuzco Entryway
n.d.

260.
José Sabogal
Pottery Sellers
1925

261.
José Sabogal
Slope of Huaynapata
n.d.

262.
José Sabogal
Christ of Mullachayoc
1925

263.
José Sabogal
Plaza Mayor de Cuzco / Sacsayhuamán
1930

255

256

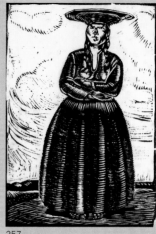
257

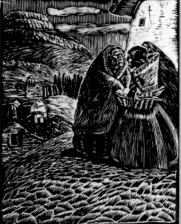
258

259

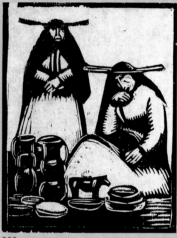
260

261

262

263

Fernando Villegas

The Incorporation of Popular Art into the Imaginative World of Twentieth-Century Peruvian Artists

The concept of popular art entered the imaginative world of the Peruvian nation following José Sabogal's journey to Mexico in 1923. It was in that nationalistic social environment that the Peruvian painter absorbed the interest of Mexican intellectuals and artists in collecting traditional objects. But while in Mexico the term "popular art" was derived from a tradition primarily associated with the indigenous legacy (Antología 1982, 20), in Peru it was defined as a mestizo art, a fusion of cultural elements from pre-Columbian society and the Viceroyalty that defined the new Peru.

Mestizaje was first used as a conscious program in the field of architecture, and its first fruits can be seen in the great hall of the Palacio de Gobierno (1924) and the façade of the Escuela de Bellas Artes (1924). In 1925, Sabogal brought to Lima the canvases he had painted on his last visit to Cuzco, one of which, *La Fuente de Arones* (The Arones Fountain, 1925), was described by Carlos Solari (1927) as depicting a "piece of mixed Hispanic and indigenous sculpture." The painter responded to Solari's comment, saying that he saw in the fountain the fusion of two cultures. That there exist two versions of this image in oil (fig. 1, p. 278) and one woodcut (cat. 265) shows its importance in shaping Sabogal's thinking.

Similarly, *Inhabitant of the Peruvian Highlands* (cat. 200) by the Peruvian painter Francisco Laso was a forerunner of Sabogal's idea of uniting past and present in the form of an allegorical figure, with clear references to his contemporary aspect; the merging of two periods in a single painting underlies the thinking that Sagobal carried over to his definition of popular art. Like Laso, Sabogal also incorporated into his paintings the ceramics made by indigenous people and mestizos. As early as his second exhibition in Lima, *India del Cuzco* (Indian Woman of Cuzco, 1921) shows a woman in indigenous costume holding a ceramic jar. Similarly, *Pottery Sellers* (1925) (cat. 260) gives us information about his first encounters with the ceramics of Puno, more precisely those from the town of Santiago de Pupuja.

In 1923, Sabogal discovered the tradition of making *mates*—engraved gourds—on the festivals of Huancayo (cats. 268-270). In 1928, he incorporated motifs from engraved gourds into a number of covers he designed for the magazine *Amauta* (Yllia 2006) and into the poster for his exhibition at the Asociación Amigos del Arte in Buenos Aires. The mestizo element of popular art was defined in the text "El mate y el yaraví," written for *Amauta* (Sabogal Diéguez 1929, 19).

Sabogal contributed to the decoration of the Peruvian pavilion at the exhibition marking the centenary of Bolivian independence in 1925 with a project in which the predominant motifs were Inca-style geometrical patterns and those derived from the *keros* (earthenware pots) made under the Viceroyalty. The pavilion included a section for textiles from Cotahuasi and other indigenous products, as well as rugs from that area, also based on Inca motifs, others from Ayacucho, ceramics from Puno, and engraved *mates* (fig. 2, p. 278).

For the Peruvian pavilion at the 1929 Ibero-American Exposition of Seville, Sabogal created a series of friezes based on *keros* dating from the colonial period. Both the *mate* and the *kero* were seen in a light that was purely aesthetic and apolitical. The painter thought that the *keros* were forerunners of the *mates* made under the Viceroyalty and the Republic, from both a technical and a figurative point of view (Sabogal 1975, 71). Their technical and aesthetic similarities led Sabogal to bring them together to create a vision of what he defined as Peruvian. We now know that popular art inherited from the Viceroyalty an aesthetic tradition that first manifested itself in the eighteenth century (Valcárcel 1949, 15); the engraved *mate* was a descendant of colonial silverware (Carpio 2006, 27), and the *retablos* ("Cajones de San Marcos") derived from carvings in Huamanga alabaster (Macera 2009, 181).

The work of the Instituto de Arte Peruano (IAP), set up in 1931 in association with the Museo Nacional, whose director at that time was Luis E. Valcárcel, was at first centered on the study of pre-Columbian art, in keeping with the museum's main collection and program. The recognition of that inheritance as initiating a cultural process in the national imagination was fundamental to Sabogal's thinking. The watercolors by the painter Camilo Blas, the first artist to join the IAP, dedicated to the study of the pre-Columbian period and the Viceroyalty, provide evidence of that process (cats. 272, 274).

The Peña Pancho Fierro, an informal club and meeting place for intellectuals and

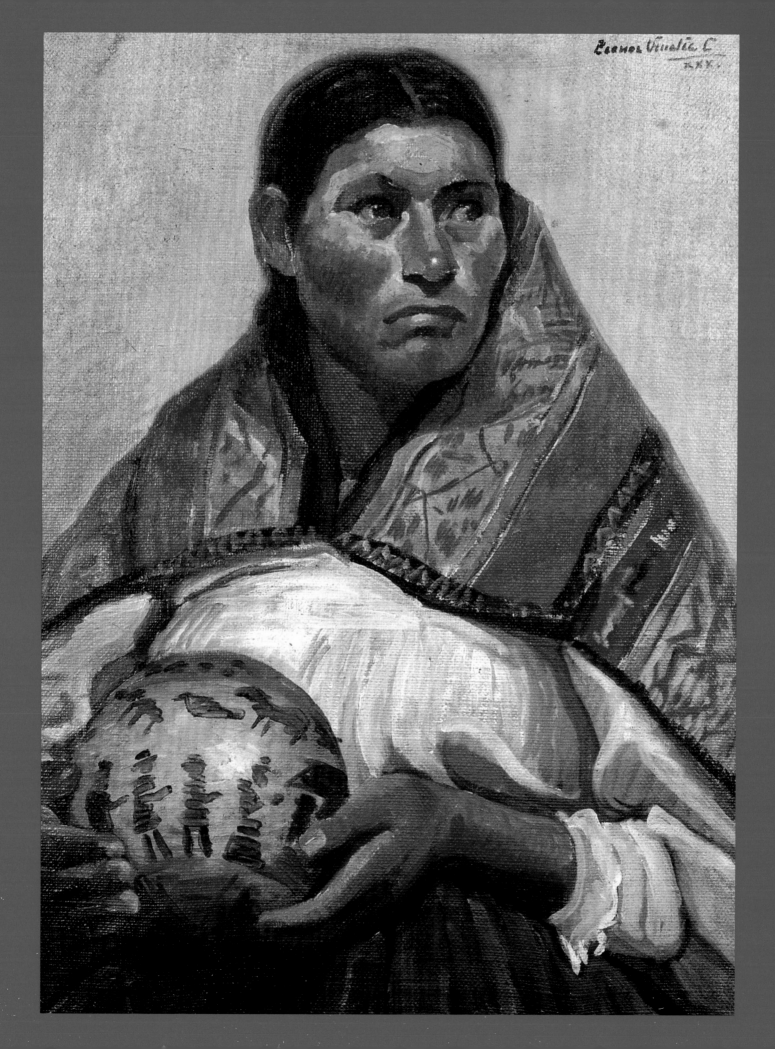

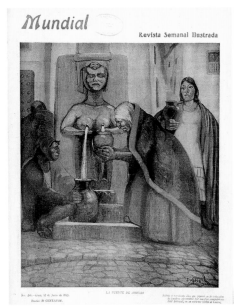

Mundial

Revista Semanal Ilustrada

Fig. 1

265

Fig. 2

Fig. 3

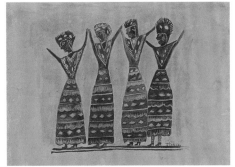

Fig. 4

EL "KERO" I. A. P. 2

MVSEO Đ LA CVL TVRA PERVANA

266

Fig. 1
José Sabogal
The Arones Fountain
Cover of the journal
Mundial, June 1925,
Biblioteca Nacional
del Perú, Lima

265.
José Sabogal
The Arones Fountain
1925

Fig. 2
**Room of Cotahuasi
textiles and indigenous
industries**
Peruvian pavilion,
**Exposition for the
Centenary of Bolivia**
Published in the journal
Mundial, November 1925
Biblioteca Nacional
del Perú, Lima

Fig. 3
**Carlos Quizpez Asín
showing Mercedes Gibson
the details inspired by
carved gourds on his
panels for the Negro
Negro centre**
Published in the journal
Flora, April 1951
Archivo Carlos Quizpez
Asín

Fig. 4
**Julia Codesido
Dancers,** n.d.
Museo Nacional de la
Cultura Peruana, Lima

266.
**José Sabogal
Artwork for the cover
of El "Kero",**
About 1950

artists, run by sisters Alicia and Celia Bustamante, opened in 1936 and hosted the first exhibitions of popular art (Carpio and Yllia 2006). Alicia Bustamante was a painter and a pioneer in this genre, and she began to build up her collection in 1934 ("La gran Ausente" 1968, 57). She put on the first exhibition of popular art in Lima in 1939 (Arguedas 1969, 30), sponsored by the government of Benavides. On that occasion the official view was to bring all of Peru together in Lima (Benítes 2010, 41), and the exhibition included Andean artifacts that catered to the tastes of 1930s Lima, removed from their original users and the purposes for which they were made. These were art objects valued for their Peruvian content.

One of the intellectuals most keenly interested in bringing the Andean world into the city was the writer José María Arguedas, distinguished for his literary work and his ethnographic studies of Junín and Ayacucho. Arguedas analyzed the phenomenon of transculturization, understood as the mutual influence of dominant white and subjugated Indian cultures. He first developed his thinking alongside the Bustamante sisters at the Peña Pancho Fierro and later with Valcárcel and Sabogal at the Museo Nacional.

In the 1940s and 1950s, the IAP revived the traditions of the Viceroyalty, in contrast with the primarily Indian legacy of the *mate* and the *kero*, which had predominated in the 1920s. On her visit to Ayacucho in 1943, Alicia Bustamante met Joaquín López Antay and suggested that he include scenes showing local customs and everyday life in his traditional *sanmarcos*, the predecessors of the now famous *retablos* (Arguedas 1958, 148) (cat. 284). She also introduced the imaginative world of Cuzco, with the work of Hilario Mendívil and Georgina Dueñas (fig. 6, p. 286). The Bustamante sisters were true patrons of folk artists, bringing them to Lima and providing them with exhibition space. We should also mention an engraver of *mates*, Catalina Zanabria de Medina, who was closely associated with the Bustamantes' group (De Gálvez 1969).

Sabogal and his group surmounted the dichotomy on which nineteenth-century Creole nationalism—still a force in the twentieth century—had been built, separat-

ing the Spanish and Indian legacies. Jorge Vinatea Reinoso and Elena Izcue represented that tendency: the former by embracing indigenous or purely Creole imaginative traditions (Majluf and Wuffarden 1997, 343) and the latter by painting pre-Columbian subjects (Majluf and Wuffarden 1999). Therein lies their difference from Peruvian artists of the 1920s.

It is nevertheless interesting that the first painting in which an Andean woman is portrayed with an engraved *mate* should have been painted by Elena Izcue, an artist associated with pre-Columbian subjects. It was reproduced on the cover of *Mundial* in January 1924. Vinatea Reinoso's travels in the Andean south of Peru gave him the opportunity to depict Puno ceramics in *Dia de feria en Pucará* (Fair Day in Pucará, 1927). In addition, both Manuel Domingo Pantigoso, in *Tocapus* (1922), and Francisco González Gamarra, in *Escena Inca* (Inca Scene, 1924), were inspired by colonial-period *keros* (Cossío del Pomar 1927), a demonstration that popular art had a place in the imagination of the decade's most important artists.

The thinking of Sabogal and his group was presented at the Peruvian pavilion in the 1937 Paris International Exposition, where popular art objects were presented as the product of Peruvian cultural processes (Revista del Museo Nacional 1937, 188–189). In the same year, the painter Enrique Camino Brent was able to identify the traditional ceramic figure of the "Torito de Santiago de Pupuja" at the station in Pucará (Revista del Museo Nacional, 1960). Sabogal's *Peruvian Art Landscape* (1947) (cat. 282) uses the colors of ancient Peruvian ceramics (Villegas 2008, 69). By placing an Inca "Illa" in the shape of an alpaca in the background (cat. 278), Sabogal seems to be suggesting the animal's transformation into the "Torito de Pucará" (Stastny 1981). The bull serves as an emblem and symbol of the mestizo imagination in a number of Sabogal's paintings (cat. 281). Its importance is also visible in the work of other artists, such as Carlos Quizpez Asín. As early as 1951 he had included the motif of the *mate* in the decorative linocut panels he made to decorate the club Negro Negro, a center of Lima's bohemian nightlife (fig. 3, p. 278).

The first official collection of popular art was created at the IAP when the Museo Nacional de la Cultura Peruana was opened in 1946. The room displaying popular art opened in December 1948, but before then there had been exhibits of popular art, including pieces from the collections of Arturo Jiménez Borja, Alicia Bustamante, and Elvira Luza. In order to ensure continuity in the study of popular art objects, members of IAP recorded them in various media, mainly watercolor. This collection, which was published only recently, is proof that there was an interest in studying the forms and conventions of popular art that Sabogal and his group were trying to make their own. This mestizo narrative also included the study of the colors of pre-Columbian ceramics, which were subsequently used in the watercolors of *mates* (fig. 4, p. 278) and *keros* painted between 1948 and 1954.

The importance of *costumbrista* subject matter, which appears in the work of Sabogal and his group, as well as being a significant factor in popular art, should not be underestimated. Sabogal exhibited subjects of that kind at the Casa Brandes in 1919 and the Casino Español in 1921. Engraved *mates* were reassessed because of the scenes of everyday life which decorated them, and this interest was a factor in the acquisition by the IAP of paintings by Arce Naveda and Concepción Mirones, as well as in the support offered to the painter Mario Urteaga (cat. 225). This interest also led Alicia Bustamante to ask López Antay to include *costumbrista* scenes of the area in his *retablos*. The desire to record aspects of local life led Sabogal to reassess the mulatto painter Francisco Fierro; in 1953 a permanent gallery was devoted to Fierro's work, including his portrait and twenty watercolors. Inspired by Fierro, Sabogal and his students made watercolors of traditional costumes from all parts of Peru (cats. 249-253). For Sabogal, Fierro was a summation of mingled elements dating back to the earliest mestizo, Garcilaso de la Vega, and he was an indispensable point of reference, justifying the *costumbrista* work of Sabogal and his group, this time at the national level.

The objects defined by Sabogal and his group as being popular art of a mestizo character transcend their own nature, which is diverse and complex. They are cultural objects that carry on a time-honored historic process. At the same time, they express the ways of life and thought of the society that produced them. Their aesthetic aspect is not of prime importance, but is the sum of their ritual and practical purposes. They were introduced to Lima by its painters at a time when the fragmentary and discontinuous process of modernization taking place in the Andes was in danger of making them disappear.

The strong links between academic artists and popular art were of great importance: they put a new value on popular art, collected it, and incorporated its language into their work. In the 1940s, Enrique Camino Brent made glazed ceramic *chuas* (traditional dishes) in the style of Puno, and he was the first popular artist to paint a portrait in oil of Joaquín López Antay (1957), in which he holds a *retablo* as his attribute. He appears to have followed in the footsteps of Leonor Vinatea Cantuarias, who in 1930 painted an anonymous woman potter of Huancayo, holding a *mate* (cat. 264); in the 1930s Sabogal himself had made a drawing of a *mate* engraver, Mariano Flores (cat. 271).

The principal legacy of Sabogal and his group was the serious and profound study of what Peruvian art signified for them at a time when it was impossible to separate nationalism and art; in other words, one had to look at one's own culture, master its language, and create an art that reflected the memories and traditions of Peru. What made that theoretical program so firm and solid was its primary aim—to understand Peru in all its diversity. It would be the popular and academic artists of the following generations, away from the prejudices of those earlier days, who would be able to conceive of a Peru and its art that would come, as Arguedas said, from "every bloodline."

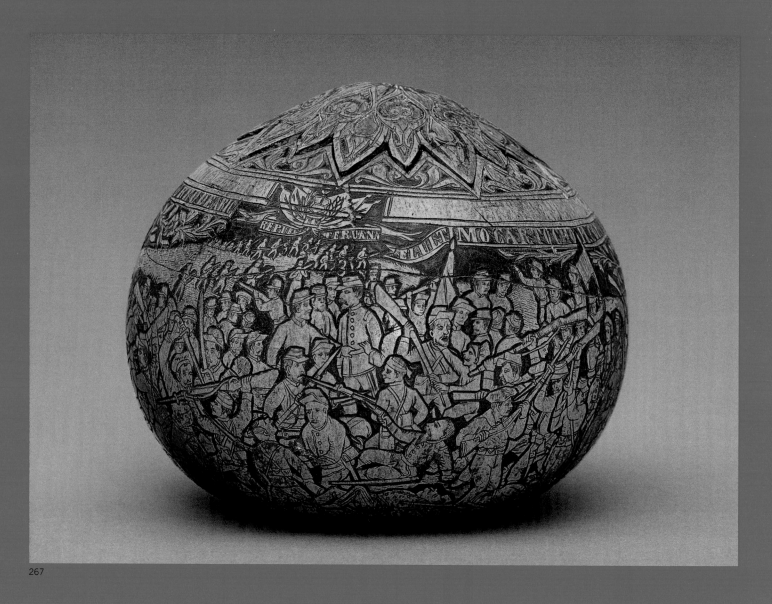

267

267.
MARIANO INÉS FLORES
CARVED GOURD DEPICTING SCENES FROM THE WAR OF THE PACIFIC
About 1920

This gourd, the work of one of the greatest known engravers, Mariano Inés Flores, is in the form of an *azucarero* (sugar bowl). Its lid has lanceolate edges, decorated with motifs of *mudejar* inspiration, and its belly depicts a narrative scene. The inscription in the upper part enables us to identify the scene as the Battle of Arica (1880), an important episode in the War of the Pacific, in which Peru and Bolivia fought against Chile. That war, which ended in defeat for Peru, marked a crucial moment in the intensification of the search for a coherent national identity.

That subject, which is relatively frequent in Flores's work, therefore represents for Ríos Acuña (2010) a reflection on the idea of a Peruvian nation. The presence of the coat of arms of the Republic of Peru above the scene reinforces that idea. The artist has depicted with striking realism the tangled bodies on the battlefield. The high quality of the drawing, and the attention to detail characteristic of Mariano Inés Flores's work are clearly seen in the individualization of the soldiers' faces, all of them different. The blank strip that goes round the upper part of the composition is always seen in Mariano Inés Flores's gourds, and was intended to carry a dedicatory inscription.

According to Statsny (1981, 134), of all forms of cultural expression in Peru the art of engraving gourds may have the longest continuous history. The earliest decorated gourds were found at Huaca Prieta, a site on the northern coast of Peru occupied about four thousand years ago. In the colonial period the production of engraved gourds arrived in the central highlands, where the largest centers are still found today, in the regions of Junín and Huancavelica, where Mariano Inés Flores was born.

E.H.

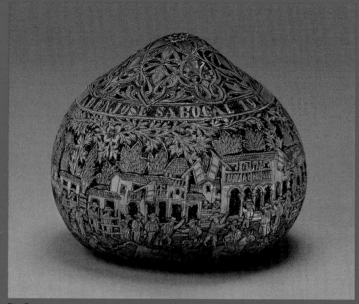

Fig 5

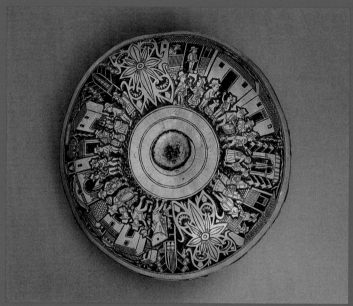

268

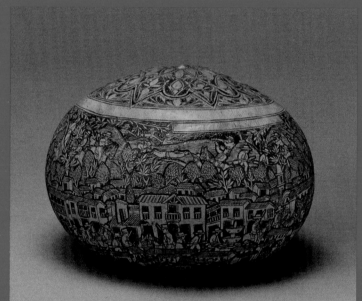

269

271

270

Fig. 5
Mariano Inés Flores
Engraved gourd dedicated to José Sabogal
1928
Private collection, Lima

268.
Anonymous
Carved gourd depicting parades of musicians and Amerindians in festive clothing
First half
of the 20th century

269.
Anonymous
Carved gourd depicting military scenes
First half
of the 20th century

270.
Anonymous
Carved gourd depicting rural scenes
First half
of the 20th century

271.
José Sabogal
Gourd engraver
n.d.

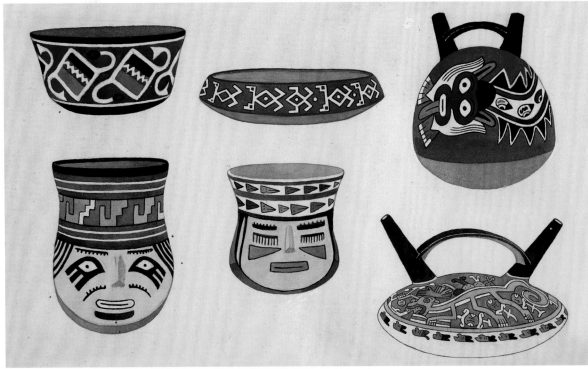

272

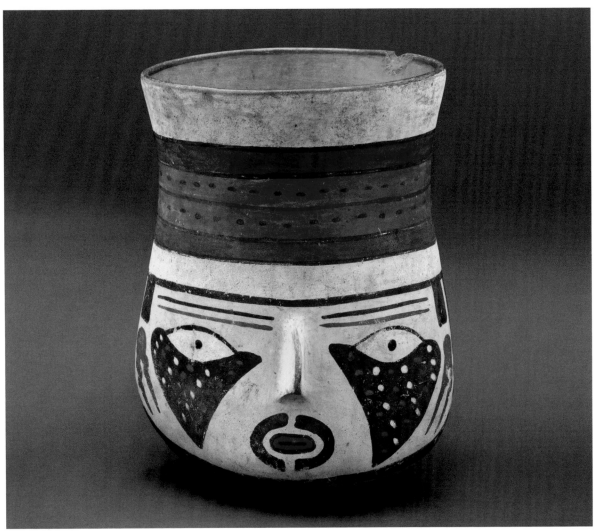

273

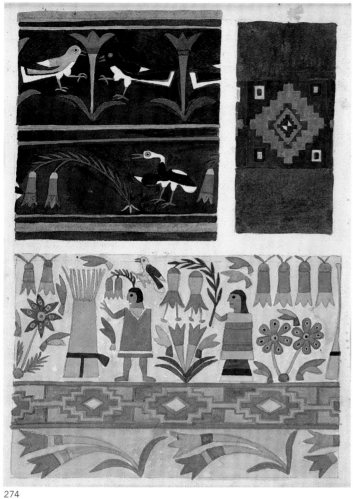

274

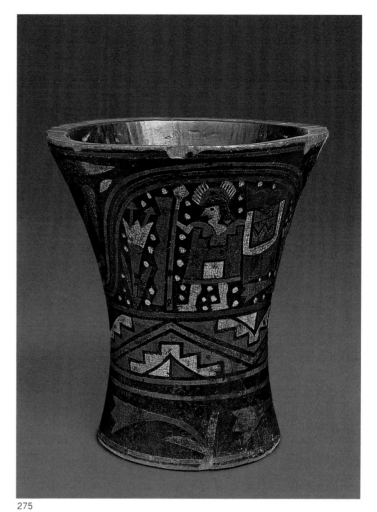

275

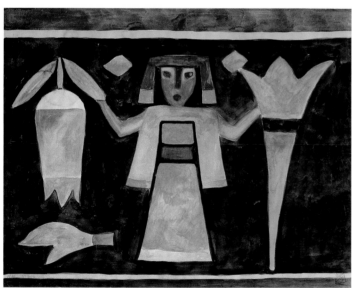

276

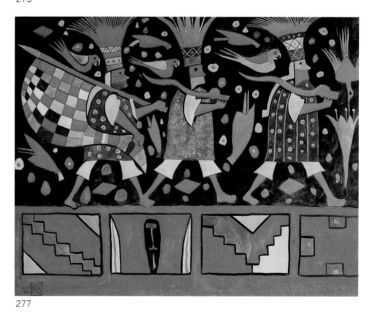

277

278

279

280

281

278.
Inca
Conopa (votive object)
in the shape of an alpaca
1450–1532 A.D.

279.
Anonymous
Conopa (votive object)
in the shape of an alpaca
19th century

280.
Anonymous
Roof ornament
in the shape of a bull
19th century

282.
José Sabogal
Peruvian Art Landscape
1947

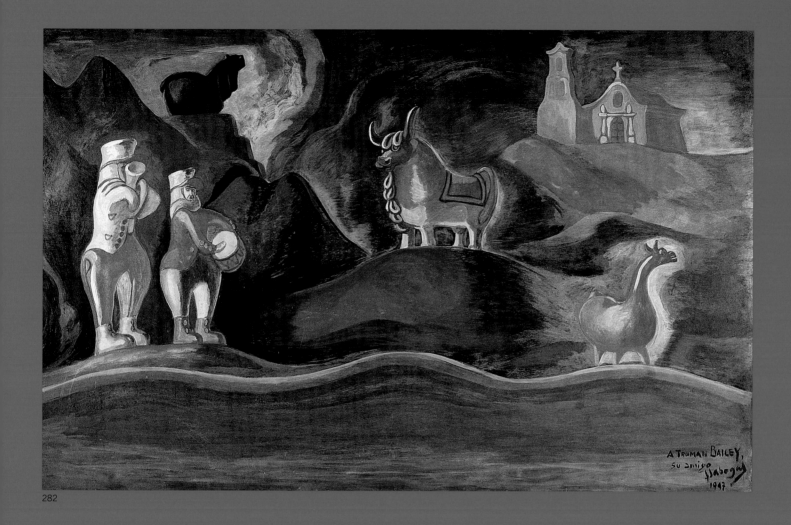

282

281.
ANONYMOUS
ROOF ORNAMENT IN THE SHAPE OF A BULL
About 1960

This type of bull, often called the "Torito de Pucará," after the place where most of them are sold, is made in Santiago de Pupuja, near Pucará, in the Department of Puno. The opening in the bull's back is a reminder that its form is derived from that of the Inca *conopa*, a ceremonial receptacle based on the body of a camelid. In the early twentieth century, interest in the bulls of Santiago de Pupuja as souvenirs led to their being made in larger sizes with decoration. The ornamental folds below the neck and the use of green glaze, a technique that reached Peru in the sixteenth century, are characteristic of these large bulls. The spiral motifs

probably refer to those painted using ochre on the flanks of live bulls during agricultural ceremonies. At these events, alcohol and/or chili powder are also put in the animal's nostrils and under its tail, which may explain the dilated nostrils and the tail folded back over the hindquarters of the bull shown here.

In the mountainous areas of Peru, these bulls are placed on the roof of a house in order to protect it and to guarantee the household's prosperity and fertility. It is likely that the association between the bull and fertility goes beyond their function in agricultural work. In fact, in indigenous

myths, the bull is often seen as an avatar of the serpent *Amaru*. *Amaru*, who is also associated with the rainbow, lives in lagoons, sources of water that are vital for the fertility of cultivated fields. According to Fedora Martínez (2009), the identification of the bull with the serpent *Amaru* may originate from the similarity between the Quechua word *turu*, meaning the primordial mud from which the rainbow sprang, and *toro*, the Spanish word for a bull.

E.H.

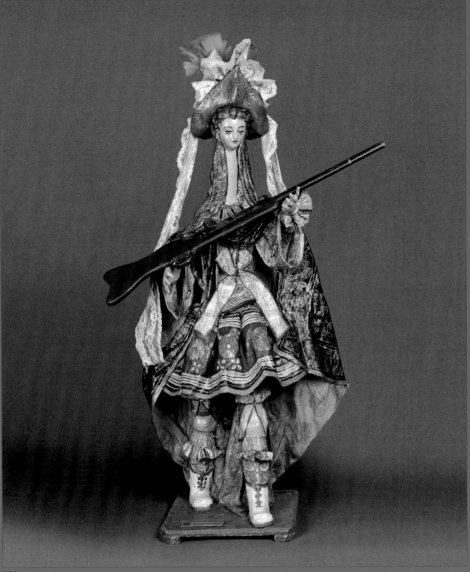

283

283.
JUANA MENDÍVIL DUEÑAS DE OLARTE
ARQUEBUSIER ARCHANGEL
Second half of the 20th century

This statuette, with its long neck and serene features, is typical of the style embraced by Hilario Mendívil in the 1950s and continued by his descendants. This piece in particular shows the influence of the baroque style of the Cuzco School. In fact, its subject, the archangel portrayed as an arquebusier, a mixture of religious and secular themes, is found in many paintings from the colonial period, in which armed archangels wear extravagant garments based on the dress of Spanish aristocrats of that time. The tabard, cape, and large plumed hat worn here by the archangel are clearly inspired by these paintings.

The artist has used a variety of materials and techniques to express, in three dimensions, the beauty and lavishness of the costume. While painting was often favored in more academic artistic circles, the art of sculpture has always dominated popular art. The maguey and plaster are delicately sculpted, then pieces of cloth are pasted onto them and painted in bright colors. Lace and feathers add a finishing touch to the decoration of the hat. Floral motifs and gilding form part of the heritage of the baroque, as reinterpreted by Cuzco's indigenous artists. By combining the use of the maguey, a local material known in the pre-Columbian era, with a subject inspired by colonial art and with innovative stylistic elements that clearly place this piece among the works of the Mendívil Dueñas family, this vividly colored statuette demonstrates its maker's creativity and skill. The sculptures made by the Mendívil Dueñas family are part of a process of reinterpretation, hybridization, and creation that brilliantly reflects the complexity and the historical, cultural, and artistic richness of Cuzco.

E.H.

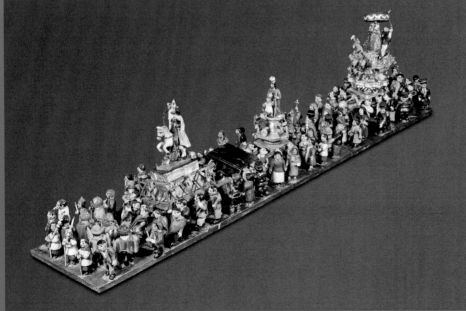

Fig 6

Fig. 6
**Hilario Mendívil
and Georgina Dueñas**
Corpus Christi Procession
About 1950
Museo Nacional
de la Cultura Peruana, Lima

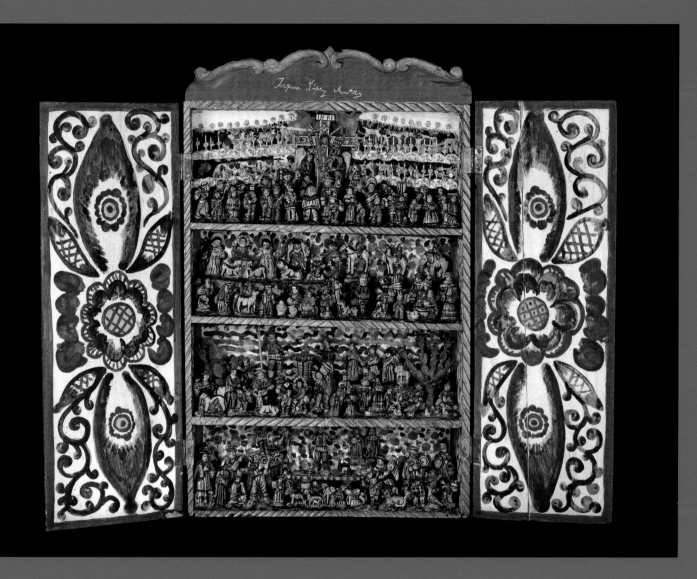

284

284.
JOAQUÍN LÓPEZ ANTAY
ALTARPIECE
About 1970

This *retablo*, with its four levels depicting complex scenes, is unusually impressive. The decoration of the background, with small, multicolored touches of paint, is characteristic of Joaquín López Antay's work. The two uppermost levels contain scenes based on Catholic themes: a figure of Christ on the Cross, flanked by two angels and surrounded by a great number of candles, while in the section below them, the Three Kings present their gifts to the Infant Jesus. In both cases, the presence of Andean figures, some of them playing musical instruments, suggests that these scenes represent festivals celebrating those events rather than illustrating the biblical episodes them-selves. The scenes represented in the two lower sections refer to events more specifically connected with the life of the people in the Ayacucho region: harvesting prickly pears, for example, and below that, a celebration attended by a throng of musicians playing traditional instruments including the *waqra* (horn) and the drum.

The *retablos* are descended from the *sanmarcos* ritual boxes used in the nineteenth century during rituals such as cattle branding. Catholic patron saints were found in the upper part, and a representation of the ritual in which the box was used occupied the lower one. When the art of making *sanmarcos* declined with the modernization of Peru in the early twentieth century, interest in popular art on the part of the *indigenistas* led to their transformation. Alicia Bustamante in particular helped to make objects of that kind better known in Lima's artistic circles. In order to meet the demands of that clientele, a wider variety of subjects were treated, placing greater emphasis on scenes depicting popular culture (Ulfe 2009). Alicia Bustamante then suggested the word *retablo* to distinguish these new objects from the traditional *sanmarcos*.

E.H.

Indigenismo and Peruvian Architecture

José García Bryce

Indigenismo emerged in Peru in the early years of the twentieth century and gained ground in the 1920s, manifesting itself equally strongly in political and social life and in culture and the arts: painting and sculpture, literature, music, the graphic arts, and architecture. The value placed on what was native to Peru was associated with the idea of affirming selfhood and with the search for a specifically Peruvian modernity, distinct from that of the Western countries from the industrialized world.

Peruvian *indigenismo* enjoyed a certain official status in the period from 1919 to 1930, known as the "Oncenio [eleven years] de Leguía" (Coronado 2009, 9). The 1920s were also a time of ideological fervor and left-wing political programs, such as those of José Carlos Mariátegui and Víctor Raúl Haya de la Torre, who supported the claims of indigenous cultures and emphasized Peru's Indian dimension. Interest in those phenomena required knowledge of ancient Peru, and Peruvian archaeology came of age at that time with the seminal work of Julio C. Tello and his students and colleagues. The contribution made by archaeology—including the contact between artists and architects, on the one hand, and archaeologists and students of the arts of ancient Peru, on the other—was of great importance for architecture and *indigenista* art.

There were early glimpses of *indigenismo* in nineteenth-century art. For example, Francisco Laso's painting *Inhabitant of the Peruvian Highlands* (1855) and the search for Inca identity in the literature and theater of Cuzco (Majluf 2004b, 125) were forerunners of the literary *indigenismo* of the 1910s and 1920s (Sánchez 1981, 57). Following World War One, said Sánchez, with the rise of a systematic nationalism, people went in search of older national traditions, and popular and folk culture began to arouse great interest, leading to a resurgence of Peruvian Indian culture in both its folkloric and its ideological aspects.

What Was Happening in Architecture at that Time?

Architects did not succeed in forming a group comparable to that of the painters who gathered round the figure of José Sabogal. Unlike painting, *indigenista* architecture had a somewhat fragmentary existence, but it was no less important as a means of expressing something unmistakably Peruvian in the context of the historicist and eclectic architecture of the time.

Some scattered examples of *indigenista* (as well as neocolonial) architecture appeared in the 1910s, as for example the house of Dr Teófilo Falcón, mentioned by the painter and art critic Teófilo Castillo in one of his articles in *Variedades* (1914, 792–793). Castillo supported the idea of a "Peruvianist" architecture outside pre-Hispanic or Hispano-colonial traditions. The disjunction between *indigenista* and Hispanist approaches was visible as early as the turn of the century. Sánchez said that the *indigenistas* "felt obliged" to be anti-Hispanic, a disjunction

that had less impact in the field of architecture and among architects. Architects who thought about the question tended instead to propose a version of Peruvianism based on *mestizaje*, the hybridization of Indian and Spanish traditions. There are parallels there with *indigenista* painting. *Indigenista* painters depicted what they saw in the Peru of their day, which was a native Peru full of syncretic elements. They represented things that were characteristically Peruvian, especially the Andes, emphasizing the indigenous components of a *mestizo* Peru. Mariátegui's "peruanicemos el Perú"—let us make Peru Peruvian—becomes "peruanicemos el arte moderno del Perú"—let us make Peru's modern art Peruvian.

In *indigenista* architecture it was not a matter of incorporating the spatial and volumetric forms and compositions of the different styles of ancient Peruvian architecture: the truncated pyramids, ramps, and plazas of the religious administrative centers, or the *cancha*, or domestic compound, the basic unit of Inca architecture. In general these are not forms easily adapted to today's architectural programs. Nor was it a matter of going back to pre-Hispanic building systems, with their thick walls of adobe, mud brick, or stone and their roofs made from tree trunks and *ichu*, a type of grass. Following the historicist and eclectic practice of nineteenth-century architecture, the *indigenista* approach was to incorporate the individual architectonic and decorative elements of historic styles, in this case those of the cultures of ancient Peru, into the

Fig. 1. Attributed to the workshop of Manuel Piqueras Cotolí, Altar proposal for Santa Rosa de Lima's Basilica, about 1936, Wood, Javier Luna Elías Collection, Lima

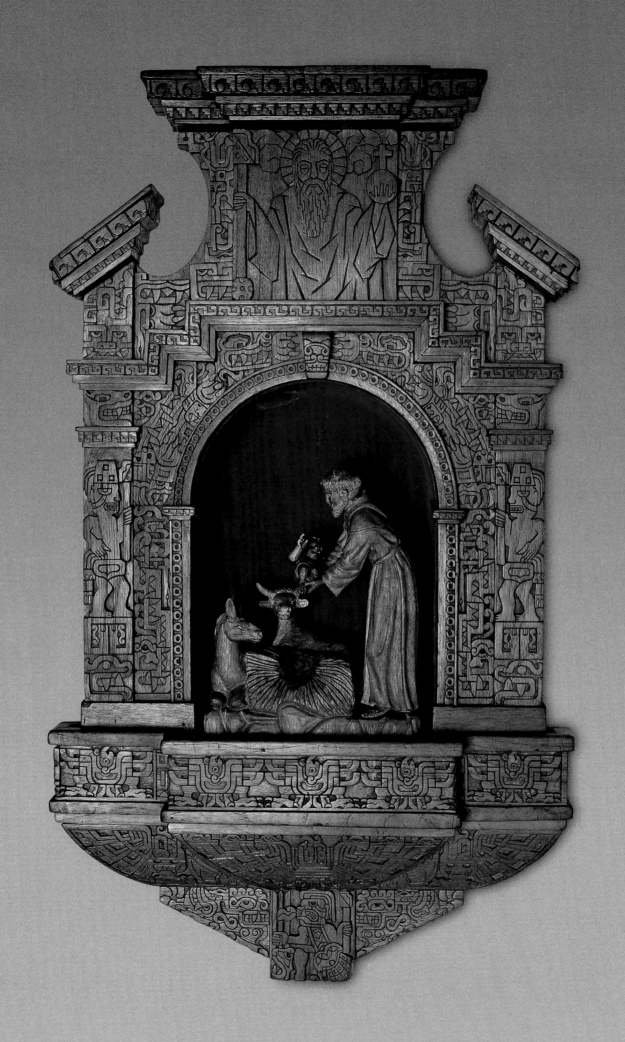

Fig. 2

Fig. 3

Fig. 4

Fig. 5

Fig. 6

Fig. 2
Claudio Sahut
Proposal for the Museo
Larco
1921

Fig. 3
Emilio Harth-terré
Proposal for a "Cuzco
model" of Peruvian
architecture
Published in the journal
Ciudad y Campo
January-February 1928

Fig. 4
H. Baranger
View of the Peruvian
pavilion
Exposition internationale,
Paris
1937
Canadian Centre for
Architecture, Montreal

Fig. 5
Manuel Piqueras Cotoli
and Héctor Velarde
Proposal for the Santa
Rosa Basilica in Lima
Published in the journal
El Arquitecto Peruano
January 1939

Fig. 6
Emilio Harth-terré
Proposal for the La Torre
Ribaudo House
1930s

architecture of the day—private homes and public buildings—without altering their typology or their relationship with their urban setting, and using contemporary building materials and systems. In that regard, architects who developed a theory of Peruvianist architecture and promoted it also asserted the legitimacy of functionalism and the use of modern building materials and systems. It was not a question of reviving the ancient architecture of Peru but of creating a modern architecture with an indigenous Peruvian stamp.

When making a critique of Peruvianist architecture it is important to bear in mind that training in Peru was still classical and historicist. Most architects belonged to a generation that still thought it legitimate to use historic styles, either to express the character of their projects or for evocative purposes. Héctor Velarde and Emilio Harth-terré belonged to that generation, and in addition to designing and building, they published texts on architecture and art in which they endorsed the Peruvianist movement. Héctor Velarde maintained that modern architecture should "become Peruvian and part of our visual environment and lend itself to certain changes, to make it appropriate for us" (1938). Harth-terré recommended that one should "... encourage the search for an expression of art that is Peruvian—and therefore contemporary and of the moment... That unease begins to be felt when, in [an] architectural work of functional or contemporary design, the dominant decorative element ... is already a characteristic, whether it develops within a Peruvian-baroque tendency, or creates ... its own decoration..." (1945). We may understand here that the "dominant element" would consist of forms derived from the arts of ancient Peru.

The idea that architects and their clients had of what should or could be a building in "Peruvian" or "indigenous" style becomes concrete in the designs and completed works to which I will now refer.

The first of these is the present Museo Nacional de la Cultura Peruana in the Avenida Alfonso Ugarte (fig. 8, p. 292). In the mid-1920s, Víctor Larco Herrera, a collector of archaeological objects, arranged for the museum to be built. He sponsored

an architectural competition, one of the conditions being that the design should be in the "Inca style." The architect chosen was Ricardo de Jaxa Malachowski. He cast forms derived from the Inca and Tiahuanaco cultures within a symmetrical design, similar to that of the traditional academicist "divisions." Drawings of another scheme for the museum, by the architect Claudio Sahut, also survive (fig. 2, p. 290), and in them, too, the "Inca style" is interpreted according to the classical canons of symmetry and axial hierarchy.

The 1920s marked an acceleration in the transformation of Lima, with its growing population and broad new avenues. In the same year that Víctor Larco's museum was built, the city was expanding into a new area to the south: the district of Santa Beatriz. The presence of trees and retreats with gardens of the new *chalets*—small detached houses—gave Santa Beatriz a feeling of the country in the city, influenced by the model of the North American suburb.

A new park for Lima was created in Santa Beatriz: the Parque de la Reserva, named in honor of the reservists who defended Lima in the war with Chile. The architect Claudio Sahut and the engineer Alberto Jochamowitz were responsible for planning and creating the park. Its design included an area of informal landscape in which the park's principal *indigenista* features are to be found: José Sabogal's so-called *huaca* (fig. 9, p. 292) and the Fountain of the Ceramics by D. Vásquez Paz (fig. 10, p. 292). The *huaca* has the appearance of a small ensemble with pitched roofs, resting on a broad base of battered walls decorated with friezes of stepped motifs. It is perhaps reminiscent of the house of an ancient ruler, or of a shrine. It belongs to the architectural genre of the pavilions that were traditionally built in parks or large gardens. Apart from their practical functions, from the eighteenth century onwards, with the rise of Romanticism, they were also intended to have evocative associations. With their historicist forms, they evoked the past or distant, exotic places. Sabogal's *huaca* evokes not antiquity, the Orient, or the European Middle Ages, but ancient Peru. In other words, the subject of the Romantic process of evocation is being Peruvianized, follow-

ing Mariátegui's recommendation ("let us Peruvianize Peru"). The second work, the fountain, is interesting because it interprets *indigenista* material—ceramics and sloping or trapezoidal forms—in a modernist or "Art Deco" style.

An article published to mark the opening of the Parque de la Reserva emphasized the *indigenista* aspects of the ensemble, presenting the park as an assertion of national culture, in opposition to the academicist and Eurocentric view of the arts promoted by conservative currents of opinion. I quote: "... especially praiseworthy is the fact that in whole native ornamental motifs have been used, breaking with the school that wished to turn our country into a subsidiary, using ornamental motifs derived from Europe and classical Greece... The Park ... signifies ... the official recognition of *indigenismo* as a concept in the fields of ornament and decoration" ("El Parque de la reserva..." 1929, 27).

In the 1920s, the *indigenista* tendency also found expression in some of the private houses built in the new developments, including that of the archaeologist Julio C. Tello in Calle O'Donovan, in Miraflores (fig. 11, p. 292). The architect was Enrique Rivero Tremouille, but judging from the design, Tello must have made a decisive contribution. This house combined the picturesque style of the *chalets* of the 1920s and 1930s with a varied repertory of architectural and decorative motifs influenced by Inca, Chavín, and other cultures, which give the house a distinctly *indigenista* character and, at the same time, the suggestion of architectural caprice. With reference to "*indigenista* houses," Emilio Harth-terré published a series of "models of Peruvian architecture" that is appropriate to mention here; it included a neo-Inca "Cuzco model" (1928, 14) (fig. 3, p. 290). The "models" were of suburban houses without tiled roofs, like those in Lima, a city whose "residential districts" had begun to grow rapidly. Another project, also by Harth-terré and dating from the 1930s, is of interest in this connection: the design for the La Torre Ribaudo house (fig. 6, p. 290), which is more like an expression of "*indigenista* functionalism," in some ways reminiscent of Frank Lloyd Wright.

In the years following the "Oncenio de Leguía," *indigenismo* continued to feature

291

Fig. 7

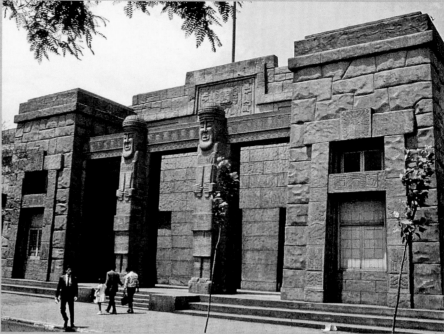

Fig. 8

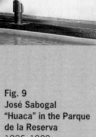
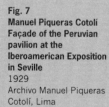

Fig. 9

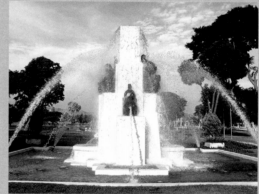

Fig. 10

Fig. 11

Fig. 7
Manuel Piqueras Cotolí
Façade of the Peruvian
pavilion at the
Iberoamerican Exposition
in Seville
1929
Archivo Manuel Piqueras
Cotolí, Lima

Fig. 8
Ricardo de Jaxa
Malachowski
Museo Larco
(now Museo Nacional
de la Cultura Peruana)
1924

Fig. 9
José Sabogal
"Huaca" in the Parque
de la Reserva
1926–1929

Fig. 10
Manuel
or
Daniel Vásquez Paz
Fountain of the Ceramics
in the Parque de la Reserva
1926–1929

Fig. 11
Enrique Rivero Tremouille
House of Julio C. Tello
in Miraflores, Lima
1930

as an expression of national culture in occasional works and designs. One example is the plan to build a national vocational school for Peruvian textile arts, designed by the architect Eduardo Velaochaga. It was to be built on what was then called Avenida Wilson, and its purpose was to revive the art of textiles, covering both the country's modern textile production and its pre-Hispanic counterpart, a central component of ancient Peruvian cultures. The initiative enjoyed the support of Luís E. Valcárcel, one of the leading representatives of *indigenismo*, and the design was to be in the "Inca" architectural style (Velaochaga 1933, 27). In the case of the vocational school there was a certain convergence of *indigenismo* and Hispanic conventions, since the project was meant to form part of the "Exposición de Lima 1935," which was to have been held to mark the fourth centennial of Lima's founding by the Spaniards, a project with clear Hispanist connotations.

That a style that was both modern and *indigenista* was the most appropriate in which to represent Peru at an international exhibition was the concept underlying the architecture of the Peruvian pavilion at the 1937 Exposition Internationale in Paris (fig. 4, p. 290). The architect Roberto Haaker Fort was commissioned to design the pavilion, in collaboration with the French architects Carré and Schlinger. The engineer Alberto Jochamowitz was also involved, specifically in fitting out the interiors and designing the furniture. The architecture of the pavilion, which could be described as "*indigenista* Art Deco," was fairly consistent with the scope of the exhibition: pre-Hispanic Peru and the modern Peru of the 1930s. The exhibition consisted of various sections: archaeological objects from the Chimú, Mochica, and Paracas cultures; modern objects inspired by *indigenismo*, made by Elena and Victoria de Izcue; and photographs. Subjects of these included the Peruvian landscape, Inca architecture, and modern Peru. The latter was represented by public buildings and social projects undertaken by the Benavides government, and by the extractive industries, principally mining. Two themes thus run through the image of Peru projected by the pavilion: the cultures of ancient Peru as a force for national unity, something of which it should be proud, and the progress achieved by modern Peru, specifically under the government of Oscar Benavides.

In the context of *indigenismo*, it is important not to overlook the work of Manuel Piqueras Cotolí, a Spanish sculptor and architect who settled in Lima in 1919 (Wuffarden 2003). Piqueras's "neo-Peruvian" architecture was based on a fusion of Hispano-colonial and pre-Hispanic architecture, and was intended to express the racial and cultural *mestizaje* of the Peruvian nation. Piqueras himself used to say that it was possible to attempt or to resurrect "an architecture that was distinctly Peruvian-modern, one in which were reflected the spirit, the rhythms, and the soul of a people; of the peoples and the cultures who have passed through this land" (Wuffarden 2003). Historians of colonial architecture of southern Peru and Bolivia seem to have coined the term "*mestizo* architecture" at around that time, referring (rightly or wrongly) to the architecture of Puno and Arequipa.

In the buildings completed by Piqueras in Lima (the Salón Ayacucho, in the now lost Palacio de Gobierno, and the façade of the Escuela de Bellas Artes, both dated 1924), the *indigenista* element appears only in the decoration, and in combination with motifs from the Spanish baroque tradition, in architectural contexts that might be considered neocolonial. The pre-Hispanic or *indigenista* component (mainly Inca and Tiahuanaco) was more in evidence in the Peruvian pavilion at the 1929 Ibero-American Exposition in Seville (fig. 7, p. 292) and in the design for the basilica of Santa Rosa from the early 1930s, sketched in rough by Piqueras and drawn by Héctor Velarde (fig. 1, p. 289, fig. 5, p. 290) (Velarde 1940, 240–252). Velarde himself used Inca and Tiahuanaco subjects, similar to those on the doors of the basilica, on the façade of the Museo Nacional de Antropología y Arqueología de la Magdalena. They can also be seen in the bottom section of the monument to Fermín Tangüis, near the Parque de la Reserva.

Emilio Harth-terré, who, as we have seen, also proposed the idea of an architecture of "fusion" or convergence of the "… Peruvian Hispanic and the pre-Columbian element," described Piqueras's contribution to Peruvian architecture as follows: "Let us remember the precursors of that movement, Claudio Sahut and Manuel Piqueras Cotolí, born in other lands, who felt, in matters of art, attracted to ours" (1945). Harth-terré's article was published in the 1940s, but by that time the Peruvianist current had already begun its slow process of extinction. Nevertheless, there are echoes of the neo-Peruvian project in some works by architects of a younger generation, such as Enrique Seoane Ros (the "Wilson" building and the lower part of the Ministry of Education) and Alejandro Alva Manfredi ("Inca" motifs in a number of houses).

The use in architecture of forms or decoration derived from pre-Hispanic models was rejected by those who defended the classical academicist canon. An instance of that was the adverse critique made by the painter Enrique Barreda of the design for the Basilica of Santa Rosa, despite his friendship with Piqueras and the high regard in which he held him. Barreda's objection was that it was an attempt to "erase … the work … of four centuries of Latin culture… What is inadmissible is … that our whole life as artists should be based exclusively on Inca or pre-Inca models" (Barreda y Laos 1939). The disjunction between *indigenismo* and *Hispanismo* is felt again here, but it gradually lost force, to be replaced by the disjunction between modernism and traditionalism.

The conflict between the new architecture and the use of historicist forms, which preoccupied architects from the beginning of the twentieth century, and the definitive arrival in Peru of the modern movement in the late 1940s, marked the end of historicism. With it, *indigenismo* and the other Peruvianist tendencies died out as legitimate practices in architecture.

POPULAR BELIEFS AND TRADITIONAL CELEBRATIONS IN MODERN PERU

Hans H. Brüning's Photographs of Festivals in the Lambayeque Region

Bernd Schmelz

In July 1875, Hans Hinrich Brüning (Hoffeld, 1848–Kiel, 1928) boarded in Hamburg a ship bound for Peru. He landed in Callao on September 12. The following day he traveled by sea to Eten on the north coast (fig. 3, p. 36). Shortly afterwards, he got a job as a machine technician at a sugarcane hacienda in Pátapo. Brüning would often change jobs over the next twenty years. He frequently traveled, especially around the north coast, and had close contact not just with the economic elite of the region, but with the local people in general.

In 1897, Brüning returned to Germany. He stayed there eighteen months, doing ethnographic and linguistic research. While at a considerable distance from his adoptive home, Peru, Brüning evidently realized how intensely interested he was in researching the ethnography of the country. Back in Peru, he would use his time systematically to add observations, sketches, and photographs to his ethnographic documentation. On October 9, 1898, he left Germany again and arrived in Peru on December 10. The following years found him again living and working mainly on the north coast of Peru. As part of his numerous research trips, he went up the Rio Marañón in 1902, on an expedition led by Edward Jan Habich and Manuel Antonio Mesones Muro.

In 1909, Brüning bought a house in Lambayeque. In 1916, he tried to sell his extensive archaeological collection, which was stored in his house. He always regarded this collection as the foundation stone for research into the cultural history of the

north coast of Peru. In 1921, long, tough negotiations resulted in the sale of the greater part of the collection to the Peruvian state, which then founded the country's first regional museum. It was called Museo Brüning and was initially based in Brüning's home. He himself was appointed its first director, receiving a monthly salary (Schmelz 2007), but he retired in 1924 for health reasons. The following year, Brüning left Peru for good and returned to Germany (Schmelz 2010a).

Brüning the Photographer

Brüning was an amateur photographer of great technical ability with a passion for the newest technical innovations—the high quality of his photographs and music recordings are a testament to this. He conscientiously noted what he did and how he experimented with new photographic materials and apparatus. In 1888, he ordered from Germany the new, pliable, transparent celluloid film rolls invented the year before. Until then, he had exposed his pictures on glass plates, and until 1887 was using the colloidal wet-plate process, but abandoned it for the dry plates, which were easier to handle. His preferred formats were 9 x 12 and 13 x 18 centimeters.

Brüning left almost his entire collection of more than three thousand photographs to the Museum für Völkerkunde Hamburg. His photographic estate spans the late nineteenth century and the first quarter of the twentieth. He photographed land-

scapes, flora, fauna, buildings from different ages, and, of course, people in a wide variety of everyday scenes. He thus created a pictorial ethnographic study that, for its time, is second to none in all Latin America.

Geographically, the collection concentrates mainly on the Lambayeque province, where Brüning lived for most of his life, while its content is centered on religious festivals. Of all the holy days in the liturgical calendar of the Catholic Church, the central points for Brüning were Epiphany, Holy Week, and Corpus Christi. He also photographed a variety of smaller festivals honoring local patron (or other) saints, as well as festivals commemorating miracles.

Brüning the Scientist

Brüning lived in Peru for almost fifty years. He took an interest in its cultural history early on, and in 1880 began visiting pre-Hispanic ruins and collecting archaeological artifacts. Photography, his initial passion, served his newfound interest, and he took his first archaeological pictures in October 18, 1888, in Chancay (cat. 15). From 1893, Brüning began a more systematic documentation of his archaeological trips through notes and photographs (Chávez 2006).

Tirelessly he collected artifacts and historical documents from the sixteenth to the twentieth centuries, wrote down ethnographic observations, and took photographs. In science, Brüning was self-taught:

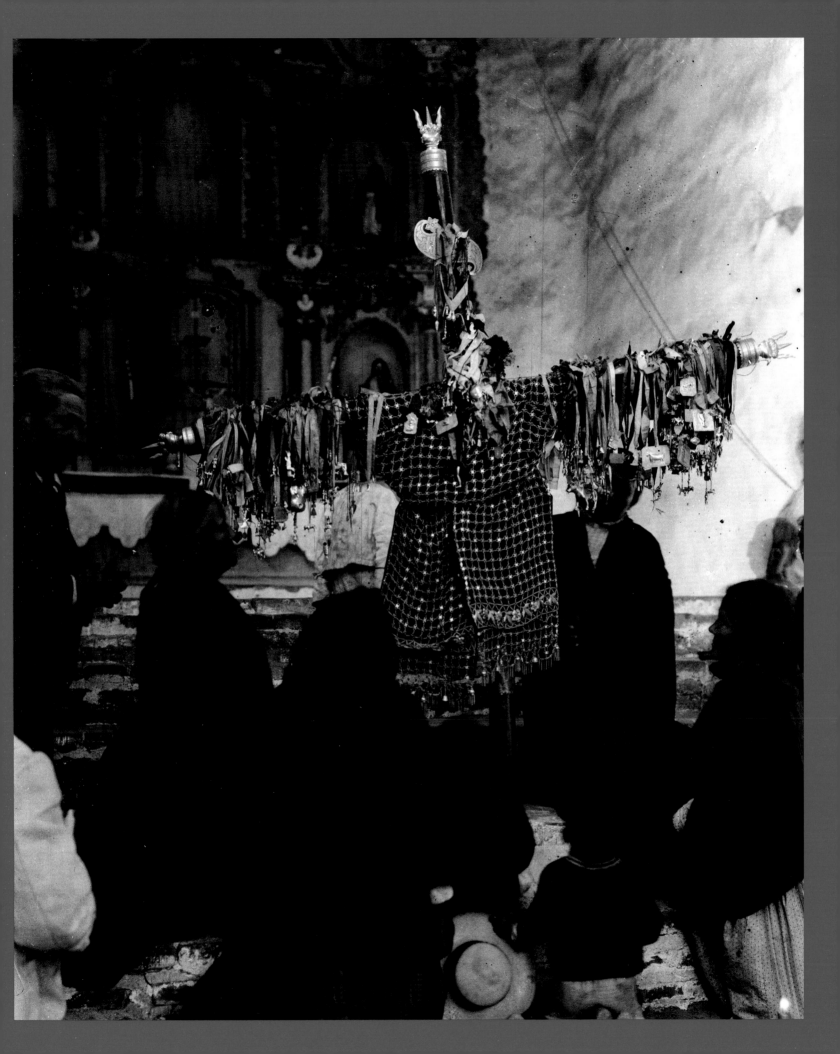

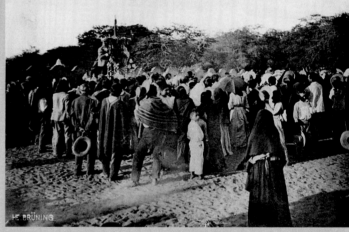

Fig. 1

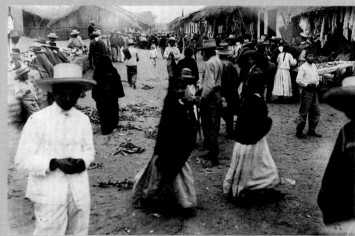

Fig. 2

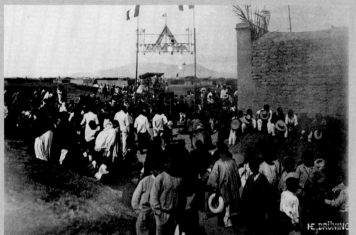

Fig. 3

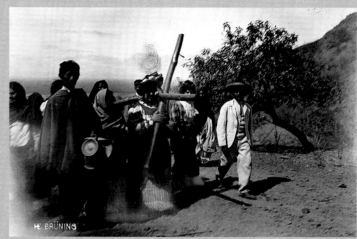

Fig. 4

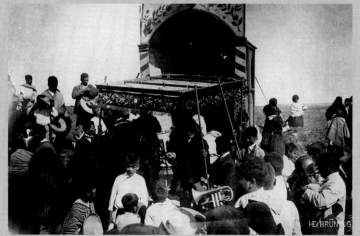

Fig. 5

Fig. 6

Fig. 1
Hans H. Brüning
Procession with Different Figures of Saints in Honour of the Child of God (Eten)
1906–1907
Museum für Völkerkunde Hamburg, Hamburg

Fig. 2
Hans H. Brüning
The Cross Is Carried on the Shoulders upon Chalpón Hill, in this Case by the Women (Motupe)
1907
Museum für Völkerkunde Hamburg, Hamburg

Fig. 3
Hans H. Brüning
Triumphal Arch at the Entrance of the Village, Decorated with Two National Flags (Eten)
1906–1907
Museum für Völkerkunde Hamburg, Hamburg

Fig. 4
Hans H. Brüning
The Cross is Dressed (Motupe)
1907
Museum für Völkerkunde Hamburg, Hamburg

Fig. 5
Hans H. Brüning
Music Group at the Procession in Honor of the Child of God (Eten)
1906–1907
Museum für Völkerkunde Hamburg, Hamburg

Fig. 6
Hans H. Brüning
Stands in the Streets of Motupe during the Feast of the Cross of Chalpón Hill (Motupe)
1907
Museum für Völkerkunde Hamburg, Hamburg

everything he knew about archaeology, history, ethnology, and linguistics he acquired through his own efforts.

Especially remarkable is his scientific approach; he took care to examine each article calmly and thoroughly. A perfect example is the language recordings he intended to do in Eten. In 1905, Brüning settled there to pursue intensive language studies. Originally, he wanted to stay just a few months, getting old people to help him learn Mochica, which was on the verge of becoming extinct. When the attempt proved too difficult, he stayed on in the little fishing village until 1909 (Aristizábal and Schmelz 2009).

His photographs from this time are particularly valuable, providing an ethnography of the local population. Eten was founded in the sixteenth century by the Spanish. Most of the population were Indians, who already lived there and in the surrounding region. However, in the seventeenth century, Eten suddenly became known far beyond its regional borders: in 1649, an apparition of the Infant Jesus appeared twice in the Church of Santa María Magdalena. The Catholic Church carefully researched the phenomena, and the same year officially declared them to be miracles (Schmelz 2010b). The resulting festival in honor of the double apparition is still today one of the most important in the Lambayeque region. Let us look more closely at Brüning's work photographing it.

Eten: Festival in Honor of the Apparition of the Infant Jesus

While the nineteenth century had mainly just written sources to draw on to imagine how the festival developed, the early twentieth had an essential new source: the photographs of Hans H. Brüning, which provided a valuable insight into different aspects of life in Eten. The people, who previously only existed as descriptions in written or oral communications, now became visible. The pictures show us not just what they looked like but their environment, activities, and forms of worship. This applies to the festival in honor of the apparition of the Infant Jesus, for the pictures Brüning took in 1906/1907 were the first ever taken of this event.

One characteristic of the festival at that time was the participation of different figures of saints (fig. 1, p. 298), as we see in the photos but also in Brüning's notes: "In the Milagros procession the saints [are walking] backwards, or at least turning their faces towards the monstrance following behind. Many *posas* in the street the procession takes through the village. A ceremony before each of them. Two more outside the village, one quite solidly built".[1]

Today, saints do not feature so heavily in the festival, although a few individuals might still bring along figures such as the Mother of God. The exception is the continuing participation of the patron saint, Santa María Magdalena, at the head of the procession.

The procession would lead from the church to the chapel outside the village, built in the eighteenth century in the *Arenal* (the local word for desert) of the earlier settlement; then the procession would make its way back to the church. Leaving and returning to the village, the saints, monstrance, and priest would pass through the triumphal arch, an act that is still obligatory today (fig. 3, p. 298). Even within the village, presumably people who lived along each street set up magnificent triumphal arches for the saints and the procession to pass through (cat. 286). Another important element of the procession was the brass band, which remains so today (fig. 5, p. 298).

The faithful accompanying the procession wore clothes suitable for a feast day. The women put on black dresses and dark or bright shawls, while the men wore European suits with either tie or bowtie. Many wore a poncho. Sombreros were carried during the procession. It is clear that the festival was very well attended in Brüning's day, and the presence of the different saints emphasizes its significance.

Motupe: Festival in Honor of the Cross on Mount Chalpón

Another important festival documented by Brüning's camera was that in honor of the cross on Chalpón Mountain in Motupe. Today, the festival is one of the most important in Peru. In the first half of the nineteenth century, Motupe and the surrounding area were witness to a figure who would be very significant in Motupe's history: a Franciscan hermit who lived in the mountains surrounding Motupe and Olmos. His name was Juan Agustín Abad, but he was also called "Padre Guatemala" and "El Ermitaño." He lived in caves, where he erected crosses, and he made regular visits to the surrounding towns and villages.

One day the hermit did not appear, so local people set off in search of his dwelling place and to find the crosses he had left behind. He had told them that he would leave a cross in each town for which he had pastoral care. This was to protect the town. Again and again, search parties set out from Motupe to the mountains, but it was only in 1868 that two local men, José Mercedes Anteparra and Rudecindo Ramírez, found their cross in a cave on Mount Chalpón (Schmelz 1992).

The cross was venerated from then on, giving rise to a festival that grew and grew over the course of the years, having begun rather modestly. It was given its own festival organization, or *mayordomía*, which at the time was responsible for many of the region's festivals. The first *mayordomo* and hence chief organizer was one of the men who had found the cross: José Mercedes Anteparra. Since he remained *mayordomo* until his death in 1921, he left a strong personal imprint on the first phase of the festival. We have for this period of 1868–1921 two complementary sources about the festival: a monograph by Carlos Bachmann (1921) about the Lambayeque province and the photographs of Hans H. Brüning, who documented the festival in Motupe in August 1907.

The festival began in the mountains, and the cross was carried on the shoulders of the festival organizers and the faithful (fig. 2, p. 298). Once the foothills were reached and the way began to even out, the cross was put on its *anda* (portable platform) and decorated before entering the village. This was called "dressing" the cross. At the end of the festival, on the way out of the village, the decorations were removed—the cross was "undressed"—and it was carried on smooth ground on the *anda*. When the way got steeper, it was once more carried on people's shoulders and returned to its cave (Schmelz 1992).

Brüning photographed the "naked" cross in the mountain being carried, as well as the process of its decoration, where a man stood on the *anda* and prepared the cross for its "triumphal march" into the village (fig. 4, p. 298). According to written and oral testimony, this tradition has not changed.

Interest in the cross and its festival was great, and the pictures taken in the village and at the entrance to the village show crowds of people around the cross. Like the Eten photos, they show the different ways people were dressed, mixing Indian and European garments—a process already well under way. A few years later, the Indian element would vanish completely, a phenomenon that happened faster among the men than among the women.

Brüning also shot the Veneration of the Cross in the church. One notices that, unlike in the photos of the procession, very few people are around. There are just some adults and children, mostly kneeling before the cross or sitting on the other side. Lighted candles have been set on the floor. The cross itself, placed on the steps to the altar, seems plain by compari-

son with the present day. In its center is a net-like shirt, and from the two arms hang countless *milagros*, little metal ex-votos brought by the pious in thanks for a miracle or to ask for one. Then, as now, the left and right ends of the cross had silver "hands," and on the top was a three-pointed crown (cat. 285).

Another essential, and worldly, part of the religious festival had already been added by then, and Brüning recorded it: in the village center, booths were set up to sell all kinds of goods. This fair-like aspect of the festival was therefore present early on, and it remains important to this day (fig. 6, p. 298).

Today, this festival of the cross in Motupe is the most important religious festival on the north coast of Peru, and is attended by people from all over the country. Motupe would be unthinkable without this identity-defining cross.

The Legacy of Hans H. Brüning

Apart from the photographs, the Museum für Völkerkunde Hamburg also holds the rest of the Brüning estate: boxes of diaries;

archaeological, ethno-historical, and ethnographical notes and drawings; historical documents (originals or copies); letters; and numerous newspaper and journal articles. His twenty-one cylinders of music recordings are held in the phonogram archive of the Ethnologisches Museum in Berlin (Schmelz 2003; Ziegler 2003).

Brüning's ethnological studies were far ahead of his time. Such a comprehensive grasp of the culture of the people of a specific region, encompassing archaeology, ethno-history, and ethnography, is the hallmark of many modern-day ethnologists, who understand anthropology to be a combination of cultural studies and human science. Because it is so comprehensive, the Brüning collection is today a uniquely valuable resource on the ethnography and history of the north coast of Peru.

1. Page 78 of Hans H. Brüning's notebook, inscribed by him with "8" and "1 September 1905 bis 30 September 1906." C.f. Schaedel 1988, 166.

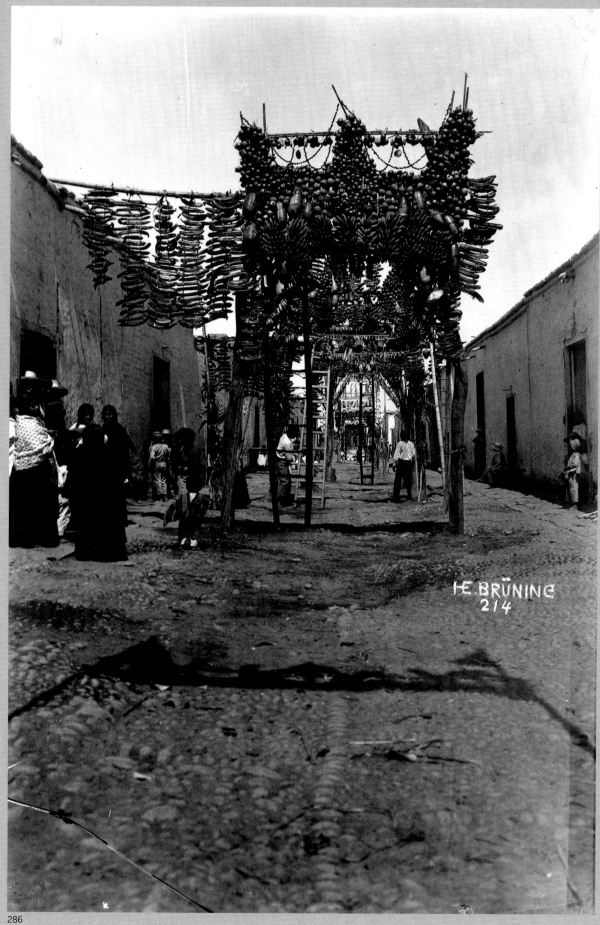

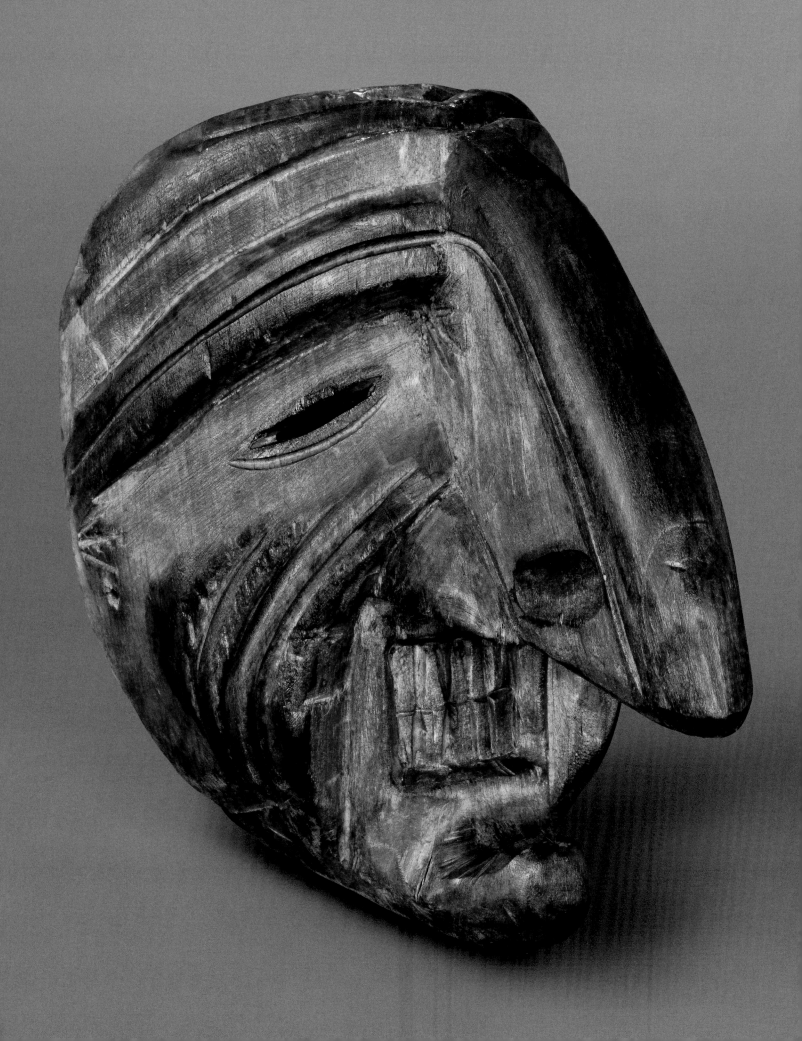

Heritage and Identity in the Traditional Festivals of the Central Highlands of Peru

Fedora Martínez – Soledad Mujica

Traditional festivals in the Andes are kaleidoscopic celebrations, colorful spaces where memory, custom, and contemporary culture overlap. Andean families and communities attend an annual cycle of festivities marking rites of passage (birth, puberty, marriage, and death), major festivals of the syncretic Catholic calendar, and the rhythms of agricultural labor, all of which form the cultural context for celebrations in the central highlands of Peru. Dance is a fundamental element, because it brings together the ideas of heritage (material and non-material inheritances) and identity, connecting individual and collective senses of self through costumes, music, singing, and dancing.

The beat and pulse of the dance tell the story of what changes and what persists in the culture of the peoples who create it. Seen from that point of view, dances are synchronic bridges connecting time, space, and human desires. For example, the *huaylarsh*, a dance from the Mantaro Valley in Junín Province, today represents the enterprising spirit of the "Mantarino" in the city. Immigrants to Lima perform it at their festivals where it has lost its place in traditional calendars and is now performed in dance competitions. The vigor of its steps, the brightly colored costumes, and the orchestra, dominated by wind instruments, turn *huaylarsh* competitions into pieces of postmodern street theater.

The Andean *fiesta* brings memory into the present moment: themes inherited from the past converge, and at the same time the mnemonic relationship between remembering and forgetting is acted out. Identity—which is constantly being constructed—is located in the festive present. In searching for just those markers of heritage and identity in the festivities of the central sierra, we have identified three categories of dances: based on historical events, based on social hierarchies, or "telluric"—grounded in the earth.

Historical Dances

The Spanish Conquest turned the indigenous world upside down. Restrictions were put on singing and dancing. Erstwhile struggles among the Inca elite for control of the *Tahuantinsuyu*, the Empire, ceased. Within the desolation, there remained the benchmark of the capture and death of the Inca Atahualpa. The destruction of the paradigm itself was articulated around that crucial event: the individual's death marked the destruction of a way of life. There then emerged the dance that nostalgically commemorates the pre-Conquest Andean world. The mood its performance creates is a lament for the downfall of that world, but it is a sign that the two populations would in future live together.

The capture and death of Atahualpa (fig. 2, p. 306) is a dance-drama performed in some towns in the central Andean area, including Chiquián (Ancash, August 30), Carhuamayo (Junín, August 30), Sapallanga (Junín, September 8), and Oyón (Lima, August 29). Twenty-five towns in the upper regions of Huánuco perform the capture and death of Atahualpa under different names: "Apu Inca," "Capitán Pizarro," "Apu Inca y Pallas," "Chunchos, Pallas y Capitán Pizarro," "Pallas," and "Capitán Pizarro y Ruku"; performance dates fall between May and December (Pino Matos 2010).

In the drama entitled *Tamboy*, the Inca Atahualpa is captured and dies every year in the memories of the people of Carhuamayo. However, when it was recorded in 1982, the ending was suddenly changed by the *chutos* (members of the Inca's court): they did not allow the Inca to be captured by the Spaniards, pleasing the audience but clearly disconcerting the director. This drama, with its dances and choral singing, is modern, dating from the twentieth century, and the scenario does not contain that humorous departure from the text. It was a rare, spontaneous alteration in the staging of the play, which showed the subtle interplay of circumstances that change a custom.

In other places in the central sierra there are historical interpolations such as the dance called *Apu Inca*, from Sapallanga, Junín. Some half-remembered, half-forgotten events involving the figures of Atahualpa (sixteenth century) and Juan Santos Atahualpa (eighteenth century) have become elided: nowadays, only Atahualpa is referenced. However, Juan Santos Atahualpa, the indigenous rebel who took refuge in the central forests, took the name *Apu Inca*, the same as that given to the dance commemorating the "Inca Atahualpa."

The active participation of the indigenous population of the central sierra in the

Resistance during the war with Chile (1879–1884), led by Andrés Avelino Cáceres, finds expression in the following dances: the *Maqtada*, from the Yanamarca Valley (Jauja); the *Avelinos*, from San Jerónimo de Tunán; and the *Auquish capitán*, from Huaripampa, (Jauja). All are performed in the Mantaro Valley, Junín region. During the years of the Resistance, some sections of society reviled participation by indigenous people; Cáceres himself later distanced himself from his involvement with the rebel guerrilla fighters, but that was not taken into account by those who devised the dances. Events that demonstrated social cohesion were incorporated into the dance, and the disagreements with Cáceres were glossed over. The *Maqtada* is also an example of history's ability to constantly remake itself. This celebration takes the form of a popular military parade, incorporating incidents from more recent conflicts (fig. 7, p. 307). For example, the destruction in 2001 of the Twin Towers of the World Trade Center has been re-enacted: models of the towers made out of paper and reeds were carried on a float, airplanes on another, higher one. As they passed the viewing-platform, the planes were released and fell onto the buildings.

The *Maqtada* is performed in Holy Week, and it is interesting to note that the *Tayta Cáceres* ("Father Cáceres") and the *Maqtada* appear to have supplanted the Catholic festival. There are parallels between the La Breña campaign led by Cáceres and Christ's journey to Calvary.

Dances Based on Social Hierarchies

In Quechua there are two ways of saying 'we': one of them does not involve third parties (*ñuqayku*: "ourselves, not including our interlocutor"); the other is inclusive (*ñuqanchik*: "ourselves, including our interlocutor"). It is a concept that differentiates, includes, and reveals a predisposition to characterize the "other." In the central sierra, there are dances that demonstrate historic class differences; their choreographic elements express social, ethnic, and hierarchical distinctions. Mocking the "other," or rebuking those who break accepted codes of behavior, is one element of the festival.

In the *Tunantada* (Jauja and Junín), the Spaniards are portrayed with a certain sarcasm: the dancers' physical movements seem to transmit the message, "Look, we can be as elegant as you" (fig. 4, p. 306). The *Chonguinada* (Pasco and Junín) also satirizes the Spaniards. It is performed on various occasions, for example at the Festival of the Cross in Pucará (Huancayo, Junín) on the fourth of May, when the cross returns from the town to the top of the mountain. Covered in flowers, it is accompanied on its journey by people dancing the *Chonguinada*, right up to the peak, its final destination.

Enslaved people are represented in the dance called *Los Negritos* (Huánuco, Pasco, Junín, Huancavelica, and the Lima Sierra). This Christmas dance commemorates the salutation of the Infant Jesus by people of African descent, a custom dating back to colonial times. Groups of dancers wear masks appropriating the African type. In contrast with *Los Negritos*, the *Chacra negro* dance (Huaripampa, Junín) celebrates the end of slavery (fig. 3, p. 306).

The "inclusive we"—*ñuqanchik*—features in the dance *Shapish* (Chupaca, Junín). It is said that in ancient times the Huanca people moved temporarily to the central forests, and returned with new customs, new products, and clothes showing Amazonian influences.

Telluric Dances

Pachamama is an ancient Andean concept, still alive in contemporary Peru. It is a survivor of a divine universe whose devotees were persecuted from the sixteenth century onward. Between mountains (*apus*), springs, and lakes (*paqarinas*), the culture of indigenous people was transferred to the new colonial towns, peasant communities consolidated under the Republic of Peru. In that long process the affective and emotional bonds between human beings and nature were not totally broken: a religious vision of nature—*Pachamama*, Mother Earth—survived.

Since Mother Earth—in all her manifestations—is the source of life, she will always be shown great respect. It is in that cultural context that we find ancestral celebrations whose purpose is to preserve the balance between society and nature.

Veneration of the earth is seen in its pure state in celebrations connected with farming and animal husbandry. Preparation of the soil for sowing is reflected in festivals like *El Lishtay*, in Tapuc (Pasco Region) (fig. 5, p. 307), *La rayada* in Chongos Bajo (Junín) (fig. 8, p. 307), and *La fajina* in Comas (Junín). Harvest and threshing are landmarks in the farming year, occasions for noisy celebration, with men and women singing their own songs.

Cattle-raising is another activity with its traditional festivals. Rural communities count their members' herds every year, to estimate the use of grazing on communal land, and they hold a celebration afterwards. The *herranza* (branding) is the occasion for their best-known festival, held in late July and August and in some places continuing until September.

The *herranza* is also known as *Santiago*, *Señalakuy*, or *Tayta Shanti*. In the Mantaro Valley (Junín), the wealthiest *mestizo* families will hire a band whose members typically play the harp, violin, saxophone, and clarinet. In this case all the musicians are men, and the music solely instrumental.

In the high Andes, poorer families will hire a *santiaguero* group, consisting of three instrumentalists and a singer. One plays the *waqra*, an instrument made of horns, with a deep, virile sound that gives *herranza* songs their rough, masculine quality, and is said to be the "voice" of the bull. Another musician plays the violin, adapted to the Andean style, and the third the *tinya*, a small pre-Colombian drum, played by a woman. Accompanied by the instruments, she will sing in a high-pitched voice old Quechua verses asking *Pachamama* to provide fodder for the animals, and the *wamani*—the spirit of the mountains—to protect the cattle (fig. 6, p. 307). The woman's voice gives the music an intense, delicate quality that contrasts with and complements the sound of the *waqra*. The ancient sounds of the fiesta can be heard in these songs, almost totally unaffected by *mestizaje* (hybridization). High up in Jauja (Junín), especially in Masma, *waqra* duos are traditional: four horns playing in pairs, united by the beat of the *tinya* and the woman's voice.

Water is revered in rural life. In the Lima Sierra, the festival is called the *Fiesta del agua* or *Fiesta de la champería*; in Ayacucho, *Yarqa aspiy* or *Yaku raymi*. Agriculture depends on rain in non-irrigated areas; for irrigation, lakes are connected with farmland via channels and ditches. Between the source of the water and its branches a sacred space is created, inhabited by deities and guardians. The structure of the fiesta is geo-mythical. The irrigation channel that reaches cultivated plots is part of the life of those who till the soil. The source of water that feeds it is higher up—the *paqarina*, source of primordial waters. Villagers work communally to clean the ditches, physically and symbolically. Fields have their protective deities, who have to be gratified, in rituals structured by hierarchies, gender, and age.

Families are organized hierarchically according to their responsibilities: young people, both men and women, play an important part in the work, and in the singing and dancing. The festival of Carnival is also associated with cycles of nature: it promotes fertility and the renewal of the natural environment. Festivals based on agricultural tasks thus help to affirm tradition and are slow to incorporate cultural change.

The *Huaconada* dance in Mito, Concepción, and Junín, is the reminiscence of an ancient rite of social control, in which the *huacones*, a council of old men, punish villagers who have broken the community's rules (Mujica 2004). Today, the *huacón* has a dual character: he represents the *wamani*—the spirit of the mountain—and the council of elders, protecting the Miteños' cultural identity (fig. 1, p. 306, cat. 287). It is a dance that restores the ancestral status quo that has been lost politically, and offers new methods of local government that the industrialized world has not fully incorporated into the democratic system.

The tendency of dance to restore order can also be seen in the *danza de las tijeras*, the scissor dance of Apurímac, Ayacucho, and Huancavelica. The dancer, unlike the *huacón*, brings the high mountains, the plains, and the deep "telluric" roots of the Andean human world into one integrated space (Nuñez 1986).

Dance bestows social prestige and brings together members of both nuclear and extended families. An expression of their history, it is a crucial marker of identity for Peruvians.

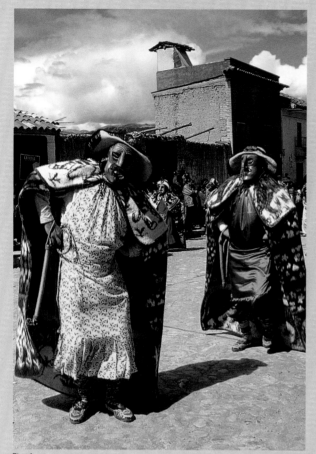

Fig. 1

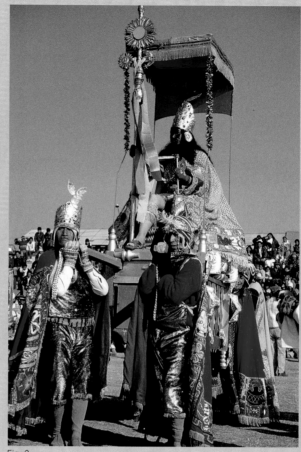

Fig. 2

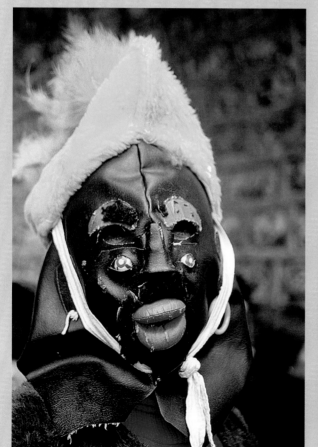

Fig. 3

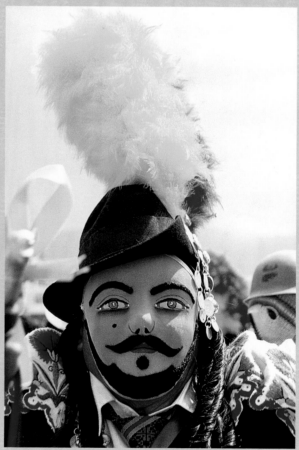

Fig. 4

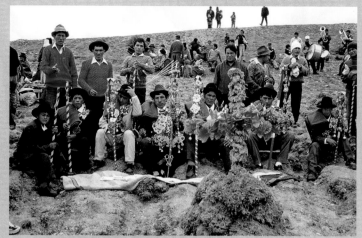

Fig. 5

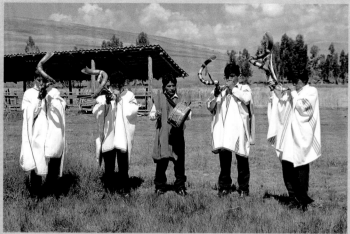

Fig. 6

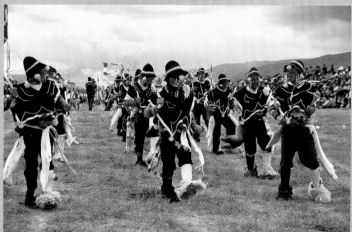

Fig. 7

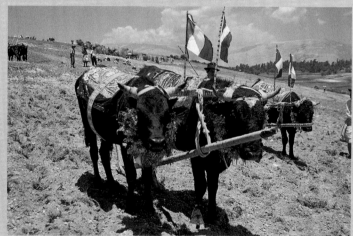

Fig. 8

Fig. 1
The *Huaconada*
(Mito, Concepción)
2001

Fig. 2
Dance of the Capture
and Death of Atahualpa
(Carhuamayo, Junín)
2001

Fig. 3
The *Chacra negro*
(Huaripampa, Jauja)
2001

Fig. 4
The *Tunantada*
(Huaripampa, Jauja)
2001

Fig. 5
The *Lishtay*
(Tapuc, Pasco)
2001

Fig. 6
The *Herranza*
(Mama Chicche, Jauja)
2001

Fig. 7
The *Maqtada*
(Yanamarca Valley, Jauja)
2001

Fig. 8
The *Rayada*
(Santiago León de
Chongas Bajo, Junín)
2001

Continuities
and Discontinuities:
The Feast of San Isidro
in Moche

Sébastien Petrie

The Spanish invasion of Peru strongly disrupted indigenous forms of worship. What remains of these cults today? The links between pre-Hispanic customs and those observed today depend on the local and regional context. Despite the unification of the territory by the Inca, there were indeed wide cultural differences in Peru in the pre-Hispanic era.

In Moche, the feast of San Isidro Labrador, the patron saint of farmers, shows how the pre-Hispanic cults were transformed. The village of Moche is seven kilometers from Trujillo, the third biggest city in Peru. The archaeological site of Huacas del Sol y de la Luna, the capital of the Mochica culture, is in the vicinity. This village has been associated with the Mochica and Chimú pre-Hispanic cultures on the north coast since the early twentieth century. The celebration of the feast of San Isidro will therefore be presented in a regional context.

Conquest and Upheavals

The area around Moche is part of the Moche Valley where the Chimú capital, Chan Chan, once stood. Very little is known about the north coast of Peru in the period before the Spanish Conquest. It appears that the indigenous people were grouped by occupation under the control of local lords. The Chimú worshipped several heavenly bodies and natural entities, the most important of which was the moon.

The present-day organization of the territory is the legacy of the Spanish Conquest. The Spanish introduced changes to govern the population more efficiently and to appropriate its wealth. The main change was the introduction of *reducciones* or "reductions." Instituted around 1566, this entailed regrouping the indigenous peoples in villages around a church with a tax collector under royal protection. The reductions, "although they were established for evangelical, tax, and supervisory purposes, and to maintain a pool of labor, probably enabled the indigenous coastal people to survive in homogeneous groups to the present day, avoiding extermination and, more importantly, slavery" (Collin Delavaud 1984, 240). The reductions thus enabled the indigenous population to subsist as cultural groups within the limits allowed by the Spanish conquerors.

The Spanish evangelists saw indigenous festivals as the root of paganism, which had to be extirpated in order to stamp out pre-Hispanic cults. Feast days were therefore the primary target of the Spanish priests' campaign against idolatry that prohibited all forms of worship of pagan gods. The system of reductions gave the Catholic Church better control over the Indians' faith, not only by forbidding pre-Hispanic customs, but by imposing a new festive framework in accordance with the Catholic faith. The Trujillo diocese forced the indigenous people to celebrate the local patron saint as well as Christmas, New Year, Epiphany, the Resurrection, the Ascension,

the Holy Spirit, Corpus Christi, the Virgin, and the apostles Saint Peter and Saint Paul (Restrepo 1992, 497). This festive calendar was the common framework that all the indigenous people in Trujillo had to follow. However, it was not the entire festive calendar for the reduction. The compulsory feasts were complemented by local choices that reflected the aspirations and interests of the members of the community and the ecclesiastical bodies.

Although by introducing the reductions the Spanish imposed a framework within which the Catholic faith was to develop, local festivities were developed by the brotherhoods or associations of community members. The brotherhoods permitted the continuity of pre-Hispanic belief and kinship systems within the new colonial order (Celestino 1998). Each reduction chose the cult of a saint, a virgin, or a cross, and the brotherhoods organized the festivities. According to the interests, values, and culture of the members of a reduction, celebrations were different. They put the accent on the different symbols that were important to them, including pre-Hispanic symbols and beliefs; the saint therefore becomes the emblem of local aspirations. This is why we do not find the same religious practices connected with a particular saint throughout Peru. In fact, there is a wide range of festive practices for the same saint. The feast of San Isidro is celebrated in several villages in Peru, among others in the Lamay District in the Cuzco region (Sánchez Gamarra 1971), but the representation of the saint

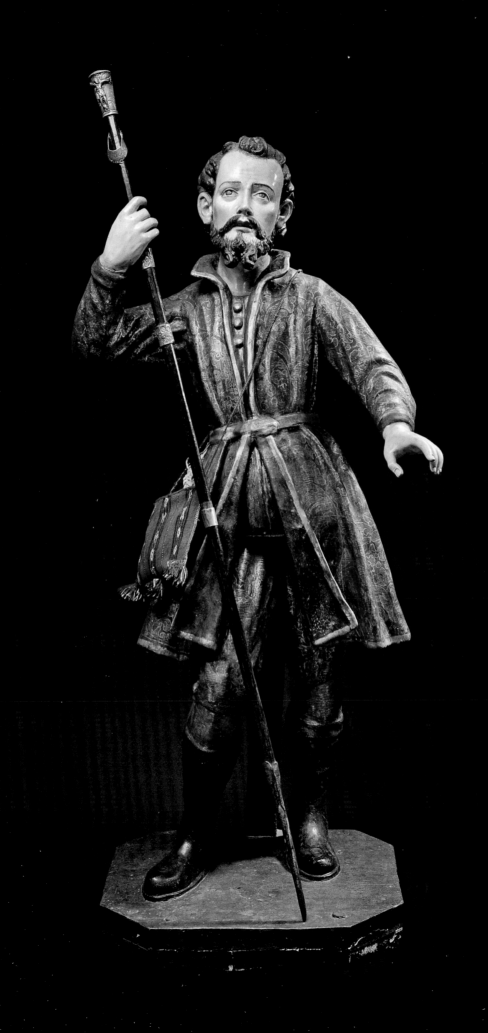

and the symbols used during the celebrations are quite unlike those found in Moche.

The Feast of San Isidro in Moche

In 1998, the feast took the form of a forty-four-day procession through the countryside around the village, culminating in three days of festivities (main days of the celebration). Each day, the faithful carried the saint on a litter to the house of an individual, the *altarero*, who had to build an arch of fruits for San Isidro, who would spend the day in his house. When the saint had visited all the *altareros*, he was taken to the village for the main feast. He was placed on his litter with his hat, medals, silver shovel, scepter, and a fruit arch (fig. 2, p. 311). Moreover, groups of dancers disguised as devils (*diablicos*) followed him everywhere during the last three days (figs. 3, 4, p. 311).

San Isidro's journey through the countryside around Moche is a fairly recent custom, dating from the late 1930s. But the three days of the main feast are an older tradition, patterned on traditional patron saints' days. This pattern is clearly Spanish in its division of time (eve, feast day, day after). Various Catholic liturgical events are fitted into this frame: mass, procession, and pilgrimage to the cemetery. The festival accentuates a strong Catholic identity in Moche, perpetuating the rites of the Church. There is therefore a break in the pre-Hispanic religious scheme with the imposition of a festive organization and a Catholic pantheon.

Despite any differences there may have been between the Catholic religion brought by the Spanish and the pre-Hispanic religion, there are some meeting points. For example, both the Andean and Spanish groups use a litter to carry idols. Spanish ecclesiastics made use of these common features so the indigenous people would identify more closely with the Catholic faith. Processions, dances, and music also figure in both festive worlds. It was therefore easy for the clergy to make the indigenous people accept them. That is why it is often difficult to pinpoint the origin of some present-day festive customs. The *diablicos*, near-universal figures in Peruvian festive customs, are one of the most convincing examples. Dances were part of pre-Hispanic celebrations, which could make us believe that the *diablicos* were of pre-Hispanic origin, but the devils' dance existed in Spain in the sixteenth century (Pollak-Eltz 1983, 179). Are the *diablicos* of Spanish origin or did the indigenous people adopt them and then develop their own dance? The rhythm and choreography could give some clues, but the lack of precise information leaves us in doubt.

Plants are offered to the saint during the feast of San Isidro, usually maize and manioc. These offerings are left whole, that is, including the stalks and leaves as well as the edible part. The worshippers say that what they are offering is the power to reproduce the plant and not only its fruit. A similar custom can be seen in Mochica iconography (cat. 52): a mythical being is holding whole manioc and maize plants suggesting that the gift of these plants bestows the power of reproduction on the recipients.

Offerings of fruits in the form of an arch can also be compared to pre-Hispanic customs, as indicated by the chronicler Calancha (1976 [1638], 1240). It appears that the Chimú offered fruits specifically to the moon, while they used other types of offerings for other gods. For example, red and white maize flour was offered to the sea god (Rostworowski 1981, 134). The moon was the main god for the Chimú, whereas the Inca worshipped the sun as their principal deity. The moon was responsible for creating food, so the patron saint of agriculture was naturally associated with its cult. Even in the twentieth century, there seems to have been a correlation between the moon and agriculture. Sabogal Wiesse (1974), who wrote about the reduction of Santiago de Cao, was told that the moon had an influence on the time of sowing, the growth of the plants, harvest time, and irrigation. But the points of convergence between the moon and San Isidro are not confined to this custom; let us now look at the representation of the saint himself.

The silver shovel with which San Isidro is represented is interesting because its shape is similar to that of a pre-Hispanic cult object, the *tumi*, a sacrificial knife, widespread in the iconography of the north coast. The shovel is an important agricultural tool. Yet, in Catholic symbolism, San Isidro is usually shown with a billhook, a flail, or a plough and oxen. Apparently it is only at Moche that he appears with a shovel. In his other hand he holds a baton that the Mocheros call *bastón de soberanía* (scepter). Although the *Mocheros* attach no meaning to this cult object, Chimú iconography can give us clues to its relationship with San Isidro. Martínez de la Torre, who worked on the major themes in Chimú pottery, noticed that the baton is associated with people in power (Martínez de la Torre 1986, 143). Note that these figures may also have a *tumi* (fig. 1, p. 311). San Isidro therefore seems to have the same two objects as the power figures in Chimú iconography.

Moreover, Chimú characters are associated with the moon by their semi-circular headdress. The same kind of device appears in Mochica iconography. San Isidro does not wear this kind of hat, but he has an arch of fruits that recalls its semi-circular shape. The arch is commonly found in pre-Hispanic iconography. We see it among the Mochica in the form of a two-headed snake (cat. 83). Arches are found throughout the Andes in the form of the rainbow, and also in Inca celebrations (Calancha 1976 [1638], 851). We know, too, that fruit arches are used in other villages on the north coast of Peru, not necessarily in connection with San Isidro. They are found in the villages of Virú, Santiago de Cao, and Eten for the feast of San Isidro; in Ferreñafe and Monsefú (cat. 286) for the Corpus Christi celebrations; and at Jayanca for the feast of the Ascension. All these feasts are celebrated at the same time of year, in May and June. The distribution of fruit arches in the territory once occupied by the Chimú leads us to believe that they have the same pre-Hispanic symbolic origin.

There seem to be symbolic continuities on the north of Peru, but they are dissimulated within various festivities proper to each community. The Spanish evangelists imposed a festive scheme that destroyed indigenous cults, but the reduction system and the brotherhoods enabled some pre-Hispanic symbols to survive within various local versions of Catholic feasts.

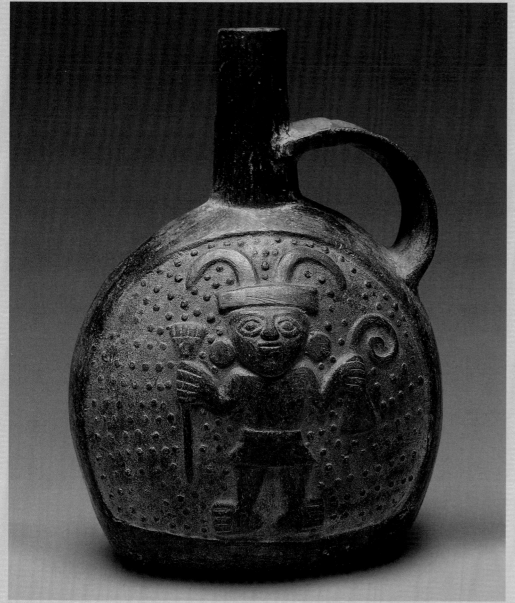

Fig. 1

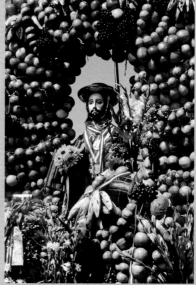

Fig. 2

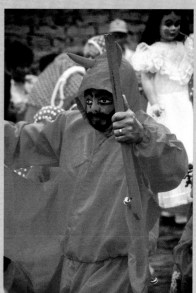

Fig. 3

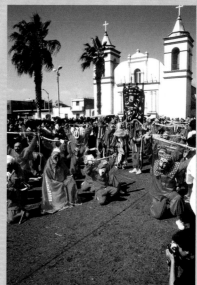

Fig. 4

Fig. 1
Chimú
Bottle depicting a figure
holding a staff and a *tumi*
900–1476 A.D.
Museo América
de Madrid

Fig. 2
The Feast of San Isidro
Labrador (Moche)

Fig. 3
Dancer dressed as a devil
(*diablico*)

Fig. 4
Dancers dressed as devils
(*diablicos*) at Moune

The Devil Walks in Northern Peru

Luis Millones

Introduction

The gods of pre-Hispanic Peru were neither good nor evil; they were simply powerful. Scrupulous observance of the community's traditional rules and rituals could swing the balance of divine will in believers' favor. But there was always the possibility that supernatural beings would act outside the established rules. In that case the answer was to consult a religious expert, now called a *maestro curandero*, a master healer, to explain the behavior of the gods and solve troublesome problems.

When the distinction between benevolent gods and those responsible solely for evil reached the Americas, it did so by way of Christian preaching. The message of the Bible came with a long history, no doubt derived from the wars between the gods of the Middle East. The Christian God, and on the other side, Satan, Beelzebub, and their like, were the heirs of these battles, and the decline of the Middle Ages saw the birth of the "evil rival," a figure who, from the thirteenth century, gained importance until European expansion brought him to the New World. When Columbus made his voyages the Christian clergy enjoyed considerable power, and it is therefore understandable that every expedition of the conquistadors should include a priest, to ensure that its members observed Catholic ritual. Furthermore, the legal justification for the long process of conquest rested on the need to evangelize the populations of those territories.

So with every European came a devil, inextricable from his Christianity. It might be a devil based on doctrine, or one rooted in popular culture. They have nothing in common. The "theological" Devil is a fallen angel, defeated in a heroic struggle, who dared defy the God of the Old Testament. Even in his fall he is imagined as powerful, and the picture of him painted by Dante Alighieri shows him devouring sinners in the heart of his dark kingdom. That image came to us from Europe, but it was reproduced ad nauseam. We can see the working of those insatiable jaws in the murals of Cuzco's churches and in the drawings (fig. 2, p. 314) by the chronicler Guamán Poma de Ayala. The other devil is a weaker figure, very widely represented in Spanish picaresque literature, who could be a late version of the multitude of supernatural beings that reached the declining Roman Empire from every part of Europe and the East. He is a devil who is close to human beings, with whom he interacts daily, seeking forms of mutual support and coexistence (fig. 4, p. 314). That relationship makes him vulnerable, and he can go from being a trickster to being tricked himself, with or without divine approval. European folklore is full of this comic image, which sits unproblematically alongside sermons from the pulpit, in which the other devil receives much greater attention.

There are more than two images of the Enemy. We have cited the extreme ends of a series of perceptions that became more complicated when evangelization had to compete with American religions, where opposition between Good and Evil, as a form of supernatural activity, was meaningless.

The presence in the Americas of people with significant cultural achievements was interpreted as being the work of the Devil in pre-Hispanic societies. As the imitator of divine action, in the Americas the Devil was believed to have created a world in which he was God. Even today, painters in Sarhua, Ayacucho, depict the figure of a man resembling Christ in front of one of a monkey, both with a group of animals representing their creations (fig. 3, p. 314). The Christian God is accompanied by domestic animals, the monkey by wild animals—a metaphor for thought about indigenous peoples and Christian invaders. In that framework, the territory of the Americas was full of demons, and all its sacred images, ritual practices, and pilgrimages were judged sacrilegious, defined as forms of disobedience to the first commandment.

The North Coast of Peru

When the Spaniards arrived, the Chimú state was in ruins and its territory fragmented, although its language (or languages) and other cultural features were still alive. There were various obstacles to its evangelization, primarily an accelerating decline in population. Proximity to the ports where Europeans and Africans disembarked exposed people to diseases to which they had no immunity, especially when the forced labor to which they were subjected meant that they quickly

Fig. 1. Baltasar Jaime Martinez Compañon, *Omeco-machacuai*, 1782–1785, Real Biblioteca de Madrid

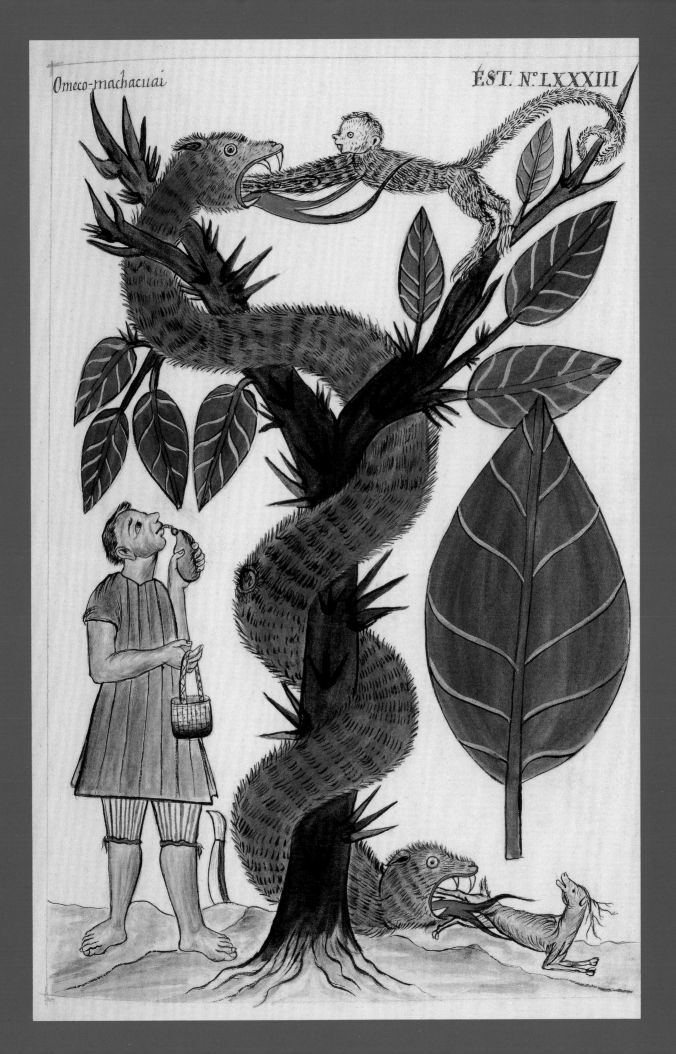

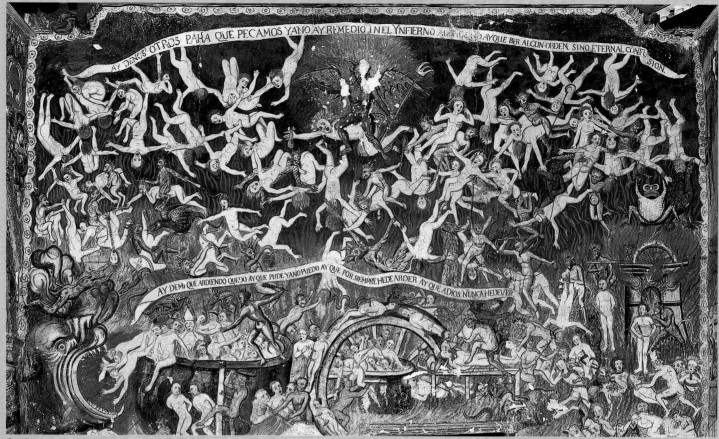

Fig. 2

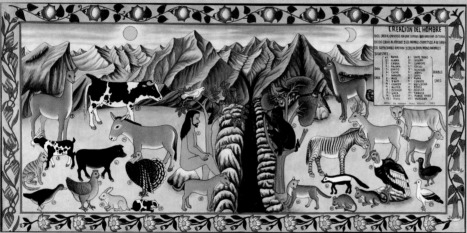

Fig. 3

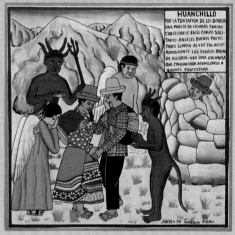

Fig. 4

succumbed to epidemics. To this was added the disastrous attempt to use Quechua as a *lingua franca*, which not only failed on the coast, but also led to the disappearance of the region's other languages. These factors made the region a focus for cultural miscegenation: the coast was a melting pot for old European traditions and a few African ones, remnants of Inca domination, and some pockets of Mochica or Chimú culture, all of which provided a setting in which the character we are talking about found a ready foothold.

The Christian Devil probably arrived in Peru with the Franciscans, as early as 1533. It is thought that Fray Alonso de Escarcena brought the word of Christ to Chiclayo (Lambayeque region) before continuing south and in 1534 evangelizing present-day Trujillo (Odriozola 1873, vol. IV, 390). His methods were the same as those used by dominant religions throughout history: the defeated gods were turned into demons and it became a crime to worship them. The degree of enforcement depended on circumstances, but the American empire of Charles V lived under the threat posed by the Reformation, and the Church's role as vigilante took extreme form in the Tribunal of the Holy Inquisition. It is important to make clear that it did not exercise its powers over the indigenous population: it was the descendants of Europeans and Africans whom it persecuted. The Andean Indians were subject to ecclesiastical visitations, the purpose of which was to oversee the work of priests, and to punish those among the indigenous population who had been reported as following any religious practice alien to Catholicism, usually defined as "idolatry." This was not done consistently. Punishment was very rigorous in the seventeenth century, but declined visibly in the eighteenth, under the Bourbon administration. In any case, the process of assimilation and the reinterpretation of Christianity by the indigenous population resulted in the religious beliefs and practices we see today.

The Maestros Curanderos and the Devil in the North

The geographical area with which we are concerned lies between the Pacific and the Cordillera Occidental. Its physical location

meant that divinities could be seen as being embodied in marine creatures and in awe-inspiring mountains, and they were (and still are) invulnerable to any form of hostile preaching. Even when the official religions of the Inca and the Chimú had vanished, when their temples had been looted and ransacked, their tombs desecrated and their artistic objects sold off, the memory of their rituals survived, in particular the use of the juice of the San Pedro cactus (*Trichocereus pachanoi*). The preparation of this hallucinogenic cactus and the explanation of the visions it produces provided the most reliable means of giving meaning to the life of local populations since the earliest days of colonization.

The practice was denounced as the work of the Devil, and expert practitioners in it were persecuted until very recently. Rising above the prejudice with which they have been viewed since the sixteenth century, the *curanderos* are able to build a relationship with the supernatural that makes them vital arbiters in the face of the uncontrollable power of the divinity that rules men's lives. That negotiation is expressed through a contest between the practitioner, who, acting in his patient's interests, uses magical means to attack the source of his problems, and on the other hand, the practitioner whose task is to treat the victim of the attack, and who therefore has to counteract it by responding to it with superior power.

This situation gave rise to the ambiguous idea that there exist *maestros* who are solely "evil-doers," whose only activity is do "harm," a concept which in this case means bringing misfortune upon the person identified by the one who has called upon the *maestro*'s services. If the spell is effective, the person "harmed" will experience family problems, fail in business, lose his job, and suffer accidents or illnesses. He may soon discover that he has been "bewitched" (the word commonly used), and he will turn to a *curandero* who will solve his problems and, if possible, turn them against his aggressor. This leads to the inevitable conclusion that all *curanderos* are also potential "evil-doers," although they emphatically deny it, and try to present themselves as people born with that power, or who have trained themselves in

the "art" of healing both physical and spiritual ailments, thanks to the grace of the Christian God. The "evil-doers," on the other hand—all the other local *maestros*, that is, apart from the person being interviewed at the time—have acquired their power through a pact with the Devil: they are therefore called *compactados*.

The omnipresence of the Enemy is embodied physically in *encantos*, places with the ability to do "harm" to anyone who passes through them or encounters one of their manifestations, which may take the form of a human being or that of a particular creature, such as the *huerequeque* (*Burhinus superciliaris*, the Peruvian stone curlew), the fox (*Pseudalopex culpaeus*), or the skunk (*Conepatus humboldtii*), which are the Devil's most frequent disguises, although his favorite form is the snake, especially one with two heads, as depicted in the eighteenth century by the watercolorists employed by the Bishop of Trujillo, Don Baltasar Jaime Martínez Compañón (fig. 1, p. 313). It is interesting to note that in the north of Peru it is not unusual to stumble across reptiles of the family Amphisbaenidae (worm lizards), which are not in fact snakes. They could be described as lizards with no legs, whose head and tail could be confused at first sight. Their presence fed into the European image of the Enemy (alongside many of his other forms) as a monstrous snake, often with two heads.

On the other hand, one may easily wander inadvertently into the area of the *encantos*. All pre-Columbian or colonial ruins are inhabited or are actually *encantos*, including the mountains and hills that are sacred according to local tradition, and the springs connected with them, and even the temporary lakes formed after an occurrence of the El Niño phenomenon. The beings that live in the *encantos*, or embody them, taking one of the above-mentioned human or animal forms, are called "Moors" or "Gentiles," names given to the members of an earlier human race who have survived and are now demons or servants of the Devil.

It is obvious that to call demons Moors or Gentiles is a result of Christian persecution, and at the same time it is evidence of the ability to assimilate Western concepts and to adapt them in order to explain the

ups and downs of daily life in the north. And while this submerged yet living form of humanity is believed to exist throughout the region, there are specific places in which its activities are concentrated. Looking only at the Lambayeque region, a notable case is that of the dunes of Casagrande, in the Mórrope District. Called "Hell," it is a place ruled by the Devil and described as an ancient city, where those who have offended the *encantos* are imprisoned. Those held there suffer forms of punishment known from Christian doctrine, but the most severe is to be in thrall to the Devil's sexual appetite (Millones 2010, 98–166). To the northeast of the town of Mórrope there is a group of pre-Columbian remains, built of rectangular adobe bricks and mortar. In its heyday, it must have been of great importance, but is now in a very poor state. Nevertheless, the *curanderos* (healers) all agree that this funeral mound, called Cucufana, is one of the most active, and that it is directly linked with the Casagrande dunes.

This description of a mental world might suggest a constant state of fear or anxiety about offending the subterranean deities at every turn. Nothing could be further from the truth. The "practitioners" themselves say that anyone who is under the power of the Devil is so because he has not obtained the services of a good *curandero*, and that all the *encantos* and their powers are reversible and harmless when faced with the power of the San Pedro cactus, properly administered. Even the Devil, in the words of Santos Vera, the most famous of the Lambayeque *curanderos*, "is a poor creature." He is not able to withstand a properly conducted ritual, and inevitably loses the fight when confronted with a *maestro* well versed in his art, using the correct dose of the juice of the cactus (Millones 2010, 165).

Lastly, it should be pointed out that the *maestros* are the first to say their power comes from their being Christian, of having been chosen to combat the Moors or Gentiles, whose ultimate source of power is the Devil. This opinion is shared by the people of Lambayeque, especially in areas officially defined as rural. Needless to say, the Catholic Church rejects that notion, which is as persistent as it is widespread. It is quite right to do so: the rules of the game on the north coast of Peru are set by San Pedro—a Saint Peter who does not reside in Rome.

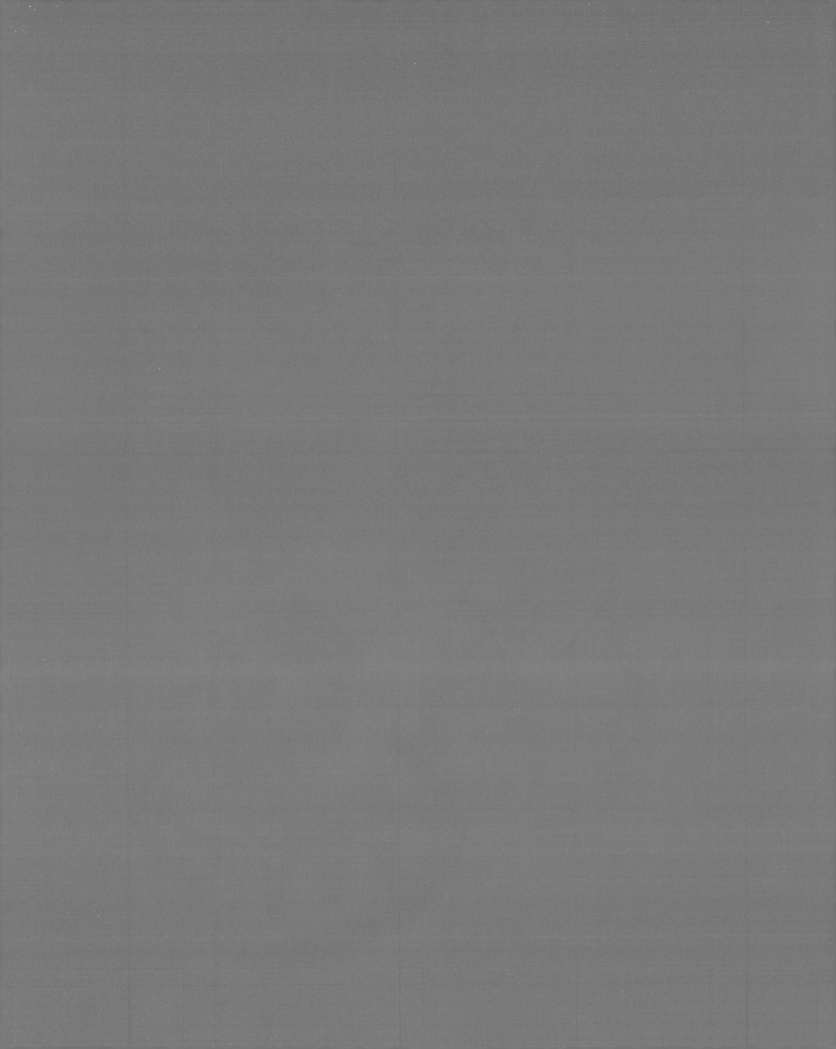

REMEMBERING
THE TWENTIETH CENTURY

Irving Penn, American photographer

France Trinque

"I decided to spend Christmas
in Cuzco [...] and set myself up as town
photographer."

Irving Penn (1917–2009) was one of the most influential American photographers of the twentieth century. As a fashion photographer he was responsible for over 150 covers for *Vogue* and was also well known for his portraits of celebrities, including Colette, Picasso, Cocteau, Miles Davis, and Yves Saint-Laurent. He took photographs of every type for magazines and the advertising industry, while working at the same time on projects of his own. His work includes studies of nudes, still lifes (some of them in the *vanitas* genre), and ethnological photographs, which he took first in Peru and later in Dahomey (present-day Benin), Papua-New Guinea, Cameroon, and Morocco.

Penn studied under the innovative teacher Alexey Brodovitch at the Museum School of Industrial Art in Philadelphia, where he graduated in 1938. He then worked as a graphic designer in New York, producing illustrations for *Harper's Bazaar*. After having acquired a prestigious Rolleiflex camera and having experimented with it for a while, he adopted a new medium and devoted a year to painting. He traveled around the American South and lived in Mexico in 1942. In the following year, he joined the staff of *Vogue*, and at the suggestion of its art director, Alexander Liberman (1912–1999), he started working for the magazine as a photographer.

Penn remained loyal to studio photography over a career spanning almost seventy years, placing his models against a neutral background in order to give them emphasis and to draw out their inner qualities. The human figure occupies so central a place in Penn's work that his fashion photographs are considered portraits in themselves. The clarity of his composition and his economy of means soon won him admiration and recognition throughout the art world. This is how Edward Steichen, director of the photography department at New York's Museum of Modern Art, wrote of Penn in the late 1940s: "His Fulbright portraits are penetrating and incisive characterizations of individuals. In photographing people or objects, it is usually the sculptor's kind of interest in form rather than the painter's that dominates the image, and each object or person appears as a unity in itself."[1]

In December 1948, after completing a photo shoot for *Vogue* in Lima, Penn did not immediately return to New York with his colleagues, but went to Cuzco, where he stayed for several days. He rented a local photographer's studio and went out in search of Peruvians from the countryside, in town for the Christmas holidays, so that he could take portrait photos of them.

"[In 1948] I decided to spend Christmas in Cuzco, a town I had heard about and had a hunch about... By incredible providence, there in the center of town was a daylight studio! A Victorian leftover, one broad wall of light to the north, a stone floor, a painted cloth backdrop—a dream come true. I hired the use of the studio for the next three days, sending the proprietor away to spend Christmas with his family, and set myself up as town photographer. When subjects arrived to be photographed they found me instead of him. Instead of them paying me, I paid them for posing, a very confusing affair."[2]

These were fashion photographs that Penn took of his Peruvian models, wearing their traditional dress. By highlighting the texture and design of their clothes, he went beyond purely aesthetic considerations to express his models' individual personality and human dignity by isolating them from their environment. A year later, a selection from this series of timeless portraits was published in color in the December 1949 issue of *Vogue*.

After he left Cuzco, equipped with a portable studio, Penn continued to work in this genre for over twenty years, during which he traveled in Morocco, New Guinea, and elsewhere. Published each year in *Vogue* and in a 1974 collection with the evocative title *Worlds in a Small Room*, his strange, fascinating ethnological portraits, which are so unusual for a fashion photographer, remain truthful and moving.

1. "Irving Penn...by Edward Steichen," an accompaniment to the article "Christmas at Cuzco," *Vogue*, December 1949, p. 91.
2. Sarah Greenough, *Irving Penn Platinum Prints*, National Gallery of Art, Washington, Yale University Press, New Haven and London, 2005, p. 36.

PAGES 321–325: **290-294. Irving Penn, *Cuzco: Three Sitting Men in Masks (Neg. 611)*,** 1948; ***Cuzco: Cuzco Children (Neg. 260)*,** 1948; ***Cuzco: Many Skirted Indian Woman*,** 1948; ***Cuzco: Woman with Braided Hair*,** 1948; ***Cuzco: Town Photographer with Girl and Basket*,** 1948

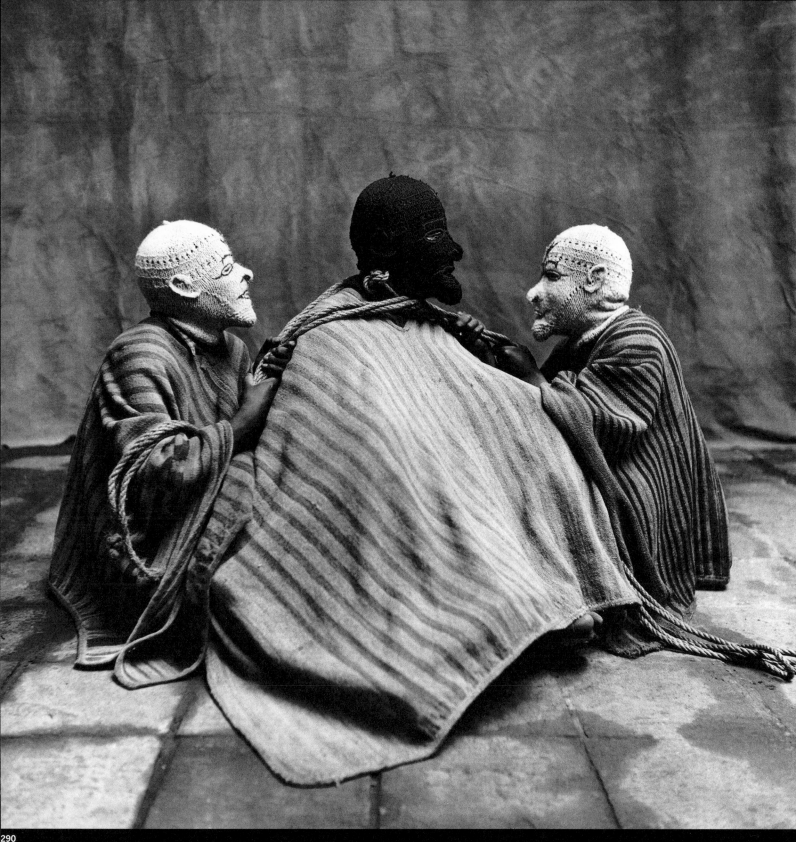

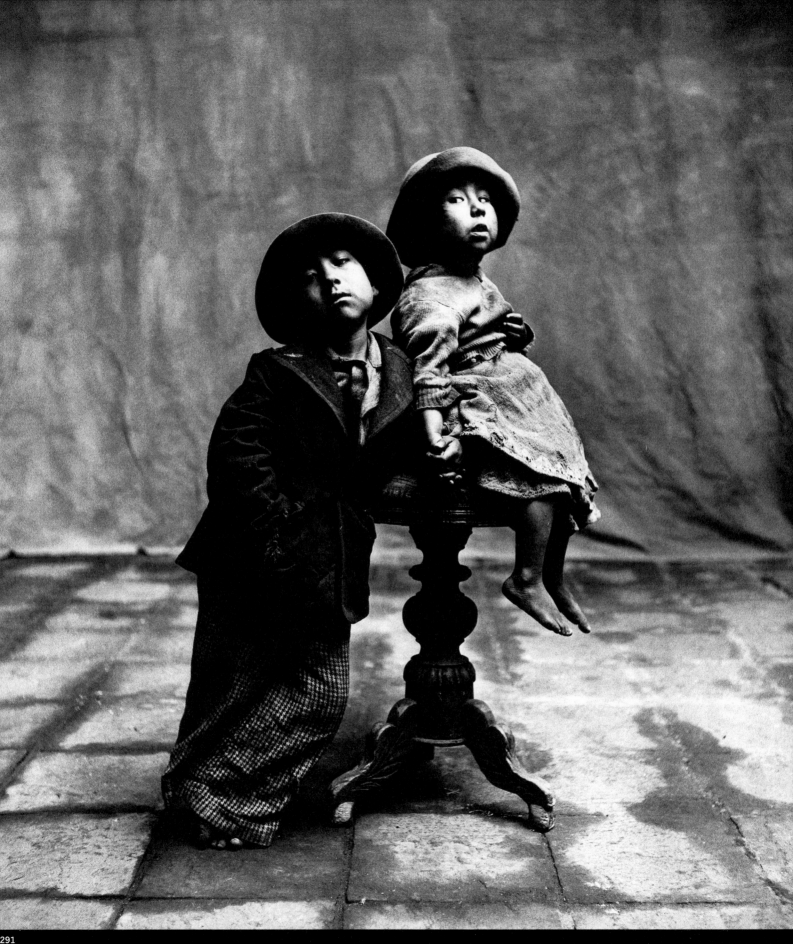

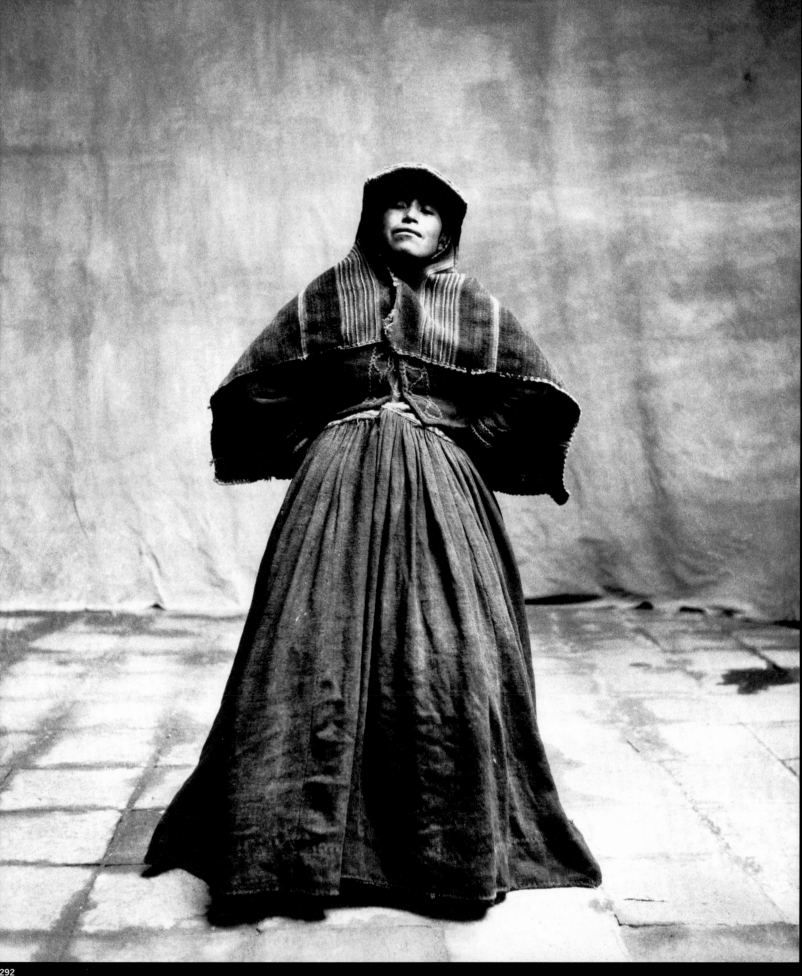

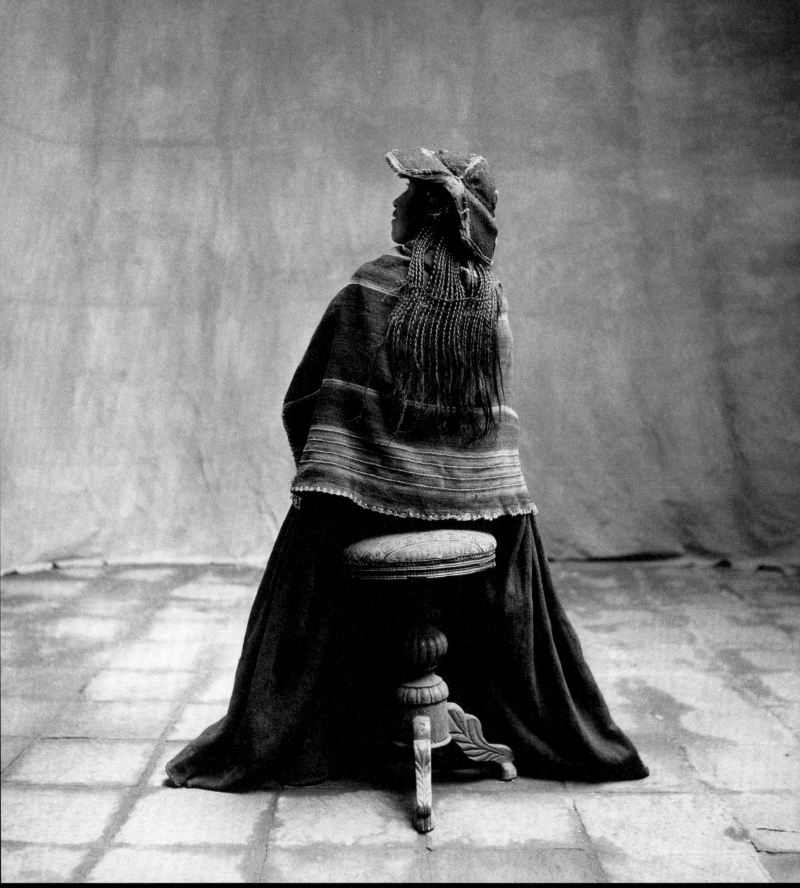

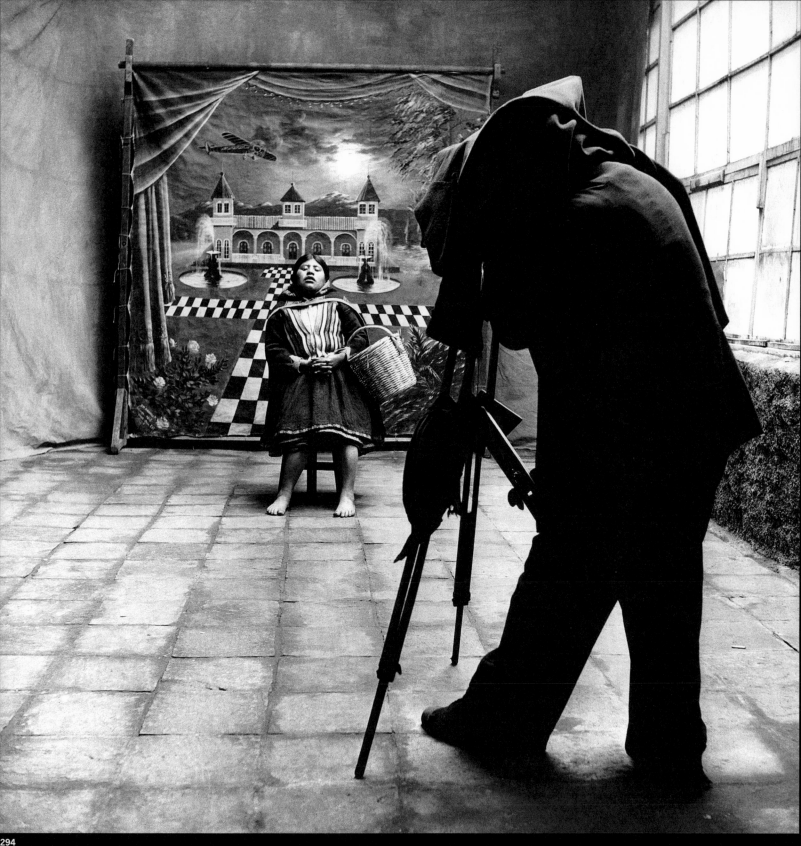

Interview with Ruth Shady

Rosario Yori

Caral is the oldest civilization in the Americas, the birthplace of the Peruvian nation and the site from which it sprang. Where does its uniqueness lie?

As a civilization, it represented a more advanced stage in the cultural development of the societies living in this region. Until that time, the sole concern of the population had been subsistence, but when they adopted a more complex, urban way of life, that was no longer the case, because survival was assured. There was a surplus, leading to specialization in different forms of activity: administering resources, establishing the social order, improving living conditions, and increasing productivity. Society became highly organized, and forms of knowledge began to emerge.

What image does Peru, one of the earliest civilizations, present to the rest of the world?

An important detail is that this civilization was not in contact with neighboring cultures, because in terms of development it was at least 1,500 years ahead of them. In the Old World, Egypt and Mesopotamia were in contact; advances made by one society were exchanged with another. But not here. It seems to me that this makes our part of the world very interesting from the point of view of ways of living.

The Inca Empire has been idealized as a unified, harmonious utopia. What part does that utopia play in our identity today?

We have always been a multicultural nation, but one aspect of the individuality we succeeded in cultivating in the past was the way we interacted regardless of our geographical and cultural differences. And that was not only true in relation to the Inca civilization; it began with Caral, where Quechua originated, because of the need for a common language. The Incas adopted it because it was widely established and enabled them to have dealings with cultures outside Peru—in Argentina, Ecuador, and Chile. But its adoption was not a sign that integration was inevitable.

The twentieth century was the "golden age" of Peruvian archaeology. What is its role in contemporary Peruvian society?

Archaeology plays a crucial role since, until we can decipher the meaning of the *quipu*, it is the only means we have of obtaining historical information about how the country was governed and how the land and its resources were managed. In Peru, imported models were adopted that didn't suit our geographical, cultural, or social conditions. That has meant that, from the 1940s at least, there has been constant migration to the coast. The country has grown unevenly: barely twenty-four percent of our population lives in rural areas. José María Arguedas used to say we were turning our backs on the "hanging gardens" it had cost earlier societies such huge efforts to create in our rugged mountainous terrain. Now we are abandoning them to settle in the coastal ranges. The role of archaeology is to show that it is possible to manage this land in a more harmonious way.

Archaeology alone will save Peru?

Not archaeology, but the thinking it stimulates. Archaeology encourages us to think about what we did and what we need to do in organizing our country and its resources.

Despite what you say, the state has not given priority to conserving our heritage.

We archaeologists are partly to blame for that. You said the twentieth century was the time when archaeology had the highest profile and the greatest importance. We did, of course, have a major cultural presence, but we limited ourselves to doing research, without being interested in communicating it to a wider public. That's something that has to change. It's impossible to imagine that archaeology will play a role in this country when our politicians don't understand it. Archaeology recovers historical information that we cannot obtain by any other means; if an archaeological site is destroyed, it's like a burned book that we will never read.

People haven't understood that to invest in archaeology means more than preserving a piece of pottery...

We're not interested in pottery. Archaeology is a vitally important source of development.

"Archaeology is a vitally important source of development."

Mexico receives over twenty-six million tourists every year, we have barely two million. We have a world-class heritage, which must provide a firm foundation for development. And it's not just Machu Picchu. We're finished with the goose that laid the golden eggs.

What about the public? We too live among archaeological remains; Lima was built on a series of fortifications. It all hangs on education. When they leave their hometowns and villages, migrant populations (which means those living in the major part of the country) try to settle wherever they can; and they frequently occupy archaeological sites, which nobody owns. But the real owner is the nation.

A large part of our archaeological heritage is currently outside the country. How do you feel about that? Our archaeological riches are a legacy, and a legacy has to be treated with care. We should not allow it to be pillaged, nor to leave the country.

You have pointed out the importance of tourism for development. Is Peru is a tourist destination equal to the demands of an international market? First of all, Peru needs to be fully aware of what it is, and to be proud of it. That is the foundation for developing tourism. A few years ago, a survey was carried out among tourists. The question was: "Why did you choose Peru as a destination?" Ninety percent of respondents said it was for its archaeological heritage, but nobody took the exercise into account. We're promoting our beaches and trying to compete with other countries that have had them for years. That's not our strength; it's not Peru's brand. We need to develop policies for tourism that are appropriate to this country and its specific characteristics. Our strength lies in our archaeological resources; our cuisine and other cultural offerings are additions to that.

Ruth Shady is a Peruvian anthropologist, archaeologist and educator.

Interview with Fernando de Szyszlo

During the Conquest, painting was used as a tool of indoctrination and evangelization. What was the role of art in creating a Peruvian identity?
Colonial art in Peru is an interesting phenomenon, because priests needed images for their churches. So they brought over a number of Spanish painters, and, above all, great numbers of engravings, and they got artists to copy their subjects. But as far as indigenous artists were concerned, they didn't really copy them so much as re-create them, and [the result] has a lot to do with their own traditions. The art they produced—colonial Peruvian art—doesn't have a third dimension; it consists of a flat painting, without volume, and there are no empty spaces. That "horror vacui" is a pre-Colombian legacy. And here's the interesting phenomenon: despite the fact that it was a colonial art, subject to the demands of those who commissioned it, native artists succeeded in reinterpreting the things they were required to paint. That didn't happen under the Republic. Under the Republic, art became colonial again, because it turned into an imitation of European art.

It is paradoxical to say colonial art enjoyed greater freedom than art under the Republic. It should be the other way round. What happened?
Under the Republic, circumstances led both public and artists to believe that to be free was to make European-style art. So they produced art that, for me, is without any interest. The classic example is Luis Montero's *The Funeral of Atahualpa*, painted between 1865 and 1867; Peru had been independent for forty-five years, and the painter tried to make the death of Atahualpa European.

Under the Republic, Peruvian painting was colonial for the first time; it lacked autonomy. One painter escaped that fate: the mulatto Gil de Castro, whose painting has character. But the first strong reaction against that situation came around 1920, with the *indigenista* group.

What were the political implications of that movement?
Only that they painted indigenous people. That really shocked the Peruvian society of the time, which rejected *indigenismo*. This turned it into the first modern movement, because it was contrary to what its society wanted.

But in themselves the results were very poor. *Indigenismo* tried to create a Peruvian painting, but there was a major confusion: the movement identified Peruvian subjects with Peruvian painting. A Peruvian subject is within anyone's reach; anyone can paint an Indian in his typical dress. They did more than that, of course. They tried to be innovative in painting, vaguely influenced by Mexican murals and Gauguin, but their work was dominated by depicting folkloric subjects.

If, as you say, Peruvian subjects do not define Peruvian painting, where is that definition to be found?
It's very difficult to say what it consists of. There is a sense that it is distinct, that it reflects a local reality. It's like asking what is Peruvian in César Vallejo's poetry. It's very hard to say, and yet it's different from all the other poetry of its time. And you know that it's adding something real. Vallejo, as Ortega y Gasset said, is himself plus his circumstances. In other words, he's Vallejo, plus all the surrounding circumstances: the Andean mindset, the Peruvian conception of history and class.

You have said that you are always trying to paint a recurrent feeling that expresses itself in your work in different ways. Do you believe Peru also pursues a recurrent feeling in its art?
The nation has nothing to do with this process. You try to bring out something that is hidden deep inside yourself, in your subconscious. If it emerges, it has distinct characteristics of its own. There are no subjects in Peruvian art. It would be very easy to make a painting with its own characteristics if there were any identifiable characteristics. What links Goya with Picasso is that rather tragic, violent feeling that Spanish painting has; in French painting, what links Poussin with Cézanne is a delicate, refined approach to painting, a special feeling for color. If only we could say, "that's it," because then it would be very easy to make Peruvian painting, and it's actually the hardest thing to do.

It's a problem that has to do with what surrealism tries to do: take things from the

"Under the Republic, Peruvian painting was colonial for the first time."

individual unconscious which, while being genuine products of that unconscious, also have links with the collective unconscious. So, what is valid for me is valid for other people; and the more profound it is, the more people there are for whom it is valid. Bach brought from within himself music that is played in Japan, Argentina, or Russia. He found within himself something that is valid for the whole world; you don't have to be Protestant, or understand Latin, to be moved by one of his cantatas.

Is it true that you found part of your voice as an artist in the Quechua tradition and by looking at the pre-Colombian past? What presence does it have in Peruvian art?
It was not that it helped me find my voice, but I realized that there was something that made an impression on me, especially in the poem "Elegía a la muerte del Inca Atahualpa." It's not as easy to point to what it was. It's an obscure thing that a person has to discover for himself. André Breton said: "It's a question of finding out what

message I alone transmit, and to whose fate I must respond with my brain." And Rilke said: "To write a poem one has to have loved, suffered, felt joy, seen birth and death; then we have to forget those sensations so that when they return they are in our bloodstream, and the work can come forth." When an inner feeling is connected with the subconscious of other peoples, it becomes a language. That means there is no need to say whether it is true or not; it is there in reality.

Peru is a country with a great deal of popular art, but there is a gap between that and "Art," which operates on a more hegemonic plane. How do these two talk to one another?
They are different things because they are made from a different perspective. They may be in contact, but it has never been the same to make a statue of the Virgin as to design a salt cellar. Benvenuto Cellini's salt cellars are wonderful, but the spirit behind the creation of Michelangelo's *Pietà* is of a different order. It's very easy to see that in

pre-Colombian art. A piece of Chancay ceramic and a piece of Paracas weaving are on the borderline between art and craftsmanship. Nevertheless, there is no individual behind them, it is anonymous art, produced by a group and not by an individual.

In a very difficult political climate, as under the government of General Velasco Alvarado, the radical Left tried to mix craftsmanship and art. It's not that easy. An illustration of what happened at that time is that the work of a craftsman from Ayacucho who made *retablos* was submitted to the São Paolo Biennial. A number of us protested. At the time I wrote a letter to the newspaper, in which I said racehorses were very beautiful, but that wasn't a reason to let them compete in Formula One. Everything has its place, and you can't mix them up.

Fernando de Szyszlo is a Peruvian artist and leading figure in developing Latin American abstract art.

Interview with Víctor Pimentel Gurmendi

Rosario Yori

What part do conservation of historic monuments and commemoration of the past play in building a nation?

It's quite easy to answer that because I have lived and experienced it. As a student in Italy, I discovered something that didn't exist over here: *il restauro dei monumenti*. In Peru, if you asked people about a monument, they would describe something that was worth preserving, perhaps for its artistic value. But the idea that a building could be restored and preserved was not envisaged. My professors in Italy opened up much wider horizons for me. When I returned to Peru in 1960, the Consejo Nacional de Monumentos (National Council for Historic Monuments) still had no technical department, but one was set up. I traveled all over Peru for that purpose. When I arrived in Cuzco, I noticed they were demolishing the house of the Inca Garcilaso de la Vega, our first mestizo chronicler. That outraged me.

That is one of Peru's pioneering restoration projects. What is its legacy?

Since I had just been appointed director of Historic Monuments, I stopped the work and we persuaded the government to take over the building. A development project approved by the city council was already in place, designed by the distinguished architect Emilio Harth-terré. Since I was against the demolition and the new development, I proposed that it be restored, and we discussed the submissions. Here am I, a

young man just back from Italy, about to propose something unheard of: to restore something that was falling down. Something decisive happened: Harth-terré withdrew his design and supported mine. It was then that the valorization of the past began. The restoration of the house of the Inca Garcilaso is seen as marking a new stage in preserving aspects of the Latin American past that have historic value. Interest in preserving the past and comprehending it is of vital importance in understanding how a nation takes material form and cohesion.

In the case of Peru, what are these elements that awaken feelings of national unity?

Until recent decades, the iconic site was Machu Picchu, which is exceptional, but every day there emerges evidence of our creative and cultural past. It's difficult to identify Peru's rich heritage with a single image. For the distant past, and because it presents aspects that have recurred throughout two thousand years of Peru's culture, it would have to be Caral, a UNESCO World Heritage site, one of the world's earliest civilizations and a great landmark for a nation.

That does not mean, of course, that other cultural heritages, such as the work of noted craftsmen, are of less value. I recall how, when the Casa da la Cultura awarded the national prize for visual arts to Joaquín López Antay, many people were indignant. They did not take pride in that

acknowledgement of the cultural and artistic value of his work. That's inconceivable! Culture belongs to every group of people who make something sublime.

What are the major restoration projects in Peru?

The House of Garcilaso started a tradition. The Monastery of Santa Catalina in Arequipa and the restoration of notable monuments in the historic centers of Ayacucho, Cajamarca, Cuzco, Trujillo, and Lima are other good examples. Another big project, in which I was involved, was the former seminary of San Antonio de Abad, in Cuzco, which was closed for twenty years following the 1950 earthquake. I talked to the authorities and prepared a design for a hotel. Nothing was demolished; the building was so well constructed that it was not damaged in the quake. It was preserved in its entirety and adapted as far as possible without compromising the authenticity of its architectural structure.

What you propose is interesting: that a historic monument should not necessarily be preserved as a "cult object," but can fit into modern life.

That happens all over the world, of course. The Baths of Caracalla, which are in ruins, are used for big concerts. In Peru a tremendous amount of work is currently being done by young archaeologists and private enterprises, which are investing in the conservation of archeological sites. Our

"Our heritage
is what identifies
us to the world as a
civilized nation."

heritage is protected by the State, but it belongs to every Peruvian. It has taken an effort to convince people that it is important not only for the economy, but for our identity itself. Our heritage is what identifies us to the world as a civilized nation.

In the case of Peru, which embraces so many different traditions, cultures, and historical epochs, how can these differences be reconciled in the search for a common goal?
That's not easy to answer. We're a multiethnic, multicultural group of nations. Our intellectuals are trying to help us find unity within that variety and a way of identifying ourselves as nation within that diversity. In that respect, I'm rather optimistic. At present, young people are concerned about the past, but they don't want to copy it. The past has to be respected and preserved in its purity and authenticity, but not mystified by imitation. We're talking another language now.

National stories are constantly changing and being remade. When will we know that a new symbol of the nation has emerged?

It will emerge when we begin to see the past through Peruvian eyes. Many people have brought us to this point. That way of seeing first arose in the period of *indigenismo*, in the 1920s and 1930s. It's gaining strength now. Today, in every creative vision in Peru there is an interest in preserving the past, so that we can all have a clearer image of ourselves.

You mention a time when the past was not seen very sympathetically. When did that change?
At the time of the Conquest, Inca culture and earlier ones were not taken into account. To put it simplistically, the Conquistadors were interested in founding Spanish cities and extracting gold. Our knowledge of history tells us that when the Republic was established in 1821, there were people who wanted to record and preserve that local ancestral heritage, starting with San Martín, who founded the Biblioteca Nacional (National Library) and the Museo Nacional de Antigüedades (National Museum of Antiquities). But when was there a genuine wish to look at the past and assess it? That's very recent, with the setting up of the Consejo Nacional

de Monumentos (National Council for Monuments) and the Patronato Nacional de Arqueología (National Archaeology Board). There then came a trend that promoted what was indigenous and autochthonous. At present, I repeat, there are real efforts to be inclusive. We must make sure this process of unification is real, that this new Peru comes about without disputes or deaths.

How should we manage our historical heritage?
It can be done successfully if we do it with respect for the customs and traditions of each place, without compromising its authenticity. If we achieve that respect, we'll have a country that is unitary, but with diverse habits and customs. We don't have to deny those differences, but need to balance our mutual strengths and weaknesses. In Peru, there are no second-class citizens.

Víctor Pimentel Gurmendi is a Peruvian architect, specializing in the restoration of historic monuments.

Interview with José Matos Mar

Rosario Yori

Peru changed radically in the twentieth century due to the experience of migration. What were its social, political, and cultural impacts?
The major changes began in 1940. Throughout the 1940s, people from the "other Peru," discriminated against, marginalized and forgotten, asked themselves how they could change their situation. Everything had failed (neither presidents nor government did anything) and people thought that if they went to the coast they would find work and escape poverty at last. That was the start of the great migrations on the part of people who had been abandoned. This phenomenon, which I have called an "outpouring of the population," happened at the end of the twentieth century. Hundreds of families, thousands of individuals, migrated to all Peru's coastal cities, mainly to Lima, and in doing so they altered the country's demographic profile. By 1972, Peru was no longer a rural country, but an urban one.

When they settled on the coast, these members of the "other Peru" caused a structural change that was silent and peaceful, but in conflict with the authorities. Once they had arrived, these people—who couldn't find employment and received nothing from the state—built their own houses and their own neighborhoods, and created their own way of life. And since there were so many of them, they imposed it on the rest of the country. They became successful, prosperous citizens, because they found work as street vendors and small businessmen. They were changing the socio-economic structure of Peruvian society, bringing about the unprecedented growth of a middle class. They became modern citizens. What took place was a structural and cultural change. They made their neighborhoods similar to the towns they came from, introducing their own values and customs, and they changed the face of Lima. For the first time in Peru's history there was a society that embraced the whole nation, consisting of thirty million Peruvians, all of them citizens who participated in it on an equal footing.

While that "outpouring of the population" may be seen as chaotic, it brought with it a productive figure, the entrepreneur, a citizen who, even if he did it outside the law, managed to get ahead. What is his place in modern Peru?
When they reached the cities, migrants found there was no work or that it was very limited. Since the government did not realize that the problem was that people wanted modernity and well being, and that it wasn't only a housing problem, they had to create their own forms of work. That was the origin of the informal sector. They [the entrepreneurs] created an astonishing informal economy. Many of them were successful, but many others failed. And with that came all kinds of illegality. Since Peru has never had good governments, we're facing a situation in which illegal activities flourish. The state has been completely overwhelmed.

Could it be said that Lima is a "provincial" city, or that these migrants, despite being a majority, have been unable to impose their traditions and cultures?
It's not provincial; Lima is a multicultural city. Thirty percent of the population of Peru lives in Lima: ten million people. Of them, six and a half million live in the three "new Limas" created by different generations of migrants and consisting of shantytowns and the vast districts that grew out of them. By their mere presence, these migrants said, "We're as much Peruvian as you, so accept our customs," and they imposed them. When I was a student, I was the "*cholo* [mestizo] Matos," and I was discriminated against. Not now. Discrimination is decreasing all the time. We're all Peruvians.

If the country is as well integrated as that, who's marginal in Peru now?
There's no marginality. There's no discrimination. There's no "Indian," no "*cholo*," no "savage." There's been another important change: with the rise of capitalism and globalization, regional identities are being recreated and strengthened. Our experience is a good one, because it is an achievement of the people, not the government.

Isn't that a bit optimistic? In Peru there are still forms of discrimination on grounds of ideas, race, customs...
We're physically integrated, but not integrated in terms of national identity. People from the provinces are no longer discrimi-

nated against, but they still can't shout: "Viva Peru!" There's still no symbol of national identity. But if we have a couple of good governments it could happen, especially now we're physically integrated, and we know and respect each other, because those "others" have won respect. That's the power of culture. I'm optimistic in the sense that I believe things are moving in the right direction.

What could be a symbol of modern Peru?
Some are appearing, but we don't have big symbols. We don't have any national heroes. They have to come along.

You say that the "outpouring of population" was due to the weakness of our political class. What is needed to govern this country?
That's the thing. They [politicians] created their own "outpouring," their own shanty-towns. The problem is that in the space of seventy years, along with migration, we've seen that "official" Peru suffered from a number of problems, the main one being the political parties. The Cold War ended in 1989. Capitalism had triumphed and Communist parties and the Left disappeared from the map. Official Peru didn't grasp the change and was unable to organize a good government. The most recent presidents of Peru—Fujimori, Toledo, and Humala—have been "outsiders," members of no party. In Peru today, there are no political parties and hardly any political leaders; the state has been unable to organize itself. There's a crisis of government and a crisis of the state. A major reform is needed.

Apart from migration, what have been the major structural changes that have driven our history forward?
Very few. That's Peru's tragedy. One major structural change was the coming of the Spaniards, Pizarro's arrival at Cajamarca, and his capture of Atahualpa. From having our own indigenous lifestyle we became a colony of Spain. That was a structural change: all forms of government and territorial organization were transformed. Since then there haven't been many other structural changes. Velasco tried to make one in 1969, with the agrarian reform, which did away with the oligarchy in Peru. There have been no changes since then—and we need so many! The main need is to improve the country's physical integration: to develop roads, ports, and airports. If we can do that, as the song says, ¡Viva Peru y sereno!

José Matos Mar is a Peruvian anthropologist, specializing in contemporary Peru.

Interview with Mario Vargas Llosa

Victor Pimentel
Rosario Yori

In your essay "Sueño y realidad de América Latina" [Dream and Reality in Latin America] you question the existence of a collective Latin American identity. You say, "One of the recurrent obsessions of Latin American culture has been to define its identity. It's a pointless, dangerous, and impossible aspiration, because identity is something that belongs to individuals, not to collectivities." Is there such a thing as a Peruvian cultural identity? How can we explain efforts to define it, especially since the establishment of the Republic?

I do not believe that collective identities exist, and it therefore follows that no Peruvian identity exists. Identities exist for individuals, and basically in open societies where an individual can make rational choices and thus choose his lifestyle, his vocation, his work, and other activities. Those things define an identity that separates the person from the group and gives him sovereignty, individuality. Collective identities do of course exist, but in primitive societies, in the world of the tribe, where the individual could not survive on his own in a world where everything is threatening, dangerous, and hazardous; he has to be part of a larger entity in order to defend himself against the precariousness his life entails. As man conquers nature and establishes himself more securely, there appears within the group the most distinctive characteristic of human life: differences. And these dif-

ferences lead to the emergence of the sovereign individual.

As I see it, collective identities are political and ideological concepts, developed by those who believe that the individual is no more than an expression, almost an exudation, of the collectivity. I do not believe that is true, even in the most totalitarian empires. In the case of Peru, the Tahuantin-suyo was an expansionist empire that incorporated cultures, tribes, and nations, and followed an extraordinarily civilized policy of respecting the beliefs, languages, and customs of the societies that it absorbed, imposing only a common name. That is much closer to the truth of the matter than the idea of collective identities in which we all answer to a more or less sole pattern, established by the collectivity. If there is a continent and a nation where the idea of a collective identity is completely anomalous and meaningless, it is Latin America and Peru.

What does it mean to be Peruvian?

What does it mean to be Peruvian? To be white, Indian, Chinese, black, mestizo, Japanese? It's all those things, and many others. Nevertheless, there is no doubt that there are shared definitions that establish among Peruvians a community of interests, common issues, a past, and a culture. I believe that this enormous diversity, which prevents our having an identity, is a blessing, especially nowadays, when borders are disappearing and globalization is imposing itself. We should not be surprised at globalization: we are

better prepared to face it than other societies precisely because of the extraordinary variety of ways in which one can be Peruvian.

To be Peruvian is to be everything. That's a very reassuring thing in a world in which peoples who look inward are being overwhelmed by circumstances in which isolation is an obstacle to development and progress. Peru is a multiple society, but that doesn't mean we are chaotic. It defines us, and at the same time brings us together, because it is also true of the countries surrounding us, with whom we share common definitions that are much more important than our differences, which are minimal.

From the early days of the Republic, one of our deepest wishes has been that Peru should modernize, implying the arrival and appropriation of foreign ideas. Modernity, in that sense, is what emerges from encounters and exchanges. How can we explain its slow progress in Peru?

That slowness is due, basically, to underdevelopment. Our education system, the major tool for modernizing a society, is very poor. Education in Peru is, unfortunately, highly inequitable. There is elite education, which is mainly private, for a small minority. Meanwhile, public education, which is deeply democratic and fosters equality of opportunity, exists neither in Peru nor anywhere else in Latin America. That is one of the great weaknesses and failures of our governments: not to have

"Peru is becoming increasingly mestizo, and that's a process to celebrate."

promoted an excellent public education system that would create that equality of opportunities, a basic need in a democratic society.

Less than a century after Peru's Declaration of Independence, new visions of modernity were disseminated by intellectuals like José Carlos Mariátegui and Haya de la Torre. That early twentieth-century modernity was linked with ideas such as socialism and communism, and it also addressed the question of the Indian and his role in the country's life as a republic: his marginality, education, and exclusion. At the same time, currents such as *indigenismo* were emerging in Latin America. Why did that social project not thrive in Peru? Why has the Indian not found his place in modern Peru?

That was another major weakness of the Republic, which arises from the idea of integrating the victims of the Conquest, who had been marginalized, segregated, and exploited during the colonial period. The Republic is not solving the problem, but maintaining, even aggravating it.

The emergent *indigenista* movement expressed the demands of what Arguedas called the "beleaguered nation" of Peru, the Indian nation. There's a very positive element in that: its denunciation of the great silence in the official history of Peru in respect of a huge part of the society represented by that beleaguered nation. How is it to be integrated into the whole? There is an immense debate in Peru on that subject, which has always been badly framed, as some sort of irreducible opposition between the Indian and the Hispanic Peru; as though they were incompatible and one of them could obtain justice only by eliminating the other. Today it is utterly naive to think that Peru will achieve real social justice with the restoration of the Empire of the Incas, or in a Peru that is totally Indian. The problem is how to integrate that beleaguered nation by giving it every opportunity to participate in modernity, while preserving all the cultural riches that are part of its heritage. This is not easy, because there are no models to follow: there isn't a single country in the world that has found a happy and just answer to this problem. Those countries that have achieved integration have done so by sacrificing their traditional culture and experiencing a cultural

transfer. There are many aspects of traditional indigenous culture that are compatible with modernity and should be preserved and integrated, but at the same, there are a number of impediments that are incompatible with it and should be rejected.

***Mestizaje* is a vehicle for doing that.** And it's happening. In Mexico the problem was solved when the Mexican Revolution made *mestizaje* inevitable. In Peru it's becoming increasingly visible. With the development that has taken place in the past few years, it's interesting to see that the middle classes that have emerged are mestizo. They are the dominant presence among the middle classes. Peru is becoming increasingly mestizo, and that is a process to celebrate, because it's a very real form of integration. There remains the problem of the indigenous peasantry, who are the most marginalized class in Peru. As I have said, no one can deny that education is the vehicle for integration.

Mario Vargas Llosa is a Peruvian writer and recipient of the 2010 Nobel Prize in Literature.

ANNEXES

Chronology
Major Events in Peru and the World

Victor Pimentel
assisted by Leslie Barry

3500–1800 B.C. The emergence of monumental architecture, population increase and widespread production of textiles characterizes the Late Pre-ceramic Period.

About 3000 B.C. Caral is settled, becoming the major site of the period with its pyramidal platforms and large circular or semicircular plazas, considered the first city in the Americas.

1800–900 B.C. Pottery appears. New sites emerge along the coastal valleys, exploiting the rivers for cultivation.

900–200 B.C. The widespread Chavín culture and religion in the Central Andes flourishes. In the South, another important culture is Paracas, famous for its impressive funerary textiles.

200 B.C.–600 A.D. Regional cultures emerge and develop: the Mochica and Gallinazo cultures along the north coast, Lima along the central coast, Nazca along the south coast, Recuay in the northern highlands, and Tiahuanaco in the Titicaca basin.

600–1000 Climatic and environmental changes occur in the Andean region; during this period the Huari in the highlands and the Tiahuanaco in the Titicaca basin expand their dominion and cultural traits to the whole central Andean region.

1000–1476 The Chimú Empire, on the north coast, the Chancay, occupying the central coast, and the Ica-Chincha cultures of the south coast consolidate and expand. The Chachapoya, occupying the northern highland regions, and the Wanka, of the southern highlands, oppose a fierce resistance to the first expansion of the Inca.

Mid-13th century The Inca city of Cuzco, future capital of the Inca Empire, is founded.

1438–71 The *Tahuantinsuyu*, or Inca Empire, expands under the rule of Emperor Pachacutec.

Mid-15th century Machu Picchu is built by the Inca.

1471–1532 The Inca Empire, the largest empire in pre-Columbian America, spans from southern Colombia to central Chile.

1492 First voyage of Christopher Columbus to the Americas.

1494 Treaty of Tordesillas divides Spain and Portugal's territories of conquest.

1510–11 The first African slaves are brought to the Americas; Dominican Friar Antonio de Montesinos begins efforts to combat American indigenous slavery.

1516–56 Charles V, Habsburg King of Spain, reigns.

1519 Hernán Cortés lands in the Yucatán and encounters the indigenous Aztec Empire for the first time.

1532 Francisco Pizarro captures Atahualpa, the last Emperor of the *Tahuantinsuyu*.

1534 The Spanish found the city of Cuzco, former capital of the Inca Empire.

1535 The city of Lima is founded.

1536–37 Cuzco succumbs to the Indian rebellion and is seized.

1540 Manco Inca Yupanqui (Manco Cápac II) founds the small independent neo-Inca state of Vilcabamba. Pope Paul III approves the establishment of the Society of Jesus (the Jesuits).

1542 The Peruvian Viceroyalty is founded; the first viceroy is Blasco Nuñez Vela. The first colonial silver mines open at Potosí.

1546 The first colonial silver mines are developed at Potosí.

1549 The first Jesuits arrive in the Americas.

1551 Charles V issues royal decrees, or *cédulas*, founding the first royal universities in the Americas. On May 12, the National University of San Marcos is founded in Lima.

1555 The Colegio de San Andrés, a school of painting and sculpture located in Quito, receives its royal warrant; the school's students include indigenous and mestizo people.

1560 The *Taqui Onqoy* (Dance of Disease) rebellion in Peru—also called "The revolt of the Huacas"—attempts to overthrow European rule.

1569 Francisco de Toledo is appointed the fifth viceroy of Peru. Reorganization of the colony begins and the Inquisition is established in Lima.

1572 Túpac Amaru I, the last Incan Emperor from Vilcabamba, is executed in Cuzco.

1573 The Law of the Indies establishes the grid as the standard city plan in the American Spanish colonies.

1574 The first European painter in South America, Jesuit Bernardino Bitti, arrives in Lima.

1579 San Martín de Porres, the first black saint of the Americas, is born in Lima. The first book by an American-born author is published: *Rhetorica Christiana*, by Diego de Valadés, the first mestizo friar in America.

1581 The last of the Inca territories is captured by the Spanish.

1586 Saint Rose of Lima is born; she is the first person native to the Americas to be canonized by the Catholic Church.

1588 The Spanish Armada is defeated by the English navy under Elizabeth I.

1598 The Spanish colony of New Mexico (North America) is founded.

1599 The oldest dated painting by an Indian artist in South America, *Portrait of the Mulatos of Esmeraldas*, is painted by Andrés Sánchez Galque of the Quito School.

1605 The Seminario de San Antonio Abad is founded in Cuzco.

1609 *Comentarios Reales de los Incas*, by the mestizo writer Inca Garcilaso de la Vega, son of an Incan princess and a Spanish captain, is published in Lisbon.

1610 Beginning with the public celebration of the beatification of Ignatius of Loyola, the Society of Jesus promotes the cult of the infant Jesus "de Huanca" dressed as an Inca emperor.

1613–15 Guamán Poma de Ayala writes his *Nueva Corónica y Buen Govierno*, denouncing the ill-treatment of native Andean people by the Spanish after the Conquest.

Mid-17th century–1712 Cuzco enjoys its "Golden Age."

1649 The Cuzco painters guild is founded.

1650 The Great Earthquake of Cuzco strikes.

The sculpture *Christ of the Good Death*, believed to have stopped the earthquake, becomes the "Lord of the Earthquakes" and patron saint of Cuzco.

1673–99 Bishop Manuel de Mollinedo y Angulo, Cuzco's greatest arts patron, holds tenure.

About 1680–1780 The "Inca Renaissance" flourishes; members of the indigenous aristocracy and some religious orders express idealized recreations of an Inca past through the arts and culture.

1687–88 Accusing Spanish masters of istreatment, Andean painters declare their intention to form their own guild, setting a precedent for the Cuzco School of Painting.

1700 The reign of the Bourbon monarchy begins in Spain.

1713 Amédée François Frézier visits Peru and records details of colonial life, including attempts by the Spanish to repress indigenous festivities.

1717 Viceroyalty of New Granada is founded at Santa Fe de Bogotá (encompassing Colombia, Ecuador, Venezuela and Panama).

1741 Quito's first painters guild is founded.

1767 The Jesuits are expelled from Spain, Spanish America and the Philippines.

1776 The creation of the Viceroyalty of Río de la Plata (Argentina, Paraguay, Uruguay and Bolivia) diminishes the territory of the Viceroyalty of Peru; The Declaration of Independence announces the founding of the United States of America.

1778 The Free Trade agreement of the Bourbons permitting direct trade with Spain has a significant impact on the sculpture workshops of Quito and the painting workshops of Cuzco.

1780–81 The "Great Revolt by Túpac Amaru II" (José Gabriel Condorcanqui, 1738–1781, descendant of Túpac Amaru I) nearly drives the Spanish from the South Andes, before his eventual defeat. Prohibition of Inca plays and images, along with a general repression of indigenous culture by the Spanish, follows the failed revolt.

1789 The French Revolution begins.

1804 Napoleon is declared Emperor of France; Haiti becomes the first independent state in Latin America.

1805 The British defeat the Spanish fleet at the Battle of Trafalgar.

1808 The French invade Spain, and Napoleon's brother Joseph seizes the Spanish throne.

1809 The first South American independence movements take shape in Bolivia and Ecuador.

1810 Argentina, Chile, Colombia, Mexico and Venezuela declare independence.

1811 El Salvador, Paraguay and Uruguay declare independence.

1821 San Martín declares Peru's independence: complete emancipation is considered to be 1824, following the defeat of Spanish troops at the Battle of Ayacucho by Antonio José de Sucre. Spain, will not recognize Peruvian independence until 1879. Panama wins independence.

1825 Peruvian coat of arms is introduced, replacing that of the former Viceroyalty.

1840s–50s The first Peruvian daguerrotypes are produced in urban centers.

1848 The United States of America invades Mexico, conquering New Mexico, Arizona and Texas.

1854 Slavery is abolished in Peru.

1861–65 Slavery is abolished in the United States; Civil War breaks out between the Confederate States and the United States of America.

Early 1860s The first indigenous figures appear in Peruvian photography, with the rise of commercial photographic studios.

1867 The British North America Act establishes the Dominion of Canada through Confederation.

1877 The works held in Ignacio Merino's Paris studio are repatriated and exhibited in Peru. The Escuela Municipal de Dibujo y Escultura and the Galería Municipal are opened in Lima.

1879–84 Peru is at war with Chile.

The Peruvian resistance is led by Andrés Avelino Cáceres, with the participation of indigenous peoples.

1911 The existence of Machu Picchu, an Inca site located 80 kilometers northwest of Cuzco, is most notably brought to international attention by Hiram Bingham after his explorations of the site.

1917 The Russian Revolution begins.

1919–39 The nationalist regime of President Augusto B. Leguía promotes an official political Indigenismo movement.

1919 The Escuela Nacional de Bellas Artes [National Fine Arts School] is founded in Lima; José Sabogal (1888–1956) exhibits *Impresiones del Ccoscco*. Julio C. Tello arrives in Chavín de Huántar for the first time.

1926 José Carlos Mariátegui establishes the magazine *Amauta* to serve as a forum for discussions of Socialism, art and culture in Peru and Latin America; indigenist artists actively participate in this publication.

1940s–50s The Agrupación Espacio, a group of architects, artists and intellectuals strongly promote modernist art and architecture.

1943 Sabogal retires from the Escuela Nacional de Bellas Artes. Under

the new director, the painter Ricardo Grau (1907–1960), the school marks a departure from Indigenismo.

1948 The American fashion photographer Irving Penn (1917–2009) travels to Cuzco, where he produces a series of portraits of the local population.

1947 The Galería de Lima is founded, it later becomes the Instituto de Arte Contemporáneo and a site for major international exhibitions in Peru.

1950s Peruvian abstract art is closely linked to European Informalism and American Abstract Expressionism.

1953 The first Cuban Revolution begins.

1958 The first Salón de Arte Abstracto is held.

1968–75 The leftist military dictatorship of Juan Velasco Alvarado enacts a cultural program promoting populist revivals of Indigenist imagery.

1975 Following a coup d'état, Francisco Morales Bermúdez is appointed President of Peru. Under his leadership, Peru is a late participant in Operation Condor.

1975–77 The Premio Nacional de Arte [National Art Prize] is given to Joaquín López Antay; he is included in the XIV São Paulo Biennial along with a group of popular artists. Antay's award and inclusion in the Biennial is not

supported by some artists—particularly the members of the Asociación de Artistas Plásticos del Perú (ASPAP)— including Fernando de Szyszlo.

1980 Fernando Belaúnde is re-elected, marking a return to democracy after eleven years of military dictatorship.

1989 Fall of the Berlin Wall.

1990 Alberto Kenya Fujimori Fujimori defeats Mario Vargas Llosa in the Peruvian presidential election. Fujimori will remain in power until 2000, when accusations of corruption cause him to flee to Japan.

1992 Capture of Abimael Guzmán, the leader of the Shining Path, and end of the armed conflict that pitted this far-left movement against the Peruvian state.

2001 Through a democratic election, Alejandro Toledo Manrique becomes Peru's first "Amerindian" president. The presidential handover takes place in Machu Picchu, where Toledo goes to pay tribute to Peru's indigenous peoples and cultures, from which he is descended.

2011 Ollanta Humala, a leftist candidate, is elected president of Peru. This former member of the country's army has rather moderate economic views, and his government has placed emphasis on combatting social inequality.

Biographies

Roxana Chirinos Lazo
Erell Hubert
Victor Pimentel

PEDRO AZABACHE BUSTAMANTE
Moche, 1918–2012

Pedro Azabache studied at Lima's Escuela Nacional de Bellas Artes from 1937 to 1942. He was a student of Sabogal and Codesido and one of the few artists who directly continued the *indigenismo* tradition. He held his first solo exhibition in 1944, at the invitation of the poet José Gálvez Barrenechea. In 1962, he founded the Escuela de Bellas Artes in Trujillo and was its first director, painting and teaching art there until 1973. He has been awarded the Gold Medal of the City of Trujillo and the Simón Bolívar Gold Medal of the Universidad Nacional de Trujillo. Since 1999 he has been living in his home-cum-studio in the countryside of Moche, near Trujillo. His work, with its close connection with the landscapes of the Andes, provides a colorful record of Peruvian history, especially that of its coast.

HIRAM BINGHAM III
Honolulu, 1875 – Washington, 1956

Hiram Bingham, the son of Protestant missionaries, obtained his Ph.D. in history from Harvard in 1905, specializing in the economic and political history of South America. After teaching briefly at Prince-ton, he was appointed professor of South American history at Yale in 1907, thus becoming the first academic scholar to specialize in Latin America. While traveling in Peru in 1909 he visited the Inca site of Choquequirao. That visit was proba-

bly partly instrumental in the launch of the Yale Peruvian Expedition in 1911, during which Hiram Bingham and his team of archeologists found the site of Machu Picchu, following up their discovery with digs carried out between 1912 and 1915. During World War I, he served with the American Air Force. After the war, he turned to political activity. He was lieutenant governor of Connecticut from 1922 to 1924 and a Republican senator for the state from 1924 to 1933.

CAMILO BLAS
(JOSÉ ALFONSO SÁNCHEZ URTEAGA)
Cajamarca, 1903 – Lima, 1985

Camilo Blas was the nephew of the painter Mario Urteaga, who certainly influenced his choice of career. In 1920, he won first prize for painting in a competition marking the centennial of the independence of the city of Trujillo. He then went to Lima, where he completed his studies in law, and under the guidance of Daniel Hernández he learned the mysteries of art at the Escuela Nacional de Bellas Artes, where he became professor of visual arts in 1933. He became part of the group headed by José Sabogal, and joined the *indigenista* movement. On his return from a trip to Bolivia with Sabogal, he visited Cuzco, whose streetscape, style, and architecture made a great impression on him. It was also here that he embarked on the study of woodcut. As the head of the Instituto de Arte Peruano's department of drawing, he was, along with his colleagues, a student of popu-

lar art. He took part in a number of national and international exhibitions, winning significant awards such as the Gold and Silver Medal at the Ibero-American Exposition of 1929–1930 in Sevilla, the Gold and Silver Medal at the 1937 Paris Exposition, and the Premio Nacional de Fomento a la Cultura Ignacio Merino, in his native Peru, in 1946. His work is characterized by its intensity of color and smoothly modeled figures.

HANS HINRICH BRÜNING
Hoffeld, Germany, 1848 –
Kiel, Germany, 1928

The son of farmers, Hans H. Brüning studied at the Höhere Gewerbeschule/Polytechnische Schule (Polytechnic School) in Hanover. He then fought in the Franco-Prussian War of 1870 and worked in an armaments factory in Hamburg from 1871 to 1875. In 1875, he left for Peru, settling on the north coast, where he was to spend most of his life before he returned to Germany in 1925 for health reasons. During his years in Peru, Brüning took detailed notes on the archeological sites he visited, and on the traditions and festivals of villages on the north coast. He even compiled a dictionary of the Mochica language. Brüning also exploited the possibilities of the new technologies developed in the late nineteenth and early twentieth centuries, leaving behind many photographs and sound recordings. His collection of pre-Columbian art was acquired by the first regional museum of archeology in Peru, opened in 1921.

ENRIQUE CAMINO BRENT
Lima, 1909–1960

Enrique Camino Brent, a very versatile artist, was one of the driving forces of *indigenismo*. In 1922, aged barely twelve, he became a student at the Escuela Nacional de Bellas Artes (ENBA). One of the most prominent themes in his work is architecture, which he displayed an interest in from an early age, enrolling at Lima's school of engineering in 1930. In 1936, he presented his first exhibition at the famous Sociedad Filarmónica in Lima. From 1937, he was a distinguished professor at the ENBA, where he championed Peruvian identity through his depiction of national subjects. In 1943 he resigned from the ENBA in solidarity with José Sabogal, who had been forced to resign from his post, and in 1946 he joined the Instituto de Arte Peruano. His interest in popular art forms led him to study traditional crafts, and he encouraged the production of the ceramic bulls for which Pucará is famous. He exhibited in Lima and other South American cities, and in the USA, Mexico, Europe, and Morocco. He was successful not only as an artist but also as an architect and designer. He was director and a professor at the Escuela de Bellas Artes of Huamanga from 1957 until his death.

MARTÍN CHAMBI JIMÉNEZ
Coaza, 1891 – Cuzco, 1973

Martín Chambi, from a modest family, was forced to leave school early, and made his living selling alcohol in the mines near Puno. In the course of his travels he met British photographers, who awakened his interest in photography. In 1908, he went to Arequipa, where he learned the art of photography in the studio of Max T. Vargas, and later worked with the photographer brothers Carlos and Miguel Vargas. In 1917, he moved to Sicuani and then to Cuzco, where he settled with his family and set up his own studio. From then on he devoted himself to making portraits and postcards, and especially to photographing the city and its popular customs. In 1924, he went to Machu Picchu to photograph views of the citadel. In 1927, he exhibited his work at the Hotel Bolívar, Lima. He had a successful career as a photographic correspondent

for the magazine *Variedades* and the daily newspaper *La Crónica*. He won major prizes, such as the Gold Medal at the Exposición Internacional del Centenario, held in La Paz, Bolivia, in 1925. He retired in 1950, having made innumerable beautiful photographs of Peruvian life and history.

JULIA CODESIDO ESTENÓS
Lima, 1883–1979

As the daughter of a well-to-do family, Julia Codesido experienced the culture of different parts of the world from a very early age. In 1918, after living in Europe for eighteen years, she returned to Lima and entered the art school in the city's Quinta Heeren district, then headed by the painter Teófilo Castillo; in 1919, she applied to the Escuela Nacional de Bellas Artes (ENBA), where she studied under Daniel Hernández. At the ENBA she met José Sabogal, and under his guidance she developed not only as an artist, but also as an active participant in the *indigenista* movement. In 1929, she held her first one-woman show in the exhibition hall of Lima's Academia Nacional de Música Alcedo. In 1931 she was appointed professor at the ENBA, resigning in 1943 in support of Sabogal, who had been forced to leave the institution. In 1935 she traveled to Mexico, where she met José Clemente Orozco, Diego Rivera, David Alfaro Siqueiros, and the avant-garde artist Rufino Tamayo. She exhibited internationally at the Palacio de Bellas Artes de México, the Petit Palais in Paris, and the San Francisco Museum of Art. Without question, Codesido was an outstanding member of the *indigenista* movement. Her work contains clear examples of an art that is personal, free, and rhythmic, with occasional forays into cubism and abstraction. She was interested in vernacular art and not only studied and observed its forms but succeeded in incorporating them into her work.

PANCHO (FRANCISCO) FIERRO
Lima, 1807–1879

Pancho Fierro, the son of a black slave and a Peruvian priest born in Spain, is beyond question the most representative painter of Peruvian *costumbrismo*. He made prints, mural pain-

tings and advertisements, but he is known first and foremost for his watercolors, which depict characters and scenes from everyday life in Peru, especially in Lima. Although he had no formal training as a draftsman, Pancho Fierro was in close contact with other artists and intellectuals of his day, including Ignacio Merino and Leonce Angrand. His career as an artist began in 1820 and by 1830 he appears to have created a range of "types" embodying particular aspects of Peru's national culture, giving greater prominence to these characteristic figures than to narrative scenes. The same characters then appear over and over again in watercolors, many of them by Fierro himself, who made his living from the sale of his works.

JUAN MANUEL FIGUEROA AZNAR
Caraz, 1878 – Paucartambo, 1951

Figueroa practiced painting and photography in parallel. In 1901, he went to Areq-uipa and worked in Max T. Vargas's studio. He exhibited paintings and *foto-óleos* at Oldrati, the jeweler's, at Estudio Vargas, and in Mollendo. He went to Cuzco to restore the Convento de San Francisco, and he held a photographic exhibition at José Gabriel Gonzáles's studio. In 1919, he went to Lima and showed a series of controversial *foto-óleos* (photos enhanced by painting) at Luis S. Ugarte's studio. He moved to Cuzco, where he set up his own photography center in what had been Miguel Chani's gallery, concentrating on making portraits and selling postcards and photographic enlargements. In 1922, he joined the Sociedad de Bellas Artes in Cuzco. He was artistic director of the Misión del Arte Incaico, which staged the drama *Ollantay*, a widely acclaimed work performed with great success in Buenos Aires. He moved later to Paucartambo, where he worked as a painter and photographer.

MARIANO INÉS FLORES
San Juan, about 1845 –
San Mateo, 1949

Mariano Ines Flores, from the region of Huancavelica, was one of the earliest gourd engravers to be recognized. At the turn of the

twentieth century he was so widely known that he received a commission from the then President Leguía. His contacts with the *indigenista* group reveal themselves in a gourd dated 1930, with a dedication to the painter José Sabogal. In 1932, Sabogal himself announced Inés Flores's death in one of his bulletins, and it was not until 1946 that Arturo Jiménez Borja discovered that he was still alive. In keeping with the traditions of the Huancavelica region, Mariano Inés Flores used a form of paint based on lampblack to highlight his engraved motifs. His gourds, which are carved with great attention to detail, depict scenes from everyday life, often against an architectural background or decorated with plants and flowers, as well as illustrating significant historical events. He also helped to popularize art by reinterpreting the work of academic artists such as Montero and Merino.

ELENA IZCUE
Lima, 1889–1970

Elena Izcue worked extensively in the field of graphic and decorative art. She became a student at the Escuela Nacional de Bellas Artes in Lima when it opened in 1919, and went to Paris in 1927 to study book illustration, printing on textiles, print-making, ceramics, and stage design. She worked in various studios in Paris, including that of the couturier, Worth, and under Marcel Gromaire at the Atelier Montparnasse. In Peru, she played a leading role in developing art education and promoting the visual arts. Her interests included pre-Columbian art, a source for the motifs in her book *El arte peruano en la escuela*, published in 1925. In 1940, a year after returning to Peru, she was appointed director of the new Taller Nacional de Artes Gráficas Aplicadas, and in 1942 she was given the task of setting up the Talleres Artesanales, designed to revive the traditional crafts of northern Peru, in which she continued to work for many years.

RAFAEL LARCO HOYLE
Trujillo, 1901 – Lima, 1966

Rafael Larco Hoyle, the son of the collector Rafael Larco Herrera, developed an interest in pre-Columbian cultures from an early age. Based on artifacts that both he and his father had bought, on July 28, 1926, Larco Hoyle opened the Museo Rafael Larco Herrera on the Chiclín estate. At the time it comprised around 45,000 works from the north coast of Peru, and Larco Hoyle was able to add to the collection when he traveled in the Andes and the southern parts of the country. In 1949, he moved his collection to Lima, to the museum we know today, which is built on the architectural pattern of the country houses of the Trujillo region. As well as being a major collector, Larco Hoyle was an archeologist, leading expeditions to study the Cupisnique, Salinar, Virú and Mochica cultures, and in 1948 establishing a timeline for the cultures of the north coast of Peru.

FRANCISCO LASO
Tacna, 1823 – San Mateo, 1869

The Peruvian painter Francisco Laso studied at Lima's Academia Nacional de Dibujo y Pintura, first under Javier Cortez and then under Ignacio Merino. He later became assistant director of the school, and went to Europe for the first time in 1842. During that first visit, which lasted seven years, he worked in the studios of Paul Delaroche and Charles Gleyre in Paris, and in Italy he discovered the work of Renaissance painters, including Titian and Veronese, who had a strong influence on his work. He made two other visits to Europe, in 1853 and 1863. In Peru, he traveled through the Andes in search of Peruvian subjects. His work is characterized by an academic style that is very European in its execution, applied to local subject-matter. In the latter part of his life, Laso became involved in politics. He wrote for a number of newspapers and magazines and represented Lima in the Constitutional Assembly of 1867.

BERNARDO LEGARDA
Quito, late 17th century–1773

Bernardo Legarda, who was active from 1731 to 1773, is probably the most important Baroque sculptor in the Quito school. He ran a studio in San Francisco Square in Quito, where a group of (mostly indigenous) craftsmen produced a range of objects, most frequently for religious use. Various media were used in his studio—painting, sculpture of statues or altarpieces, glasswork, mirrors, silver- and goldwork—but Legarda is best known for his often-copied sculpture of the Virgin of the Apocalypse for the San Francisco church in 1734. He also worked for the great families, cataloguing and assessing their collections. He appraised the Jesuits' collection after the expulsion of the order in 1767. These activities brought him wide recognition in his lifetime and linked him with the religious and secular elites of Quito.

JOAQUÍN LÓPEZ ANTAY
Huamanga, 1897–1981

Joaquín López Antay, from the region of Ayacucho, was a sculptor of *retablos*, boxes, and crucifixes. He learned the art of sculpture from his grandmother, Manuela Momediano, and his meeting with the *indigenista* painter Alicia Bustamante, in the 1940s, marked a turning point in his work. From making *sanmarcos*, ritual boxes consisting of two sections, in which patron saints were represented in the upper one, with scenes of rituals such as cattle branding below them, he moved on to larger objects and a wider range of subjects. Alicia Bustamante suggested the term *retablo* and commissioned works depicting scenes that were more representative of popular culture. In 1975, he won the Premio Nacional de Cultura (or "de las Artes"), which made him the first "craftsman" to be recognized as an "artist" by Peru's urban arts elite; it provoked a debate between high art and popular art that continues to this day.

JOSÉ CARLOS MARIÁTEGUI
Moquegua, 1894 – Lima, 1930

Mariátegui started his career as a journalist and quickly became interested in socialism. In 1919, he set off for Europe, where he met eminent socialist thinkers such as Henri Barbusse and Antonio Gramsci. When he returned to Peru in 1923, he embarked on the first in-depth study of Peru from a Marxist angle. His major work is *7 Ensayos de Interpretación de la*

Realidad Peruana, published in 1928. That same year, he took part in the foundation of the Socialist Party. In addition to his political activities, Mariátegui wrote art critiques and called for greater social commitment from artists and intellectuals. He was particularly interested in the avant-garde art movements and promoted their work in his review *Amauta*, where he worked as editor. In 1925, he coined the term *indigenismo* for the role of the avant-garde in promoting the involvement of indigenous peoples in the life of the nation, which he believed necessary for building a new Peru.

HILARIO MENDÍVIL VELASCO
Cuzco, 1928–1977

The sculptor Hilario Mendívil belongs to Cuzco's long artistic tradition, one of the high points of which was the Cuzco School of the eighteenth century. Its influence can be felt in Mendívil's work in the rich decoration of his costumes and his preference for religious subjects. In collaboration with his wife, Georgina Dueñas (Cuzco, 1934–1998), he also applied the traditional technique of making sculpture by covering pieces of *maguey* (the agave plant) with plaster. But he also developed a style of his own, notable for the elongated necks of his subjects. From the 1950s onward, *indigenista* artists helped to spread public awareness of his talents beyond Cuzco; Alicia Bustamante in particular exhibited his work in Lima. Mendívil then received many awards, such as the Premio Nacional de la Artesanía Peruana. Following his death, his wife, and later his children, continued to make works of art in the "Mendívil" style.

ARCE NAVEDA
Active in the mid-to late 19th century

Thought to have come from Huancabamba (in the Piura region), Arce Naveda was active during the second half of the nineteenth century. Most of his paintings showed scenes of peasant life in the sierra of northern Peru and often featured Amerindians. His style is local, and it differs from academic painting in the big cities not only in the themes he chose, but in his preference for dark colors and the com-

bination of vanishing points characteristic of the northern pictorial tradition, also later found in the work of Mario Urteaga. His work gained greater recognition in the mid-twentieth century when the Indigenist artists' interest in the everyday life of indigenous peoples brought his paintings into the collection of the Instituto de Arte Peruano in Lima.

IRVING PENN
Plainfield, New Jersey, 1917 –
New York, 2009

Irving Penn was one of the twentieth century's most influential photographers. He studied design in Philadelphia with Alexey Brodovitch, and then worked as a graphic artist in New York. In 1943, he became Alexander Liberman's assistant at *Vogue*, and he contributed regularly to the magazine, represented mainly by his portraits and fashion photographs. He also photographed nudes and still lifes, and he did advertising work and ethnographic studies during his extensive travels. His photographs were exhibited for the first time at New York's Museum of Modern Art in 1948. In December of that year, he went to Cuzco, where he rented a studio and photographed local people. From the mid-1980s, he took up painting and drawing again, and began to experiment increasingly with the physical properties of photography.

MANUEL PIQUERAS COTOLÍ
Lucena, Spain, 1885 – Lima, 1937

The sculptor and architect Manuel Piqueras Cotolí received his first prize for sculpture at the age of fifteen. In Madrid, he was apprenticed to the sculptor Miguel Blay Fábregas and remained with him for eight years. In 1914, he went to Rome, where he met the director of the Museo Vaticano Etnologico, who introduced him to pre-Colombian art. In 1919, he was appointed professor of sculpture at Lima's new art school, the Escuela Nacional de Bellas Artes. In 1924, he completed its façade, which displays his characteristic combination of Hispanic and native elements, especially pre-Colombian motifs. A critic of the day described the façade as being in the "neo-Peruvian" style, a term applied to Piqueras Cotolí's work

ever since. When the Leguía government fell in 1930, he lost his professorial post, and in 1937 he died suddenly from a cerebral hemorrhage.

JOSÉ SABOGAL DIÉGUEZ
Cajabamba, 1888 – Lima, 1956

José Sabogal was the founder of Peru's so-called *indigenista* movement. His personal and artistic development was closely connected with his research and travels. Between 1908 and 1913, he visited various parts of Europe and North Africa. Later, he moved to Argentina, where he entered the Escuela de Bellas Artes in Buenos Aires. After graduating he was appointed professor of art in Jujuy Province. In 1918 he returned to Peru and spent six months in Cuzco, where he worked intensively, sharpening his vision of Peru and painting *costumbrista* canvases depicting town and country people as well as Andean landscapes. He participated in the city's intense intellectual life, meeting the writer Abraham Valdelomar and the scholar Luis E. Valcárcel. They formed a group of friends with similar interests and perspectives on Peru. In 1919 he came to Lima, where he presented his first solo exhibition under the title *Impresiones del Ccoscco*. That exhibition, whose Andean subject matter was highly praised by the critic and artist Teófilo Castillo, marked the beginning of a brilliant career that in 1920 led to his appointment as the first professor of painting at the Escuela Nacional de Bellas Artes (ENBA), and, from 1932 to 1943, its second director. In 1922 he traveled to Mexico, where he steeped himself in Mexican nationalism, mural art, and the concept of the visual arts as a means of understanding one's reality. He met artists such as Diego Rivera and José Clemente Orozco, who enriched his thinking about art. He played an active part in setting up the journal *Amauta*, founded by José Carlos Mariátegui, many of whose covers he designed and whose title he chose. In 1931 Luis E. Valcárcel set up the Instituto de Arte Peruano (IAP). Sabogal was appointed director of this institution for the study of Peru's various artistic disciplines, a post he occupied until his death. With his students at IAP, he was instrumental in preserving, disseminating, and re-evaluating the popular arts of Peru.

JULIO CESAR TELLO
Huarochiri, 1880 – Lima, 1947

Julio C. Tello was a leading Peruvian archeologist and is sometimes referred to as the father of Peruvian archeology. He was born into a Quechua family of modest means, and obtained his Ph.D. in medicine from the Universidad Nacional Mayor de San Marcos in 1908 and a Ph.D. in anthropology from Harvard in 1911. He was responsible for many crucial discoveries in the development of Peruvian archeology, including the site of Chavín de Huántar in 1919, the cemeteries of the Paracas culture in 1925, and the site of Cerro Sechín in 1937. His publications on pre-Columbian cultures, the relationship between archeology and national identity, and the preservation of the archeological heritage revolutionized Peruvian archeology. He played a central role in the recognition that pre-Columbian cultures developed independently in the Andes, an idea that was still contested in the nineteenth century. He was also the director of Peru's first national archeological museum.

MARIO URTEAGA ALVARADO
Cajamarca, 1875–1957

Urteaga was a self-taught artist, interested in drawing and painting from his high school days, but his family's lack of money meant that he had to leave school and start work while still a boy. He went to Lima, where in 1905 he exhibited a portrait of the army officer Roque Sáenz Peña, later president of Argentina. In 1911, he returned to Cajamarca, where he opened a photographic studio, published newspaper articles on art and national politics, and devoted himself to painting. He exhibited a number of works, including *Fiesta Campesina* (Country Fiesta), which reflects his interest in *costumbrista* subjects related to rural life. His first exhibition in Lima, in 1917, was favorably received, and he held further exhibitions in Lima and elsewhere. He won first prize at the Fifth Summer Salon in Viña del Mar, Chile. He continued to exhibit and his work won universal acclaim among Peruvian artists. Mario Urteaga is one of the great masters; he portrayed ordinary life with unusual beauty, and his depiction of street fights, burials, seed-time, and the institution of the "serenade" are unique in Peruvian art.

LUIS EDUARDO VALCÁRCEL
Moquegua, 1891 – Lima, 1987

A historian, anthropologist, journalist, lawyer, and writer, Valcárcel was one of Peru's most influential intellectuals in the twentieth century. He grew up in Cuzco, where he came to know the Andes and its people. In 1913, he founded the Instituto Histórico del Cusco, which aimed to protect Peruvian cultural heritage, particularly against illegal trade in archaeological artifacts. In 1920, along with intellectuals like Uriel García and Luis Felipe Aguilar, he was a member of the "Resurgimiento" group, which undertook the defense of the "Indians." The ideas of this group are manifested in the *Indigenismo* movement. Valcárcel held the post of Minister of Education (1945–1947) in José Luis Busta-mante y Rivero's government. He was a pioneer of ethnology in Peru, and he founded the Museo Nacional de la Cultura Peruana in 1946. Throughout his life, he studied Peruvian heritage and strived to enhance it, particularly through his work with universities and museums.

LEONOR VINATEA CANTUARIAS
Lima, 1897–1968

Leonor Vinatea was a member of the *indigenista* movement. She enrolled at the Escuela Nacional de Bellas Artes, where she studied painting and drawing under Daniel Hernández, completing her training in art with José Sabogal. Her painting reveals a new way of looking at the Peruvian environment, in which village life and customs, and the landscapes of the Andes and the coast, are reflected in her delicate palette. She held a number of national and international exhibitions, including the Second Summer Salon commemorating the Battle of Ayacucho (1925). She won the Silver Medal at the 1937 Paris Exposition and showed her work in Los Angeles and Viña del Mar, where it was well received. She took a great interest in education, and was founding professor of decorative arts at the Instituto Femenino de Estudios Superiores, part of the Pontificia Universidad Católica del Perú. She was art director of the publishing house Editorial Sanmarti, and she contributed illustrations, articles, and essays to the Lima magazine *Social*.

JORGE VINATEA REINOSO
Arequipa, 1900–1930

Jorge Vinatea Reinoso died very young from tuberculosis, leaving behind an important artistic legacy. From childhood he had been interested in drawing and painting. He was self-taught, and he developed an interest in caricature, publishing his work in celebrated magazines such as *Mundial* and *Variedades*, where the quality of his drawing and the humor of his caricatures stood out. His cultural interests brought him into contact with the artists and intellectuals of his day, enabling him to mount an exhibition at the photographic studio of brothers Carlos and Miguel Vargas in Arequipa. In 1919, he enrolled at the Escuela Nacional de Bellas Artes (ENBA), studying painting with Daniel Hernández and sculpture with Manuel Piqueras Cotolí. In 1925, recognizing his ability, Hernández appointed him assistant professor of painting at the ENBA. In 1926 he presented an exhibition in the school's galleries, consisting of oil paintings and watercolors of scenes in Arequipa, Cuzco, and Puno. His painting entitled *Mercado Arequipeño* (Market in Arequipa) was shown at the First Pan-American Exhibition of Oil Paintings, held at the Los Angeles Museum in 1925–6. He visited southern Peru, producing oil paintings of great technical refinement, depicting Andean subjects. He was not close to Sabogal's immediate circle of artists, and while it was rather independent from the *indigenista* movement, his work expresses a specifically Peruvian identity and reality.

List of Exhibited Works

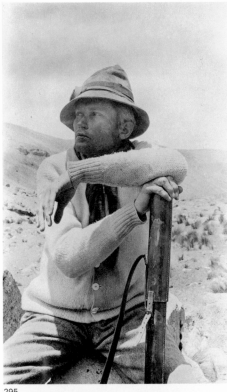

295

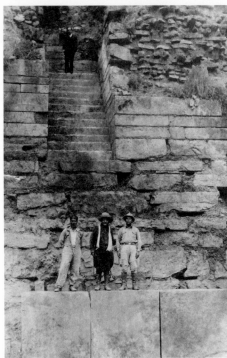

296

25.
Cupisnique, north coast
Stirrup-spout bottle depicting a feline head and a human head
1200–200 B.C.
Ceramic, traces of red pigment
25.5 x 14 x 12.2 cm
Museo Larco, Lima
ML010862

39.
Huari, south coast, possibly Rio Grande Valley
Feathered hanging
700–1200A.D.
Cotton, feathers
65.8 x 216 cm
The Montreal Museum of Fine Arts
1953. A.D..2

30.
Huari, possibly south coast
Four-cornered hat with geometric motifs
700–1200A.D.
Camelid wool
H. 8.5 cm
The Montreal Museum of Fine Arts
1938.Dt.12

33.
Huari, possibly south coast
Four-cornered hat with geometric motifs
700–1200A.D.
Camelid wool, cotton
H. 17.8 cm
Seattle Art Museum
50.38

34.
Huari, possibly south coast
Four-cornered hat with geometric motifs
700–1200A.D.
Camelid wool, cotton
11.43 x 12.7 cm
Seattle Art Museum
76.51

35.
Huari, possibly south coast
Face-neck jar depicting a figure wearing a striped poncho
700–1200A.D.
Painted ceramic
H. 19.69 cm
Seattle Art Museum
46.67

105.
Inca, north coast
Paccha (libation vessel) with five representations of *Spondylus*
1450–1532A.D.
Ceramic
23.7 x 23.5 x 24.6 cm
Colección Museo de Arte de Lima. Ex Colección Óscar Rodríguez Razzetto. Donación Petrus Fernandini
2007.16.70

109.
Inca, north coast, Túcume
Clothed female figurine
1450–1532A.D.
Spondylus shell, camelid wool, copper-silver alloy
8.6 x 4.6 x 8.6 cm
Museo de Sitio Túcume, Lambayeque
77.154

120.
Inca, southern highlands
Quipu (knotted-cord records)
1450–1532A.D.
Cotton
80 x 168 cm
Museo Larco, Lima
ML600004

116.
Inca, southern highlands
Urpu (arybalo) with geometric motifs
1450–1532A.D.
Painted ceramic
70 x 37 x 48 cm
Museo Larco, Lima
ML040408

115.
Inca, southern highlands
Urpu (arybalo) with geometric motifs
1450–1532A.D.
Painted ceramic
61 x 33 x 41 cm
Museo Larco, Lima
ML040409

307.
Inca, southern highlands
Urpu (arybalo) with geometric motifs
1450–1532A.D.
Painted ceramic
115 x 75 x 59 cm
Museo Larco, Lima
ML040411

308.
Inca, southern highlands, Cuzco
Conopa (votive object) in the shape of an alpaca
1450–1532A.D.
Stone
8.9 x 11.9 x 5.4 cm
Yale Peabody Museum of Natural History, New Haven
YPM 16910

118.
Inca, southern highlands, Cuzco
Jar with snake-shaped handles
1450–1532A.D.
Painted ceramic
15.3 x 14 cm
Yale Peabody Museum of Natural History, New Haven
YPM 16887

117.
Inca, southern highlands, Cuzco
Paccha (libation vessel) in the shape of stacked bowls
1450–1532A.D.
Painted ceramic
16.5 x 10 cm
Yale Peabody Museum of Natural History, New Haven
YPM 16922

112.
Inca, southern highlands, possibly Cuzco
Pair of *keros* (ceremonial cups) decorated with geometric motifs and camelids
1450–1532A.D.
Wood, silver
18.9 x 14.5 cm
Museo de Arte del Sur Andino, Urubamba, Cuzco

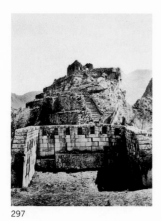
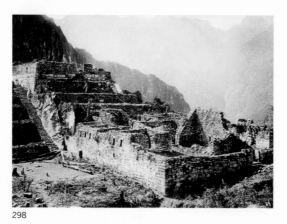
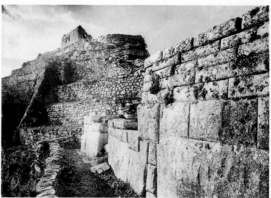

297

298

299

119.
Inca, southern highlands, Machu Picchu
Plates with a bird-shaped handle
1450–1532A.D.
Painted ceramic
5 x 14 cm; d. 10 cm
Museo de Arte del Sur Andino, Urubamba, Cuzco

187.
Inca, southern highlands, Machu Picchu
Tupus **(pins for clothing) with circular heads**
1450–1532A.D.
Silver
L. 6.5 cm; d. 29 cm
Museo de Arte del Sur Andino, Urubamba, Cuzco

111.
Inca, southern highlands, Ollantaytambo
Kero **(ceremonial cup) decorated with geometric motifs**
1450–1532A.D.
Painted ceramic
15.2 x 14 cm
Yale Peabody Museum of Natural History, New Haven
YPM 16926

110.
Inca, southern highlands, Sacsayhuaman
Tiana **(seat)**
1450–1532A.D.
Cedar wood
27 x 42.5 x 34 cm
Musée du quai Branly, Paris
71.1878.2.459

56.
Inca, possibly southern highlands
Double bowl depicting a bird, a camelid and a feline
1450–1532 A.D.
Painted ceramic
9.4 x 13.7 x 17.8 cm
The Metropolitan Museum of Art, The Michael C.
Rockefeller Memorial Collection, Gift of Nelson A.
Rockefeller, 1979
1979.206.1149

125.
Inca, possibly southern highlands
Female figurine
1450–1532 A.D.
Gold
14.9 x 3.5 cm
The Metropolitan Museum of Art, Gift of Louise
Reinhardt Smith, 1995
1995.481.5

127.
Inca, possibly southern highlands
Female figurine
1450–1532 A.D.
Silver
5.5 x 1.5 cm
Museos "Oro del Perú" – "Armas del Mundo",
Fundación Miguel Mujica Gallo, Lima
M-01180

128.
Inca, possibly southern highlands
Llama figurine
1450–1532 A.D.
Silver
H. 5.2 cm
The Metropolitan Museum of Art, Gift
and Bequest of Alica K. Bache, 1974, 1977
1974.271.36

129.
Inca, possibly southern highlands
Llama figurine
1450–1532 A.D.
Gold
5.7 x 1.1 x 6.2 cm
Museos "Oro del Perú" – "Armas del Mundo",
Fundación Miguel Mujica Gallo, Lima-Perú
M-01142

126.
Inca, possibly southern highlands
Male figurine
1450–1532 A.D.
Silver
6 x 2 cm
Museos "Oro del Perú" – "Armas del Mundo",
Fundación Miguel Mujica Gallo, Lima
M-01179

124.
Inca, possibly southern highlands
Male figurine
1450–1532 A.D.
Gold
12 x 4 x 3 cm
Museos "Oro del Perú" – "Armas del Mundo",
Fundación Miguel Mujica Gallo, Lima
M-5012

107.
Inca, possibly southern highlands
Tumi **(ceremonial knife) decorated with a camelid head**
1450–1532 A.D.
Bronze
16 x 14.6 cm
The Montreal Museum of Fine Arts
1962. A.D.1

108.
Inca, possibly southern highlands
Tumi **(ceremonial knife) decorated with a figure sacrificing a camelid**
1450–1532 A.D.
Bronze
17 x 16.5 cm
The Montreal Museum of Fine Arts
1948. A.D.27

113.
Colonial Inca, southern highlands, Cuzco
Kero **(ceremonial cup) depicting the victory of the Inca over the Chanca**
18th century
Painted wood
20 x 11.1 cm
Yale Peabody Museum of Natural History, New Haven
YPM 30207

121.
Colonial Inca, southern highlands, Lake Titicaca
Unku **(tunic) with stylized floral and butterfly motifs**
Late 16th–early 17th century
Camelid wool, cotton
100.5 x 86 cm
American Museum of Natural History, New York
B/1502
Courtesy of the Division of Anthropology, American
Museum of Natural History

114.
Colonial Inca, possibly southern highlands
Kero **(ceremonial cup) in the shape of a feline head**
18th century
Painted wood
25 x 22 cm
Yale Peabody Museum of Natural History, New Haven
YPM 30205

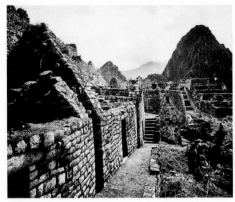

300

92.
Lambayeque, north coast
Back of litter
750–1375 A.D.
Wood, gold, silver, cinnabar, sulphurous copper,
ammonia, shells, turquoise, feathers
58 x 114 x 5 cm
Museos "Oro del Perú" – "Armas del Mundo",
Fundación Miguel Mujica Gallo, Lima
M-02550

84.
Lambayeque, north coast
Bottle depicting a masked figure carried on a litter
750–1375 A.D.
Ceramic
21.7 x 13.5 x 17 cm
American Museum of Natural History, New York
41.2/8569
Courtesy of the Division of Anthropology, American
Museum of Natural History

132.
Lambayeque, north coast
Crescent-shaped nose ornament
750–1375 A.D.
Gold
5.3 x 17 cm
Museo Arqueológico Nacional Brüning de
Lambayeque
MB-00298

91.
Lambayeque, north coast
**Double-spout vessel decorated with human figures
and snake heads**
750–1375 A.D.
Gold
27 x 23 x 16 cm
Museos "Oro del Perú" – "Armas del Mundo",
Fundación Miguel Mujica Gallo, Lima
M-01464

146.
Lambayeque, north coast
Drinking cup decorated with standing figures
750–1375 A.D.
Gold, turquoise
H. 20 cm; d. 17 cm
Museos "Oro del Perú" – "Armas del Mundo",
Fundación Miguel Mujica Gallo, Lima
M-1463

142.
Lambayeque, north coast
Drinking cup depicting standing figures
750–1375 A.D.
Gold and tin alloy
24.1 x 11.4 cm
Seattle Art Museum
99.83

144.
Lambayeque, north coast
**Drinking cup with rattle base and circular
incrustations**
750–1375 A.D.
Gold, turquoise
13 x 10 cm
Museos "Oro del Perú" – "Armas del Mundo",
Fundación Miguel Mujica Gallo, Lima
M-00098

143.
Lambayeque, north coast
**Drinking cup with rattle base decorated
with standing figures**
750–1375 A.D.
Gold, silver
13.3 x 9.9 cm
Museo Nacional Sicán, Ferreñafe
MNS-166

89.
Lambayeque, north coast
Funerary mask
750–1375 A.D.
Gold
21 x 34.8 cm
Museo Nacional Sicán, Ferreñafe
MNS-217

85.
Lambayeque, north coast
Funerary mask
750–1375 A.D.
Gold, silver, amber, emerald
7 x 31 x 59 cm
Museos "Oro del Perú" – "Armas del Mundo",
Fundación Miguel Mujica Gallo, Lima
M-00262

145.
Lambayeque, north coast
**Gloves decorated with standing figures and
geometric motifs**
750–1375 A.D.
Gold, turquoise
15 x 55 cm; 12.8 x 53.5 cm
Museos "Oro del Perú" – "Armas del Mundo",
Fundación Miguel Mujica Gallo, Lima
M-01571-72

41.
Lambayeque, north coast
**"Huaco Rey" bottle (with Naymlap [winged
figure]'s face depicted on the spout)**
750–1375 A.D.
Ceramic
18.3 x 11.9 x 14.7 cm
Museo Nacional Sicán, Ferreñafe
MNS-512

37.
Lambayeque, north coast
Mantle fragment with anthropomorphic figures
750–1375 A.D.
Camelid wool, cotton
148 x 62 cm
The Montreal Museum of Fine Arts
1948. A.D.35

100.
Lambayeque, north coast
**Miniature ornament depicting a musician
with a drum and a whistle**
750–1375 A.D.
Gold
3.1 x 2 cm
Museo Arqueológico Nacional Brüning
de Lambayeque
MB-00152

101.
Lambayeque, north coast
**Miniature ornament depicting a musician
with a rattle and a trumpet**
750–1375 A.D.
Gold
3.4 x 1.5 cm
Museo Arqueológico Nacional Brüning
de Lambayeque
MB-00151

130.
Lambayeque, north coast
Nose ornament
750–1375 A.D.
Gold
2.9 x 7.9 cm
Museo Arqueológico Nacional Brüning
de Lambayeque
MB-00314

103.
Lambayeque, north coast
**Ornamental plaque depicting divers collecting
Spondylus shells**
750–1375 A.D.
Gold
13.5 x 11.8 x 1.4 cm
Museo Arqueológico Nacional Brüning
de Lambayeque
MB-00193

137.
Lambayeque, north coast
Pectoral with anthropomorphic components
750–1375 A.D.
Silver
41.4 x 73 cm
Museo Arqueológico Nacional Brüning
de Lambayeque
MB-00329

138.
Lambayeque, north coast
Pectoral with frog-shaped components
750–1375 A.D.
Gold
33.7 x 49.5 x 23 cm
Museo Arqueológico Nacional Brüning
de Lambayeque
MB-00008

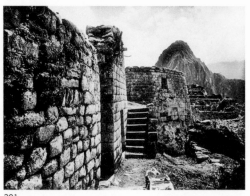

301

302

303

304

97.
Lambayeque, north coast
Rattle
750–1375 A.D.
Gold
16.1 x 8.7 cm
Museo Nacional Sicán, Ferreñafe
MNS-73

131.
Lambayeque, north coast
Semi-circular nose ornament
750–1375 A.D.
Gold
6 x 11.5 cm
Museo Arqueológico Nacional Brüning
de Lambayeque
MB-00299

141.
Lambayeque, north coast
Set of ornaments in the shape of miniature cups
750–1375 A.D.
Gold
5.1 x 4.2 cm
Museo Arqueológico Nacional Brüning
de Lambayeque
MB-00022, MB-00023, MB-00024, MB-00025,
MB-00026

88.
Lambayeque, north coast
Tumi **(ceremonial knife)**
750–1375 A.D.
Gold, silver, turquoise
36.2 cm
The Metropolitan Museum of Art, Gift and Bequest
of Alica K. Bache, 1974, 1977
1974.271.60

86.
Lambayeque, north coast
Tumi **(ceremonial knife) depicting a figure
with** *Spondylus* **shells on its head**
750–1375 A.D.
Gold
4.5 x 12.6 x 35 cm
Museos "Oro del Perú" – "Armas del Mundo",
Fundación Miguel Mujica Gallo, Lima
M-00795

96.
Lambayeque, north coast, Chotuna
**Double-body bottle depicting a figure carried
on a litter**
750–1375 A.D.
Painted ceramic
17.6 x 18.3 x 17.1 cm
Museo de Sitio Chotuna, Lambayeque
MB-0625

87.
Lambayeque, north coast, Pur Pur
**Double-body bottle topped by a winged figure
(Naymlap)**
750–1375 A.D.
Painted ceramic
17.8 x 7.5 x 15.1 cm
Museo Larco, Lima
ML020207

106.
Lambayeque, north coast, Túcume
Miniature offerings
750–1375 A.D.
Silver, copper
9.3 x 5.7 (max.); 1 x 1.8 cm (min.)
Museo de Sitio Túcume, Lambayeque
77.129-77.153

50.
Mochica, north coast
Bottle in the shape of male genitalia
100–800 A.D.
Painted ceramic
11.9 x 11.8 x 16.6 cm
Museo Larco, Lima
ML004204

64.
Mochica, north coast
**Cup with rattle base decorated with geometric
motifs**
100–800 A.D.
Painted ceramic
14 x 13.7 x 13.7 cm
Museo Larco, Lima
ML005435

66.
Mochica, north coast
**Figurine depicting the goddess of the sacrifice
ceremony**
100–800 A.D.
Ceramic
H. 14.6 cm
The Metropolitan Museum of Art,
Gift of Mr. and Mrs. Nathan Cummings, 1964
64.228.58

82.
Mochica, north coast
Portrait vessel depicting a Mochica lord
100–800 A.D.
Painted ceramic
32.6 x 16.8 x 19.9 cm
Museo Larco, Lima
ML000231

81.
Mochica, north coast
Portrait vessel depicting a Recuay man
100–800 A.D.
Painted ceramic
16 x 14.5 x 13.9 cm
Museo Larco, Lima
ML000427

98.
Mochica, north coast
Pututo **(conch)**
100–800 A.D.
Shell (*Strombus*), gilded copper
22.5 x 13.2 x 17.6 cm
Museo Larco, Lima
ML200001

47.
Mochica, north coast
**Stirrup-spout bottle depicting a deity
with miniature human figures stuck to its body**
100–800 A.D.
Painted ceramic
20.9 x 13.4 x 17.4 cm
Museo Larco, Lima
ML002308

67.
Mochica, north coast
**Stirrup-spout bottle depicting a seated deity
with its hands joined**
100–800 A.D.
Painted ceramic
25.2 x 13.4 x 21.6 cm
Museo Larco, Lima
ML003119

61.
Mochica, north coast
Stirrup-spout bottle depicting a seated prisoner
100–800 A.D.
Painted ceramic
22.2 x 13.3 x 18.7 cm
Museo Larco, Lima
ML002041

49.
Mochica, north coast
**Stirrup-spout bottle depicting a woman
masturbating a skeletal male figure**
100–800 A.D.
Painted ceramic
22.5 x 12.1 x 20.2 cm
Museo Larco, Lima
ML004341

53.
Mochica, north coast
**Stirrup-spout bottle in the shape of a deified
maize cob**
100–800 A.D.
Painted ceramic
22.6 x 13.5 x 18 cm
Museo Larco, Lima
ML003291

59.
Mochica, north coast
**Stirrup-spout bottle in the shape of a kneeling
warrior**
100–800 A.D.
Painted ceramic
24.6 x 16.7 x 13.6 cm
Museo Larco, Lima
ML001573

54.
Mochica, north coast
**Stirrup-spout bottle in the shape
of an anthropomorphized potato**
100–800 A.D.
Painted ceramic
21.3 x 14.6 x 14 cm
Museo Larco, Lima
ML007293

51.
Mochica, north coast
Stirrup-spout bottle in the shape of female genitalia
100–800 A.D.
Ceramic
22.2 x 16.3 x 17.4 cm
Museo Larco, Lima
ML004202

102.
Mochica, north coast
Trumpet with warrior-shaped appliqué
100–800 A.D.
Ceramic
10.8 x 35 x 14 cm
Museo Larco, Lima
ML016181

65.
Mochica, north coast
***Tumi* (ceremonial knife)**
100–800 A.D.
Copper
26.2 x 174.7 x 0.3 cm
Museo Larco, Lima
ML100772

62.
Mochica, north coast, Chimbote
**Bottle in the shape of a pyramidal architectural
structure**
100–800 A.D.
Painted ceramic
27.5 x 18 x 18 cm
Museo Larco, Lima
ML002893

58.
Mochica, north coast, Facalá
**Stirrup-spout bottle depicting the "Sacrifice
Ceremony"**
100–800 A.D.
Painted ceramic
28.7 x 15.4 x 15.4 cm
Museo Larco, Lima
ML010847

44.
Mochica, north coast, Huacas de Moche
Bottle depicting the deity called "Wrinkle Face"
100–800 A.D.
Painted ceramic
25.2 x 15.7 x 18 cm
Proyecto Arqueológico Huacas del Sol y de la Luna,
Trujillo
PU-112

45.
Mochica, north coast, Huancaco
Stirrup-spout bottle depicting a dance of the dead
100–800 A.D.
Painted ceramic
19.8 x 14.5 x 18.5 cm
Museo Larco, Lima
ML002872

140.
Mochica, north coast, possibly La Mina
**Forehead ornament with feline head and octopus
tentacles ending in catfish heads**
100–800 A.D.
Gold, chrysocolla, shells
28.5 x 41.4 x 4.5 cm
Museo de la Nación, Lima
MN-14602

83.
Mochica, north coast, Pur Pur
**Bottle depicting a human figure below
a bicephalous snake**
100–800 A.D.
Painted ceramic
38 x 30.7 x 12 cm
Museo Larco, Lima
ML006859

52.
Mochica, north coast, Pur Pur
**Bottle depicting a mountain deity holding maize
and yucca**
100–800 A.D.
Painted ceramic
26.5 x 16.9 x 21 cm
Museo Larco, Lima
ML002269

60.
Mochica, north coast, Pur Pur
**Stirrup-spout bottle depicting a combat
and prisoner-taking scene**
100–800 A.D.
Painted ceramic
27.9 x 18.6 x 18.6 cm
Museo Larco, Lima
ML010851

28.
Mochica, north coast, Pur Pur
**Stirrup-spout bottle depicting a human figure
taking coca**
100–800 A.D.
Painted ceramic
18.8 x 13 x 18 cm
Museo Larco, Lima
ML001064

57.
Mochica, north coast, Pur Pur
**Stirrup-spout bottle depicting a sea eagle
catching a fish**
100–800 A.D.
Painted ceramic
24.1 x 13.1 x 18.1 cm
Museo Larco, Lima
ML013649

46.
Mochica, north coast, Pur Pur
**Stirrup-spout bottle depicting a seated musician
and a dance scene**
100–800 A.D.
Painted ceramic
21.2 x 16.5 x 13.9 cm
Museo Larco, Lima
ML012778

80.
Mochica, north coast, Pur Pur
**Stirrup-spout bottle in the shape of a feline holding
a knife and a severed head**
100–800 A.D.
Ceramic
25 x 14.9 x 17.8 cm
Museo Larco, Lima
ML010854

305

99.
Mochica, north coast, Pur Pur
Whistle depicting a figure playing the pan pipe
100–800 A.D.
Copper, turquoise (or malachite, or chrysocolla)
5.3 x 2.9 x 6.8 cm
Museo Larco, Lima
ML100812

90.
Mochica, north coast, San José de Moro
Stirrup-spout bottle depicting the "Burial Scene"
100–800 A.D.
Painted ceramic
21.6 x 12.7 cm
Programa Arqueológico de San José de Moro, Lima
MA16-C18-R15-C33

74.
Mochica, north coast, Sipán
**Bead (among ten) from a necklace depicting
a spider on its web and whose body is a human face**
100–800 A.D.
Gold
8.3 x 5.2 cm
Museo Tumbas Reales de Sipán, Lambayeque
MNTRS-244-INC-02

73.
Mochica, north coast, Sipán
**Bead (among ten) from a necklace depicting
a spider on its web and whose body is a human face**
100–800 A.D.
Gold
8.3 x 5.6 cm
Museo Tumbas Reales de Sipán, Lambayeque
MNTRS-245-INC-02

69.
Mochica, north coast, Sipán
**Coxal protector decorated with a figure holding a
knife and a severed head**
100–800 A.D.
Gold
53.4 x 49.2 cm
Museo Tumbas Reales de Sipán, Lambayeque
MNTRS-55-INC-02

71.
Mochica, north coast, Sipán
Crescent-shaped headdress ornament
100–800 A.D.
Gold
22 x 27 cm
Museo Tumbas Reales de Sipán, Lambayeque
MNTRS-220-INC-02

68.
Mochica, north coast, Sipán
Earspool depicting a warrior
100–800 A.D.
Gold, turquoise, wood
D. 9.2 cm
Museo Tumbas Reales de Sipán, Lambayeque
MNTRS-77-INC-02

72.
Mochica, north coast, Sipán
**Figurine depicting a supernatural
half-human, half-bird being**
100–800 A.D.
Copper
11.5 x 7.2 x 6.5 cm
Museo de Sitio de Huaca Rajada Sipán
S/T14-Cu-77

309.
Mochica, north coast, Sipán
Headdress ornament in the shape of a human head
100–800 A.D.
Gilded copper
11 x 13.7 cm
Museo Tumbas Reales de Sipán, Lambayeque
MNTRS-256-INC-02

76.
Mochica, north coast, Sipán
Necklace element in the shape of a feline head
100–800 A.D.
Gilded copper
16 x 9.8 cm
Museo de Sitio de Huaca Rajada Sipán
S/T14-Cu-42G

75.
Mochica, north coast, Sipán
Necklace component in the shape of a feline head
100–800 A.D.
Gilded copper
9.8 x 16 cm
Museo Tumbas Reales de Sipán, Lambayeque
MNTRS-17-INC-02

79.
Mochica, north coast, Sipán
Ornament in the shape of a human head
100–800 A.D.
Gold, silver, lapis lazuli
15.5 x 15.2 cm
Museo Tumbas Reales de Sipán, Lambayeque
MNTRS-37-INC-02

70.
Mochica, north coast, Sipán
Pectoral made of white and red *Spondylus* beads
100–800 A.D.
Shells (*Spondylus* and *Conus*)
20.6 x 58.5 cm
Museo Tumbas Reales de Sipán, Lambayeque
MNTRS-175-INC-02

78.
Mochica, north coast, Sipán
**Rattle depicting a figure holding a knife
and a severed head**
100–800 A.D.
Silver
8.3 x 16 x 2.3 cm
Museo Tumbas Reales de Sipán, Lambayeque
MNTRS-379-INC-02

77.
Mochica, north coast, Sipán
**Rattle depicting a figure holding a knife
and a severed head**
100–800 A.D.
Gold
9.9 x 18.4 cm
Museo Tumbas Reales de Sipán, Lambayeque
MNTRS-444-INC-02

63.
Mochica, north coast, Sipán
Warrior statuette
100–800 A.D.
Gilded copper
28.3 x 14.5 cm
Museo Tumbas Reales de Sipán, Lambayeque
MNTRS-265-INC-02

306.
Mochica, north coast, Tanguche
Flaring bowl decorated with feline-headed snakes
100–800 A.D.
Painted ceramic
14.5 x 31.7 cm
Museo Larco, Lima
ML040249

55.
Mochica, north coast, Virú Valley
Stirrup-spout bottle in the shape of a seated feline
100–800 A.D.
Ceramic, bones, shells
20.3 x 9.4 x 15.1 cm
Museo Larco, Lima
ML017900

27.
Nazca, south coast
Double-spout vessel depicting the mythical anthropomorphic being
1–700 A.D.
Painted ceramic
15.5 x 17 cm
The Montreal Museum of Fine Arts
1981(?).Ad.1

36.
Nazca, south coast
Poncho with stylized anthropomorphic motifs
100–700 A.D.
Camelid wool
87 x 197 cm
The Montreal Museum of Fine Arts
1948.Ad.45

38.
Nazca-Huari, south coast
Poncho with felines
500–900 A.D.
Camelid wool
92 x 77 x 92 cm
The Montreal Museum of Fine Arts
1948.Ad.44

29.
Paracas, south coast
Mantle with anthropomorphic figures
700–1 B.C.
Camelid wool
254 x 147 cm
The Montreal Museum of Fine Arts
1947.Ad.19

42.
Recuay, northern highlands
Bottle in the shape of a man with a llama
200–600 A.D.
Painted ceramic
17.1 x 10.2 x 14 cm
The Metropolitan Museum of Art,
The Michael C. Rockefeller Memorial Collection,
Gift of Nelson A. Rockefeller, 1979
1978.412.146

10.
Recuay, northern highlands
Paccha (libation vessel) depicting a scene
of ritual intercourse
200–600 A.D.
Painted ceramic
21.1 x 25 x 19.8 cm
Museo Larco, Lima
ML004393

48.
Salinar, north coast, Salinar
Stirrup-spout bottle depicting a woman masturbating a man
200 B.C.–100 A.D.
Painted ceramic
21.4 x 17.8 x 9.8 cm
Museo Larco, Lima
ML004443

31.
Tiahuanaco, possibly south coast
Four-cornered hat with geometric motifs
700–1200 A.D.
Camelid wool
H. 11 cm
The Montreal Museum of Fine Arts
1938.Dt.11

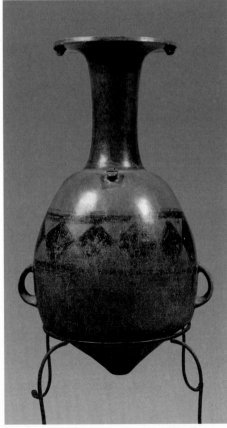

306

307

21.
Anonymous
Joven Rafael Larco Hoyle en el campo
[Young Rafael Larco Hoyle in the field]
n.d.
Gelatin silver print
Private collection, Lima

165.
Anonymous
La Última Cena [The Last Supper]
n.d.
Oil on canvas
153.5 x 123.5 cm
Museo Nacional de Arqueología, Antropología,
e Historia del Perú, Lima
92/138

11.
Anonymous
Rafael Larco Hoyle con un vaso de su colección
[Rafael Larco Hoyle with a vessel from his collection]
n.d.
Gelatin silver print
Private collection, Lima

19.
Anonymous
Rafael Larco Hoyle en el campo
[Rafael Larco Hoyle in the field]
n.d.
Gelatin silver print
Private collection, Lima

20.
Anonymous
Museo de Chiclín [Chiclín Museum]
n.d.
Gelatin silver print
Private collection, Lima

179.
Anonymous
Processional shield: *Virgin and Child* (obverse)
The Nativity (reverse)
17th century
Oil on copper, gilded iron and tin
87 x 70 cm
Hispanic Society of America, New York
LA2331

173.
Anonymous
Tapestry panel depicting coats of arms
17th century
Silk, cotton
44.5 x 41 cm
The Montreal Museum of Fine Arts
1961.Dt.10

164.
Anonymous
Saint Agnes
1650–1720
Oil on copper
15.8 x 12.1 cm
Hispanic Society of America, New York
A1954

353

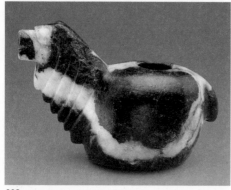

308

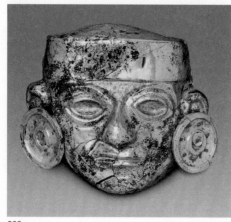

309

154.
Anonymous
Cristo de los Temblores [Lord of the Earthquakes]
18th century
Painting on copper, silver frame
D. 23 cm
Museo de Arte del Sur Andino, Urubamba, Cuzco

183.
Anonymous
Tupu (pin for clothing) with a semi circular head decorated with a feline
18th century
Silver
H. 32.5 cm
Vivian and Jaime Liébana Collection, Lima

147.
Anonymous
El Niño Jesús con la corona imperial inca y el ajuar de sacerdote católico [The Child Jesus Wearing the Imperial Inca Crown and the Robes of a Catholic Priest]
First half of the 18th century
Oil on canvas
86 x 75 cm
Mónica Taurel de Menacho Collection, Lima

157.
Anonymous
Monstrance
1770–1780
Silver
61 x 25 x 25 cm
Barbosa-Stern Collection
CBS-0349/AG

197.
Anonymous
Alegoría de América [Allegory of America]
19th century
Stone of Huamanga
45.5 x 18.7 x 12.8 cm
Museo Nacional de la Cultura Peruana, Lima
52/61 (a,b)

189.
Anonymous
Ceremonial axe
19th century
Wood, Silver
63 cm
Vivian and Jaime Liébana Collection, Lima

186.
Anonymous
Tupu (pin for clothing) depicting musicians and local animals
19th century
Silver
23.5 x 4.5 cm (pendants: 21 cm)
José Carlos Delgado Collection, Lima

188.
Anonymous
Tupu (pin for clothing) depicting the two-headed eagle
19th century
Silver
23 x 9 cm
José Carlos Delgado Collection, Lima

185.
Anonymous
Tupu (pin for clothing) depicting the Inca and a princess
Beginning of the 19th century
Silver
21.3 x 6.7 cm
José Carlos Delgado Collection, Lima

324.
Anonymous
Kero de la Independencia
[*Kero* (ceremonial cup) of the Independence]
About 1821
Painted wood
8.5 x 6.3 cm
Museo Nacional de la Cultura Peruana, Lima
84/13

312.
Anonymous
Coin (Peso de San Martín)
1822
Silver
Museo Numismático del Perú, Lima
01 515

313.
Anonymous
Coin (Libertad Parada)
1825
Silver
Museo Numismático del Perú, Lima
02 155

295.
Anonymous
Hiram Bingham at Coropuna
1911
Gelatin silver print
Hispanic Society of America, New York
12074

196.
Anonymous
Indians Posing in a Studio of the National Fine Arts School of Peru
1934
Gelatin silver print
15 x 11.3 cm
Escuela Nacional Superior Autónoma de Bellas Artes del Perú, Lima

22.
Anonymous
Julio C. Tello during the Unearthing of the Stone Sculptures at Cerro Sechín
1937
Gelatin silver print
Museo Nacional de Arqueología, Antropología, e Historia del Perú, Lima

296.
Anonymous
Julio C. Tello Standing in Front of the "New Temple" of Chavín de Huántar
1940
Gelatin silver print
Museo Nacional de Arqueología, Antropología, e Historia del Perú, Lima

23.
Anonymous
West Side of the Main Temple at Chavín de Huántar
1940
Gelatin silver print
Museo Nacional de Arqueología, Antropología, e Historia del Perú, Lima

24.
Anonymous
Julio C. Tello with Genaro Farfán, Julio Espejo, Manuel Chávez Ballón, Luis Ccosi Salas, and Pedro Rojas Ponce in Wiñay Wayna (Cuzco)
1942
Gelatin silver print
Museo Nacional de Arqueología, Antropología, e Historia del Perú, Lima

184.
Anonymous, Altiplano
Tupu (pin for clothing) depicting a cherub
18th century
Silver
30 x 7.4 cm
José Carlos Delgado Collection, Lima

175.
Anonymous, possibly Altiplano
Incense burner in the shape of an armadillo
Second half of the 18th century
Silver, gold
H. 8.5 cm; d. 15 cm
Vivian and Jaime Liébana Collection, Lima

177.
Anonymous, Alto Peru
Tray with poppies and chinchillas
About 1730
Gilded silver
25 x 36.7 x 2.3 cm
Hispanic Society of America, New York
LR2201

182.
Anonymous, Alto Peru
Tupu (pin for clothing) depicting the sun
and the moon
19th century
Silver, gold, amber, emerald
38 x 14 cm
Museo Pedro de Osma, Lima
82.0.1793

178.
Anonymous, possibly Arequipa
Crown of a statue
1790–1810
Gilded silver
33 x 25 cm
Barbosa-Stern Collection
CBS-0364/AG

193.
Anonymous, central highlands, Ayacucho
Jewelry box
19th century
Silver filigree
10 x 23 x 16 cm
Museo de Arte de Lima. Donación Doris Skinner
de Valle
V-2.7-0005

192.
Anonymous, central highlands, Huamanga
Set of miniature furniture
18th century
Silver filigree
9 x 7 cm (max.); 5.5 x 2 cm (min.)
Barbosa-Stern Collection
CBS-0327/AGF à CBS-0327.14/AGF

180.
Anonymous, central highlands, Huamanga
Aureole
19th century
Gilded silver filigree, gemstones
D. 26 cm
Barbosa-Stern Collection
CBS-0361/AGF

198.
Anonymous, central highlands, Huamanga
Unión eclesiástica de Cusco y Huamanga
[Ecclesiastic Union of Cuzco and Huamanga]
1825–1835 (retouched in 1943)
Painted stone of Huamanga
29 x 23 x 8.5 cm
Barbosa-Stern Collection
CBS-0300/EPH

269.
Anonymous, central highlands, Junín region
Carved gourd depicting military scenes
First half of the 20th century
Gourd
18 x 22 cm
Museo de Artes y Tradiciones Populares, Lima
AJB-247

268.
Anonymous, central highlands, Junín region
**Carved gourd depicting parades of musicians
and Amerindians in festive clothing**
First half of the 20th century
Gourd
19 x 23 cm
Museo de Artes y Tradiciones Populares, Lima
AJB-269

270.
Anonymous, central highlands, Junín region
Carved gourd depicting rural scenes
First half of the 20th century
Gourd
6 x 23 cm
Museo de Artes y Tradiciones Populares, Lima
AJB-286

287.
Anonymous, central highlands, Mito
Mask of "Huacón" (Dance of the Huaconada)
20th century
Wood
21 x 15 x 16.5 cm
Museo Nacional de la Cultura Peruana, Lima
2.2012.2

190.
Anonymous, central highlands, Moya
Chicote de baile [Dance whip]
About 1875–1925
Leather, silver
120 x 12 x 12 cm
Museo de Arte de Lima. Ex Colección Luisa
Alvarez-Calderón. Fondo de Adquisiciones 2001
V-2.7-0222

329.
Anonymous, central highlands, Sapallanga
**Embroidered jacket with sun motif above Peru's
coat of arms, insects, and floral motifs**
Early 20th century
Velvet, threads, stones
75 x 64 cm
Museo de Artes y Tradiciones Populares, Lima
AJB-971

160.
Anonymous, Cuzco School
Archangel Michael Triumphant
17th century
Polychromed mahogany, gold, and silver leaves
198.1 x 115.8 x 83.8 cm
New Orleans Museum of Art: Museum purchase
and gift of Mr. And Mrs. Arthur Q. Davis and the Stern
Fund
74.279

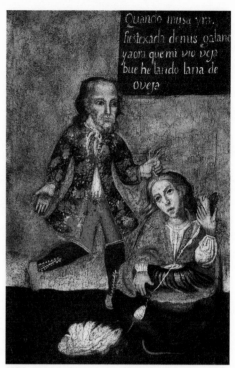
310

158.
Anonymous, Cuzco School
Defensa de la Eucaristía con Santa Rosa de Lima
[Defense of the Eucharist with Saint Rose of Lima]
About 1675–1685
Oil on canvas
137 x 110 cm
Pastor de la Torre Collection

159.
Anonymous, Cuzco School
Arcángel Eliel con arcabuz [Archangel Eliel
with Harquebus]
About 1690–1720
Oil on canvas
168.5 x 108 cm
Museo de Arte de Lima. Donación Pedro de Osma
V-2.0-0004

166.
Anonymous, Cuzco School
Baúl de Nacimiento [Nativity chest]
18th century
Painted wood, polychrome plaster, and maguey
(agave), metal
46.7 x 105 x 47.8 cm
Museo Pedro de Osma, Lima
82.0.2497

155.
Anonymous, Cuzco School
El Cristo de los Temblores [Lord of the Earthquakes]
18th century
Oil on canvas, gold leaf
178 x 132 cm
Pastor de la Torre Collection

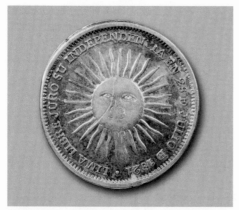

311 verso

311 recto

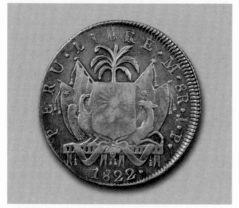

312 verso

312 recto

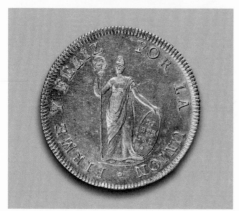

313 verso

313 recto

150.
Anonymous, Cuzco School
Niño de la espina [Child of the Thorn]
18th century
Oil on canvas
97 x 86 cm
Barbosa-Stern Collection
CBS-0086/PL

152.
Anonymous, Cuzco School
Nuestra Señora de Cocharcas
[Virgin of Cocharcas]
18th century
Oil on canvas
97 x 77 cm
Barbosa-Stern Collection
CBS-0609/PL

161.
Anonymous, Cuzco School
Santiago Matamoros [Saint James the Moorslayer]
18th century
Oil on linen
158.1 x 115.6 cm
New Orleans Museum of Art. Museum purchase
74.281

151.
Anonymous, Cuzco School
Virgen del Rosario de Pomata
[Virgin of the Rosary of Pomata]
18th century
Oil on canvas
132 x 93 cm
Barbosa-Stern Collection
CBS-0008/PL

171.
Anonymous, Cuzco School
*Unión de la descendencia imperial Incaica
con la casa de los Loyola y Borgia*
[Union of the Imperial Inca Descendants
with the Houses of Loyola and Borgia]
1718
Oil on canvas, gold leaf
175.2 x 168.3 cm
Museo Pedro de Osma, Lima
82.0.550

148.
Anonymous, Cuzco School
Procesión del Corpus Christi
[Corpus Christi Procession]
About 1740
Oil on canvas, gold and silver leaves
86.4 x 200.2 cm
Museo Pedro de Osma, Lima
82.0.494

162.
Anonymous, Cuzco School
The Rest on the Flight into Egypt
About 1750
Oil on canvas, gold leaf (period frame covered
with mother-of-pearl)
50.8 x 71.1 cm
Hispanic Society of America, New York
LA2189

156.
Anonymous, Cuzco School
La Trinidad trifacial [Trifacial Trinity]
1750–1770
Oil on canvas
182 x 124 cm
Museo de Arte de Lima. Donación Memoria Prado
V-2.0-0035

149.
Anonymous, Cuzco School
Virgen Niña Hilando [Young Virgin Spinning]
Second third of the 18th century
Oil on canvas, gold leaf
112.5 x 80.5 cm
Museo Pedro de Osma, Lima
82.0.647

181.
Anonymous, Cuzco School
Nuestra Señora de los ángeles de Urquillos
[Our Lady of the Angels of Urquillos]
About 1780–1785
Oil on canvas
74.5 x 59.5 cm
Barbosa-Stern Collection
CBS-0494/PL

310.
Anonymous, Cuzco School
Maltrato de la vieja hilando
[Abuse of the Old Woman Spinning]
Late 18th century
Oil on canvas
56 x 42 cm
Barbosa-Stern Collection
CBS-0063/PL

172.
Anonymous, Cuzco School
Genealogía de los Incas [Genealogy of the Incas]
About 1835–1845
Oil on canvas
105.6 x 103 cm
Museo Pedro de Osma, Lima
FA.3.83

195.
Anonymous, Lima
Incense burner in the shape of a turkey
18th century
Silver
19.5 x 13 x 18 cm
Museo Pedro de Osma, Lima
82.0.2097

194.
Anonymous, Lima
Incense burner in the shape of a deer
19th century
Silver
16.5 x 15 x 13 cm
Museo Pedro de Osma, Lima
82.0.2128

174.
Anonymous, possibly Lima
Depósito eucarístico con forma de pelícano
[Eucharistic urn in the shape of a pelican]
About 1750–1760
Partially gilded silver, gemstones
83 x 91 cm
Monasterio Nuestra Señora del Prado, Lima

163.
Anonymous, Quito School
La Adoración de los Reyes Magos
[The Adoration of the Magi]
18th century (?)
Oil on wood
38.5 x 30.6 cm
The Montreal Museum of Fine Arts
723.2011

191.
Anonymous, southern highlands
Vara **(staff of Indigenous chief)**
19th century
Wood, silver
131 x 8 cm
Museo de Arte de Lima. Donación Fondo Alicia
Lastres de la Torre
V-2.7-0299

326.
Anonymous, southern highlands
Illa chacra **(votive object)**
About 1950
Alabaster from Lake Titicaca
2.3 x 18.5 x 21.2 cm
Museo Nacional de la Cultura Peruana, Lima
54/4

279.
Anonymous, possibly southern highlands
Conopa **(votive object) in the shape of an alpaca**
19th century
Wood
10.1 x 14.1 x 6.4 cm
Private collection, Quebec

314

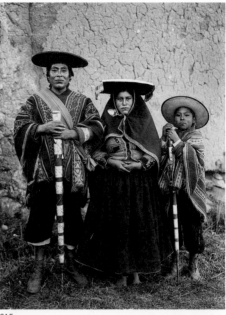

315

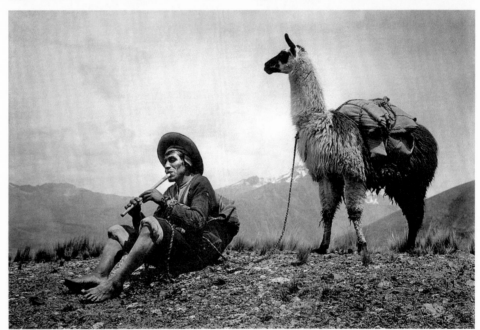

316

280.
Anonymous, southern highlands, Espinar
Roof ornament in the shape of a bull
19th century
Painted ceramic
16 x 23.7 x 12.7 cm
Private collection, Quebec

288.
Anonymous, southern highlands, Huayllabamba
San Isidro Labrador
18th century
Maguey (agave), paste, cloth
101 x 50 x 30 cm
Museo de Arte del Sur Andino, Urubamba, Cuzco

289.
Anonymous, southern highlands, Puno
Mask of the Devil (Dance of the Diablada)
20th century
Cardboard, papier-mâché, mirror, light bulbs
47 x 46.3 x 36 cm
Museo Nacional de la Cultura Peruana, Lima
1.86.66

328.
Anonymous, southern highlands, Puno
Archangel costume (Dance of the Diablada)
First half of the 20th century
Cardboard, cloth, stones
74 x 82 cm
Museo de Artes y Tradiciones Populares, Lima
AJB-1339

317

318

327.
Anonymous, southern highlands, Puno
Archangel helmet (Dance of the Diablada)
First half of the 20th century
Bronze, plastic, feathers
23 x 20 x 30 cm
Museo de Artes y Tradiciones Populares, Lima
AJB-1338

281.
Anonymous, southern highlands, Santiago de Pupuja
Roof ornament in the shape of a bull
About 1960
Painted ceramic
29.2 x 28.8 x 13 cm
Private collection, Quebec

[Not illustrated]
Anonymous, southern highlands, Sicuani
Illa chacra (votive object)
Early 20th century
Stone
3.8 x 10 x 13.5 cm
Musée du quai Branly, Paris
71.1939.115.4

176.
Anonymous, southern Peru
Missal stand
18th century
Silver
33 x 40 x 27 cm
Barbosa-Stern Collection
CBS-0744/AG

227.
Pedro Azabache (born in Campiña de Moche, 1918)
Procesión del Santo Sepulcro
[Holy Sepulchre Procession]
1944
Oil on canvas
63.5 x 78.5 cm
Museo de la Nación, Lima
MN/AC-165

3.
Hiram Bingham (Honolulu, 1875–Washington, 1956)
Three-Sided Building Later Called the Principal
or Main Temple
About 1911–1912
Gelatin silver print
15.2 x 20.3 cm
Hispanic Society of America, New York, 25676,
and Yale Peabody Museum of Natural History,
New Haven

4.
Hiram Bingham (Honolulu, 1875–Washington, 1956)
View of the Side of the Torreón after Bingham
Cleared It of Vegetation
About 1911–1912
Gelatin silver print
15.2 x 20.3 cm
Yale Peabody Museum of Natural History, New Haven

1.
Hiram Bingham (Honolulu, 1875–Washington, 1956)
Panorama of Machu Picchu
About 1911–1913
Gelatin silver print
Yale Peabody Museum of Natural History, New Haven
ANT. 269152

2.
Hiram Bingham (Honolulu, 1875–Washington, 1956)
Excavations at the Main Temple
1912
Gelatin silver print
15.2 x 20.3 cm
Hispanic Society of America, New York, 13297,
and Yale Peabody Museum of Natural History,
New Haven

16.
Hiram Bingham (Honolulu, 1875–Washington, 1956)
In the Wonderland of Peru: The Work Accomplished
by the Peruvian Expedition of 1912
National Geographic, vol. 24, no. 4, April 1913
Private collection, Quebec

218.
Camilo Blas (Cajamarca, 1903–Lima, 1985)
Indian Women Threshing
1928
Oil on cardboard
37.1 x 52.7 cm
The Museum of Modern Art, New York
A649.1942

274.
Camilo Blas (Cajamarca, 1903–Lima, 1985)
Estudio de motivos inca coloniales
[Study of Colonial Inca Motifs]
About 1931–1940
Tempera on paper
35.8 x 26.9 cm
Museo de Arte de Lima. Donación Petrus Fernandini
2008.3.1325

272.
Camilo Blas (Cajamarca, 1903–Lima, 1985)
Estudio de vasijas precolombinas
[Study of Precolumbian Vessels]
About 1931–1940
Tempera on paper
36.7 x 53.8 cm
Museo de Arte de Lima. Donación Petrus Fernandini
2008.3.1354

252.
Camilo Blas (Cajamarca, 1903–Lima, 1985)
Indígena de Sicuani [Native of Sicuani]
1951
Watercolor on paper
65 x 50.2 cm
Museo Nacional de la Cultura Peruana, Lima
2001.3.289

237.
Hans H. Brüning (Hoffeld, 1848–Kiel, 1928)
Der Kassenmacher Manuel aus Eten, mit Flöte
und Trommel [The Drummer Manuel of Eten
with Flute and Drum]
n.d.
Albumen silver print
18 x 13 cm
Museum für Völkerkunde, Hamburg
17.176

242.
Hans H. Brüning (Hoffeld, 1848–Kiel, 1928)
Dreikönigsfest in Ferreñafe, Mond, Sonne und Stern
[Epiphany in Ferreñafe: Moon, Sun and Star]
n.d.
Albumen silver print
13 x 18 cm
Museum für Völkerkunde, Hamburg
17.192

15.
Hans H. Brüning (Hoffeld, 1848–Kiel, 1928)
Alte Grabstätte, Palo bei Chancay
[Ancient Tomb, Palo near Chancay]
1888
Albumen silver print
4 x 5 cm
Museum für Völkerkunde, Hamburg
17.578

243.
Hans H. Brüning (Hoffeld, 1848–Kiel, 1928)
Die verstorbene Inés Guerra
[The Deceased Inés Guerra]
1890
Albumen silver print
18 x 13 cm
Museum für Völkerkunde, Hamburg
17.147

13.
Hans H. Brüning (Hoffeld, 1848–Kiel, 1928)
Mauer aus vorspanischer Zeit bei Galindo
[Pre-hispanic Wall Near Galindo]
1894
Albumen silver print
13 x 18 cm
Museum für Völkerkunde, Hamburg
17.150

14.
Hans H. Brüning (Hoffeld, 1848–Kiel, 1928)
Zwei Säulen und Ruinen in der Huaca de Sacachique
[Two Columns and Ruins in Huaca de Sacachique]
1895
Albumen silver print
13 x 18 cm
Museum für Völkerkunde, Hamburg
17.151

12.
Hans H. Brüning (Hoffeld, 1848–Kiel, 1928)
Ausgrabung, Hacienda Huando, Valle de Chancay
[Excavation, Hacienda Huando, Chancay Valley]
1899
Albumen silver print
13 x 18 cm
Museum für Völkerkunde, Hamburg
17.1077

286.
Hans H. Brüning (Hoffeld, 1848–Kiel, 1928)
*Triumphbogen aus Früchten zu Fronleichnam
in Monsefú* [Triumphal Arch Made of Fruits
for the Feast of Corpus Christi]
1904
Albumen silver print
18 x 13 cm
Museum für Völkerkunde, Hamburg
17.134

238.
Hans H. Brüning (Hoffeld, 1848–Kiel, 1928)
Wasserträgerinnen in Eten [Water Carriers in Eten]
1906–1907
Albumen silver print
13 x 18 cm
Museum für Völkerkunde, Hamburg
17.1351

285.
Hans H. Brüning (Hoffeld, 1848–Kiel, 1928)
*Kreuzfest in Motupe, Verehrung des Kreuzes: Altar
im Hintergrund* [Feast of the Holy Cross in Motupe,
Adoration: Altar in the Background]
1907
Albumen silver print
18 x 13 cm
Museum für Völkerkunde, Hamburg
17.1348

297.
Hans H. Brüning (Hoffeld, 1848–Kiel, 1928)
Diary
1912
Ink on paper
18 x 11.7 cm
Museum für Völkerkunde, Hamburg

17.
Hans H. Brüning (Hoffeld, 1848–Kiel, 1928)
*Estudios monográficos del departamento
de Lambayeque,* fascicle II, "Olmos"
Dionisio Mendoza, Chiclayo, 1922
24.1 x 17.3 cm
Museum für Völkerkunde, Hamburg
33.674

18.
Hans H. Brüning (Hoffeld, 1848–Kiel, 1928)
*Estudios monográficos del departamento
de Lambayeque,* fascicle III, "Jayanca"
Dionisio Mendoza, Chiclayo, 1922
24.2 x 17 cm
Museum für Völkerkunde, Hamburg
33.675

226.
Enrique Camino Brent (Lima, 1909–Lima, 1960)
Cristo de Tayankani [Christ of Tayankani]
1937
Oil on canvas
89 x 89 cm
Museo de Arte de Lima. Donación Manuel Cisneros
Sánchez y Teresa Blondet de Cisneros
V-2.0-0402

223.
Enrique Camino Brent (Lima, 1909–Lima, 1960)
Montesierpe
1946
Oil on canvas
69.5 x 80 cm
Museo Nacional de Arqueología, Antropología,
e Historia del Perú, Lima
92/383 - 7609

222.
Enrique Camino Brent (Lima, 1909–Lima, 1960)
Poblacho Serrano [Small Highland Village]
1946
Oil on canvas
80 x 80 cm
Museo de la Nación, Lima
MN/AC-145

221.
Enrique Camino Brent (Lima, 1909–Lima, 1960)
Casona [House]
1948
Oil on canvas
79.8 x 80 cm
Museo de la Nación, Lima
MN/AC-146

276.
Enrique Camino Brent (Lima, 1909–Lima, 1960)
Kero con motivo de Coya
[Drawing of a Colonial *Kero*]
1953
Watercolour on paper
68.8 x 89 cm
Museo Nacional de la Cultura Peruana, Lima
2001.3.473

277.
Enrique Camino Brent (Lima, 1909–Lima, 1960)
Kero post Inca: Desfile de guerreros selváticos
[Drawing of a Colonial *Kero*: Jungle Warriors
Parade]
1953
Watercolor on paper
69 x 88.8 cm
Museo Nacional de la Cultura Peruana, Lima
2201.3.527

224.
Enrique Camino Brent (Lima, 1909–Lima, 1960)
La escalera roja, Cuzco [The Red Stairway, Cuzco]
1954
Oil on canvas
59 x 59 cm
Pinacoteca Municipal "Ignacio Merino"
de la Municipalidad Metropolitana de Lima
22.235.669-0044

233.
Martín Chambi (Coasa, 1891–Cuzco 1973)
Juan de la Cruz Sihuana
1925
Gelatin silver print
50 x 40 cm
Museo de Arte de Lima. Donación Archivo Chambi y
Fundación Telefónica
V-2.11-0975

314.
Martín Chambi (Coasa, 1891–Cuzco 1973)
Autorretrato con placa [Self-portrait Holding Plate]
About 1925–1930
Gelatin silver print
25 x 20 cm
Museo de Arte de Lima. Donación Archivo Chambi y
Fundación Telefónica
V-2.11-0964

232.
Martín Chambi (Coasa, 1891–Cuzco 1973)
Mujer con niño [Woman with Child]
About 1926
Gelatin silver print
25 x 20 cm
Museo de Arte de Lima. Donación Archivo Chambi
y Fundación Telefónica
V-2.11-0973

6. and 235.
Martín Chambi (Coasa, 1891–Cuzco 1973)
*Aerial View of Machu Picchu With Mountains
in the Background, Peru*
1927
Gelatin silver print
35.9 x 45.8 cm
Collection Centre Canadien d'Architecture /
Canadian Centre for Architecture, Montréal
PH1984:0480

9.
Martín Chambi (Coasa, 1891–Cuzco 1973)
*Interior View of the Royal Mausoleum Showing
the Entrance Stonework Below the Torreón, Machu
Picchu, Peru*
1927
Gelatin silver print
18 x 24 cm
Collection Centre Canadien d'Architecture / Canadian
Centre for Architecture, Montréal
PH1994:0255

299.
Martín Chambi (Coasa, 1891–Cuzco 1973)
*Partial View of the Industrial Sector Showing Walls,
a Staircase and Buildings, Including the Double
Masma at the Right, Machu Picchu, Peru*
1927
Gelatin silver print
17.7 x 23.7 cm
Collection Centre Canadien d'Architecture / Canadian
Centre for Architecture, Montréal
PH1994:0275

8.
Martín Chambi (Coasa, 1891–Cuzco 1973)
*Partial View of the King's Group Showing the
Courtyard and Unidentified Buildings, Machu
Picchu, Peru*
1927
Gelatin silver print
23 x 17 cm
Collection Centre Canadien d'Architecture / Canadian
Centre for Architecture, Montréal
PH1994:0264

301.
Martín Chambi (Coasa, 1891–Cuzco 1973)
*View Along a Path Showing Unidentified Buildings,
the House of Ñusta and the Staircase Leading
to the Torreón With the Industrial Sector
in the Background, Machu Picchu, Peru*
1927
Gelatin silver print
16.9 x 22.9 cm
Collection Centre Canadien d'Architecture / Canadian
Centre for Architecture, Montréal
PH1994:0247

305.
Martín Chambi (Coasa, 1891–Cuzco 1973)
*View of a Courtyard, Entrance and Interior
of an Unidentified Building, King's Group,
Machu Picchu, Peru*
1927
Gelatin silver print
23.5 x 17.7 cm
Collection Centre Canadien d'Architecture / Canadian
Centre for Architecture, Montréal
PH1994:0266

304.
Martín Chambi (Coasa, 1891–Cuzco 1973)
*View of an Entrance Leading to an Alley, Machu
Picchu, Peru*
1927
Gelatin silver print
23.5 x 17.8 cm
Collection Centre Canadien d'Architecture / Canadian
Centre for Architecture, Montréal
PH1994:0267

300.
Martín Chambi (Coasa, 1891–Cuzco 1973)
*View of Intihuatana Hill and the Little Temple
and an Exterior Wall of the Principal Temple in the
Right Foreground, Sacred Plaza, Machu Picchu, Peru*
1927
Gelatin silver print
17.8 x 23.8 cm
Collection Centre Canadien d'Architecture / Canadian
Centre for Architecture, Montréal
PH1994:0271

303.
Martín Chambi (Coasa, 1891–Cuzco 1973)
*View of the Entrance to the House of Ñusta
and the Staircase Leading to the Torreón,
Machu Picchu, Peru*
1927
Gelatin silver print
23.7 x 17.8 cm
Collection Centre Canadien d'Architecture / Canadian
Centre for Architecture, Montréal
PH1994:0252

298.
Martín Chambi (Coasa, 1891–Cuzco 1973)
*View of the Principal Temple with Intihuatana Hill
and the Little Temple in the Background, Sacred
Plaza, Machu Picchu, Peru*
1927
Gelatin silver print
22.7 x 17.8 cm
Collection Centre Canadien d'Architecture / Canadian
Centre for Architecture, Montréal
PH1994:0268

302.
Martín Chambi (Coasa, 1891–Cuzco 1973)
*View of the Staircase Leading to the Torreón,
the Façade of the House of Ñusta, the Wall
of an Unidentified Building in the Left Foreground,
and the Industrial Sector in the Background,
Machu Picchu, Peru*
1927
Gelatin silver print
17.7 x 23.5 cm
Collection Centre Canadien d'Architecture / Canadian
Centre for Architecture, Montréal
PH1994:0248

7.
Martín Chambi (Coasa, 1891–Cuzco 1973)
*View of the Upper Portion of the Staircase
of the Fountains with Unidentified Buildings
on the Left, Machu Picchu, Peru*
1927
Gelatin silver print
23.2 x 17.9 cm
Collection Centre Canadien d'Architecture / Canadian
Centre for Architecture, Montréal
PH1994:0262

241.
Martín Chambi (Coasa, 1891–Cuzco 1973)
Peregrinos en Q'Olloriti [Q'Olloriti Pilgrims]
1931
Gelatin silver print
10 x 15 cm
Courtesy of Archivo Fotografico Martin Chambi,
Cuzco

236.
Martín Chambi (Coasa, 1891–Cuzco 1973)
Mestiza with Chicha, Cuzco
1932 (printed in 1978)
Gelatin silver print
29.1 x 25.9 cm
The Museum of Modern Art, New York
407.2012

239.
Martín Chambi (Coasa, 1891–Cuzco 1973)
*Procesión del Corpus Christi en la aldea
de Andahuaylillas* [Corpus Christi Procession
in the Village of Andahuaylillas]
1932
Gelatin silver print
10 x 15 cm
Courtesy of Archivo Fotografico Martin Chambi,
Cuzco

240.
Martín Chambi (Coasa, 1891–Cuzco 1973)
Hermano Cura [Brother Priest]
1933
Gelatin silver print
10 x 15 cm
Courtesy of Archivo Fotografico Martin Chambi,
Cuzco

316.
Martín Chambi (Coasa, 1891–Cuzco 1973)
Tristeza andina, La Raya [Andean Sadness, La Raya]
1933
Gelatin silver print
10 x 15 cm
Courtesy of Archivo Fotografico Martin Chambi,
Cuzco

315.
Martín Chambi (Coasa, 1891–Cuzco 1973)
Indian Vayaroc and Family, Tinta Kanchis
1934 (printed in 1978)
Gelatin silver print
23 x 17.6 cm
The Museum of Modern Art, New York
409.2012

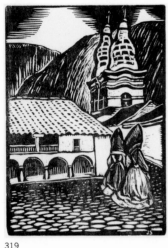

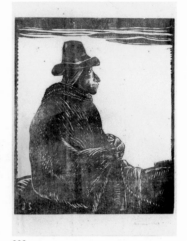

319 320 321 322

234.
Martín Chambi (Coasa, 1891–Cuzco 1973)
Cargador de Chicha **[Chicha-bearer]**
1940
Gelatin silver print
18 x 24 cm
Courtesy of Archivo Fotografico Martin Chambi,
Cuzco

229.
Julia Codesido (Lima, 1892–Lima, 1979)
Cristo **[Christ]**
1907
Oil on wood
27.6 x 21.6 cm
The Museum of Modern Art, New York
SC682.1942

228.
Julia Codesido (Lima, 1892–Lima, 1979)
Las Velas **[The Candles]**
1931
Oil on canvas
152.5 x 100 cm
Universidad Nacional de Ingeniería, Lima

250.
Julia Codesido (Lima, 1892–Lima, 1979)
Traje de Tinta **[Costume from Tinta]**
1948
Watercolor on paper
65.2 x 49.8 cm
Museo Nacional de la Cultura Peruana, Lima
2001.3.290

318.
Julia Codesido (Lima, 1892–Lima, 1979)
Hermano del Señor de los Milagros
[Brother of the Lord of Miracles]
About 1950
Watercolour on paper
69 x 63 cm
Museo Nacional de la Cultura Peruana, Lima
2001.3.219

253.
Julia Codesido (Lima, 1892–Lima, 1979)
Indio músico de Puno **[Indian Musician from Puno]**
About 1950
Watercolor on paper
77 x 43.5 cm
Museo Nacional de la Cultura Peruana, Lima
2001.3.281

230.
Julia Codesido (Lima, 1892–Lima, 1979)
Tres jefes indios **[Three Indian Chiefs]**
About 1950
Oil on canvas
95 x 121 cm
Pinacoteca Municipal "Ignacio Merino"
de la Municipalidad Metropolitana de Lima
22.235.669-0529

251.
Julia Codesido (Lima, 1892–Lima, 1979)
India de Angasmarca **[Indian of Angasmarca]**
1951
Watercolor on paper
65.5 x 50.2 cm
Museo Nacional de la Cultura Peruana, Lima
2001.3.294

231.
Eugène Courret (Angoulême, France, 1841–[?])
Souvenir de Lima, **photographic album**
1868–1872
Silver albumen prints on paper
Hispanic Society of America, New York
175641

311.
Anastasio Dávalos (active in Lima about 1800–1840)
Coin for the Pledge of Independence ceremony
1821
Silver
2.9 cm
Museo Numismático del Perú, Lima
05 025

168.
Garcilaso de la Vega (Cuzco, 1539–Cordoba,
Spain, 1616)
Histoire des Yncas, rois du Pérou
[History of the Incas, Kings of Peru]
Translated from Spanish by Jean Beaudoin
Jean Frederic Bernard, Amsterdam, 1737
28.5 x 22 cm
Bibliothèque et Archives nationales du Québec,
Montréal
985 G216hib D 1737 BMRA V.1

167.
Garcilaso de la Vega (Cuzco, 1539–Cordoba,
Spain, 1616)
Primera parte de los Commentarios reales
[First Part of the Royal Commentaries]
Pedro Crasbeeck, Lisbon, 1609
27 x 20 cm
Bibliothèque et Archives nationales du Québec,
Montréal
RES/BC/7

169.
Theodore de Bry (edition and illustrations)
(Liège, 1528–Frankfurt, 1598)
and Girolamo Benzoni (text) (Milan, 1519–[?])
Americae pars sexta **[America Part Six]**
Theodor de Bry, Frankfurt, 1596
Royal Ontario Museum, Toronto
967.79.6

5.
Ellwood C. Erdis (1867–1944)
Hiram Bingham at the Main Camp
September 1912
Gelatin silver print
Hispanic Society of America, New York
13622
and Yale Peabody Museum of Natural History, New Haven

210.
Francisco (Pancho) Fierro (Lima, 1807–Lima, 1879)
Bendedora de la Noche Buena
[Saleswoman at Christmas Eve]
Mid-19th century
Watercolour on paper
30.6 x 23 cm
Hispanic Society of America, New York
A2243

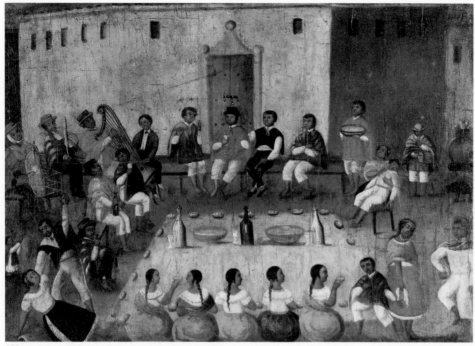

323

206.
Francisco (Pancho) Fierro (Lima, 1807–Lima, 1879)
Chichera en los toros [Chicha (Maize Beer) Seller]
Mid-19th century
Watercolour on paper
30.7 x 23 cm
Hispanic Society of America, New York
A2223

208.
Francisco (Pancho) Fierro (Lima, 1807–Lima, 1879)
Combite ala Pelea de Gallos
[Celebration at the Cockfight]
Mid-19th century
Watercolour on paper
30.7 x 23 cm
Hispanic Society of America, New York
A2262

209.
Francisco (Pancho) Fierro (Lima, 1807–Lima, 1879)
Danza de Diablos el día de Cuasimodo
[Dance of the Devils on Quasimodo Day]
Mid-19th century
Watercolour on paper
30.7 x 23 cm
Hispanic Society of America, New York
A2292

213.
Francisco (Pancho) Fierro (Lima, 1807–Lima, 1879)
En las lomas de Amancaes [In the Hills
of Amancaes]
Mid-19th century
Watercolour on paper
22.8 x 30.7 cm
Hispanic Society of America, New York
A2221

202.
Francisco (Pancho) Fierro (Lima 1807 – Lima 1879)
Fraile Betlemita [Bethlemite Friar]
Mid-19th century
Watercolour on paper
30.8 x 23 cm
Hispanic Society of America, New York
A2286

205.
Francisco (Pancho) Fierro (Lima, 1807–Lima, 1879)
Padre de la Buena Muerte [Father of the Buena
Muerte]
Mid-19th century
Watercolour on paper
30.7 x 23 cm
Hispanic Society of America, New York
A2208

212.
Francisco (Pancho) Fierro (Lima, 1807–Lima, 1879)
Peón de las minas, Potosí [Miner, Potosi (Bolivia)]
Mid-19th century
Watercolour on paper
17.8 x 11.6 cm
Hispanic Society of America, New York
A3102

201.
Francisco (Pancho) Fierro (Lima, 1807–Lima, 1879)
*Procesión del Jueves Santo por la calle
de San Agustín* [Holy Thursday Procession
on San Augustín Street]
Mid-19th century
Watercolour on paper
44.4 x 475 cm
Hispanic Society of America, New York
A1582-1/14

207.
Francisco (Pancho) Fierro (Lima, 1807–Lima, 1879)
Soldados y sus rabonas en marcha [Travelling
Soldiers and Their Camp Followers]
Mid-19th century
Watercolour on paper
23 x 30.7 cm
Hispanic Society of America, New York
A2267

204.
Francisco (Pancho) Fierro (Lima, 1807–Lima, 1879)
Tapada (Veiled Woman from Lima)
Mid-19th century
Watercolour on paper
17.9 x 11.8 cm
Hispanic Society of America, New York
A3116

203.
Francisco (Pancho) Fierro (Lima, 1807–Lima, 1879)
Tapada (Veiled Woman from Lima)
Mid-19th century
Watercolour on paper
14.7 x 8.8 cm
Hispanic Society of America, New York
LA1782

211.
Francisco (Pancho) Fierro (Lima, 1807–Lima, 1879)
The Lama and Chola of the Sierra
Mid-19th century
Watercolour on paper
23 x 30.7 cm
Hispanic Society of America, New York
A2485-8

267.
Mariano Inés Flores (San Juan, about 1845–
San Mateo, 1949)
**Azucarero con escenas de la Guerra del Pacífico
[Carved Gourd Depicting Scenes from the War
of the Pacific]**
About 1920
Gourd
12.5 x 15 x 15 cm
Museo de Arte de Lima. Donación Oswaldo Avilez
D'Acunha
2008.31.1

275.
Inca, southern highlands, Pisac
Kero (ceremonial cup) depicting warriors
18th century
Wood, polychrome pastes
18.6 x 19.9 x 18.4 cm
Musée du quai Branly, Paris
71.1887.127.1

278.
Inca, possibly southern highlands
Conopa (votive object) in the shape of an alpaca
1450–1532 A.D.
Stone
7.62 x 5.08 cm
Seattle Art Museum
61.38

317.
Elena Izcue (Lima, 1889–Lima, 1970)
El arte Peruano en la escuela
[Peruvian Art in the School]
Excelsior, Paris, 1925
27.8 x 21.8 cm
Private collection, Quebec
Courtesy of Museo de Arte de Lima

170.
George Juan (Monforte del Cid, Spain, 1713–Madrid, 1773) and Antoine de Ulloa (Seville, 1716–Isla de León, Spain, 1795)
Voyage historique de l'Amérique méridionale fait par ordre du roi d'Espagne [Historic Trip to South America Done by Order of the King of Spain]
Arkstee & Merkus, Amsterdam-Leipzig, 1752
27 x 21 cm
Bibliothèque et Archives nationales du Québec, Montréal
985/UL425/S RES v.1

199.
Francisco Laso (Tacna, 1823–San Mateo, 1869)
La Hilandera [The Spinner]
1849
Oil on canvas
40.5 x 23.5 cm
Museo de Arte de Lima. Donación Manuel Cisneros Sánchez y Teresa Blondet de Cisneros
V-2.0-1102

200.
Francisco Laso (Tacna, 1823–San Mateo, 1869)
Habitante de las cordilleras del Perú
[Inhabitant of the Peruvian Highlands]
1855
Oil on canvas
138 x 88 cm
Pinacoteca Municipal "Ignacio Merino" de la Municipalidad Metropolitana de Lima
22.2335.669-0077

153.
Attributed to Bernardo Legarda
(Quito, late 17th century–1773)
Virgin of the Fifth Seal
About 1740
Painted wood, silver
67.3 cm
New Orleans Museum of Art. Museum purchase, the Ella West Freeman Foundation Matching Fund
69.44

284.
Joaquín López Antay (Huamanga, 1897–1981)
Retablo [Altarpiece]
About 1970
Painted wood, polychrome paste
92.5 x 118 x 14 cm
Museo de Arte de Lima. Fondo de Adquisiciones 2008
2008.20.1

246.
José Carlos Mariategui (Moquegua, 1894–Lima, 1930)
7 Ensayos de interpretación de la realidad peruana (Carátula Julia Codesido)
[7 Essays on the Interpretation of Peruvian Reality (Cover by Julia Codesido)]
Amauta, Lima, 1928
24.1 x 17 cm
Private collection, Quebec

283.
Juana Mendívil Dueñas de Olarte (Cuzco, 1959)
Arcángel arcabucero [Arquebusier Archangel]
Second half of the 20th century
Painted wood, polychrome paste, pasted canvas
80 x 41 x 32 cm
Museo de Artes y Tradiciones Populares, Lima
I-2330

323.
Arce Naveda
(active during the second half of the 19th century)
Fiesta de Indios [Indian Feast]
Second half of the 19th century
Oil on canvas
54.6 x 75.3 cm
Museo Nacional de la Cultura Peruana, Lima
51/117

273.
Nazca, south coast, possibly Palpa
Vase in the shape of a human head
1–700 A.D.
Painted ceramic
14.5 x 11.1 cm
The Montreal Museum of Fine Arts
1946.Dp.8

291.
Irving Penn (Plainfield, 1917–New York, 2009)
Cuzco: Cuzco Children (Neg. 260)
1948
Gelatin silver print
The Irving Penn Foundation, New York

292.
Irving Penn (Plainfield, 1917–New York, 2009)
Cuzco: Many-Skirted Indian Woman
1948
Gelatin silver print
The Irving Penn Foundation, New York

290.
Irving Penn (Plainfield, 1917–New York, 2009)
Cuzco: Three Sitting Men in Masks (Neg. 611)
1948
Vintage gelatin silver print
The Irving Penn Foundation, New York

294.
Irving Penn (Plainfield, 1917–New York, 2009)
Cuzco: Town Photographer with Girl and Basket
1948
Platinum palladium print mounted to board
The Irving Penn Foundation, New York

293.
Irving Penn (Plainfield, 1917–New York, 2009)
Cuzco: Woman with Braided Hair
1948
Vintage gelatin silver print
The Irving Penn Foundation, New York

271.
José Sabogal (Cajabamba, 1888–Lima, 1956)
Burilador de mates [Gourd Engraver]
n.d.
Wood engraving
15 x 13 cm
Museo Banco Central de Reserva del Perú, Lima
PX272

261.
José Sabogal (Cajabamba, 1888–Lima, 1956)
Cuesta de Huaynapata [Slope of Huaynapata]
n.d.
Wood engraving
29 x 23 cm
Museo Banco Central de Reserva del Perú, Lima
PX293

324

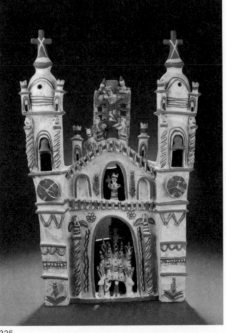

325

326

256.
José Sabogal (Cajabamba, 1888–Lima, 1956)
Retrato de india [Portrait of an Indian]
n.d.
Wood engraving
17 x 18 cm
Museo Banco Central de Reserva del Perú, Lima
PX287

259.
José Sabogal (Cajabamba, 1888–Lima, 1956)
Zaguán cusqueño [Cuzco Entryway]
n.d.
Wood engraving
21 x 21 cm
Museo Banco Central de Reserva del Perú, Lima
PX281

214.
José Sabogal (Cajabamba, 1888–Lima, 1956)
Cusqueña a Misa
[Woman from Cuzco Going to Mass]
1919
Oil on canvas
85 x 72 cm
Museo de Arte de Lima. Donación Gino Bianchini
V-2.0-00351

215.
José Sabogal (Cajabamba, 1888–Lima, 1956)
Hilandera [Spinner]
1923
Oil on canvas
65 x 53 cm
Museo Banco Central de Reserva del Perú, Lima
PO079

260.
José Sabogal (Cajabamba, 1888–Lima, 1956)
Cacharreras [Pottery Sellers]
1925
Wood engraving
20 x 15 cm
Museo Banco Central de Reserva del Perú, Lima
PX295

320.
José Sabogal (Cajabamba, 1888–Lima, 1956)
Ccori Calle, Cuzco [Ccori Street, Cuzco]
1925
Wood engraving
33.5 x 25.5 cm
Alvaro and Susana Roca-Rey Collection, Lima
AARMQ020

262.
José Sabogal (Cajabamba, 1888–Lima, 1956)
Cristo de Mullachayoc [Christ of Mullachayoc]
1925
Wood engraving
32.5 x 22 cm
Museo de Arte de Lima. Fondo de Adquisiciones 1996
V-2.0-1651

265.
José Sabogal (Cajabamba, 1888–Lima, 1956)
La fuente de Arones [The Arones Fountain]
1925
Wood engraving
18 x 16 cm
Museo Banco Central de Reserva del Perú, Lima
PX291

257.
José Sabogal (Cajabamba, 1888–Lima, 1956)
Mujer del alcalde [The Mayor's Wife]
1925
Wood engraving
32 x 21 cm
Museo Banco Central de Reserva del Perú, Lima
PX288

244.
José Sabogal (Cajabamba, 1888–Lima, 1956)
Mujer del Collao [Woman of Collao]
1925
Wood engraving
22 x 16 cm
Museo Banco Central de Reserva del Perú, Lima
PX289

321.
José Sabogal (Cajabamba, 1888–Lima, 1956)
Portales, Cuzco [Porticoes, Cuzco]
1925
Wood engraving
33.5 x 27.5 cm
Alvaro and Susana Roca-Rey Collection, Lima
AARMQ021

255.
José Sabogal (Cajabamba, 1888–Lima, 1956)
Sín título (Retrato de indígena) [Untitled
(Portrait of an Indian)]
1925
Wood engraving
25 x 21.1 cm
Museo de Arte de Lima. Fondo de Adquisiciones 1996
V-2.0-1600

319.
José Sabogal (Cajabamba, 1888–Lima, 1956)
Ayacucho
About 1925
Wood engraving
39 x 30 cm
Museo de la Nación, Lima
MN/AC-116

217.
José Sabogal (Cajabamba, 1888–Lima, 1956)
El Recluta [The Recruit]
1926
Oil on canvas
60.5 x 60.5 cm
Universidad Nacional de Ingeniería, Lima
1998/06236

258.
José Sabogal (Cajabamba, 1888–Lima, 1956)
Viejas cusqueñas [Old Women from Cuzco]
1926
Wood engraving
26 x 21 cm
Museo Banco Central de Reserva del Perú, Lima
PX296

254.
José Sabogal (Cajabamba, 1888–Lima, 1956)
India del Collao [Indian of Collao]
1928
Wood engraving
22 x 17 cm
Museo Banco Central de Reserva del Perú, Lima
PX286

322.
José Sabogal (Cajabamba, 1888–Lima, 1956)
Abigeo [Cattle Thief]
1930 (printed in 1948)
Wood engraving
35 x 29 cm
Alvaro and Susana Roca-Rey Collection, Lima
AARMQ022

[Not illustrated]
José Sabogal (Cajabamba, 1888–Lima, 1956)
Mujer del "Varayoc", Cuzco [Wife of the Chief]
1930 (printed in 1948)
Wood engraving
39.5 x 23.5 cm
Alvaro and Susana Roca-Rey Collection, Lima
ARRMQ023

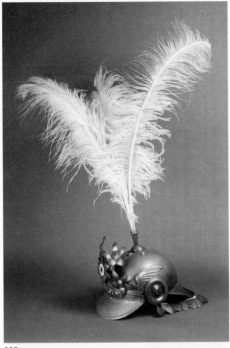

327

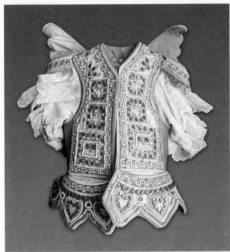

328

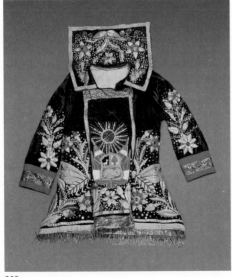

329

263.
José Sabogal (Cajabamba, 1888–Lima, 1956)
Plaza Mayor de Cuzco / Sacsayhuamán
1930
Wood engraving
32 x 27 cm
Museo de la Nación, Lima
MN/AC-117

216.
José Sabogal (Cajabamba, 1888–Lima, 1956)
Cholita Ayacuchana [Young Girl from Ayacucho]
1937
Oil on wood
76.2 x 76.2 cm
The Museum of Modern Art, New York
SC785.1942

220.
José Sabogal (Cajabamba, 1888–Lima, 1956)
Torre Bermeja [Scarlet Tower]
1946
Oil on canvas
55.7 x 55.8 cm
Museo de la Nación, Lima
MN/AC-234

282.
José Sabogal (Cajabamba, 1888–Lima, 1956)
Paisaje de Arte Peruano [Peruvian Art Landscape]
1947
Oil on wood
119 x 194 cm
Alvaro and Susana Roca-Rey Collection, Lima
ARRMQ016

247.
José Sabogal (Cajabamba, 1888–Lima, 1956)
El Toro en las Artes Populares del Perú
[The Bull in the Popular Arts of Peru]
Instituto de Arte Peruano, Lima, 1949
24.5 x 17.3 cm
Private collection, Quebec

249.
José Sabogal (Cajabamba, 1888–Lima, 1956)
Alcalde de Pisaj [Mayor of Pisaj]
About 1950
Watercolour on paper
69 x 45 cm
Museo Nacional de la Cultura Peruana, Lima
2001.3.241

266.
José Sabogal (Cajabamba, 1888–Lima, 1956)
**Artwork for the cover of *El "Kero", Vaso de
libaciones cusqueño***
About 1950
Ink on paper
39 x 29 cm
Museo Nacional de la Cultura Peruana, Lima
2001.3.38

248.
José Sabogal (Cajabamba, 1888–Lima, 1956)
El "Kero"
Publicaciones del Instituto de Arte Peruano 2, Museo
de la Cultura Peruana, Lima, 1952
24.5 x 17.3 cm
Private collection, Quebec

325.
Mamerto Sánchez Cárdenas (Quinua, Ayacucho, 1942)
Roof ornament in the shape of a church
About 1970
Painted ceramic
55 x 37 x 20.3 cm
Private collection, Quebec

225.
Mario Urteaga (Cajamarca, 1875–1957)
Entierro de Veterano [Burial of an Illustrious Man]
1936
Oil on canvas
58.4 x 82.5 cm
The Museum of Modern Art, New York
806.1942

245.
Aristides Vallejo (Santiago de Chuco, 1905–Lima,
1949)
*Peruanidad, Órgano Antológico del Pensamiento
Nacional*, Vol. III, No. 14
June–August 1943
25.1 x 17.8 cm
Private collection, Quebec

264.
Leonor Vinatea Cantuarias (Lima, 1897–1968)
Retrato de mujer Serrana [Woman of the Highlands]
1930
Oil on canvas
66 x 50 cm
Alvaro and Susana Roca-Rey Collection, Lima
AARMQ042

219.
Leonor Vinatea Cantuarias (Lima, 1897–1968)
Pastoras [Shepherdesses]
1944
Oil on canvas
197 x 174 cm
Museo de la Nación, Lima
MN/AC-189

List of Figures

Fig. 6, p. 286
Hilario Mendívil and Georgina Dueñas
Corpus Christi Procession
About 1950
Museo Nacional de la Cultura Peruana, Lima

Indigenismo and Peruvian Architecture
José García Bryce

Fig. 1, p. 289
Attributed to the studio of Manuel Piqueras Cotolí
Proposal for an altar in the Santa Rosa de Lima Basilica
About 1936
Javier Luna Elías Collection, Lima
Photo © 2011 Joaquín Rubio

Fig. 2, p. 290
Claudio Sahut
Proposal for the Museo Larco
1921
Photo Archivo José García Bryce

Fig. 3, p. 290
Emilio Harth-terré
Proposal of a "Cuzco model" for Peruvian architecture
1928
Published in the magazine *Ciudad y Campo*, vol. 37, (January-February 1928)

Fig. 4, p. 290
H. Baranger
View of the Peruvian Pavilion, Paris International Exposition
1937
Collection Centre Canadien d'Architecture / Canadian Centre for Architecture, Montreal
© Collection Centre Canadien d'Architecture / Canadian Centre for Architecture, Montréal

Fig. 5, p. 290
Manuel Piqueras Cotolí and Héctor Velarde
Proposal for the Santa Rosa de Lima Basilica
1939
Published in the magazine *El Arquitecto Peruano*, vol. 3, no. 18 (January 1939)

Fig. 6, p. 290
Emilio Harth-terré
Proposal for the La Torre Ribaudo House
1930s

Fig. 7, p. 292
Manuel Piqueras Cotolí
Façade of the Peruvian Pavilion at the Ibero-American Exposition in Seville
1929
Archivo Manuel Piqueras Cotolí, Lima
Photo Daniel Giannoni

Fig. 8, p. 292
Ricardo de Jaxa Malachowski
Museo Larco (now Museo Nacional de la Cultura Peruana)
1924
Photo José García Bryce

Fig. 9, p. 292
José Sabogal
"Huaca" in the Parque de la Reserva
1926–1929
Photo © 2011 Joaquín Rubio

Fig. 10, p. 292
Manuel or Daniel Vásquez Paz
Pottery Fountain of the Parque de la Reserva
1926–1929
Photo © 2011 Joaquín Rubio

Fig. 11, p. 292
Enrique Rivero Tremouille
House of Julio C. Tello in Miraflores, Lima
1930
Photo José García Bryce

POPULAR BELIEFS AND TRADITIONAL
CELEBRATIONS IN MODERN PERU

Hans H. Brüning's Photographs of Festivals
in the Lambayeque Region
Bernd Schmelz

Fig. 1, p. 298
Hans H. Brüning
Procession with Different Figures of Saints in Honor of the Son of God (Eten)
1906–1907
Museum für Völkerkunde, Hamburg
Photo © Museum für Völkerkunde, Hamburg

Fig. 2, p. 298
Hans H. Brüning
Women Shoulder the Cross on the Way to Chalpón Hill (Motupe)
August 7, 1907
Museum für Völkerkunde, Hamburg
Photo © Museum für Völkerkunde, Hamburg

Fig. 3, p. 298
Hans H. Brüning
Triumphal Arch at the Entrance of the Village, Decorated with Two National Flags (Eten)
1906–1907
Museum für Völkerkunde, Hamburg
Photo © Museum für Völkerkunde, Hamburg

Fig. 4, p. 298
Hans H. Brüning
The Cross is Dressed (Motupe)
August 1907
Museum für Völkerkunde, Hamburg
Photo © Museum für Völkerkunde, Hamburg

Fig. 5, p. 298
Hans H. Brüning
Band Playing at the Procession in Honor of the Son of God (Eten)
1906–1907
Museum für Völkerkunde, Hamburg
Photo © Museum für Völkerkunde, Hamburg

Fig. 6, p. 298
Hans H. Brüning
Stands in the Streets of Motupe during the Chalpón Hill Feast of the Cross (Motupe)
August 1907
Museum für Völkerkunde, Hamburg
Photo © Museum für Völkerkunde, Hamburg

Heritage and Identity in the Traditional Festivals
of the Central Highlands of Peru
Fedora Martínez and Soledad Mujica

Fig. 1, p. 306
The *Huaconada* (Mito, Concepción)
2001
Photo Soledad Mujica Bayly

Fig. 2, p. 306
**Capture and Death of Atahualpa
The Inca on his litter (Carhuamayo, Junín)**
2001
Photo Soledad Mujica Bayly

Fig. 3, p. 306
**The *Chacra negro*
Black character (Huaripampa, Jauja)**
2001
Photo Soledad Mujica Bayly

Fig. 4, p. 306
**The *Tunantada*
Spanish character (Huaripampa, Jauja)**
2001
Photo Soledad Mujica Bayly

Fig. 5, p. 307
**The *Lishtay*
Mayors asking permission to Mother Earth to start cultivating (Tapuc, Pasco)**
2001
Photo Soledad Mujica Bayly

Fig. 6, p. 307
**The *Herranza*
Group playing *waqra* and snare drum (Mama Chicche, Jauja)**
2001
Photo Soledad Mujica Bayly

Fig. 7, p. 307
**The *Maqtada*
Cáceres Troup (Yanamarca Valley, Jauja)**
2001
Photo Soledad Mujica Bayly

Fig. 8, p. 307
**The *Rayada*
Pair of oxen (Santiago León de Chongas Bajo, Junín)**
2001
Photo Soledad Mujica Bayly

References

"El Parque de la Reserva recientemente inaugurado es de excepcional belleza y arte." 1929. *Ciudad y Campo* 4 (43): 26–32.

"El Museo Nacional y la Exposición de Paris." 1937. *Revista del Museo Nacional* 6 (2): 184–200.

"Notas Necrológicas Enrique Camino Brent (1909–1960)." 1960. *Revista del Museo Nacional* 24: 297–299.

"La gran ausente." 1968. *Caretas* 381.

Antología de textos sobre arte popular. 1982. México: Fondo Nacional para el Fomento de las Artesanías, Fondo Nacional para Actividades Sociales.

Alcalá, Luisa Elena. 1999. "Imagen e historia. La representación del milagro en la pintura colonial." In *Los Siglos de Oro en los virreinatos de América*, 107–125. Madrid: Sociedad Estatal para la Conmemoración de los Centenarios de Felipe II y Carlos V.

Alva, Walter. 1988. "Discovering the New World's Richest Unlooted Tomb." *National Geographic* 174 (4): 510–548.

———. 2004. *Sipán, Descubrimiento e Investigación*. Lambayeque: Edition by the author.

Alva, Walter, and Christopher B. Donnan. 1993. *Royal Tombs of Sipán*. Los Angeles: Fowler Museum of Cultural History, University of California.

Alva, Walter, and Susana Meneses de Alva. 1983. "Los Murales de Úcupe en el Valle de Zaña, Norte del Perú." *Beiträge zur Allgemeinen und Vergleichenden Archäologie* 5: 335–358.

Anonymous Jesuit. 1968 [c. 1590]. "Relación de las costumbres antiguas de los naturales del Pirú." In *Crónicas Peruanas de Interés Indígena*, edited by F. Esteve Barba, 151–189. Madrid: Ediciones Atlas.

Antrobus, Pauline. 1997. *Peruvian Art of the Patria Nueva, 1919–1930*. Ph.D. dissertation, University of Essex, Colchester.

Archivo Arzobispal del Cuzco. 1644–1673. *Cuentas de la Cofradía del Santísimo Sacramento fundada en la Catedral del Cuzco y en San Francisco*.

Archivo General de Indias. 1658–1675. *Cartas y expedientes: personas eclesiásticas*. Audiencia de Lima, 333.

Arguedas, José María. 1958. "Notas elementales sobre el arte popular religioso y la cultura mestiza de Huamanga." *Revista del Museo Nacional* 27: 140–194.

———. 1969. "La colección Alicia Bustamante y la Universidad." *El Comercio*, 12 January: 30.

Aristizábal, Catherine, and Bernd Schmelz. 2009. *Hans H. Brüning y la etnohistoria del norte del Perú. Cimientos para consolidar las relaciones interdisciplinarias entre Perú y Alemania*. Hamburg: Museum für Völkerkunde.

Armas Medina, Fernando de. 1953. *Cristianización del Perú (1532–1600)*. Sevilla: Escuela de Estudios Hipano-Americanos de Sevilla.

Arriaga, Pablo José de. 1999 [1621]. *Extirpación de la idolatría del Pirú*. Cuzco: Centro Bartolomé de las Casas.

Arzáns de Orsúa y Vela, Bartolomé. 1965 [c. 1705–1736]. *Historia de la Villa Imperial de Potosí*. Edited by L. Hanke and G. Mendoza. Providence: Brown University Press.

Bachmann, Carlos J. 1921. *Departamento de Lambayeque. Monografía histórico-geográfica*. Lima: Imp. Torres Aguirre.

Barreda y Laos, Enrique. 1939. "Algo sobre el arte en el Perú." *El Arquitecto Peruano* 3 (18).

Barrios, Fortunata, and Pablo Hare, eds. 2010. *Juan Manuel Figueroa Aznar. Fotografías*. Lima: Ediciones Roka.

Bawden, Garth. 1994. "La paradoja estructural: la cultura Moche como ideología política." In *Moche: propuestas y perspectivas*, edited by S. Uceda and E. Mujica, 389–412. Trujillo: Universidad Nacional de La Libertad.

Benites, Mariano. 2010. "Apuntes y recuerdos de Ayacucho." In *Arte de Ayacucho: Celebración de la vida*, edited by F. Torres. Lima: Universidad Ricardo Palma, Instituto Cultural Peruano Norteamericano.

Benvenuto Murrieta, Pedro. 2003. *Quince plazuelas, una alameda y un callejón: Lima en los años de 1884 a 1887*. Lima: Universidad del Pacífico.

Bertonio, Ludovico. 1612. *Vocabulario de la lengua Aymara*. Juli: Francisco del Canto.

Betanzos, Juan de. 1968 [c. 1551]. "Suma y narración de los Incas." In *Crónicas Peruanas de Interés Indígena*, edited by F. Esteve Barba, 1–56. Madrid: Ediciones Atlas.

Bingham, Alfred. 1989. *Portrait of an Explorer: Hiram Bingham, Discoverer of Machu Picchu*. Ames: Iowa State University Press.

Bingham, Hiram. 1913a. "The Discovery of Machu Picchu." *Harper's Monthly Magazine* 127: 709–719.

———. 1913b. "In the Wonderland of Peru." *National Geographic* 24 (4): 387–573.

———. 1922. *Inca Land: Explorations in the Highlands of Peru*. Boston: Houghton Mifflin.

———. 1930. *Machu Picchu, A Citadel of the Incas*. New Haven: Yale University Press.

———. 1948. *Lost City of the Incas: The Story of Machu Picchu and its Builders*. New York: Hawthorne Books.

Bray, Tamara L. 2003. "Inka Pottery as Culinary Equipment: Food, Feasting, and Gender in Imperial State Design." *Latin American Antiquity* 14 (1): 3–28.

Brüning, Hans Heinrich. 1989 [1922]. *Estudios monográficos del Departamento de Lambayeque*. Edited by J. Vreeland. Chiclayo: Sociedad de Investigación de la Ciencia, Cultura y Arte Norteño.

Bueno, Cosme. 1951 [1769]. *Geografía del Perú virreinal: siglo XVIII*. Lima: Azángaro.

Buntinx, Gustavo, and Luis Eduardo Wuffarden. 1991. "Incas y reyes españoles en la pintura colonial peruana: la estela de Garcilaso." *Márgenes* 8: 151–210.

———. 2003. *Mario Urteaga: nuevas miradas*. Lima: Fundación Telefónica, Museo de Arte de Lima.

Burger, Richard L. 2004. "Scientific Insights into Daily Life at Machu Picchu." In *Machu Picchu: Unveiling the Mystery of the Incas*, edited by R.L. Burger and L.C. Salazar, 85–106. New Haven: Yale University Press.

———. 2008. "Chavín de Huantar and Its Sphere of Influence." In *Handbook of South American Archaeology*, edited by H. Silverman and W.H. Isbell, 681–703. New York: Springer.

———. 2009. "The Emergence of Figuration in Prehistoric Peru." In *Image and Imagination: A Global History of Figurative Representation*, edited by C. Renfrew and I. Morley, 255–270. Cambridge: McDonald Institute of Archaeological Research.

Cabello Valboa, Miguel. 1951 [1586]. *Miscelánea antártica: una historia del Perú antiguo*. Edited by Instituto de Etnología. Lima: Universidad Nacional Mayor de San Marcos.

Calancha, Antonio de la. 1976 [1638]. *Crónica moralizada*. Edited by I. Prado pastor. Vol. 3. Lima: Universidad Nacional Mayor de San Marcos.

Carcedo, Paloma and Luisa Parodi Vetter. 1999. "Usos de minerales y metales a través de las crónicas." In *Los Incas, Arte y Símbolos*, edited by F. G. Y. Pease et al., 167-213. Lima: Banco de Crédito del Perú.

Carcedo, Paloma and Izumi Shimada. 1985. "Behind the Golden Mask: Sican gold artefacts from Batan Grande, Peru." In *Art of pre-Columbian Gold: Jan Mitchell Collection*, edited by J. Jones, 60-75. London: Weidenfeld and Nicolson.

Carpio, Kelly, and María Eugenia Yllia. 2006. "Alicia y Celia Bustamante. La Peña Pancho Fierro y el arte popular." *Illapa* 3: 45–60.

Castillo Butters, Luis Jaime. 1989. *Personajes míticos, escenas y narraciones en la iconografía mochica*. Lima: Fondo Editorial de la Pontificia Universidad Católica del Perú.

———. 2001a. "Rafael Larco y el museo arqueológico Rafael Larco Herrera." In *Los Mochicas*, XII–XXIV. Lima: Museo Arqueológico Rafael Larco Herrera.

———. 2001b. "The Last of the Mochicas: A View from the Jequepeque Valley." In *Moche Art and Archaeology in Ancient Peru*, edited by J. Pillsbury, 307–332. Washington D.C.: National Gallery of Art.

———. 2005. "Las Sacerdotisas de San José de Moro, Rituales Funerarios de Mujeres de Elite en la Costa Norte del Perú." In *Divina y Humana, La Mujer en los Antiguos Perú y México*, edited by M. Castañeda Landázuri and G. Astete, 18–29. Lima: Ministerio de Educación.

Castillo Butters, Luis Jaime et al. 2009. "Ideología y Poder en la Consolidación, Colapso y Reconstitución del Estado Mochica del Jequetepeque. El Proyecto Arqueológico de San José de Moro (1991-2006)." *Ñawpa Pacha* 29: 1-86.

Castillo Butters, Luis Jaime, and Ulla Holmquist. 2000. "Mujeres y poder en la iconografía mochica tardía." In *El hechizo de las imágenes. Estatus social, género y etnicidad en la historia peruana*, edited by N. Henriquez Ayin, 13–34. Lima: Fondo Editorial de la Pontificia Universidad Católica del Perú.

Castillo Butters, Luis Jaime, and Santiago Uceda. 2008. "The Mochicas." In *Handbook of South American Archaeology*, edited by H. Silverman and W.H. Isbell, 707–729. New York: Springer.

Castillo, Teófilo. 1914. "De arquitectura." *Variedades* 10 (327).

Castro, Ignacio de. 1978 [1795]. *Relación del Cuzco*. Lima: Universidad Nacional Mayor de San Marcos.

Celestino, Olinda. 1998. Transformaciones religiosas en los Andes peruanos, 2. Evangelizaciones. *Gazeta de Antropología* (14), http://www.ugr.es/~pwlac/G14_05Olinda_Celestino.pdf.

Ceruti, Constanza. 2010. "Human bodies as objects of dedication at Inca mountain shrines (northwestern Argentina)." *World Archaeology* 36 (1): 103–122.

Chang-Rodríguez, Eugenio. 2009. "José Carlos Mariátegui y la Polémica del Indigenismo." *América Sin Nombre* 13–14: 103–112.

Chávez, Christine. 2006. "Auf den Spuren eines Pioniers. Hans Hinrich Brüning und die Archäologie Nordperus." In *Schatze der Anden: die Inka-Galerie und die Schatzkammern im Museum fur Volkerkunde Hamburg*, edited by W. Köpke and B. Schmelz, 86–111. Hamburg: Museum für Völkerkunde.

Claro, Samuel. 1969. "Música dramática en el Cuzco durante el siglo XVIII y catálogo de manuscritos de música del seminario de San Antonio Abad (Cuzco, Peru)." *Anuario* 5: 1–48.

Cobo, Bernabé. 1956 [1639]. "Fundación de Lima." In *Obras del P. Bernabé Cobo*, edited by F. Mateos. Madrid: Ediciones Atlas.

Collin Delavaud, Claude. 1984. *Las regiones costeñas del Perú septentrional: ocupación humana, desarollo regional*. Piura: Centro de Investigación y Promoción del Campesinado, Lima: Fondo Editorial de la Pontificia Universidad Católica del Perú.

Concolorcorvo. 1965 [1773]. *El Lazarillo: A Guide for Inexperienced Travelers between Buenos Aires and Lima*. Translated by W.D. Kline. Bloomington: Indiana University Press.

Conrad, Geoffrey W. 1980. "Plataformas funerarias." In *Chan Chan, metrópoli Chimú*, edited by R. Ravines, 217–230. Lima: Instituto de Estudios Peruanos.

———. 1982. "The Burial Platforms of Chan Chan: Some Social and Political Implications." In *Chan Chan, Andean Desert City*, edited by M.E. Moseley and K.C. Day, 87–117. Albuquerque: University of New Mexico Press.

Coronado, Jorge. 2009. *The Andes Imagined: Indigenismo, Society, and Modernity*. Pittsburgh: Pittsburgh University Press.

Cossío del Pomar, Felipe. 1927. "Desde París. Los Salones de Pintura." *Variedades* 23 (1010).

Covey, Alan R. 2008. "The Inca Empire." In *Handbook of South American Archaeology*, edited by H. Silverman and W.H. Isbell, 809–830. New York: Springer.

Cummins, Thomas B.F. 1998. "Let Me See! Reading is for Them: Colonial Andean Images and Objects 'como es costumbre tener los caciques Señores.'" In *Native Traditions in the Postconquest World*, edited by E. Hill Boone and T.B.F. Cummins, 91–148. Washington D.C.: Dumbarton Oaks Research Library and Collection.

Daggett, Richard. 1991. "Paracas: Discovery and Controversy." In *Paracas Art and Architecture: Object and Context in South Coastal Peru*, edited by A. Paul, 35–60. Iowa City: University of Iowa Press.

De Gálvez, Elvira. 1969. "Alicia Bustamante, una gran artista que impulsó el arte nativo." *La Prensa*, 5 January: 31.

Dean, Carolyn. 1990. "Painted Images of Cuzco's Corpus Christi: Social Conflict and Cultural Strategy in Viceregal Peru." Ph.D dissertation, University of California, Los Angeles.

———. 1999. *Inka Bodies and the Body of Christ: Corpus Christi in Colonial Cuzco, Peru*. Durham: Duke University Press.

Degregori, Carlos Iván et al. 1978. *Indigenismo, clases sociales y problema nacional: la discusión sobre el "problema indígena" en el Perú*. Lima: Centro Latinoamericano de Trabajo Social.

Díaz del Castillo, Bernal. 1991 [1632]. *Historia verdadera de la conquista de Nueva España*. México, D.F.: Alianza Editorial.

Di Capua, Costanza. 2002. "La luna y el Islam, la serpiente y el Inca, la semántica de la Inmaculada en España y su mensaje ulterior en la Virgen de Quito," In *De la imagen al ícono: estudios de arqueología e historia del Ecuador*, edited by C. Di Capua, 209–232. Quito: Édiciones Abya-Yala.

Donnan, Christopher B. 1975. "The Thematic Approach to Moche Archaeology." *Journal of Latin American Lore* 1 (2): 147–162.

———. 1978. *Moche Art of Peru, Pre-Columbian Symbolic Communication*. Los Angeles: Museum of Cultural History, University of California.

———. 1982. "Dance in Moche Art." *Ñawpa Pacha* 20: 97-120.

———. 1989. "En busca de Naymlap: Chotuna, Chornancap y el valle de Lambayeque." In *Lambayeque*, edited by J.A. de Lavalle, 105–136. Lima: Banco de Crédito del Perú.

———. 1990. "An Assessment of the Validity of the Naymlap Dynasty." In *The Northern Dynasties: Kingship and Statecraft in Chimor*, edited by M.E. Moseley and A. Cordy-Collins, 243–274. Washington D.C.: Dumbarton Oaks Research Library and Collection.

———. 1992. "Oro en el arte Moche." In *Oro del antiguo Perú*, edited by W. Alva and J. A. de Lavalle, 119-193. Lima: Banco de Crédito del Perú.

———. 2010. "Moche State Religion, a Unifying Force in Moche Political Organization." In *New Perspectives on Moche Political Organization*, edited by J. Quilter and L.J. Castillo Butters, 45–67. Washington D.C.: Dumbarton Oaks Research Library and Collection.

Donnan, Christopher B., and Luis Jaime Castillo Butters. 1992. "Finding the Tomb of a Moche Priestess." *Archaeology* 6 (45): 38–42.

Donnan, Christopher B., and Donna McClelland. 1979. *The Burial Theme in Moche Iconography*, Studies in pre-Columbian & Archaeology No. 21. Washington: Dumbarton Oaks, Trustees for Harvard University.

Elera, Carlos. 1993. "El complejo cultural Cupisnique: antecedentes y desarrollo de su ideología religiosa." In *El Mundo Ceremonial Andino*, edited by L. Millones and Y. Onuku, 229–257. Osaka: Museo Nacional de Etnología.

Elera, Carlos G. 2008. "Sicán: arquitectura, tumbas y paisaje." In *Señores de los reinos de la Luna*, edited by K. Makowski, 304–313. Lima: Banco de Crédito del Perú.

Eliade, Mircea. 1985. *Symbolism, the Sacred and the Arts*. Edited by D. Apostolos-Cappadona. New York: Crossroad.

Esquivel y Navia, Diego de. 1980 [1780]. *Noticias Cronológicas de la Gran Ciudad del Cuzco*. Edited by F. Denegri Luna, H. Villanueva Urteaga, and C. Gutiérrez Muñoz. Lima: Fundación Augusto N. Wiese.

Estenssoro, Juan Carlos. 2005. "Construyendo la memoria: la figura del inca y el reino del Perú, de la conquista a Túpac Amaru II." In *Los incas, reyes del Perú*, edited by N. Majluf, 137–141. Lima: Banco de Crédito del Perú.

Esteras Martín, Cristina. 1997. *Platería del Perú virreinal, 1535–1825*. Madrid-Lima: Grupo BBV-Banco Continental.

———. 2004. "120. Eucharistic Urn in the Form of a Pelican," In *The Colonial Andes, Tapestries and Silverwork, 1530–1830*, edited by E. Phipps, J. Hecht, and C. Esteras Martín, 322–324. New York: Metropolitan Museum of Art, New Haven: Yale University Press.

Evans, Clifford. 2011. *Rafael Larco, Fundador* [cited 8 December 2011]. Available from http://www.museolarco.org/biografia.shtml.

Falchetti, Ana Maria. 2003. "The seed of life: the symbolic power of gold-copper alloys and metallurgical transformations." In *Gold and Power in ancient Costa Rica, Panama and Colombia*, edited by J. Quilter and J. W. Hoopes, 345-381. Washington D.C.: Dumbarton Oaks Research Library and Collection.

Favre, Henri. 1996. *L'indigenisme*. Paris: Presses Universitaires de France.

Fernández Alvarado, Julio César. 1992. "Al Encuentro de Naymlap." *Dominical. Suplemento del Diario La Industria de Chiclayo* 20 (1130): 6–7.

———. 1994. "Naymlap. Historia o Realidad: Un Ensayo de la Validez Ideológica Prehispánica." *Folklore. Arte. Turismo y Cultura Popular* 2 (1): 25–31.

———. 2004. *SINTO, Señorío e Identidad en la Costa Norte Lambayecana*. Chiclayo: CROPOTUR.

Franco, Regulo. 2008. "La señora de Cao." In *Señores de los reinos de la Luna*, edited by K. Makowski, 280–287. Lima: Banco de Crédito del Perú.

Fraresso, Carole. 2007. "L'usage du métal dans la parure et les rites de la culture Mochica (150-850 apr. J.-C.), Pérou." Ph.D. dissertation, Université Michel de Montaigne Bordeaux 3, Bordeaux.

———. 2008a. "Sistema técnico de la metalurgia de transformación en la cultura Mochica: nuevas perspectivas." In *Arqueología mochica. Nuevos enfoques*, edited by L. J. Castillo Butters et al., 153-178. Lima: Fondo Editorial de la Pontificia Universidad Católica del Perú.

———. 2008b. "Symbolic Sounds and Technical Characteristics of Moche Rattles from Huaca de la Luna Burials, Peru (A.D. 300-400)." In *Studien zur Musikarchäologie VI: Challenges and Objectives in Music Archaeology*, edited by A. A. Both et al., 439-460. Rahden / Westfalen: Leidorf.

——. 2010. "Estudio arqueometalúrgico de un taller de transformación de cobre y de aleaciones tumbaga en las Huacas de Moche." *Bulletin de l'Institut français d'études andines* 39 (2): 351-387.

——. 2011. "Ancient Peruvian Gold and Silver Jewellery: Fashion and Religion." In *Berg Fashion Library Encyclopaedia of World Dress and Fashion*, 1-8. Oxford: Berg Publishers.

Frézier, Amédée-François. 1735. *A Voyage to the South-Sea, and along the Coasts of Chili and Peru, in the Years 1712, 1713, and 1714*. London: Christian Bowyer.

Garay Albújar, Andrés, and Jorge Villacorta Chávez. 2007. *Max T. Vargas y Emilio Díaz. Dos figuras fundacionales de la fotografía del sur andino peruano, 1896–1926*. Lima: Instituto Peruano de Arte y Diseño, Instituto Cultural Peruano Norteamericano.

García Sáiz, María Concepción. 2002. "Una contribución andina al barroco americano." In *El Barroco Peruano*, edited by R. Mujica Pinilla, 200–221. Lima: Banco de Crédito del Perú.

Gheyn, Jacob de. 1607. *Maniement d'armes, d'arquebuses, mousquetz, et piques*. Amsterdam: R. de Baudous.

Giersz, Milosz, Krzysztof Makowski, and Patrycja Przadka. 2005. *El mundo sobrenatural mochica. Imágenes escultóricas de las deidades antropomorfas en el Museo Arqueológico Rafael Larco Herrera*. Lima: Fondo Editorial de la Pontificia Universidad Católica del Perú.

Gisbert, Teresa. 1980. *Iconografía y mitos indígenas en el arte*. La Paz: Gisbert y Cía.

——. 2004. *Iconografía y mitos indígenas en el arte*. La Paz: Editorial Gisbert.

Goldstein, Paul S. 2005. *Andean Diaspora: The Tiwanaku Colonies and the Origins of South American Empire*. Gainesville: University Press of Florida.

Golte, Jürgen. 2009. *Moche. Cosmología y Sociedad. Una interpretación iconográfica*. Lima: Instituto de Estudios Peruanos, Centro Bartolomé de las Casas.

——. 2011. "Formas básicas y formas combinadas en la cerámica mochica." *Túpac Yawri* 2: 85–107.

Gonzáles Holguín, Diego. 1952 [1607]. *Vocabulario de la lengua general de todo el Perú llamada Qquichua o del Inca*. Lima: Universidad Nacional Mayor de San Marcos.

Gradowska, Ana et al. 1992. *Magna Mater. El sincretismo hispanoamericano en algunas imágenes marianas*. Caracas: Museo de Bellas Artes.

Greer, Paolo. 2009. "Machu Picchu Antes de Bingham." *El Antoniano* 19 (114): 32–39.

Guamán Poma de Ayala, Felipe. 1980 [1615]. *Primer nueva corónica i buen gobierno*. Edited by J.V. Murra and R. Adorno. Mexico D.F.: Siglo Veintiuno Editores.

Gutiérrez de Ceballos, Alfonso Rodríguez. 1999. "Trinidad trifacial." In *Los Siglos de Oro en los virreinatos de América*, 362–264. Madrid: Sociedad Estatal para la conmemoración de los centenarios de Felipe II y Carlos V.

Hampe, Teodoro. 1998. "Max Uhle y los orígenes del Museo Nacional." In *Max Uhle y el Perú antiguo*, edited by P. Kaulicke, 123–156. Lima: Fondo Editorial de la Pontificia Universidad Católica del Perú.

Harth-terré, Emilio. 1928. "Modelos de arquitectura peruana." *Ciudad y Campo y Caminos* 5 (37).

——. 1933. "Los hoteles y el turismo peruano." *Cadelp* 1 (5): 20–21.

——. 1945. "Análisis de una arquitectura peruana contemporánea." *El Arquitecto Peruano* 9 (92).

Heyerdahl, Thor, Daniel H. Sandweiss, and Alfredo Narváez Vargas. 1995. *Pyramids of Túcume: The Quest for Peru's Forgotten City*. New York: Thames and Hudson.

Hocquenghem, Anne-Marie. 1987. *Iconografía mochica*. Lima: Fondo Editorial de la Pontificia Universidad Católica del Perú.

Hocquenghem, Anne-Marie. 1996. "Relación entre mito, rito, canto y baile e imagen: afirmación de la identidad, legitimación del poder y perpetuación del orden." In *Cosmología y música en los Andes*, edited by M. P. Baumann, 137-173. Frankfurt: Vervuert, Madrid: Biblioteca Ibero-Americana.

Holmquist, Ulla. 2010. *Museo Larco. Trésors de l'ancien Pérou*. Lima: Asociación Rafael Larco Hoyle.

Hosler, Dorothy. 1994. *The sounds and colors of power: the sacred metallurgy of ancient West Mexico*. Cambridge: MIT Press.

Isbell, William H. 2008. "Wari and Tiwanaku: International Identities in the Central Andean Middle Horizon." In *Handbook of South American Archaeology*, edited by H. Silverman and W.H. Isbell, 731–759. New York: Springer.

Itier, Cesar. 2008. *Les Incas*. Paris: Éditions Broché.

Jackson, Margaret. 2004. "The Chimú Sculptures of Huacas Tacaynamo and El Dragon, Moche Valley, Peru." *Latin American Antiquity* 15(3): 298–322.

——. 2008. *Moche Art and Visual Culture in Ancient Peru*. Albuquerque: University of New Mexico Press.

Jáuregui, Jesús, and Carlos Bonfiglioli, eds. 1996. *Las danzas de conquista I. México contemporáneo*. México D.F.: Fondo de Cultura Económica de España.

Kagan, Richard. 1998. *Imágenes urbanas del mundo hispánico, 1493–1780*. Madrid: Ediciones El Viso.

Kauffman Doig, Federico. 1992. "Mensaje iconográfico de la orfebrería lambayecana." In *Oro del antiguo Perú*, edited by J.A. De Lavalle, 237–263. Lima: Banco de Crédito del Perú.

Kaulicke, Peter. 2001. *Memoria y muerte en el antiguo Perú*. Lima: Fondo Editorial de la Pontificia Universidad Católica del Perú.

Koninklijk Museum voor Schone Kunsten. 1992. *America Bride of the Sun: 500 Years Latin America and the Low Countries*. Ghent: Imschoot.

Kosok, Paul. 1965. *Life, Land and Water in Ancient Peru*. New York: Long Island University Press.

Kuon Arce, Elizabeth et al. 2009. *Cuzco-Buenos Aires: ruta de intelectualidad americana (1900–1950)*. Lima: Fondo Editorial de la Universidad de San Martín de Porres.

Kutscher, Gerdt. 1983. *Nordperuanische Gefäßmalereien des Moche-Stils*. Munchen: Beck.

Larco Hoyle, Rafael. 1939. *Los Mochicas*. Vol. 2. Lima: Casa editora La Crónica y Variedades.

——. 1948. *Cronología arqueológica del norte del Perú*. Buenos Aires: Sociedad Geográfica Americana.

Lauer, Mirko. 1976. *Introducción a la pintura peruana del siglo XX*. Lima: Mosca Azul Editores.

Lechtman, Heather. 1991. "La metalurgia precolombina: tecnología y valores." In *Los orfebres olvidados de América*, 10-18. Santiago: Museo Chileno de Arte Precolombino, Ediciones Engrama.

Le Guen, Olivier. 2008. "Ubèel pixan: el camino de las almas. Ancestros familiares y colectivos entre los Mayas Yucatecos." *Peninsula* 3 (1): 83–120.

Li Ning Anticona, José. 2000. *El Gollete estribo de la cerámica precolombina peruana, interpretación estética*. Lima: Fondo Editorial de la Universidad Nacional Mayor de San Marcos.

Lieske, Barbel. 2001. *Göttergestalten der Altperuanischen Moche-Kultur*. Berlin: Freie Universität, Zentralinstitut Lateinamerika-Institut.

Macera, Pablo. 2009. "Los Retablos andinos y Joaquín López Antay." In *Trincheras y Fronteras del Arte Popular Peruano*, edited by M. Pinto, 177–204. Lima: Fondo Editorial del Congreso del Perú.

Majluf, Natalia. 1994. "El indigenismo en México y Perú. Hacia una visión comparativa." In *Arte, historia e identidad en América: Visiones comparativas*, edited by G. Curiel, R. González Mello and J. Gutiérrez Haces, 611–628. Mexico: Universidad Nacional Autónoma de México.

——. 1995. "The Creation of the Image of the Indian in Nineteenth-Century Peru: The Paintings of Francisco Laso (1823–1869)." Ph.D. dissertation, University of Texas, Austin.

——. 1997. "Ce n'est pas le Pérou, or, the Failure of Authenticity: Marginal Cosmopolitans at the Paris Universal Exhibition of 1855." *Critical Inquiry* 23 (4): 868–893.

——. 2004a. "Dance Staff." In *The Colonial Andes. Tapestries and Silverworks, 1530–1830*, edited by E. Phipps, J. Hecht, and C. Esteras Martín, 372–374. New York: Metropolitan Museum of Art.

——. 2004b. "El indigenismo." In *Enciclopedia Temática del Perú. XV - Arte y Arquitectura*, edited by L.E. Wuffarden *et al*. Lima: El Comercio.

——, ed. 2005. *Los incas, reyes del Perú*. Lima: Banco de Crédito del Perú.

——. 2011. *Luis Montero. 'Los funerales de Atahualpa.'* Lima: Museo de Arte de Lima.

Majluf, Natalia, and Marcus B. Burke. 2008. *Tipos del Perú: la Lima criolla de Pancho Fierro*. Madrid: Ediciones El Viso, New York: Hispanic Society of America.

Majluf, Natalia, and Luis Eduardo Wuffarden. 1997. *Vinatea Reinoso 1900–1931*. Lima: Telefónica del Perú.

——. 1999. *Elena Izcue. El arte precolombino en la vida moderna*. Madrid: Ediciones de Umbral.

——. 2010. *Camilo Blas*. Lima: Museo de Arte de Lima.

Makowski, Krzysztof. 1994. "Los señores de Loma Negra." In *Vicús*, edited by K. Makowski, 83–142. Lima: Banco de Crédito del Perú.

——. 1996. "Los seres radiantes, el águila y el búho. La imagen de la divinidad en la cultura Mochica, s. II–VIII d.C., costa norte del Perú." In *Imágenes y mitos. Ensayos sobre las artes figurativas en los Andes Prehispánicos*, edited by K. Makowski, I. Amaro Bullon, and M. Hernández, 13–114. Lima: Fondo Editorial Sidea, Australis.

——. 2000. "La Arqueología y el estudio de las religiones andinas." In *Los Dioses del Antiguo Perú*, edited by K. Makowski et al., xix–xxiv. Lima: Banco de Crédito del Perú.

——. 2001. "Ritual y narración en la iconografía Mochica." *Arqueológicas* 25: 175–205.

——. 2003. "La deidad suprema en la iconografía mochica ¿como definirla?" In *Moche: Hacia el final del milenio*, edited by S. Uceda and E. Mujica, 343–382. Lima: Fondo Editorial de la Pontificia Universidad Católica del Perú, Universidad Nacional de Trujillo.

——. 2006. "Late Pre-Hispanic Styles and Cultures of the Peruvian North Coast: Lambayeque, Chimú, Casma." In *Weaving for the Afterlife. Peruvian Textiles from the Maiman Collection*, edited by K. Makowski, et al., 67–102. Tel Aviv: Ampal, NER-HAV Group of Companies.

——. 2008. "El rey y el sacerdote." In *Señores de los reinos de la Luna*, edited by K. Makowski, 77–110. Lima: Banco de Crédito del Perú.

——. 2008. "¿Reyes o Curacas? Las particularidades del ejercicio del poder en los Andes prehispánicos." In *Señores de los reinos de la Luna*, edited by K. Makowski, 1–12. Lima: Banco de Crédito del Perú.

Martínez, Fedora. 2009. "Arte, devoción y Fe. Torito protector." *Gaceta Cultural del Perú* 39: 14-15.

Martinez Compañon, Baltazar Jaime. 1978 [1778–1788]. *La obra del obispo Martínez Compañón sobre Trujillo del Perú en el siglo XVIII*. Edited by R. Porras

Barrenechea. Madrid: Ediciones Cultura Hispánica del Centro Iberoamericano de Cooperación.

Martínez de la Torre, María Cruz. 1986. "Temas iconográficos de la cerámica chimú." *Revista Española de Antropología Americana* 16: 137–152.

Mauss, Marcel. 1923-1924. "Essai sur le don. Forme et raison de l'échange dans les sociétés archaïques." *L'Année sociologique*, Nouvelle série 1: 30-186.

McEwan, Gordon F. 2005. *Pikillacta: The Wari Empire in Cuzco*. Iowa City: University of Iowa Press.

Mesa, José de, and Teresa Gisbert. 1982. *Historia de la pintura cuzqueña*. Lima: Fundación Augusto N. Wiese.

Millones, Luis. 1979. "Los dioses de Santa Cruz (comentarios a la crónica de Juan Santa Cruz Pachacuti Yupanqui Salcamaygua)." *Revista de Indias* 34 (155/158): 123–161.

——. 2010. *Después de la muerte. Voces del Limbo y el Infierno en territorio andino*. Lima: Fondo Editorial del Congreso del Perú.

Mogrovejo, Juan. 2008. "El Sacerdote Lechuza de la Huaca de la Cruz." In *Señores de los reinos de la Luna*, edited by K. Makowski, 294–303. Lima: Banco de Crédito del Perú.

Molina, Cristóbal de. 1989 [1574–1575]. *Fábulas y mitos de los incas*. Edited by H. Urbano and P. Duviols. Madrid: Historia 16.

Moore, Jerry D., and Carol J. Mackey. 2008. "The Chimú Empire." In *Handbook of South American Archaeology*, edited by H. Silverman and W.H. Isbell, 783–807. New York: Springer.

Moseley, Michael E. 2001. *The Incas and their Ancestors: The Archaeology of Peru*. New York: Thames and Hudson.

Mould de Pease, Mariana, and Martín H. Romero Pacheco. 2008. *Machu Picchu: antes y después de Hiram Bingham: entre el saqueo de "antigüedades" y el estudio científico*. Lima: Biblioteca del Centro de Estudios Históricos Luis E. Valcárcel.

Mujica Pinilla, Ramón. 1992. *Ángeles apócrifos en la pintura virreinal*. Lima: Fondo de Cultura Económica, Instituto de Estudios Tradicionales.

——. 2002. "El arte y los sermones." In *El Barroco Peruano*, edited by R. Mujica Pinilla, 218–313. Lima: Banco de Crédito del Perú.

——. 2004. "El 'Niño Jesús Inca' y los jesuitas en el Cusco virreinal." In *Perú indígena y virreinal*, edited by R.J. López Guzmán, 102–106. Madrid: Sociedad Estatal para la Acción Cultural Exterior.

——. 2009. "De centros y periferias: Del grabado europeo al lienzo virreinal peruano." In *De Amberes al Cusco. El grabado europeo como fuente del arte virreinal*, edited by C. Michaud and J. Torres della Pina, 71–83. Lima: Impulso Empresa de Servicios SAC.

Mujica, Soledad. 2004. *La huaconada de Mito*. Lima: Kunay, Centro Andino de Comunicaciones.

Murúa, Martín de. 1616. *Historia General del Piru*. Ms. Ludwig XIII 16. J. Paul Getty Museum, Los Angeles.

Narváez Vargas, Alfredo. 1995. "El Ave Mítica Lambayeque: Nuevas Propuestas Iconográficas (I)." *Utopia Norteña* (1): 109–123.

——. 1996. "Las Pirámides de Túcume. El Sector Monumental." In *Túcume*, edited by T. Heyerdahl, A. Narváez Vargas, and D.H. Sandweiss, 83–151. Lima: Banco de Crédito del Perú.

——. 2006. "Kuélap. En el reino de las nubes." In *Raíces vivas del Perú. Living Roots of Peru*, 128–153. Lima: Servicios Editoriales del Perú.

Netherly, Patricia. 1990. "Out of Many, One: The Organization of Rule in the North Coast Polities." In *The Northern Dynasties: Kingship and Statecraft in Chimor*, edited by M.E. Moseley and A. Cordy-Collins, 461–487. Washington

D.C.: Dumbarton Oaks Research Library and Collection.

Nuñez Rebaza, Lucy. 1986. *La vigencia de la danza de las tijeras en Lima Metropolitana*. Lima: Asociación peruana para el fomento de las ciencias sociales, Lima.

Odriozola, Manuel de, ed. 1873. *Documentos históricos del Perú en las epocas del coloniaje despues de la conquista y de la independencia hasta la presente*. Vol. 4. Lima: Tipografía de Aurelio Alfaro.

Oliva, Anello. 1895 [1598]. *Libro primero del manuscrito original del R.P. Anello Oliva S.J. – Historia del reino y provincias del Perú, de sus incas reyes, descubrimiento y conquista por los españoles de la corona de Castilla, con otras singularidades concernientes a la historia*. Edited by J.F. Pazos Varela and L. Varela de Orbegoso. Lima: Imprenta y Libreria de S. Pedro.

Orlove, Benjamin S. 1993. "Putting Race in Its Place: Order in Colonial and Postcolonial Peruvian Geography." *Social Research* 60 (2): 301–336.

Paredes Nuñez, Arturo. 1987. "Elementos para una Evaluación de los Términos Lambayeque y Sicán." *Yunga* 1 (1): 90–100.

Patterson, Thomas C. 1995. *Toward a Social History of Archaeology in the United States*. New York: Harcourt Brace and Company.

Penhall, Michele M. 2001. "El pictorialismo en los Andes." In *La recuperación de la memoria. El primer siglo de la fotografía. Perú, 1842–1942*, edited by N. Majluf and L.E. Wuffarden, 156–161. Lima: Museo de Arte de Lima y Fundación Telefónica.

Pino Matos, José Luis. 2010. *El recuerdo del Inca. Tradición, conflicto e identidad*. Lima: Dirección de Registro y Estudio de la Cultura en el Perú Contemporáneo, Programa Qhapaq Ñan (Instituto Nacional de Cultura).

Piqueras Cotolí, Manuel. 1992. "Algo sobre el ensayo de estilo neoperuano." *Historia, urbanismo, arquitectura, construcción, arte: H.U.A.C.A.* (3).

Pollak-Eltz, Angelina. 1983. "Masks and masquerades in Venezuela." In *The Power of Symbols: Masks and Masquerade in the Americas*, edited by N.R. Crumrine and M.M. Halpin, 174–192. Vancouver: University of British Columbia Press.

Poole, Deborah. 1997. *Vision, Race, and Modernity. A Visual Economy of the Andean Image World*. Princeton: Princeton University Press.

Portocarrero Suárez, Felipe. 2007. *El Imperio Prado, 1890–1970*. Lima: Centro de Investigación de la Universidad del Pacífico.

Pozorski, Shelia, and Thomas Pozorski. 2008. "Early Cultural Complexity on the Coast of Peru." In *Handbook of South American Archaeology*, edited by H. Silverman and W.H. Isbell, 607–631. New York: Springer.

Proulx, Donald A. 2006. *A Sourcebook of Nasca Ceramic Iconography: Reading a Culture Through Its Art*. Iowa City: University of Iowa Press.

——. 2008. "Paracas and Nasca: Regional Cultures on the South Coast of Peru." In *Handbook of South American Archaeology*, edited by H. Silverman and W.H. Isbell, 561–585. New York: Springer.

Quilter, Jeffrey, and Luis Jaime Castillo Butters, eds. 2010. *New Perspectives on Moche Political Organization*. Washington D.C.: Dumbarton Oaks Research Library and Collection.

Ramirez, Susan. 1981. "La organización económica de la costa norte: un análisis preliminar del periodo prehispánico tardío." In *Etnohistoria y antropología andina*, edited by A. Castelli, M. Koth de Paredes, and M. Mould de Pease, 281–297. Lima: Centro de Proyección Cristiana.

Ramirez, Susan. 2002. "El saqueo de una huaca en la costa norte Peruana: una historia, dos versiones." In *El mundo al revés : contactos y conflictos transculturales en el Perú del siglo XVI*, edited by S. Ramirez, 232-241. Lima: Fondo Editorial de la Pontificia Universidad Católica del Perú.

——. 1996. *The World Upside Down: Cross-Cultural Contact and Conflict in Sixteenth-Century Peru*. Stanford: Stanford University Press.

Ramos Smith, Maya. 1990. *La danza en México durante la época colonial*. México D.F.: Alianza Editorial.

Ranney, Edward. 2001. "Martín Chambi. De Coasa y del Cusco." In *La recuperación de la memoria. El primer siglo de la fotografía. Perú, 1842–1942*, edited by N. Majluf and L.E. Wuffarden, 134–155. Lima: Museo de Arte de Lima y Fundación Telefónica.

Reichel-Dolmatoff, Gerardo. 1988. *Orfebrería y Chamanismo: Un Estudio Iconográfico del Museo del Oro del Banco de la Republica, Colombia*. Bogotá: Villegas Editores.

Reichlen, Henry, and Paule Reichlen. 1949. "Recherches archéologiques dans les Andes de Cajamarca. Premier rapport de la mission ethnologique française au Pérou Septentrional." *Journal de la Société des Américanistes* 38: 137–174.

Restrepo Manrique, Daniel. 1992. *La Iglesia de Trujillo (Perú) bajo el episcopado de Baltasar Jaime Martínez Compañón, 1780–1790*. 2 vols. Vitoria-Gasteiz: Eusko Jaurlaritzaren Argitalpen Zerbitzu Nagusia – Servicio Central de Publicaciones del Gobierno Vasco.

Ríos Acuña, Sirley. 2010. "El arte del mate decorado: trayectoria histórica y continuidad cultural." In *Patrimonio cultural inmaterial latinoamericano II. Artesanías*, 129–187. Cuzco: Centro Regional para la Salvaguardia del Patrimonio Cultural Inmaterial de América Latina.

Riviale, Pascal. 1996. *Un siecle d'archéologie française au Pérou (1821–1914)*. Paris: L'Harmattan.

Rostworowski de Diez Canseco, María. 1981. *Recursos naturales renovables y pesca, siglos XVI y XVII*. Lima: Instituto de Estudios Peruanos.

——. 1983. *Estructuras andinas del poder. Ideología religiosa y política*. Lima: Instituto de Estudios Peruanos.

——. 1992. *Pachacamac y el Señor de los Milagros: una trayectoria milenaria*. Lima: Instituto de Estudios Peruanos.

Rowe, John H. 1951. "Colonial Portraits of Inca Nobles." In *The Civilizations of Ancient America: Selected Papers of the XXIX International Congress of Americanists*, edited by S. Tax, 258–268. Chicago: University of Chicago Press.

——. 1954. *Max Uhle, 1856–1944. A Memoir of the Father of Peruvian Archaeology*, University of California Publications in American Archaeology and Ethnology 46 (1). Berkeley: University of California, Berkeley.

——. 1998. "Max Uhle y la idea del tiempo en la arqueología americana." In *Max Uhle y el Perú antiguo*, edited by P. Kaulicke, 5–21. Lima: Fondo Editorial de la Pontificia Universidad Católica del Perú.

Rubiños y Andrade, Justo Modesto. 1936 [1782]. "Sucesión Cronológica o Serie Historial de los Curas de Mórrope y Pacora en la Provincia de Lambayeque del Obispado de Truxillo del Perú." *Revista Histórica* 10 (3): 289–363.

Rucabado, Julio. 2008. "En los dominios de Naymlap." In *Señores de los reinos de la Luna*, edited by K. Makowski, 183–199. Lima: Banco de Crédito del Perú.

Sabogal Dieguez, José. 1929. "Los mates y el yaravi." *Amauta* 4 (26): 17–20.

——. 1975. *Del Arte en el Perú y otros ensayos.* Lima: Instituto Nacional de Cultura.

Sabogal Wiesse, José R. 1974. "La villa de Santiago de Cao, ayer. Narración de don Enrique." *Anuario Indigenista* 34: 91–151.

Salazar, Carmen. 1993. "Encuentro entre dos mundos: las creencias acerca de la generación y explotación de los metales en las minas andinas, siglos XVI–XVIII." In *Etnicidad, economía y simbolismo en los Andes*, edited by S. Arze et al., p. 237-253. La Paz: Hisbol, SBH-ASUR; Lima: Institut français d'études andines.

Salazar, Lucy C. 2004. "Machu Picchu: Mysterious Royal Estate in the Cloud Forest." In *Machu Picchu: Unveiling the Mystery of the Incas*, edited by R.L. Burger and L.C. Salazar, 21–47. New Haven: Yale University Press.

——. 2007. "Machu Picchu's Silent Majority: A Consideration of the Inka Cemeteries." In *Variations in the Expression of Inka Power*, edited by R.L. Burger, C. Morris, and R. Matos Mendieta, 165–183. Washington D.C.: Dumbarton Oaks Research Library and Collection.

Salazar, Lucy C., and Richard L. Burger. 2004. "Lifestyles of the Rich and Famous: Luxury and Daily Life in the Households of Machu Picchu's Elite." In *Palaces of the Ancient New World*, edited by S.T. Evans and J. Pillsbury, 325–357. Washington D.C.: Dumbarton Oaks Research Library and Collection.

Sánchez Gamarra, Mery Alinda. 1971. "Fiesta de San Isidro, patrón de los agricultores." *Allpanchis* 3: 87–98.

Sánchez, Luis Alberto. 1981. "Reflexiones sobre la idea del indigenismo en la literatura peruana." *Oiga* 5 (23–25).

Sarmiento de Gamboa, Pedro. 1943 [1572]. *Historia de los Incas.* Buenos Aires: Emece.

Scanu, Marcelo. 1986–1987. "Santuarios de altura en los Andes." *Revista del Museo Nacional* 48: 213–249.

Schaedel, Richard P. 1966. "The Huaca El Dragón." *Journal de la Société des Américanistes* 55 (2): 383–496.

——. 1985. "Coast-Highland Interrelationships and Ethnic Groups in the Northern Perú (500 B.C.–A.D. 1980)." In *Andean Ecology and Civilization. An Interdisciplinary Perspective on Andean Ecological Complementarity*, edited by Y. Masuda, I. Shimada and C. Morris, 443–473. Tokyo: Tokyo University Press.

——. 1988. *La etnografía muchik en las fotografías de H. Brüning 1886–1925.* Lima: Cofide: Oficina de Asuntos Culturales de la Corporación Financiera de Desarrollo S.A.

Schmelz, Bernd. 1992. *Kontinuität und Wandel religiöser Feste im Departamento Lambayeque (Peru).* Bonn: Holos Verlag.

——. 2003. "Hans Heinrich Brüning – documentalista etnográfico de la costa norte del Perú." In *Walzenaufnahmen aus Peru 1910–1925 / Grabaciones en cilindro del Perú 1910–1925*, edited by S. Ziegler, 72–79. Berlin: Berliner Phonogramm-Archiv, Staatliche Museen.

——. 2007. *Hans H. Brüning (1848–1928) y su herencia científica al Perú.* Hamburg: Museum für Völkerkunde.

——. 2010a. "Der Forscher Hans H. Brüning (1848–1928) und sein Nachlass." In *Händler, Pioniere, Wissenschaftler. Hamburger in Lateinamerika*, edited by J.A.U. Mücke, 109–118. Berlin: Lit.

——. 2010b. *Eten (Peru) en el siglo XVII. El milagro de la aparición del Niño Jesús.* Hamburg: Museum für Völkerkunde.

Shady Solis, Ruth. 2006. "America's First City? The Case of Late Archaic Caral." In *Andean Archaeology III: North and South*, edited by W.H. Isbell and H. Silverman, 28–66. New York: Springer.

Shimada, Izumi. 1985. "La cultura Sicán: Una caracterización arqueológica." In *Presencia histórica de Lambayeque*, edited by E. Mendoza Samillán, 76–133. Lima: Ediciones y Representaciones H. Falconi.

——. 1986. "Batán Grande and Cosmological Unity in the Prehistoric Central Andes." In *Andean Archaeology*, edited by R. Matos Mendieta, S.A. Turpin, and H.H. Eling, 163–188. Los Angeles: University of California.

——. 1990. "Cultural Continuities and Discontinuities on the Northern North Coast of Peru, Middle-Late Horizons." In *The Northern Dynasties: Kingship and Statecraft in Chimor*, edited by M.E. Moseley and A. Cordy-Collins, 297–392. Washington D.C.: Dumbarton Oaks Research Library and Collection.

——. 1995. *Cultura Sicán: Dios, riqueza y poder en la costa norte del Perú.* Lima: Fundación del Banco Continental para el Fomento de la Educación y de la Cultura.

Shimada, Izumi, and Carlos G. Elera. 2007. *Informe de la Temporada del Año 2006 del Proyecto Arqueológico Sicán en Huaca Loro en el Sitio de Sicán, Valle Medio de La Leche, Provincia de Ferreñafe, Departamento de Lambayeque.* Report presented to the Instituto Nacional de Cultura.

Silverman, Helaine, and Donald A. Proulx. 2002. *The Nasca.* Oxford-Malden, Mass.: Blackwell.

Stastny, Francisco. 1976. "Arcángel o Lliviac." Paper read at Ciclo de conferencias Iconografía e iconología at Instituto de Investigaciones Estéticas, Universidad Nacional Autónoma de México.

——. 1981. *Las artes populares del Perú.* Lima: Edubanco.

——. 1993. *Síntomas medievales en el "barroco americano".* Lima: Instituto de Estudios Peruanos.

——. 1997. "Platería colonial, un trueque divino." In *Plata y plateros del Perú*, edited by J. Torres della Pina and V. Mujica Diez de Canseco, 119–265. Lima: Patronato Plata del Perú.

——. 2001. "De la confesión al matrimonio: ejercicios en la representación de correlaciones con incas coloniales." *Revista del Museo Nacional* 49: 105–167.

Stevenson, Robert. 1980. "Cuzco Cathedral: 1546–1750." *Inter-American music review* 3 (1): 29–71.

Stone-Miller, Rebecca. 2002. *Art of the Andes: from Chavín to the Inca.* London: Thames and Hudson.

Taylor, Gérald. 1980. *Rites et traditions de Huarochiri: manuscrit quechua du début du 17ᵉ siècle.* Paris: L'Harmattan.

Tello, Julio C. 1923. *Wira-Kocha.* Lima: s.n. Originally published in *Inca* 1 (1, 3).

——. 1960. *Chavín, cultura matriz de la civilización andina.* Lima: Impr. de la Universidad de San Marcos.

Tello, Julio C., and Toribio Mejía Xesspe. 1967. *Historia de los museos nacionales del Perú, 1822–1946.* Lima: Museo Nacional de Antropología y Arqueología, Instituto y Museo de Arqueología de la Universidad Nacional de San Marcos.

Torres Bohl, José. 1989. *Apuntes sobre José Sabogal. Vida y obra.* Lima: Fondo Editorial del Banco Central de Reserva del Perú.

Trimborn, Hermann. 1979. *El reino de Lambayeque en el antiguo Perú.* St. Augustin: Haus Völker und Kulturen, Anthropos-Institut.

Uceda Castillo, Santiago. 1996. "El poder y la muerte en la sociedad Moche." In *Al final del camino*, edited by L. Millones and M. Lemlif, 20–36. Lima: Seminario Interdisciplinario de Estudios Andinos.

——. 1999. "Esculturas en miniatura y una maqueta en madera: El culto a los Muertos y a los Ancestros en la época Chimú." *Beiträge zur Allgemeinen und Vergleichenden Archäologie* 19: 259–311.

——. 2004a. "Los Sacerdotes del Arco Bicéfalo: Tumbas y Ajuares Hallados en la Huaca de la Luna y su Relación con los Rituales Moche, Parte I." *Arkinka, Revista de Arquitectura, Diseño y Construcción* 98: 96-104.

——. 2004b. "Los Sacerdotes del Arco Bicéfalo: Tumbas y Ajuares Hallados en la Huaca de la Luna y su Relacion con los Rituales Moche, Parte II." *Arkinka, Revista de Arquitectura, Diseño y Construcción* 99: 92-99.

Uceda Castillo, Santiago and Carlos Rengifo Chunga. 2006. "La especialización del trabajo: teoría e arqueología." *Bulletin de l'Institut français d'études andines* 35 (2): 149-185.

Uceda, Santiago, and Ricardo Morales. 2010. *Moche, Pasado y Presente.* Trujillo: Patronato Huacas del Valle de Moche, Fondo Contravalor Perú Francia, Universidad Nacional de Trujillo.

Ulfe, María Eugenia. 2009. "Representaciones del (y lo) indígena en los retablos peruanos." *Bulletin de l'Institut français d'études andines* 38 (2): 307–326.

Unanue, José Hipólito. 1985 [1793]. *Guía política, eclesiástica y militar del Virreynato del Perú, para el año de 1793.* Edited by J. Durand. Lima: Cofide: Oficina de Asuntos Culturales de la Corporación Financiera de Desarrollo S.A.

Unruh, Vicky. 1989. "Mariátegui's Aesthetic Thought: A Critical Reading of the Avant-Gardes." *Latin American Research Review* 24 (3): 45–69.

Urton, Gary. 2003. *Signs of the Inka Khipu: Binary Coding in the Andean Knotted-String Records.* Austin: University of Texas Press.

Valcárcel, Luis E. 1949. "Supervivencias precolombinas en el Perú actual." *Revista del Museo Nacional* 18: 3–18.

——. 1964. *Historia del Perú Antiguo.* Lima: Editorial J. Mejia Baca.

Valdizán, Hermilio. 1934. *Víctor Larco Herrera: el hombre, la obra.* Santiago de Chile: Imprenta Nascimento.

Vega, Garcilaso de la. 1964 [1609]. *Comentarios Reales.* Edited by A. Cortina. Buenos Aires: Espasa-Calpe Argentina.

Velaochaga, Eduardo. 1933. "Escuela de Arte Textil Peruano." *Cadelp* 1 (4).

Velarde, Héctor. 1938. "La arquitectura y nuestro medio." *El Arquitecto Peruano* 2 (11).

——. 1940. "Anteproyecto de Monumento – Basílica a Santa Rosade Lima, Patrona de las Américas." In *The Fifteenth International Congress of Architects. Report*, 240–252. Washington: American Institute of Architects.

Vetter Parodi, Luis María, and Paloma Carcedo de Mufarech. 2009. *El tupo: símbolo ancestral de identidad femenina.* Lima: Gráfica Biblos.

Vich, Cynthia. 2000. *Indigenismo de vanguardia en el Perú. Un estudio sobre el 'Boletín Titikaka.'* Lima: Fondo Editorial de la Pontificia Universidad Católica del Perú.

Villegas, Fernando. 2006. "El Instituto de Arte Peruano (1931–1973): José Sabogal y el mestizaje en arte." *Illapa* 3: 21–34.

——. 2008. "José Sabogal y el arte mestizo: El Instituto de Arte Peruano y sus acuarelas." Licenciatura, Universidad Nacional Mayor de San Marcos.

Wachtel, Nathan. 1971. *La vision des vaincus. Les Indiens du Pérou devant la conquête espagnole, 1530–1570.* Paris: Gallimard.

Weiner, Annette B. 1992. *Inalienable possessions: the paradox of keeping-while-giving*. Berkeley: University of California.

Willey, Gordon R., and Jeremy A. Sabloff. 1974. *A History of American Archaeology*. London: Thames and Hudson.

Woloszyn, Janusz. 2008. *Un millar de rostros silenciosos. Los "huacos retrato" en la cultura Moche*. Lima: Universidad de Varsovia, Fondo Editorial de la Pontificia Universidad Católica del Perú.

Wuffarden, Luis Eduardo. 1999a. "La ciudad y sus emblemas: imágenes del criollismo en el virreinato del Perú." In *Los Siglos de Oro en los virreinatos de América*, 59–76. Madrid: Sociedad Estatal para la conmemoración de los centenarios de Felipe II y Carlos V.

——. 1999b. "Virgen hilandera." In *Los Siglos de Oro en los virreinatos de América*, 344–346. Madrid: Sociedad Estatal para la conmemoración de los centenarios de Felipe II y Carlos V.

——. 2003. "Manuel Piqueras Cotolí, neoperuano de ambos mundos." In *Manuel Piqueras Cotolí (1885-1937), arquitecto, escultor y urbanista entre España y el Peru*, 21–61. Lima: Museo de Arte de Lima.

——. 2005. "La descendencia real y el 'renacimiento inca' en el virreinato." In *Los incas, reyes del Perú*, edited by N. Majluf, 189–201. Lima: Banco de Crédito del Perú.

Wuffarden, Luis Eduardo, and Natalia Majluf. 1997. *Vinatea Reinoso 1900–1931*. Lima: Telefónica del Perú.

Yllia Miranda, María Eugenia. 2006. "El mate mestizo de José Sabogal." In *El fruto decorado. Mates bruilados del valle del Mantaro (siglos XVIII–XX)*, 45–54. Lima: ICPNA.

Zevallos Quiñones, Jorge. 1971. *Cerámica de la cultura Lambayeque (Lambayeque I)*. Trujillo: Universidad Nacional de Trujillo.

——. 1989a. *Los cacicazgos de Lambayeque*. Trujillo: Consejo Nacional de Ciencia, Tecnología e Innovación Tecnológica – CONCYTEC.

——. 1989b. "Introducción a la cultura Lambayeque." In *Lambayeque*, edited by J.A. de Lavalle, 15–103. Lima: Banco de Crédito del Perú.

Ziegler, Susanne. 2003. *Walzenaufnahmen aus Peru 1910–1925 / Grabaciones en cilindro del Perú 1910–1925*. Berlin: Berliner Phonogramm-Archiv, Staatliche Museen.

The Inca Empire, about 1532, with the principal Inca and pre-Inca archeological sites

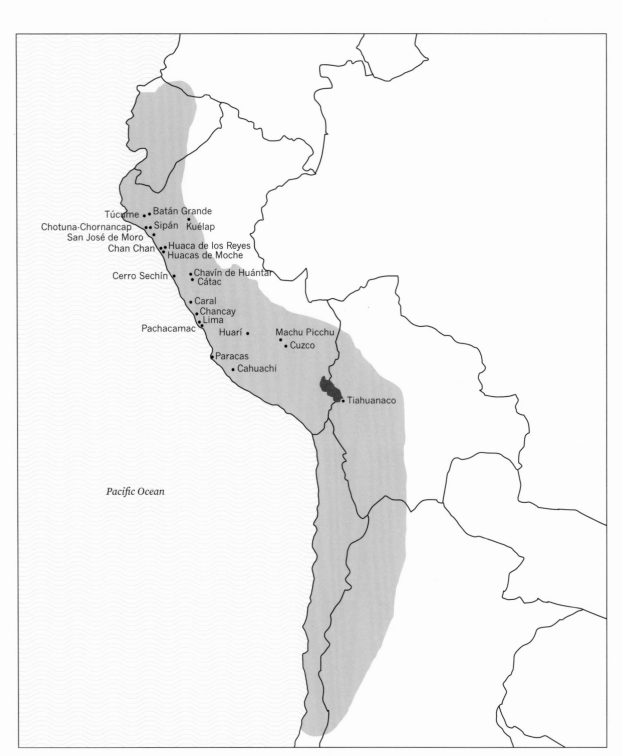

Territory of the *Tahuantinsuyu* in 1532 (shown in gray)

0 500 km

Túcume Batán Grande
Chotuna-Chornancap Sipán Kuélap
San José de Moro
Chan Chan Huaca de los Reyes
Huacas de Moche
Cerro Sechín Chavín de Huántar
Cátac
Caral
Chancay
Lima
Pachacamac Huarí Machu Picchu
Cuzco
Paracas
Cahuachi
Tiahuanaco

Pacific Ocean

The Viceroyalty of Peru,
with its towns and cities and principal
centers of artistic production

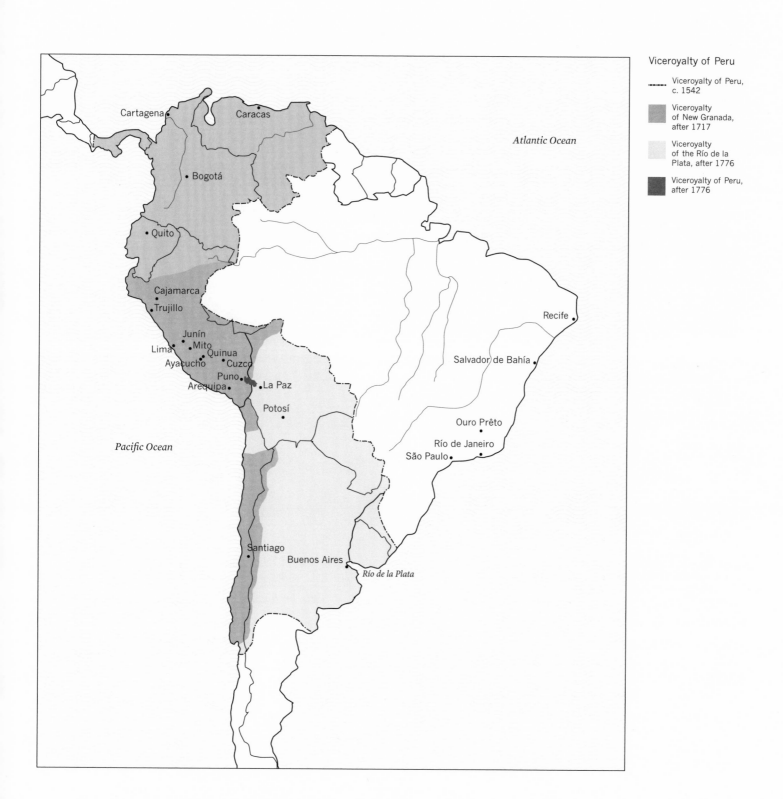

Viceroyalty of Peru

- - - Viceroyalty of Peru, c. 1542

Viceroyalty of New Granada, after 1717

Viceroyalty of the Río de la Plata, after 1776

Viceroyalty of Peru, after 1776

Atlantic Ocean

Cartagena
Caracas
Bogotá
Quito
Cajamarca
Trujillo
Junín
Lima
Mito
Quinua
Ayacucho
Cuzco
Puno
Arequipa
La Paz
Potosí
Recife
Salvador de Bahía
Ouro Prêto
Río de Janeiro
São Paulo
Santiago
Buenos Aires
Río de la Plata

Pacific Ocean

Photo credits – Works in the exhibition

Courtesy of the Division of Anthropology, American Museum of Natural History: cats. 84, 121

© Bibliothèque et Archives nationales du Québec. Photo Michel Legendre: cats. 167, 168, 170

Centre de conservation du Québec. Photo Jacques Beardsell: cat. 29

Courtesy Archivo Fotográfico Martín Chambi, Cuzco – Peru: cats. 234, 239, 240, 241, 316

Teo Allain Chambi: cats. 112, 119, 187, 288

© Collection Centre Canadien d'Architecture / Canadian Centre for Architecture, Montréal: cats. 6, 7, 8, 9, 235, 298, 299, 300, 301, 302, 303, 304, 305

Archivo de la Escuela Nacional Superior Autónoma de Bellas Artes del Perú: cat. 196

Daniel Giannoni: cats. 140, 150, 151, 152, 154, 157, 174, 176, 178, 180, 181, 191, 192, 198, 200, 310

Courtesy of The Hispanic Society of America, New York: cats. 162, 164, 177, 179, 211, 201, 202, 203, 204, 205, 206, 207, 208, 209, 210, 211, 212, 213, 231, 295

Image © The Metropolitan Museum of Art / Art Resource, NY: cats. 42, 56, 66, 88, 125, 128

Digital image © The Museum of Modern Art / Licensed by SCALA / Art Resource, NY: cats. 216, 218, 225, 229, 236, 315

The Montreal Museum of Fine Arts, Marilyn Aitken: cat. 37

The Montreal Museum of Fine Arts, Jean-François Brière: cats. 163, 281, 325

The Montreal Museum of Fine Arts, Denis Farley: cats. 27, 32, 36, 38, 39

The Montreal Museum of Fine Arts, Christine Guest: cats. 30, 31, 40, 43, 107, 108, 173, 245, 248, 273, 279, 280

© 2012. musée du quai Branly, photo Thierry Ollivier, Michel Urtado / Scala, Florence: cats. 110, 275

Museo de Arte de Lima: cats. 105, 156, 159, 199, 226, 267, 272, 274, 284, 314

Courtesy of the Museo de Arte de Lima: cat. 317

Museo Larco, Lima – Perú: cats. 62, 120, 139

Museos "Oro del Perú" – "Armas del Mundo", Fundación Miguel Mujica Gallo, Lima-Perú / Patricia Arana: cats. 145, 146

Museos "Oro del Perú" – "Armas del Mundo", Fundación Miguel Mujica Gallo, Lima-Perú / © 2011 Joaquín Rubio: cats. 85, 86, 91, 92, 124, 126, 127, 129, 144

Museo Pedro de Osma, Lima – Perú: cats. 148, 171, 172

Museo de Sitio Túcume, Lambayeque: cats. 106, 109

© Museum für Völkerkunde Hamburg: cats. 12, 13, 14, 15, 17, 18, 237, 238, 242, 243, 285, 286, 297

New Orleans Museum of Art: cats. 153, 160, 161

Copyright © by The Irving Penn Foundation: cats. 290, 292, 291, 293, 294

Pinacoteca Municipal "Ignacio Merino" de la Municipalidad Metropolitana de Lima: cats. 224, 230

With permission of the Royal Ontario Museum © ROM: cat. 169

© 2011 Joaquín Rubio: cats. 10, 12, 22, 23, 24, 25, 26, 28, 41, 44, 45, 46, 47, 48, 49, 50, 51, 52, 53, 54, 55, 57, 58, 59, 60, 61, 63, 64, 65, 67, 68, 69, 70, 71, 72, 73, 74, 75, 76, 77, 78, 79, 80, 81, 82, 83, 87, 89, 90, 93, 94, 95, 96, 97, 98, 99, 100, 101, 102, 103, 104, 115, 116, 123, 130, 131, 132, 133, 134, 135, 136, 137, 138, 141, 143, 147, 149, 155, 158, 165, 166, 175, 182, 183, 184, 185, 186, 188, 189, 190, 193, 194, 195, 197, 214, 215, 217, 219, 220, 221, 222, 223, 227, 228, 232, 233, 244, 246, 247, 249, 250, 251, 252, 253, 254, 255, 256, 257, 258, 259, 260, 261, 262, 263, 264, 265, 266, 268, 269, 270, 271, 276, 277, 282, 283, 287, 289, 296, 306, 307, 309, 311, 312, 313, 318, 319, 320, 321, 322, 323, 324, 326, 327, 328, 329

Seattle Art Museum, Paul Macapia: cats. 33, 34, 142

Seattle Art Museum, Elizabeth Mann: cats. 35, 278

Yale Peabody Museum of Natural History, New Haven: cats. 111, 113, 114, 117, 118, 308

Courtesy of The Hispanic Society of America, New York et Hiram Bingham-Yale Peabody Museum/ National Geographic Stock: cats. 2, 3, 5

Hiram Bingham / National Geographic Stock: cat. 1

Hiram Bingham-Yale Peabody Museum/National Geographic Stock: cat. 4

C. Daniel Howell and Mark O Thiessen / National Geographic Stock: cat. 16

Private collection, Lima: cat. 11

Private collection, Lima: cat. 19

Private collection, Lima: cat. 20

Private collection, Lima: cat. 21

ISBN The Montreal Museum of Fine Arts:
978-2-89192-365-1
ISBN Seattle Art Museum edition: 978-2-89192-366-8
ISBN 5 Continents Editions: 978-88-7439-629-0

Aussi publié en français sous le titre
Pérou : Royaumes du Soleil et de la Lune
ISBN Musée des beaux-arts de Montréal:
978-2-89192-364-4
ISBN 5 Continents Editions: 978-88-7439-567-5

Distributed in the United States and Canada by Harry N. Abrams, Inc., New York. Distributed outside the United States and Canada, excluding France and Italy, by Abrams & Chronicle Books Ltd UK, London

The Montreal Museum of Fine Arts
P.O. Box 3000
Station H
Montreal, Quebec
Canada
H3G 2T9
www.mmfa.qc.ca

5 Continents Editions
Piazza Caiazzo, 1
20124 Milan, Italy
www.fivecontinentseditions.com

Legal deposit: 1st quarter 2013
Bibliothèque et Archives nationales du Québec
National Library of Canada

Printed in Italy

Printed and bound in Italy in December 2012 by Grafiche Flaminia, Trevi (PG) for 5 Continents Editions, Milan